# GARDNER'S
# ART
## THROUGH THE
# AGES

## NON-WESTERN PERSPECTIVES

### THIRTEENTH EDITION

## FRED S. KLEINER

WADSWORTH
CENGAGE Learning™

Australia • Brazil • Japan • Korea • Mexico • Singapore • Spain • United Kingdom • United States

WADSWORTH
CENGAGE Learning

**Gardner's Art through the Ages: Non-Western Perspectives, Thirteenth Edition**
Fred S. Kleiner

Publisher: Clark Baxter

Senior Development Editor: Sharon Adams Poore

Assistant Editor: Kimberly Apfelbaum

Editorial Assistant: Nell Pepper

Senior Media Editor: Wendy Constantine

Senior Marketing Manager: Diane Wenckebach

Marketing Communications Manager: Heather Baxley

Senior Project Manager, Editorial Production: Lianne Ames

Senior Art Director: Cate Rikard Barr

Senior Print Buyer: Judy Inouye

Production Service/Layout: Joan Keyes,
    Dovetail Publishing Services

Text Designer: tani hasegawa

Photo Researchers: Sarah Evertson, Stephen Forsling

Cover Designer: tani hasegawa

Cover Image: Serpent Mound, Mississippian, Ohio,
    ca. 1070. © Tony Linck/Superstock.

Compositor: Thompson Type

For product information and technology assistance, contact us at
**Cengage Learning Academic Resource Center,
1-800-423-0563**
For permission to use material from this text or product, submit all requests online at **www.cengage.com/permissions.**
Further permissions questions can be emailed to
**permissionrequest@cengage.com**

Library of Congress Control Number: 2008936369

ISBN-13: 978-0-495-57367-8
ISBN-10: 0-495-57367-1

**Wadsworth**
25 Thomson Place
Boston, MA 02210-1202
USA

Cengage Learning products are represented in Canada by Nelson Education, Ltd.

For your course and learning solutions, visit **academic.cengage.com**

Purchase any of our products at your local college store or at our preferred online store **www.ichapters.com**

Printed in the United States of America
6 7 15 14

# About the Author

FRED S. KLEINER (Ph.D., Columbia University) is the co-author of the 10th, 11th, and 12th editions of *Art through the Ages* and more than a hundred publications on Greek and Roman art and architecture, including *A History of Roman Art,* also published by Wadsworth. He has taught the art history survey course for more than three decades, first at the University of Virginia and, since 1978, at Boston University, where he is currently Professor of Art History and Archaeology and Chair of the Art History Department. Long recognized for his inspiring lectures and devotion to students, Professor Kleiner won Boston University's Metcalf Award for Excellence in Teaching as well as the College Prize for Undergraduate Advising in the Humanities in 2002 and is a two-time winner of the Distinguished Teaching Prize in the College of Arts and Sciences Honors Program. He was Editor-in-Chief of the *American Journal of Archaeology* from 1985 to 1998.

Also by Fred Kleiner: *A History of Roman Art* (Wadsworth 2007; ISBN 0534638465), winner of the 2007 Texty Prize as the best new college textbook in the humanities and social sciences. In this authoritative and lavishly illustrated volume, Professor Kleiner traces the development of Roman art and architecture from Romulus' foundation of Rome in the eighth century BCE to the death of Constantine in the fourth century CE, with special chapters devoted to Pompeii and Herculaneum, Ostia, funerary and provincial art and architecture, and the earliest Christian art.

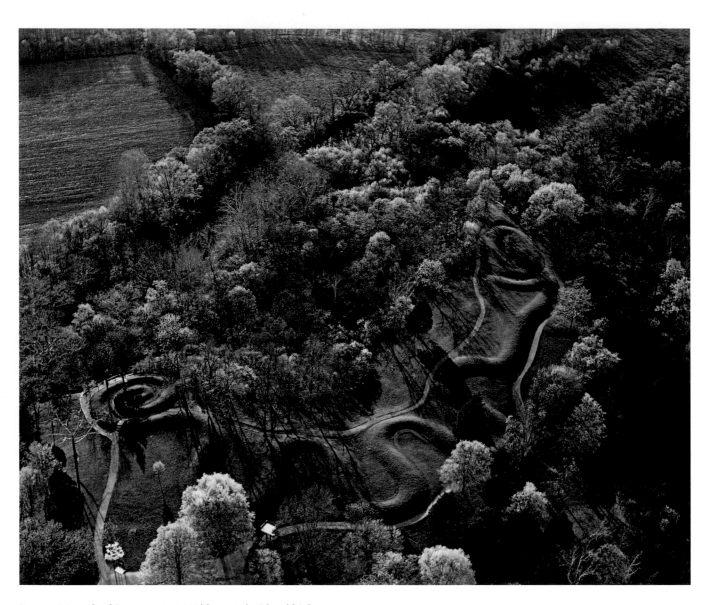

Serpent Mound, Ohio, ca. 1070. 1,200′ long, 20′ wide, 5′ high.

# About the Cover Art

Serpent Mound is one of the largest monuments surviving from the Native American cultures that flourished in North America before the arrival of Europeans at the end of the 15th century. First excavated in the 1880s, this "effigy mound" represents one of the first efforts at preserving a Native American site from destruction at the hands of pot hunters and farmers. Scholars believe that the people known as the Mississippians built Serpent Mound during the 11th century. Unlike most other ancient Native American mounds, this one appears not to have been either a burial site or temple platform. The Mississippians, however, strongly associated snakes with the earth and the fertility of crops, explaining why they would construct a mound in the shape of a snake. A stone figurine found at one Mississippian site, for example, depicts a woman digging her hoe into the back of a large serpentine creature whose tail turns into a vine of gourds. Some researchers, however, have proposed another possible meaning, and assigned a date around 1070, for the construction of Serpent Mound. The date corresponds to the years following the brightest appearance in recorded history of Halley's Comet in 1066. Scholars have suggested that the serpentine form of the mound is not an effigy of a snake; rather, it replicates the comet streaking across the night sky.

The names of the artists and patrons responsible for conceiving and constructing Serpent Mound are unknown. This is typical of most of the history of art worldwide, and although it has become standard since the Renaissance for Western artists to sign and date their work, anonymous artworks remained the norm in most of the non-Western world until very recently. *Art through the Ages: Non-Western Perspectives* surveys the art and architecture of Asia, Native America, Africa, and Oceania from prehistory to the present, and examines how artworks of all kinds, whether anonymous or signed, always reflect the diverse historical contexts in which they were created.

# CONTENTS

# CHAPTER 12
## OCEANIA 225

# PREFACE

When Helen Gardner published the first edition of *Art through the Ages* in 1926, she could not have imagined that more than 80 years later instructors all over the world would still be using her textbook in their classrooms. Indeed, if she were alive today, she would not recognize the book that long ago became—and remains—the most widely read introduction to the history of art and architecture in the English language. During the past half century, successive authors have constantly reinvented Helen Gardner's groundbreaking global survey, always keeping it fresh and current, and setting an ever-higher standard in both content and publication quality with each new edition. I hope both professors and students will agree that this 13th edition lives up to that venerable tradition.

Certainly, this latest edition offers much that is fresh and new (enumerated below), but some things have not changed, including the fundamental belief that guided Helen Gardner—namely, that the primary goal of an introductory art history textbook should be to foster an appreciation and understanding of historically significant works of art of all kinds from all periods and from all parts of the globe. Because of the longevity and diversity of the history of art, it is tempting to assign responsibility for telling its story to a large team of specialists. The Gardner publishers themselves took this approach for the first edition they produced after Helen Gardner's death, and it has now become the norm for introductory art history surveys. But students overwhelmingly say that the very complexity of the global history of art makes it all the more important for the story to be told with a consistent voice if they are to master so much diverse material. I think Helen Gardner would be pleased to know that this new edition of *Art through the Ages* once again has a single storyteller.

Along with the late Richard Tansey and my more recent collaborator, Christin Mamiya, with whom I had the honor and pleasure of working on the 10th, 11th, and 12th editions, I continue to believe that the most effective way to tell the story of art through the ages, especially to someone studying art history for the first time, is to organize the vast array of artistic monuments according to the civilizations that produced them and to consider each work in roughly chronological order. This approach has not merely stood the test of time. It is the most appropriate way to narrate the *history* of art. The principle that underlies my approach to every period of art history is that the enormous variation in the form and meaning of the paintings, sculptures, buildings, and other artworks men and women have produced over the past 30,000 years is largely the result of the constantly changing contexts in which artists and architects worked. A historically based narrative is therefore best suited for a global history of art because it permits the author to situate each work discussed in its historical, social, economic, religious, and cultural context. That is, after all, what distinguishes art history from art appreciation.

In the first (1926) edition of *Art through the Ages,* Helen Gardner discussed Henri Matisse and Pablo Picasso in a chapter entitled "Contemporary Art in Europe and America." Since then many other artists have emerged on the international scene, and the story of art through the ages has grown longer and even more complex. More important, perhaps, the discipline of art history has changed markedly in recent decades, and so too has Helen Gardner's book. In fact, although Gardner was a pioneer in writing a global history of art in the early part of the 20th century, even she would be surprised that so many college courses now include *only* the arts of non-Western cultures. That is why Wadsworth introduced *Art through the Ages: Non-Western Perspectives* in 2006.

This new edition fully reflects the latest art historical research emphases while maintaining the traditional strengths that have made previous editions of *Art through the Ages* so popular. While sustaining attention to style, chronology, iconography, and technique, I also ensure that issues of patronage, function, and context loom large in every chapter. I treat artworks not as isolated objects in sterile 21st-century museum settings but with a view toward their purpose and meaning in the society that produced them at the time they were produced. I examine not only the role of the artist or architect in the creation of a work of art or a building, but also the role of the individuals or groups who paid the artists and influenced the shape the monuments took. Further, I devote more space than previously to the role of women and women artists in societies worldwide over time. In every chapter, I have tried to choose artworks and buildings that reflect the increasingly wide range of interests of scholars today, while not rejecting the traditional list of "great" works or the very notion of a "canon." Consequently, the selection of works in this edition encompasses every artistic medium and almost every era and culture in the non-Western world, and includes many works that until recently art historians would not have considered to be "art" at all.

The 12th edition of *Art through the Ages* was the number-one choice for art history survey courses and the best-selling version of the book in its long history, and for this 13th edition I have retained all of the features that made its predecessor so successful. This non-Western version of the global survey contains the chapters on the art

and architecture of South and Southeast Asia, China and Korea, Japan, the Islamic world, Native North and South America, Africa, and Oceania. It boasts roughly 300 photographs, plans, and drawings, virtually all in color and reproduced according to the highest standards of clarity and color fidelity. Included are many new or upgraded photos by a host of new photographers as well as redesigned maps and plans.

The captions to the illustrations in this edition of *Art through the Ages*, as before, contain a wealth of information, including the name of the artist or architect, if known; the formal title (printed in italics), if assigned, description of the work, or name of the building; the provenance or place of production of the object or location of the building; the date; the material(s) used; the size; and the current location if the work is in a museum or private collection. As in previous editions, scales accompany all plans, but for the first time scales now also appear next to each photograph of a painting, statue, or other artwork. The works illustrated vary enormously in size, from colossal sculptures carved into mountain cliffs and paintings that cover entire walls or ceilings to tiny figurines and jewelry that one can hold in the hand. Although the captions contain the pertinent dimensions, it is hard for students who have never seen the paintings or statues in person to translate those dimensions into an appreciation of the real size of the objects. The new scales provide an effective and direct way to visualize how big or how small a given artwork is and its relative size compared with other objects in the same chapter and throughout the book.

Also new to this edition are the Quick-Review Captions that students found so useful when these were introduced in 2006 in the first edition of *Art through the Ages: A Concise History*. These brief synopses of the most significant aspects of each artwork or building illustrated accompany the captions to all images in the book. They have proved invaluable to students preparing for examinations. In the 13th edition I have also provided two new tools to aid students in reviewing and mastering the material. Each chapter now ends with a full-page feature called The Big Picture, which sets forth in bullet-point format the most important characteristics of each period or region discussed in the chapter. Small illustrations of characteristic works discussed accompany the summary of major points. Finally, I have attempted to tie all of the chapters together by providing with each copy of *Art through the Ages* a poster-size Global Timeline. This too features illustrations of key monuments of each age and geographical area as well as a brief enumeration of the most important art historical developments during that period. The timeline is global in scope to permit students to compare developments in the non-Western world with contemporaneous artworks produced in the West. The poster has four major horizontal bands corresponding to Europe, the Americas, Asia, and Africa, and 34 vertical columns for the successive chronological periods from 30,000 BCE to the present.

Boxed essays once again appear throughout the book as well. This popular feature first appeared in the 11th edition of *Art through the Ages*, which won both the Texty and McGuffey Prizes of the Text and Academic Authors Association for the best college textbook of 2001 in the humanities and social sciences. In this edition the essays are more closely tied to the main text than ever before. Consistent with that greater integration, most boxes now incorporate photographs of important artworks discussed in the text proper that also illustrate the theme treated in the boxed essays. These essays fall under six broad categories, one of which is new to the 13th edition.

*Architectural Basics* boxes provide students with a sound foundation for the understanding of architecture. These discussions are concise explanations, with drawings and diagrams, of the major aspects of design and construction. The information included is essential to an understanding of architectural technology and terminology. The boxes address questions of how and why various forms developed, the problems architects confronted, and the solutions they used to resolve them. Topics discussed include the form and meaning of the stupa, the origin and development of the mosque, and the construction of wooden buildings in China.

*Materials and Techniques* essays explain the various media artists employed from prehistoric to modern times. Since materials and techniques often influence the character of artworks, these discussions contain essential information on why many monuments appear as they do. Hollow-casting in bronze in Shang China, Japanese woodblock prints, and Andean weaving are among the many subjects treated.

*Religion and Mythology* boxes introduce students to the principal elements of the world's great religions, past and present, and to the representation of religious and mythological themes in painting and sculpture of all periods and places. These discussions of belief systems and iconography give readers a richer understanding of some of the greatest artworks ever created. The topics include Buddhism and Buddhist iconography, Muhammad and Islam, and Aztec religion.

*Art and Society* essays treat the historical, social, political, cultural, and religious context of art and architecture. The subjects addressed include the Japanese tea ceremony, the Mesoamerican ball game, art and leadership in Africa, and tattoo in Polynesia.

*Written Sources* present and discuss key historical documents illuminating important monuments of art and architecture throughout the world. The passages quoted permit voices from the past to speak directly to the reader, for example King Ashoka explaining his conversion to Buddhism, which initiated a new era in Asian art.

A new category is *Artists on Art* in which artists and architects throughout history discuss both their theories and individual works. Examples include Sinan the Great discussing the mosque he designed for Selim II, and Xia He's exposition of the six canons of Chinese painting.

Rounding out the features in the book itself is a Glossary containing definitions of all terms introduced in the text in italics and a Bibliography of books in English, including both general works and a chapter-by-chapter list of more focused studies.

The 13th edition of *Art through the Ages* is not, however, a stand-alone text, but one element of a complete package of learning tools. In addition to the Global Timeline, every new copy of the book comes with a password to *ArtStudy Online*, a web site with access to a host of multimedia resources that students can employ throughout the entire course, including image flashcards, tutorial quizzes, podcasts, vocabulary, and more. Instructors have access to a host of teaching materials, including digital images with zoom capabilities, video, and Google Earth™ coordinates.

A work as diverse as this history of non-Western art could not be undertaken or completed without the counsel of experts in all areas treated. As with previous editions, the publisher has enlisted dozens of art historians to review every chapter of *Art through the Ages: Non-Western Perspectives* in order to ensure that the text lived up to the Gardner reputation for accuracy as well as readability. I take great pleasure in acknowledging here the invaluable contributions to the 13th edition made by the following for their critiques of various chapters: Charles M. Adelman, University of Northern Iowa; Kirk Ambrose, University of Colorado–Boulder; Susan Ashbrook, Art Institute of Boston; James J. Bloom, Florida State University; Suzaan Boettger, Bergen Community College; Colleen Bolton, Mohawk Valley Community College; Angi Elsea Bourgeois, Mississippi State University; Lawrence E. Butler, George Mason University; Alexandra Carpino, Northern Arizona University; Hipolito Rafael Chacon, The University

of Montana; Catherine M. Chastain, North Georgia College & State University; Daniel Connolly, Augustana College; Michael A. Coronel, University of Northern Colorado; Nicole Cox, Rochester Institute of Technology; Jodi Cranston, Boston University; Kathy Curnow, Cleveland State University; Giovanna De Appolonia, Boston University; Marion de Koning, Grossmont College; John J. Dobbins, University of Virginia; B. Underwood DuRette, Thomas Nelson Community College; Daniel Ehnbom, University of Virginia; Lisa Farber, Pace University; James Farmer, Virginia Commonwealth University; Jerome Feldman, Hawaii Pacific University; Sheila ffolliott, George Mason University; Ferdinanda Florence, Solano Community College; William B. Folkestad, Central Washington University; Mitchell Frank, Carleton University; Sara L. French, Wells College; Norman P. Gambill, South Dakota State University; Elise Goodman, University of Cincinnati; Kim T. Grant, University of Southern Maine; Elizabeth ten Grotenhuis, Silk Road Project; Sandra C. Haynes, Pasadena City College; Valerie Hedquist, The University of Montana; Susan Hellman, Northern Virginia Community College; Marian J. Hollinger, Fairmont State University; Cheryl Hughes, Alta High School; Heidrun Hultgren, Kent State University; Joseph M. Hutchinson, Texas A&M University; Julie M. Johnson, Utah State University; Sandra L. Johnson, Citrus College; Deborah Kahn, Boston University; Fusae Kanda, Harvard University; Catherine Karkov, Miami University; Wendy Katz, University of Nebraska–Lincoln; Nita Kehoe-Gadway, Central Wyoming College; Nancy L. Kelker, Middle Tennessee State University; Cathie Kelly, University of Nevada–Las Vegas; Katie Kempton, Ohio University; John F. Kenfield, Rutgers University; Monica Kjellman-Chapin, Emporia State University; Kathryn E. Kramer, State University of New York–Cortland; Carol Krinsky, New York University; Lydia Lehr, Atlantic Cape Community College; Krist Lien, Shelton State Community College; Ellen Longsworth, Merrimack College; Dominic Marner, University of Guelph; Jack Brent Maxwell, Blinn College; Anne McClanan, Portland State University; Brian McConnell, Florida Atlantic University; Amy McNair, University of Kansas; Patrick McNaughton, Indiana University; Cynthia Millis, Houston Community College–Southwest; Cynthia Taylor Mills, Brookhaven College; Keith N. Morgan, Boston University; Johanna D. Movassat, San Jose State University; Heidi Nickisher, Rochester Institute of Technology; Bonnie Noble, University of North Carolina–Charlotte; Abigail Noonan, Rochester Institute of Technology; Karen Michelle O'Day, University of Wisconsin–Eau Claire; Allison Lee Palmer, University of Oklahoma; Martin Patrick, Illinois State University; Jane Peters, University of Kentucky; Julie Anne Plax, University of Arizona; Donna Karen Reid, Chemeketa Community College; Albert W. Reischuch, Kent State University; Jonathan Ribner, Boston University; Cynthea Riesenberg, Washington Latin School; James G. Rogers Jr., Florida Southern College; Carey Rote, Texas A&M University–Corpus Christi; David J. Roxburgh, Harvard University; Conrad Rudolph, University of California–Riverside; Catherine B. Scallen, Case Western Reserve University; Natasha Seaman, Berklee College of Music; Malia E. Serrano, Grossmont College; Fred T. Smith, Kent State University; Laura Sommer, Daemen College; Nancy Steele-Hamme, Midwestern State University; Andrew Stewart, University of California–Berkeley; John R. Stocking, University of Calgary; Francesca Tronchin, Ohio State University; Kelly Wacker, University of Montevallo; Carolynne Whitefeather, Utica College; Nancy L. Wicker, University of Mississippi; Alastair Wright, Princeton University; Michael Zell, Boston University.

I am also happy to have this opportunity to express my gratitude to the extraordinary group of people at Wadsworth involved with the editing, production, and distribution of *Art through the Ages*. Some of them I have now worked with on various projects for more than a decade and feel privileged to count among my friends. The success of the Gardner series in all of its various permutations depends in no small part on the expertise and unflagging commitment of these dedicated professionals: Sean Wakely, executive vice president, Cengage Arts and Sciences; P. J. Boardman, vice president and editor-in-chief, Cengage Arts and Sciences; Clark Baxter, publisher; Sharon Adams Poore, senior development editor; Helen Triller-Yambert, development editor; Lianne Ames, senior content project manager; Kimberly Apfelbaum, assistant editor; Wendy Constantine, senior media editor; Nell Pepper, editorial assistant; Cate Rickard Barr, senior art director; Scott Stewart, vice president managing director sales; Diane Wenckebach, senior marketing manager; as well as Kim Adams, Heather Baxley, William Christy, Doug Easton, tani hasegawa, Cara Murphy, Ellen Pettengell, Kathryn Stewart, and Joy Westberg.

I am also deeply grateful to the following for their significant contributions to the 13th edition of *Art through the Ages*: Joan Keyes, Dovetail Publishing Services; Ida May Norton, copy editor; Sarah Evertson and Stephen Forsling, photo researchers; Pete Shanks and Jon Peck, accuracy readers; Pat Lewis, proofreader; John Pierce, Thompson Type; Rick Stanley, Digital Media Inc., U.S.A; Don Larson, Mapping Specialists; Anne Draus, Scratchgravel; and Cindy Geiss, Graphic World. I also wish to acknowledge my debt to Edward Tufte for an illuminating afternoon spent discussing publication design and production issues and for his invaluable contribution to the creation of the scales that accompany all reproductions of paintings, sculptures, and other artworks in this edition.

Finally, I owe thanks to my colleagues at Boston University and to the thousands of students and the scores of teaching fellows in my art history courses during the past three decades. From them I have learned much that has helped determine the form and content of *Art through the Ages* and made it a much better book than it otherwise might have been.

**Fred S. Kleiner**

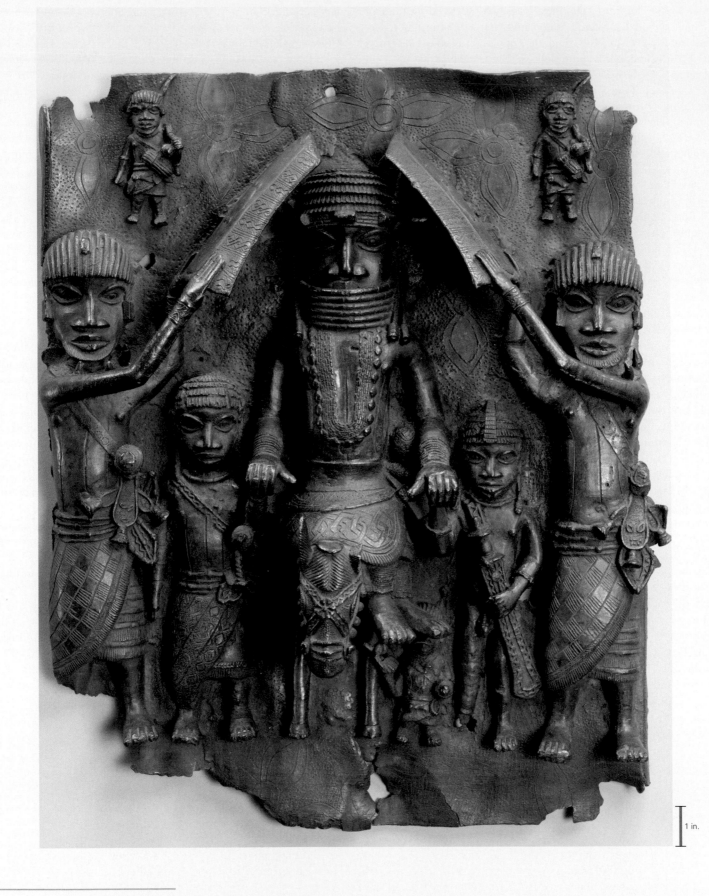

1 in.

I-1 King on horseback with attendants, from Benin, Nigeria, ca. 1550–1680. Bronze, 1′ 7 $\frac{1}{2}$″ high. Metropolitan Museum of Art, New York (Michael C. Rockefeller Memorial Collection, gift of Nelson A. Rockefeller).

This African artist used hierarchy of scale to distinguish the relative rank of the figures, making the king the largest. The sculptor created the relief by casting (pouring bronze into a mold).

# INTRODUCTION: WHAT IS ART HISTORY?

Except when referring to the modern academic discipline, people do not often juxtapose the words "art" and "history." They tend to think of history as the record and interpretation of past human actions, particularly social and political actions. Most think of art, quite correctly, as part of the present—as something people can see and touch. Of course, people cannot see or touch history's vanished human events, but a visible, tangible artwork is a kind of persisting event. One or more artists made it at a certain time and in a specific place, even if no one today knows just who, when, where, or why. Although created in the past, an artwork continues to exist in the present, long surviving its times. The first painters and sculptors died 30,000 years ago, but their works remain, some of them exhibited in glass cases in museums built only a few years ago.

Modern museum visitors can admire these objects from the remote past—and countless others humankind has produced over the millennia—without any knowledge of the circumstances that led to the creation of those works. The beauty or sheer size of an object can impress people, the artist's virtuosity in the handling of ordinary or costly materials can dazzle them, or the subject depicted can move them. Viewers can react to what they see, interpret the work in the light of their own experience, and judge it a success or a failure. These are all valid responses to a work of art. But the enjoyment and appreciation of artworks in museum settings are relatively recent phenomena, as is the creation of artworks solely for museum-going audiences to view.

Today, it is common for artists to work in private studios and to create paintings, sculptures, and other objects commercial art galleries will offer for sale. Usually, someone the artist has never met will purchase the artwork and display it in a setting the artist has never seen. This practice is not a new phenomenon in the history of art—an ancient potter decorating a vase for sale at a village market stall probably did not know who would buy the pot or where it would be housed—but it is not at all typical. In fact, it is exceptional. Throughout history, most artists created paintings, sculptures, and other objects for specific patrons and settings and to fulfill a specific purpose, even if today no one knows the original contexts of most of those works. Museum visitors can appreciate the visual and tactile qualities of these objects, but they cannot understand why they were made or why they appear as they do without knowing the circumstances of their creation. Art *appreciation* does not require knowledge of the historical context of an artwork (or a building). Art *history* does.

Thus, a central aim of art history is to determine the original context of artworks. Art historians seek to achieve a full understanding not only of why these "persisting events" of human history look the way they do but also of why the artistic events happened at all. What unique set of circumstances gave rise to the erection of a particular building or led an individual patron to commission a certain artist to fashion a singular artwork for a specific place? The study of history is therefore vital to art history. And art history is often very important to the study of history. Art objects and buildings are historical documents that can shed light on the peoples who made them and on the times of their creation in a way other historical documents cannot. Furthermore, artists and architects can affect history by reinforcing or challenging cultural values and practices through the objects they create and the structures they build. Thus, the history of art and architecture is inseparable from the study of history, although the two disciplines are not the same.

The following pages introduce some of the distinctive subjects art historians address and the kinds of questions they ask, and explain some of the basic terminology they use when answering these questions. Readers armed with this arsenal of questions and terms will be ready to explore the multifaceted world of art through the ages.

# ART HISTORY IN THE 21ST CENTURY

Art historians study the visual and tangible objects humans make and the structures humans build. From the earliest Greco-Roman art critics on, scholars have studied objects that their makers consciously manufactured as "art" and to which the artists assigned formal titles. But today's art historians also study a vast number of objects that their creators and owners almost certainly did not consider to be "works of art." That is certainly true for many of the works examined in this book. Art historians, however, generally ask the same kinds of questions about what they study, whether they employ a restrictive or expansive definition of art.

## The Questions Art Historians Ask

**HOW OLD IS IT?** Before art historians can construct a history of art, they must be sure they know the date of each work they study. Thus, an indispensable subject of art historical inquiry is *chronology,* the dating of art objects and buildings. If researchers cannot determine a monument's age, they cannot place the work in its historical context. Art historians have developed many ways to establish, or at least approximate, the date of an artwork.

*Physical evidence* often reliably indicates an object's age. The material used for a statue, painting, or vase—bronze, stone, or porcelain, to name only a few—may not have been invented before a certain time, indicating the earliest possible date someone could have fashioned the work. Or artists may have ceased using certain materials—such as specific kinds of inks and papers for drawings—at a known time, providing the latest possible dates for objects made of those materials. Sometimes the material (or the manufacturing technique) of an object or a building can establish a very precise date of production or construction.

*Documentary evidence* can help pinpoint the date of an object or building when a dated written document mentions the work.

*Internal evidence* can play a significant role in dating an artwork. A painter might have depicted an identifiable person or a kind of hairstyle, clothing, or furniture fashionable only at a certain time. If so, the art historian can assign a more accurate date to that painting.

*Stylistic evidence* is also very important. The analysis of *style*—an artist's distinctive manner of producing an object—is the art historian's special sphere. Unfortunately, because it is a subjective assessment, stylistic evidence is by far the most unreliable chronological criterion. Still, art historians find style a very useful tool for establishing chronology.

**WHAT IS ITS STYLE?** Defining artistic style is one of the key elements of art historical inquiry, although the analysis of artworks solely in terms of style no longer dominates the field as it once did. Art historians speak of several different kinds of artistic styles.

*Period style* refers to the characteristic artistic manner of a specific time, usually within a distinct culture, such as "Classic Maya" in Mesoamerica or "Southern Song" in China.

*Regional style* is the term art historians use to describe variations in style tied to geography. Like an object's date, its *provenance,* or place of origin, can significantly determine its character. Very often two artworks from the same place made centuries apart are more similar than contemporaneous works from two different regions.

The different kinds of artistic styles are not mutually exclusive. For example, an artist's personal style may change dramatically during a long career. Art historians then must distinguish among the different period styles of a particular artist.

**WHAT IS ITS SUBJECT?** Another major concern of art historians is, of course, subject matter, encompassing the story, or narrative; the scene presented; the action's time and place; the persons involved; and the environment and its details. Some artworks, such as modern abstract paintings, have no subject, not even a setting. The "subject" is the artwork itself. But when artists represent people, places, or actions, viewers must identify these aspects to achieve complete understanding of the work. Art historians traditionally separate pictorial subjects into various categories, such as religious, historical, mythological, *genre* (daily life), portraiture, *landscape* (a depiction of a place), *still life* (an arrangement of inanimate objects), and their numerous subdivisions and combinations.

*Iconography*—literally, the "writing of images"—refers both to the content, or subject of an artwork, and to the study of content in art. By extension, it also includes the study of *symbols,* images that stand for other images or encapsulate ideas. Artists also may depict figures with unique *attributes,* such as a scepter, headdress, or costume that identifies a figure as a king (FIG. I-1). Throughout the history of art, artists also have used *personifications*—abstract ideas codified in human form. Worldwide, people visualize Liberty as a robed woman with a torch because of the fame of the colossal statue set up in New York City's harbor in the 19th century. Even without considering style and without knowing a work's maker, informed viewers can determine much about the work's period and provenance by iconographical and subject analysis alone.

**WHO MADE IT?** Although signing (and dating) works is quite common (but by no means universal) today, in the history of art countless works exist whose artists remain unknown. Because personal style can play a large role in determining the character of an artwork, art historians often try to assign, or *attribute,* anonymous works to known artists. Sometimes they assemble a group of works all thought to be by the same person, even though none of the objects in the group is the known work of an artist with a recorded name. Scholars base their *attributions* on internal evidence, such as the distinctive way an artist draws or carves drapery folds or earlobes. It requires a keen, highly trained eye and long experience to become a *connoisseur,* an expert in assigning artworks to "the hand" of one artist rather than another. Attribution is subjective, of course, and

ever open to doubt. At present, for example, international debate rages over attributions to the famous 17th-century Dutch painter Rembrandt.

Sometimes a group of artists works in the same style at the same time and place. Art historians designate such a group as a *school.* "School" does not mean an educational institution. The term connotes only chronological, stylistic, and geographic similarity. Art historians speak, for example, of the Kano School in 17th-century Japan.

**WHO PAID FOR IT?** The interest many art historians show in attribution reflects their conviction that the identity of an artwork's maker is the major reason the object looks the way it does. For them, personal style is of paramount importance. But in many times and places, artists had little to say about what form their work would take. They toiled in obscurity, doing the bidding of their *patrons,* those who paid them to make individual works or employed them on a continuing basis. The role of patrons in dictating the content and shaping the form of artworks is also an important subject of art historical inquiry.

## The Words Art Historians Use

Like all specialists, art historians have their own specialized vocabulary. That vocabulary consists of hundreds of words, but certain basic terms are indispensable for describing artworks and buildings of any time and place. They make up the essential vocabulary of *formal analysis,* the visual analysis of artistic form. Definitions of the most important of these art historical terms follow.

**FORM AND COMPOSITION** *Form* refers to an object's shape and structure, either in two dimensions (for example, a figure painted on a silk scroll) or in three dimensions (such as a statue carved from a stone block). Two forms may take the same shape but may differ in their color, texture, and other qualities. *Composition* refers to how an artist organizes (*composes*) forms in an artwork, either by placing shapes on a flat surface or by arranging forms in space.

**MATERIAL AND TECHNIQUE** To create art forms, artists shape materials (pigment, clay, stone, gold, and many more) with tools (pens, brushes, chisels, and so forth). Each of the materials and tools available has its own potentialities and limitations. Part of all artists' creative activity is to select the *medium* and instrument most suitable to the artists' purpose. The processes artists employ, such as applying paint to silk with a brush, and the distinctive, personal ways they handle materials constitute their *technique.* Form, material, and technique interrelate and are central to analyzing any work of art.

**LINE** Among the most important elements defining an artwork's shape or form is *line.* A line can be understood as the path of a point moving in space, an invisible line of sight. More commonly, however, artists and architects make a line tangible by drawing (or chiseling) it on a *plane,* a flat surface. A line may be very thin, wirelike, and delicate. It may be thick and heavy. Or it may alternate quickly from broad to narrow, the strokes jagged or the outline broken. When a continuous line defines an object's outer shape, art historians call it a *contour line.*

**COLOR** Light reveals all colors. Light in the world of the painter and other artists differs from natural light. Natural light, or sunlight, is whole or *additive light.* As the sum of all the wavelengths composing the visible *spectrum,* natural light may be disassembled or fragmented into the individual colors of the spectral band. The painter's light in art—the light reflected from pigments and objects—is *subtractive light.* Paint pigments produce their individual colors by reflecting a segment of the spectrum while absorbing all the rest. Green pigment,

for example, subtracts or absorbs all the light in the spectrum except that seen as green.

**TEXTURE** The term *texture* refers to the quality of a surface, such as rough or shiny. Art historians distinguish between true texture, or the tactile quality of the surface, and represented texture, as when painters depict an object as having a certain texture even though the pigment is the true texture. Texture is, of course, a key determinant of any sculpture's character. A viewer's first impulse is usually to handle a piece of sculpture—even though museum signs often warn "Do not touch!" Sculptors plan for this natural human response, using surfaces varying in texture from rugged coarseness to polished smoothness. Textures are often intrinsic to a material, influencing the type of stone, wood, clay, or metal sculptors select.

**SPACE, MASS, AND VOLUME** *Space* is the bounded or boundless "container" of objects. For art historians, space can be the literal three-dimensional space occupied by a statue or a vase or contained within a room or courtyard. Or space can be *illusionistic,* as when painters depict an image (or illusion) of the three-dimensional spatial world on a two-dimensional surface.

*Mass* and *volume* describe three-dimensional objects and space. In both architecture and sculpture, mass is the bulk, density, and weight of matter in space. Yet the mass need not be solid. It can be the exterior form of enclosed space. Mass can apply to a solid wood or stone statue, to a mosque or a Buddhist temple—architectural shells enclosing sometimes vast spaces—and to a hollow metal statue or baked clay pot. Volume is the space that mass organizes, divides, or encloses. It may be a building's interior spaces, the intervals between a structure's masses, or the amount of space occupied by three-dimensional objects such as sculpture, pottery, or furniture. Volume and mass describe both the exterior and interior forms of a work of art—the forms of the matter of which it is composed and the spaces immediately around the work and interacting with it.

**CARVING AND CASTING** Sculptural technique falls into two basic categories, *subtractive* and *additive. Carving* is a subtractive technique. The final form is a reduction of the original mass of a block of stone, a piece of wood, or another material. Wooden statues were once tree trunks, and stone statues began as blocks pried from mountains. All sculptors of stone or wood cut away (subtract) "excess material." When they finish, they "leave behind" the statue.

In additive sculpture, the artist builds up the forms, usually in clay around a framework, or *armature.* Or a sculptor may fashion a *mold,* a hollow form for shaping, or *casting,* a fluid substance such as bronze (FIG. I-1).

**RELIEF SCULPTURE** *Statues* that exist independent of any architectural frame or setting and that viewers can walk around are *freestanding* sculptures, or *sculptures in the round,* whether the artist produced the piece by carving or casting. In *relief* sculpture, the subjects project from the background but remain part of it. In *high-relief* sculpture, the images project boldly. In the Benin plaque illustrated on page xiv (FIG. I-1), the relief is so high that not only do the forms cast shadows on the background, but some parts are even in the round. In *low relief,* or *bas-relief,* the projection is slight. Relief sculpture, like sculpture in the round, can be produced either by carving or casting.

**ARCHITECTURAL DRAWINGS** Buildings are groupings of enclosed spaces and enclosing masses. People experience architecture both visually and by moving through and around it, so they perceive architectural space and mass together. Architects can represent

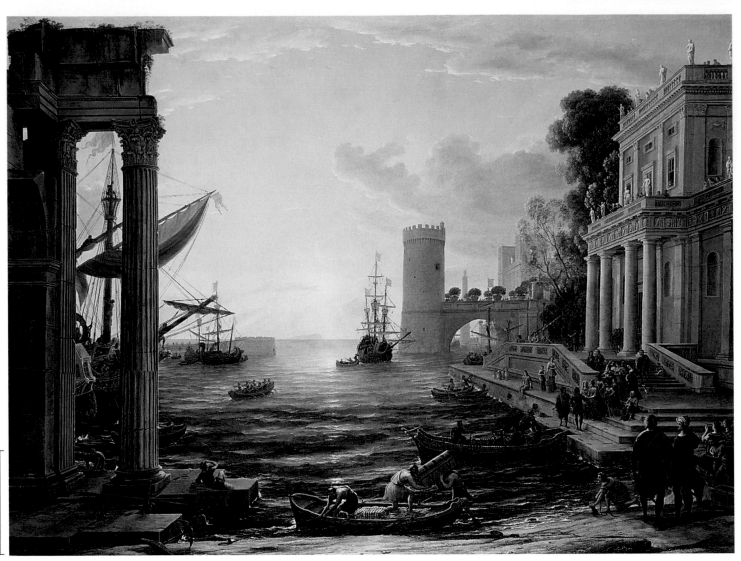

1 ft.

**I-2** CLAUDE LORRAIN, *Embarkation of the Queen of Sheba*, 1648. Oil on canvas, 4′ 10″ × 6′ 4″. National Gallery, London.

To create the illusion of a deep landscape, Claude Lorrain employed perspective, reducing the size of and blurring the most distant forms. Also, all diagonal lines converge on a single point.

these spaces and masses graphically in several ways, including as plans, sections, elevations, and cutaway drawings.

A *plan*, essentially a map of a floor, shows the placement of a structure's masses and, therefore, the spaces they circumscribe and enclose. A *section*, like a vertical plan, depicts the placement of the masses as if someone cut through the building along a plane. Drawings showing a theoretical slice across a structure's width are *lateral sections*. Those cutting through a building's length are *longitudinal* sections. An *elevation* drawing is a head-on view of an external or internal wall. A *cutaway* combines in a single drawing an exterior view with an interior view of part of a building.

This overview of the art historian's vocabulary is not exhaustive, nor have artists used only painting, drawing, sculpture, and architecture as media over the millennia. Ceramics, jewelry, and textiles are just some of the numerous other arts. All of them involve highly specialized techniques described in distinct vocabularies. As in this introductory chapter, new terms are in *italics* where they first appear. The comprehensive Glossary at the end of the book contains definitions of all italicized terms.

## DIFFERENT WAYS OF SEEING

Even a cursory look at the works illustrated in this book will quickly reveal that throughout history, artists have created an extraordinary variety of works for a multitude of different purposes. Despite this diversity, the art produced by most non-Western artists differs from art produced in the Western world by the absence of two of the most characteristic ways that Western artists have used to represent people, objects, and places since the Greeks pioneered them a half millennium before the Common Era—perspective and foreshortening.

**PERSPECTIVE AND FORESHORTENING** *Perspective* is a device to create the illusion of depth or space on a two-dimensional surface. The French painter CLAUDE LORRAIN (1600–1682) employed several perspectival devices in *Embarkation of the Queen of Sheba* (FIG. I-2), a painting of a biblical episode set in a 17th-century European harbor with a Roman ruin in the left foreground. For example, the figures and boats on the shoreline are much larger than those in the distance. Decreasing the size of an object makes it

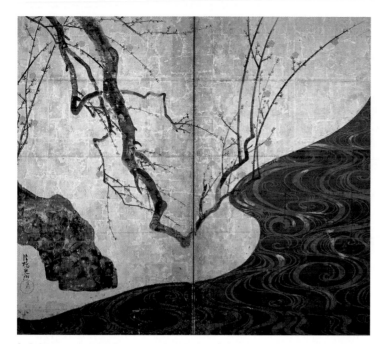

**I-3** OGATA KORIN, *White and Red Plum Blossoms,* Edo period, ca. 1710–1716. Pair of twofold screens. Ink, color, and gold leaf on paper, each screen 5′ 1⅝″ × 5′ 7⅞″. MOA Art Museum, Shizuoka-ken.

Ogata Korin was more concerned with creating an interesting composition of shapes on a surface than with locating objects in space. Asian artists rarely employed Western perspective.

appear farther away. Also, the top and bottom of the port building at the painting's right side are not parallel horizontal lines, as they are in a real building. Instead, the lines converge beyond the structure, leading viewers' eyes toward the hazy, indistinct sun on the horizon. These perspectival devices—the reduction of figure size, the convergence of diagonal lines, and the blurring of distant forms—have been familiar features of Western art for 2,500 years. But it is important to note at the outset that all kinds of perspective are only pictorial conventions, even when one or more types of perspective may be so common in a given culture that people, including most readers of this book, accept them as "natural" or as "true" means of representing the natural world.

In *White and Red Plum Blossoms* (FIG. I-3), a Japanese landscape painting on two folding screens, OGATA KORIN (1658–1716) used none of these Western perspective conventions. He showed the two plum trees as seen from a position on the ground, but viewers look down on the stream between them from above. Less concerned with locating the trees and stream in space than with composing shapes on a surface, the painter played the water's gently swelling curves against the jagged contours of the branches and trunks. Neither the French nor the Japanese painting can be said to project "correctly" what viewers "in fact" see. One painting is not a "better" picture of the world than the other. The European and Asian artists simply approached the problem of picture-making differently.

Artists also represent single figures in space in varying ways. When the Flemish artist PETER PAUL RUBENS (1577–1640) painted *Lion Hunt* (FIG. I-4), he used *foreshortening* for all the hunters and animals—that is, he represented their bodies at angles to the picture plane. When in life one views a figure at an angle, the body appears to contract as it extends back in space. Foreshortening is a kind of perspective. It produces the illusion that one part of the body is farther away than another, even though all the forms are on the same surface. Especially noteworthy in *Lion Hunt* are the gray horse at the

left, seen from behind with the bottom of its left rear hoof facing viewers and most of its head hidden by its rider's shield, and the fallen hunter at the painting's lower right corner, whose barely visible legs and feet recede into the distance.

Like the Japanese painter (FIG. I-3), the African sculptor who depicted the Benin King on horseback with his attendants (FIG. I-1) did not employ any of the Western conventions seen in the Rubens painting (FIG. I-4). Although the Rubens painting and the Benin plaque are of approximately the same date, the African figures are all in the foreground, stand (or sit) in upright positions, and face the viewer directly. The sculptor represented nothing at an angle. The viewer even looks at the horse head-on and sees only its two front legs and head. Once gain, neither approach to picture-making is the "correct" manner. The artists' strikingly divergent styles reflect the significantly different societies of 17th-century Europe and Africa.

**PROPORTION AND SCALE** The Rubens painting and the Benin relief also differ markedly in the artists' treatment of proportion and scale. *Proportion* concerns the relationships (in terms of size) of the parts of persons, buildings, or objects. People can judge "correct proportions" intuitively ("that statue's head seems the right size for the body"). Or proportion can be a mathematical relationship between the size of one part of an artwork or building and the other parts within the work. Proportion in art implies using a *module,* or basic unit of measure. When an artist or architect uses a formal system of proportions, all parts of a building, body, or other entity will be fractions or multiples of the module. A module might be a *column*'s diameter, the height of a human head, or any other component whose dimensions can be multiplied or divided to determine the size of the work's other parts.

In certain times and places, artists have formulated *canons,* or systems, of "correct" or "ideal" proportions for representing human figures, constituent parts of buildings, and so forth. In ancient Greece,

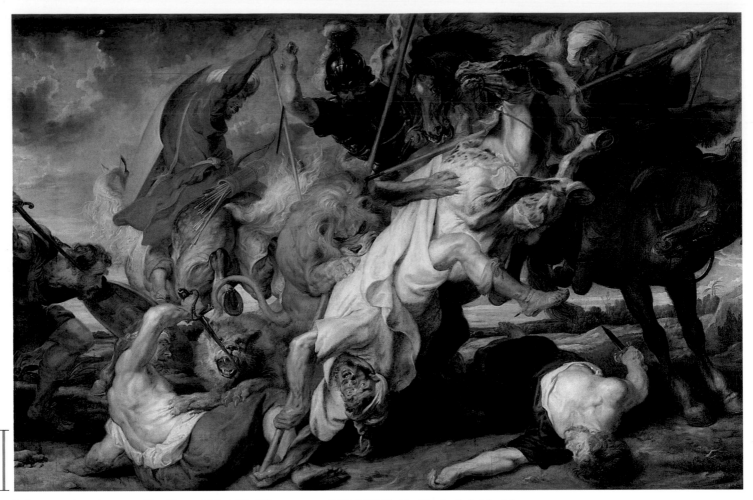

**I-4** PETER PAUL RUBENS, *Lion Hunt,* 1617–1618. Oil on canvas, 8′ 2″ × 12′ 5″. Alte Pinakothek, Munich.

Foreshortening—the representation of a figure or object at an angle to the picture plane—is a common device in Western art for creating the illusion of depth. Foreshortening is a type of perspective.

many sculptors devised canons of proportions so strict and all-encompassing that they calculated the size of every body part in advance, even the fingers and toes, according to mathematical ratios.

In other cases, artists have used *disproportion* to focus attention on one body part (often the head) or to single out a group member (usually the leader). These intentional "unnatural" discrepancies in proportion constitute what art historians call *hierarchy of scale,* the enlarging of elements considered the most important. On the Benin plaque (FIG. I-1), the sculptor enlarged all the heads for emphasis and also varied the size of each figure according to its social status. Central, largest, and therefore most important is the Benin king, mounted on horseback. The horse has been a symbol of power and wealth in many societies from prehistory to the present. That the Benin king is disproportionately larger than his horse, contrary to nature, further aggrandizes him. Two large attendants fan the king. Other figures of smaller size and status at the Benin court stand on the king's left and right and in the plaque's upper corners. One tiny figure next to the horse is almost hidden from view beneath the king's feet. In contrast, in the Rubens painting (FIG. I-4), no figure is larger than any other.

One problem that students of art history—and professional art historians too—confront when studying illustrations in art history books is that although the relative sizes of figures and objects in a painting or sculpture are easy to discern, it is impossible to determine the absolute size of the works reproduced because they all appear at approximately the same size on the page. Readers of *Art through the Ages* can learn the size of all artworks from the dimensions given in the captions and, more intuitively, from the scales that appear—for the first time in this 13th edition—at the lower left or right corner of the illustration.

**ART AND CULTURE** The history of art can be a history of artists and their works, of styles and stylistic change, of materials and techniques, of images and themes and their meanings, and of contexts and cultures and patrons. The best art historians analyze artworks from many viewpoints. But no art historian (or scholar in any other field), no matter how broad-minded in approach and no matter how experienced, can be truly objective. Like artists, art historians are members of a society, participants in its culture. How can scholars (and museum visitors and travelers to foreign locales) comprehend cultures unlike their own? They can try to reconstruct the original cultural contexts of artworks, but they are limited by their distance from the thought patterns of the cultures they study and by the obstructions to understanding—the assumptions, presuppositions, and prejudices peculiar to their own culture—their own thought patterns raise. Art historians may reconstruct a distorted picture of the past because of culture-bound blindness.

A single instance underscores how differently people of diverse cultures view the world and how various ways of seeing can cause sharp differences in how artists depict the world. Illustrated here are

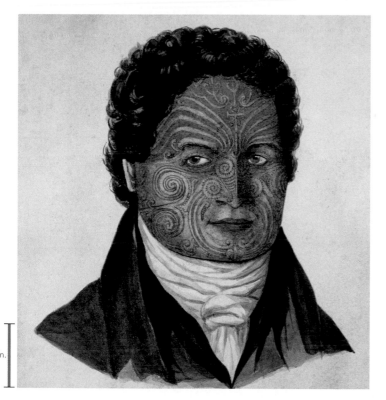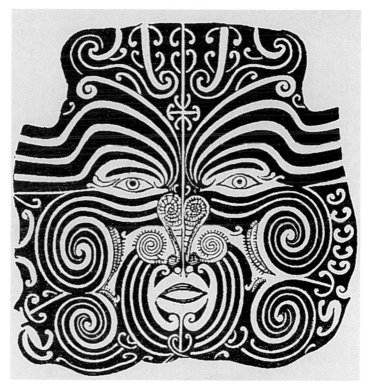

**I-5** *Left:* JOHN HENRY SYLVESTER, *Portrait of Te Pehi Kupe,* 1826. Watercolor, $8\frac{1}{4}" \times 6\frac{1}{4}"$. National Library of Australia, Canberra (Rex Nan Kivell Collection). *Right:* TE PEHI KUPE, *Self-Portrait,* 1826. From Leo Frobenius, *The Childhood of Man* (New York: J. B. Lippincott, 1909).

These strikingly different portraits of the same Maori chief reveal how differently Western and non-Western artists "see" a subject. Understanding the cultural context of artworks is vital to art history.

two contemporaneous portraits (FIG. I-5) of a 19th-century Maori chieftain—one by an Englishman, JOHN SYLVESTER (active early 19th century), and the other by the New Zealand chieftain himself, TE PEHI KUPE (d. 1829). Both reproduce the chieftain's facial tattooing. The European artist (FIG. I-5, *left*) included the head and shoulders and underplayed the tattooing. The tattoo pattern is one aspect of the likeness among many, no more or less important than the chieftain's European attire. Sylvester also recorded his subject's momentary glance toward the right and the play of light on his hair, fleeting aspects that have nothing to do with the figure's identity.

In contrast, Te Pehi Kupe's self-portrait (FIG. I-5, *right*)—made during a trip to Liverpool, England, to obtain European arms to take back to New Zealand—is not a picture of a man situated in space and bathed in light. Rather, it is the chieftain's statement of the supreme importance of the tattoo design that symbolizes his rank among his people. Remarkably, Te Pehi Kupe created the tattoo patterns from memory, without the aid of a mirror. The splendidly composed insignia, presented as a flat design separated from the body and even from the head, is Te Pehi Kupe's image of himself. Only by understanding the cultural context of each portrait can viewers hope to understand why either representation appears as it does.

As noted at the outset, the study of the context of artworks and buildings is one of the central concerns of art historians. *Art through the Ages: Non-Western Perspectives* seeks to present a history of art and architecture in Asia, the Islamic world, the Americas, Oceania, and Africa that will help readers understand not only the subjects, styles, and techniques of paintings, sculptures, buildings, and other art forms created in those parts of the world from the earliest times to the present but also their cultural and historical contexts. That story now begins.

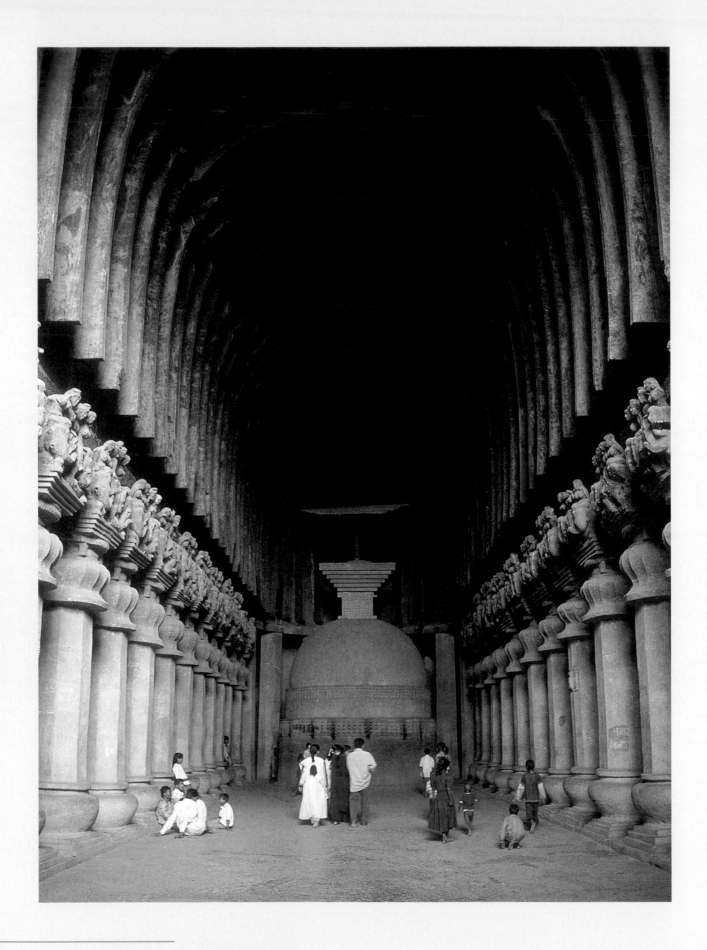

**1-1** Interior of the chaitya hall, Karle, India, ca. 50 CE.

An early example of Buddhist architecture, the chaitya hall at Karle is carved out of the living rock. It has a pillared ambulatory that allows worshipers to circumambulate the stupa in the apse of the cave.

# SOUTH AND SOUTHEAST ASIA BEFORE 1200

South and Southeast Asia is a vast geographic area comprising, among others, the nations of India, Pakistan, Sri Lanka, Thailand, Vietnam, Cambodia, Bangladesh, and Indonesia (MAP **1-1**). Not surprisingly, the region's inhabitants display tremendous cultural and religious diversity. The people of India alone speak more than 20 different major languages. Those spoken in the north belong to the Indo-European language family, whereas those in the south form a completely separate linguistic family called Dravidian. The art of South and Southeast Asia is equally diverse—and very ancient. When Alexander the Great and his army reached India in 326 BCE, the civilization they encountered was already more than two millennia old. The remains of the first cities in the Indus Valley predate the palaces of Homer's Trojan War heroes by a millennium. Covered in this chapter are the art and architecture of South and Southeast Asia from their beginnings almost five millennia ago through the 12th century. Chapter 2 treats the later art of the region up to the present day.

## INDIA AND PAKISTAN

In the third millennium BCE, a great civilization arose over a wide geographic area along the Indus River in Pakistan and extended into India as far south as Gujarat and east beyond Delhi. Archaeologists have dubbed this early South Asian culture the Indus Civilization.

### Indus Civilization

The Indus Civilization flourished from about 2600 to 1500 BCE, and evidence indicates there was active trade during this period between the peoples of the Indus Valley and Mesopotamia. The most important excavated Indus sites are Harappa and Mohenjo-daro. These early, fully developed cities featured streets oriented to compass points and multistoried houses built of carefully formed and precisely laid kiln-baked bricks. But in sharp contrast to the contemporaneous civilizations of Mesopotamia and Egypt, no surviving Indus building has yet been identified as a temple or a palace.

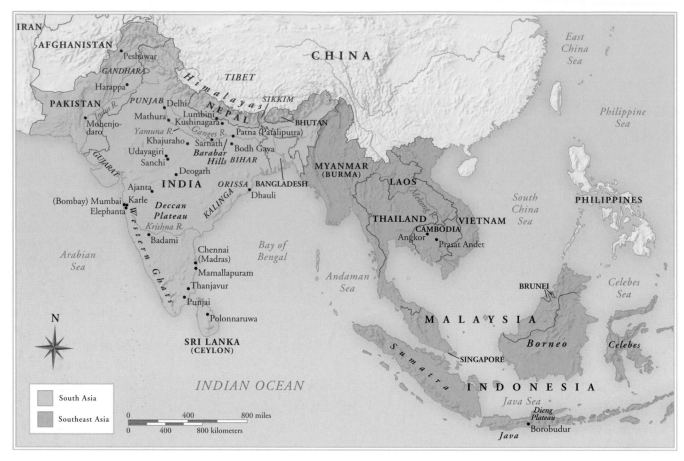

**MAP 1-1** South and Southeast Asian sites before 1200.

**MOHENJO-DARO** The Indus cities boasted one of the world's first sophisticated systems of water supply and sewage. Throughout Mohenjo-daro, hundreds of wells provided fresh water to homes that featured some of the oldest recorded private bathing areas and toilet facilities with drainage into public sewers. In the heart of the city stood the so-called Great Bath, a complex of rooms centered on a sunken brick pool (FIG. **1-2**) 39 feet long, 23 feet wide, and 8 feet deep. The builders made the pool watertight by sealing the joints between the bricks with bitumen, an asphaltlike material also used in Mesopotamia. The bath probably was not a purely recreational facility but rather a place for ritual bathing of the kind still practiced in the region today.

Excavators have discovered surprisingly little art from the long-lived Indus Civilization, and all of the objects found are small.

**1-2** Great Bath, Mohenjo-daro, Pakistan, ca. 2600–1900 BCE.

The Indus cities of the third millennium BCE had sophisticated water-supply and sewage systems, which made possible this brick complex used for ritual bathing of a kind still practiced in South Asia today.

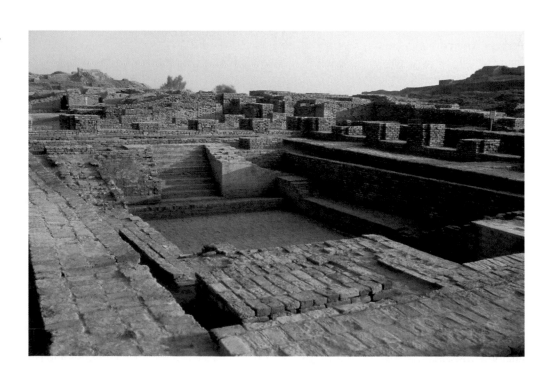

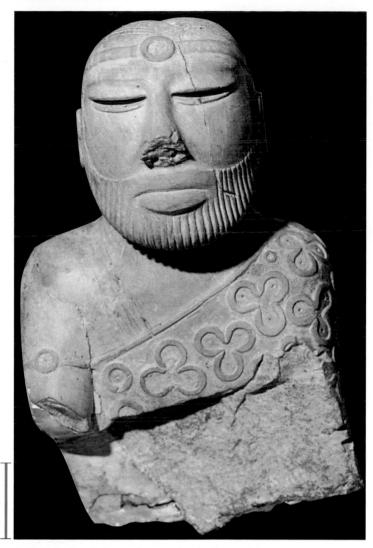

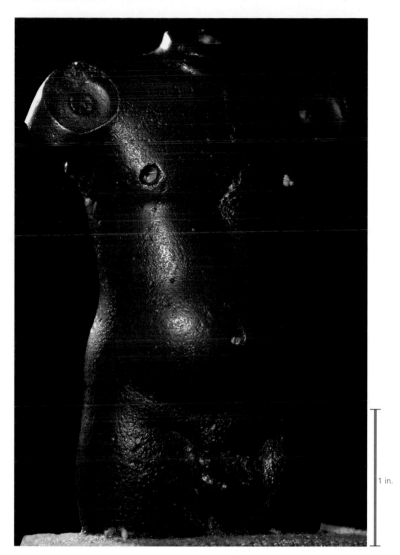

**1-3** Robed male figure, from Mohenjo-daro, Pakistan, ca. 2000–1900 BCE. Steatite, $6\frac{7}{8}''$ high. National Museum of Pakistan, Karachi.

Little art survives from the Indus Civilization, and all of it is of small scale. This bearded figure, which scholars think represents a priest-king, has iconographic similarities to some Sumerian sculptures.

**1-4** Nude male torso, from Harappa, Pakistan, ca. 2000–1900 BCE. Red sandstone, $3\frac{3}{4}''$ high. National Museum, New Delhi.

This miniature figure, with its emphasis on sensuous polished surfaces and swelling curves, already displays many of the stylistic traits that would characterize South Asian sculpture for thousands of years.

Perhaps the most impressive sculpture discovered is a robed male figure (FIG. **1-3**) with half-closed eyes, a low forehead, and a closely trimmed beard with shaved upper lip. He wears a headband with a central circular emblem, matched by a similar armband. Holes on each side of his neck suggest that he also wore a necklace of precious metal. *Trefoils* (cloverlike designs with three stylized leaves) decorate his elegant robe. They, as well as the circles of the head- and arm-bands, originally held red paste and shell inlays, as did the eyes. Art historians often compare the Mohenjo-daro statuette to Sumerian sculptures, in which the trefoil motif appears in sacred contexts, and scholars usually refer to the person portrayed as a "priest-king," the ambiguous term used for some Sumerian leaders. The identity and rank of the Mohenjo-daro figure, however, are uncertain. Nonetheless, the elaborate costume and precious materials make clear that he too was an elite individual.

**HARAPPA** Quite different in style is the miniature red-sandstone torso of a nude male figure (FIG. **1-4**) found at Harappa. Scholars usually compare this figure, which is less than four inches tall, to Greek statues of much later date, but the treatment of anatomy separates it sharply from the classical tradition. The highly polished surface of the stone and the swelling curves of the abdomen reveal the Indus artist's interest in the fluid movement of a living body, not in the logical anatomical structure of Greek sculpture. This sense of pulsating vigor and the emphasis on sensuous surfaces would continue to be chief characteristics of South Asian sculpture for thousands of years.

**INDUS SEALS** The most common Indus art objects are steatite seals with incised designs. They are similar in many ways to the stamp seals found at contemporaneous sites in Mesopotamia. Most of the Indus examples have an animal or tiny narrative carved on the face, along with an as-yet-untranslated script. On the back, a *boss* (circular knob) with a hole permitted insertion of a string so that the seal could be worn or hung on a wall. As in the ancient Near East, the Indus peoples sometimes used the seals to make impressions on clay, apparently for securing trade goods wrapped in textiles. The animals most frequently represented include the humped bull, elephant, rhinoceros, and tiger. Each is portrayed in strict profile, as in the paintings and reliefs of all other early cultures. Some of the narrative seals appear to show that the Indus peoples considered trees sacred, as both Buddhists and Hindus later did. Many historians have suggested

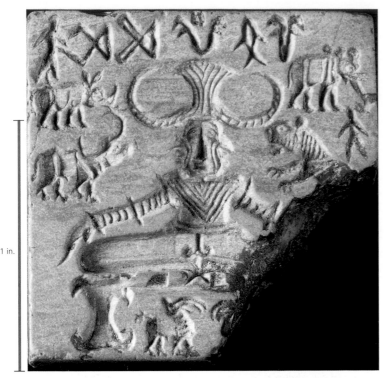

**1-5** Seal with seated figure in yogic posture, from Mohenjo-daro, Pakistan, ca. 2300–1750 BCE. Steatite coated with alkali and baked, $1\frac{3}{8}'' \times 1\frac{3}{8}''$. National Museum, New Delhi.

This seal depicting a figure (with three faces?) wearing a horned headdress and seated in a posture used in yoga is evidence that this important Indian meditative practice began as early as the Indus Civilization.

religious and ritual continuities between the Indus Civilization and later Indian culture.

One of the most elaborate seals (FIG. 1-5) depicts a male figure with a horned headdress and, perhaps, three faces, seated (with erect penis) among the profile animals that regularly appear alone on other seals. The figure's folded legs with heels pressed together and his arms resting on the knees suggest a yogic posture (compare FIG. 1-12). *Yoga* is a method for controlling the body and relaxing the mind used in later Indian religions to yoke, or unite, the practitioner to the divine. Although most scholars reject the identification of this figure as a prototype of the multiheaded Hindu god Shiva (FIG. 1-18) as Lord of Beasts, the yogic posture argues that this important Indian meditative practice began as early as the Indus Civilization.

## Vedic and Upanishadic Period

By 1700 BCE, the urban phase of the Indus Civilization had ended in most areas. The production of sculptures, seals, and script gradually ceased, and village life replaced urban culture. Very little art survives from the next thousand years, but the religious foundations laid during this period helped define most later South and Southeast Asian art.

**VEDAS** The basis for the new religious ideas were the oral hymns of the Aryans, a mobile herding people from Central Asia who occupied the Punjab, an area of northwestern India, in the second millennium BCE. The Aryans ("Noble Ones") spoke Sanskrit, the earliest language yet identified in South Asia. Around 1500 BCE, they composed the first of four *Vedas*. These Sanskrit compilations of religious learning (Veda means "knowledge") included hymns intended for priests (called Brahmins) to chant or sing. The Brahmins headed a social hierarchy, perhaps of pre-Aryan origin, that became known as the caste system, which still forms the basis of Indian society today. Below the priests were the warriors, traders, and manual laborers (including artists and architects), respectively. The Aryan religion centered on sacrifice, the ritual enactment of often highly intricate and lengthy ceremonies in which the priests placed materials, such as milk and soma (an intoxicating drink), into a fire that took the sacrifices to the gods in the heavens. If the Brahmins performed these rituals accurately, the gods would fulfill the prayers of those who sponsored the sacrifices. These gods, primarily male, included Indra, Varuna, Surya, and Agni, gods associated, respectively, with the rains, the ocean, the sun, and fire. There is no evidence to indicate the Aryans made images of these deities.

**UPANISHADS** The next phase of South Asian urban civilization developed east of the Indus heartland, in the Ganges River Valley. Here, from 800 to 500 BCE, religious thinkers composed a variety of texts called the *Upanishads*. Among the innovative ideas of the Upanishads were *samsara, karma,* and *moksha* (or *nirvana*). Samsara is the belief that individuals are born again after death in an almost endless round of rebirths. The type of rebirth can vary. One can be reborn as a human being, an animal, or even a god. An individual's past actions (karma), either good or bad, determine the nature of future rebirths. The ultimate goal of a person's religious life is to escape from the cycle of birth and death by merging the individual self into the vital force of the universe. This escape is called either moksha (liberation, for Hindus) or nirvana (cessation, for Buddhists).

**HINDUISM AND BUDDHISM** Hinduism and Buddhism, the two major modern religions originating in Asia, developed in the late centuries BCE and the early centuries CE. Hinduism, the dominant religion in India today, discussed in more detail later, has its origins in Aryan religion. The founder of Buddhism was the Buddha, a historical figure who advocated the path of *asceticism*, or self-discipline and self-denial, as the means to free oneself from attachments to people and possessions, thus ending rebirth (see "Buddhism and Buddhist Iconography," page 13). Unlike their predecessors in South Asia, both Hindus and Buddhists use images of gods and holy persons in religious rituals. To judge from surviving works, Buddhism has the older artistic tradition. The earliest Buddhist monuments date to the Maurya period.

## Maurya Dynasty

When Alexander the Great reached the Indus River in 326 BCE, his troops refused to go forward. Reluctantly, Alexander abandoned his dream of conquering India and headed home. After Alexander's death three years later, his generals divided his empire among themselves. One of them, Seleucus Nicator, reinvaded India, but Chandragupta Maurya (r. 323–298 BCE), founder of the Maurya dynasty, defeated him in 305 BCE and eventually consolidated almost all of present-day India under his domain. Chandragupta's capital was Pataliputra (modern Patna) in northeastern India, far from the center of the Indus Civilization. Megasthenes, Seleucus's ambassador to the Maurya court, described Pataliputra in his book on India as a large and wealthy city enclosed within mighty wooden walls so extensive that the circuit had 64 gates and 570 towers.

## Buddhism and Buddhist Iconography

### THE BUDDHA AND BUDDHISM

The Buddha (Enlightened One) was born around 563 BCE as Prince Siddhartha Gautama, the eldest son of the king of the Shakya clan. A prophecy foretold that he would grow up to be either a world conqueror or a great religious leader. His father preferred the secular role for young Siddhartha and groomed him for kingship by shielding the boy from the hardships of the world. When he was 29, however, the prince rode out of the palace, abandoned his wife and family, and encountered firsthand the pain of old age, sickness, and death. Siddhartha responded to the suffering he witnessed by renouncing his opulent life and becoming a wandering ascetic searching for knowledge through meditation. Six years later, he achieved complete enlightenment, or buddhahood, while meditating beneath a pipal tree (the Bodhi tree) at Bodh Gaya ("place of enlightenment") in eastern India. Known from that day on as Shakyamuni (Wise Man of the Shakya clan), the Buddha preached his first sermon in the Deer Park at Sarnath. There he set in motion the Wheel (*chakra*) of the Law (*dharma*) and expounded the Four Noble Truths that are the core insights of Buddhism: (1) Life is suffering; (2) the cause of suffering is desire; (3) one can overcome and extinguish desire; (4) the way to conquer desire and end suffering is to follow the Buddha's Eightfold Path of right understanding, right thought, right speech, right action, right livelihood, right effort, right mindfulness, and right concentration. The Buddha's path leads to nirvana, the cessation of the endless cycle of painful life, death, and rebirth. The Buddha continued to preach until his death at 80 at Kushinagara. His disciples carried on his teaching and established monasteries where others could follow the Buddha's path to enlightenment and nirvana.

This earliest form of Buddhism is called Theravada (the Path of the Elders) Buddhism. The new religion developed and changed over time as the Buddha's teachings spread from India throughout Asia. The second major school of Buddhist thought, Mahayana (Great Path) Buddhism, emerged around the beginning of the Christian era. Mahayana Buddhists refer to Theravada Buddhism as Hinayana (Lesser Path) Buddhism and believe in a larger goal than nirvana for an individual—namely, buddhahood for all. Mahayana Buddhists also revere *bodhisattvas* ("Buddhas-to-be"), exemplars of compassion who restrain themselves at the threshold of nirvana to aid others in earning merit and achieving buddhahood. Theravada Buddhism became the dominant sect in southern India, Sri Lanka, and mainland Southeast Asia, whereas Mahayana Buddhism took root in northern India and spread to China, Korea, Japan, and Nepal.

A third important Buddhist sect, especially popular in East Asia, venerates the Amitabha Buddha (Amida in Japanese), the Buddha of Infinite Light and Life. The devotees of this Buddha hope to be reborn in the Pure Land Paradise of the West, where the Amitabha resides and can grant them salvation. Pure Land teachings maintain that people have no possibility of attaining enlightenment on their own but can achieve paradise by faith alone.

### BUDDHIST ICONOGRAPHY

The earliest (first century CE) depictions of the Buddha in human form show him as a robed monk. Artists distinguished the Enlightened One from monks and bodhisattvas by *lakshanas,* body attributes indicating the Buddha's suprahuman nature. These distinguishing marks include an *urna,* or curl of hair between the eyebrows, shown as a dot; an *ushnisha,* a cranial bump shown as hair on the earliest images (FIGS. 1-10 to 1-12) but later as an actual part of the head (FIG. 1-13); and, less frequently, palms and soles imprinted with a wheel (FIG. 1-12). The Buddha is also recognizable by his elongated ears, the result of wearing heavy royal jewelry in his youth, but the enlightened Shakyamuni is rarely bejeweled, as are many bodhisattvas (FIG. 1-15). Sometimes the Buddha appears with a halo, or sun disk, behind his head (FIGS. 1-10, 1-12, and 1-13).

Representations of the Buddha also feature a repertory of *mudras,* or hand gestures, conveying fixed meanings. These include the *dhyana* (meditation) mudra, with the right hand over the left, palms upward (FIG. 1-10); the *bhumisparsha* (earth-touching) mudra, right hand down reaching to the ground, calling the earth to witness the Buddha's enlightenment (FIG. 1-11*b*); the *dharmachakra* (Wheel of the Law, or teaching) mudra, a two-handed gesture with right thumb and index finger forming a circle (FIG. 1-13); and the *abhaya* (do not fear) mudra, right hand up, palm outward, a gesture of protection or blessing (FIGS. 1-11*c* and 1-12).

Episodes from the Buddha's life are among the most popular subjects in all Buddhist artistic traditions. No single text provides the complete or authoritative narrative of the Buddha's life and death. Thus, numerous versions and variations exist, allowing for a rich artistic repertory. Four of the most important events are his birth at Lumbini from the side of his mother, Queen Maya (FIG. 1-11*a*); his achievement of buddhahood while meditating beneath the Bodhi tree at Bodh Gaya (FIG. 1-11*b*); his first sermon as the Buddha at Sarnath (FIGS. 1-11*c* and 1-13); and his attainment of nirvana when he died (*parinirvana*) at Kushinagara (FIGS. 1-11*d* and 1-26). Buddhists erected monasteries and monuments at the four sites where these key events occurred, although the Buddha himself disapproved of all luxury, including lavish religious shrines with costly figural art. Monks and lay pilgrims from throughout the world continue to visit these places today.

**ASHOKA** The greatest Maurya ruler was Ashoka (r. 272–231 BCE), who left his imprint on history by converting to Buddhism and spreading the Buddha's teaching throughout and beyond India (see "Ashoka's Conversion to Buddhism," page 14). Ashoka formulated a legal code based on the Buddha's dharma and inscribed his laws on enormous *monolithic* (one-piece stone) columns erected throughout his kingdom. Ashoka's pillars reached 30 to 40 feet high and are the first monumental stone artworks in India. The pillars penetrated deep into the ground, connecting earth and sky, forming an "axis of the universe," a pre-Buddhist concept that became an important motif in Buddhist architecture. The columns stood along pilgrimage routes to sites associated with the Buddha and on the roads leading to Pataliputra. Capping Ashoka's pillars were elaborate capitals, also carved from a single block of stone. The finest of these comes from Sarnath, where the Buddha

## Ashoka's Conversion to Buddhism

The reign of the Maurya king Ashoka marks both the beginning of monumental stone art and architecture (FIG. 1-6) in India and the first official sponsorship of Buddhism. The impact of Ashoka's conversion to Buddhism on the later history of art and religion in Asia cannot be overstated.

An edict carved into a rock at Dhauli in the ancient region of Kalinga (roughly equivalent to the modern state of Orissa on the Bay of Bengal) records Ashoka's embrace of nonviolence and of the teachings of the Buddha after an especially bloody conquest that claimed more than 100,000 lives. The inscription also captures Ashoka's missionary zeal, which spread Buddhism far beyond the boundaries of his kingdom.

> The Beloved of the Gods [Ashoka], conqueror of the Kalingas, is moved to remorse now. For he has felt profound sorrow and regret because the conquest of a people previously unconquered involves slaughter, death, and deportation.... [King Ashoka] now thinks that even a person who wrongs him must be forgiven ... [and he] considers moral conquest [conquest by dharma] the most important conquest. He has achieved this moral conquest repeatedly both here and among the peoples living beyond the borders of his kingdom.... Even in countries which [King Ashoka's] envoys have not reached, people have heard about dharma and about [the king's] ordinances and instructions in dharma.... This edict on dharma has been inscribed so that my sons and great-grandsons who may come after me should not think new conquests worth achieving.... Let them consider moral conquest the only true conquest.*

The story of Ashoka at Kalinga and his renunciation of violent aggression still resonates today. It inspired one of the most important 20th-century Indian sculptors to take up the theme and imbue it with contemporary meaning (FIG. 2-15).

*Rock Edict XIII. Translated by N. A. Nikam and Richard McKeon, *The Edicts of Aśoka* (Chicago: University of Chicago Press, 1959), 27–30.

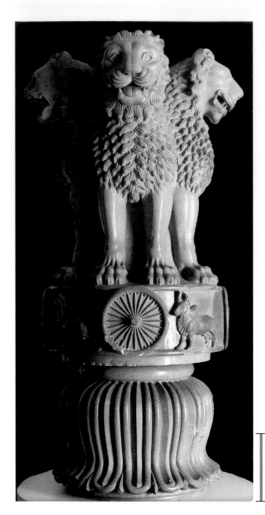

**1-6** Lion capital of the column erected by Ashoka at Sarnath, India, ca. 250 BCE. Polished sandstone, 7' high. Archaeological Museum, Sarnath.

Ashoka formulated a legal code based on the Buddha's teachings and inscribed those laws on columns erected throughout his kingdom. The lions on this capital once supported the Buddha's Wheel of the Law.

1 ft.

gave his first sermon and set the Wheel of the Law in motion. It is a seven-foot lion capital (FIG. 1-6). Stylistically, Ashoka's capital owes much to the ancient Near East, especially the Achaemenid art of Persepolis, but its iconography is Buddhist. Two pairs of back-to-back lions (the Buddha is often referred to as "the lion") stand on a round abacus decorated with four wheels and four animals symbolizing the four quarters of the world. The lions once carried a large stone wheel on their backs. The wheel (chakra) referred to the Wheel of the Law but also indicated Ashoka's stature as a *chakravartin* ("holder of the wheel"), a universal king imbued with divine authority. The open mouths of the four lions that face the four quarters of the world may signify the worldwide announcement of the Buddha's message.

### Shunga, Andhra, and Kushan Dynasties

The Maurya dynasty came to an abrupt end when its last ruler was assassinated by one of his generals, who founded a new dynasty in his own name. The Shungas, however, never ruled an empire as extensive as that of the Mauryas. Their realm was confined to central

India. They were succeeded by the Andhras, who also controlled the Deccan plateau to the south. By the middle of the first century CE, an even greater empire, the Kushan, rose in northern India. Its most celebrated king was Kanishka, who came to power during the late first or early second century CE and who set up capitals at Peshawar and other sites in Gandhara, a region largely in Pakistan today, close to the Afghanistan border. The Kushans grew rich on trade between China and the west along one of the main caravan routes bringing the luxuries of the Orient to the Roman Empire (see "Silk and the Silk Road," Chapter 3, page 54). Kanishka even struck coins modeled on the imperial coinage of Rome, some featuring Greco-Roman deities, but Kanishka's coins also carried portraits of himself and images of the Buddha and various Hindu deities.

**SANCHI** The unifying characteristic of this age of regional dynasties in South Asia was the patronage of Buddhism. One of the most important Buddhist monasteries, founded during Ashoka's reign and in use for more than a thousand years, is at Sanchi in central India. It consists of many buildings constructed over the centuries, including *viharas* (celled structures where monks live), large *stupas* (see "The Stupa," page 15), *chaitya halls* (halls with rounded, or *apsidal*, ends for housing smaller stupas), and temples for sheltering images.

The Great Stupa at Sanchi dates originally to Ashoka's reign, but its present form (FIG. 1-7), with its tall stone fence and four gates, dates from ca. 50 BCE to 50 CE. The solid earth-and-rubble dome stands 50 feet high. Worshipers enter through one of the gateways, walk on the lower circumambulation path, then climb the stairs on the south side to circumambulate at the second level. Carved onto the different parts of the Great Stupa are more than 600 brief inscriptions showing that the donations of hundreds of individuals (more than a

## The Stupa

An essential element of Buddhist sanctuaries is the *stupa*, a grand circular mound modeled on earlier South Asian burial mounds of a type familiar in many other ancient cultures. The stupa was not a tomb, however, but a monument housing relics of the Buddha. When the Buddha died, his cremated remains were placed in eight *reliquaries*, or containers, similar in function to the later reliquaries housed in medieval churches at pilgrimage sites throughout the Christian world. But unlike their Western equivalents, which were put on display, the Buddha's relics were buried in solid earthen mounds (stupas) that could not be entered. In the mid-third century BCE, Ashoka opened the original eight stupas and spread the Buddha's relics among thousands of stupas in all corners of his realm. Buddhists venerated the Buddha's remains by *circumambulation*, walking around the stupa in a clockwise direction. The circular movement, echoing the movement of the earth and the sun, brought the devotee into harmony with the cosmos. Stupas come in many sizes, from tiny handheld objects to huge structures, such as the Great Stupa at Sanchi (FIG. 1-7), constructed originally by Ashoka and later enlarged.

The monumental stupas are three-dimensional *mandalas,* or sacred diagrams of the universe. The domed stupa itself represents the world mountain, with the cardinal points marked by *toranas,* or gateways. The *harmika*, positioned atop the stupa dome, is a stone fence or railing that encloses a square area symbolizing the sacred domain of the gods. At the harmika's center, a *yasti,* or pole, corresponds to the axis of the universe, a motif already present in Ashoka's pillars. Three *chatras,* or stone disks, assigned various meanings, crown the yasti. The yasti rises from the mountain-dome and passes through the harmika, thus uniting this world with the heavenly paradise. A stone fence often encloses the entire structure, clearly separating the sacred space containing the Buddha's relics from the profane world outside.

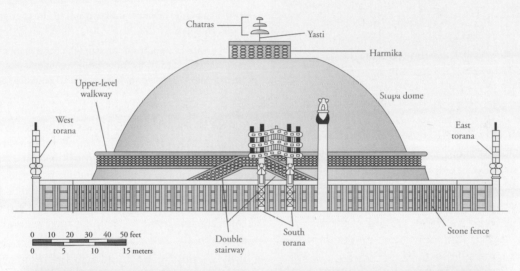

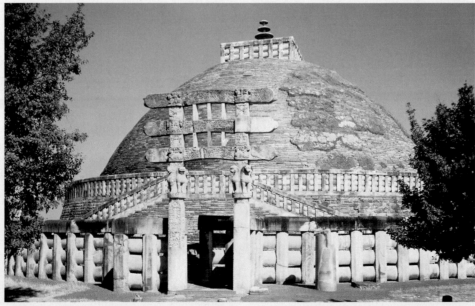

**1-7** Diagram (*top*) and view from the south (*bottom*) of the Great Stupa, Sanchi, India, third century BCE to first century CE.

The Sanchi stupa is an earthen mound containing relics of the Buddha. Buddhists walk around stupas in a clockwise direction. They believe that the circular movement brings the devotee into harmony with the cosmos.

India and Pakistan **15**

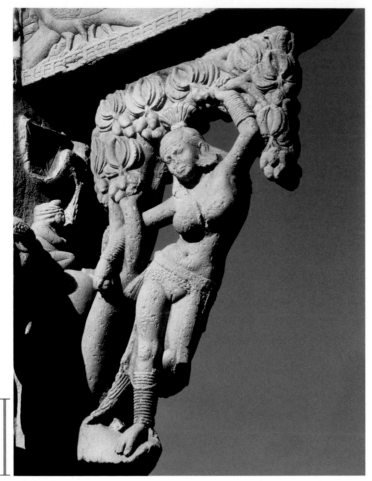

1 ft.

**1-8** Yakshi, detail of the east torana, Great Stupa, Sanchi, India, mid-first century BCE to early first century CE. Sandstone, 5′ high.

Yakshis personify fertility and vegetation. The Sanchi yakshis are scantily clad women who make mango trees flower. The yakshis' pose was later used to represent Queen Maya giving birth to the Buddha.

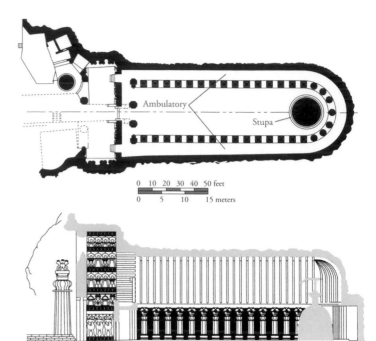

**1-9** Plan (*top*) and section (*bottom*) of the chaitya hall (FIG. **1-1**), Karle, India, ca. 50 CE.

Chaitya halls in Buddhist monasteries house stupas. The form of the rock-cut cave at Karle imitates earlier wooden halls. The massive interior (45 feet tall, 125 feet long) has excellent acoustics for devotional chanting.

third of them women) made the monument's construction possible. Veneration of the Buddha was open to all, not just the monks, and most of the dedications were by common laypeople, who hoped to accrue merit for future rebirths with their gifts.

The reliefs on the four toranas at Sanchi depict the story of the Buddha's life and those of his past lives ( *jatakas*). In Buddhist belief, everyone has had innumerable past lives, including Siddhartha. During Siddhartha's former lives, as recorded in the jatakas, he accumulated sufficient merit to achieve enlightenment and become the Buddha. In the life stories recounted in the Great Stupa reliefs, however, the Buddha never appears in human form. Instead, the artists used symbols—for example, footprints, a parasol, or an empty seat—to indicate the Buddha's presence. Some scholars regard these symbols as markers of where the Buddha once was, enabling others to follow in his footsteps.

Also carved on the east torana is a scantily clad, sensuous woman called a *yakshi* (FIG. **1-8**). These goddesses, worshiped throughout India, personify fertility and vegetation. The Sanchi yakshi reaches up to hold on to a mango tree branch while pressing her left foot against the trunk, an action that has brought the tree to flower. Buddhists later adopted this pose, with its rich associations of procreation and abundance, for representing the Buddha's mother, Maya, giving birth (FIG. **1-11***a*). Thus, the Buddhists adopted pan-Indian symbolism, such as the woman under the tree, and the sensuality of the Indus sculptural tradition (FIG. **1-4**) when creating their own Buddhist iconography.

**KARLE** The chaitya hall (FIGS. **1-1** and **1-9**) carved out of the living rock at Karle in imitation of earlier wooden structures is the best early example of a Buddhist stupa hall. Datable around 100 CE, the Karle hall has a pillared *ambulatory* (walking path) that allows worshipers to circumambulate the stupa placed at the back of the sacred cave. The hall also has excellent acoustics for devotional chanting. It is nearly 45 feet high and 125 feet long and surpasses in size even the rock-cut chamber of the temple of the Egyptian pharaoh Ramses II. Elaborate capitals atop the rock-cut pillars depict men and women riding on elephants. Outside, amorous couples (*mithunas*) flank the entrance. Like the yakshis at Sanchi, these auspicious figures symbolize the creative life force.

**GANDHARA** The first anthropomorphic representations of the Buddha probably appeared in the first century CE. Scholars still debate what brought about this momentous shift in Buddhist iconography, but one factor may have been the changing perception of the Buddha himself. Originally revered as an enlightened mortal, the Buddha increasingly became regarded as a divinity. Consequently, the Buddha's followers desired images of him to worship.

Many of the early portrayals of the Buddha in human form come from the Gandhara region. A second-century CE statue (FIG. **1-10**) carved in gray schist, the local stone, shows the Buddha, with ushnisha and urna, dressed in a monk's robe, seated in a cross-legged yogic posture similar to that of the ancient figure on the Indus seal in FIG. **1-5**. The Buddha's hands overlap, palms upward, in the dhyana mudra, the gesture of meditation (see "Buddhism," page 13). This statue (and Gandharan sculpture in general) owes much to Greco-Roman art, both in the treatment of body forms, such as the sharp, arching brows and continuous profile of forehead and nose, and in the draping of the togalike garment.

One of the earliest pictorial narrative cycles in which the Buddha appears in human form also comes from Gandhara. The schist frieze (FIG. **1-11**) depicts, in chronological order from left to right, the

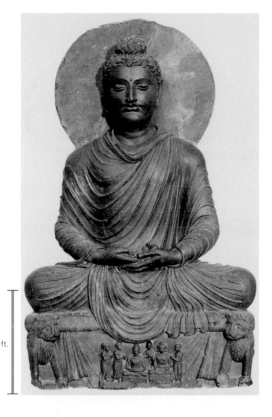

**1-10** Meditating Buddha, from Gandhara, Pakistan, second century CE. Gray schist, 3′ 7½″ high. National Museums of Scotland, Edinburgh.

Many of the earliest portrayals of the Buddha in human form come from Gandhara and depict the Enlightened One as a robed monk. The style of this Gandharan Buddha owes much to Greco-Roman art.

1 ft.

Buddha's birth at Lumbini, his enlightenment at Bodh Gaya, his first sermon at Sarnath, and the Buddha's death at Kushinagara. At the left, Queen Maya, in a posture derived from that of earlier South Asian yakshis (FIG. 1-8), gives birth to Prince Siddhartha, who emerges from her right hip, already with his attributes of ushnisha, urna, and halo. Receiving him is the god Indra. Elegantly dressed ladies, one with a fan of peacock feathers, suggest the opulent court life the Buddha left behind. In the next scene, the Buddha sits beneath the Bodhi tree while the soldiers and demons of the evil Mara attempt to distract him from his quest for knowledge. They are unsuccessful, and the Buddha reaches down to touch the earth (bhumisparsha mudra) as witness to his enlightenment. Next, the Buddha preaches the Eightfold Path to nirvana in the Deer Park at Sarnath. The sculptor set the scene by placing two deer and the Wheel of the Law beneath the figure of the Buddha, who raises his right hand (abhaya mudra) to bless the monks and other devotees who have come to hear his first sermon. In the final section of the frieze, the parinirvana, the Buddha lies dying among his devotees, some of whom wail in grief, while one monk, who realizes that the Buddha has been permanently released from suffering, remains tranquil in meditation.

Although the iconography of the frieze is Buddhist, Roman reliefs must have served as stylistic models for the sculptor. For example, the distribution of standing and equestrian figures over the relief ground, with those behind the first row seemingly suspended in the

a

b

1 ft.

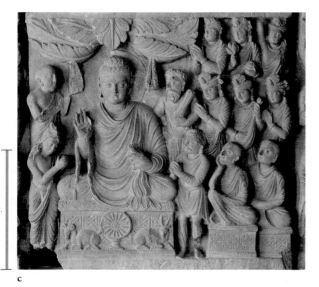

c

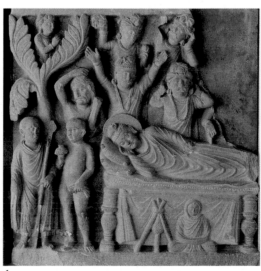

d

**1-11** The life and death of the Buddha, frieze from Gandhara, Pakistan, second century CE. Schist, 2′ 2⅜″ × 9′ 6⅛″. Freer Gallery of Art, Washington, D.C. (a) birth at Lumbini, (b) enlightenment at Bodh Gaya, (c) first sermon at Sarnath, (d) death at Kushinagara.

This Gandharan frieze is one of the earliest pictorial narrative cycles in which the Buddha appears in human form. It recounts the Buddha's life story from his birth at Lumbini to his death at Kushinagara.

India and Pakistan **17**

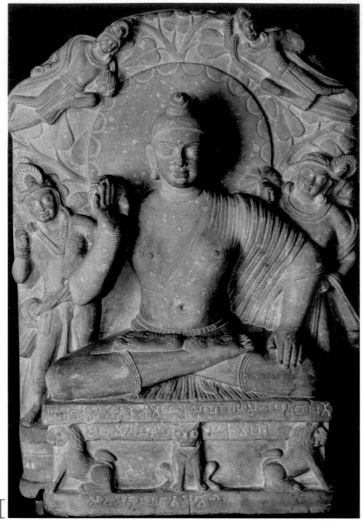

**1-12** Buddha seated on lion throne, from Mathura, India, second century CE. Red sandstone, 2′ 3½″ high. Archaeological Museum, Muttra.

Stylistically distinct from the Gandharan Buddhas are those of Mathura, where the Buddha has the body type of a yaksha but wears a monk's robe. This example depicts the Buddha under the Bodhi tree.

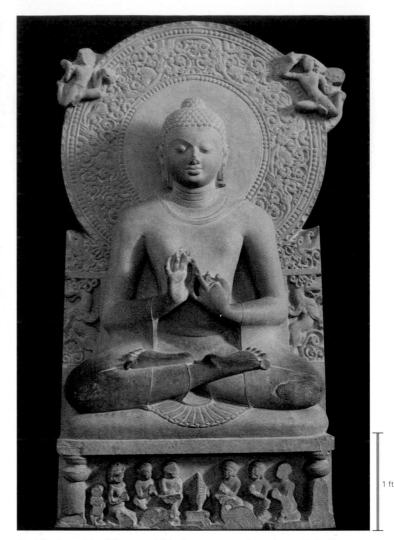

**1-13** Seated Buddha preaching first sermon, from Sarnath, India, second half of fifth century. Tan sandstone, 5′ 3″ high. Archaeological Museum, Sarnath.

Under the Guptas, artists formulated the canonical image of the Buddha, combining the Gandharan monastic-robe type with the Mathuran type of soft, full-bodied figure attired in clinging garments.

air, is familiar in Roman art of the second and third centuries CE. The figure of the Buddha on his deathbed finds parallels in the reclining figures on the lids of Roman sarcophagi. The type of hierarchical composition in which a large central figure sits between balanced tiers of smaller onlookers is also common in Roman imperial art.

**MATHURA** Contemporary to but stylistically distinct from the Gandharan sculptures are the Buddha images of Mathura, a city about 90 miles south of Delhi that was also part of the Kushan Empire. The Mathura statues (for example, FIG. **1-12**) are more closely linked to the Indian portrayals of *yakshas,* the male equivalents of the yakshis. Indian artists represented yakshas as robust, powerful males with broad shoulders and open, staring eyes. Mathura Buddhas, carved from red sandstone like the Harappa nude male (FIG. **1-4**), retain these characteristics but wear a monk's robe (with right shoulder bare) and lack the jewelry and other signs of wealth of the yakshas. The robe appears almost transparent, revealing the full, fleshy body beneath. In FIG. **1-12**, the Buddha sits in a yogic posture on a lion throne under the Bodhi tree, attended by fly-whisk bearers. He raises his right hand palm outward in the abhaya gesture, indicating to worshipers that they need have no fear. His hands and feet bear the mark of the Wheel of the Law.

## The Gupta and Post-Gupta Periods

Around 320* a new empire arose in north-central India. The Gupta emperors chose Pataliputra as their capital, deliberately associating themselves with the prestige of the former Maurya Empire. The heyday of this dynasty was under Chandragupta II (r. 375–415), whose very name recalled the first Maurya emperor. The Guptas were great patrons of art and literature.

**SARNATH** Under the Guptas, artists formulated what became the canonical image of the Buddha, combining the Gandharan monastic robe covering both shoulders with the Mathuran tradition of soft, full-bodied Buddha figures dressed in clinging garments. These disparate styles beautifully merge in a fifth-century statue (FIG. **1-13**) of the Buddha from Sarnath. The statue's smooth, unadorned surfaces conform to the Indian notion of perfect body form and emphasize the figure's spirituality. The Buddha's eyes are downcast in meditation, and he holds his hands in front of his body in the Wheel-turning gesture, preaching his first sermon. Below the Buddha is a scene with the Wheel of the Law at the center between two (now partially broken) deer sym-

*From this point on, all dates in this chapter are CE unless otherwise stated.

bolizing the Deer Park at Sarnath. Buddha images such as this one became so popular that temples housing Buddha statues seem largely to have displaced the stupa as the norm in Buddhist sacred architecture.

**AJANTA** The new popularity of Buddha imagery may be seen in the interior of a chaitya hall (FIG. **1-14**) carved out of the mountainside at Ajanta, northeast of Bombay, at about the same time a Gupta sculptor created the classic seated Buddha at Sarnath. Ajanta had been the site of a small Buddhist monastery for centuries, but royal patrons of the local Vakataka dynasty, allied to the Guptas by marriage, added more than 20 new caves in the second half of the fifth century. The typological similarity of the fifth-century Ajanta chaitya halls to the earlier example at Karle (FIG. **1-1**) is immediately evident and consistent with the conservative nature of religious architecture in all cultures. At Ajanta, however, sculptors carved into the front of the stupa an image of the Buddha standing between columns. Ajanta's fame, however, stems from the many caves that retain their painted wall (FIG. **1-15**) and ceiling decoration (see "The Painted Caves of Ajanta," below).

Buddhists and Hindus (and adherents of other faiths) practiced their religions side by side in India, often at the same site. For example, the Hindu Vakataka king Harishena (r. 462–481) and members of his court were the sponsors of new caves at the

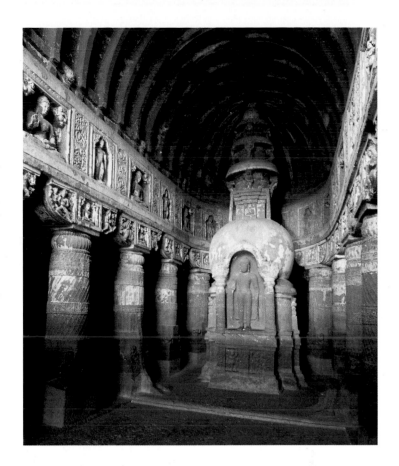

**1-14** Interior of cave 19, Ajanta, India, second half of fifth century.

The popularity of Gupta Buddha statues led to a transformation in Indian religious architecture. Cave 19 at Ajanta is a chaitya hall with an image of the Buddha carved on the front of its stupa.

## The Painted Caves of Ajanta

Art historians assume India had a rich painting tradition in ancient times, but because early Indian artists often used perishable materials, such as palm leaf and wood, and because of the tropical climate in much of India, nearly all early Indian painting has been lost. At Ajanta in the Deccan, however, paintings cover the walls, pillars, and ceilings of several caves datable to the second half of the fifth century. FIG. **1-15** reproduces a detail of one of the restored murals in cave 1 at Ajanta. The bodhisattva Padmapani sits among a crowd of devotees, both princes and commoners. With long, dark hair hanging down below a jeweled crown, he stands holding his attribute, a blue lotus flower, in his right hand. The painter rendered with finesse the sensuous form of the richly attired bodhisattva, gently modeling the figure with gradations of color and delicate highlights and shading, especially evident in the face and neck. The artist also carefully considered the placement of the painting in the cave. The bodhisattva gazes downward at worshipers passing through the entrance to the shrine on their way to the rock-cut Buddha image in a cell at the back of the cave.

To create the Ajanta murals, the painters first applied two layers of clay mixed with straw and other materials to the walls. They then added a third layer of fine white lime plaster. Unlike true fresco painting, in which the painters apply colors to wet plaster, the Indian painters waited for the lime to dry. This method produces less durable results, and the Ajanta murals have suffered water damage over the centuries. The painters next outlined the figures in dark red and then painted in the details of faces, costumes, and jewelry. They used water-soluble colors produced primarily from local minerals, including red and yellow ocher. Blue, used sparingly, came from costly lapis lazuli imported from Afghanistan. The last step was to polish the painted surface with a smooth stone.

**1-15** Bodhisattva Padmapani, detail of a wall painting in cave 1, Ajanta, India, second half of fifth century.

In this early example of Indian painting in an Ajanta cave, the artist rendered the sensuous form of the richly attired bodhisattva with gentle gradations of color and delicate highlights and shadows.

## Hinduism and Hindu Iconography

Unlike Buddhism (and Christianity, Islam, and other religions), Hinduism recognizes no founder or great prophet. Hinduism also has no simple definition but means "the religion of the Indians." Both "India" and "Hindu" have a common root in the name of the Indus River. The practices and beliefs of Hindus vary tremendously, but the literary origins of Hinduism can be traced to the Vedic period, and some aspects of Hindu practice seem already to have been present in the Indus Civilization of the third millennium BCE. Ritual sacrifice by Brahmin priests is central to Hinduism, as it was to the Aryans. The goal of sacrifice is to please a deity in order to achieve release (moksha, or liberation) from the endless cycle of birth, death, and rebirth (samsara) and become one with the universal spirit.

Not only is Hinduism a religion of many gods, but the Hindu deities have various natures and take many forms. This multiplicity suggests the all-pervasive nature of the Hindu gods. The three most important deities are the gods Shiva and Vishnu and the goddess Devi. Each of the three major sects of Hinduism today considers one of these three to be supreme—Shiva in Shaivism, Vishnu in Vaishnavism, and Devi in Shaktism. (*Shakti* is the female creative force.)

*Shiva* is the Destroyer, but, consistent with the multiplicity of Hindu belief, he is also a regenerative force and, in the latter role, can be represented in the form of a *linga* (a phallus or cosmic pillar). When Shiva appears in human form in Hindu art, he frequently has multiple limbs and heads (FIGS. 1-17, 1-18, and 1-25), signs of his suprahuman nature, and matted locks piled atop his head, crowned by a crescent moon. Sometimes he wears a serpent scarf and has a third eye on his forehead (the emblem of his all-seeing nature). Shiva rides the bull *Nandi* (FIG. 1-17) and often carries a *trident,* a three-pronged pitchfork.

*Vishnu* is the Preserver of the Universe. Artists frequently portray him with four arms (FIGS. 1-20 and 1-29) holding various attributes, including a conch-shell trumpet and discus. He sometimes reclines on a serpent floating on the waters of the cosmic sea (FIGS. 1-20 and 1-29). When the evil forces of the universe become too strong, he descends to earth to restore balance and assumes different forms (*avatars,* or incarnations), including a boar (FIG. 1-16), fish, and tortoise, as well as *Krishna,* the divine lover (FIG. 2-7), and even the Buddha himself.

*Devi* is the Great Goddess who takes many forms and has many names. Hindus worship her alone or as a consort of male gods (*Parvati* or *Uma,* wife of Shiva; *Lakshmi,* wife of Vishnu), as well as *Radha,* lover of Krishna (FIG. 2-7). She has both benign and horrific forms. She both creates and destroys. In one manifestation, she is *Durga,* a multiarmed goddess who often rides a lion. Her son is the elephant-headed *Ganesha* (FIG. 1-17).

The stationary images of deities in Hindu temples are often made of stone. Hindus periodically remove portable images of their gods, often of bronze (FIG. 1-25), from the temple, particularly during festivals to enable many worshipers to take *darshan* (seeing the deity and being seen by the deity) at one time. In temples dedicated to Shiva, the stationary form is the linga.

1 ft.

**1-16** Boar avatar of Vishnu rescuing the earth, cave 5, Udayagiri, India, early fifth century. Relief 13′ × 22′; Vishnu 12′ 8″ high.

The oldest Hindu cave temples are at Udayagiri, a site that also boasts some of the earliest Hindu stone sculptures, such as this huge relief of Vishnu as the boar Varaha rescuing the earth.

**1-17** Dancing Shiva, rock-cut relief in cave temple, Badami, India, late sixth century.

Shiva here dances the cosmic dance and has 18 arms, some holding objects, others forming mudras. Hindu gods often have multiple limbs to indicate their suprahuman nature and divine powers.

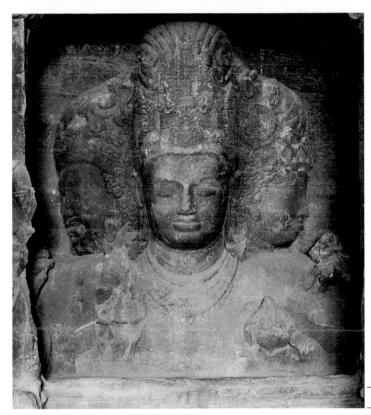

1 ft.

**1-18** Shiva as Mahadeva, cave 1, Elephanta, India, ca. 550–575. Basalt, Shiva 17′ 10″ high.

This immense rock-cut image of Shiva as Mahadeva ("Great God") emerges out of the depths of the Elephanta cave as worshipers' eyes adjust to the darkness. The god has both male and female faces.

Buddhist monastery at Ajanta. Buddhism and Hinduism are not monotheistic religions, such as Judaism, Christianity, and Islam. Instead, Buddhists and Hindus approach the spiritual through many gods and varying paths, which permits mutually tolerated differences. In fact, in Hinduism, the Buddha was one of the 10 incarnations of Vishnu, one of the three principal Hindu deities (see "Hinduism and Hindu Iconography," page 20).

**UDAYAGIRI** More early Buddhist than Hindu art has survived in India because the Buddhists constructed large monastic institutions with durable materials such as stone and brick. But in the Gupta period, Hindu stone sculpture and architecture began to rival the great Buddhist monuments of South Asia. The oldest Hindu cave temples are at Udayagiri, near Sanchi. They date to the early fifth century, some 600 years after the first Buddhist examples. Although the Udayagiri temples are architecturally simple and small, the site boasts monumental relief sculptures showing an already fully developed religious iconography. One of these reliefs (FIG. 1-16), carved in a shallow niche of rock, shows a 13-foot-tall Vishnu in his incarnation as the boar Varaha. The avatar has a human body and a boar's head. Vishnu assumed this form when he rescued the earth—personified as the goddess Bhudevi clinging to the boar's tusk—from being carried off to the bottom of the ocean. Vishnu stands with one foot resting on the coils of a snake king (note the multiple hoods behind his human head), who represents the conquered demon that attempted to abduct the earth. Rows of gods and sages form lines to witness the event.

The relief served a political as well as a religious purpose. The patron of the relief was a local king who honored the great Gupta king Chandragupta II in a nearby inscription dated to the year 401. Many scholars believe that the local king wanted viewers to see

Chandragupta (he is known to have visited the site) as saving his kingdom by ridding it of its enemies in much the same way Varaha saved the earth.

**BADAMI** During the sixth century, the Huns brought down the Gupta Empire, and various regional dynasties rose to power. In the Deccan plateau of central India, the Chalukya kings ruled from their capital at Badami. There, Chalukya sculptors carved a series of reliefs in the walls of halls cut into the cliff above the city. One relief (FIG. 1-17), datable to the late sixth century, shows Shiva dancing the cosmic dance, his 18 arms swinging rhythmically in an arc. Some of the hands hold objects, and others form prescribed mudras. At the lower right, the elephant-headed Ganesha tentatively mimics Shiva. Nandi, Shiva's bull mount, stands at the left. Artists often represented Hindu deities as part human and part animal (FIG. 1-16) or, as in the Badami relief, as figures with multiple body parts. Such composite and multilimbed forms indicate that the subjects are not human but suprahuman gods with supernatural powers.

**ELEPHANTA** Another portrayal of Shiva as a suprahuman being is found at a third Hindu cave site, on Elephanta, an island in Bombay's harbor that early Portuguese colonizers named after a life-size stone elephant sculpture there. A king of the Kalachuri dynasty that took control of Elephanta in the sixth century may have commissioned the largest of the island's cave temples. Just inside the west entrance to the cave is a shrine housing Shiva's linga, the god's emblem. Deep within the temple, in a niche once closed off with wooden doors, is a nearly 18-foot-high rock-cut image (FIG. 1-18) of Shiva as Mahadeva, the "Great God" or Lord of Lords. Mahadeva appears to emerge out of the depths of the cave as worshipers' eyes become accustomed to the darkness. This image of

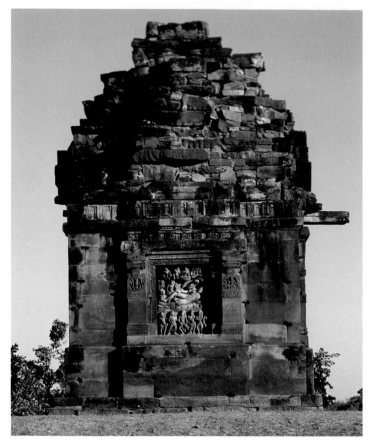

**1-19** Vishnu Temple (looking north), Deogarh, India, early sixth century.

One of the first masonry Hindu temples, the Vishnu Temple at Deogarh is a simple square building with a tower. Sculpted guardians protect its entrance. Narrative reliefs adorn the three other sides.

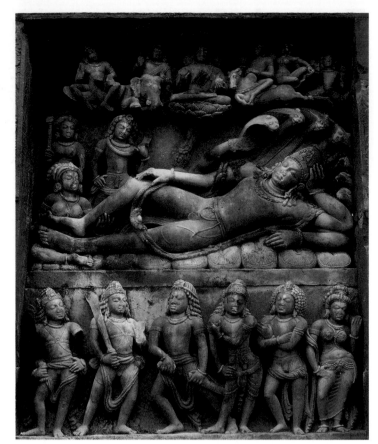

**1-20** Vishnu asleep on the serpent Ananta, relief panel on the south facade of the Vishnu Temple, Deogarh, India, early sixth century.

Sculptors carved the reliefs of the Vishnu Temple at Deogarh in classic Gupta style. In this one, the four-armed Vishnu sleeps on the serpent Ananta as he dreams the universe into reality.

Shiva has three faces, each showing a different aspect of the deity. (A fourth, unseen at the back, is implied—the god has not emerged fully from the rock.) The central face expresses Shiva's quiet, balanced demeanor. The clean planes of the face contrast with the richness of the piled hair encrusted with jewels. The two side faces differ significantly. That on the right is female, with framing hair curls. The left face is a grimacing male with a curling mustache who wears a cobra as an earring. The female (Uma) indicates the creative aspect of Shiva. The fierce male (Bhairava) represents Shiva's destructive side. Shiva holds these two opposing forces in check, and the central face expresses their balance. The cyclic destruction and creation of the universe, which the side faces also symbolize, are part of Indian notions of time, matched by the cyclic pattern of death and rebirth (samsara).

**DEOGARH** The excavated cave shrines just considered are characteristic of early Hindu religious architecture, but temples constructed using quarried stone became more important as Hinduism evolved over the centuries. As they did with the cave temples, the Hindus initially built rather small and simple temples but decorated them with narrative reliefs displaying a fully developed iconography. The Vishnu Temple (FIG. **1-19**) at Deogarh in north-central India, erected in the early sixth century, is among the first Hindu temples constructed with stone blocks. A simple square building, it has an elaborately decorated doorway at the front and a relief in a niche on each of the other three sides. Sculpted guardians and mithunas protect the doorway at Deogarh, because it is the transition point between the dangerous outside and the sacred. The temple culminates in a tower that was originally at least 40 feet tall.

The reliefs in the three niches of the Deogarh temple depict important episodes in the saga of Vishnu. On the south (FIG. **1-20**), Vishnu sleeps on the coils of the giant serpent Ananta, whose multiple heads form a kind of umbrella around the god's face. While Lakshmi massages her husband's legs (he has cramps as he gives birth), the four-armed Vishnu dreams the universe into reality. A lotus plant (said to have grown out of Vishnu's navel) supports the four-headed Hindu god of creation, Brahma. Flanking him are other important Hindu divinities, including Shiva on his bull. Below are six figures. The four at the right are personifications of Vishnu's various powers. They will defeat the two armed demons at the left. The sculptor carved all the figures in the classic Gupta style, with smooth bodies and clinging garments (compare FIG. **1-13**).

## Early Medieval Period

During the several centuries corresponding to the early medieval period in western Europe, the early Islamic period in the Near East (see Chapter 7), the Tang and Song dynasties in China (see Chapter 3), and the Nara and Heian periods in Japan (see Chapter 5), regional dynasties ruled parts of India. Among the most important of these kingdoms were the Palas and Chandellas in northern India and the Pallavas and Cholas in the south. Whereas Buddhism spread rapidly throughout eastern Asia, in medieval India it gradually declined, and

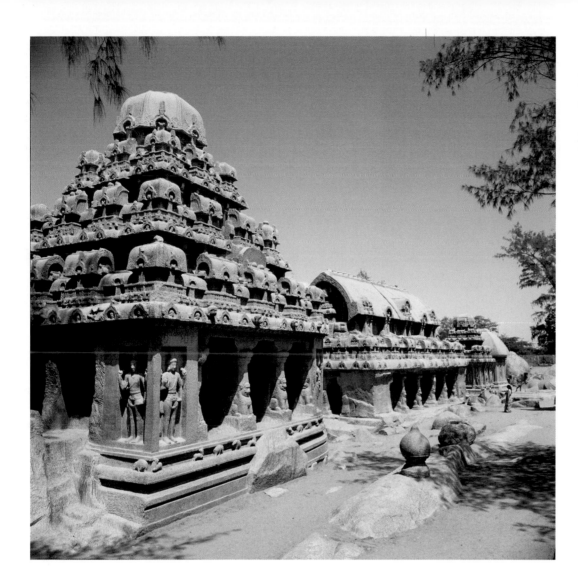

**1-21** Rock-cut rathas, Mamallapuram, India, second half of seventh century. From *left* to *right*: Dharmaraja, Bhima, Arjuna, and Draupadi rathas.

Indian architects also created temples by sculpting them from the living rock. The seventh-century rathas ("chariots" of the gods) at Mamallapuram were all carved from a single huge granite outcropping.

the various local kings vied with one another to erect glorious shrines to the Hindu gods.

**MAMALLAPURAM** In addition to cave temples and masonry temples, Indian architects created a third type of monument: freestanding temples carved out of rocky outcroppings. Sculpted monolithic temples are rare. Some of the earliest and most impressive are at Mamallapuram, south of Madras on the Bay of Bengal, where they are called *rathas,* or "chariots" (that is, vehicles of the gods). In the late seventh century, the Pallava dynasty had five rathas (FIG. **1-21**) carved out of a single huge granite boulder jutting out from the sand. The group is of special interest because it illustrates the variety of temple forms at this period, based on earlier wooden structures, before a standard masonry type of temple became the rule in southern India.

The largest Mamallapuram ratha, the Dharmaraja (FIG. **1-21**, *left*), dedicated to Shiva, is an early example of the typical southern-style temple with stepped-pyramid vimana (see "Hindu Temples," page 24). The tower ascends in pronounced tiers of cornices decorated with miniature shrines. The lower walls include carved columns and figures of deities inside niches. The Bhima ratha to the right, dedicated to Vishnu, has a rectangular plan and a rounded roof; the next ratha, the Arjuna, is a smaller example of the southern Indian type. At the end of the row sits the very small Draupadi ratha, which was modeled on a thatched hut and is dedicated to Durga, a form of the goddess Devi. The two largest temples were never finished.

**THANJAVUR** Under the Cholas, whose territories extended into part of Sri Lanka and even Java, architects constructed temples of unprecedented size and grandeur in the southern Indian tradition. The Rajarajeshvara Temple (FIG. **1-22**) at Thanjavur, dedicated in 1010 to Shiva as the Lord of Rajaraja, was the largest and tallest temple (210 feet high) in India at its time. The temple stands inside a walled precinct. It consists of a stairway leading to two flat-roofed mandapas, the larger one having 36 pillars, and to the garbha griha in the base of the enormous pyramidal vimana that is as much an emblem of the Cholas' secular power as of their devotion to Shiva. On the exterior walls of the lower stories are numerous reliefs in niches depicting the god in his various forms.

**KHAJURAHO** At the same time the Cholas were building the Rajarajeshvara Temple at Thanjavur in the south, the Chandella dynasty was constructing temples—in northern style—at Khajuraho. The Vishvanatha Temple (FIG. **1-23**) is one of more than 20 large and elaborate temples at that site. Vishvanatha ("Lord of the World") is another of the many names for Shiva. Dedicated in 1002, the structure has three towers over the mandapas, each rising higher than the preceding one, leading to the tallest tower at the rear, in much the same way the foothills of the Himalayas, Shiva's home, rise to meet their highest peak. The mountain symbolism applies to the interior of the Vishvanatha Temple as well. Under the tallest tower, the shikhara, is the garbha griha, the small and dark inner sanctuary chamber, like a cave, which houses the image of the deity. Thus,

# Hindu Temples

The Hindu temple is the home of the gods on earth and the place where they make themselves visible to humans. At the core of all Hindu temples is the *garbha griha*, the "womb chamber," which houses images or symbols of the deity—for example, Shiva's linga (see "Hinduism," page 20). Only the Brahmin priests can enter this inner sanctuary to make offerings to the gods. The worshipers can only stand at the threshold and behold the deity as manifest by its image. In the elaborate multi-roomed temples of later Hindu architecture, the worshipers and priests progress through a series of ever more sacred spaces, usually on an east-west axis. Hindu priests and architects attached great importance to each temple's plan and sought to make it conform to the sacred geometric diagram (mandala) of the universe.

Architectural historians, following ancient Indian texts, divide Hindu temples into two major typological groups tied to geography. The most important distinguishing feature of the **northern** style of temple (FIG. 1-23) is its bee-hivelike tower or *shikhara* ("mountain peak"), capped by an *amalaka*, a ribbed cushionlike form, derived from the shape of the amala fruit (believed to have medicinal powers). Amalakas appear on the corners of the lower levels of the

shikhara too. Northern temples also have smaller towerlike roofs over the halls (*mandapas*) leading to the garbha griha.

**Southern** temples (FIG. 1-22) can easily be recognized by the flat roofs of their pillared mandapas and by their shorter towered shrines, called *vimanas*, which lack the curved profile of their northern counterparts and resemble multilevel pyramids.

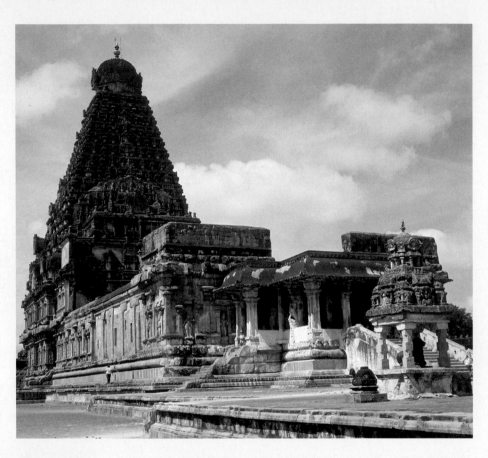

**1-22** Rajarajeshvara Temple, Thanjavur, India, ca. 1010.

The Rajarajeshvara Temple at Thanjavur is an example of the southern type of Hindu temple. Two flat-roofed mandapas lead to the garbha griha in the base of its 210-foot-tall pyramidal vimana.

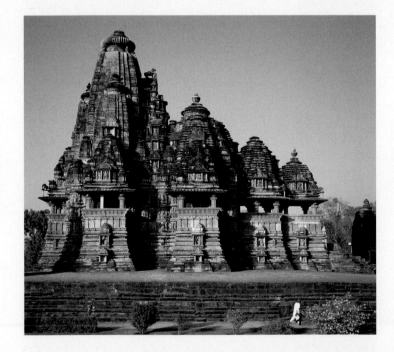

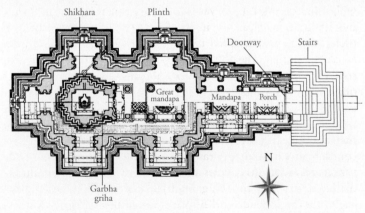

**1-23** Vishvanatha Temple (view looking north, *left*, and plan, *above*), Khajuraho, India, ca. 1000.

The Vishvanatha Temple is a northern Hindu temple type. It has four towers, each taller than the preceding one, symbolizing Shiva's mountain home. The largest tower is the beehive-shaped shikara.

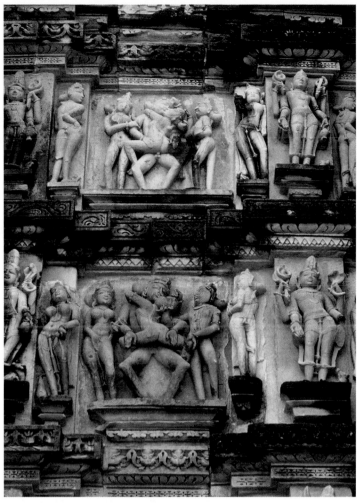

**1-24** Mithuna reliefs, detail of the north side of the Vishvanatha Temple, Khajuraho, India, ca. 1000.

Northern Hindu temples are usually decorated with reliefs depicting deities and amorous couples (mithunas). The erotic sculptures suggest the propagation of life and serve as protectors of the sacred precinct.

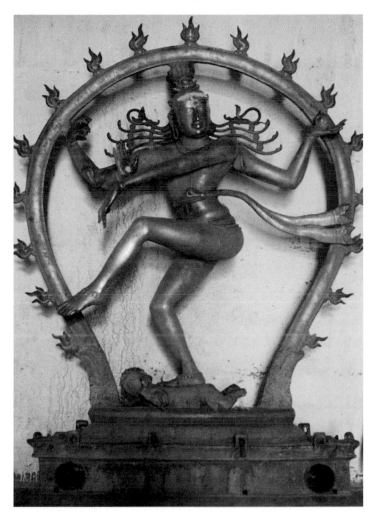

**1-25** Shiva as Nataraja, ca. 1000. Bronze. Naltunai Ishvaram Temple, Punjai.

One of many portable images of the gods used in Hindu worship, this solid-bronze statuette of Shiva as Lord of the Dance depicts the god balancing on one leg atop a dwarf representing ignorance.

temples such as the Vishvanatha symbolize constructed mountains with caves, comparable to the actual cave temples at Elephanta and other Indian sites. In all cases, the deity manifests himself or herself within the cave and takes various forms in sculptures. The temple mountains, however, are not intended to appear natural but rather are perfect mountains designed using ideal mathematical proportions.

The reliefs of Thanjavur's Rajarajeshvara Temple are typical of southern temple decoration, which is generally limited to images of deities. The exterior walls of Khajuraho's Vishvanatha Temple are equally typical of northern temples in the profusion of sculptures (FIG. **1-24**) depicting mortals as well as gods, especially pairs of men and women (mithunas) embracing or engaged in sexual intercourse in an extraordinary range of positions. The use of seminude yakshis and amorous couples as motifs on religious buildings in India has a very long history, going back to the earliest architectural traditions, both Hindu and Buddhist (Sanchi, FIG. **1-8**, and Karle). As in the earlier examples, the erotic sculptures of Khajuraho suggest fertility and the propagation of life and serve as auspicious protectors of the sacred precinct.

**SHIVA AS NATARAJA** Portable objects also play an important role in Hinduism. The statuette (FIG. **1-25**) of Shiva in the Naltunai Ishvaram Temple in Punjai, cast in solid bronze around 1000, recalls the sixth-century relief (FIG. **1-17**) in the Badami cave, but it is one of

many examples of moveable images of deities created under the Chola kings and still used in Hindu rituals today. Here, Shiva dances as Nataraja ("Lord of the Dance") by balancing on one leg atop a dwarf representing ignorance, which the god stamps out as he dances. Shiva extends all four arms, two of them touching the flaming *nimbus* (light of glory) encircling him. These two upper hands also hold a small drum (at right) and a flame (at left). Shiva creates the universe to the drumbeat's rhythm, while the small fire represents destruction. His lower left hand points to his upraised foot, indicating the foot as the place where devotees can find refuge and enlightenment. Shiva's lower right hand, raised in the abhaya mudra, tells worshipers to come forward without fear. As Shiva spins, his matted hair comes loose and spreads like a fan on both sides of his head.

At times, worshipers insert poles into the holes on the base of the Punjai Shiva to carry it, but even when stationary, the statuette would not appear as it does in FIG. **1-25**. Rather, when Hindus worship the Shiva Nataraja, they dress the image, cover it with jewels, and garland it with flowers. The only bronze part visible is the face, marked with colored powders and scented pastes. Considered the embodiment of the deity, the image is not a symbol of the god but the god itself. All must treat the image as a living being. Worship of the deity involves taking care of him as if he were an honored person. Bathed, clothed, given foods to eat, and taken for outings, the image also receives such gifts as melodic songs, bright lights (lit oil lamps),

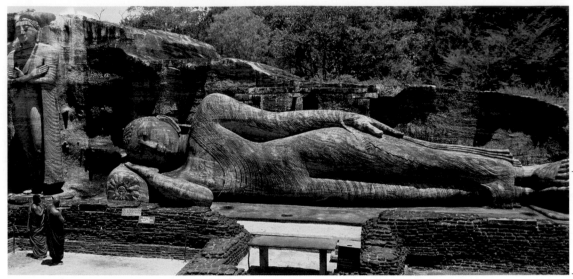

**1-26** Death of the Buddha (Parinirvana), Gal Vihara, near Polonnaruwa, Sri Lanka, 11th to 12th century. Granulite, Buddha 46′ long × 10′ high.

The sculptor of this colossal recumbent Sri Lankan Buddha emulated the classic Gupta style of a half millennium earlier in the figure's clinging robe, rounded face, and coiffure.

10 ft.

pleasing aromas (incense), and beautiful flowers—all things the god can enjoy through the senses. The food given to the god is particularly important, as he eats the "essence," leaving the remainder for the worshiper. The food is then *prasada* (grace), sacred because it came in contact with the divine. In an especially religious household, the deity resides as an image and receives the food for each meal before the family eats. When the god resides in a temple, it is then the duty of the priests to feed, clothe, and take care of him.

The Chola dynasty ended in the 13th century, a time of political, religious, and cultural change in South Asia. At this point, Buddhism survived in only some areas of India. It soon died out completely there, although the late form of northern Indian Buddhism continued in Tibet and Nepal. At the same time, Islam, which had arrived in India as early as the eighth century, became a potent political force with the establishment of the Delhi Sultanate in 1206. Hindu and Islamic art assumed preeminent roles in India in the 13th century (see Chapter 2).

# SOUTHEAST ASIA

Art historians once considered the art of Southeast Asia an extension of Indian civilization. Because of the Indian character of many Southeast Asian monuments, scholars hypothesized that Indian artists had constructed and decorated them and that Indians had colonized Southeast Asia. Today, researchers have concluded that no Indian colonization occurred. The expansion of Indian culture to Southeast Asia during the first millennium CE was peaceful and non-imperialistic, a by-product of trade. In the early centuries CE, ships bringing trade goods from India and China to Rome passed through Southeast Asia on the monsoon winds. The local tribal chieftains quickly saw an opportunity to participate, mainly with their own forest products, such as aromatic woods, bird feathers, and spices. Accompanying the trade goods from India were Sanskrit, Buddhism, and Hinduism—and Buddhist and Hindu art. But the Southeast Asian peoples soon modified Indian art to make it their own. Art historians now recognize Southeast Asian art and architecture as a distinctive and important tradition.

## Sri Lanka

Sri Lanka (formerly Ceylon) is an island located at the very tip of the Indian subcontinent. Theravada Buddhism, the oldest form of Buddhism, stressing worship of the historical Buddha, Shakyamuni

Buddha, arrived in Sri Lanka as early as the third century BCE. From there it spread to other parts of Southeast Asia. With the demise of Buddhism in India in about the 13th century, Sri Lanka now has the longest-lived Buddhist tradition in the world.

**GAL VIHARA** One of the largest sculptures in Southeast Asia is the 46-foot-long recumbent Buddha (FIG. **1-26**) carved out of a rocky outcropping at Gal Vihara in the 11th or 12th century. To the left of the Buddha, much smaller in scale, stands his cousin and chief disciple, Ananda, arms crossed, mourning Shakyamuni's death. Although more than a half millennium later in date, the Sri Lankan representation of the Buddha's parinirvana reveals its sculptor's debt to the classic Gupta sculptures of India, with their clinging garments, rounded faces, and distinctive renditions of hair (compare FIG. **1-13**). Other Southeast Asian monuments, in contrast, exhibit a marked independence from Indian models.

## Java

On the island of Java, part of the modern nation of Indonesia, the period from the 8th to the 10th centuries witnessed the erection of both Hindu and Buddhist monuments.

**BOROBUDUR** Borobudur (FIG. **1-27**), a Buddhist monument unique in both form and meaning, is colossal in size, measuring about 400 feet per side at the base and about 98 feet tall. Built over a small hill on nine terraces accessed by four stairways aligned with the cardinal points, the structure contains literally millions of blocks of volcanic stone. Visitors ascending the massive monument on their way to the summit encounter more than 500 life-size Buddha images, at least 1,000 relief panels, and some 1,500 stupas of various sizes.

Scholars debate the intended meaning of Borobudur. Most think the structure is a constructed cosmic mountain, a three-dimensional mandala where worshipers pass through various realms on their way to ultimate enlightenment. As they circumambulate Borobudur, pilgrims first see reliefs illustrating the karmic effects of various kinds of human behavior, then reliefs depicting jatakas of the Buddha's earlier lives, and, farther up, events from the life of Shakyamuni. On the circular terraces near the summit, each stupa is hollow and houses a statue of the seated Buddha, who has achieved spiritual enlightenment and preaches using the Wheel-turning mudra. At the very top is the largest, sealed stupa. It may once have contained another Buddha image, but some think it was left empty to symbolize the formlessness of true enlightenment. Although

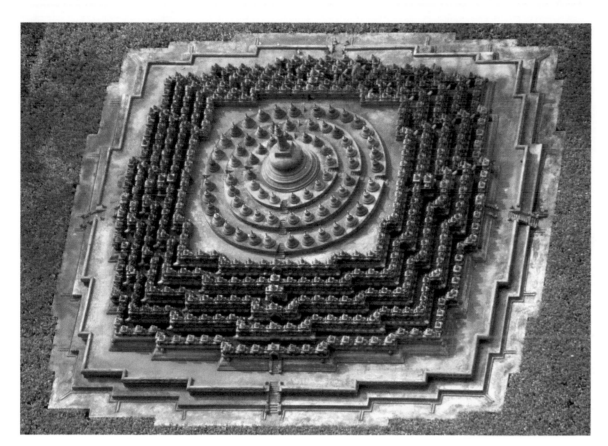

Borobudur is a colossal Buddhist monument of unique form. Built on nine terraces with more than 1,500 stupas and 1,500 statues and reliefs, it takes the form of a cosmic mountain, which worshipers circumambulate.

scholars have interpreted the iconographic program in different ways, all agree on two essential points: the dependence of Borobudur on Indian art, literature, and religion, and the fact that nothing comparable exists in India itself. Borobudur's sophistication, complexity, and originality underline how completely Southeast Asians had absorbed, rethought, and reformulated Indian religion and art by 800.

## Cambodia

In 802, at about the same time the Javanese built Borobudur, the Khmer King Jayavarman II (r. 802–850) founded the Angkor dynasty, which ruled Cambodia for the next 400 years and sponsored the construction of hundreds of monuments, including gigantic Buddhist monasteries (*wats*). For at least two centuries before the founding of Angkor, the Khmer (the predominant ethnic group in Cambodia) produced Indian-related sculpture of exceptional quality. Images of Vishnu were particularly important during the pre-Angkorian period.

**HARIHARA** A statue of Vishnu (FIG. **1-28**) from Prasat Andet shows the Hindu god in his manifestation as Harihara (Shiva-Vishnu). To represent Harihara, the sculptor divided the statue vertically, with Shiva on the god's right side, Vishnu on his left. The tall headgear reflects the division most clearly. The Shiva half, embellished with the winding locks of an ascetic, contrasts with the kingly Vishnu's plain miter. Attributes (now lost) held in the four hands also helped differentiate the two sides. Stylistically, the Cambodian statue, like the Sri Lankan parinirvana group (FIG. **1-26**), derives from Indian sculptures (FIG. **1-13**) of Gupta style. But unlike almost all stone sculpture in India, carved in relief on slabs or steles, this Khmer image is in the round. The Harihara's broken arms and ankles vividly attest to the vulnerability of this format. The Khmer sculptors, however, wanted their statues to be seen from all sides in the center of the garbha grihas of brick temples.

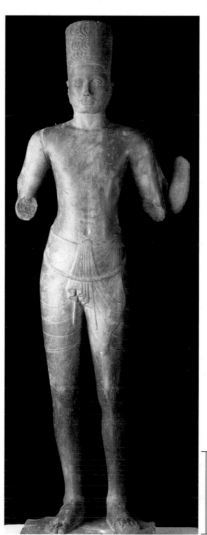

**1-28** Harihara, from Prasat Andet, Cambodia, early seventh century. Stone, 6′ 3″ high. National Museum, Phnom Penh.

Harihara is a composite of Shiva (the god's right side) and Vishnu (on the left). Although stylistically indebted to Gupta sculpture, the Khmer statue is freestanding so that it could be viewed from all sides.

1 ft.

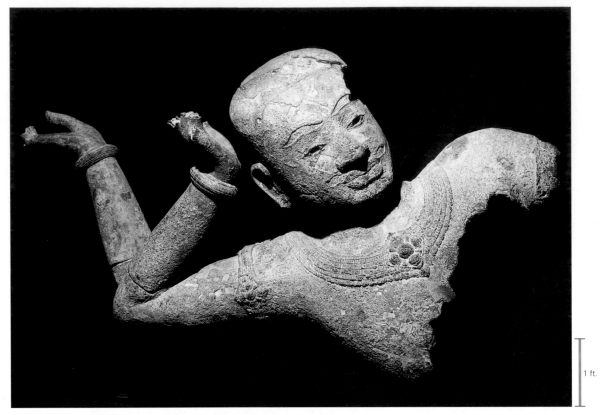

1 ft.

**1-29** Vishnu lying on the cosmic ocean, from the Mebon temple on an island in the western baray, Angkor, Cambodia, 11th century. Bronze, 8′ long.

This fragmentary hollow-cast bronze statue was originally more than 20 feet long and inlaid with gold, silver, and jewels. It portrays Vishnu asleep on the cosmic ocean at the moment of the universe's creation.

**RECLINING VISHNU** The Khmer kings were exceedingly powerful and possessed enormous wealth. A now-fragmentary statue (FIG. **1-29**) portraying Vishnu lying on the cosmic ocean testifies to both the luxurious nature of much Khmer art and to the mastery of Khmer bronze casters. The surviving portion is about 8 feet long. In complete form, at well over 20 feet long, the Vishnu statue was among the largest bronzes of the ancient and medieval worlds, surpassed only by such lost wonders as the statue of Athena in the Parthenon and the 120-foot-tall colossus of the Roman emperor Nero. Originally, gold and silver inlays and jewels embellished the image, and the god wore a separate miter on his head. The subject of the gigantic statue is the same as that carved in relief (FIG. **1-20**) on the Deogarh Vishnu Temple. Vishnu lies asleep on the cosmic ocean at the moment of the creation of the universe. In the myth, a lotus stem grows from Vishnu's navel, its flower supporting Brahma, the creator god. In this statue, Vishnu probably had a waterspout emerging from his navel, indicating his ability to create the waters as well as to create Brahma and protect the earth. The statue was displayed in an island temple in the western *baray* (reservoir) of Angkor.

**ANGKOR WAT** For more than four centuries, successive kings worked on the construction of the site of Angkor. Founded by Indravarman (r. 877–889), Angkor is an engineering marvel, a grand complex of temples and palaces within a rectangular grid of canals and reservoirs fed by local rivers. Each of the Khmer kings built a temple mountain at Angkor and installed his personal god—Shiva, Vishnu, or the Buddha—on top and gave the god part of his own royal name, implying that the king was a manifestation of the deity.

When the king died, the Khmer believed that the god reabsorbed him, because he had been the earthly portion of the deity during his lifetime, so they worshiped the king's image as the god. This concept of kingship approaches an actual deification of the ruler, familiar in many other societies, such as pharaonic Egypt.

Of all the monuments the Khmer kings erected, Angkor Wat (FIG. **1-30**) is the most spectacular. Built by Suryavarman II (r. 1113–1150), it is the largest of the many Khmer temple complexes. Angkor Wat rises from a huge rectangle of land delineated by a moat measuring about 5,000 × 4,000 feet. Like the other Khmer temples, its purpose was to associate the king with his personal god, in this case Vishnu. The centerpiece of the complex is a tall stepped tower surrounded by four smaller towers connected by covered galleries. The five towers symbolize the five peaks of Mount Meru, the sacred mountain at the center of the universe. Two more circuit walls with galleries, towers, and gates enclose the central block. Thus, as one progresses inward through the complex, the towers rise ever higher, in similar manner as the towers of Khajuraho's Vishvanatha Temple (FIG. **1-23**) but in a more complex sequence and on a much grander scale.

Throughout Angkor Wat, stone reliefs glorify both Vishnu in his various avatars and Suryavarman II. A detail of a relief (FIG. **1-31**) on the inner wall of the lowest gallery shows the king holding court. Suryavarman II sits on an elaborate wooden throne, its bronze legs rising as cobra heads. Kneeling retainers, smaller than the king because they are lesser figures in the Khmer hierarchy, hold a forest of umbrellas and fans, emblems of Suryavarman's exalted rank. In the reliefs of Angkor Wat, religion and politics are united.

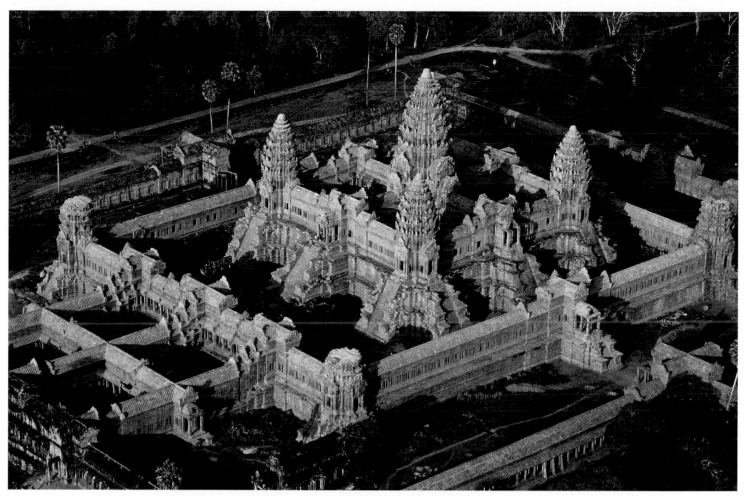

**1-30** Aerial view (looking northeast) of Angkor Wat, Angkor, Cambodia, first half of 12th century.

Angkor Wat, built by Suryavarman II to associate the Khmer king with the god Vishnu, has five towers symbolizing the five peaks of Mount Meru, the sacred mountain at the center of the universe.

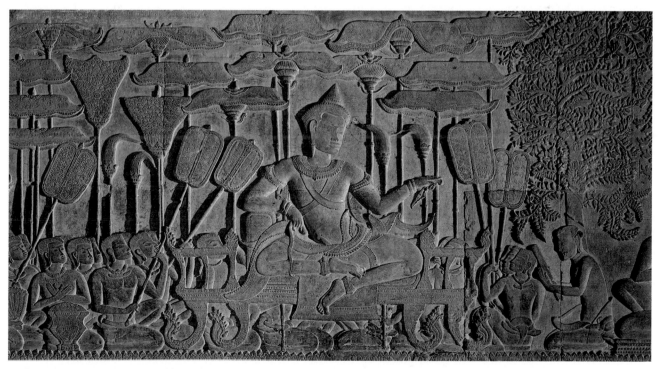

**1-31** King Suryavarman II holding court, detail of a stone relief, lowest gallery, south side, Angkor Wat, Angkor, Cambodia, first half of 12th century.

The reliefs of Angkor Wat glorify Vishnu in his various avatars, or incarnations, and Suryavarman II, whom the sculptor depicted holding court and surrounded by his attendants, all of smaller scale than the king.

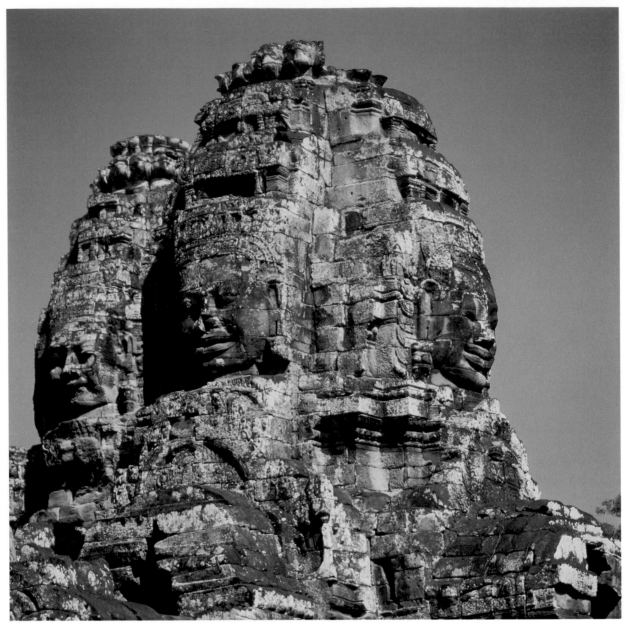

**1-32** Towers of the Bayon, Angkor Thom, Cambodia, ca. 1200.

Jayavarman VII embraced Buddhism instead of Hinduism. His most important temple, the Bayon, has towers carved with giant faces that probably depict either the bodhisattva Lokeshvara or the king himself.

**BAYON** Jayavarman VII (r. 1181–1219), Suryavarman II's son, ruled over much of mainland Southeast Asia and built more during his reign than all the Khmer kings preceding him combined. His most important temple, the Bayon, is a complicated monument constructed with unique circular terraces surmounted by towers carved with giant faces (FIG. **1-32**). Jayavarman turned to Buddhism from the Hinduism the earlier Khmer rulers embraced, but he adapted Buddhism so that the Buddha and the bodhisattva Lokeshvara ("Lord of the World") were seen as divine prototypes of the king, in the Khmer tradition. The faces on the Bayon towers perhaps portray Lokeshvara, intended to indicate the watchful compassion emanating in all directions from the capital. Other researchers

have proposed that the faces depict Jayavarman himself. The king's great experiment in religion and art was short-lived, but it also marked the point of change in Southeast Asia when Theravada Buddhism began to dominate most of the mainland. Chapter 2 chronicles this important development.

During the first to fourth centuries, Buddhism also spread to other parts of Asia—to China, Korea, and Japan. Although the artistic traditions in these countries differ greatly from one another, they share, along with Southeast Asia, a tradition of Buddhist art and an ultimate tie with India. Chapters 3 and 5 trace the changes Buddhist art underwent in East Asia, along with the region's other rich artistic traditions.

# SOUTH AND SOUTHEAST ASIA BEFORE 1200

## INDUS CIVILIZATION, ca. 2600–1500 BCE

▌ One of the world's earliest civilizations arose in the Indus Valley in the third millennium BCE. Indus cities had streets oriented to the compass points and sophisticated water-supply and sewage systems.

▌ Little Indus art survives, mainly seals with incised designs and small-scale sculptures like the statue of a "priest-king" from Mohenjo-daro.

Robed male figure, Mohenjo-daro, ca. 2000–1900 BCE

## MAURYA DYNASTY, 323–185 BCE

▌ The first Maurya king repelled the Greeks from India in 305 BCE. The greatest Maurya ruler was Ashoka (r. 272–231 BCE), who converted to Buddhism and spread the Buddha's teaching throughout South Asia.

▌ Ashoka's pillars are the first monumental stone artworks in India. Ashoka was also the builder of the original Great Stupa at Sanchi.

Lion capital of Ashoka, Sarnath, ca. 250 BCE

## SHUNGA, ANDHRA, AND KUSHAN DYNASTIES, ca. 185 BCE–320 CE

▌ The unifying characteristic of this age of regional dynasties in South Asia was the patronage of Buddhism. In addition to the stupa, the chief early type of Buddhist sacred architecture was the pillared rock-cut chaitya hall.

▌ The first representations of the Buddha in human form probably date to the first century CE. Gandharan Buddha statues owe a strong stylistic debt to Greco-Roman art.

▌ By the second century CE, the iconography of the life of the Buddha from his birth at Lumbini to his death at Kushinagara was well established.

The Buddha's first sermon at Sarnath, Gandhara, second century CE

## GUPTA AND POST-GUPTA PERIODS, ca. 320–647

▌ Gupta sculptors established the canonical Buddha image in the fifth century, combining Gandharan iconography with a soft, full-bodied figure in clinging garments.

▌ The Gupta-period Buddhist caves of Ajanta are the best surviving examples of early mural painting in India.

▌ The oldest Hindu monumental stone temples and sculptures date to the fifth and sixth centuries, including the rock-cut reliefs of Udayagiri, Badami, and Elephanta, and the Vishnu Temple at Deogarh.

Bodhisattva Padmapani, Ajanta, second half of fifth century

## MEDIEVAL PERIOD, 7th to 12th Centuries

▌ As various dynasties ruled South Asia for several hundred years, distinctive regional styles emerged in Hindu religious architecture. Northern temples, such as the Vishvanatha Temple at Khajuraho, have a series of small towers leading to a tall beehive-shaped tower, or shikhara, over the garbha griha. Southern temples have flat-roofed pillared halls (mandapas) leading to a pyramidal tower (vimana).

▌ Medieval Southeast Asian art and architecture reflect Indian prototypes, but many local styles developed. The most distinctive monuments of the period are Borobudur on Java and the Buddhist temple complexes of the Khmer kings at Angkor in Cambodia.

Vishvanatha Temple, Khajuraho, ca. 1000

**2-1** Taj Mahal, Agra, India, 1632–1647.

The first Islamic dynasty in South Asia was the 13th-century sultanate of Delhi, but the greatest was the Mughal Empire. The Taj Mahal, the most famous building in Asia, is a Mughal mausoleum.

# SOUTH AND SOUTHEAST ASIA AFTER 1200

Buddhism, which originated in South Asia in the mid-first millennium BCE, gradually declined in the medieval period in favor of Hinduism, although Buddhism continued as the dominant religion in Southeast Asia (see Chapter 1). After 1200, Hinduism remained strong in South Asia, as did Buddhism in Southeast Asia, but a newer faith—Islam—also rose to prominence. Under a succession of Hindu, Buddhist, *Muslim,* and secular rulers, the arts continued to flourish in South and Southeast Asia from the early 13th century through the British colonial period to the present.

## INDIA

Arab armies first appeared in South Asia (MAP **2-1**)—at Sindh in present-day Pakistan—in 712. With them came Islam, the new religion that had already spread with astonishing speed from the Arabian Peninsula to Syria, Iraq, Iran, Egypt, North Africa, and even southern Spain (see Chapter 7). At first, the Muslims established trading settlements but did not press deeper into the subcontinent. At the Battle of Tarain in 1192, however, Muhammad of Ghor (Afghanistan) defeated the armies of a confederation of South Asian states. The Ghorids and other Islamic rulers gradually transformed South Asian society, religion, and art.

### Sultanate of Delhi

In 1206, Qutb al-Din Aybak, Muhammad of Ghor's general, established the sultanate of Delhi (1206–1526). On his death in 1211, he passed power to his son Iltutmish (r. 1211 1236), who extended Ghorid rule across northern India.

**QUTB MINAR** To mark the triumph of Islam, Qutb al-Din Aybak built a great *congregational mosque* (see "The Mosque," Chapter 7, page 125) at Delhi, in part with pillars taken from Hindu and other temples. He named Delhi's first mosque the Quwwat al-Islam (Might of Islam) Mosque. During the course of the next century, as the Islamic population of Delhi grew, the *sultans* (Muslim rulers) enlarged

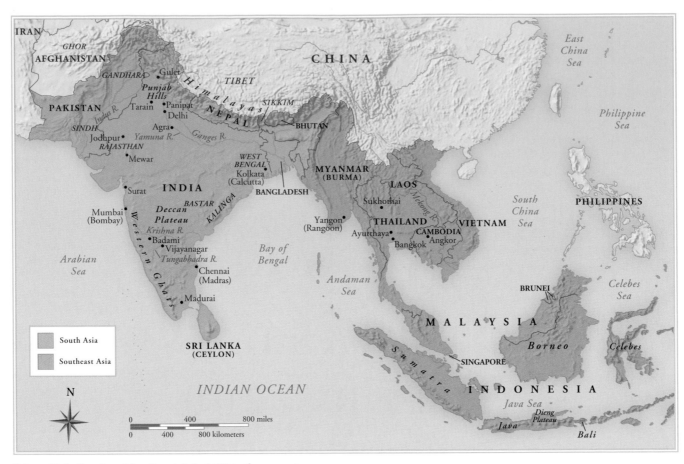

MAP 2-1 South and Southeast Asia, 1200 to the present.

the mosque to more than triple its original size. Iltutmish erected the mosque's 238-foot tapering sandstone *minaret*, the Qutb Minar (FIG. 2-2, *left*)—the tallest extant minaret in the world. It is too tall, in fact, to serve the principal function of a minaret—to provide a platform from which to call the Islamic faithful to prayer. Rather, it is a towering monument to the victory of Islam, engraved with inscriptions in Arabic and Persian proclaiming that the minaret casts the shadow of Allah over the conquered Hindu city. Added in 1311, the Alai Darvaza, the entrance pavilion (FIG. 2-2, *right*), is a mix of architectural traditions, combining Islamic pointed arches, decorative grills over the windows, and a hemispherical dome with a crowning *finial* that recalls the motifs at the top of many Hindu temple towers (see Chapter 1).

## Vijayanagar Empire

While Muslim sultans from Central Asia ruled much of northern India from Delhi, Hindu rulers controlled most of central and southern India. The most powerful of the Hindu kingdoms of the era was the Vijayanagar. Established in 1336 by Harihara, a local king, the Vijayanagar Empire (1336–1565) took its name from Vijayanagara ("City of Victory") on the Tungabhadra River. Under the patronage of the royal family, Vijayanagara, located at the junction of several trade

**2-2** Qutb Minar, begun early 13th century, and Alai Darvaza, 1311, Delhi, India.

Qutb al-Din Aybak established the sultanate of Delhi in 1206 and built the city's first mosque to mark the triumph of Islam in northern India. The 238-foot-high Qutb Minar is the tallest minaret in the world.

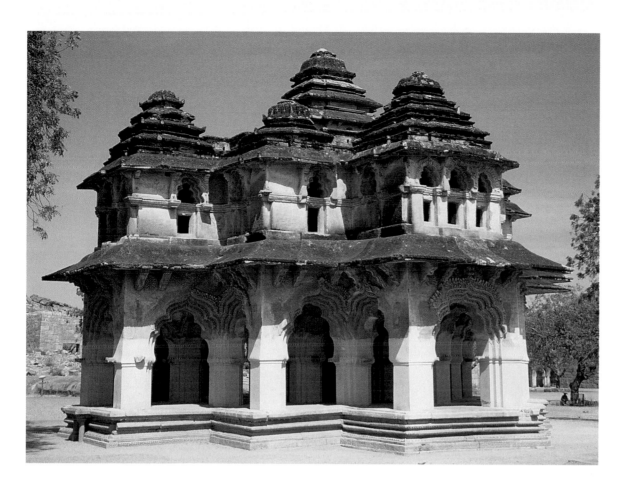

**2-3** Lotus Mahal, Vijayanagara, India, 15th or early 16th century.

The Vijayanagar Empire was the most powerful Hindu kingdom in southern India during the 14th to 16th centuries. The Lotus Mahal is an eclectic mix of Hindu temple features and Islamic architectural elements.

routes through Asia, became one of the most magnificent cities in the East. Although the capital lies in ruins today, in its heyday ambassadors and travelers from as far away as Italy and Portugal marveled at Vijayanagara's riches. Under its greatest king, Krishnadevaraya (r. 1509–1529), who was also a renowned poet, the Vijayanagar kingdom was a magnet for the learned and cultured from all corners of India.

**LOTUS MAHAL** Vijayanagara's sacred center, built up over two centuries, boasts imposing temples to the Hindu gods in the Dravida style of southern India with tall pyramidal *vimanas* (towers) over the *garbha griha*, the inner sanctuary (see "Hindu Temples," Chapter 1, page 24). The buildings of the so-called Royal Enclave are more eclectic in character. One example in this prosperous royal city is the two-story monument of uncertain function known as the Lotus Mahal (FIG. 2-3). The stepped towers crowning the vaulted second-story rooms resemble the pyramidal roofs of Dravida temple *mandapas* (pillared halls; FIG. 1-22). But the windows of the upper level as well as the arches of the ground-floor piers have the distinctive multilobed contours of Islamic architecture (FIGS. 7-1 and 7-12). The Lotus Mahal, like the entrance pavilion of Delhi's first mosque (FIG. 2-2, *right*), exemplifies the stylistic crosscurrents that typify much of South Asian art and architecture of the second millennium.

## Mughal Empire

The 16th century was a time of upheaval in South Asia. In 1565, only a generation after the poet-king Krishnadevaraya, a confederacy of sultanates in the Deccan plateau of central India brought the Vijayanagar Empire of the south to an end. Even earlier, a Muslim prince named Babur had defeated the last of the Ghorid sultans of northern India at the Battle of Panipat. Declaring himself the ruler of India, Babur established the Mughal Empire (1526–1857) at Delhi. *Mughal*, originally a Western term, means "descended from the Mongols,"

although the Mughals considered themselves descendants of Timur (r. 1370–1405), the Muslim ruler whose capital was at Samarkand in Uzbekistan. In 1527, Babur vanquished the Rajput Hindu kings of Mewar (see page 39). By the time of his death in 1530, Babur headed a vast new empire in India.

**AKBAR THE GREAT** The first great flowering of Mughal art and architecture occurred during the long reign of Babur's grandson, Akbar (r. 1556–1605), called the Great, who ascended the throne at age 14. Like his father Humayun (r. 1530–1556), Akbar was a great admirer of the narrative paintings (FIG. 7-27) produced at the court of Shah Tahmasp in Iran. Just before he died, Humayun had persuaded two Persian masters to move to Delhi and train local artists in the art of painting. When Akbar succeeded his father, he already oversaw an imperial workshop of Indian painters under the direction of the two Iranians. The young ruler enlarged their number to about a hundred and kept them busy working on a series of ambitious projects. One of these was to illustrate the text of the *Hamzanama*—the story of Hamza, Muhammad's uncle—in some 1,400 large paintings on cloth. The assignment took 15 years to complete.

The illustrated books and engravings that traders, diplomats, and Christian missionaries brought from Europe to India also fascinated Akbar. In 1580, Portuguese Jesuits brought one particularly important source, the eight-volume *Royal Polyglot Bible*, as a gift to Akbar. This massive set of books, printed in Antwerp, contained engravings by several Flemish artists. Akbar immediately set his painters to copying the illustrations.

*AKBARNAMA* Akbar also commissioned Abul Fazl (1551–1602), a member of his court and close friend, to chronicle his life in a great biography, the *Akbarnama* (*History of Akbar*), which the emperor's painters illustrated. One of the full-page miniatures (see "Indian

## Indian Miniature Painting

Although India had a tradition of mural painting dating to ancient times (see "The Painted Caves of Ajanta," Chapter 1, page 19, and FIG. 1-14), the most popular form of painting under the Mughal emperors (FIGS. 2-4 and 2-5) and Rajput kings (FIG. 2-7) was miniature painting. Art historians now call these paintings *miniatures* because of their small size (about the size of a page in this book) compared with that of paintings on walls, wooden panels, or canvas, but the original terminology derives from the fact that the earliest examples in the West employed red lead (miniatum) as a pigment. The artists who painted the Indian miniatures designed them to be held in the hands, either as illustrations in books or as loose-leaf pages in albums. Owners did not place Indian miniatures in frames and only rarely hung them on walls.

Indian artists used opaque watercolors and paper (occasionally cotton cloth) to produce their miniatures. The manufacturing and painting of miniatures were complicated processes and required years of apprenticeship training in a workshop. The painters' assistants created pigments by grinding natural materials—minerals such as malachite for green and lapis lazuli for blue; earth ochers for red and yellow; and metallic foil for gold, silver, and copper. They fashioned brushes from bird quills and kitten or baby squirrel hairs.

The artist began the painting process by making a full-size sketch of the composition. The next step was to transfer the sketch onto paper by *pouncing*, or tracing, using thin, transparent gazelle skin placed on top of the drawing and pricking the contours of the design with a pin. Then, with the skin laid on a fresh sheet of fine paper, the painter forced black pigment through the tiny holes, reproducing the outlines of the composition. Painting proper started with the darkening of the outlines with black or reddish-brown ink. Painters of miniatures sat on the ground, resting their painting boards on one raised knee. The paintings usually required several layers of color, with gold always applied

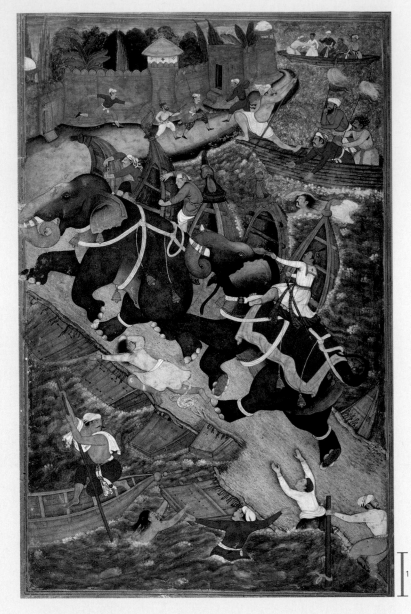

**2-4** BASAWAN and CHATAR MUNI, *Akbar and the Elephant Hawai,* folio 22 from the *Akbarnama* (*History of Akbar*) by Abul Fazl, ca. 1590. Opaque watercolor on paper, $1'\,1\frac{7}{8}'' \times 8\frac{3}{4}''$. Victoria & Albert Museum, London.

The Mughal rulers of India were great patrons of miniature painting. This example, showing the young emperor Akbar bringing the elephant Hawai under control, is also an allegory of his ability to rule.

1 in.

last. The final step was to burnish the painted surface. The artists accomplished this by placing the miniature, painted side down, on a hard, smooth surface and stroking the paper with polished agate or crystal.

Miniature Painting," above) in the emperor's personal copy of the *Akbarnama* was a collaborative effort between the painter BASAWAN, who designed and drew the composition, and CHATAR MUNI, who colored it. The painting (FIG. 2-4) depicts the episode of Akbar and Hawai, a wild elephant the 19-year-old ruler mounted and pitted against another ferocious elephant. When the second animal fled in defeat, Hawai, still carrying Akbar, chased it to a pontoon bridge. The enormous weight of the elephants capsized the boats, but Akbar managed to bring Hawai under control and dismount safely. The young ruler viewed the episode as an allegory of his ability to govern—that is, to take charge of an unruly state.

For his pictorial record of that frightening day, Basawan chose the moment of maximum chaos and danger—when the elephants crossed the pontoon bridge, sending boatmen flying into the water. The composition is a bold one, with a very high horizon and two strong diagonal lines formed by the bridge and the shore. Together these devices tend to flatten out the vista, yet at the same time Basawan created a sense of depth by diminishing the size of the figures in the background. He was also a master of vivid gestures and anecdotal detail. Note especially the bare-chested figure in the foreground clinging to the end of a boat, the figure near the lower-right corner with outstretched arms sliding into the water as the bridge sinks, and

**2-5** Bichitr, *Jahangir Preferring a Sufi Shaykh to Kings*, ca. 1615–1618. Opaque watercolor on paper, 1′ 6$\frac{7}{8}$″ × 1′ 1″. Freer Gallery of Art, Washington, D.C.

The impact of European art on Mughal painting is evident in this allegorical portrait of the haloed emperor Jahangir on an hourglass throne, seated above time, favoring spiritual power over worldly power.

father, acquired many luxury goods from Europe, including globes, hourglasses, prints, and portraits.

The influence of European as well as Persian styles on Mughal painting under Jahangir is evident in Bichitr's allegorical portrait (FIG. 2-5) of Jahangir seated on an hourglass throne, a miniature from an album made for the emperor around 1615–1618. As the sands of time run out, two cupids (clothed, unlike their European models more closely copied at the top of the painting) inscribe the throne with the wish that Jahangir would live a thousand years. Bichitr portrayed his patron as an emperor above time and also placed behind Jahangir's head a radiant halo combining a golden sun and a white crescent moon, indicating that Jahangir is the center of the universe and its light source. One of the inscriptions on the painting gives the emperor's title as "Light of the Faith."

At the left are four figures. The lowest, both spatially and in the social hierarchy, is the Hindu painter Bichitr himself, wearing a red turban. He holds a miniature representing two horses and an elephant, costly gifts from Jahangir, and another self-portrait. In the miniature-within-the-miniature, Bichitr bows deeply before the emperor. In the larger painting, the artist signed his name across the top of the footstool Jahangir uses to step up to his hourglass throne. Thus, the ruler steps on Bichitr's name, further indicating the painter's inferior status.

Above Bichitr is a portrait in full European style of King James I of England (r. 1603–1625), copied from a painting by John de Critz (ca. 1552–1642) that the English ambassador to the Mughal court had given Jahangir as a gift. Above the king is a Turkish sultan, a convincing study of physiognomy but probably not a specific portrait. The highest member of the foursome is an elderly Muslim Sufi *shaykh* (mystic saint). Jahangir's father, Akbar, had visited the mystic to pray for an heir. The current emperor, the answer to Akbar's prayers, presents the holy man with a sumptuous book as a gift. An inscription explains that "although to all appearances kings stand before him, Jahangir looks inwardly toward the dervishes [Islamic holy men]" for guidance. Bichitr's allegorical painting portrays his emperor in both words and pictures as favoring spiritual over worldly power.

the oarsman just beyond the bridge who strains to steady his vessel while his three passengers stand up or lean overboard in reaction to the surrounding commotion.

**JAHANGIR** That the names Basawan and Chatar Muni are known is significant in itself. In contrast to the anonymity of pre-Mughal artists in India, many of those whom the Mughal emperors employed signed their artworks. Another of these was BICHITR, whom Akbar's son and successor, Jahangir (r. 1605–1627), employed in the imperial workshop. The Mughals presided over a cosmopolitan court with refined tastes. After the establishment of the East India Company (see page 40), British ambassadors and merchants were frequent visitors to the Mughal capital, and Jahangir, like his

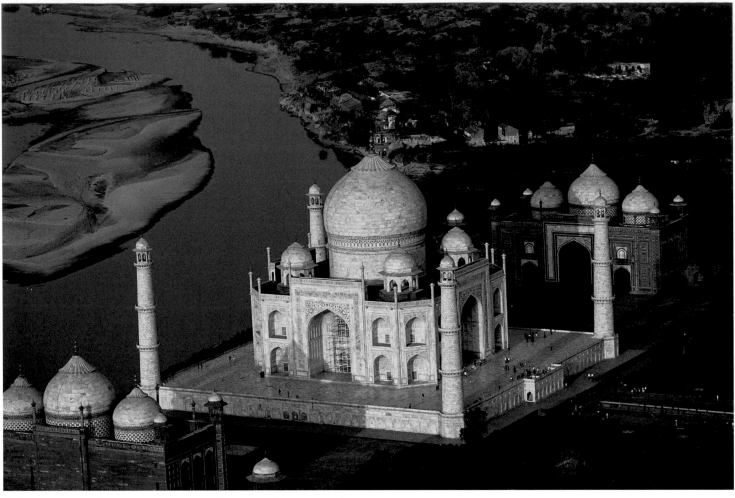

**2-6** Aerial view of the Taj Mahal, Agra, India, 1632–1647.

This Mughal mausoleum seems to float magically over reflecting pools in a vast garden (FIG. 2-1). The tomb may have been conceived as the Throne of God perched above the gardens of Paradise on Judgment Day.

**TAJ MAHAL** Monumental tombs were not part of either the Hindu or Buddhist traditions but had a long history in Islamic architecture. The Delhi sultans had erected tombs in India, but none could compare in grandeur to the fabled Taj Mahal (FIGS. **2-1** and **2-6**) at Agra. Shah Jahan (r. 1628–1658), Jahangir's son, built the immense *mausoleum* as a memorial to his favorite wife, Mumtaz Mahal, although it eventually became the ruler's tomb as well. The dome-on-cube shape of the central block has antecedents in earlier Islamic mausoleums (FIGS. 7-10 and 7-18) and other Islamic buildings such as the Alai Darvaza (FIG. 2-2, *right*) at Delhi, but modifications and refinements in the design of the Agra tomb have converted the earlier massive structures into an almost weightless vision of glistening white marble. The Agra mausoleum seems to float magically above the tree-lined reflecting pools (FIG. 2-1) that punctuate the garden leading to it. Reinforcing the illusion that the marble tomb is suspended above the water is the absence of any visible means of ascent to the upper platform. A stairway does exist, but the architect intentionally hid it from the view of anyone who approaches the memorial.

The Taj Mahal follows the plan of Iranian garden pavilions, except that the building stands at one end rather than in the center of the formal garden. The tomb is octagonal in plan and has typically Iranian arcuated niches (FIG. 7-25) on each side. The interplay of shadowy voids with light-reflecting marble walls that seem paper-thin creates an impression of translucency. The pointed arches lead the eye in a sweeping upward movement toward the climactic dome, shaped like a crown (*taj*). Four carefully related minarets and two flanking triple-domed pavilions (FIG. 2-6) enhance and stabilize the soaring form of the mausoleum. The architect achieved this delicate balance between verticality and horizontality by strictly applying an all-encompassing system of proportions. The Taj Mahal (excluding the minarets) is exactly as wide as it is tall, and the height of its dome is equal to the height of the facade.

Abd al-Hamid Lahori (d. 1654), a court historian who witnessed the construction of the Taj Mahal, compared its minarets to ladders reaching toward Heaven and its surrounding gardens to Paradise. In fact, inscribed on the gateway to the gardens and the walls of the mausoleum are carefully selected excerpts from the Koran that confirm the historian's interpretation of the tomb's symbolism. The designer of the Taj Mahal may have conceived the mausoleum as the Throne of God perched above the gardens of Paradise on Judgment Day. The minarets hold up the canopy of that throne. In Islam, the most revered place of burial is beneath the Throne of God.

## Hindu Rajput Kingdoms

The Mughal emperors ruled vast territories, but much of northwestern India (present-day Rajasthan) remained under the control of Hindu Rajput (literally "sons of kings") rulers. These small kingdoms, some claiming to have originated well before 1500, had stub-

Govardhan Chand (r. 1741–1773) of Guler. The painters that the rulers of the Punjab Hill states employed, referred to collectively as the Pahari School, had a distinctive style. Although Pahari painting owed much to Mughal drawing style, its coloration, lyricism, and sensuality are readily recognizable. In *Krishna and Radha in a Pavilion,* the lovers sit naked on a bed beneath a jeweled pavilion in a lush garden of ripe mangoes and flowering shrubs. Krishna gently touches Radha's breast while gazing directly into her face. Radha shyly averts her gaze. It is night, the time of illicit trysts, and the dark monsoon sky momentarily lights up with a lightning flash indicating the moment's electric passion. Lightning is a standard element used in Rajput and Pahari miniatures to symbolize sexual excitement.

## Nayak Dynasty

The Nayakas, governors under the Vijayanagar kings, declared their independence in 1529, and after their former overlords' defeat in 1565 at the hands of the Deccan sultanates, they continued Hindu rule in the far south of India for two centuries (1529–1736).

**GREAT TEMPLE, MADURAI** Construction of some of the largest temple complexes in India occurred under Nayak patronage. The most striking features of these huge complexes are their gateway towers called *gopuras* (FIG. **2-8**), decorated from top to bottom with painted sculptures. After erecting the gopuras, the builders

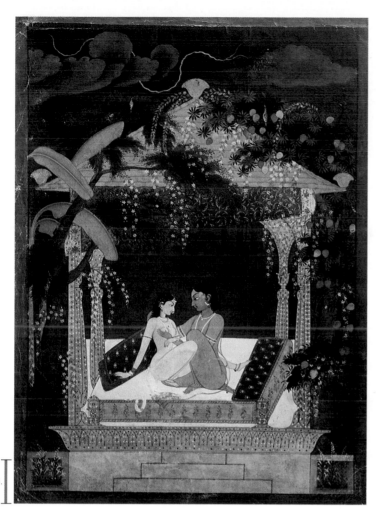

**2-7** *Krishna and Radha in a Pavilion,* ca. 1760. Opaque watercolor on paper, $11\frac{1}{8}'' \times 7\frac{3}{4}''$. National Museum, New Delhi.

The love of Krishna (the "Blue God") for Radha is the subject of this colorful, lyrical, and sensual Pahari watercolor. Krishna's love was a model of the devotion paid to the Hindu god Vishnu.

bornly resisted Mughal expansion, but even the strongest of them, Mewar, eventually submitted to the Mughal emperors. When Jahangir defeated the Mewar forces in 1615, the Mewar maharana (great king), like the other Rajput rulers, maintained a degree of independence but had to pay tribute to the Mughal Empire until it collapsed in 1857.

Rajput painting resembles Mughal (and Persian) painting in format and material, but it differs sharply in other respects. Most Rajput artists, for example, worked in anonymity, never inserting self-portraits into their paintings as the Mughal painter Bichitr did in his miniature (FIG. **2-5**) of Jahangir on an hourglass throne.

***KRISHNA AND RADHA*** One of the most popular subjects for Rajput paintings was the amorous adventures of Krishna, the "Blue God," the most popular of the *avatars,* or incarnations, of the Hindu god Vishnu, who descends to earth to aid mortals (see "Hinduism," Chapter 1, page 20). Krishna was a herdsman who spent an idyllic existence tending his cows, fluting, and sporting with beautiful herdswomen. His favorite lover was Radha. The 12th-century poet Jayadeva related the story of Krishna and Radha in the *Gita Govinda* (*Song of the Cowherd*). Their love was a model of the devotion, or *bhakti,* paid to Vishnu. Jayadeva's poem was the source for hundreds of later paintings, including *Krishna and Radha in a Pavilion* (FIG. **2-7**), a miniature painted in the Punjab Hills, probably for Raja

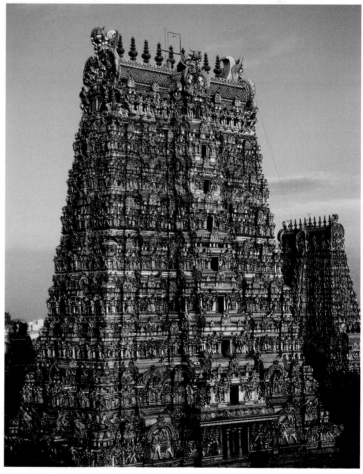

**2-8** Outermost gopuras of the Great Temple, Madurai, India, completed 17th century.

The colossal gateway towers erected during the Nayak dynasty at the Great Temple at Madurai feature brightly painted stucco sculptures representing the vast pantheon of Hindu deities.

**2-9** FREDERICK W. STEVENS, Victoria Terminus (Chhatrapati Shivaji Terminus), Mumbai (Bombay), India, 1878–1887.

Victoria Terminus, named after Queen Victoria of England, is a monument to colonial rule. Designed by a British architect, it is a European transplant to India, modeled on late medieval Venetian architecture.

constructed walls to connect them and then built more gopuras, always expanding outward from the center. Each set of gopuras was taller than those of the previous wall circuit. The outermost towers reached colossal size, dwarfing the temples at the heart of the complexes. The tallest gopuras of the Great Temple at Madurai, dedicated to Shiva (under his local name, Sundareshvara, the Handsome One) and his consort Minakshi (the Fish-Eyed One), stand about 150 feet tall. Rising in a series of tiers of diminishing size, they culminate in a barrel-vaulted roof with finials. The ornamentation is extremely rich, consisting of row after row of brightly painted stucco sculptures representing the vast pantheon of Hindu deities and a host of attendant figures. Reconsecration of the temple occurs at 12-year intervals, at which time the gopura sculptures receive a new coat of paint, which accounts for the vibrancy of their colors today. The Madurai Nayak temple complex also contains large and numerous mandapas, as well as great water tanks the worshipers use for ritual bathing. These temples were, and continue to be, almost independent cities, with thousands of pilgrims, merchants, and priests flocking from far and near to the many yearly festivals the temples host.

## The British in India

English merchants first arrived in India toward the end of the 16th century, attracted by the land's spices, gems, and other riches. On December 31, 1599, Queen Elizabeth I (r. 1558–1603) granted a charter to the East India Company, which sought to compete with the Portuguese and Dutch in the lucrative trade with South Asia. The company established a "factory" (trading post) at the port of Surat, approximately 150 miles from Mumbai (Bombay) in western India in 1613. After securing trade privileges with the Mughal emperor Jahangir, the British expanded their factories to Chennai (Madras), Kolkata (Calcutta), and Bombay by 1661. These outposts gradually spread throughout India, especially after the British defeated the ruler of Bengal in 1757. By the opening of the 19th century, the East India Company effectively ruled large portions of the subcontinent, and in 1835, the British declared English India's official language. A great rebellion in 1857 persuaded the British Parliament that the East India Company could no longer be the agent of British rule. The next year Parliament abolished the company and replaced its governor-general with a viceroy of the crown. Two decades later, in 1877, Queen Victoria (r. 1837–1901) assumed the title Empress of India with sovereignty over all the former Indian states.

**VICTORIA TERMINUS** The British brought the Industrial Revolution and railways to India. One of the most enduring monuments of British rule, still used by millions of travelers, is Victoria Terminus (FIG. 2-9) in Mumbai, named for the new empress of India (but now called Chhatrapati Shivaji Terminus). A British architect, FREDERICK W. STEVENS (1847–1900), was the designer. Construction of the giant railway station began in 1878 and took a decade to complete. Although built of the same local sandstone used for temples and statues throughout India's long history, Victoria Terminus is a European transplant to the subcontinent, the architectural counterpart of colonial rule. Conceived as a cathedral to modernization, the terminus fittingly has an allegorical statue of Progress

**2-10** *Maharaja Jaswant Singh of Marwar*, ca. 1880. Opaque watercolor on paper, 1′ 3½″ × 11⅝″. Brooklyn Museum, Brooklyn (gift of Mr. and Mrs. Robert L. Poster).

Jaswant Singh, the ruler of Jodhpur, had himself portrayed as if he were a British gentleman in his sitting room, but the artist employed the same materials that Indian miniature painters had used for centuries.

heritage of the wealth and splendor of his family's rule. The other, a wide gold band with a cameo, is the Order of the Star of India, a high honor his British overlords bestowed on him.

The painter of this portrait worked on the same scale and employed the same materials—opaque watercolor on paper—that Indian miniature painters had used for centuries, but the artist copied the ruler's likeness from a photograph. This accounts in large part for the realism of the portrait. Indian artists sometimes even painted directly on top of photographs. Photography arrived in India at an early date. In 1840, just one year after its invention in Paris, the *daguerreotype* was introduced in Calcutta. Indian artists readily adopted the new medium, not just to produce portraits but also to record landscapes and monuments.

In 19th-century India, however, admiration of Western art and culture was by no means universal. During the half century after Jaswant Singh's death, calls for Indian self-government grew ever louder. Under the leadership of Mahatma Gandhi (1869–1948) and others, India achieved independence in 1947—not, however, as a unified state but as the two present-day nations of India and Pakistan. The contemporary art of South Asia is the subject of the last section of this chapter.

# SOUTHEAST ASIA

India was not alone in experiencing major shifts in political power and religious preferences during the past 800 years. The Khmer of Angkor (see Chapter 1), after reaching the height of their power at the beginning of the 13th century, lost one of their outposts in northern Thailand to their Thai vassals at midcentury. The newly founded Thai kingdoms quickly replaced Angkor as the region's major powers, while Theravada Buddhism (see "Buddhism and Buddhist Iconography," Chapter 1, page 13) became the religion of the entire mainland except Vietnam. The Vietnamese, restricted to the northern region of today's Vietnam, gained independence in the 10th century after a thousand years of Chinese political and cultural domination. They pushed to the south, ultimately destroying the indigenous Cham culture, which had dominated there for more than a millennium. A similar Burmese drive southward in Myanmar matched the Thai and Vietnamese expansions. All these movements resulted in demographic changes during the second millennium that led to the cultural, political, and artistic transformation of mainland Southeast Asia. A religious shift also occurred in Indonesia. With Islam growing in importance, all of Indonesia except the island of Bali became predominantly Muslim by the 16th century.

## Thailand

Southeast Asians practiced both Buddhism and Hinduism, but by the 13th century, in contrast to developments in India, Hinduism was in decline and Buddhism dominated much of the mainland. Two prominent Buddhist kingdoms came to power in Thailand during the 13th and early 14th centuries. Historians date the beginning of the Sukhothai kingdom to 1292, the year King Ramkhamhaeng (r. 1279–1299) erected a four-sided stele bearing the first inscription written in the Thai language. Sukhothai's political dominance proved short-lived, however. Ayutthaya, a city founded in central Thailand in 1350, quickly became the more powerful kingdom and warred sporadically with other states in Southeast Asia until the mid-18th century. Scholars nonetheless regard the Sukhothai period as the golden age of Thai art. In the inscription on his stele, Ramkhamhaeng ("Rama the Strong") described Sukhothai as a city of monasteries and many images of the Buddha.

crowning its tallest dome. Nonetheless, the building's design looks backward, not forward. Inside, passengers gaze up at groin-vaulted ceilings and *stained-glass* windows, and the exterior of the station resembles a Western church with a gabled facade and flanking towers. Stevens modeled Victoria Terminus, with its tiers of screened windows, on the architecture of late medieval Venice.

**JASWANT SINGH** With British rulers and modern railways also came British or, more generally, European ideas, but Western culture and religion never supplanted India's own rich traditions. Many Indians, however, readily adopted the trappings of European society. When Jaswant Singh (r. 1873–1895), the ruler of Jodhpur in Rajasthan, sat for his portrait (FIG. **2-10**), he chose to sit in an ordinary chair rather than on a throne, with his arm resting on a simple table with a bouquet and a book on it. In other words, he posed as an ordinary British gentleman in his sitting room. Nevertheless, the painter, an anonymous local artist who had embraced Western style, left no question about Jaswant Singh's regal presence and pride. The ruler's powerful chest and arms, along with the sword and his leather riding boots, indicate his abilities as a warrior and hunter. The curled beard signified fierceness to Indians of that time. The unflinching gaze records the ruler's confidence. Perhaps the two necklaces Jaswant Singh wears best exemplify the combination of his two worlds. One necklace is a bib of huge emeralds and diamonds, the

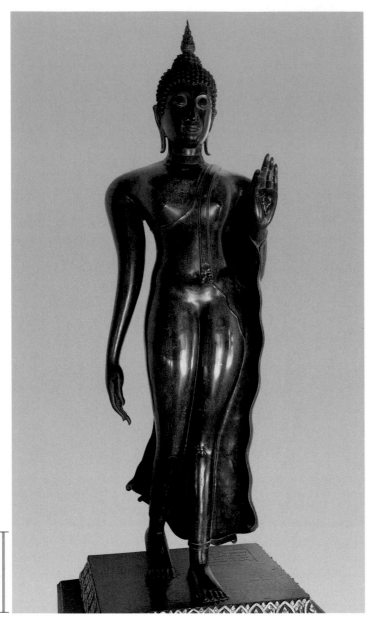

1 ft.

**2-11** Walking Buddha, from Sukhothai, Thailand, 14th century. Bronze, 7′ 2½″ high. Wat Bechamabopit, Bangkok.

The walking-Buddha statuary type is unique to Thailand and displays a distinctive approach to body form. The Buddha's body is soft and elastic, and the right arm hangs loosely, like an elephant trunk.

**WALKING BUDDHA** Theravada Buddhism came to Sukhothai from Sri Lanka (see Chapter 1). At the center of the city stood Wat Mahathat, Sukhothai's most important Buddhist monastery. Its *stupa* (mound-shaped Buddhist shrine; see "The Stupa," Chapter 1, page 15) housed a *relic* of the Buddha (Wat Mahathat means "Monastery of the Great Relic") and attracted crowds of pilgrims. Sukhothai's crowning artistic achievement was the development of a type of walking-Buddha statue (FIG. **2-11**) displaying a distinctively Thai approach to body form. The bronze Buddha has broad shoulders and a narrow waist and wears a clinging monk's robe. He strides forward, his right heel off the ground and his left arm raised with the hand held in the gesture that in Buddhist art signifies "do not fear" to encourage worshipers to come forward in reverence. A flame leaps from the top of the Buddha's head, and a sharp nose projects from his rounded face. The right arm hangs loosely, seemingly without muscles or joints, like an elephant's trunk. The Sukhothai artists intended the body type to suggest a supernatural being and to ex-

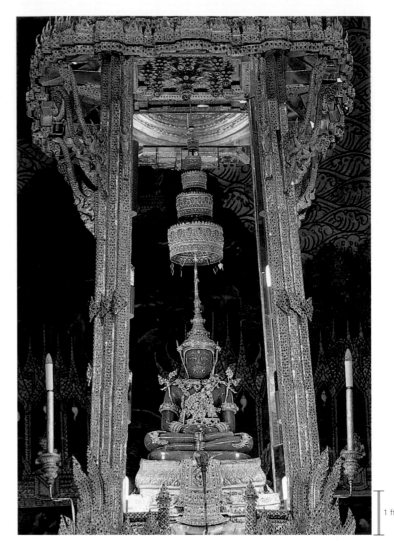

1 ft.

**2-12** *Emerald Buddha*, Emerald Temple, Bangkok, Thailand, 15th century. Jade or jasper, 2′ 6″ high.

The Thai king dresses the *Emerald Buddha*, carved from green jade or jasper, in a monk's robe and a king's robe at different times of the year, underscoring the image's symbolic role as both Buddha and king.

press the Buddha's beauty and perfection. Although images in stone exist, the Sukhothai artists handled bronze best, a material well suited to their conception of the Buddha's body as elastic. The Sukhothai walking-Buddha statuary type does not occur elsewhere in Buddhist art.

*EMERALD BUDDHA* A second distinctive Buddha image from northern Thailand is the *Emerald Buddha* (FIG. **2-12**), housed in Bangkok in the Emerald Temple on the Royal Palace grounds. The sculpture is small, only 30 inches tall, and conforms to the ancient type of the Buddha seated in meditation in a yogic posture with his legs crossed and his hands in his lap, palms upward (FIG. **1-10**). It first appears in historical records in 1434 in northern Thailand, where Buddhist chronicles record its story. The chronicles describe the Buddha image as plaster-encased, and thus no one knew the statue was green stone. A lightning bolt caused some of the plaster to flake off, disclosing its gemlike nature. Taken by various rulers to a series of cities in northern Thailand and in Laos over the course of more than 300 years, the small image finally reached Bangkok in 1778 in the possession of the founder of the present Thai royal dynasty.

The *Emerald Buddha* is not, in fact, emerald but probably green jade. Nonetheless, its nature as a gemstone gives it a special aura. The

Thai believe the gem enables the universal king, or *chakravartin*, possessing the statue to bring the rains. The historical Buddha renounced his secular destiny for the spiritual life, yet his likeness carved from the gem of a universal king allows fulfillment of the Buddha's royal destiny as well. The Buddha can also be regarded as the universal king. Thus, the combination of the sacred and the secular in the small image explains its symbolic power. The Thai king dresses the *Emerald Buddha* at different times of the year in a monk's robe and a king's robe (in FIG. 2-12 the Buddha wears the royal garment), reflecting the image's dual nature and accentuating its symbolic role as both Buddha and king. The Thai king possessing the image therefore has both religious and secular authority.

## Myanmar

Myanmar, like Thailand, is overwhelmingly a Theravada Buddhist country today. Important Buddhist monasteries and monuments dot the countryside.

**SCHWEDAGON PAGODA** In Rangoon, an enormous complex of buildings, including shrines filled with Buddha images, has as its centerpiece one of the largest stupas in the world, the Schwedagon Pagoda (FIG. 2-13). (*Pagoda* derives from the Portuguese version of a word for stupa.) The Rangoon pagoda houses two of the Buddha's hairs, traditionally said to have been brought to Myanmar by merchants who received them from the Buddha himself. Rebuilt several times, this highly revered stupa is famous for the gold, silver, and jewels encrusting its surface. The Schwedagon Pagoda stands 344 feet high. Covering its upper part are 13,153 plates of gold, each about a foot square. At the very top is a seven-tiered umbrella crowned with a gold ball inlaid with 4,351 diamonds, one of which weighs 76 carats. This great wealth was a gift to the Buddha from the laypeople of Myanmar to produce merit.

## Vietnam

The history of Vietnam is particularly complex, as it reveals both an Indian-related art and culture, broadly similar to those of the rest of Southeast Asia, and a unique and intense relationship with China's art and culture. Vietnam's tradition of fine ceramics is of special interest. The oldest Vietnamese ceramics date to the Han period (206 BCE–220 CE), when the Chinese began to govern the northern area of Vietnam. China directly controlled Vietnam for a thousand years, and early Vietnamese ceramics closely reflected Chinese wares. But during the Ly (1009–1225) and Tran (1225–1400) dynasties, when Vietnam had regained its independence, Vietnamese potters developed an array of ceramic shapes, designs, and *glazes* that brought their wares to the highest levels of quality and creativity.

**UNDERGLAZE CERAMICS** In the 14th century, the Vietnamese began exporting *underglaze* wares modeled on the blue-and-white ceramics first produced in China (see "Chinese Porcelain," Chapter 4, page 76). During the 15th and 16th centuries, the ceramic industry in Vietnam became the supplier of pottery of varied shapes to an international market extending throughout Southeast Asia and to the Middle East. A 16th-century Vietnamese dish (FIG. 2-14) with two mynah birds on a flowering branch reveals both the potter's debt to China and how the spontaneity, power, and playfulness of Vietnamese painting contrast with the formality of Chinese

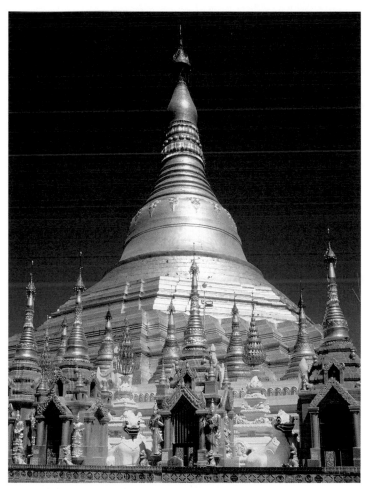

**2-13** Schwedagon Pagoda, Rangoon (Yangon), Myanmar (Burma), 14th century or earlier (rebuilt several times).

The 344-foot-tall Schwedagon Pagoda houses two of the Buddha's hairs. Silver and jewels and 13,153 gold plates sheathe its exterior. The gold ball at the top is inlaid with 4,351 diamonds.

**2-14** Dish with two mynah birds on a flowering branch, from Vietnam, 16th century. Stoneware painted with underglaze cobalt, 1' 2½" in diameter. Pacific Asia Museum, Pasadena.

Vietnamese ceramists exported underglaze pottery throughout Southeast Asia and beyond. The spontaneity of the depiction of mynah birds on this dish contrasts with the formality of Chinese porcelains.

wares (FIG. 4-5). The artist suggested the foliage with curving and looped lines executed in almost one continuous movement of the brush over the surface. This technique—very different from the more deliberate Chinese habit of lifting the brush after painting a single motif in order to separate the shapes more sharply—facilitated rapid production. Combined with the painter's control, it created a fresh and unique design that made Vietnamese pottery attractive to a wide export market.

# CONTEMPORARY ART

Contemporary art in India and Southeast Asia is as multifaceted a phenomenon as contemporary art elsewhere in the world. In India, for example, many traditional artists work at the village level, making images of deities out of inexpensive materials, such as clay, plaster, and papier-mâché, for local use. Some urban artists use these same materials to produce elaborate religious tableaux, such as depictions of the goddess Durga killing the buffalo demon that are used during the annual 10-day Durga Festival in Calcutta. Participants in the festival often ornament the tableaux with thousands of colored electric lights. The most popular art form for religious imagery, however, is the brightly colored print, sold for only a few rupees each. In the Buddhist countries of Southeast Asia (Thailand, Cambodia, Myanmar, and Laos), some artists continue to produce traditional images of the Buddha, primarily in bronze, for worship in homes, businesses, and temples.

Many contemporary artists, in contrast, create works for the international market. Although many of them received their training in South or Southeast Asia or Japan, others attended schools in Europe or the United States, and some artists now work outside their home countries. They face one of the fundamental quandaries of many contemporary Asian artists—how to identify themselves and situate their work between local and international, traditional and modern, and non-Western and Western cultures.

**MEERA MUKHERJEE** One Indian artist who successfully bridged these two poles of modern Asian art was MEERA MUKHERJEE (1923–1998). Mukherjee studied with European masters in Germany, but when she returned to India, she rejected much of what she had learned in favor of the techniques long employed by traditional sculptors of the Bastar tribe in central India. Mukherjee went to live with Bastar bronze-casters, who had perfected a variation on the classic *lost-wax process*. Beginning with a rough core of clay, the Bastar sculptors build up what will be the final shape of the statue by placing long threads of beeswax over the core. Then they apply a coat of clay paste to the beeswax and tie up the mold with metal wire. After heating the mold over a charcoal fire, which melts the wax, they pour liquid bronze into the space once occupied by the wax threads. Large sculptures require many separate molds. The Bastar artists complete their statues by welding together the separately cast sections, usually leaving the seams visible.

Many scholars regard *Ashoka at Kalinga* (FIG. 2-15) as Mukherjee's greatest work. Twice life-size and assembled from 26 cast-bronze sections, the towering statue combines the intricate surface textures of traditional Bastar work with the expressively swelling abstract forms of some 20th-century European sculpture. Mukherjee chose as her subject the third-century BCE Maurya emperor Ashoka standing on the battlefield at Kalinga. There, Ashoka witnessed more

**2-15** MEERA MUKHERJEE, *Ashoka at Kalinga*, 1972. Bronze, 11′ 6¾″ high. Maurya Sheraton Hotel, New Delhi.

Mukherjee combined the bronze-casting techniques of the Bastar tribe with the swelling forms of 20th-century European sculpture in this statue of King Ashoka meant to be a pacifist's protest against violence.

than 100,000 deaths and, shocked by the horrors of the war he had unleashed, rejected violence and adopted Buddhism as the official religion of his empire (see "Ashoka's Conversion to Buddhism," Chapter 1, page 14). Mukherjee conceived her statue as a pacifist protest against political violence in late-20th-century India. By reaching into India's remote history to make a contemporary political statement and by employing the bronze-casting methods of tribal sculptors while molding her forms in a modern idiom, she united her native land's past and present in a single work of great emotive power.

# SOUTH AND SOUTHEAST ASIA AFTER 1200

## SULTANATE OF DELHI, 1206–1526

▌ Qutb al-Din Aybak (r. 1206–1211) established the sultanate of Delhi in 1206, bringing Muslim rule to northern India.

▌ To mark the triumph of Islam, he built Delhi's first mosque and its 238-foot minaret, the tallest in the world.

Qutb Minar, Delhi,
begun early 13th century

## VIJAYANAGAR EMPIRE, 1336–1565

▌ The most powerful Hindu kingdom in southern India when Muslim sultans ruled the north was the Vijayanagar Empire.

▌ Vijayanagar buildings like the Lotus Mahal display an eclectic mix of Hindu and Islamic architectural motifs.

Lotus Mahal, Vijayanagara,
15th or early 16th century

## MUGHAL EMPIRE, 1526–1857

▌ Babur (r. 1526–1530) defeated the Delhi sultans in 1526 and established the Mughal Empire.

▌ The first great flowering of Mughal art and architecture occurred under Akbar the Great (r. 1556–1605), who sponsored a series of important painting projects, including his illustrated biography, the *Akbarnama*.

▌ Shah Jahan (r. 1628–1658) built the Taj Mahal as a memorial to his favorite wife. The mausoleum may symbolize the Throne of God above the gardens of Paradise.

Basawan and Chatar Muni,
*Akbar and the Elephant Hawai*, ca. 1590

## OTHER SOUTH AND SOUTHEAST ASIAN KINGDOMS,
15th to 19th Centuries

▌ During the Mughal Empire, Hindu Rajput kings ruled much of northwestern India. The coloration and sensuality of Rajput painting distinguish it from the contemporaneous Mughal style.

▌ Between 1529 and 1736 the Hindu Nayak dynasty controlled southern India and erected temple complexes with immense gateway towers (gopuras) decorated with painted stucco sculptures of Hindu deities.

▌ In Thailand, Theravada Buddhism was the dominant religion. The Sukhothai walking-Buddha statuary type displays a unique approach to body form, for example, the Buddha's trunklike right arm.

▌ Myanmar's Schwedagon Pagoda in Rangoon is one of the largest stupas in the world and is encrusted with gold, silver, and jewels.

Walking Buddha, from Sukhothai,
14th century

## BRITISH COLONIAL PERIOD (1600–1947) TO THE PRESENT

▌ Queen Elizabeth I (r. 1558–1603) established the East India Company, which eventually effectively ruled large portions of the subcontinent. In 1877, Queen Victoria I (r. 1837–1901) assumed the title Empress of India.

▌ Victoria Terminus is an architectural symbol of colonial rule, a European transplant to India capped by an allegorical statue of Progress.

▌ Under the leadership of Mahatma Gandhi (1869–1948), India and Pakistan achieved independence from England in 1947.

▌ Contemporary South Asian art ranges from the traditional to the modern and embraces both native and Western styles.

Frederick W. Stevens, Victoria Terminus,
Mumbai, 1878–1887

1 ft.

**3-1** FAN KUAN, *Travelers among Mountains and Streams,* Northern Song period, early 11th century. Hanging scroll, ink and colors on silk, 6′ 7$\frac{1}{4}$″ × 3′ 4$\frac{1}{4}$″. National Palace Museum, Taibei.

Landscape painting was one of the premier art genres in China. Chinese painters, however, did not aim to represent specific places but to capture the essence of nature using brush and ink on silk.

# CHINA AND KOREA TO 1279

East Asia is a vast area, varied in both topography and climate. Dominated by the huge land mass of China, the region also encompasses the peninsula of Korea and the islands of Japan (MAP 3-1). The early arts of China and Korea are discussed in this chapter, and early Japanese art and architecture are treated in Chapter 5. Chapters 4 and 6 examine later developments in China and Korea and in Japan.

## CHINA

China's landscape includes sandy plains, mighty rivers, towering mountains, and fertile farmlands. Its political and cultural boundaries have varied over the millennia, and at times its territory has grown to about twice the area of the United States, encompassing Tibet, Chinese Turkestan (Xinjiang), Mongolia, Manchuria, and parts of Korea. China boasts the world's largest population and is ethnically diverse. The spoken language varies so much that speakers of different dialects do not understand one another. However, the written language, which employs *characters* (signs that record spoken words, even if those words are spoken differently in the various dialects), has made possible a shared Chinese literary, philosophic, and religious tradition.

### Neolithic Age through Shang Dynasty

China is the only continuing civilization that originated in the ancient world. The Chinese archaeological record, extraordinarily rich, begins in Neolithic times. Discoveries in recent years have expanded the early record enormously and have provided evidence of settled village life as far back as the seventh or early sixth millennium BCE. Excavators have uncovered sites with large multifamily houses constructed of wood, bamboo, wattle, daub, and mud plaster and equipped with hearths. These early villages also had pens for domesticated animals, kilns for pottery production, pits for storage and refuse, and cemeteries for the dead. Chinese Neolithic artisans produced impressive artworks, especially from jade and clay.

**YANGSHAO POTTERY** Mastery of the art of pottery occurred at a very early date in China. The potters of the Yangshao Culture, which arose along the Yellow River in northeastern China, produced fine

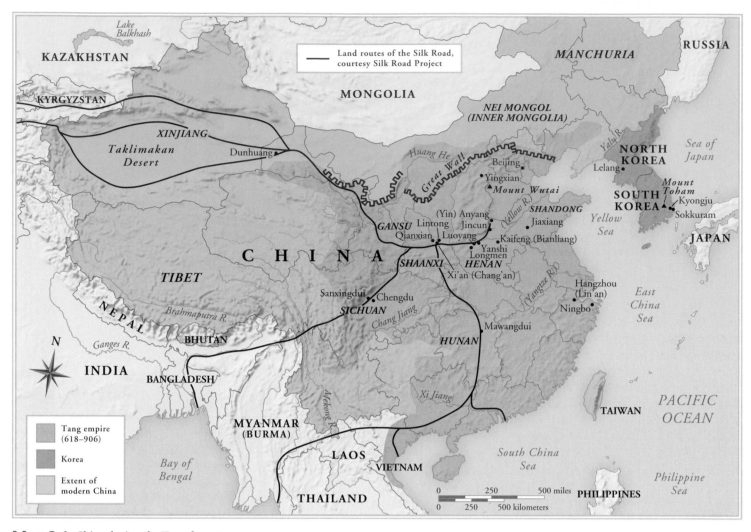

MAP 3-1 China during the Tang dynasty.

decorated *earthenware* bowls (see "Chinese Earthenwares and Stonewares," page 62) even before the invention of the potter's wheel in the fourth millennium BCE. In the third millennium, the Yangshao potters of Gansu Province formed by hand and then painted vessels (FIG. 3-2) of astonishing sophistication. The multiplicity of shapes suggests that the vessels served a wide variety of functions in daily life, but most of the finds come from graves. Decoration is in red and brownish-black on a cream-colored ground. Some pots and bowls include stylized animal motifs, but most feature abstract designs. The painters reveal a highly refined aesthetic sensibility, effectively integrating a variety of angular and curvilinear geometric motifs, including stripes, zigzags, lozenges, circles, spirals, and waves.

**SHANG DYNASTY** During the past century, archaeologists have begun to confirm China's earliest royal dynasties, long thought to have been mythical. In 1959 excavators found what they believe to be traces of the Xia (ca. 2000–1600 BCE), China's oldest dynasty, at Yanshi in Henan Province. Much better documented, however, is the Shang dynasty (ca. 1600–1050 BCE), the first great Chinese dynasty of

**3-2** Yangshao Culture vases, from Gansu Province, China, mid-third millennium BCE.

Neolithic Chinese artists produced vessels of diverse shapes even before the invention of the potter's wheel and decorated them with abstract motifs in red and brownish-black on a cream-colored ground.

## Shang Bronze-Casting

Among the finest bronzes of the second millennium BCE are those that Shang artists created using piece molds. The Shang bronze-workers began the process by producing a solid clay model of the desired object. When the model dried to durable hardness, they pressed damp clay around it to form a mold that hardened but remained somewhat flexible. At that point, they carefully cut the mold in pieces, removed the pieces from the model, and baked the pieces in a kiln to form hard earthenware sections. Sculptors then carved the intricate details of the relief decoration into the inner surfaces of the piece molds. Next, the artists shaved the model to reduce its size to form a core for the piece mold. They then reassembled the mold around the model using bronze spacers to preserve a void between the model and the mold—a space equivalent to the layer of wax used in the lost-wax method. The Shang bronze-casters then added a final clay layer on the outside to hold everything together, leaving open ducts for pouring molten bronze into the space between the model and the mold and to permit gases to escape. Once the mold cooled, they broke it apart, removed the new bronze vessel, and cleaned and polished it.

Shang bronzes show a mastery in casting rivaling that of any other ancient civilization. The great numbers of cast-bronze vessels strongly suggest well-organized workshops. Shang bronzes held wine, water, grain, or meat for sacrificial rites. Each vessel's shape matched its intended purpose. All were highly decorated with abstract and animal motifs. On the guang illustrated here (FIG. **3-3**), the multiple designs and their fields of background spirals integrate so closely with the form of the libation-pouring vessel that they are not merely an external embellishment but an integral part of the

**3-3** Guang, probably from Anyang, China, Shang dynasty, 12th or 11th century BCE. Bronze, $6\frac{1}{2}''$ high. Asian Art Museum of San Francisco, San Francisco (Avery Brundage Collection).

Shang artists perfected the casting of elaborate bronze vessels decorated with animal motifs. The animal forms, real and imaginary, on this libation guang are probably connected with the world of spirits.

1 in.

sculptural whole. Some motifs on the guang's side may represent the eyes of a tiger and the horns of a ram. A horned animal forms the front of the lid, and at the rear is a horned head with a bird's beak. Another horned head appears on the handle. Fish, birds, elephants, rabbits, and more abstract composite creatures swarm over the surface against a background of spirals. The fabulous animal forms, real and imaginary, on Shang bronzes are unlikely to have been purely decorative. They are probably connected with the world of spirits addressed in the rituals.

the Bronze Age. The Shang kings ruled from a series of royal capitals in the Yellow River valley and vied for power and territory with the rulers of neighboring states. In 1928 excavations at Anyang (ancient Yin) brought to light the last Shang capital. There, archaeologists found a large number of objects—turtle shells, animal bones, and bronze containers—inscribed in the earliest form of the Chinese language. These fragmentary records and the other finds at Anyang provide important information about the Shang kings and their affairs. They reveal a warlike, highly stratified society. Walls of pounded earth protected Shang cities. Servants, captives, and even teams of charioteers with chariots and horses accompanied Shang kings to their tombs, a practice also documented at the Royal Cemetery at Ur.

The excavated tomb furnishings include weapons and a great wealth of objects in jade, ivory, lacquer, and bronze. Not only the kings received lavish burials. The tomb of Fu Hao, the wife of Wu Ding (r. ca. 1215–1190 BCE), contained an ivory beaker inlaid with

turquoise and more than a thousand jade and bronze objects. Many of the vessels found in Shang tombs, for example, the guang (FIG. **3-3**), shaped like a covered gravy boat, were used in sacrifices to ancestors and in funerary ceremonies. In some cases families erected shrines for ancestor worship above the burial places. Shang artists cast their elaborate bronze vessels in piece molds (see "Shang Bronze-Casting," above).

**SANXINGDUI** Recent excavations in other regions of China have greatly expanded historical understanding of the Bronze Age. They suggest that at the same time Anyang flourished under its Shang rulers in northern China, so did other major centers with distinct aesthetic traditions. In 1986, pits at Sanxingdui, near Chengdu in southwestern China, yielded a treasure of elephant tusks and objects in gold, bronze, jade, and clay of types never before discovered. They attest to an independent kingdom of enormous wealth contemporary with the better-known Shang dynasty.

gated proportions and large, staring eyes. It stands on a base composed of four legs formed of fantastic animal heads with horns and trunklike snouts. The statue tapers gently as it rises, and the figure gradually becomes rounder. Just below the neck, great arms branch dramatically outward, ending in oversized hands that once held an object, most likely one of the many elephant tusks buried with the bronze statue. Chinese representations of the human figure on this scale are otherwise unknown at this early date. Surface decoration of squared spirals and hook-pointed curves is all that links this gigantic statue with the intricate Shang piece-mold bronze vessels (FIG. 3-3). Systematic excavations and chance finds will probably produce more surprises in the future and cause art historians to revise once again their picture of Chinese art in the second half of the second millennium BCE.

## Zhou and Qin Dynasties

Around 1050 BCE, the Zhou, former vassals of the Shang, captured Anyang and overthrew their Shang overlords. The Zhou dynasty proved to be the longest lasting in China's history—so long that historians divide the Zhou era into two periods: Western Zhou (ca. 1050–771 BCE) and Eastern Zhou (770–256 BCE). The dividing event is the transfer of the Zhou capital from Chang'an (modern Xi'an) in the west to Luoyang in the east. The closing centuries of Zhou rule include a long period of warfare among competing states (Warring States Period, ca. 475–221 BCE). The Zhou fell to one of these states, the Qin, in 256 BCE.

**ZHOU JADE** Under the Zhou, the development of markets and the introduction of bronze coinage brought heightened prosperity and a taste for lavish products, such as bronzes inlaid with gold and silver. Late Zhou bronzes featured scenes of hunting, religious rites, and magic practices. These may relate to the subjects and compositions of lost paintings mentioned in Zhou literature. Other materials favored in the late Zhou period were *lacquer*, a varnishlike substance made from the sap of the Asiatic sumac, used to decorate wood furniture and other objects (see "Lacquered Wood," Chapter 4, page 78), and jade (see "Chinese Jade," page 51). The carving of jade objects for burial with the dead, beginning in Neolithic times, reached a peak of technical perfection during the Zhou dynasty. Among the most common finds in tombs of the period are *bi* disks (FIG. 3-5)—thin, flat circular pieces of jade with a hole in the center, which may have symbolized the circle of Heaven. Bi disks were status symbols in life as well as treasured items the dead took with them to the afterlife. After a battle, for example, the victors forced their defeated foes to surrender their bi disks as symbols of their submission. The disks also had a high monetary value.

**THE FIRST EMPEROR** During the Warring States Period, China endured more than two centuries of political and social turmoil. This was also a time of intellectual and artistic upheaval, when conflicting schools of philosophy, including Legalism, Daoism, and Confucianism, emerged (see "Daoism and Confucianism," page 52). Order was finally restored when the powerful armies of the ruler of the state of Qin (from which the modern name "China" derives) conquered all rival states. Known to history by his title, Qin Shi Huangdi (the First Emperor of Qin), between 221 and 210 BCE he controlled an area equal to about half of modern China, much larger than the territories of any of the earlier Chinese dynasties. During his reign, Shi Huangdi ordered the linkage of active fortifications along the northern border of his realm to form the famous Great Wall. The wall defended China against the fierce nomadic peoples of the north, especially the Huns, who eventually made their

1 ft.

**3-4** Standing male figure, from pit 2, Sanxingdui, China, ca. 1200–1050 BCE. Bronze, 8′ 5″ high, including base. Museum, Sanxingdui.

Excavations at Sanxingdui have revealed a Chinese civilization contemporary to the Shang but with a different artistic aesthetic. This huge statue has elongated proportions and large, staring eyes.

The most dramatic find, a bronze statue (FIG. 3-4) more than eight feet tall, matches anything from Anyang in masterful casting technique. Very different in subject and style from the Shang bronzes, it initially shocked art historians who had formed their ideas about Bronze Age Chinese aesthetics based on Shang material. This figure—of unknown identity—is highly stylized, with elon-

## Chinese Jade

The Chinese first used jade—or, more precisely, nephrite—for artworks and ritual objects in the Neolithic period. Nephrite polishes to a more lustrous, slightly buttery finish than jadeite (the stone Chinese sculptors preferred from the 18th century on), which is quite glassy. Both stones are beautiful and come in colors other than the well-known green and are tough, hard, and heavy. In China, such qualities became metaphors for the fortitude and moral perfection of superior persons. The Chinese also believed jade possessed magical qualities that could protect the dead. In a Han dynasty tomb, for example, archaeologists discovered the bodies of a prince and princess dressed in suits composed of more than 2,000 jade pieces sewn together with gold wire.

Because of its extreme hardness, jade could not be carved with the Neolithic sculptor's stone tools. Researchers can only speculate on how these early artists were able to cut, shape, and incise the nephrite objects found at many Neolithic Chinese sites. The sculptors probably used cords embedded with sand to incise lines into the surfaces. Sand placed in a bamboo tube drill could perforate the hard stone, but the process would have been long and arduous, requiring great patience as well as superior skill.

Even after the invention of bronze tools, Chinese sculptors still had to rely on grinding and abrasion rather than simple drilling and chiseling to produce the intricately shaped, pierced, and engraved works such as the *bi* (FIG. 3-5) said to have come from a royal Eastern Zhou tomb at Jincun. Rows of raised spirals, created by laborious grinding and polishing, decorate the disk itself. Within the inner circle and around the outer edge of the bi are elegant dragons. The Chinese thought dragons inhabited the water and flew between Heaven and Earth, bringing rain, so these animals long have been symbols of good fortune in East Asia. They also symbolized the rulers' power to mediate between Heaven and Earth. To sculpt the dragons on the bi from Jincun required long hours of work to pierce through the hard jade. The bi testifies to the Zhou sculptor's mastery of this difficult material.

1 in.

**3-5** Bi disk with dragons, from Jincun(?), near Luoyang, China, Eastern Zhou dynasty, fourth to third century BCE. Nephrite, $6\frac{1}{2}''$ in diameter. Nelson-Atkins Museum of Art, Kansas City.

This intricately shaped jade bi required long hours of grinding, piercing, engraving, and polishing to produce. The Chinese believed dragons were symbols of good fortune and flew between Heaven and Earth.

---

way to eastern Europe. By sometimes brutal methods, the First Emperor consolidated rule through a centralized bureaucracy and adopted standardized written language, weights and measures, and coinage. He also repressed schools of thought other than Legalism, which espoused absolute obedience to the state's authority and advocated strict laws and punishments. Chinese historians long have condemned the First Emperor, but the bureaucratic system he put in place had a long-lasting impact. Its success was due in large part to Shi Huangdi's decision to replace the feudal lords with talented salaried administrators and to reward merit rather than favor high birth.

**TERRACOTTA ARMY, LINTONG** In 1974 excavations started at the site of the immense burial mound of the First Emperor of Qin at Lintong. For its construction, the ruler conscripted more than 700,000 laborers and had the tomb filled with treasure. The project continued after his death. The mound itself remains unexcavated except for some test trenches, but researchers believe it contains a vast underground funerary palace designed to match the fabulous palace the emperor occupied in life. The historian Sima

Qian (136–85 BCE) described both palaces, but scholars did not take his account seriously until the discovery of pits around the tomb filled with more than 6,000 life-size painted terracotta figures (FIG. 3-6) of soldiers and horses, as well as bronze horses and chariots. The terracotta army served as the First Emperor's bodyguard deployed in perpetuity outside his tomb.

The Lintong army, composed of cavalry, chariots, archers, lancers, and hand-to-hand fighters, was one of the 20th century's greatest archaeological discoveries. Lesser versions of Shi Huangdi's army have since been uncovered at other Chinese sites, suggesting that the First Emperor's tomb became the model for many others. The huge assemblage at Lintong testifies to a very high degree of organization in the Qin imperial workshop. Manufacturing this army of statues required a veritable army of sculptors and painters as well as a large number of huge kilns. The First Emperor's artisans could have opted to use the same molds over and over again to produce thousands of identical soldiers standing in strict formation. In fact, they did employ the same molds repeatedly for different parts of the statues but assembled the parts in many different combinations. Consequently, the stances, arm positions, garment folds, equipment,

## Daoism and Confucianism

Daoism and Confucianism are both philosophies and religions native to China. Both schools of thought attracted wide followings during the Warring States Period (ca. 475–221 BCE), when political turbulence led to social unrest.

Daoism emerged out of the metaphysical teachings attributed to Laozi (604?–531? BCE) and Zhuangzi (370?–301? BCE). It takes its name from Laozi's treatise *Daodejing* (*The Way and Its Power*). Daoist philosophy stresses an intuitive awareness, nurtured by harmonious contact with nature, and shuns everything artificial. Daoists seek to follow the universal path, or principle, called the Dao, whose features cannot be described but only suggested through analogies. For example, the Dao is said to be like water, always yielding but eventually wearing away the hard stone that does not yield. For Daoists, strength comes from flexibility and inaction. Historically, Daoist principles encouraged retreat from society in favor of personal cultivation in nature and the achievement of a perfect balance between *yang*, active masculine energy, and *yin*, passive feminine energy.

Confucius (551–479 BCE) was born in the state of Lu (roughly modern Shandong Province) to an aristocratic family that had fallen on hard times. From an early age, he showed a strong interest in the rites and ceremonies that helped unite people into an orderly society. As he grew older, he developed a deep concern for the suffering the civil conflict of his day caused. Thus, he adopted a philosophy he hoped would lead to order and stability. The *junzi* ("superior person" or "gentleman"), who possesses *ren* ("human-heartedness"), personifies the ideal social order Confucius sought. Although the term *junzi* originally assumed noble birth, in Confucian thought anyone can

become a junzi by cultivating the virtues Confucius espoused, especially empathy for suffering, pursuit of morality and justice, respect for ancient ceremonies, and adherence to traditional social relationships, such as those between parent and child, elder and younger sibling, husband and wife, and ruler and subject.

Confucius's disciple Mencius (or Mengzi, 371?–289? BCE) developed the master's ideas further, stressing that the deference to age and rank that is at the heart of the Confucian social order brings a reciprocal responsibility. For example, a king's legitimacy depends on the goodwill of his people. A ruler should share his joys with his subjects and will know his laws are unjust if they bring suffering to the people.

Confucius spent much of his adult life trying to find rulers willing to apply his teachings, but he died in disappointment. However, he and Mencius had a profound impact on Chinese thought and social practice. Chinese traditions of venerating deceased ancestors and outstanding leaders encouraged the development of Confucianism as a religion as well as a philosophic tradition. Eventually, Emperor Wu (r. 140–87 BCE) of the Han dynasty established Confucianism as the state's official doctrine. Thereafter, it became the primary subject of the civil service exams required for admission into and advancement within government service.

"Confucian" and "Daoist" are broad, imprecise terms scholars often use to distinguish aspects of Chinese culture stressing social responsibility and order (Confucian) from those emphasizing cultivation of individuals, often in reclusion (Daoist). But both philosophies share the idea that anyone can cultivate wisdom or ability, regardless of birth.

---

coiffures, and facial features vary, sometimes slightly, sometimes markedly, from statue to statue. Additional hand modeling of the cast body parts before firing permitted the sculptors to differentiate

the figures even more. The Qin painters undoubtedly added further variations to the appearance of the terracotta army. The result of these efforts was a brilliant balance of uniformity and individuality.

**3-6** Army of the First Emperor of Qin in pits next to his burial mound, Lintong, China, Qin dynasty, ca. 210 BCE. Painted terracotta, average figure 5′ 10⅞″ high.

The First Emperor was buried beneath an immense mound guarded by more than 6,000 life-size terracotta soldiers. Although produced from common molds, every figure has an individualized appearance.

# Han Dynasty

Soon after the First Emperor's death, the people who had suffered under his reign revolted, assassinated his corrupt and incompetent son, and founded the Han dynasty in 206 BCE. The Han ruled China for four centuries, integrating many of the Qin reforms in a more liberal governing policy. They also extended China's southern and western boundaries, penetrating far into Central Asia (modern Xinjiang). Han merchants even traded indirectly with distant Rome (via the so-called Silk Road (see "Silk and the Silk Road," p. 54).

**THE MARQUISE OF DAI** In 1972 archaeologists excavated the tomb of the Marquise of Dai at Mawangdui in Hunan Province. The tomb contained a rich array of burial goods used during the funerary ceremonies and to accompany the deceased woman into the afterlife. Among the many finds were decorated lacquer utensils, various textiles, and an astonishingly well-preserved corpse in the innermost of four nested sarcophagi. Most remarkable, however, was the discovery of a painted T-shaped silk banner (FIG. **3-7**) draped over the marquise's coffin. Scholars generally agree that the area within the cross at the top of the T represents Heaven. Most of the vertical section below is the human realm. At the very bottom is the Underworld. In the heavenly realm, dragons and immortal beings appear between and below two orbs—the red sun and its symbol, the raven, on the right, and the silvery moon and its symbol, the toad, on the left. Below, the standing figure on the first white platform near the center of the vertical section is probably the Marquise of Dai herself—one of the first portraits in Chinese art. The woman awaits her ascent to Heaven, where she can attain immortality. Nearer the bottom, the artist depicted her funeral. Between these two sections is a form resembling a bi disk (FIG. **3-5**) with two intertwining dragons. Their tails reach down to the Underworld and their heads point to Heaven, unifying the whole composition.

**WU FAMILY SHRINES** Even more extensive Han pictorial narratives appear on the walls of the Wu family shrines at Jiaxiang in Shandong Province, dating between 147 and 168 CE. The shrines document the emergence of private, nonaristocratic families as patrons of religious and mythological art with political overtones. Dedicated to deceased male family members, the Wu shrines consist of three low walls and a pitched roof. On the interior surfaces, carved images of flat polished stone stand out against an equally flat,

**3-7** Funeral banner, from tomb 1 (tomb of the Marquise of Dai), Mawangdui, China, Han dynasty, ca. 168 BCE. Painted silk, 6′ 8¾″ × 3′ ¼″. Hunan Provincial Museum, Changsha.

This T-shaped silk banner was draped over the coffin of the Marquise of Dai, who is shown at the center awaiting her ascent to immortality in Heaven, the realm of the red sun and silvery moon.

1 ft.

though roughly textured, ground. The historical scenes include a representation of the third-century BCE hero Jing Ke's attempt to assassinate the tyrannical First Emperor of Qin. On the slab shown in FIG. **3-8**, a *rubbing* (an impression made by placing paper over the surface and rubbing with a pencil or crayon) taken from the stone

**3-8** The archer Yi(?) and a reception in a mansion, Wu family shrine, Jiaxiang, China, Han dynasty, 147–168 CE. Rubbing of a stone relief, 3′ × 5′.

The Wu family shrines depict historical, legendary, and contemporaneous subjects. Here, the hero Yi shoots down suns to save the Earth from scorching. To the right is a ceremonial scene in a Han mansion.

1 ft.

## Silk and the Silk Road

Silk is the finest natural fabric ever produced. It comes from the cocoons of caterpillars called silkworms. The manufacture of silk was a well-established industry in China by the second millennium BCE. The basic procedures probably have not changed much since then. Farmers today still raise silkworms from eggs, which they place in trays. The farmers also must grow mulberry trees or purchase mulberry leaves, the silkworms' only food source. Eventually, the silkworms form cocoons out of very fine filaments they extrude as liquid from their bodies. The filaments soon solidify with exposure to air. Before the transformed caterpillars emerge as moths and badly damage the silk, the farmers kill them with steam or high heat. They soften the cocoons in hot water and unwind the filaments onto a reel. The filaments are so fine that workers generally unwind those from five to ten cocoons together to bond into a single strand while the filaments are still soft and sticky. Later, the silkworkers twist several strands together to form a thicker yarn and then weave the yarn on a loom to produce silk cloth. Both the yarn and the cloth can be dyed, and the silk fabric can be decorated by weaving threads of different colors together in special patterns (*brocades*) or by stitching in threads of different colors (*embroidery*). Many Chinese artists painted directly on plain silk.

Greatly admired throughout most of Asia, Chinese silk and the secrets of its production gradually spread throughout the ancient world. The Romans knew of silk as early as the second century BCE and treasured it for garments and hangings. Silk came to the Romans along the ancient fabled Silk Road, a network of caravan tracts across Central Asia linking China and the Mediterranean world (MAP 3-1). The western part, between the Mediterranean region and India, developed first, due largely to the difficult geographic conditions to India's northeast. In Central Asia, the caravans had to skirt the Taklimakan Desert, one of the most inhospitable environments on earth, as well as to climb high, dangerous mountain passes. Very few traders traveled the entire route. Along the way, goods usually passed through the hands of people from many lands, who often only dimly understood the ultimate origins and destinations of what they traded. The Roman passion for silk ultimately led to the modern name for the caravan tracts, but silk was by no means the only product traded along the way. Gold, ivory, gems, glass, lacquer, incense, furs, spices, cotton, linens, exotic animals, and other merchandise precious enough to warrant the risks passed along the Silk Road.

Ideas moved along these trade routes as well. Most important perhaps, travelers on the Silk Road brought Buddhism to China from India in the first century CE, opening up a significant new chapter in both the history of religion and the history of art in China.

---

relief, the archer at the upper left is probably the hero Yi. He saves the Earth from scorching by shooting down the nine extra suns, represented as crows in the Fusang tree. (The small orbs below the sun on the Mawangdui banner, FIG. 3-7, probably allude to the same story.) The lowest zone shows a procession of umbrella-carriages moving to the left. Above, underneath the overhanging eaves of a two-story mansion, robed men bearing gifts pay homage to a central figure of uncertain identity, who is represented as larger and therefore more important. Two men kneel before the larger figure. Women occupy the upper story. Again, one figure, at the center and facing forward, is singled out as the most important. The identities of the individual figures are unknown. Interpretations vary widely, and in the past decade scholars have discovered that some of the Wu reliefs have recarved inscriptions, leading them to question even the traditional date of the slabs. Nonetheless, these scenes of homage and loyalty are consistent with the Confucian ideals of Han society.

**HAN HOUSES AND PALACES** No actual remains of Han buildings survive, but ceramic models of houses deposited in Han tombs, together with representations such as those in the Wu family shrines, provide a good idea of Chinese architecture during the early centuries CE. An especially large painted earthenware model (FIG. 3-9) reproduces a Han house with sharply projecting tiled roofs resting on a framework of timber posts, lintels, and brackets. This construction method (FIG. 3-10) typifies much Chinese architecture even today (see "Chinese Wooden Construction," page 55). Descriptions of Han palaces suggest they were grandiose versions of the type of house reproduced in this model but with more luxurious decoration, including walls of lacquered wood and mural paintings.

## Period of Disunity

For three and a half centuries, from 220 to 581,* civil strife divided China into competing states. Scholars variously refer to this era as the Period of Disunity or the period of the Six Dynasties or of the Northern and Southern Dynasties. The history of this era is extremely complex, but one development deserves special mention—the occupation of the north by peoples who were not ethnically Han Chinese and who spoke non-Chinese languages. It was in the northern states, connected to India by the desert caravan routes of the Silk Road (see "Silk and the Silk Road," above), that Buddhism first took root in China during the Han dynasty. Certain practices shared with Daoism, such as withdrawal from ordinary society, helped Buddhism gain an initial foothold in the north. But Buddhism's promise of hope beyond the troubles of this world earned it an ever broader audience during the upheavals of the Period of Disunity. In addition, the fully developed Buddhist system of thought attracted intellectuals. Buddhism never fully displaced Confucianism and Daoism, but it did prosper throughout China for centuries and had a profound effect on the further development of the religious forms of those two native traditions.

**ZHAO BUDDHA** A gilded bronze statuette (FIG. 3-11) of Shakyamuni Buddha, the historical Buddha, bears an inscription giving its date as 338. Although some scholars have questioned whether the inscription is a later addition, many art historians still accept the statuette as the earliest precisely datable Chinese image of the Buddha, created during the Later Zhao dynasty (319–351). The oldest Chinese Buddhist texts describe the Buddha as golden and radiating

---

*From this point on, all dates in this chapter are CE unless otherwise stated.

## Chinese Wooden Construction

**A**lthough the basic unit of Chinese architecture, the rectangular hall with columns supporting a roof, was common in many ancient civilizations, Chinese buildings are distinguished by the curving silhouettes of their roofs and by their method of construction. The Chinese, like other ancient peoples, used wood to construct their earliest buildings. Although those structures do not survive, scholars believe many of the features giving East Asian architecture its specific character may date to the Zhou dynasty. Even the simple buildings reproduced on Han stone carvings (FIG. 3-8) and in clay models (FIG. 3-9) reveal a style and a method of construction long basic to China.

The typical Chinese hall has a pitched roof with projecting eaves. Wooden columns, lintels, and brackets provide the support. The walls serve no weight-bearing function. They act only as screens separating inside from outside and room from room. The colors of Chinese buildings, predominantly red, black, yellow, and white, are also distinctive. Chinese timber architecture is customarily multi-colored throughout, save for certain parts left in natural color, such as railings made of white marble. The builders usually painted the screen walls and the columns red. Chinese designers often chose dazzling combinations of colors and elaborate patterns for the beams, brackets, eaves, rafters, and ceilings. The builders painted or lacquered the surfaces to protect the timber from rot and wood parasites, as well as to produce an arresting aesthetic effect.

FIG. 3-10 shows the basic construction method of Chinese architecture, with the major components of a Chinese building labeled. The builders laid *beams* (no. 1) between columns, decreasing the length of the beams as the structure rose. The beams supported vertical *struts* (no. 2), which in turn supported higher beams and eventually the *purlins* (no. 3) running the length of the building and carrying the roof's sloping *rafters* (no. 4). Unlike the rigid elements of the triangular trussed timber roof common in the West, which produce flat sloping rooflines, the varying lengths of the Chinese structure's cross beams and the variously placed purlins can create curved profiles. Early Chinese roofs have flat profiles (FIGS. 3-8 and 3-9), but curving rafters (FIGS. 3-10 and 3-23) later became the norm, not only in China but throughout East Asia. The interlocking clusters of brackets were capable of supporting roofs with broad overhanging *eaves* (no. 5), another typical feature of Chinese architecture. Multiplication of the *bays* (spaces between the columns) could extend the building's length to any dimension desired, although each bay could be no wider or longer than the length of a single tree trunk. The proportions of the structural elements could be fixed into modules, allowing for standardization of parts. This enabled rapid construction of a building. Remarkably, the highly skilled Chinese workers fit the parts together without using any adhesive substance, such as mortar or glue.

1 ft.

**3-9** Model of a house, Han dynasty, first century CE. Painted earthenware, 4′ 4″ high. Nelson-Atkins Museum of Art, Kansas City.

This model of a Han house provides invaluable information about the form, coloration, and construction methods of Chinese architecture. The flat profile of the rooflines is typical of earlier Chinese buildings.

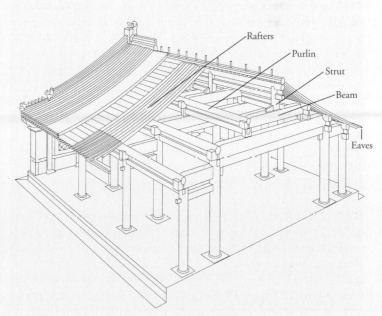

**3-10** Chinese raised-beam construction (after L. Liu).

Chinese walls serve no weight-bearing function. They act only as screens separating inside from outside and room from room. Tang dynasty and later buildings usually have curved rafters and eaves.

## Chinese Painting Materials and Formats

Mural paintings in caves (FIG. 3-15) were popular in China, as they were in South Asia (FIG. 1-15), but Chinese artists also employed several distinctive materials and formats for their paintings.

The basic requirements for paintings not on walls were the same as for writing—a round tapered brush, soot-based ink, and either silk or paper. The Chinese were masters of the brush. Sometimes Chinese painters used modulated lines for contours and interior details that elastically thicken and thin to convey depth and mass. In other works, they used *iron-wire lines* (thin, unmodulated lines with a suggestion of tensile strength) to define each individual figure in their paintings.

Chinese painters also used richly colored minerals as pigments, finely ground and suspended in a gluey medium, and watery washes of mineral and vegetable dyes.

The formats of Chinese paintings on silk or paper tend to be personal and intimate, and they are usually best viewed by only one or two people at a time. The most common types are

*Hanging scrolls* (FIGS. 3-1, 3-25, and 3-26). Chinese painters often mounted pictures on, or painted directly on, unrolled vertical scrolls for display on walls.

*Handscrolls* (FIGS. 3-12, 3-17, and 3-21). Paintings were also frequently attached to or painted on long, narrow scrolls that the viewer unrolled horizontally, section by section from right to left.

*Album leaves* (FIGS. 3-24 and 4-14). Many Chinese artists painted small panels on paper leaves, which were collected in albums.

*Fans* (FIG. 4-13). Stiff round or arched folding fans were also popular painting formats.

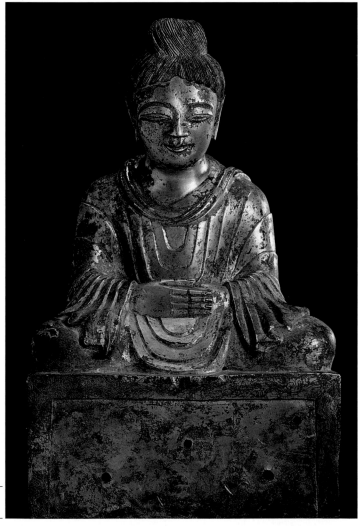

1 in.

**3-11** Shakyamuni Buddha, from Hebei Province, Later Zhao dynasty, Period of Disunity, 338. Gilded bronze, 1′ 3½″ high. Asian Art Museum of San Francisco, San Francisco (Avery Brundage Collection).

This earliest datable Chinese Buddha image is stylistically indebted to Gandharan prototypes (FIG. 1-10), but the sculptor, unfamiliar with Buddhist iconography, misrepresented the dhyana mudra.

light, characteristics that no doubt account for the choice of gilded bronze as the sculptor's medium. In both style and iconography, this early Buddha resembles the prototype conceived and developed at Gandhara (FIG. 1-10). The Chinese figure recalls its presumed South Asian models in the flat, relieflike handling of the robe's heavy concentric folds, the ushnisha (cranial bump) on the head, and the cross-legged position. So new were the icon and its meaning, however, that the Chinese sculptor misrepresented the canonical dhyana mudra, or meditation gesture (see "Buddhism and Buddhist Iconography," Chapter 1, page 13). Here, the Buddha clasps his hands across his stomach. In South Asian art, they are turned palms upward, with thumbs barely touching in front of the torso.

**LADY FENG'S HEROISM** Secular arts also flourished in the Period of Disunity, as rulers sought calligraphers and painters to lend prestige to their courts. The most famous early Chinese painter with whom extant works can be associated was GU KAIZHI (ca. 344–406). Gu was a friend of important members of the Eastern Jin dynasty (317–420) and won renown as a calligrapher, a painter of court portraits, and a pioneer of landscape painting. A *handscroll* (see "Chinese Painting Materials and Formats," above) attributed to Gu Kaizhi in the 11th century is not actually by his hand, but it provides a good idea of the key elements of his art. Called *Admonitions of the Instructress to the Court Ladies*, the horizontal scroll contains painted scenes and accompanying explanatory text. Like all Chinese handscrolls, this one was unrolled and read from right to left, with only a small section exposed for viewing at one time.

The handscroll section illustrated here (FIG. 3-12) records a well-known act of heroism, the Lady Feng saving her emperor's life by placing herself between him and an attacking bear—a perfect model of Confucian behavior. As in many early Chinese paintings, the artist set the figures against a blank background with only a minimal setting for the scene, although in other works Gu provided landscape settings for his narratives. The figures' poses and fluttering drapery ribbons, in concert with individualized facial expressions, convey a clear quality of animation. This style accords well with painting ideals expressed in texts of the time, when representing inner vitality and spirit took precedence over reproducing surface appearances (see "Xie He's Six Canons," page 57).

## Xie He's Six Canons

China has a long and rich history of scholarship on painting, preserved today in copies of texts from as far back as the fourth century and in citations to even earlier sources. Few of the first texts on painting survive, but later authors often quoted them, preserving the texts for posterity. Thus, educated Chinese painters and their clients could steep themselves in a rich art historical tradition. Perhaps the most famous subject of later commentary is a set of six "canons," or "laws," of painting that Xie He formulated in the early sixth century. The canons, as translated by James Cahill,* are as follows:

1. Engender a sense of movement through spirit consonance.
2. Use the brush with the bone method.
3. Responding to things, depict their forms.
4. According to kind, describe appearances [with color].
5. Dividing and planning, positioning and arranging.
6. Transmitting and conveying earlier models through copying and transcribing.

Several variant translations have also been proposed, and scholars actively debate the precise meaning of these succinct (Xie He employed only four characters for each) and cryptic laws. Interpreting the canons in connection with existing paintings is often difficult but nonetheless offers valuable insights into what the Chinese valued in painting.

The simplest canons to understand are the third, fourth, and fifth, because they show Chinese painters' concern for accuracy in rendering forms and colors and for care in composition, concerns common in many cultures. However, separating form and color into different laws gives written expression to a distinctive feature of early Chinese painting. Painters such as Gu Kaizhi (FIG. 3-12) and Yan Liben (FIG. 3-17) used an outline-and-color technique. Their brushed-ink outline drawings employ flat applications of color. To suggest volume, they used ink shading along edges, such as drapery folds.

Also noteworthy is the order of the laws, suggesting Chinese painters' primary concern: to convey the vital spirit of their subjects and their own sensitivity to that spirit. Next in importance was the handling of the brush and the careful placement of strokes, especially of ink. The sixth canon also speaks to a standard Chinese painting practice: copying. Chinese painters, like painters in other cultures throughout history, trained by copying the works of their teachers and other painters. In addition, artists often copied famous paintings as sources of forms and ideas for their own works and to preserve great works created using fragile materials. In China, as elsewhere, change and individual development occurred in constant reference to the past, the artists always preserving some elements of it.

*James Cahill, "The Six Laws and How to Read Them," *Ars Orientalis* 4 (1961), 372–381.

**3-12** GU KAIZHI, *Lady Feng and the Bear,* detail of *Admonitions of the Instructress to the Court Ladies,* Period of Disunity, late fourth century. Handscroll, ink and colors on silk, entire scroll 9¾″ × 11′ 4½″. British Museum, London.

Lady Feng's act of heroism to save the life of her emperor was a perfect model of Confucian behavior. In this early Chinese representation of the episode, the painter set the figures against a blank background.

China **57**

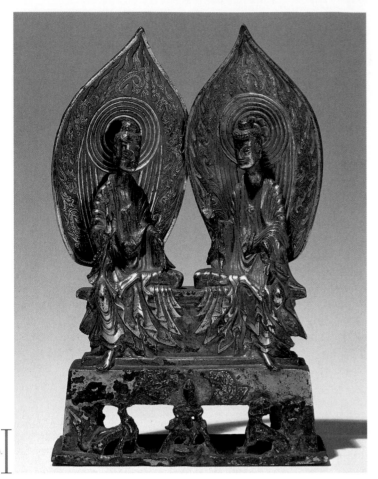

1 in.

**3-13** Shakyamuni and Prabhutaratna, from Hebei Province, Northern Wei dynasty, 518. Gilded bronze, 10¼″ high. Musée Guimet, Paris.

The sculptor of this statuette transformed the Gandhara-derived style of earlier Chinese Buddhist art (FIG. 3-11). The bodies have elongated proportions, and the garment folds form sharp ridges.

**MEETING OF TWO BUDDHAS** A gilded bronze statuette (FIG. 3-13) shows how the sculptors of the Northern Wei dynasty (386–534) transformed the Gandhara-derived style of earlier Buddhist art in China (FIG. 3-11). Dated 518, the piece was probably made for private devotion in a domestic setting or as a votive offering in a temple. It represents the meeting of Shakyamuni Buddha (at the viewer's right) and Prabhutaratna, the Buddha who had achieved nirvana in the remote past, as recounted in the most famous *sutra*, the *Lotus Sutra*, an encyclopedic collection of Buddhist thought and poetry. When Shakyamuni was preaching on Vulture Peak, Prabhutaratna's stupa miraculously appeared in the sky. Shakyamuni opened it and revealed Prabhutaratna himself, who had promised to be present whenever the Lotus Law was preached. Shakyamuni sat beside him and continued to expound the law. The meeting of the two Buddhas symbolized the continuity of Buddhist thought across the ages.

Behind each Buddha is a flamelike nimbus (*mandorla*). Both figures sit in the *lalitasana* pose—one leg folded and the other hanging down. This standard pose, which indicates relaxation, underscores the ease of communication between the two Buddhas. Their bodies have elongated proportions, and their smiling faces have sharp noses and almond eyes. The folds of the garments drop like a waterfall from their shoulders to their knees and spill over onto the pedestal, where they form sharp ridges resembling the teeth of a saw. The rhythmic sweep and linear elegance of the folds recall the brushwork of contemporaneous painting.

# Tang Dynasty

The emperors of the short-lived Sui dynasty (581–618) succeeded in reuniting China and prepared the way for the brilliant Tang dynasty (618–907). Under the Tang emperors, China entered a period of unequaled magnificence (MAP 3-1). Chinese armies marched across Central Asia, prompting an influx of foreign peoples, wealth, and ideas into China. Traders, missionaries, and other travelers journeyed to the cosmopolitan Tang capital at Chang'an, and the Chinese, in turn, ventured westward. Chang'an was laid out on a grid scheme and occupied more than 30 square miles. It was the greatest city in the world during the seventh and eighth centuries.

**LONGMEN CAVES** In its first century, the new dynasty continued to support Buddhism and to sponsor great monuments for Buddhist worshipers. Cave complexes decorated with reliefs and paintings, modeled on those of India (see Chapter 1), were especially popular. One of the most spectacular Tang Buddhist sculptures is carved into the face of a cliff in the great Longmen Caves complex near Luoyang. Work at Longmen had begun almost two centuries earlier, during the Period of Disunity, under the Northern Wei dynasty (386–534). The site's 2,345 shrines and more than 100,000 statues and 2,800 inscriptions attest to its importance as a Buddhist center.

The colossal relief (FIG. 3-14) that dominates the Longmen complex features a central figure of the Buddha that is 44 feet tall—seated. An inscription records that the project was completed in 676 when Gaozong (r. 649–683) was the Tang emperor and that in 672 the empress Wu Zetian underwrote a substantial portion of the considerable cost with her private funds. Wu Zetian was an exceptional woman by any standard, and when Gaozong died in 683, she declared herself emperor and ruled until 705, when she was forced to abdicate at age 82.

Wu Zetian's Buddha is the Vairocana Buddha, not the historical Buddha of FIGS. 3-11 and 3-13 but the Mahayana Cosmic Buddha, the Buddha of Boundless Space and Time (see "Buddhism," Chapter 1, page 13). Flanking him are two of his monks, attendant bodhisattvas, and guardian figures—all smaller than the Buddha but still of colossal size (shown in FIG. 3-14 are visitors to the site, whose size underscores the scale of the work). The sculptors represented the Buddha in serene majesty. An almost geometric regularity of contour and smoothness of planes emphasize the volume of the massive figure. The folds of his robes fall in a few concentric arcs. The artists suppressed surface detail in the interest of monumental simplicity and dignity.

**DUNHUANG GROTTOES** The westward expansion of the Tang Empire increased the importance of Dunhuang, the westernmost gateway to China on the Silk Road. Dunhuang long had been a wealthy, cosmopolitan trade center, a Buddhist pilgrimage destination, and home to thriving communities of Buddhist monks and nuns of varied ethnicity, as well as to adherents of other religions. In the course of several centuries, the Chinese cut hundreds of sanctuaries with painted murals into the soft rock of the cliffs near Dunhuang. Known today as the Mogao Grottoes and in antiquity as the Caves of a Thousand Buddhas, the Dunhuang grottoes also contain sculptured images of painted unfired clay and stucco. The earliest recorded cave at Dunhuang was dedicated in 366, but the oldest extant caves date to the early fifth century. The Dunhuang caves are especially important because in 845 the emperor Wuzong instituted a major persecution, destroying 4,600 Buddhist temples and 40,000 shrines and forcing the return of 260,500 monks and nuns to lay life. Wuzong's policies did not affect Dunhuang, then under Tibetan rule, so the site preserves much of the type of art lost elsewhere.

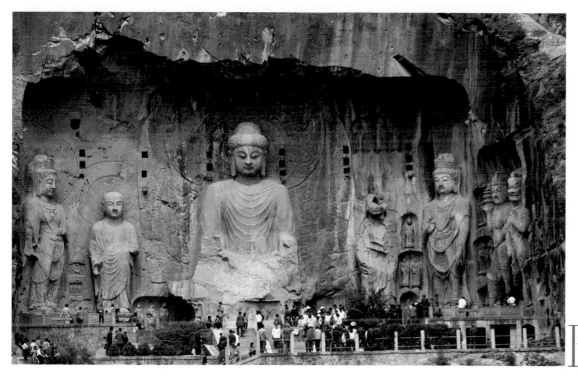

10 ft.

*Paradise of Amitabha* (FIG. 3-15), on the wall of one of the Dunhuang caves, shows how the splendor of the Tang era and religious teachings could come together in a powerful image. Buddhist Pure Land sects, especially those centered on Amitabha, Buddha of the West, had captured the popular imagination in the Period of Disunity under the Six Dynasties and continued to flourish during the Tang dynasty. Pure Land teachings asserted that individuals had no hope of attaining enlightenment through their own power because of the waning of the Buddha's Law. Instead, they could obtain rebirth in a realm free from spiritual corruption simply through faith in Amitabha's promise of salvation. Richly detailed, brilliantly colored pictures steeped in the opulence of the Tang dynasty, such as this one, greatly aided worshipers in gaining faith by visualizing the wonders of the Pure Land Paradise. Amitabha sits in the center of a raised platform, his principal bodhisattvas and lesser divine attendants surrounding him. Before them a celestial dance takes place. Bodhisattvas had strong appeal in East Asia as compassionate beings ready to achieve buddhahood but dedicated to humanity's salvation. Some received direct worship and became the main subjects of sculpture and painting.

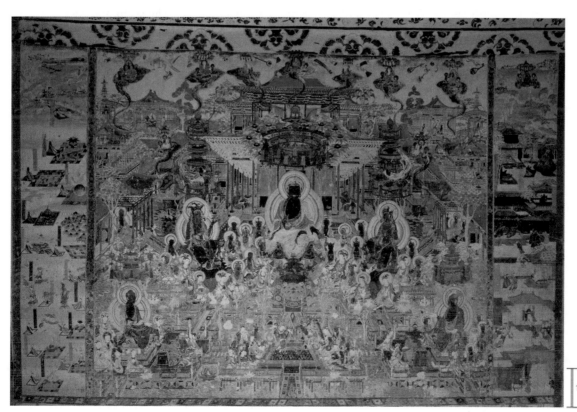

3-15 *Paradise of Amitabha*, cave 172, Dunhuang, China, Tang dynasty, mid-eighth century. Wall painting 10′ high.

This richly detailed, brilliantly colored mural aided Tang worshipers at Dunhuang in visualizing the wonders of the Pure Land Paradise promised to those who had faith in Amitabha, the Buddha of the West.

1 ft.

China **59**

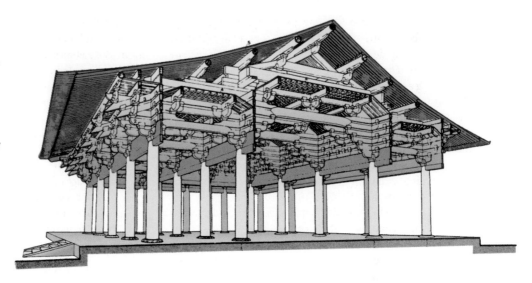

**3-16** Schematic cross-section and perspective drawing of east main hall, Foguang Si (Buddha Radiance Temple), Mount Wutai, China, Tang dynasty, ca. 857 (after L. Liu).

A complex grid of beams and purlins and a thicket of interlocking brackets support the 14-foot overhang of the eaves of the timbered and tiled curved roof of this early Chinese Buddhist temple.

**MOUNT WUTAI** In the Dunhuang mural, Amitabha appears against a backdrop of ornate buildings characteristic of the Tang era. The Tang rulers embellished their empire with extravagant wooden structures, colorfully painted and of colossal size, decorated with furnishings of great luxury and elaborate gold, silver, and bronze ornaments. Unfortunately, few Tang buildings survive. Among them is the Foguang Si (Buddha Radiance Temple) on Mount Wutai, one of the oldest surviving Buddhist temples in China. It lacks the costly embellishment of imperial structures in the capital, but its east main hall (FIG. 3-16) displays the distinctive curved roofline of later Chinese architecture (FIG. 3-10), which was not present in the Han examples (FIGS. 3-8 and 3-9) discussed earlier. A complex grid of beams and purlins and a thicket of interlocking brackets support the overhang of the eaves—some 14 feet out from the column faces—as well as the timbered and tiled roof.

**YAN LIBEN** The Tang emperors also fostered a brilliant tradition of painting. Although few examples are preserved, many art his-

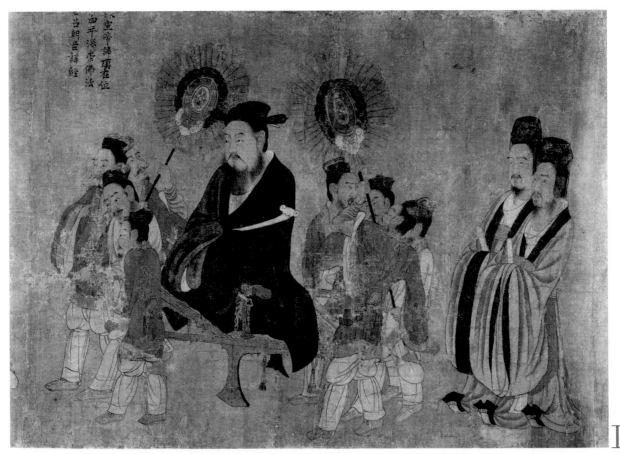

**3-17** Attributed to YAN LIBEN, *Emperor Xuan and Attendants,* detail of *The Thirteen Emperors,* Tang dynasty, ca. 650. Handscroll, ink and colors on silk, detail 1′ 8¼″ × 1′ 5½″; entire scroll 17′ 5″ long. Museum of Fine Arts, Boston.

This handscroll portrays 13 Chinese rulers as Confucian exemplars of moral and political virtue. Yan Liben, a celebrated Tang painter, was a master of line drawing and colored washes.

torians regard the early Tang dynasty as the golden age of Chinese figure painting. In perfect accord with contemporary and later Chinese poets' and critics' glowing descriptions of Tang painting style are the unrestored portions of *The Thirteen Emperors* (FIG. 3-17), a masterpiece of line drawing and colored washes. The painting has long been attributed to YAN LIBEN (d. 673). Born into an aristocratic family and the son of a famous artist, Yan Liben was prime minister under the emperor Gaozong as well as a celebrated painter. This handscroll depicts 13 Chinese rulers from the Han to the Sui dynasties. Its purpose was to portray these historical figures as exemplars of moral and political virtue, in keeping with the Confucian ideal of learning from the past. Each emperor stands or sits in an undefined space. The emperor's great size relative to his attendants immediately establishes his superior stature. Simple shading in the faces and the robes gives the figures an added semblance of volume and presence.

The detail in FIG. 3-17 represents the emperor Xuan of the Chen dynasty (557–589) seated among his attendants, two of whom carry the ceremonial fans that signify his rank and focus the viewer's attention on him. Xuan stands out from the others also because of his dark robes. His majestic serenity contrasts with his attendants' animated poses, which vary sharply from figure to figure, lending vitality to the composition.

**TOMB OF YONGTAI** Wall paintings in the tomb of the Tang princess Yongtai (684–701) at Qianxian, near Chang'an, permit an analysis of court painting styles unobscured by problems of authenticity and reconstruction. When she was 17 years old, Yongtai was either murdered or forced to commit suicide by Wu Zetian. Her underground tomb dates to 706, however, because her formal burial had to await Wu Zetian's own death. The detail illustrated here (FIG. 3-18) depicts palace ladies and their attendants, images of pleasant court life to accompany the princess into her afterlife. The figures appear as if on a shallow stage. The artist did not provide any indications of background or setting, but intervals between the two rows and the figures' grouping in an oval suggest a consistent ground plane. The women assume a variety of poses, seen in full-face and in three-quarter views, from the front or the back. The device of paired figures facing into and out of the space of the picture appears often in paintings of this period and effectively conveys depth. Thick, even contour lines describe full-volumed faces and suggest solid forms beneath the drapery, all with the utmost economy. This simplicity of form and line, along with the measured cadence of the poses, creates an air of monumental dignity.

**TANG CERAMIC SCULPTURE** Tang ceramists also achieved renown and produced thousands of earthenware figures of people, domesticated animals, and fantastic creatures for burial in tombs. These statuettes attest to a demand for ceramic sculpture by a much wider group of patrons than ever before, but terracotta funerary sculpture has a long history in China. The most spectacular example is the ceramic army (FIG. 3-6) of the First Emperor of Qin. The subjects of the Tang figurines are also much more diverse than in earlier periods. The depiction of a broad range of foreigners, including Semitic traders and Central Asian musicians on camels, accurately reflects the cosmopolitanism of Tang China.

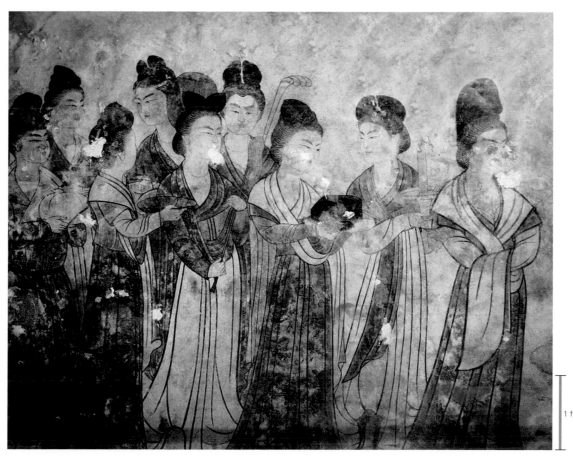

1 ft.

**3-18** Palace ladies, detail of a wall painting, tomb of Princess Yongtai, Qianxian, China, Tang dynasty, 706. Detail 5′ 10″ high.

The paintings in this Tang princess's tomb depict scenes of pleasant court life. The muralist used thick, even contour lines and did not provide any setting, but the composition effectively conveys depth.

## Chinese Earthenwares and Stonewares

China has no rival in the combined length and richness of its ceramic history. Beginning with the makers of the earliest pots in prehistoric villages, ancient Chinese potters showed a flair for shaping carefully prepared and kneaded clay into diverse, often dramatic and elegant vessel forms. Until Chinese potters developed true *porcelains* (extremely fine, hard, white ceramics; see "Chinese Porcelain," Chapter 4, page 76) in about 1300, they produced only two types of clay vessels or objects—earthenwares and stonewares. For both types, potters used clays colored by mineral impurities, especially iron compounds ranging from yellow to brownish-black.

The clay bodies of *earthenwares* (FIG. 3-2), fired at low temperatures in open pits or simple kilns, remain soft and porous, thus allowing liquids to seep through. Chinese artists also used the low-fire technique to produce terracotta sculptures, even life-size figures of humans and animals (FIG. 3-6). Over time, Chinese potters developed kilns capable of firing clay vessels at much higher temperatures—more than 2,000° Fahrenheit. High temperatures produce *stonewares,* named for their stonelike hardness and density.

Potters in China excelled at the various techniques commonly used to decorate earthenwares and stonewares. Most of these decorative methods depend on changes occurring in the kiln to chemical compounds found in clay as natural impurities. When fired, many compounds change color dramatically, depending on the conditions in the kiln. For example, if little oxygen remains in a hot kiln, iron oxide (rust) turns either gray or brownish-black, whereas an abundance of oxygen produces a reddish hue.

Chinese potters also decorated vessels simply by painting their surfaces. In one of the oldest decorative techniques, the potters applied *slip* (a mixture of clay and water like a fine, thin mud)—by painting, pouring, or dipping—to a clay body not yet fully dry. The

natural varieties of clay produced a broad, if not bright, range of colors, as seen in Neolithic vessels (FIG. 3-2). But Chinese potters often added compounds such as iron oxide to the slip to change or intensify the colors. After the vessels had partially dried, the potters could incise lines through the slip down to the clay body to produce designs such as those seen in later Chinese stonewares (FIG. 3-22). Chinese artists also inlaid designs, carving them into plain vessel surfaces and then filling them with slip or soft clay of a contrasting color. These techniques spread throughout East Asia (FIG. 3-29).

To produce a hard, glassy surface after firing, potters coated plain or decorated vessels with a *glaze,* a finely ground mixture of minerals. Clear or highly translucent glazes were often used, but so too were opaque, richly colored glazes. Sometimes the painters allowed the thick glazes to run down the side of a vase or a figurine (FIG. 3-19) to produce dramatic effects.

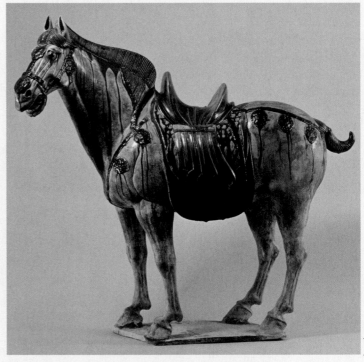

1 in.

**3-19** Neighing horse, Tang dynasty, eighth to ninth century. Glazed earthenware, 1′ 8″ high. Victoria & Albert Museum, London.

Tang ceramists achieved renown for their earthenware figurines decorated with colorful lead glazes that ran in dramatic streams down the sides when a piece was fired, as in this statuette.

The artists painted some figurines with colored slips and decorated others, such as the spirited, handsomely adorned neighing horse in FIG. 3-19, with colorful lead glazes that ran in dramatic streams down the objects' sides when fired (see "Chinese Earthenwares and Stonewares," above). The popularity of the horse as a subject of Chinese art reflects the importance the emperors placed on the quality of their stables. The breed represented here is powerful in build. Its beautifully arched neck terminates in a small, elegant head. Richly harnessed and saddled, the horse testifies to its rider's nobility.

### Song Dynasty

The last century of Tang rule brought many popular uprisings and the empire's gradual disintegration. After an interim of internal strife known as the Five Dynasties period (907–960), General Zhao

Kuangyin succeeded in consolidating the country once again. He established himself as the first emperor (r. 960–976) of the Song dynasty (960–1279), which ruled China from a capital in the north at Bianliang (modern Kaifeng) during the Northern Song period (960–1127). Under the Song emperors, many of the hereditary privileges of the elite class were curtailed. Political appointments were made on the basis of scores on civil service examinations, and education came to be a more important prerequisite for Song officials than high birth.

The three centuries of Song rule, including the Southern Song period (1127–1279) when the capital was at Lin'an (modern Hangzhou) in southern China, were also a time of extraordinary technological innovation. Under the Song emperors, the Chinese invented the magnetic compass for sea navigation, printing with movable clay type, paper money, and gunpowder. Song China was the most

**3-20** Fan Kuan, detail of *Travelers among Mountains and Streams* (FIG. 3-1), Northern Song period, early 11th century. Hanging scroll, ink and colors on silk, entire scroll 6′ 7¼″ × 3′ 4¼″; detail 2′ 10¼″ high. National Palace Museum, Taibei.

Fan Kuan, a Daoist recluse, spent long days in the mountains studying the effects of light on rock formations and trees. He was one of the first masters at recording light, shade, distance, and texture.

1 ft.

technologically advanced society in the world in the early second millennium.

**FAN KUAN** For many observers, the Song dynasty also marks the apogee of Chinese landscape painting, which first emerged as a major subject during the Period of Disunity. Although many of the great Northern Song masters worked for the imperial court, FAN KUAN (ca. 960–1030) was a Daoist recluse (see "Daoism and Confucianism," page 52) who shunned the cosmopolitan life of Bianliang. He believed nature was a better teacher than other artists, and he spent long days in the mountains studying configurations of rocks and trees and the effect of sunlight and moonlight on natural forms. Just as centuries later Giorgio Vasari would credit Italian Renaissance painters with the conquest of naturalism, so too did Song critics laud Fan Kuan and other leading painters of the day as the first masters of the recording of light, shade, distance, and texture. Yet the comparison with 15th- and 16th-century Italy is misleading. Chinese landscape painters such as Fan Kuan did not aim to produce portraits of specific places. They did not seek to imitate or to reproduce nature. Rather, they sought to capture the essence of nature and of its individual elements using brush and ink on silk. Their paintings are tributes to nature, not representations of individual rock or tree formations.

In *Travelers among Mountains and Streams* (FIG. **3-1**), datable to the early 11th century, Fan Kuan painted a vertical landscape of massive mountains rising from the distance. The overwhelming natural forms dwarf the few human and animal figures (for example, the mule train in the lower right corner; FIG. **3-20**), which the artist reduced to minute proportions. The nearly seven-foot-long silk hanging scroll cannot contain nature's grandeur, and the landscape

continues in all directions beyond its borders. The painter showed some elements from level ground (for example, the great boulder in the foreground), and others obliquely from the top (the shrubbery on the highest cliff). The shifting perspectives lead the viewer on a journey through the mountains. To appreciate the painted landscape fully, the viewer must focus not only on the larger composition but also on intricate details and on the character of each brush stroke. Numerous "texture strokes" help model massive forms and convey a sense of tactile surfaces. For the face of the mountain, for example, Fan Kuan employed small, pale brush marks, the kind of texture stroke the Chinese call "raindrop strokes."

**HUIZONG** A century after Fan Kuan painted in the mountains of Shanxi, HUIZONG (1082–1135; r. 1101–1126) assumed the Song throne at Bianliang. Less interested in governing than in the arts, he brought the country to near bankruptcy and lost much of China's territory to the armies of the Tartar Jin dynasty (1115–1234), who captured the Song capital in 1126 and took Huizong prisoner. He died in their hands nine years later. An accomplished poet, calligrapher, and painter, Huizong reorganized the imperial painting academy and required the study of poetry and calligraphy as part of the official training of court painters. *Calligraphy,* or the art of writing, was highly esteemed in China throughout its history, and prominent inscriptions are frequent elements of Chinese paintings (see "Calligraphy and Inscriptions on Chinese Paintings," Chapter 4, page 80). Huizong also promoted the careful study both of nature and of the classical art of earlier periods, and was an avid art collector as well as the sponsor of a comprehensive catalogue of the vast imperial art holdings.

**3-21** Attributed to Huizong, *Auspicious Cranes,* Northern Song period, 1112. Section of a handscroll, ink and colors on silk, 1' 8$\frac{1}{8}$" × 4' 6$\frac{3}{8}$". Liaoning Provincial Museum, Shenyang.

The Chinese regarded the 20 white cranes that appeared at Huizong's palace in 1112 as an auspicious sign. This painting of that event is a masterful combination of elegant composition and realistic observation.

A short handscroll (FIG. **3-21**) usually attributed to Huizong is more likely the work of court painters under his direction, but it displays the emperor's style as both calligrapher and painter. Huizong's characters represent one of many styles of Chinese calligraphy. They are made up of thin strokes, and each character is meticulously aligned with its neighbors to form neat vertical rows. The painting depicts cranes flying over the roofs of Bianliang. It is a masterful combination of elegant composition and realistic observation. The painter carefully recorded the black and red feathers of the white cranes and depicted the birds from a variety of viewpoints to suggest they were circling around the roof. Huizong did not, however, choose this subject because of his interest in the anatomy and flight patterns of birds. The painting was a propaganda piece commemorating the appearance of 20 white cranes at the palace gates during a festival in 1112. The Chinese regarded the cranes as an auspicious sign, proof that Heaven had blessed Huizong's rule. Although few would ever have viewed the handscroll, the cranes were also displayed on painted banners on special occasions, where they could be seen by a larger public.

**CIZHOU POTTERY** Song-era artists also produced superb ceramics. Some reflect their patrons' interests in antiquities and imitate the powerful forms of the Shang and Zhou bronzes. Song ceramics, however, more commonly had elegant shapes with fluid silhouettes. Many featured monochromatic glazes, such as the famous celadon wares, also produced in Korea (FIG. **3-29**). A quite different kind of pottery, loosely classed as Cizhou, emerged

**3-22** Meiping vase, from Xiuwi, China, Northern Song period, 12th century. Stoneware, Cizhou type, with sgraffito decoration, 1' 7$\frac{1}{2}$" high. Asian Art Museum of San Francisco, San Francisco (Avery Brundage Collection).

Chinese potters developed the technique of sgraffito (incising the design through a colored slip) during the Northern Song period. This Cizhou vase features vines and flowers created by cutting through a black slip.

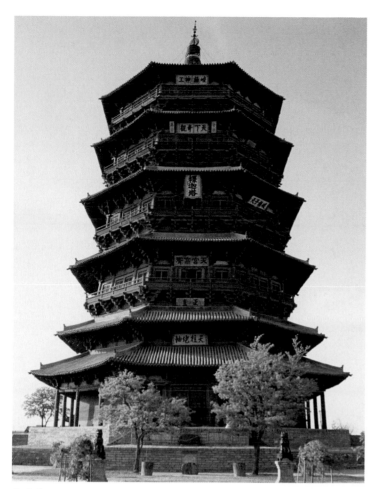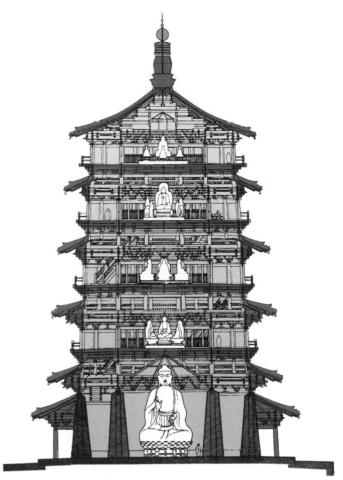

**3-23** View (*left*) and cross-section (*right; after L. Liu*) of Foguang Si Pagoda, Yingxian, China, Liao dynasty, 1056.

The tallest wooden building in the world is this pagoda in the Yingxian Buddhist temple complex. The nine-story tower shows the Chinese wooden beam-and-bracket construction system at its most ingenious.

in northern China. The example shown (FIG. **3-22**) is a vase of the high-shouldered shape known as *meiping*. Chinese potters developed the subtle techniques of *sgraffito* (incising the design through a colored slip) during the Northern Song period. They achieved the intricate black-and-white design here by cutting through a black slip (see "Chinese Earthenwares and Stonewares," page 62). The tightly twining vine and flower-petal motifs on this vase closely embrace the vessel in a perfect accommodation of surface design to vase shape.

**FOGUANG SI PAGODA** For two centuries during the Northern Song period, the Liao dynasty (907–1125) ruled part of northern China. In 1056 the Liao rulers built the Foguang Si Pagoda (FIG. **3-23**), the tallest wooden building ever constructed, at Yingxian in Shanxi Province. The *pagoda*, or tower, the building type most often associated with Buddhism in China and other parts of East Asia, is the most eye-catching feature of a Buddhist temple complex. It somewhat resembles the tall towers of Indian temples and their distant ancestor, the Indian stupa (see "The Stupa," Chapter 1, page 15). Like stupas, many early pagodas housed relics and provided a focus for devotion to the Buddha. Later pagodas served other functions, such as housing sacred images and texts. The Chinese and Koreans built both stone and brick pagodas, but wooden pagodas were also common and became the standard in Japan.

The nine-story octagonal pagoda at Yingxian is 216 feet tall and made entirely of wood (see "Chinese Wooden Construction," page

55). Sixty giant four-tiered bracket clusters carry the floor beams and projecting eaves of the five main stories. They rest on two concentric rings of columns at each level. Alternating main stories and windowless mezzanines with cantilevered balconies, set back farther on each story as the tower rises, form an elevation of nine stories altogether. Along with the open veranda on the ground level and the soaring pinnacle, the balconies visually lighten the building's mass. The cross-section (FIG. **3-23**, *right*) shows the symmetrical placement of statues of the Buddha inside, the colossal scale of the ground-floor statue, and the intricacy of the beam-and-bracket system at its most ingenious.

**SOUTHERN SONG PERIOD** When the Jin captured Bianliang and Emperor Huizong in 1126 and took control of northern China, Gaozong (r. 1127–1162), Huizong's sixth son, escaped and eventually established a new Song capital in the south at Lin'an. From there, he and his successors during the Southern Song period ruled their reduced empire until 1279.

Court sponsorship of painting continued in the new capital, and, as in the Northern Song period, some of the emperors were directly involved with the painters of the imperial painting academy. During the reign of Ningzong (r. 1194–1224), members of the court, including Ningzong himself and Empress Yang, frequently added brief poems to the paintings created under their direction. Some of the painters belonged to families that had worked for the Song emperors for several generations.

**3-24** MA YUAN, *On a Mountain Path in Spring*, Southern Song period, early 13th century. Album leaf, ink and colors on silk, $10\frac{3}{4}'' \times 17''$. National Palace Museum, Taibei.

Unlike Fan Kuan (FIG. 3-1), Ma Yuan reduced the landscape on this silk album leaf to a few elements and confined them to one part of the page. A tall solitary figure gazes out into the infinite distance.

**MA YUAN** The most famous Song family of painters was the Ma family, which began working for the Song dynasty during the Northern Song period. MA YUAN (ca. 1160–1225) painted *On a Mountain Path in Spring* (FIG. **3-24**), a silk album leaf, for Ningzong in the early 13th century. In his composition, in striking contrast to Fan Kuan's much larger *Travelers among Mountains and Streams* (FIG. 3-1), the landscape is reduced to a few elements and confined to the foreground and left side of the page. A tall solitary figure gazes out into the infinite distance. Framing him are the carefully placed diagonals of willow branches. Near the upper right corner a bird flies toward the couplet that Ningzong added in ink, demonstrating his mastery of both poetry and calligraphy:

> *Brushed by his sleeves, wild flowers dance in the wind;*
> *Fleeing from him, hidden birds cut short their songs.*

Some scholars have suggested that the author of the two-line poem is actually Empress Yang, but the inscription is in Ningzong's hand. In any case, landscape paintings such as this one are perfect embodiments of the Chinese ideals of peace and unity with nature.

**LIANG KAI** Religious painting was also popular under the Southern Song emperors. Neo-Confucianism, a blend of traditional Chinese thought and selected Buddhist concepts, became the leading philosophy, but many painters still depicted Buddhist themes. Chan Buddhism (see "Chan Buddhism," page 67), which stressed the quest for personal enlightenment through meditation, flourished under the Song dynasty. LIANG KAI (active early 13th century) was a master of an abbreviated, expressive style of ink painting that found great favor among Chan monks in China, Korea, and Japan. He served in the painting academy of the imperial court in Hangzhou, and his early works include poetic landscapes typical of the Southern Song. Later in life, he left the court and concentrated on figure painting, including Chan subjects.

Surviving works attributed to Liang Kai include an ink painting (FIG. **3-25**) of the Sixth Chan Patriarch, Huineng, crouching as he chops bamboo. In Chan thought, the performance of even such mundane tasks had the potential to become a spiritual exercise. More specifically, this scene represents the patriarch's "Chan moment," when the sound of the blade striking the bamboo resonates within his spiritually attuned mind to propel him through the final doorway to enlightenment. The scruffy, caricature-like representation of the revered figure suggests that worldly matters, such as physical appearance or signs of social status, do not burden Huineng's mind. Liang Kai used a variety of brushstrokes in the execution of this deceptively simple picture. Most are pale and wet, ranging from the fine lines of Huineng's beard to the broad texture strokes of the tree. A few darker strokes, which define the vine growing around the tree and the patriarch's clothing, offer visual accents in the painting. This kind of quick

## Chan Buddhism

**U**nder the Song emperors (960–1279), the new school of *Chan* Buddhism gradually gained importance, until it was second only to Neo-Confucianism.

The Chan school traced its origins through a series of patriarchs (the founder and early leaders, joined in a master–pupil lineage). The First Chan Patriarch was Bodhidharma, a semilegendary sixth-century Indian missionary. By the time of the Sixth Chan Patriarch, Huineng (638–713; FIG. 3-25), in the early Tang period, the religious forms and practices of the school were already well established.

Although Chan monks adapted many of the rituals and ceremonies of other schools over the course of time, they focused on the cultivation of the mind or spirit of the individual in order to break through the illusions of ordinary reality, especially by means of meditation.

In Chan thought, the means of enlightenment lie within the individual, and direct personal experience with some ultimate reality is the necessary step to its achievement. Meditation is a critical practice. In fact, the word "Chan" is a translation of the Sanskrit word for meditation. Bodhidharma is said to have meditated so long in a cave that his arms and legs withered away.

The "Northern School" of Chan holds that enlightenment comes only gradually after long meditation. The "Southern School" believes that the breakthrough to enlightenment can be sudden and spontaneous.

These beliefs influenced art and aesthetics as they developed in China and spread to Korea and Japan. In Japan, Chan (Japanese *Zen*) had an especially extensive, long-term impact on the arts and remains an important school of Buddhism there today (see "Zen Buddhism," Chapter 6, page 106).

**3-25** LIANG KAI, *Sixth Chan Patriarch Chopping Bamboo,* Southern Song period, early 13th century. Hanging scroll, ink on paper, 2′ 5¼″ high. Tokyo National Museum, Tokyo.

Liang Kai was a master of an expressive style of ink painting. Here, he depicted the Sixth Chan Patriarch's "Chan moment," when the chopping sound of his blade propelled the patriarch to enlightenment.

and seemingly casual execution of paintings has traditionally been interpreted as a sign of a painter's ability to produce compelling pictures spontaneously as a result of superior training and character, or, in the Chan setting, progress toward enlightenment.

**ZHOU JICHANG** Another leading Southern Song painter of Buddhist themes was ZHOU JICHANG (ca. 1130–1190), who painted *Lohans Giving Alms to Beggars* (FIG. 3-26) around 1178. The scroll was one in a series of 100 scrolls produced at the southern coastal city of Ningbo for an abbot who invited individual donors to pay for the paintings as offerings in the nearby Buddhist temple. *Lohans* are enlightened disciples of the Buddha who have achieved freedom

from rebirth (nirvana) by suppression of all desire for earthly things. They were charged with protecting the Buddhist Law until the arrival of the Buddha of the Future. In his Ningbo scroll, Zhou Jichang arranged the foreground, middle ground, and background vertically to clarify the lohans' positions relative to one another and to the beggars. The lohans move with slow dignity in a plane above the ragged wretches who scramble miserably for the alms their serene benefactors throw down. The extreme difference in deportment between the two groups distinguishes their status, as do their contrasting features. The lohans' vividly colored attire, flowing draperies, and quiet gestures set them off from the dirt-colored and jagged shapes of the people physically and spiritually beneath them. In this painting,

# KOREA

Korea is a northeast Asian peninsula that shares borders with China and Russia and faces the islands of Japan (MAP 3-1). Korea's pivotal location is a key factor in understanding the relationship of its art to that of China and the influence of its art on that of Japan. Ethnically, the Koreans are related to the peoples of eastern Siberia and Mongolia as well as to the Japanese. At first, the Koreans used Chinese characters to write Korean words, but later they invented their own phonetic alphabet. Korean art, although frequently based on Chinese models, is not merely derivative but has, like Korean civilization, a distinct identity.

## Three Kingdoms Period

Pottery-producing cultures appeared on the Korean peninsula in the Neolithic period no later than 6000 BCE, and the Korean Bronze Age dates from ca. 1000 BCE. Bronze technology was introduced from the area that is today northeastern China (formerly known as Manchuria). About 100 BCE, during the Han dynasty, the Chinese established outposts in Korea. The most important was Lelang, which became a prosperous commercial center. By the middle of the century, however, three native kingdoms—Koguryo, Paekche, and Silla—controlled most of the Korean peninsula and reigned for more than seven centuries until Silla completed its conquest of its neighbors in 668. During this era, known as the Three Kingdoms period (ca. 57 BCE–688 CE), Korea remained in continuous contact with both China and Japan. Buddhism was introduced into Korea from China in the fourth century CE. The Koreans in turn transmitted it from the peninsula to Japan in the sixth century.

**SILLA CROWN** Tombs of the Silla kingdom have yielded spectacular artifacts representative of the wealth and power of its rulers. Finds in the region of Kyongju justify the city's ancient name—Kumsong ("City of Gold"). The gold-and-jade crown (FIG. 3-27) from a tomb at Hwangnamdong, near Kyongju, dated to the fifth or sixth century, also attests to the high quality of artisanship among Silla artists. The crown's major elements, the band and the uprights, as well as the myriad spangles adorning them, were cut from sheet gold and embossed along the edges. Gold rivets and wires secure the whole, as do the comma-shaped pieces of jade further embellishing the crown. Archaeologists interpret the uprights as stylized tree and antler forms believed to symbolize life and supernatural power. The Hwangnamdong crown has no counterpart in China, although the technique of working sheet gold may have come to Korea from northeast China.

## Unified Silla Kingdom

Aided by China's emperor, the Silla kingdom conquered the Koguryo and Paekche kingdoms and unified Korea in 668. The era of the Unified Silla Kingdom (688–935) is roughly contemporary with the Tang dynasty's brilliant culture in China, and many consider it to be Korea's golden age.

**BUDDHIST SOKKURAM** The Silla rulers embraced Buddhism both as a source of religious enlightenment and as a protective force. They considered the magnificent Buddhist temples they constructed in and around their capital of Kyongju to be supernatural defenses against external threats as well as places of worship. Unfortunately, none of these temples survived Korea's turbulent history.

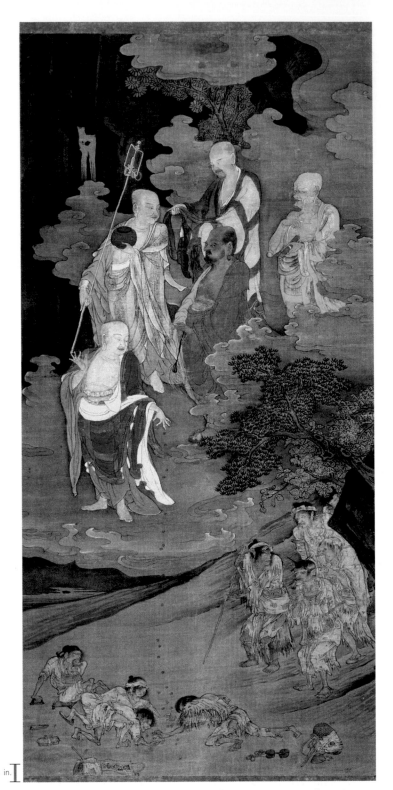

**3-26** ZHOU JICHANG, *Lohans Giving Alms to Beggars,* Southern Song period, ca. 1178. Hanging scroll, ink and colors on silk, $3' 7\frac{7}{8}'' \times 1' 8\frac{7}{8}''$. Museum of Fine Arts, Boston.

In this hanging scroll made for a Buddhist monastery, Zhou Jichang arranged the fore-, middle-, and background vertically to elevate the lohans in their bright attire above the ragged, dirt-colored beggars.

1 in.

consistent with Xie He's principles (see "Xie He's Six Canons," page 57), Zhou Jichang used color for symbolic and decorative purposes, not to imitate nature or depict the appearance of individual forms. The composition of the landscape—the cloudy platform and lofty peaks of the lohans and the desertlike setting of the beggars—also distinguishes the two spheres of being.

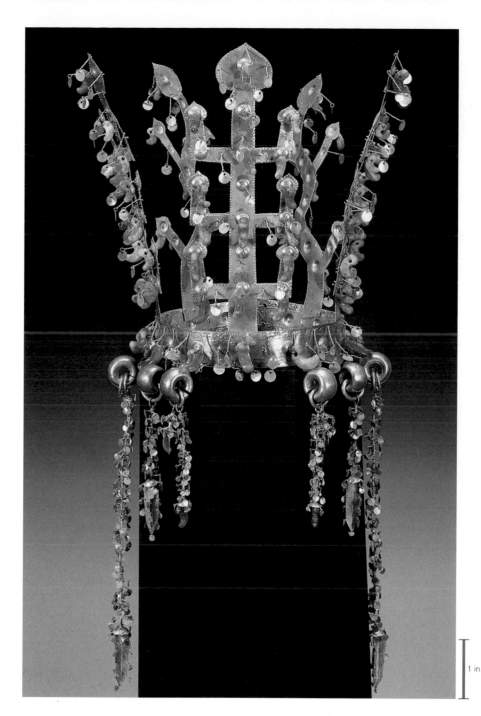

**3-27** Crown, from north mound of tomb 98, Hwangnamdong, near Kyongju, Korea, Three Kingdoms period, fifth to sixth century. Gold and jade, $10\frac{3}{4}''$ high. Kyongju National Museum, Kyongju.

This gold-and-jade crown from a Silla tomb attests to the wealth of that kingdom and the skill of its artists. The uprights may be stylized tree and antler forms symbolizing life and supernatural power.

1 in.

However, at Sokkuram, near the summit of Mount Toham, northeast of the city, a splendid granite Buddhist monument is preserved. Scant surviving records suggest that Kim Tae-song, a member of the royal family who served as prime minister, supervised its construction. He initiated the project in 742 to honor his parents in his previous life. Certainly the intimate scale of Sokkuram and the quality of its reliefs and freestanding figures support the idea that the monument was a private chapel for royalty.

The main *rotunda* (circular area under a dome; FIG. **3-28**) measures about 21 feet in diameter. Despite its modest size, the Sokkuram project required substantial resources. Unlike the Chinese Buddhist caves at Longmen (FIG. **3-14**), the interior wall surfaces and sculpture were not cut from the rock in the process of excavation. Instead, workers assembled hundreds of granite pieces of various shapes and sizes, attaching them with stone rivets instead of mortar.

Sculpted images of bodhisattvas, lohans, and guardians line the lower zone of the wall. Above, 10 niches contain miniature statues of seated bodhisattvas and believers. All these figures face inward toward the 11-foot-tall statue of Shakyamuni, the historical Buddha, which dominates the chamber and faces the entrance. Carved from a single block of granite, the image represents the Buddha as he touched the earth to call it to witness the realization of his enlightenment at Bodh Gaya (FIG. **1-11***b*). Although remote in time and place from the Sarnath Buddha (FIG. **1-13**) in India, this majestic image remains faithful to its iconographic prototype. More immediately, the Korean statue draws on the robust, round-faced figures (FIG. **3-14**) of Tang China, and its drapery is a more schematic version of the fluid type found in Tang sculpture. However, the figure has a distinctly broad shouldered dignity combined with harmonious proportions that are without close precedents. Art historians consider it one of the finest images of the Buddha in East Asia.

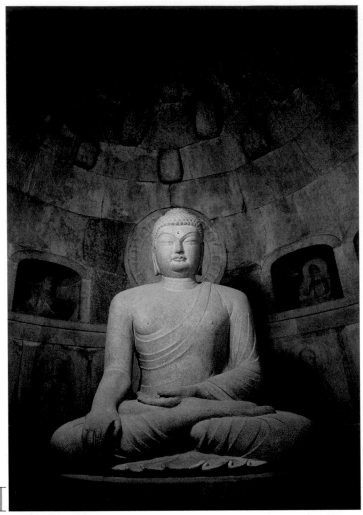

**3-28** Shakyamuni Buddha, in the rotunda of the cave temple, Sokkuram, Korea, Unified Silla Kingdom, 751–774. Granite, 11′ high.

Unlike rock-cut Chinese Buddhist shrines, this Korean cave temple was constructed using granite blocks. Dominating the rotunda is a huge statue depicting the Buddha at the moment of his enlightenment.

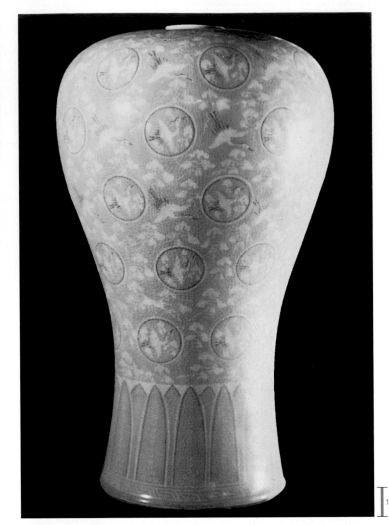

**3-29** Maebyong vase, Koryo dynasty, ca. 918–1000. Celadon with inlaid decoration, 1′ 4½″ tall. Kansong Art Museum, Seoul.

Celadon wares feature highly translucent iron-pigmented glazes with incised designs. This green maebyong vase is decorated with engraved cranes highlighted by white and colored slip in the incised lines.

## Koryo Dynasty

Although Buddhism was the established religion of Korea, Confucianism, introduced from China during the Silla era, increasingly shaped social and political conventions. In the ninth century, the three old kingdoms began to reemerge as distinct political entities, but by 935 the Koryo (from Koguryo) had taken control, and they dominated for the next three centuries. The Unified Silla and Koryo kingdoms overlap slightly (the period ca. 918–935) because both kingdoms existed during these shifts in power. In 1231 the Mongols, who had invaded China, pushed into Korea, beginning a war lasting 30 years. In the end, the Koryo had to submit to forming an alliance with the Mongols, who eventually conquered all of China (see Chapter 4).

**CELADON WARE** Koryo potters in the 12th century produced the famous Korean *celadon* wares, admired worldwide. Celadon wares feature highly translucent iron-pigmented glazes, fired in an oxygen-deprived kiln to become gray, pale blue, pale green, or brownish-olive. Incised or engraved designs in the vessel alter the thickness of the glaze to produce elegant tonal variations.

A vase in the shape called *maebyong* in Korean (FIG. **3-29**; *meiping* in Chinese, FIG. **3-22**) probably dates to the early Koryo period (ca. 918–1000). It is decorated using the inlay technique for which Koryo potters were famous. The artist incised delicate motifs of flying cranes—some flying down and others, in *roundels* (circular frames), flying up—into the clay's surface and then filled the grooves with white and colored slip. Next, the potter covered the incised areas with the celadon green glaze. Variation in the spacing of the motifs shows the potter's sure sense of the dynamic relationship between ornamentation and ceramic volume.

**KOREA, CHINA, AND JAPAN** China's achievements in virtually every field spread beyond even the boundaries of the vast empires it at various times controlled. Although Buddhism began in India, the Chinese adaptations and transformations of its teachings, religious practices, and artistic forms were those that spread farther east. The cultural debt of China's neighbors to China is immense. Nevertheless, Korea was the crucial artistic, cultural, and religious link between the mainland and the islands of Japan, the subject of Chapter 5.

## CHINA AND KOREA TO 1279

### SHANG DYNASTY, ca. 1600–1050 BCE

▪ The Shang dynasty was the first great Chinese dynasty of the Bronze Age. The Shang kings ruled from a series of capitals in the Yellow River valley.

▪ Shang bronze-workers were among the best in the ancient world and created a wide variety of elaborately decorated vessels using a sophisticated piece-mold casting process.

Guang, from Anyang,
12th or 11th century BCE

### ZHOU AND QIN DYNASTIES, ca. 1050–206 BCE

▪ The Zhou dynasty was the longest in China's history. The Western Zhou kings (ca. 1050–771 BCE) ruled from Chang'an and the Eastern Zhou kings (770–256 BCE) from Luoyang. During the last centuries of Zhou rule, Daoism and Confucianism gained wide followings in China.

▪ Zhou artists produced lavish works in bronze, lacquer, and especially jade.

▪ China's First Emperor founded the short-lived Qin dynasty (221–206 BCE) after defeating the Zhou and all other rival states.

▪ A terracotta army of more than 6,000 soldiers guarded the First Emperor's burial mound at Lintong. The tomb itself remains unexcavated.

Army of the First Emperor of Qin,
Lintong, ca. 210 BCE

### HAN DYNASTY AND PERIOD OF DISUNITY, 206 BCE–581 CE

▪ The Han dynasty (206 BCE–220 CE) extended China's boundaries to the south and west and even traded indirectly with Rome via the fabled Silk Road.

▪ Earthenware models found in tombs give a good idea of the appearance and construction methods of Han wooden buildings.

▪ Civil strife divided China into competing states from 220 to 581 CE. The earliest Chinese images of the Buddha and the first paintings that can be associated with an artist whose name was recorded date to this so-called Period of Disunity.

▪ In the early sixth century, Xie He formulated his six canons of Chinese painting.

Model of a Han dynasty house,
first century CE

### TANG DYNASTY, 618–907

▪ China enjoyed unequaled prosperity and power under the Tang emperors, whose capital at Chang'an became the greatest and most cosmopolitan city in the world.

▪ The Tang dynasty was the golden age of Chinese figure painting. The few surviving works include Yan Liben's *The Thirteen Emperors* handscroll illustrating historical figures as exemplars of Confucian ideals. The Dunhuang caves provide evidence of the magnificence of Tang Buddhist art, especially mural painting.

▪ Korea also enjoyed an artistic golden age at this time under the Unified Silla Kingdom (688–935).

Yan Liben, *The Thirteen Emperors*,
ca. 650

### SONG DYNASTY, 960–1279

▪ Song China (Northern Song, 960–1127, capital at Bianliang; Southern Song, 1127–1279, capital at Lin'an) was the most technologically advanced society in the world in the early second millennium.

▪ In art, the Song era marked the apogee of Chinese landscape painting. Fan Kuan, a Daoist recluse, was a pioneer in recording light, shade, distance, and texture in his hanging scrolls.

▪ For part of this period, the Liao dynasty (907–1125) ruled northern China and erected the tallest wooden building in the world, the Foguang Si Pagoda at Yingxian.

Fan Kuan, *Travelers among Mountains
and Streams*, early 11th century

**4-1** Throne room, Hall of Supreme Harmony, Forbidden City, Beijing, China, Ming dynasty, 15th century and later.

The Ming emperors—the Sons of Heaven—ruled China for almost three centuries from the Forbidden City (FIG. 4-6) in Beijing. Few ever entered the palace's magnificent throne room.

# 4

# CHINA AND KOREA
# AFTER 1279

The 13th century was a time of profound political upheaval in Asia. The opening decade brought the establishment of a Muslim sultanate at Delhi (see Chapter 2) after the Islamic armies of Muhammad of Ghor wrested power from India's Hindu kings. Momentous changes followed immediately in China.

## CHINA

In 1210, the Mongols invaded northern China from Central Asia (MAP **4-1**), opening a new chapter in the history and art of that ancient land. Under the dynamic leadership of Genghis Khan (1167–1230), the Mongol armies made an extraordinarily swift advance into China. By 1215 the Mongols had destroyed the Jin dynasty's capital at Beijing and had taken control of northern China. Two decades later, they attacked the Song dynasty in southern China. It was not until 1279, however, that the last Song emperor fell at the hands of Genghis Khan's grandson, Kublai Khan (1215–1294). Kublai proclaimed himself the new emperor of China (r. 1279–1294) and founded the Yuan dynasty.

### Yuan Dynasty

During the relatively brief tenure of the Yuan (r. 1279–1368), trade between Europe and Asia increased dramatically. It was no coincidence that the most famous early European visitor to China, Marco Polo (1254–1324), arrived during the reign of Kublai Khan. Part fact and part fable, Marco Polo's chronicle of his travels to and within China was the only eyewitness description of East Asia available in Europe for several centuries. Marco Polo's account makes clear that the Venetian had a profound admiration for Yuan China. He marveled not only at Kublai Khan's opulent lifestyle and palaces but also at the volume of commercial traffic on the Yangtze River, the splendors of Hangzhou, the use of paper currency, porcelain, and coal, the efficiency of the Chinese postal system, and the hygiene of the Chinese people. In the early second millennium, China was richer and technologically more advanced than late medieval Europe.

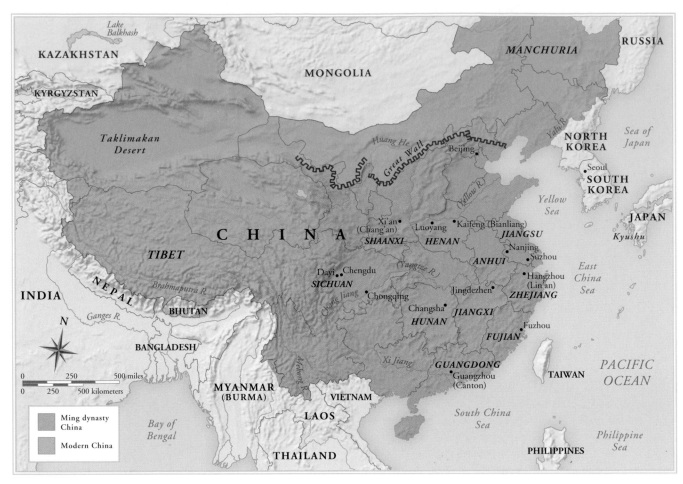

MAP 4-1 China during the Ming dynasty.

**ZHAO MENGFU AND GUAN DAOSHENG** The Mongols were great admirers of Chinese art and culture, but they were very selective in admitting former Southern Song subjects into their administration. In addition, many Chinese loyal to the former emperors refused to collaborate with their new foreign overlords, whom they considered barbarian usurpers. One who did accept an official post under Kublai Khan was Zhao Mengfu (1254–1322), a descendant of the first Song emperor. A learned man, skilled in both calligraphy and poetry, he won renown as a painter of horses and of landscapes.

Zhao's wife, GUAN DAOSHENG (1262–1319), was also a successful painter, calligrapher, and poet. Although she painted a variety of subjects, including Buddhist murals in Yuan temples, Guan became famous for her paintings of bamboo. The plant was a popular subject because it was a symbol of the ideal Chinese gentleman, who bends in adversity but does not break, and because depicting bamboo branches and leaves approximated the cherished art of calligraphy (see "Calligraphy and Inscriptions on Chinese Paintings," page 80). *Bamboo Groves in Mist and Rain* (FIG. **4-2**), a *handscroll* (see

4-2 GUAN DAOSHENG, *Bamboo Groves in Mist and Rain* (detail), Yuan dynasty, 1308. Section of a handscroll, ink on paper, $9\frac{1}{8}''$ × $3'\,8\frac{7}{8}''$. National Palace Museum, Tabei.

Guan Daosheng was a calligrapher, poet, and painter. She achieved the misty atmosphere in this landscape by restricting the ink tones to a narrow range and by blurring the bamboo thickets in the distance.

**4-3** WU ZHEN, *Stalks of Bamboo by a Rock,* Yuan dynasty, 1347. Hanging scroll, ink on paper, 2′ 11½″ × 1′ 4⅝″. National Palace Museum, Tabei.

Wu Shen was one of the leading Yuan literati (scholar-artists). The bamboo plants in his hanging scroll are perfect complements to the prominently featured black Chinese calligraphic characters.

1 in.

"Chinese Painting Materials and Formats," Chapter 3, page 56), is one of her best paintings. Guan achieved the misty atmosphere by restricting the ink tones to a narrow range and by blurring the bamboo thickets in the distance, suggesting not only the receding landscape but fog as well.

**WU ZHEN** The Yuan painter WU ZHEN (1280–1354), in stark contrast to Zhao Mengfu and Guan Daosheng, shunned the Mongol court and lived as a hermit, far from the luxurious milieu of the Yuan emperors. He was among the *literati,* or scholar-artists, who emerged during the Song dynasty. The literati painted primarily for a small audience of their educational and social peers. Highly educated and steeped in traditional Chinese culture, these men and women came from prominent families. They cultivated calligraphy, poetry, painting, and other arts as a sign of social status and refined taste. Literati art is usually personal in nature and often shows nostalgia for the past.

Wu Zhen's treatment of the bamboo theme, *Stalks of Bamboo by a Rock* (FIG. **4-3**), differs sharply from Guan's. The artist clearly differentiated among the individual bamboo plants and reveled in the abstract patterns the stalks and leaves form. The bamboo plants in his *hanging scroll* are perfect complements to the calligraphic beauty of the Chinese black characters and red seals so prominently featured on the scroll (see "Calligraphy and Inscriptions," page 80). Both the bamboo and the inscriptions gave Wu Zhen the opportunity to display his proficiency with the brush.

**HUANG GONGWANG** One of the great works of Yuan literati painting is *Dwelling in the Fuchun Mountains* (FIG. **4-4**) by HUANG GONGWANG (1269–1354), a former civil servant and a teacher of Daoist philosophy. According to the artist's explanatory inscription at the end of the long handscroll, he sketched the full composition in one burst of inspiration, but then added to and modified his painting whenever he felt moved to do so over a period of years. In the

1 in.

**4-4** HUANG GONGWANG, *Dwelling in the Fuchun Mountains,* Yuan dynasty, 1347–1350. Section of a handscroll, ink on paper, 1′ ⅞″ × 20′ 9″ (full scroll). National Palace Museum, Tabei.

In this Yuan handscroll, the painter built up the textured mountains with richly layered wet and dry brush strokes and ink-wash accents that capture the landscape's inner structure and momentum.

## Chinese Porcelain

**N**o other Chinese art form has achieved such worldwide admiration, inspired such imitation, or penetrated so deeply into everyday life as *porcelain* (FIGS. **4-5** and **4-16**). Long imported by neighboring countries as luxury goods and treasures, Chinese porcelains later captured great attention in the West, where potters did not succeed in mastering the production process until the early 18th century.

In China, primitive porcelains emerged during the Tang dynasty (618–906), and mature forms developed in the Song (960–1279). Like *stoneware* (see "Chinese Earthenwares and Stonewares," Chapter 3, page 62), porcelain objects are fired at an extremely high temperature (well over 2,000°F) in a kiln until the clay fully fuses into a dense, hard substance resembling stone or glass. Unlike stoneware, however, porcelain is made from a fine white clay called kaolin mixed with ground petuntse (a type of feldspar). True porcelain is translucent and rings when struck. Its rich, shiny surface resembles that of jade, a luxurious natural material the Chinese long admired (see "Chinese Jade," Chapter 3, page 51).

Chinese ceramists often decorate porcelains with colored designs or pictures, working with finely ground minerals suspended in water and a binding agent (such as glue). The minerals change color dramatically in the kiln. The painters apply some mineral colors to the clay surface before the main firing and then apply a clear *glaze* over them. The *underglaze* decoration fully bonds to the piece in the kiln, but only a few colors are possible because the raw materials must withstand intense heat. The most stable and widely used coloring agents for porcelains are cobalt compounds, which fire to an intense blue (FIG. **4-5**). Rarely, potters use copper compounds to produce stunning reds by carefully manipulating the kiln's temperature and oxygen content. To obtain a wider palette, ceramic decorators must paint on top of the glaze after firing the work (FIG. **4-16**). The *overglaze* colors, or *enamels,* then fuse to the glazed surface in an additional firing at a much lower temperature. Enamels also offer glaze

**4-5** Temple vase, Yuan dynasty, 1351. White porcelain with cobalt-blue underglaze, 2′ 1″ × 8$\frac{1}{8}$″. Percival David Foundation of Chinese Art, London.

This vase is an early example of porcelain with cobalt-blue underglaze decoration. Dragons and phoenixes, symbols of male and female energy, respectively, are the major painted motifs.

1 in.

decorators a much brighter palette, with colors ranging from deep browns to brilliant reds and greens, but they do not have the durability of underglaze decoration.

detail shown in FIG. 4-4, the painter built up the textured mountains with richly layered brush strokes, at times interweaving dry brush strokes and at other times placing dry strokes over wet ones, darker strokes over lighter ones, often with ink-wash accents. The rhythmic play of brush and ink captures the landscape's inner structure and momentum.

**JINGDEZHEN PORCELAIN** By the Yuan period, Chinese potters had extended their mastery to fully developed porcelains, a very technically demanding medium (see "Chinese Porcelain," above). A tall temple vase (FIG. **4-5**) from the Jingdezhen kilns, which during the Ming dynasty became the official source of porcelains for the court, is one of a nearly identical pair dated by inscription to 1351. The inscription also says the vases, together with an incense burner, made up an

altar set donated to a Buddhist temple as a prayer for peace, protection, and prosperity for the donor's family. The vase is one of the earliest dated examples of fine porcelain with cobalt-blue underglaze decoration. The painted decoration consists of bands of floral motifs between broader zones containing auspicious symbols, including phoenixes in the lower part of the neck and dragons (compare FIG. 3-5) on the main body of the vessel, both among clouds. These motifs may suggest the donor's high status or invoke prosperity blessings. Because of their vast power and associations with nobility and prosperity, the dragon and the phoenix also symbolize the emperor and empress, respectively, and often appear on objects made for the imperial household. The dragon also may represent *yang,* the Chinese principle of active masculine energy, while the phoenix may represent *yin,* the principle of passive feminine energy.

**4-6** Aerial view (looking north) of the Forbidden City, Beijing, China, Ming dynasty, 15th century and later.

The layout of the Forbidden City provided the perfect setting for the elaborate ritual surrounding the Ming emperor. Successive gates regulated access to the Hall of Supreme Harmony (FIG. 4-1).

## Ming Dynasty

In 1368, Zhu Yuanzhong led a popular uprising that drove the last Mongol emperor from Beijing. After expelling the foreigners from China, he founded the native Chinese Ming dynasty (r. 1368–1644), proclaiming himself its first emperor under the official name of Hongwu (r. 1368–1398). The new emperor built his capital at Nanjing, but the third Ming emperor, Yongle (r. 1403–1424), moved the capital back to Beijing. Although Beijing had been home to the Yuan dynasty, Ming architects designed much of the city as well as the imperial palace at its core.

**THE FORBIDDEN CITY** The Ming builders laid out Beijing as three nested walled cities. The outer perimeter wall was 15 miles long and enclosed the walled Imperial City, with a perimeter of 6 miles, and the vast imperial palace compound, the moated Forbidden City (FIG. 4-6), so named because of the highly restricted access to it. There resided the Ming emperor, the Son of Heaven. The layout of the Forbidden City provided the perfect setting for the elaborate ritual of the imperial court. For example, the entrance gateway, the Noon Gate (in the foreground in the aerial view) has five portals. Only the emperor could walk through the central doorway. The two entrances to its left and right were reserved for the imperial family and high officials. Others had to use the outermost passageways. More gates and a series of courtyards and imposing buildings, all erected using the traditional Chinese bracketing system (see "Chinese Wooden Construction," Chapter 3, page 55), led eventually to the Hall of Supreme Harmony, perched on an immense platform above marble staircases, the climax of a long north-south axis. Within the hall, the emperor sat on his throne on another high stepped platform (FIG. 4-1).

**SUZHOU GARDENS** At the opposite architectural pole from the formality and rigid axiality of palace architecture is the Chinese pleasure garden. Several Ming gardens at Suzhou have been meticulously restored, including the huge (almost 54,000 square feet) Wangshi

**4-7** Wangshi Yuan (Garden of the Master of the Fishing Nets), Suzhou, China, Ming dynasty, 16th century and later.

Ming gardens are arrangements of natural and artificial elements intended to reproduce the irregularities of nature. This approach to design is the opposite of the formality and axiality of the Ming palace.

**4-8** Liu Yuan (Lingering Garden), Suzhou, China, Ming dynasty, 16th century and later.

A favorite element of Chinese gardens was fantastic rockwork. For the Lingering Garden, workmen dredged the stones from a nearby lake and sculptors shaped them to produce an even more natural look.

## MATERIALS AND TECHNIQUES

### Lacquered Wood

**4-9** Table with drawers, Ming dynasty, ca. 1426–1435. Carved red lacquer on a wood core, 3′ 11″ long. Victoria & Albert Museum, London.

The Orchard Factory was the leading Ming workshop for lacquered wood furniture. The lacquer on this table was thick enough to be carved with floral motifs and the imperial dragon and phoenix.

From ancient times the Chinese used lacquer to cover wood. Lacquer is produced from the sap of the Asiatic sumac tree, native to central and southern China. When it dries, it cures to great hardness and prevents the wood from decaying. Often colored with mineral pigments, lacquered objects have a lustrous surface that transforms the appearance of natural wood. The earliest examples of lacquered wood to survive in quantity date to the Eastern Zhou period (770–256 BCE).

The first step in producing a lacquered object is to heat and purify the sap. Then the lacquer worker mixes the minerals—carbon black and cinnabar red are the most common—into the sap. To apply the lacquer, the artisan uses a hair brush similar to a calligrapher's or painter's brush, applying the lacquer one layer at a time. Each coat must dry and be sanded before another coat can be applied. If a sufficient number of layers is built up, the lacquer can be carved as if it were the wood itself (FIG. 4-9).

Other techniques for decorating lacquer include inlaying metals and lustrous materials, such as mother-of-pearl, and sprinkling gold powder into the still-wet lacquer. These techniques also flourished in both Korea and Japan (FIG. 6-10).

1 ft.

**4-10** SHANG XI, *Guan Yu Captures General Pang De*, Ming dynasty, ca. 1430. Hanging scroll, ink and colors on silk, 6′ 5″ × 7′ 7″. Palace Museum, Beijing.

The official painters of the Ming court lived in the Forbidden City and specialized in portraiture and history painting. This very large scroll celebrates a famed general of the third century.

Yuan (Garden of the Master of the Fishing Nets; FIG. 4-7). Designing a Ming garden was not a matter of cultivating plants in rows or of laying out terraces, flower beds, and avenues in geometric fashion, as was the case in many other cultures. Instead, Ming gardens are often scenic arrangements of natural and artificial elements intended to reproduce the irregularities of uncultivated nature. Verandas and pavilions rise on pillars above the water, and stone bridges, paths, and causeways encourage wandering through ever-changing vistas of trees, flowers, rocks, and their reflections in the ponds. The typical design is a sequence of carefully contrived visual surprises.

A favorite garden element, fantastic rockwork, is a prominent feature of Liu Yuan (Lingering Garden; FIG. 4-8) in Suzhou. Workmen dredged the stones from nearby Lake Tai, and sculptors shaped them to create an even more natural look. The one at the center of FIG. 4-8 is about 20 feet tall and weighs about five tons. The Ming gardens of Suzhou were the pleasure retreats of high officials and the landed gentry, sanctuaries where the wealthy could commune with nature in all its representative forms and as an ever-changing and boundless presence. Chinese poets never cease to sing of the restorative effect of gardens on mind and spirit.

**ORCHARD FACTORY** The Ming court's appetite for luxury goods gave new impetus to brilliant technical achievement in the decorative arts. Like the Yuan rulers, the Ming emperors turned to the Jingdezhen kilns for fine porcelains. For objects in lacquered wood (see "Lacquered Wood," page 78), their patronage went to a large workshop known today as the Orchard Factory. A table with drawers (FIG. 4-9), made between 1426 and 1435, is one of the workshop's masterpieces. The artist carved floral motifs, along with the dragon and phoenix imperial emblems, into the thick cinnabar-colored lacquer, which had to be built up in numerous layers.

**SHANG XI** At the Ming court, the official painters lived in the Forbidden City itself, and portraiture of the imperial family was their major subject. The court artists also depicted historical figures as exemplars of virtue, wisdom, or heroism. An exceptionally large example of Ming history painting is a hanging scroll that SHANG XI (active in the second quarter of the 15th century) painted around 1430. *Guan Yu Captures General Pang De* (FIG. 4-10) represents an episode from the tumultuous third century (Period of Disunity; see Chapter 3), whose wars inspired one of the first great Chinese novels, *The Romance of the Three Kingdoms*. Guan Yu was a famed general of the Wei dynasty (220–280) and a fictional hero in the novel. The painting depicts the historical Guan Yu, renowned for his loyalty to his emperor and his military valor, being presented with the captured enemy general Pang De. In his painting, Shang Xi used color to focus attention on Guan Yu and his attendants, who stand out sharply from the ink landscape. He also contrasted the victors' armor and bright garments with the vulnerability of the captive, who has been stripped almost naked, further heightening his humiliation.

China **79**

# Calligraphy and Inscriptions on Chinese Paintings

Many Chinese paintings (FIGS. 3-21, 3-24, 4-3, and 4-11 to 4-13) bear inscriptions, texts written on the same surface as the picture, or *colophons*, texts written on attached pieces of paper or silk. Throughout history, the Chinese have held *calligraphy* (Greek, "beautiful writing") in very high esteem—higher, in fact, than painting. Inscriptions appear almost everywhere in China—on buildings and in gardens, on furniture and sculpture. Chinese calligraphy and painting have always been closely connected. Even the primary implements and materials for writing and drawing are the same—a round tapered brush, soot-based ink, and paper or silk. Calligraphy depends for its effects on the controlled vitality of individual brush strokes and on the dynamic relationships of strokes within a *character* (an elaborate Chinese sign that by itself can represent several words) and among the characters themselves. Training in calligraphy was a fundamental part of the education and self-cultivation of Chinese scholars and officials, and inscriptions are especially common on literati paintings. Many stylistic variations exist in Chinese calligraphy. At the most formal extreme, each character consists of distinct straight and angular strokes and is separate from the next character. At the other extreme, the characters flow together as cursive abbreviations with many rounded forms.

A long tradition in China links pictures and poetry. Famous poems frequently provided subjects for paintings, and poets composed poems inspired by paintings. Either practice might prompt inscriptions on art, some addressing painted subjects, some praising the painting's quality or the character of the painter or another individual. In praise of a beloved teacher, Shen Zhou added a long poem in beautiful Chinese characters to his painting of Mount Lu (FIG. 4-11). Sometimes inscriptions explain the circumstances of the work. Guan Daosheng's *Bamboo Groves in Mist and Rain* (FIG. 4-2) has two inscriptions (not included in the detail reproduced here). One is a dedication to another noblewoman. The other is a statement that she painted the handscroll "in a boat on the green waves of the lake." Later admirers and owners of paintings frequently inscribed their own appreciative words. The inscriptions are often quite prominent and sometimes compete for the viewer's attention with the painted motifs (FIG. 4-3).

Painters, inscribers, and even owners usually also added *seal* impressions in red ink (FIGS. 4-2 to 4-4 and 4-11 to 4-15) to identify themselves. With all these textual additions, some paintings that have passed through many collections may seem cluttered to Western eyes. However, the historical importance given to these inscriptions and the works' ownership history has been and remains a critical aspect of painting appreciation in China.

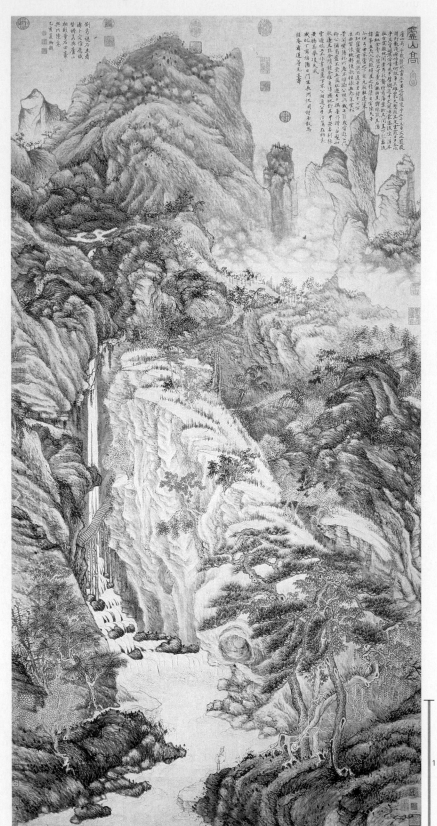

**4-11** SHEN ZHOU, *Lofty Mount Lu*, Ming dynasty, 1467. Hanging scroll, ink and color on paper, 6' 4¼" × 3' 2⅝". National Palace Museum, Tabei.

The inscriptions and seals are essential elements in this scroll, in which Shen Zhou used the lofty peaks of Mount Lu to express visually the grandeur of a beloved teacher's virtue and character.

1 ft.

**SHEN ZHOU** The work of Shang Xi and other professional court painters, designed to promote the official Ming ideology, differs sharply in both form and content from the venerable tradition of literati painting, which also flourished during the Ming dynasty. As under the Yuan emperors, the Ming literati worked largely independently of court patronage. One of the leading figures was SHEN ZHOU (1427–1509), a master of the Wu School of painting, so called because of the ancient name (Wu) of the city of Suzhou. Shen Zhou came from a family of scholars and painters and turned down an offer to serve in the Ming bureaucracy in order to devote himself to poetry and painting. His hanging scroll *Lofty Mount Lu* (FIG. **4-11**), a birthday gift to one of his teachers, bears a long poem he wrote in the teacher's honor (see "Calligraphy and Inscriptions on Chinese Paintings," page 80). Shen Zhou had never seen Mount Lu, but he chose the subject because he wished the lofty mountain peaks to express the grandeur of his teacher's virtue and character. The artist suggested the immense scale of Mount Lu by placing a tiny figure at the bottom center of the painting, sketched in lightly and partly obscured by a rocky outcropping. The composition owes a great deal to early masters like Fan Kuan (FIG. **3-1**). But, characteristic of literati painting in general, the scroll is in the end a very personal conversation—in pictures and words—between Shen Zhou and the teacher for whom he painted it.

**DONG QICHANG** One of the most intriguing and influential literati of the late Ming dynasty was DONG QICHANG (1555–1636), a wealthy landowner and high official who was a poet, calligrapher, and painter. He also amassed a vast collection of Chinese art and achieved great fame as an art critic. In Dong Qichang's view, most Chinese landscape painters could be classified as belonging to either the Northern School of precise, academic painting or the Southern School of more subjective, freer painting. "Northern" and "Southern" were therefore not geographic but stylistic labels. Dong Qichang chose these names for the two schools because he determined that their characteristic styles had parallels in the northern and southern schools of *Chan* Buddhism (see "Chan Buddhism," Chapter 3, page 67). Northern Chan Buddhists were "gradualists" and believed that enlightenment could be achieved only after long training. The Southern Chan Buddhists believed that enlightenment could come suddenly. The professional, highly trained court painters belonged to the Northern School. The leading painters of the Southern School were the literati, whose freer and more expressive style Dong Qichang judged to be far superior.

Dong Qichang's own work—for example, *Dwelling in the Qingbian Mountains* (FIG. **4-12**), painted in 1617—belongs to the Southern School he admired so much. Subject and style, as well as the incorporation of a long inscription at the top, immediately reveal his debt to earlier literati painters. But Dong Qichang was also an innovator, especially in his treatment of the towering mountains, where shaded masses of rocks alternate with flat, blank bands, flattening the composition and creating highly expressive and abstract patterns. Some critics have called Dong Qichang the first *modernist* painter, because his work foreshadows developments in 19th-century European landscape painting.

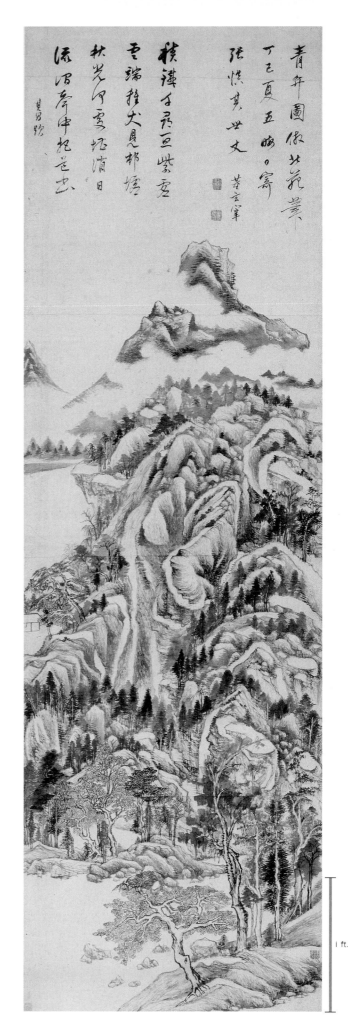

**4-12** DONG QICHANG, *Dwelling in the Qingbian Mountains,* Ming dynasty, 1617. Hanging scroll, ink on paper, 7′ 3½″ × 2′ 2½″. Cleveland Museum of Art, Cleveland (Leonard C. Hanna Jr. bequest).

Dong Qichang, the "first modernist painter," conceived his landscapes as shaded masses of rocks alternating with blank bands, flattening the composition and creating expressive, abstract patterns.

**4-13** WEN SHU, *Carnations and Garden Rock,* Ming dynasty, 1627. Fan, ink and colors on gold paper, 6⅜″ × 1′ 9¼″. Honolulu Academy of Arts, Honolulu (gift of Mr. Robert Allerton).

Flower painting was the specialty of Ming women artists, as was fan painting, a format imported from Japan. Wen Shu's depiction of a rock formation and three flower sprays is an example of both genres.

1 in.

**WEN SHU** Landscape painting was the most prestigious artistic subject in Ming China, and it was the preferred theme of male literati. Ming women artists usually painted other subjects, especially flowers. WEN SHU (1595–1634), the daughter of an aristocratic Suzhou family and the wife of Zhao Jun, descended from Zhao Mengfu and the Song imperial house, was probably the finest flower painter of the Ming era. Her *Carnations and Garden Rock* (FIG. **4-13**) is also an example of Chinese arc-shaped fan painting, a format imported from Japan. In this genre, the artist paints on flat paper, but then folds the completed painting and mounts it on sticks to form a fan. The best fan paintings were probably never used as fans. Collectors purchased them to store in albums. As in her other flower paintings, Wen Shu focused on a few essential elements, in this instance a central rock formation and three sprays of flowers, and presented them against a plain background. Using delicate brush strokes and a restricted palette, she brilliantly communicated the fragility of the red flowers, con-

trasting them with the solidity of the brown rock. The spare composition creates a quiet mood of contemplation.

## Qing Dynasty

The Ming bureaucracy's internal decay permitted another group of invaders, the Manchus of Manchuria, to overrun China in the 17th century. The Qing dynasty (r. 1644–1911) the Manchus established quickly restored effective imperial rule in the north. Southern China remained rebellious until the second Qing emperor, Kangxi (r. 1662–1722), succeeded in pacifying all of China. The Manchus adapted themselves to Chinese life and cultivated knowledge of China's arts.

**SHITAO** Traditional literati painting continued to be fashionable among conservative Qing artists, but other painters experimented with extreme effects of massed ink or individualized brushwork patterns. Bold and freely manipulated compositions with a new, expres-

**4-14** SHITAO, *Man in a House beneath a Cliff,* Qing dynasty, late 17th century. Album leaf, ink and colors on paper, 9½″ × 11″. C. C. Wang Collection, New York.

Shitao experimented with extreme effects of massed ink and individualized brushwork patterns. In this album leaf, he surrounded a hut with vibrant, free-floating colored dots and sinuous contour lines.

1 in.

sive force began to appear. A prominent painter in this mode was SHITAO (DAOJI, 1642–1707), a descendant of the Ming imperial family who became a Chan Buddhist monk at age 20. His theoretical writings, most notably his *Sayings on Painting from Monk Bitter Gourd* (his adopted name), called for use of the "single brush stroke" or "primordial line" as the root of all phenomena and representation. Although he carefully studied classical paintings, Shitao opposed mimicking earlier works and believed he could not learn anything from them unless he changed them. In *Man in a House beneath a Cliff* (FIG. **4-14**), Shitao surrounded the figure in a hut with vibrant, free-floating colored dots and multiple sinuous contour lines. Unlike traditional literati, Shitao did not so much depict the landscape's appearance in his *album leaf* painting as animate it, molding the forces running through it.

**LANG SHINING** During the Qing dynasty, European Jesuit missionaries were familiar figures at the imperial court. Many of the missionaries were also artists, and they were instrumental in introducing modern European (that is, High Renaissance and Baroque)

painting styles to China. The Chinese, while admiring the Europeans' technical virtuosity, found Western style unsatisfactory. Those Jesuit painters who were successful in China adapted their styles to Chinese tastes. The most prominent European artist at the Qing court was GIUSEPPE CASTIGLIONE (1688–1768), who went by the name LANG SHINING in China. His hybrid Italian-Chinese painting style is on display in *Auspicious Objects* (FIG. **4-15**), which he painted in 1724 in honor of the Yongzheng (r. 1723–1735) emperor's birthday. Castiglione's emphasis on a single source of light that creates consistent shadows, and his interest in three-dimensional volume, are unmistakably European. But the influence of Chinese literati painting on the Italian artist is equally clear, especially in the composition of the branches and leaves of the overhanging pine tree. Above all, the subject is purely Chinese. The white eagle, the pine tree, the rocks, and the red mushroomlike plants (lingzhi) are traditional Chinese symbols. The eagle connotes imperial status, courage, and military achievement. The evergreen pines and the rocks connote longevity, which eating lingzhi will promote, according to Chinese belief. All are fitting motifs with which to celebrate the birthday of an emperor.

**QING PORCELAIN** Qing potters at the imperial kilns at Jingdezhen continued to expand on the Yuan and Ming achievements in developing fine porcelain pieces with underglaze and overglaze decoration, and this art form gained wide admiration in Europe. A dish (FIG. **4-16**) with a lobed rim exemplifies the overglaze technique. All of its colors—black, green, brown, yellow, and even blue—come from applying enamels (see "Chinese Porcelain," page 76). The decoration reflects important social changes in China. Economic prosperity and the possibility of advancement through success on civil service examinations made it realistic for many more families to hope that their sons could achieve wealth and higher social standing. In the

**4-16** Dish with lobed rim, Qing dynasty, ca. 1700. White porcelain with overglaze, 1′ 1⅝″ diameter. Percival David Foundation of Chinese Art, London.

This dish featuring the three star gods of happiness, success, and longevity exemplifies the overglaze porcelain technique in which all the colors come from applying enamels on top of the glaze surface.

1 ft.

**4-15** GIUSEPPE CASTIGLIONE (LANG SHINING), *Auspicious Objects*, Qing dynasty, 1724. Hanging scroll, ink and colors on silk, 7′ 11⅜″ × 5′ 1⅞″. Palace Museum, Beijing.

Castiglione was a Jesuit painter in Qing China who successfully combined European lighting techniques and three-dimensional volume with traditional Chinese literati subjects and compositions.

China   **83**

**4-17** YE YUSHAN and others, *Rent Collection Courtyard* (detail of larger tableau), Dayi, China, 1965. Clay, 100 yards long with life-size figures.

In this propagandistic tableau incorporating 114 figures, sculptors depicted the exploitation of peasants by their merciless landlords during the grim times before the Communists' takeover of China.

center of the dish are Fu, Lu, and Shou, the three celestial star gods of happiness, success, and longevity. The cranes and spotted deer, believed to live to advanced ages, and the pine trees around the rim are all symbols of long life. Artists represented similar themes in the inexpensive woodblock prints produced in great quantities during the Qing era. They were the commoners' equivalent of Castiglione's imperial painting of auspicious symbols (FIG. 4-15).

## Modern China

The overthrow of the Qing dynasty and the establishment of the Republic of China under the Nationalist Party in 1912 did not bring an end to the traditional themes and modes of Chinese art. But the Marxism that triumphed in 1949, when the Communists took control of China and founded the People's Republic, inspired a social realism that broke drastically with the past. The intended purpose of Communist art was to serve the people in the struggle to liberate and elevate the masses.

**YE YUSHAN** In *Rent Collection Courtyard* (FIG. 4-17), a 1965 tableau 100 yards long and incorporating 114 life-size figures, YE YUSHAN (b. 1935) and a team of sculptors grimly represented the old times before the People's Republic. Peasants, worn and bent by toil, bring their taxes (in produce) to the courtyard of their merciless, plundering landlord. The message is clear—this kind of exploitation must not occur again. Initially, the authorities did not

reveal the artists' names. The anonymity of those who depicted the event was significant in itself. The secondary message was that only collective action could effect the transformations the People's Republic sought.

**XU BING** In the late 1980s and 1990s, Chinese artists began to make a mark on the *postmodern* international scene. One of them was XU BING (b. 1955), who created a large installation called *A Book from the Sky* (FIG. 4-18) in 1988. First exhibited in China and then in Japan, the United States, and Hong Kong, the work presents an enormous number of woodblock-printed texts in characters that resemble Chinese writing but that the artist invented. Producing them required both an intimate knowledge of real Chinese characters and extensive training in block carving. Xu's work, however, is no hymn to tradition. Critics have interpreted it both as a stinging critique of the meaninglessness of contemporary political language and as a commentary on the unintelligibility of the past. Like many works of art, past and present, Eastern and Western, this piece can be read on many levels.

## KOREA

The great political, social, religious, and artistic changes that occurred in China from the time of the Mongols to the People's Republic find parallels elsewhere in East Asia, especially in Korea.

dynasty, however, the Ming emperors of China attempted to take control of northeastern Korea. General Yi Song-gye repelled them and founded the last Korean dynasty, the Choson in 1392. The long rule of the Choson kings ended only in 1910, when Japan annexed Korea.

**NAMDAEMUN, SEOUL** Public building projects helped give the new Korean state an image of dignity and power. One impressive early monument, built for the new Choson capital of Seoul, is the city's south gate, or Namdaemun (FIG. **4-19**). It combines the imposing strength of its impressive stone foundations with the sophistication of its intricately bracketed wooden superstructure. In East Asia, elaborate gateways, often in a processional series, are a standard element in city designs as well as royal and sacred compounds, all usually surrounded by walls, as at Beijing's Forbidden City (FIG. **4-6**). These gateways served as magnificent symbols of the ruler's authority, as did the triumphal arches of imperial Rome.

## Choson Dynasty

At the time the Yuan overthrew the Song dynasty in China, the Koryo dynasty (918–1392), which had ruled Korea since the downfall of China's Tang dynasty, was still in power (see Chapter 3). The Koryo kings outlasted the Yuan as well. Toward the end of the Koryo

**4-19** Namdaemun, Seoul, South Korea, Choson dynasty, first built in 1398.

The new Choson dynasty leaders constructed the south gate to their new capital of Seoul as a symbol of their authority. Namdaemun combines stone foundations with Chinese-style bracketed wooden construction.

**CHONG SON** Over the long course of the Choson dynasty, Korean painters worked in many different modes and treated the same wide range of subjects seen in Ming and Qing China. One of Korea's most renowned painters was CHONG SON (1676–1759), a great admirer of Chinese Southern School painting who brought his own unique vision to the traditional theme of the mountainous landscape. In his *Kumgang (Diamond) Mountains* (FIG. **4-20**), Chong Son evoked a real scene, an approach known in Korea as "true view" painting. He used sharper, darker versions of the fibrous brush strokes that most Chinese literati favored in order to represent the bright crystalline appearance of the mountains and to emphasize their spiky forms.

## Modern Korea

After its annexation in 1910, Korea remained part of Japan until 1945, when the Western Allies and the Soviet Union took control of the peninsula nation at the end of World War II. Korea was divided into the Democratic People's Republic of Korea (North Korea) and the Republic of Korea (South Korea) in 1948. South Korea has emerged as a fully industrialized nation, and its artists have had a wide exposure to art styles from around the globe. While some Korean artists continue to work in a traditional East Asian manner, others have embraced developments in contemporary Europe and America.

**SONG SU-NAM** One painter who has very successfully combined native and international traditions is SONG SU-NAM (b. 1938), a professor at Hongik University in Seoul and one of the founders of the Oriental Ink Movement of the 1980s. His *Summer Trees* (FIG. **4-21**), painted in 1983, owes a great deal to the *Post-Painterly Abstraction* movement of the 20th century and to the work of American painters such as Morris Louis. But in place of Louis's acrylic resin on canvas, Song used ink on paper, the preferred medium of East Asian literati. He forsook, however, the traditional emphasis on brush strokes to explore the subtle tonal variations that broad stretches of ink wash made possible. Nonetheless, the painting's name recalls the landscapes of earlier Korean and Chinese masters. This simultaneous respect for tradition and innovation has been a hallmark of both Chinese and Korean art through their long histories.

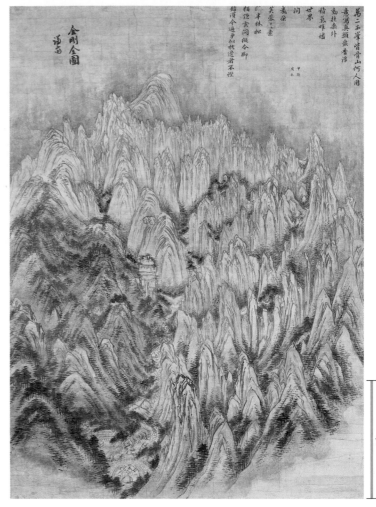

**4-20** CHONG SON, *Kumgang Mountains*, Choson dynasty, 1734. Hanging scroll, ink and colors on paper, 4′ 3½″ × 1′ 11¼″. Hoam Art Museum, Kyunggi-Do.

In a variation on Chinese literati painting, Chong Son used sharp, dark brush strokes to represent the bright crystalline appearance of the Diamond Mountains and to emphasize their spiky forms.

**4-21** SONG SU-NAM, *Summer Trees*, 1983. Ink on paper, 2′ 1⅝″ high. British Museum, London.

Song Su-nam combined native and international traditions in *Summer Trees*, an ink painting that evokes Asian landscape painting but owes a great deal to American Post-Painterly Abstraction.

# CHINA AND KOREA
# AFTER 1279

## YUAN DYNASTY, 1279–1368

▮ The Mongols invaded northern China in 1210 and defeated the last Song emperor in 1279. Under the first Yuan emperor, Kublai Khan, and his successors, China was richer and technologically more advanced than Europe.

▮ The Mongols admired Chinese art and culture, and traditional landscape painting and calligraphy in particular continued to flourish during the century of Yuan rule.

▮ The Jingdezhen kilns gained renown for porcelain pottery with cobalt-blue underglaze decoration.

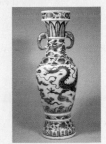

Temple vase, Yuan dynasty, 1351

## MING DYNASTY, 1368–1644

▮ A popular uprising in 1368 drove the last Mongol emperor from Beijing. The new native Ming dynasty expanded the capital and constructed a vast new imperial palace compound, the Forbidden City. Surrounded by a moat and featuring an axial plan, it was the ideal setting for court ritual.

▮ At the opposite architectural pole are the gardens of Suzhou. The Ming designers employed pavilions, bridges, ponds, winding paths, and sculpted rocks to reproduce the irregularities of uncultivated nature.

▮ Ming painting is also diverse, ranging from formal official portrait and history painting to literati painting. Male painters favored landscapes, and female artists specialized in flowers, sometimes painted on fans.

▮ The Orchard Factory satisfied the Ming court's appetite for luxury goods with furniture and other objects in lacquered wood.

Forbidden City, Beijing, 15th century and later

## QING DYNASTY, 1644–1911

▮ In 1644 the Ming dynasty fell to the Manchus, northern invaders who, like the Yuan, embraced Chinese art.

▮ Traditional painting styles remained fashionable, but some Qing painters, such as Shitao, experimented with extreme effects of massed ink and free brushwork patterns.

▮ Increased contact with Europe brought many Jesuit missionaries to the Qing court. The most prominent Jesuit artist was Giuseppe Castiglione, who developed a hybrid Italian-Chinese painting style.

▮ The Jingdezhen imperial potters developed multicolor porcelains using the overglaze enamel technique.

Shitao, *Man in a House beneath a Cliff*, late 17th century

## MODERN CHINA, 1912–Present

▮ The overthrow of the Qing dynasty did not bring a dramatic change in Chinese art, but when the Communists gained control in 1949, state art focused on promoting Marxist ideals. Teams of sculptors produced vast propaganda pieces like *Rent Collection Courtyard*.

▮ Contemporary art in China is multifaceted. Some artists, for example, Xu Bing, have made their mark on the postmodern international art scene.

Ye Yushan, *Rent Collection Courtyard*, 1965

## KOREA, 1392–Present

▮ The last Korean dynasty was the Choson (r. 1392–1910), which established its capital at Seoul and erected impressive public monuments like the Namdaemun gate to serve as symbols of imperial authority.

▮ After the division of Korea into two republics following World War II, South Korea emerged as a modern industrial nation. Some of its artists have successfully combined native and international traditions. Song Su-nam's landscapes owe a great deal to American Post-Painterly Abstraction.

Song Su-nam, *Summer Trees*, 1983

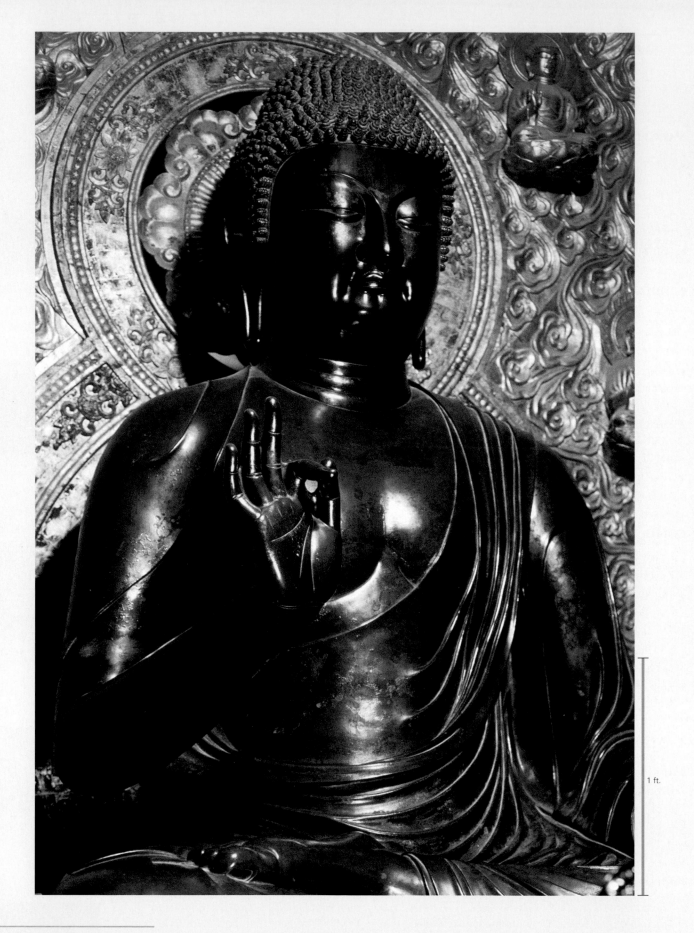

1 ft.

**5-1** Detail of Yakushi, Yakushi triad (FIG. 5-8), kondo, Yakushiji, Nara Prefecture, Japan, Nara period, late seventh or early eighth century CE. Bronze, detail 3′ 10″ high.

The introduction of Buddhism in 552 CE profoundly changed the character of Japanese art and architecture. This early masterpiece of Japanese Buddhist sculpture reveals debts to both China and India.

# JAPAN BEFORE 1333

The Japanese archipelago (MAP 5-1) consists of four main islands—Hokkaido, Honshu, Shikoku, and Kyushu—and hundreds of smaller ones, a surprising number of them inhabited. Over the centuries, the Japanese have demonstrated a remarkable ability to surmount geographical challenges, such as Japan's mountainous island terrain that makes travel and communication difficult. Japanese culture, however, does not reveal the isolation typical of some island civilizations but rather reflects a responsiveness to imported ideas, such as Buddhism and Chinese writing systems, that filtered in from continental eastern Asia. Acknowledging this responsiveness to mainland influences does not suggest that Japan simply absorbed these imported ideas and practices. Indeed, throughout its history, Japan has developed a truly distinct culture. Ultimately, Japan's close proximity to the continent has promoted extensive exchange with mainland cultures, but the sea has helped protect it from outright invasions and allowed it to develop an individual and unique character.

## JAPAN BEFORE BUDDHISM

The introduction of Buddhism to Japan in 552 CE so profoundly changed the character of Japanese art and architecture that art historians traditionally divide the early history of art in Japan into pre-Buddhist and Buddhist eras.

### Jomon and Yayoi Periods

Japan's earliest distinct culture, the Jomon (ca. 10,500–300 BCE), emerged roughly 10,000 years before the Buddha's birth. The term *jomon* ("cord markings") refers to the technique Japanese potters of this era used to decorate earthenware vessels. The Jomon people were hunter-gatherers, but unlike most hunter-gatherer societies, which were nomadic, the Jomon enjoyed surprisingly settled lives. Their villages consisted of pit dwellings—shallow round excavations with raised earthen rims and thatched roofs. Their settled existence permitted the Jomon people to develop distinctive ceramic technology, even before their

MAP 5-1 Japan before 1333.

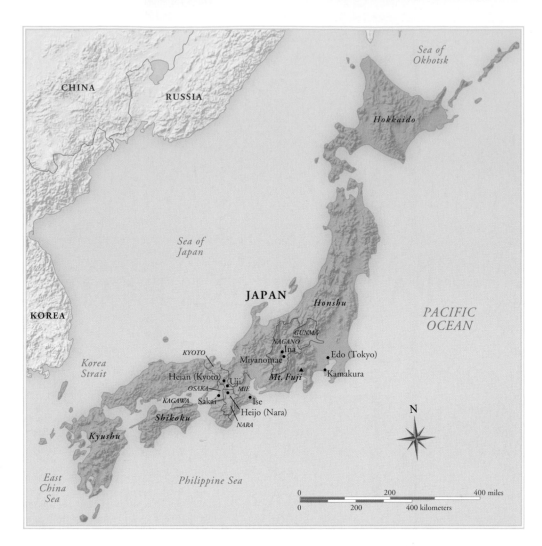

development of agriculture. In fact, archaeologists have dated some ceramic *sherds* (pottery fragments) found in Japan to before 10,000 BCE—older than sherds from any other area of the world.

## MIDDLE JOMON POTTERY

In addition to rope markings, incised lines and applied coils of clay adorned Jomon pottery surfaces. The most impressive examples come from the Middle Jomon period (2500–1500 BCE). Much of the population then lived in the mountainous inland region, where lo-cal variations in ceramic form and surface treatment flourished. However, all Jomon potters shared a highly developed feeling for modeled, rather than painted, ceramic ornament. Jomon pottery displays such a wealth of applied clay coils, striped incisions, and sometimes quasi-figural motifs that the sculptural treatment in certain instances even jeopardizes the basic functionality of the vessel. Jomon vessels served a wide variety of purposes, from storage to cooking to bone burial. Some of the most elaborate pots may have served ceremonial functions. A dramatic example (FIG. **5-2**) from Miyanomae shows a characteristic, intricately modeled surface and a partially sculpted rim. Jomon pottery contrasts strikingly with China's most celebrated Neolithic earthenwares (FIG. **3-2**) in that the Japanese vessels are extremely thick and heavy. The harder, thinner, and lighter Neolithic Chinese earthenware emphasizes basic ceramic form and painted decoration.

**YAYOI** Jomon culture gradually gave way to Yayoi (ca. 300 BCE–300 CE). The period takes its name from the Yayoi district of Tokyo, where evidence of this first post-Jomon civilization was discovered, but the culture emerged in Kyushu, the southernmost of the main Japanese islands, and spread northward. Increased interaction with both China and Korea and immigration from Korea brought dramatic social and technological transformations during the Yayoi period. People continued to live in pit dwellings, but their villages grew in size, and they developed fortifications, indicating a perceived need for defense. In the third century CE, Chinese visitors noted that Japan had walled towns, many small kingdoms, and a highly stratified social structure. Wet-rice agriculture provided the social and economic foundations for such development. The Yayoi period was a time of tremendous change in Japanese material culture as well. The Yayoi produced pottery that was less sculptural than Jomon ceramics and sometimes polychrome, and they developed bronze casting and loom weaving.

**5-2** Vessel, from Miyanomae, Nagano Prefecture, Japan, Middle Jomon period, 2500–1500 BCE. Earthenware, 1′ 11⅔″ high. Tokyo National Museum, Tokyo.

Jomon pottery is the earliest art form of Japan. Characteristic features are the applied clay coils, striped incisions, and quasi-figural motifs that in some examples jeopardize the functionality of the vessel.

1 in.

**5-3** Dotaku with incised figural motifs, from Kagawa Prefecture, Japan, late Yayoi period, 100–300 CE. Bronze, 1' 4⅞" high. Tokyo National Museum, Tokyo.

Yayoi dotaku were based on Han Chinese bells, but they were ceremonial objects, not musical instruments. They feature geometric decoration and the earliest Japanese images of people and animals.

1 in.

**DOTAKU** Among the most intriguing objects Yayoi artisans produced were *dotaku,* or bells. They resemble Han Chinese bell forms, but the Yayoi did not use dotaku as musical instruments. The bells were treasured ceremonial bronzes and the Japanese often deposited them in graves. Cast in clay molds, these bronzes generally featured raised geometric decoration presented in bands or blocks. On some of the hundreds of surviving dotaku, including the example illustrated here (FIG. 5-3), the ornament consists of simple line drawings of people and animals. Scholars have reached no consensus on the meaning of these images. In any case, the dotaku engravings are the earliest extant examples of pictorial art in Japan.

## Kofun Period

Historians named the succeeding Kofun period (ca. 300–552)* after the enormous earthen burial mounds, or *tumuli,* that had begun to appear in the third century (*ko* means "old"; *fun* means "tomb"). The tumuli recall the earlier Jomon practice of placing the dead on sacred mountains. The mounds grew dramatically in number and scale in the fourth century.

**TOMB OF NINTOKU** The largest tumulus (FIG. 5-4) in Japan is at Sakai and is usually identified as the tomb of Emperor Nintoku, although many scholars think the tumulus postdates his death in 399. The central mound, which takes the "keyhole" form standard for tumuli during the Kofun period, is approximately 1,600 feet long and rises to a height of 90 feet. Surrounded by three moats, the entire site covers 458 acres. Numerous objects were placed with the coffin in a stone-walled burial chamber near the summit of the mound to assist in the deceased's transition to the next life. For exalted individuals like Emperor Nintoku, objects buried included important symbolic items and imperial regalia—mirrors, swords, and comma-shaped jewels. Numerous bronze mirrors came from China, but the form of the tombs themselves and many of the burial goods suggest even closer connections with Korea. For example, the comma-shaped jewels are quite similar to those found on Korean Silla crowns (FIG. 3-27), whose simpler gilt bronze counterparts lay in the Japanese tombs.

*From this point on, all dates in this chapter are CE unless otherwise stated.

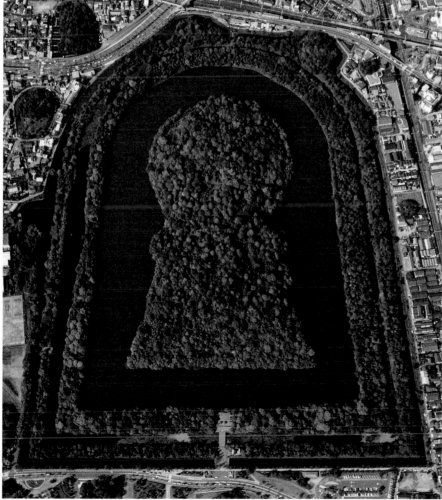

**5-4** Tomb of Emperor Nintoku, Sakai, Osaka Prefecture, Japan, Kofun period, late fourth to early fifth century.

The largest Kofun tumulus, attributed to Emperor Nintoku, has a keyhole shape and three surrounding moats. About 20,000 clay haniwa (FIG. 5-5) were originally displayed on the giant earthen mound.

The Japanese of the Kofun period set the statues both in curving rows around the tumulus and in groups around a haniwa house placed directly over the deceased's burial chamber. Presumably, the number of sculptures reflected the stature of the dead person. Emperor Nintoku's tumulus had about 20,000 haniwa statues placed around the mound.

**SHRINE OF AMATERASU** The religious system the Japanese embraced during the Yayoi and Kofun eras is known as Shinto (see "Shinto," page 93). The Japanese imperial clan traces its origins to the Shinto sun goddess Amaterasu. Her shrine (FIG. **5-6**) at Ise is the most important Shinto religious center. The location, use, and ritual reconstruction of this shrine every 20 years reflect the primary characteristics of Shinto—sacred space, ritual renewal, and purification. The Ise shrine is traditionally dated to the Kofun period. Many scholars now favor a later date, but the shrine still serves as a representative example of sacred architecture in ancient Japan. Although Japanese shrine architecture varies tremendously, scholars believe the Ise shrine preserves some of the very earliest design elements. Yet the Ise shrine is unique. Because of its connection to the Japanese imperial family, no other shrines may be constructed with the identical design. The original source for the form of the Ise complex's main hall appears to be Japanese granaries. Granaries were among the most important buildings in Japan's early agrarian society. Although not every aspect of the Ise shrine is equally ancient, the three main structures of the inner shrine convey some sense of Japanese architecture before the introduction of Buddhism and before the development of more elaborately constructed and adorned buildings.

Aside from the thatched roofs and some metallic decorations, the sole construction material at Ise is wood, fitted together in a *mortise-and-tenon* system, in which the builders slip the wallboards into slots in the pillars. Two massive freestanding posts (once great cypress trunks), one at each end of the main sanctuary, support most of the weight of the *ridgepole,* the beam at the crest of the roof. The golden-hued cypress columns and planks contrast in color and texture with the white gravel covering the sacred grounds. The roof was originally constructed of thatch, which was smoked, sewn into bundles, and then laid in layers. The smooth shearing of the entire surface produced a gently changing contour. Today, cypress bark covers the roof. Decorative elements (originally having a structural function) enhance the roofline and include *chigi,* extensions of the rafters at each end of the roof, and *katsuogi,* wooden logs placed at right angles across the ridgepole to hold the thatch of the roof in place. The Amaterasu shrine highlights the connection, central to Shinto, between nature and spirit. Not only are the construction materials derived from the natural world, but the shrine also stands at a specific location where a kami is believed to have taken up residence.

# BUDDHIST JAPAN

In 552, according to traditional interpretation, the ruler of Paekche, one of Korea's Three Kingdoms (see Chapter 3), sent Japan's ruler a gilded bronze statue of the Buddha along with *sutras* (Buddhist scriptures) translated into Chinese, at the time the written language of eastern Asia. This event marked the beginning of the Asuka period (552–645), when Japan's ruling elite embraced major elements of continental Asian culture that had been gradually filtering into Japan. These cultural components became firmly established in Japan and included Chinese writing, Confucianism (see "Daoism and Confucianism," Chapter 3, page 52), and Buddhism (see "Buddhism and Buddhist Iconography," Chapter 1, page 13). In 645 a

1 ft.

**5-5** Haniwa warrior, from Gunma Prefecture, Japan, Kofun period, fifth to mid-sixth century. Low-fired clay, 4′ 3¼″ high. Tokyo National Museum, Tokyo.

During the Kofun period, the Japanese set up cylindrical clay statues (haniwa) of humans, animals, and objects on burial tumuli. They served as a protective spiritual barrier between the living and the dead.

**HANIWA** The Japanese also placed unglazed ceramic sculptures called *haniwa* on and around the Kofun tumuli. These sculptures, usually several feet in height, as is the warrior shown here (FIG. **5-5**), are distinctly Japanese. Compared with the Chinese terracotta soldiers and horses (FIG. **3-6**) buried with the First Emperor of Qin, these statues appear deceptively whimsical as variations on a cylindrical theme (*hani* means "clay"; *wa* means "circle"). Yet haniwa sculptors skillfully adapted the basic clay cylinder into a host of forms, from abstract shapes to objects, animals (for example, deer, bears, horses, and monkeys), and human figures, such as warriors and female shamans. These artists altered the shapes of the cylinders, emblazoned them with applied ornaments, excised or built up forms, and then painted the haniwa. The variety of figure types suggests that haniwa functioned not as military guards but as a spiritual barrier protecting both the living and the dead from contamination.

## Shinto

The early beliefs and practices of pre-Buddhist Japan, which form a part of the belief system later called Shinto ("Way of the Gods"), did not derive from the teachings of any individual founding figure or distinct leader. Formal scriptures, in the strict sense, do not exist for these beliefs and practices either. Shinto developed in Japan in conjunction with the advent of agriculture during the Yayoi period. Shinto thus originally focused on the needs of this agrarian society and included agricultural rites surrounding planting and harvesting. Villagers venerated and prayed to a multitude of local deities or spirits called *kami*. The early Japanese believed kami existed in mountains, waterfalls, trees, and other features of nature, as well as in charismatic people, and they venerated not only the kami themselves but also the places the kami occupy, which are considered sacred.

Each clan (a local group claiming a common ancestor, and the basic societal unit during the Kofun period) had its own protector kami, to whom members offered prayers in the spring for successful planting and in the fall for good harvests. Clan members built shrines consisting of several buildings for the veneration of kami. Priests made offerings of grains and fruits at these shrines and prayed on behalf of the clans. Rituals of divination, water purification, and ceremonial purification at the shrines proliferated. Visitors to the shrine area had to wash before entering in a ritual of spiritual and physical cleansing.

Purity was such a critical aspect of Japanese religious beliefs that people would abandon buildings and even settlements if negative events, such as poor harvests, suggested spiritual defilement. Even the early imperial court moved several times to newly built towns to escape impurity and the trouble it caused. Such purification concepts are also the basis for the cyclical rebuilding of the sanctuaries at grand shrines. The buildings of the inner shrine (FIG. 5-6) at Ise, for example, have been rebuilt every 20 years for more than a millennium with few interruptions. Rebuilding rids the sacred site of physical and spiritual impurities that otherwise might accumulate. During construction, the old shrine remains standing until the carpenters erect an exact duplicate next to it. In this way, the Japanese have preserved ancient forms with great precision.

When Buddhism arrived in Japan from the mainland in the sixth century, Shinto practices changed under its influence. For example, until the introduction of Buddhism, painted or carved images of Shinto deities did not exist. Yet despite the eventual predominance of Buddhism in Japan, Shinto continues to exist as a vital religion for many Japanese, especially those living in rural areas.

**5-6** Main hall, Amaterasu shrine, Ise, Mie Prefecture, Japan, Kofun period or later; rebuilt in 1993.

The most important Shinto shrine in Japan is that of the sun goddess Amaterasu at Ise. Constructed of wood with a thatch roof, the shrine reflects the form of early Japanese granaries.

considerable time lag) that surviving Japanese temples have helped greatly in the reconstruction of what was almost completely lost on the continent.

**TORI BUSSHI** Among the earliest extant examples of Japanese Buddhist sculpture is a bronze *Buddha triad* (Buddha flanked by two bodhisattvas; FIG. **5-7**) dated 623. Empress Suiko commissioned the work as a votive offering when Prince Shotuku fell ill in 621. When he died, the empress dedicated the triad to the prince's well-being in his next life and to his hoped-for rebirth in paradise. The central figure in the triad is Shaka (the Indian/Chinese Sakyamuni), the historical Buddha, seated with his right hand raised in the abhaya mudra (fear-not gesture; see "Buddhism and Buddhist Iconography," Chapter 1, page 13). Behind Shaka is a flaming *mandorla* (a lotus-petal-shaped *nimbus*) incorporating small figures of other Buddhas. The sculptor, TORI BUSSHI (*busshi* means "maker of Buddhist images"), was a descendant of a Chinese immigrant. Tori's Buddha triad reflects the style of the early to mid-sixth century in China and Korea and is characterized by elongated heads and elegantly stylized drapery folds that form gravity-defying swirls.

**YAKUSHI TRIAD** In the early Nara period, Japanese sculptors began to move beyond the style of the Asuka period in favor of new ideas and forms coming out of Tang China and Korea. More direct relations with China also narrowed the time lag between developments there and their transfer to Japan. In the triad of Yakushi (the Indian Bhaisajyaguru, the Buddha of Healing who presides over the Eastern Pure Land; FIG. **5-8**) in the Yakushiji temple of the late seventh century in Nara, the sculptor favored greater anatomical definition and shape-revealing drapery (FIG. **5-1**) over the dramatic stylizations of Tori Busshi's triad. The statues of the attendant bodhisattvas Nikko and Gakko, especially, reveal the long stylistic trail back through China (FIG. **3-14**) to the sensuous fleshiness (FIG. **1-13**) and outthrust-hip poses (FIG. **1-8**) of Indian sculpture.

**HORYUJI KONDO** Tori Busshi created his Shaka triad for an Asuka Buddhist temple complex at Horyuji, seven miles south of modern Nara, but fire destroyed the temple. The statue was reinstalled around 680 in the *kondo* (Golden Hall; the main hall for worship that contained statues of the Buddha and the bodhisattvas to whom the temple was dedicated; FIG. **5-9, left**) of the successor Nara period complex (FIG. 5-9, *right*). Although periodically repaired and somewhat altered (the covered porch is an eighth-century addition; the upper railing dates to the 17th century), the structure retains its graceful but sturdy forms beneath the modifications. The main pillars (not visible in FIG. 5-9, *left*, due to the porch addition) decrease in diameter from bottom to top. The tapering provides an effective transition between the more delicate brackets above and the columns' stout forms. Also somewhat masked by the added porch is the harmonious reduction in scale from the first to the second story. Following Chinese models, the builders used ceramic tiles as roofing material and adopted the distinctive curved roofline of Tang (FIG. 3-16) and later Chinese architecture. Other buildings at the site include a five-story pagoda (FIG. 5-9, *right*) that serves as a reliquary.

Until a disastrous fire in 1949, the interior walls of the Golden Hall at Horyuji preserved some of the finest examples of Buddhist wall painting in eastern Asia. Executed around 710, when Nara became the Japanese capital, these paintings now survive only in color photographs. The most important paintings depicted the Buddhas of the four directions. Like the other three, Amida (Indian

1 ft.

**5-7** TORI BUSSHI, Shaka triad, kondo, Horyuji, Nara Prefecture, Japan, Asuka period, 623. Bronze, central figure 5′ 9½″ high.

Tori Busshi's Shaka triad (the historical Buddha and two bodhisattvas) is among the earliest Japanese Buddhist sculptures. The elongated heads and elegant swirling drapery reflect the sculptural style of China.

series of reforms led to the establishment of a centralized government in place of the individual clans that controlled the different regions of Japan. This marked the beginning of the Nara period (645–784), when the Japanese court, ruling from a series of capitals south of modern Kyoto, increasingly adopted the forms and rites of the Chinese court. In 710 the Japanese finally established what they intended as a permanent capital at Heijo (present-day Nara). City planners laid out the new capital on a symmetrical grid closely modeled on the plan of the Chinese capital of Chang'an.

For a half century after 552, Buddhism met with opposition, but by the end of that time, the new religion was established firmly in Japan. Older beliefs and practices (those that came to be known as Shinto) continued to have significance, especially as agricultural rituals and imperial court rites. As time passed, Shinto deities even gained new identities as local manifestations of Buddhist deities.

## Asuka and Nara Periods

In the arts associated with Buddhist practices, Japan followed Korean and Chinese prototypes very closely, especially during the Asuka and Nara periods. In fact, early Buddhist architecture in Japan adhered so closely to mainland standards (although generally with a

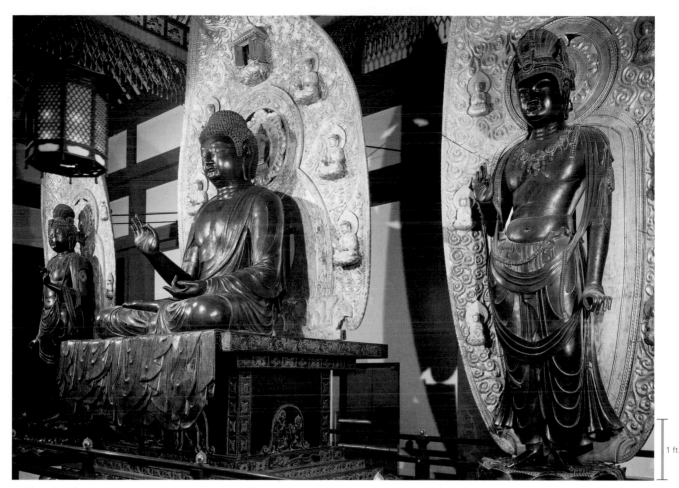

**5-8** Yakushi triad, kondo, Yakushiji, Nara Prefecture, Japan, Nara period, late seventh or early eighth century. Bronze, central figure 8′ 4″ high, including base and mandorla.

The sculptor of this Nara Buddha triad favored greater anatomical definition and shape-revealing drapery than the Asuka artist Tori Busshi (FIG. 5-7). The Nara statues display the sensuous fleshiness of Indian sculpture.

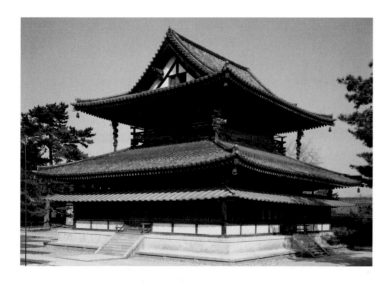

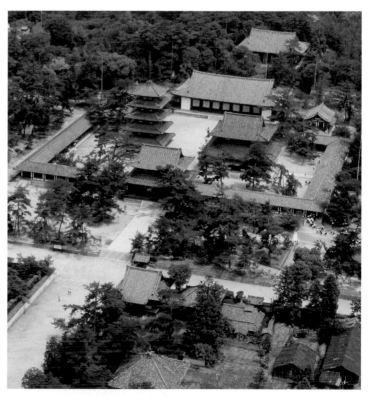

**5-9** Kondo (*above*) and aerial view of the temple complex (*right*), Horyuji, Nara Prefecture, Japan, Nara period, ca. 680.

The kondo, or Golden Hall, of a Buddhist temple complex housed statues of the Buddha and bodhisattvas. The Horyuji kondo follows Chinese models in its construction method and its curved roofline.

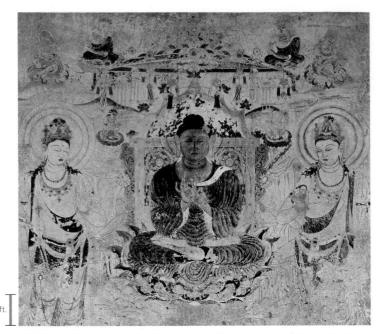

1 ft.

**5-10** Amida triad, wall painting formerly in the kondo, Horyuji, Nara Prefecture, Japan, Nara period, ca. 710. Ink and colors, 10′ 3″ × 8′ 6″. Horyuji Treasure House, Nara.

The murals of the Horyuji kondo represented the Buddhas of the four directions. Amida, the Buddha of the Western Pure Land, has red iron-wire lines and reflects Chinese Tang painting style.

Amitabha; FIG. 5-10), the Buddha of immeasurable light and infinite life, ruler of the Western Pure Land, sits enthroned in his paradisical land, attended by bodhisattvas. The exclusive worship of Amida later became a major trend in Japanese Buddhism, and much grander depictions of his paradise appeared, resembling those at Dunhuang (FIG. 3-15) in China. Here, however, the representation is simple and iconic. Although executed on a dry wall, the painting process involved techniques similar to fresco, such as transferring

designs from paper to wall by piercing holes in the paper and pushing colored powder through the perforations (*pouncing*). As with the Buddha triad (FIG. 5-8) at Yakushiji, the mature Tang style, with its echoes of Indian sensuality, surfaces in this work. The smooth brush lines, thoroughly East Asian, give the figures their substance and life. These lines, often seen in Buddhist painting, are called iron-wire lines because they are thin and of unvarying width with a suggestion of tensile strength. As in many other Buddhist paintings, the lines are red instead of black. The identity of the painters of these pictures is unknown, but some scholars have suggested they were Chinese or Korean rather than Japanese.

**DAIBUTSUDEN, TODAIJI** At the Todaiji temple complex at Nara, the kondo is known as the Daibutsuden (FIG. 5-11), or Great Buddha Hall. Originally constructed in the eighth century, the Daibutsuden was rebuilt in the early 18th century. The Nara period temple housed a 53-foot bronze image of the Cosmic Buddha, Roshana (Vairocana), inspired by Chinese colossal stone statues (FIG. 3-14) of this type. The commissioning of Todaiji and its Great Buddha statue (Daibutsu) by Emperor Shomu in 743 was historically important as part of an imperial attempt to unify and strengthen the country by using religious authority to reinforce imperial power. The temple served as the administrative center of a network of branch temples built in every province. Thus, the consolidation of imperial authority and thorough penetration of Buddhism throughout the country went hand in hand. The dissemination of a common religion contributed to the eventual disruption of the clan system and the unification of disparate political groups. So important was the erection of both the building and the Daibutsu that court and government officials as well as Buddhist dignitaries from China and India were present at the opening ceremonies in 752. Chinese Buddhist monks also came to Japan in large numbers and were instrumental in spreading Buddhist teachings throughout Japan. Sadly, the current building is significantly smaller than the original. Today the Daibutsuden has 7 bays. The original had 11. Yet even in its diminished size, the Todaiji Great Buddha Hall is the largest wooden building in the world.

**5-11** Daibutsuden, Todaiji, Nara, Japan, Nara period, 743; rebuilt ca. 1700.

The Great Buddha Hall of the Todaiji temple complex at Nara is the largest wooden building in the world. Constructed by Emperor Shomu in 743, it originally had 11 bays instead of the current 7.

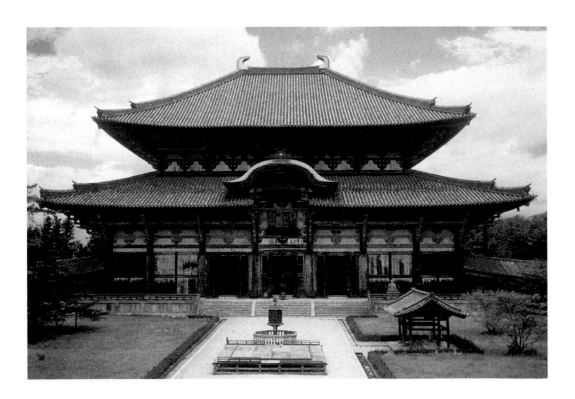

# Heian Period

In 784, possibly to escape the power of the Buddhist priests in Nara, the imperial house moved its capital north, eventually relocating in 794 in what became its home until modern times. Originally called Heiankyo ("capital of peace and tranquility"), it is known today as Kyoto. The Heian period (794–1185) of Japanese art takes its name from the new capital. Early in the period, Japan maintained fairly close ties with China, but from the middle of the ninth century on, relations between the two deteriorated so rapidly that court-sponsored contacts had ceased by the end of that century. Japanese culture became much more self-directed than it had been in the preceding few centuries.

**ESOTERIC BUDDHISM** Among the major developments during the early Heian period was the introduction of Esoteric Buddhism to Japan from China. Esoteric Buddhism is so named because of the secret transmission of its teachings. Two Esoteric sects made their appearance in Japan at the beginning of the Heian period: Tendai in 805 and Shingon in 806. The teachings of Tendai were based on the *Lotus Sutra,* one of the Buddhist scriptural narratives, and Shingon (True Word) teachings on two other sutras. Both Tendai and Shingon Buddhists believe that all individuals possess buddha nature and can achieve enlightenment through meditation rituals and careful living. To aid focus during meditation, Shingon disciples use special hand gestures (mudras) and recite particular words or syllables (*mantras* in Sanskrit, *shingon* in Japanese). Shingon became the primary form of Buddhism in Japan through the mid-10th century.

**TAIZOKAI MANDARA** Because of the emphasis on ritual and meditation in Shingon, the arts flourished during the early Heian period. Both paintings and sculptures provided followers with visualizations of specific Buddhist deities and allowed them to contemplate the transcendental concepts central to the religion. Of particular importance in Shingon meditation was the *mandara* (*mandala* in Sanskrit), a diagram of the cosmic universe. Among the most famous Japanese mandaras is the Womb World (Taizokai), which usually hung on the wall of a Shingon kondo. The Womb World is composed of 12 zones, each representing one of the various dimensions of buddha nature (for example, universal knowledge, wisdom, achievement, and purity). The mandara illustrated here (FIG. 5-12) is among the oldest and best preserved in Japan and is located at Kyoogokokuji (Toji), the Shingon teaching center established at Kyoto in 823. Many of the figures hold lightning bolts, symbolizing the power of the mind to destroy human passion. The Womb World mandara is one of a pair of paintings. The other depicts the Diamond World (Kongokai). The central motif in the Womb World is the lotus of compassion. In the Diamond World the central motif is the diamond scepter of wisdom. Both of the Toji mandaras reflect Chinese models.

**PHOENIX HALL, UJI** During the middle and later Heian period, belief in the vow of Amida, the Buddha of the Western Pure Land, to save believers through rebirth in his realm gained great prominence among the Japanese aristocracy. Eventually, the simple message of Pure Land Buddhism—universal salvation—facilitated the spread of Buddhism to all classes of Japanese society. The most

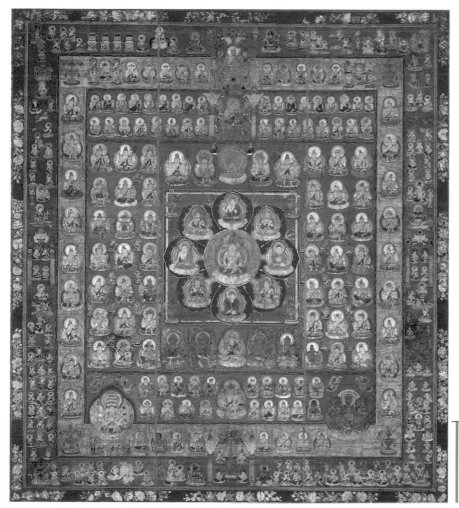

**5-12** Taizokai (Womb World) mandara, Kyoogokokuji (Toji), Kyoto, Japan, Heian period, second half of ninth century. Hanging scroll, color on silk, 6′ × 5′ $\frac{5}{8}$″.

The Womb World mandara is a diagram of the cosmic universe, composed of 12 zones, each representing one dimension of Buddha nature. Mandaras played a central role in Esoteric Buddhist rituals and meditation.

1 ft.

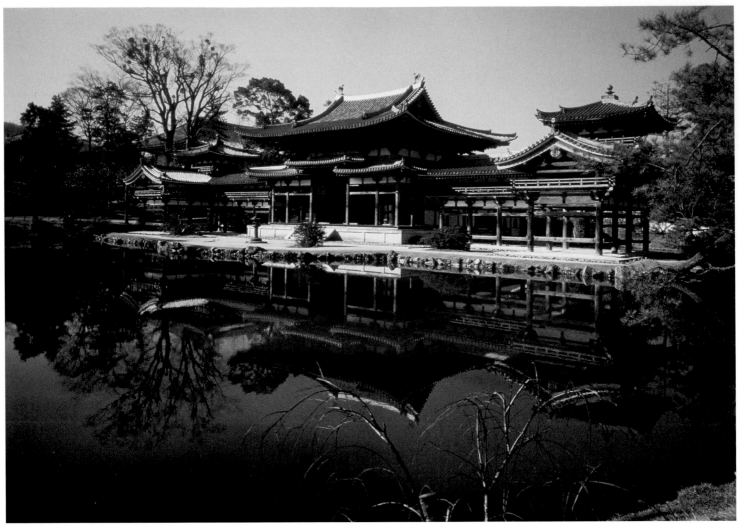

**5-13** Phoenix Hall, Byodoin, Uji, Kyoto Prefecture, Japan, Heian period, 1053.

The Phoenix Hall's elaborate winged form evokes images of Amida's palace in the Western Pure Land. Situated on a reflective pond, the temple suggests the floating weightlessness of celestial architecture.

important surviving monument in Japan related to Pure Land beliefs is the so-called Phoenix Hall (FIG. **5-13**) of the Byodoin. Fujiwara Yorimichi, the powerful regent for three emperors between 1016 and 1068, built the temple in memory of his father, Michinaga, on the grounds of Michinaga's summer villa at Uji. Dedicated in 1053, the Phoenix Hall houses a wooden statue of Amida carved from multiple joined blocks, the predominant wooden sculpture technique by this time. The building's elaborate winged form evokes images of the Buddha's palace in his Pure Land, as depicted in East Asian paintings (FIG. 3-15) in which the architecture reflects the design of Chinese palaces. By placing only light pillars on the exterior, elevating the wings, and situating the whole on a reflective pond, the Phoenix Hall builders suggested the floating weightlessness of celestial architecture. The building's name derives from its overall birdlike shape and from two bronze phoenixes decorating the ridgepole ends. In eastern Asia, these birds were believed to alight on lands properly ruled. Here, they represent imperial might, sometimes associated especially with the empress. The authority of the Fujiwara family derived primarily from the marriage of daughters to the imperial line.

***TALE OF GENJI*** Japan's most admired literary classic is *Tale of Genji*, written around 1000 by Murasaki Shikubu (usually referred to as Lady Murasaki), a lady-in-waiting at the court. Recounting the lives and loves of Prince Genji and his descendants, *Tale of Genji* provides readers with a view of Heian court culture (see "Heian Court Culture," page 99). The oldest extant examples of illustrated copies are fragments from a deluxe set of early-12th-century handscrolls (see "Chinese Painting Materials and Formats," Chapter 3, page 56). From textual and physical evidence, scholars have suggested that the set originally consisted of about 10 handscrolls produced by five teams of artisans. Each team consisted of a nobleman talented in calligraphy, a chief painter who drew the compositions in ink, and assistants who added the color. The script is primarily *hiragana*, a sound-based writing system developed in Japan from Chinese characters. Hiragana originally served the needs of women (who were not taught Chinese) and became the primary script for Japanese court poetry. In these handscrolls, pictures alternate with text, as in Gu Kaizhi's *Admonitions* scrolls (FIG. 3-12). However, the Japanese work focuses on emotionally charged moments in personal relationships rather than on lessons in exemplary behavior.

In the scene illustrated here (FIG. **5-14**), Genji meets with his greatest love near the time of her death. The bush-clover in the garden identifies the season as autumn, the season associated with the fading of life and love. A radically upturned ground plane and strong

## Heian Court Culture

**D**uring the Nara and especially the Heian periods, the Japanese imperial court developed as the center of an elite culture. In a time of peace and prosperity, the aristocracy had the leisure to play musical instruments and write poetry. Exchanging poems became a common social practice and a frequent preoccupation of lovers. Both men and women produced poems as well as paintings and calligraphy that critics generally consider "classical" today. Heian court members, especially those from the great Fujiwara clan that dominated the court for a century and a half and built the Phoenix Hall (FIG. 5-13) at Uji, compiled the first great anthologies of Japanese poetry and wrote Japan's most influential secular prose.

A lady-in-waiting to an empress of the early 11th century wrote the best-known work of literature in Japan, *Tale of Genji*. Known as

Lady Murasaki, the author is one of many important Heian women writers, including especially diarists and poets. Generally considered the world's first lengthy novel (the English translation is almost a thousand pages), *Tale of Genji* tells of the life and loves of Prince Genji and, after his death, of his heirs. The novel and much of Japanese literature consistently display a sensitivity to the sadness in the world caused by the transience of love and life. These human sentiments are often intertwined with the seasonality of nature. For example, the full moon, flying geese, crying deer, and certain plants symbolize autumn, which in turn evokes somber emotions, fading love, and dying. These concrete but evocative images frequently appear in paintings, such as the illustrated scrolls of *Tale of Genji* (FIG. 5-14).

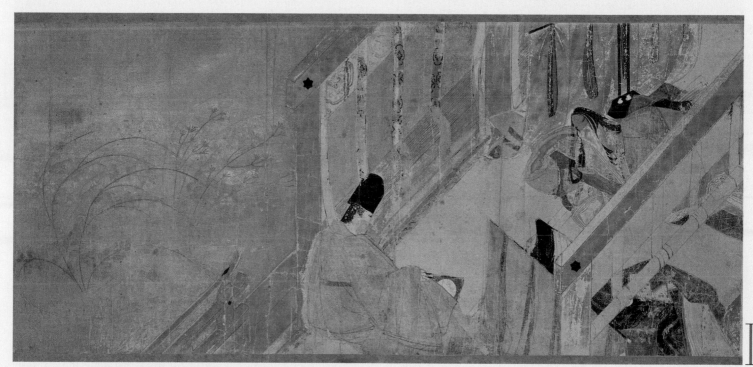

1 in.

**5-14** *Genji Visits Murasaki,* from the Minori chapter, *Tale of Genji,* Heian period, first half of 12th century. Handscroll, ink and color on paper, $8\frac{5}{8}$" high. Goto Art Museum, Tokyo.

In this handscroll illustrating Lady Murasaki's *Tale of Genji,* the upturned ground plane and diagonal lines suggest three-dimensional space. Flat fields of color emphasize the painting's two-dimensional character.

diagonal lines suggest three-dimensional space. The painter omitted roofs and ceilings to allow a privileged view of the interior spaces where the action takes place. The unusual angles were also intended as metaphors for the emotions of the characters depicted. Flat fields of unshaded color emphasize the painting's two-dimensional character. Rich patterns in the textiles and architectural ornament give a feeling of sumptuousness. The human figures appear constructed of stiff layers of contrasting fabrics, and the artist simplified and generalized the aristocratic faces, using a technique called "a line for the eye and a hook for the nose." This lack of individualization may reflect societal restrictions on looking directly at exalted persons.

Several formal features of the *Genji* illustrations—native subjects, bright mineral pigments, lack of emphasis on strong brushwork, and general flatness—were later considered typical of *yamato-e* (native-style painting; the term *yamato* means "Japan" and is used to describe anything that is characteristically Japanese).

***LEGENDS OF MOUNT SHIGI*** Heian painting was diverse in both style and subject matter. *Legends of Mount Shigi,* painted during the late 12th century, represents a different facet of Heian narrative handscroll painting. The stories belong to a genre of pious Buddhist tales devoted to miraculous events involving virtuous

1 in.

**5-15** The flying storehouse, from *Legends of Mount Shigi*, Heian period, late 12th century. Handscroll, ink and colors on paper, 1' $\frac{1}{2}$" high. Chogosonshiji, Nara.

This Heian handscroll is very different from the *Genji* scroll (FIG. 5-14) in both subject and style. The artist exaggerated each feature of the gesticulating and scurrying figures in this Buddhist miracle story.

individuals. Unlike the *Genji* scrolls, short segments of text and pictures do not alternate. Instead, the painters took advantage of the scroll format to present several scenes in a long, unbroken stretch. For example, the first scroll shows the same travelers at several stages of their journey through a continuous landscape.

The *Mount Shigi* scrolls illustrate three miracles associated with a Buddhist monk named Myoren and his mountaintop temple. The first relates the story of the flying storehouse (FIG. 5-15) and depicts Myoren's begging bowl lifting the rice-filled granary of a greedy farmer and carrying it off to the monk's hut in the mountains. The painter depicted the astonished landowner, his attendants, and several onlookers in various poses—some grimacing, others gesticulating wildly and scurrying about in frantic amazement. In striking contrast to the *Genji* scroll figures, the artist exaggerated each feature of the painted figures, but still depicted the actors and architecture seen from above.

## Kamakura Period

In the late 12th century, a series of civil wars between rival warrior families led to the end of the Japanese imperial court as a major political and social force. The victors, headed by the Minamoto family, established their *shogunate* (military government) at Kamakura in eastern Japan. The imperial court remained in Kyoto as the theoretical source of political authority, but actual power resided with the *shoguns*. The first shogun was Minamoto Yoritomo, on whom the emperor officially bestowed the title in 1185. The ensuing period of Japanese art is called the Kamakura period (1185–1332), named for

the locale. During the Kamakura shogunate, more frequent and positive contact with China brought with it an appreciation for more recent cultural developments there, ranging from new architectural styles to Zen Buddhism.

**SHUNJOBO CHOGEN** Rebuilding in Nara after the destruction the civil wars inflicted presented an early opportunity for architectural experimentation. A leading figure in planning and directing the reconstruction efforts was the priest Shunjobo Chogen (1121–1206), who is reputed to have made three trips to China between 1166 and 1176. After learning about contemporary Chinese architecture, he oversaw the rebuilding of Todaiji, among other projects, with generous donations from Minamoto Yoritomo. Chogen's portrait statue (FIG. 5-16) is one of the most striking examples of the high level of naturalism prevalent in the early Kamakura period. Characterized by finely painted details, a powerful rendering of the signs of aging, and the inclusion of such personal attributes as prayer beads, the statue of Chogen exhibits the carving skill and style of the Kei School of sculptors (see "Heian and Kamakura Artistic Workshops," page 101). The Kei School traced its lineage to Jocho, a famous sculptor of the mid-11th century. Its works display fine Heian carving techniques combined with an increased concern for natural volume and detail learned from studying, among other sources, surviving Nara period works and sculptures imported from Song China. Enhancing the natural quality of Japanese portrait statues is the use of inlaid rock crystal for the eyes, a technique found only in Japan.

## Heian and Kamakura Artistic Workshops

Until the late Heian period, major artistic commissions came almost exclusively from the imperial court or the great temples. As shogun warrior families gained wealth and power, they too became great art patrons—in many cases closely following the aristocrats' precedents in subject and style.

Artists, for the most part, did not work independently but rather were affiliated with workshops. Indeed, until recently, hierarchically organized male workshops produced most Japanese art. Membership in these workshops was often based on familial relationships. Each workshop was dominated by a master, and many of his main assistants and apprentices were relatives. Outsiders of considerable skill sometimes joined workshops, often through marriage or adoption. The eldest son usually inherited the master's position, after rigorous training in the necessary skills from a very young age. Therefore, one meaning of the term "school of art" in Japan is a network of workshops tracing their origins back to the same master, a kind of artistic clan. Inside the workshops, the master and senior assistants handled the most important production stages, but artists of lower rank helped with the more routine work. The Kamakura portrait statue (FIG. 5-16) of Shunjobo Chogen, for example, is the creation of a workshop based on familial ties.

Artistic cooperation also surfaced in court bureaus, an alternative to family workshops. These official bureaus, located at the imperial palace, had emerged by the Heian period. The painting bureau accrued particular fame. Teams of court painters, led by the bureau director, produced pictures such as the scenes in the *Tale of Genji* handscrolls (FIG. 5-14). This system remained vital into the Kamakura period and well beyond. Under the direction of a patron or the patron's representative, the master painter laid out the composition by brushing in the initial outlines and contours. Under his supervision, junior painters applied the colors. The master then completed the work by brushing in fresh contours and details such as facial features. Very junior assistants and apprentices assisted in the process by preparing paper, ink, and pigments. Unlike mastership in hereditarily run workshops, competition among several families determined control of the court painting bureau during the Heian and Kamakura periods.

Not all art was controlled by the bureaus or by family workshops. Priest-artists were trained in temple workshops to produce

1 ft.

**5-16** Portrait statue of the priest Shunjobo Chogen, Todaiji, Nara, Japan, Kamakura period, early 13th century. Painted cypress wood, 2′ 8⅜″ high.

The Kei School's interest in naturalism is seen in this moving portrait of a Kamakura priest. The wooden statue is noteworthy for its finely painted details and powerful rendering of the signs of aging.

Buddhist art objects for public viewing as well as images for private priestly meditation. Amateur painting was common among aristocrats of all ranks. As they did for poetry composition and calligraphy, aristocrats frequently held elegant competitions in painting. Both women and men participated in these activities. In fact, court ladies probably played a significant role in developing the painting style seen in the *Genji* scrolls, and a few participated in public projects.

**5-17** *Night Attack on the Sanjo Palace,* from *Events of the Heiji Period,* Kamakura period, 13th century. Handscroll, ink and colors on paper, 1′ 4¼″ high; complete scroll 22′ 10″ long. Museum of Fine Arts, Boston (Fenollosa-Weld Collection).

The *Heiji* scroll is an example of Japanese historical narrative painting. Staccato brushwork and vivid flashes of color beautifully capture the drama of the night attack and burning of Emperor Goshirakawa's palace.

**ATTACK ON SANJO PALACE** All the painting types flourishing in the Heian period continued to prosper in the Kamakura period. A striking example of handscroll painting is *Events of the Heiji Period,* which dates to the 13th century and illustrates another facet of Japanese painting—historical narrative. The scroll depicts some of the battles in the civil wars at the end of the Heian period. The section reproduced here (FIG. **5-17**) represents the attack on the Sanjo palace in the middle of the night in which the retired emperor Goshirakawa was taken prisoner and his palace burned. Swirling flames and billowing clouds of smoke dominate the composition. Below, soldiers on horseback and on foot do battle. As in other Heian and Kamakura scrolls, the artist represented the buildings seen from above at a sharp angle. Noteworthy here are the painter's staccato brushwork and the vivid flashes of color that beautifully capture the drama of the event.

**AMIDA DESCENDING** Buddhism and Buddhist painting also remained vital in the Kamakura period, and elite patrons continued to commission major Pure Land artworks. Pure Land Buddhism in Japan stressed the saving power of Amida, who, if called on, hastened to believers at the moment of death and conveyed them to his Pure Land. Pictures of this scene often hung in the presence of a dying person, who recited Amida's name to ensure salvation. In *Amida Descending over the Mountains* (FIG. **5-18**), a gigantic Amida rises from behind the mountains against the backdrop of a dark sky. His two main attendant bodhisattvas, Kannon and Seishi, have already descended and are depicted as if addressing the deceased directly. Below, two boys point to the approaching divinities. In contrast to these gesticulating figures, Amida is still and frontal, which gives his image an iconic quality. Particularly striking

is the way in which his halo (nimbus) resembles a rising moon, an image long admired in Japan for its spiritual beauty.

**MUROMACHI** The Kamakura period ended the way it began—with civil war. After several years of conflict, one shogun emerged supreme and governed Japan from his headquarters in the Muramachi district of Kyoto. The art and architecture of the Muromachi period to the present are the subject of Chapter 6.

**5-18** *Amida Descending over the Mountains,* Kamakura period, 13th century. Hanging scroll, ink and colors on silk, 4′ 3⅛″ × 3′ 10½″. Zenrinji, Kyoto.

Pictures of Amida descending to convey the dead to the Buddhist Pure Land Paradise often hung in the room of a dying person. In this hanging scroll the representation of Amida has an iconic character.

# JAPAN BEFORE 1333

## JOMON AND YAYOI PERIODS, ca. 10,500 BCE-300 CE

▌ The Jomon (ca. 10,500–300 BCE) is Japan's earliest distinct culture. It takes its name from the applied clay cordlike coil decoration of Jomon pottery.

▌ Archaeologists unearthed the first evidence for the Yayoi culture (ca. 300 BCE–300 CE) in the Yayoi district of Tokyo, but the culture emerged in Kyushu and spread northward. Increasing contact with the East Asian mainland is evident in the form of Yayoi dotaku, which were modeled on Han Chinese bells.

Middle Jomon vessel, ca. 2500–1500 BCE

## KOFUN PERIOD, ca. 300-552

▌ Kofun means "old tomb," and great earthen burial mounds are the primary characteristic of the last pre-Buddhist period of Japanese art. The largest tumulus in Japan, attributed to Emperor Nintoku, who died in 399, is at Sakai.

▌ About 20,000 clay cylindrical figures (haniwa) stood around and on top of the Sakai tumulus. Haniwa sculptures represent inanimate objects and animals as well as human figures, including warriors. They formed a protective spiritual barrier between the living and the dead.

Haniwa warrior, fifth to mid-sixth century

## ASUKA AND NARA PERIODS, 552-784

▌ Buddhism was introduced to Japan in 552, and the first Japanese Buddhist artworks, such as Tori Busshi's Shaka triad at Horyuji, date to the Asuka period (552–645).

▌ During the Nara period (645–784), a centralized imperial government was established, whose capital was at Nara from 710 to 784.

▌ Nara architecture, for example, the Horyuji kondo, followed Tang Chinese models in the use of ceramic roof tiles and the adoption of a curved roofline. The Daibutsuden constructed at Todaiji in 743 is the largest wooden building in the world.

Kondo, Horyuji, ca. 680

## HEIAN PERIOD, 794-1185

▌ In 794 the imperial house moved its capital to Heiankyo (Kyoto). Shortly thereafter, Esoteric Buddhism was introduced to Japan. Painted mandaras of the Womb World and the Diamond World facilitated meditation.

▌ A masterpiece of Heian Buddhist architecture is the Phoenix Hall at Uji, which evokes images of the celestial architecture of the Buddha's Pure Land of the West.

▌ Narrative scroll painting was a major Heian art form. Illustrated scrolls of Lady Murasaki's *Tale of Genji* feature elevated viewpoints that suggest three-dimensional space and flat colors that emphasize the painting's two-dimensional character.

*Tale of Genji*, first half of 12th century

## KAMAKURA PERIOD, 1185-1332

▌ In 1185 power shifted from the Japanese emperor to the first shogun of Kamakura. The shoguns became great patrons of art and architecture.

▌ Kamakura painting is diverse in both subject and style and includes historical narratives, such as *Events of the Heiji Period,* and Buddhist hanging scrolls.

▌ Kamakura wooden portraits—for example, the seated statue of the priest Shunjobo Chogen— are noteworthy for their realism and the use of rock crystal for the eyes.

Shunjobo Chogen, early 13th century

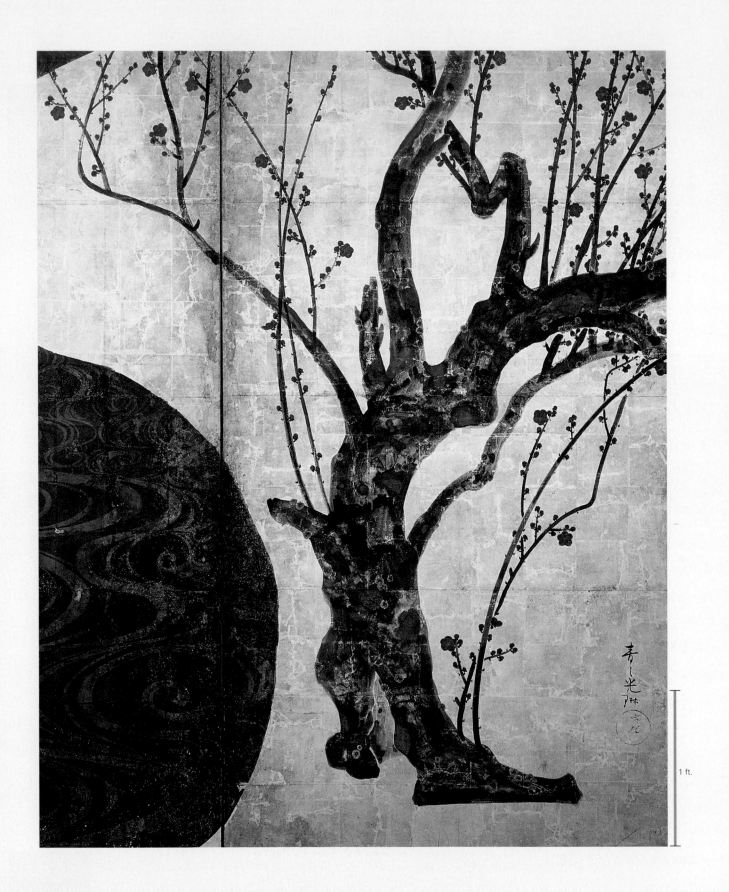

1 ft.

**6-1** OGATA KORIN, *Red Plum Blossoms,* Edo period, ca. 1710–1716. Detail of one of a pair of two-panel folding screens (FIG. I-3). Ink, color, and gold leaf on paper, each screen 5′ 1$\frac{5}{8}$″ × 5′ 7$\frac{7}{8}$″. MOA Art Museum, Shizuoka-ken.

Ogata Korin was one of the leading painters of the 18th-century Rinpa School. In this work he reduced the landscape motifs to a minimum to offer a dramatic contrast of forms and visual textures.

# JAPAN AFTER 1336

Early Japanese cultural history (see Chapter 5) reveals the dialogue that occurred between the Japanese islands and continental eastern Asia and the indebtedness of Japanese art and architecture to the paintings, sculptures, buildings, and crafts of China and Korea. Nonetheless, the Japanese developed a rich variety and unique identity in their art. This ability to incorporate foreign elements yet maintain a consciousness of their own heritage and traditions became more apparent in the arts of Japan as time progressed. It is especially evident from the 14th century to the present.

## JAPAN, 1336 TO 1868

In 1185 the Japanese emperor in Kyoto appointed the first *shogun* (military governor) in Kamakura in eastern Japan (MAP 6-1). Although the imperial family retained its right to reign and, in theory, the shogun managed the country on the ruling emperor's behalf, in reality the emperor lost all governing authority. The Japanese *shogunate* was a political and economic arrangement in which *daimyo* (local lords), the leaders of powerful warrior bands composed of *samurai* (warriors), paid obeisance to the shogun. These local lords had considerable power over affairs within their domains. The Kamakura shogunate ruled Japan for more than a century but collapsed in 1332. Several years of civil war followed, ending only when Ashikaga Takauji (1305–1358) succeeded in establishing domination of his clan over all Japan and became the new imperially recognized shogun.

### Muromachi Period

The rise of the Ashikaga clan marked the beginning of the Muromachi period (1336–1573), named after the district in Kyoto in which the Ashikaga shoguns maintained their headquarters. During the Muromachi period, Zen Buddhism (see "Zen Buddhism," page 106) rose to prominence alongside the older traditions, such as Pure Land and Esoteric Buddhism. Unlike the Pure Land faith, which stressed reliance on the saving power of Amida, the Buddha of the West, Zen emphasized rigorous discipline and personal

## Zen Buddhism

Zen (*Chan* in Chinese), as a fully developed Buddhist tradition, began filtering into Japan in the 12th century and had its most pervasive impact on Japanese culture starting in the 14th century during the Muromachi period. As in other forms of Buddhism, Zen followers hoped to achieve enlightenment. Zen teachings assert that everyone has the potential for enlightenment, but worldly knowledge and mundane thought patterns suppress it. Thus, to achieve enlightenment, followers must break through the boundaries of everyday perception and logic. This is most often achieved through meditation. Indeed, the word *zen* means "meditation." Some Zen schools stress meditation as a long-term practice eventually leading to enlightenment, whereas others emphasize the benefits of sudden shocks to the worldly mind. One of these shocks is the subject of Kano Motonobu's *Zen Patriarch Xiangyen Zhixian Sweeping with a Broom* (FIG. 6-4), in which the shattering of a fallen roof tile opens the monk's mind. Beyond personal commitment, the guidance of an enlightened Zen teacher is essential to arriving at enlightenment. Years of strict training that involve manual labor under the tutelage of this master coupled with meditation provide the foundation for a receptive mind. According to Zen beliefs, by cultivating discipline and intense concentration, Buddhists can transcend their ego and release themselves from the shackles of the mundane world.

Although Zen is not primarily devotional, followers do pray to specific deities. In general, Zen teachings view mental calm, lack of fear, and spontaneity as signs of a person's advancement on the path to enlightenment.

Zen training for monks takes place at temples, some of which have gardens designed in accord with Zen principles, such as the dry-landscape garden of Kyoto's Saihoji temple (FIG. 6-2). Zen temples also sometimes served as centers of Chinese learning and handled funeral rites. Zen temples even embraced many traditional Buddhist observances, such as devotional rituals before images, which had little to do with meditation per se.

As the teachings spread, Zen ideals reverberated throughout Japanese culture. Lay followers as well as Zen monks painted pictures and produced other artworks that appear to reach toward Zen ideals through their subjects and their means of expression. Other cultural practices reflected the widespread appeal of Zen. For example, the tea ceremony (see "The Japanese Tea Ceremony," page 110), or ritual drinking of tea, as it developed in the 15th and 16th centuries, offered a temporary respite from everyday concerns, a brief visit to a quiet retreat with a meditative atmosphere, such as the Taian teahouse (FIG. 6-7).

**6-2** Dry cascade and pools, upper garden, Saihoji temple, Kyoto, Japan, modified in Muromachi period, 14th century.

Zen temples often incorporated gardens to facilitate meditation. The dry cascade and pools of the upper garden of the Saihoji temple in Kyoto are an early example of Muromachi dry-landscape gardening (karesansui).

responsibility. For this reason, Zen held a special attraction for the upper echelons of samurai, whose behavioral codes placed high values on loyalty, courage, and self-control. Further, familiarity with Chinese Zen culture (see "Chan Buddhism," Chapter 3, page 67) carried implications of superior knowledge and refinement, thereby legitimizing the elevated status of the warrior elite.

Zen, however, was not simply the religion of Zen monks and highly placed warriors. Aristocrats, merchants, and others studied at and supported Zen temples. Furthermore, those who embraced Zen, including samurai, also generally accepted other Buddhist teachings, especially the ideas of the Pure Land sects. These sects gave much greater attention to the issues of death and salvation. Zen temples

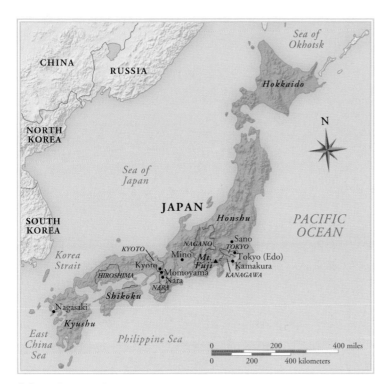

MAP 6-1 Modern Japan.

reality. The dry landscape, or rock garden, became very popular in Japan in the Muromachi period and afterward, especially at Zen temples. In its extreme form, a karesansui garden consists purely of artfully arranged rocks on a raked bed of sand.

**SESSHU TOYO** As was common in earlier eras of Japanese history, Muromachi painters usually closely followed Chinese precedents (often arriving by way of Korea). Muromachi painting nonetheless displays great variety in both style and subject matter. Indeed, individual masters often worked in different styles, as did the most celebrated Muromachi priest-painter, SESSHU TOYO (1420–1506), one of the very few Japanese painters who traveled to China and studied contemporaneous Ming painting. His most dramatic works are in the *splashed-ink* (*haboku*) style, a technique with Chinese roots. The painter of a haboku picture paused to visualize the image, loaded the brush with ink, and then applied primarily broad, rapid strokes, sometimes even dripping the ink onto the paper. The result often hovers at the edge of legibility, without dissolving into sheer abstraction. This balance between spontaneity and a thorough knowledge of the painting tradition gives the pictures their artistic strength. In the haboku landscape illustrated here (FIG. 6-3), images of mountains, trees, and buildings emerge from the ink-washed surface. Two figures appear in a boat (to the lower right), and the two swift strokes nearby represent the pole and banner of a wine shop.

stood out not only as religious institutions but also as centers of secular culture, where people could study Chinese art, literature, and learning, which the Japanese imported along with Zen Buddhism. Some Zen monasteries accumulated considerable wealth overseeing trade missions to China.

**SAIHOJI GARDENS** The Saihoji temple gardens in Kyoto bear witness to both the continuities and changes that marked religious art in the Muromachi period. In the 14th century, this Pure Land temple with its extensive gardens became a Zen institution. However, Zen leaders did not attempt to erase other religious traditions, and the Saihoji gardens in their totality originally included some Pure Land elements even as they served the Zen faith's more meditative needs. In this way, they perfectly echoed the complementary roles of these two Buddhist traditions in the Muromachi period, with Pure Land providing a promise of salvation and Zen promoting study and meditation.

Saihoji's lower gardens center on a pond in the shape of the Japanese character for "mind" or "spirit" and are thus the perfect setting for monks to meditate. Today those gardens are famous for their iridescently green mosses, whose beauty is almost otherworldly. In contrast, arrangements of rocks and sand on the hillsides of the upper garden, especially the dry cascade and pools (FIG. 6-2), are treasured early examples of Muromachi *karesansui* (dry-landscape gardening). The designers stacked the rocks to suggest a swift mountain stream rushing over the stones to form pools below. In eastern Asia, people long considered gazing at dramatic natural scenery highly beneficial to the human spirit. These activities refreshed people after too much contact with daily affairs and helped them reach beyond mundane

6-3 SESSHU TOYO, splashed-ink (haboku) landscape, detail of the lower part of a hanging scroll, Muromachi period, 1495. Ink on paper, full scroll 4′ 10¼″ × 1′ ⅞″; detail 4′ ½″ high. Tokyo National Museum, Tokyo.

In this splashed-ink landscape, the artist applied primarily broad, rapid strokes, sometimes even dripping the ink on the paper. The result hovers at the edge of legibility, without dissolving into sheer abstraction.

1 ft.

**KANO MOTONOBU** The opposite pole of Muromachi painting style is represented by the Kano School, which by the 17th century had become a virtual national painting academy. The school flourished until the late 19th century. KANO MOTONOBU (1476–1559) was largely responsible for establishing the Kano style during the Muromachi period. His *Zen Patriarch Xiangyen Zhixian Sweeping with a Broom* (FIG. **6-4**) is one of six panels depicting Zen patriarchs that Motonobu designed as sliding door paintings (*fusuma*) for the abbot's room in the Zen temple complex of Daitokuji in Kyoto. Later refashioned as a hanging scroll, the painting represents the Zen patriarch Xiangyen Zhixian (d. 898) at the moment he achieved enlightenment. Motonobu depicted the patriarch sweeping the ground near his rustic retreat as a roof tile falls at his feet and shatters. His Zen training is so deep that the resonant sound propels the patriarch into an awakening. In contrast to Muromachi splashed-ink painting, Motonobu's work displays exacting precision in applying ink in bold outlines by holding the brush perpendicular to the paper. Thick clouds obscure the mountainous setting and focus the viewer's attention on the sharp, angular rocks, bamboo branches, and modest hut that frame the patriarch. Lightly applied colors also draw attention to Xiangyen Zhixian, whom Motonobu portrayed as having let go of his broom with his right hand as he recoils in astonishment. Although very different in style, the Japanese painting recalls the subject of Liang Kai's Song hanging scroll (FIG. **3-25**).

## Momoyama Period

Despite the hierarchical nature of Japanese society during the Muromachi period, the control the Ashikaga shoguns exerted was tenuous and precarious. Ambitious daimyo often seized opportunities to expand their power, sometimes aspiring to become shoguns themselves. By the late 15th century, Japan was experiencing violent confrontations over territory and dominance. In fact, scholars refer to the last century of the Muromachi period as the Era of Warring States, intentionally borrowing the terminology used to describe a much earlier tumultuous period in Chinese history (see Chapter 3). Finally, three successive warlords seized power, and the last succeeded in restoring order and establishing a new and long-lasting shogunate. In 1573, Oda Nobunaga (1534–1582) overthrew the Ashikaga shogunate in Kyoto but was later killed by one of his generals. Toyotomi Hideyoshi (1536–1598) took control of the government after Nobunaga's assassination and ruled until he died of natural causes in 1598. In the struggle following Hideyoshi's death, Tokugawa Ieyasu (1542–1616) emerged victorious and assumed the title of shogun in 1603. Ieyasu continued to face challenges, but by 1615 he had eliminated his last rival and established his clan as the rulers of Japan for two and a half centuries. To reinforce their power, these warlords constructed huge castles with palatial residences—partly as symbols of their authority and partly as fortresses. The new era's designation, Momoyama (Peach Blossom Hill), derives from the scenic foliage at one

1 ft.

**6-4** KANO MOTONOBU, *Zen Patriarch Xiangyen Zhixian Sweeping with a Broom,* from Daitokuji, Kyoto, Japan, Muromachi period, ca. 1513. Hanging scroll, ink and color on paper, 5′ 7⅜″ × 2′ 10¾″. Tokyo National Museum, Tokyo.

The Kano School represents the opposite pole of Muromachi style from splashed-ink painting. In this scroll depicting a Zen patriarch experiencing enlightenment, Motonobu used bold outlines to define the forms.

of Hideyoshi's castles southeast of Kyoto. The Momoyama period (1573–1615), although only a brief interlude between two major shogunates, produced many outstanding artworks.

**KANO EITOKU** Each Momoyama warlord commissioned lavish decorations for the interior of his castle, including paintings, sliding doors, and folding screens (*byobu*) in ink, color, and gold leaf. Gold screens had existed since Muromachi times, but Momoyama painters made them even bolder, reducing the number of motifs and often greatly enlarging them against flat, shimmering fields of gold leaf.

The grandson of Motonobu, KANO EITOKU (1543–1590), was the leading painter of murals and screens and received numerous commissions from the powerful warlords. So extensive were these commissions (in both scale and number) that Eitoku used a painting system developed by his grandfather that relied on a team of specialized painters to assist him. Unfortunately, little of Eitoku's elaborate work remains because of the subsequent destruction of the ostenta-

**6-5** Kano Eitoku, *Chinese Lions,* Momoyama period, late 16th century. Six-panel screen, color, ink, and gold leaf on paper, 7′ 4″ × 14′ 10″. Imperial Household Agency, Tokyo.

Chinese lions were fitting imagery for the castle of a Momoyama warlord because they exemplified power and bravery. Eitoku's huge screen features boldly outlined forms on a gold ground.

tious castles he helped decorate—not surprising in an era marked by power struggles. However, a painting of Chinese lions on a six-panel screen (FIG. **6-5**) offers a glimpse of his work's grandeur. Possibly created for Toyotomi Hideyoshi, the second of the three great warlords of the Momoyama period, this screen, originally one of a pair, appropriately speaks to the emphasis on militarism so prevalent at the time. The lions Eitoku depicted are mythological beasts that have their origin in ancient Chinese legends. Appearing in both religious and secular contexts, the lions came to be associated with power and bravery and are thus fitting imagery for a military leader. Indeed, Chinese lions became an important symbolic motif during the Momoyama period. In Eitoku's painting, the colorful beasts' powerfully muscled bodies, defined and flattened by broad contour lines, stride

forward within a gold field and minimal setting elements. The dramatic impact of this work derives in part from its scale—it is more than 7 feet tall and nearly 15 feet long.

**HASEGAWA TOHAKU** Momoyama painters did not work exclusively in the colorful style exemplified by Eitoku's *Chinese Lions*. HASEGAWA TOHAKU (1539–1610) was a leading painter who became familiar with the aesthetics and techniques of Chinese Chan and Japanese Zen painters such as Sesshu Toyo (FIG. **6-3**) by studying the art collections of the Daitokuji temple in Kyoto. Tohaku sometimes painted in ink monochrome using loose brushwork with brilliant success, as seen in *Pine Forest* (FIG. **6-6**), one of a pair of six-panel byobu. His wet brush strokes—long and slow, short and quick,

**6-6** Hasegawa Tohaku, *Pine Forest,* Momoyama period, late 16th century. One of a pair of six-panel screens, ink on paper, 5′ 1 3/8″ × 11′ 4″. Tokyo National Museum, Tokyo.

Tohaku used wet brush strokes to paint a grove of great pines shrouded in mist. In Zen terms, the six-panel screen suggests the illusory nature of mundane reality while evoking a calm, meditative mood.

# The Japanese Tea Ceremony

The Japanese tea ceremony involves the ritual preparation, serving, and drinking of green tea. The fundamental practices began in China, but they developed in Japan to a much higher degree of sophistication, peaking in the Momoyama period. Simple forms of the tea ceremony started in Japan in Zen temples as a symbolic withdrawal from the ordinary world to cultivate the mind and spirit. The practices spread to other social groups, especially samurai and, by the late 16th century, wealthy merchants. Until the late Muromachi period, grand tea ceremonies in warrior residences served primarily as an excuse to display treasured collections of Chinese objects, such as porcelains, lacquers, and paintings.

Initially, the Japanese held tea ceremonies in a room or section of a house. As the popularity of the ceremonies increased, freestanding teahouses (FIG. 6-7) became common. The ceremony involves a sequence of rituals in which both host and guests participate. The host's responsibilities include serving the guests; selecting special utensils, such as water jars (FIG. 6-8) and tea bowls; and determining the tearoom's decoration, which changes according to occasion and season. Acknowledged as having superior aesthetic sensibilities, individuals recognized as master tea ceremony practitioners (tea masters) advise patrons on the ceremony and acquire students. Tea masters even direct or influence the design of teahouses and of tearooms within larger structures (including interiors and gardens) as well as the design of tea utensils. They often make simple bamboo implements and occasionally even ceramic vessels.

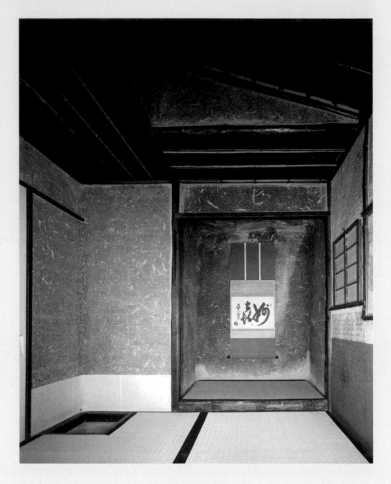

**6-7** SEN NO RIKYU, Taian teahouse (interior view), Myokian Temple, Kyoto, Japan, Momoyama period, ca. 1582.

The dimness and tiny size of Rikyu's Taian tearoom and its alcove produce a cavelike feel and encourage intimacy among the host and guests, who must crawl through a small sliding door to enter.

dark and pale—present a grove of great pines shrouded in mist. His trees emerge from and recede into the heavy atmosphere, as if the landscape hovers at the edge of formlessness. In Zen terms, the picture suggests the illusory nature of mundane reality while evoking a calm, meditative mood.

**SEN NO RIKYU** A favorite exercise of cultivation and refinement in the Momoyama period was the tea ceremony (see "The Japanese Tea Ceremony," above). In Japan, this important practice eventually came to carry various political and ideological implications. For example, it provided a means for individuals relatively new to political or economic power to assert authority in the cultural realm. For instance, upon returning from a major military campaign, Toyotomi Hideyoshi held an immense tea ceremony that lasted 10 days and was open to everyone in Kyoto. The ceremony's political associations became so serious that warlords granted or refused their vassals the right to practice it.

The most venerated tea master of the Momoyama period was SEN NO RIKYU (1522–1591), who was instrumental in establishing the rituals and aesthetics of the tea ceremony, for example, the manner of entry into a teahouse (crawling on one's hands and knees). Rikyu believed this behavior fostered humility and created the impression, however unrealistic, that there was no rank in a teahouse. Rikyu was the designer of the first Japanese teahouse built as an independent structure as opposed to being part of a house. The Taian teahouse (FIG. 6-7) at the

Myokian Temple in Kyoto, also attributed to Rikyu, is the oldest in Japan. The interior displays two standard features of Japanese residential architecture of the late Muromachi period—very thick, rigid straw mats called *tatami* (a Heian innovation) and an alcove called a *tokonoma*. The tatami accommodate the traditional Japanese customs of not wearing shoes indoors and of sitting on the floor. They can still be found in Japanese homes today. Less common in contemporary houses are tokonoma, which developed as places to hang scrolls of painting or calligraphy and to display other prized objects.

The Taian tokonoma and the tearoom as a whole have unusually dark walls, with earthen plaster covering even some of the square corner posts. The room's dimness and tiny size (about six feet square, the size of two tatami mats) produce a cavelike feel and encourage intimacy among the tea host and guests. The guests enter from the garden outside through a small sliding door that forces them humbly to crawl inside. The means of entrance emphasizes a guest's passage into a ceremonial space set apart from the ordinary world.

**SHINO CERAMICS** Sen no Rikyu also was influential in determining the aesthetics of tea ceremony utensils. He maintained that value and refinement lay in character and ability and not in bloodline or rank, and he therefore encouraged the use of tea items whose value was their inherent beauty rather than their monetary worth. Even before Rikyu, in the late 15th century during the Muromachi

6-8 Kogan, tea ceremony water jar, Momoyama period, late 16th century. Shino ware with underglaze design, 7″ high. Hatakeyama Memorial Museum, Tokyo.

The vessels used in the Japanese tea ceremony reflect the concepts of wabi, the aesthetic of refined rusticity, and sabi, the value found in weathered objects. These qualities suggest the tranquility achieved in old age.

period, admiration of the technical brilliance of Chinese objects had begun to give way to ever greater appreciation of the virtues of rustic Korean and Japanese wares. This new aesthetic of refined rusticity, or *wabi*, was consistent with Zen concepts. Wabi suggests austerity and simplicity. Related to wabi and also important as a philosophical and aesthetic principle was *sabi*—the value found in the old and weathered, suggesting the tranquility reached in old age.

Wabi and sabi aesthetics underlie the ceramic vessels produced for the tea ceremony, such as the Shino water jar named *kogan* (FIG. 6-8). The name, which means "ancient stream bank," comes from the painted design on the jar's surface as well as from its coarse texture and rough form, both reminiscent of earth cut by water. The term *Shino* generally refers to ceramic wares produced during the late 16th and early 17th centuries in kilns in Mino. Shino vessels typically have rough surfaces and feature heavy glazes containing feldspar. These glazes are predominantly white when fired but can include pinkish red or gray hues. The kogans' coarse stoneware body and seemingly casual decoration offer the same sorts of aesthetic and interpretive challenges and opportunities as dry-landscape gardens (FIG. 6-2). The kogan illustrated here, for example, has a prominent crack in one side and sagging contours (both intentional) to suggest the accidental and natural, qualities essential to the values of wabi and sabi.

## Edo Period

When Tokugawa Ieyasu consolidated his power in 1615, he abandoned Kyoto, the official capital, and set up his headquarters in Edo (modern Tokyo), initiating the Edo period (1615–1868) of Japanese history and art. The new regime instituted many policies designed to limit severely the pace of social and cultural change in Japan. Fearing destabilization of the social order, the Tokugawa rulers banned Christianity and expelled all Western foreigners except the Dutch. The Tokugawa also transformed Confucian ideas of social stratification and civic responsibility into public policy, and they tried to control the social influence of urban merchants, some of whose wealth far outstripped that of most warrior leaders. However, the population's great expansion in urban centers, the spread of literacy in the cities and beyond, and a growing thirst for knowledge and diversion made for a very lively popular culture not easily subject to tight control.

**KATSURA IMPERIAL VILLA** In the Edo period, the imperial court's power remained as it had been for centuries, symbolic and ceremonial, but the court continued to wield influence in matters of taste and culture. For example, for a 50-year period in the 17th century, a princely family developed a modest country retreat into a villa that became the standard for Japanese domestic architecture. Since the early 20th century, it has inspired architects worldwide, even as ordinary living environments in Japan became increasingly Westernized in structure and decor. The Katsura Imperial Villa (FIG. 6-9), built between 1620 and 1663 on the

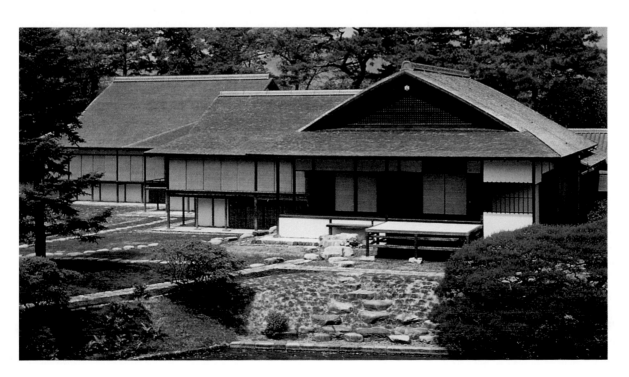

6-9 Eastern facade of the Katsura Imperial Villa, Kyoto, Japan, Edo period, 1620–1663.

This princely villa on the Katsura River has long been the standard for Japanese residential architecture. The design relies on subtleties of proportion, color, and texture instead of ornament for its aesthetic appeal.

Katsura River southwest of Kyoto, has many features that derive from earlier teahouses, such as Rikyu's Taian (FIG. 6-7). However, tea ceremony aesthetics later moved away from Rikyu's wabi extremes, and the Katsura Villa's designers and carpenters incorporated elements of courtly gracefulness as well.

Ornament that disguises structural forms has little place in this architecture's appeal, which relies instead on subtleties of proportion, color, and texture. A variety of textures (stone, wood, tile, and plaster) and subdued colors and tonal values enrich the villa's lines, planes, and volumes. Artisans painstakingly rubbed and burnished all surfaces to bring out the natural beauty of their grains and textures. The rooms are not large, but parting or removing the sliding doors between them can create broad rectangular spaces. Perhaps most important, the residents can open the doors to the outside to achieve a harmonious integration of building and garden—one of the primary ideals of Japanese residential architecture.

**THE RINPA SCHOOL** In painting, the Kano School enjoyed official governmental sponsorship during the Edo period, and its workshops provided paintings to the Tokugawa and their major vassals. By the mid-18th century, Kano masters also served as the primary painting teachers for nearly everyone aspiring to a career in the field. Even so, individualist painters and other schools emerged and flourished, working in quite distinct styles.

The earliest major alternative school to emerge in the Edo period, Rinpa, was quite different in nature from the Kano School. It did not have a similar continuity of lineage and training through father and son, master and pupil. Instead, over time, Rinpa aesthetics and principles attracted a variety of individuals as practitioners and champions. Stylistically, Rinpa works feature vivid color and extensive use of gold and silver and often incorporate decorative patterns. The Rinpa School traced its roots to Tawaraya Sotatsu, an artist who emerged as an important figure during the late Momoyama period, but Rinpa takes its first syllable from the last syllable in the name of Ogata Korin. Both Sotatsu and Korin were scions of wealthy merchant families with close connections to the Japanese court. Many Rinpa works incorporate literary themes the nobility favored.

**HONAMI KOETSU** One of the earliest Rinpa masters was HONAMI KOETSU (1558–1637), the heir of an important family in the ancient capital of Kyoto and a greatly admired calligrapher. He also participated in and produced ceramics for the tea ceremony. Many scholars credit him with overseeing the design of wooden objects with lacquer decoration (see "Lacquered Wood," Chapter 4, page 78), perhaps with the aid of Sotatsu, the proprietor of a fan-painting shop. Scholars do know that together the two artists drew on ancient traditions of painting and craft decoration to develop a style that collapsed boundaries between the two arts. Paintings, the lacquered surfaces of writing boxes, and ceramics shared motifs and compositions.

In typical Rinpa fashion, Koetsu's *Boat Bridge* writing box (FIG. 6-10) exhibits motifs drawn from a 10th-century poem about the boat bridge at Sano, in the eastern provinces. The lid presents a subtle, gold-on-gold scene of small boats lined up side by side in the water to support the planks of a temporary bridge. The bridge itself, a lead overlay, forms a band across the lid's convex surface. The raised metallic lines on the water, boats, and bridge are a few Japanese characters from the poem, which describes the experience of crossing a bridge as evoking reflection on life's insecurities. The box also shows the dramatic contrasts of form, texture, and color that mark Rinpa aesthetics, especially the juxtaposition of the bridge's dark metal and the box's brilliant gold surface. The gold decoration comes from careful sprinkling of gold dust in wet lacquer. Whatever Koetsu's contribution to the design process, specialists well versed in the demanding techniques of metalworking and lacquering produced the writing box.

**OGATA KORIN** The son of an important textile merchant, OGATA KORIN (1658–1716) was primarily a painter, but he also designed lacquers in Koetsu's manner. One of Korin's painted masterpieces is a pair of two-panel folding screens depicting red and white blossoming plum trees separated by a stream (FIGS. I-3 and 6-1). As Koetsu did with his writing box, Korin reduced the motifs to a minimum to offer a dramatic contrast of forms and visual textures. The landscape consists solely of delicate, slender branches, gnarled, aged tree trunks, and an undulating stream. Korin mixed viewpoints (he depicted the stream as seen from above but the trees from the ground)

**6-10** HONAMI KOETSU, *Boat Bridge,* writing box, Edo period, early 17th century. Lacquered wood with sprinkled gold and lead overlay, $9\frac{1}{2}'' \times 9'' \times 4\frac{3}{8}''$. Tokyo National Museum, Tokyo.

Koetsu's writing box is an early work of the Rinpa School, which drew on ancient traditions of painting and craft decoration to develop a style that collapsed boundaries between the two arts.

1 in.

to produce a striking two-dimensional pattern of dark forms on a gold ground. He even created a contrast between the dark motifs of stream and trees by varying painting techniques. The mottling of the trees comes from a signature Rinpa technique called *tarashikomi*, the dropping of ink and pigments onto surfaces still wet with previously applied ink and pigments. In sharp contrast, the pattern in the stream has the precision and elegant stylization of a textile design, produced by applying pigment through the forms cut in a paper stencil.

**LITERATI PAINTING** In the 17th and 18th centuries, Japan's increasingly urban, educated population spurred a cultural and social restlessness among commoners and samurai of lesser rank that the policies of the restrictive Tokugawa could not suppress. People eagerly sought new ideas and images, directing their attention primarily to China, as had happened throughout Japanese history, but also to the West. From each direction, dramatically new ideas about painting emerged.

Starting in the late 17th century, illustrations in printed books and imported paintings of lesser quality brought limited knowledge of Chinese literati painting (see Chapter 4) into Japan. As a result, some Japanese painters began to emulate Chinese models, although the difference in context resulted in variations. In China, literati were cultured intellectuals whose education and upbringing as landed gentry afforded them positions in the bureaucracy that governed the country. Chinese literati artists were predominantly amateurs and pursued painting as one of the proper functions of an educated and cultivated person. In contrast, although Japanese literati artists acquired a familiarity with and appreciation for Chinese literature, they were mostly professionals, painting to earn a living. Because of the diffused infiltration of Chinese literati painting into Japan, the resulting character of Japanese literati painting was less stylistically defined than in China. Despite the inevitable changes as Chinese ideas disseminated throughout Japan, the newly seen Chinese models were valuable in supporting emerging ideals of self-expression in painting by offering a worthy alternative to the Kano School's standardized repertoire.

**YOSA BUSON** One of the outstanding early representatives of Japanese literati painting was YOSA BUSON (1716–1783). A master writer of *haiku* (the 17-syllable Japanese poetic form that became popular from the 17th century on), Buson had a command of literati painting that extended beyond a knowledge of Chinese models. His poetic abilities gave rise to a lyricism that pervaded both his haiku and his painting. *Cuckoo Flying over New Verdure* (FIG. **6-11**) reveals his fully mature style. He incorporated in this work basic elements of Chinese literati painting by rounding the landscape forms and rendering their soft texture in fine fibrous brush strokes, and by including dense foliage patterns, but the cuckoo is a motif specific to Japanese poetry and literati painting. Moreover, although Buson imitated the vocabulary of brush strokes associated with the Chinese literati, his touch was bolder and more abstract, and the gentle palette of pale colors was very much his own.

*UKIYO-E* The growing urbanization in cities such as Osaka, Kyoto, and Edo led to an increase in the pursuit of sensual pleasure and entertainment in the brash popular theaters and the pleasure houses found in certain locales, including Edo's Yoshiwara brothel district. The Tokugawa tried to hold these activities in check, but their efforts were largely in vain, in part because of demographics. The population of Edo during this period included significant numbers of merchants and samurai (whose families remained in their home territories), and both groups were eager to enjoy secular city life. Those of lesser means could partake in these pleasures and amusements vicariously. Rapid developments in the printing industry led to the availability of numerous books and

**6-11** YOSA BUSON, *Cuckoo Flying over New Verdure,* Edo period, late 18th century. Hanging scroll, ink and color on silk, $5'\frac{1}{2}'' \times 2'7\frac{1}{4}''$. Hiraki Ukiyo-e Museum, Yokohama.

Buson, a master of haiku poetry, was a leading Japanese literati painter. Although inspired by Chinese works, he used a distinctive palette of pale colors and bolder, more abstract brush strokes.

printed images (see "Japanese Woodblock Prints," page 114), and these could convey the city's delights for a fraction of the cost of actual participation. Taking part in the emerging urban culture involved more than simple physical satisfactions and rowdy entertainments. Many participants were also admirers of literature, music, and art. The best-known products of this sophisticated counterculture were known as *ukiyo-e*—"pictures of the floating world," a term that suggests the transience of human life and the ephemerality of the material world. The main subjects of these paintings and especially prints came from the realms of pleasure, such as the Yoshiwara brothels and the popular theater, but Edo printmakers also frequently depicted beautiful young women in domestic settings (FIG. **6-12**) and landscapes (FIG. **6-13**).

## Japanese Woodblock Prints

During the Edo period, *ukiyo-e* (pictures of the floating world) woodblock prints became enormously popular. Sold in small shops and on the street, an ordinary print went for the price of a bowl of noodles. People of very modest income could therefore collect prints in albums or paste them on their walls. A highly efficient production system made this wide distribution of Japanese graphic art possible.

Ukiyo-e artists were generally painters who did not participate in the making of the prints that made them so famous both in their own day and today. As the designers, they sold drawings to publishers, who in turn oversaw their printing. The publishers also played a role in creating ukiyo-e prints by commissioning specific designs or adapting them before printing. Certainly, the names of both designer and publisher appeared on the final prints.

Unacknowledged in nearly all cases were the individuals who made the prints, the block carvers and printers. Using skills honed since childhood, they worked with both speed and precision for relatively low wages and thus made ukiyo-e prints affordable. The master ukiyo-e printmakers were primarily men. Women, especially wives and daughters, often assisted painters and other artists, but few gained separate recognition. Among the exceptions was the daughter of Katsushika Hokusai (FIG. 6-13), Katsushika Oi (1818–1854), who became well known as a painter and probably helped her father with his print designs.

Stylistically, Japanese prints during the Edo period tend to have black outlines separating distinct color areas (FIG. 6-12). This format is a result of the printing process. A master carver pasted painted designs face down on a wooden block. Wetting and gently scraping the thin paper revealed the reversed image to guide the cutting of the block. After the carving, only the outlines of the forms and other elements that would be black in the final print remained raised in relief. The master printer then coated the block with black ink and printed several initial outline prints. These master prints became the guides for carving the other blocks, one for each color used. On each color block, the carver left in relief only the areas to be printed in that color. Even ordinary prints sometimes required up to 20 colors and thus 20 blocks. To print a color, a printer applied the appropriate pigment to a block's raised surface, laid a sheet of paper on it, and rubbed the back of the paper with a smooth flat object. Then another printer would print a different color on the same sheet of paper. Perfect alignment of the paper in each step was critical to prevent overlapping of colors, so the block carvers included printing guides—an L-shaped ridge in one corner and a straight ridge on one side—in their blocks. The printers could cover small alignment errors with a final printing of the black outlines from the last block.

The materials used in printing varied over time but by the mid-18th century had reached a level of standardization. The blocks were planks of fine-grained hardwood, usually cherry. The best paper came from the white layer beneath the bark of mulberry trees,

**6-12** Suzuki Harunobu, *Evening Bell at the Clock,* from *Eight Views of the Parlor,* Edo period, ca. 1765. Woodblock print, $11\frac{1}{4}'' \times 8\frac{1}{2}''$. Art Institute of Chicago, Chicago (Clarence Buckingham Collection).

Harunobu's nishiki-e (brocade pictures) took their name from their costly pigments and paper. The rich color and flatness of the objects, women, and setting in this print are characteristic of the artist's style.

because its long fibers helped the paper stand up to repeated rubbing on the blocks. The printers used a few mineral pigments but favored inexpensive dyes made from plants for most colors. As a result, the colors of ukiyo-e prints were and are highly susceptible to fading, especially when exposed to strong light. In the early 19th century, more permanent European synthetic dyes began to enter Japan. The first, Prussian blue, can be seen in Hokusai's *The Great Wave off Kanagawa* (FIG. 6-13).

The popularity of ukiyo-e prints extended to the Western world as well. Their affordability and portability facilitated the dissemination of the prints, especially throughout Europe. Ukiyo-e prints appear in the backgrounds of a number of Impressionist and Post-Impressionist paintings, attesting to the appeal these works held for Westerners.

**SUZUKI HARUNOBU** The urban appetite for ukiyo pleasures and for their depiction in ukiyo-e provided fertile ground for many print designers to flourish. Consequently, competition among publishing houses led to ever-greater refinement and experimentation in printmaking. One of the most admired and emulated 18th-century designers, SUZUKI HARUNOBU (ca. 1725–1770), played a key role in developing multicolored prints. Called *nishiki-e* (brocade pictures) because of their sumptuous and brilliant color, these prints employed only the highest-quality paper and costly pigments. Harunobu gained a tremendous advantage over his fellow designers when he received commissions from members of a poetry club to design limited-edition nishiki-e prints. He transferred much of the knowledge he derived from nishiki-e to his design of more commercial prints. Harunobu even issued some of the private designs later under his own name for popular consumption.

The sophistication of Harunobu's work is evident in *Evening Bell at the Clock* (FIG. **6-12**), from a series called *Eight Views of the Parlor.* This series draws upon a Chinese series usually titled *Eight Views of the Xiao and Xiang Rivers,* in which each image focuses on a particular time of day or year. In Harunobu's adaptation, beautiful young women and the activities that occupy their daily lives became the subject. In *Evening Bell at the Clock,* two young women seen from the typically Japanese elevated viewpoint (compare FIG. **5-14**) sit on a veranda. One appears to be drying herself after a bath, while the other turns to face the chiming clock. Here, the artist has playfully transformed the great temple bell that rings over the waters in the Chinese series into a modern Japanese clock. This image incorporates the refined techniques characteristic of nishiki-e. Further, the flatness of the depicted objects and the rich color recall the traditions of court painting, a comparison many nishiki-e artists openly sought.

**KATSUSHIKA HOKUSAI** Woodblock prints afforded artists great opportunity for experimentation. For example, in producing landscapes, Japanese artists often incorporated Western perspective techniques. One of the most famous designers in this genre was KATSUSHIKA HOKUSAI (1760–1849). In *The Great Wave off Kanagawa* (FIG. **6-13**), part of a woodblock series called *Thirty-six Views of Mount Fuji,* the huge foreground wave dwarfs the artist's representation of a distant Fuji. This contrast and the whitecaps' ominous fingers magnify the wave's threatening aspect. The men in the trading boats bend low to dig their oars against the rough sea and drive their long low vessels past the danger. Although Hokusai's print draws on Western techniques and incorporates the distinctive European color called Prussian blue, it also engages the Japanese pictorial tradition. Against a background with the low horizon typical of Western painting, Hokusai placed in the foreground the traditionally flat wave and its powerfully graphic forms.

**6-13** KATSUSHIKA HOKUSAI, *The Great Wave off Kanagawa,* from *Thirty-six Views of Mount Fuji,* Edo period, ca. 1826–1833. Woodblock print, ink and colors on paper, $9\frac{7}{8}'' \times 1' 2\frac{3}{4}''$. Museum of Fine Arts, Boston (Bigelow Collection).

Against a background with the low horizon line typical of Western painting, Hokusai placed a threatening wave in the foreground, painted using the traditional flat and powerful graphic forms of Japanese art.

# MODERN JAPAN

The Edo period and the rule of the shoguns ended in 1868, when rebellious samurai from provinces far removed from Edo toppled the Tokugawa. Facilitating this revolution was the shogunate's inability to handle increasing pressure from Western nations for Japan to open itself to the outside world. Although the rebellion restored direct sovereignty to the imperial throne, real power rested with the emperor's cabinet. As a symbol of imperial authority, however, the official name of this new period was Meiji ("Enlightened Rule"), after the emperor's chosen reign name.

## Meiji Period

Oil painting became a major genre in Japan in the late 19th century during the Meiji period (1868–1912). Ambitious students studied with Westerners at government schools and during trips abroad.

**TAKAHASHI YUICHI** One oil painting highlighting the cultural ferment of the early Meiji period is *Oiran* (*Grand Courtesan;* FIG. **6-14**), by TAKAHASHI YUICHI (1828–1894). The artist created it for a client nostalgic for vanishing elements of Japanese culture.

1 ft.

**6-14** TAKAHASHI YUICHI, *Oiran* (*Grand Courtesan*), Meiji period, 1872. Oil on canvas, 2′ 6½″ × 1′ 9⅝″. Tokyo National University of Fine Arts and Music, Tokyo.

The subject of Takahashi's *Oiran* and the abstract rendering of the courtesan's garment derive from the repertory of ukiyo-e printmakers and traditional Japanese art, but the oil technique is a Western import.

Ukiyo-e printmakers frequently represented similar grand courtesans of the pleasure quarters. In this painting, however, Takahashi (historical figures from the Meiji period onward are usually referred to by their family names, which come first, in contrast to earlier eras, when the second, given, name was used) did not portray the courtesan's features in the idealizing manner of ukiyo-e artists but in the more analytical manner of Western portraiture. Yet Takahashi's more abstract rendering of the garments reflects a very old practice in East Asian portraiture.

**YOKOYAMA TAIKAN** Unbridled enthusiasm for Westernization in some quarters led to resistance and concern over a loss of distinctive Japanese identity in other quarters. Ironically, one of those most eager to preserve "Japaneseness" in the arts was Ernest Fenollosa (1853–1908), an American professor of philosophy and political economy at Tokyo Imperial University. He and a former student named Okakura Kakuzo (1862–1913) joined with others in a movement that eventually led to the founding of an arts university dedicated to Japanese arts under Okakura's direction. Their goal for Japanese painting was to make it viable in the modern age rather than preserve it as a relic. To this end, they encouraged artists to incorporate some Western techniques such as chiaroscuro, perspective, and bright hues in Japanese-style paintings. The name given to the resulting style was *nihonga* (Japanese painting), as opposed to *yoga* (Western painting).

*Kutsugen* (FIG. **6-15**), a silk scroll by YOKOYAMA TAIKAN (1868–1958), is an example of nihonga. It combines a low horizon line and subtle shading effects taken from Western painting with East Asian techniques, such as anchoring a composition in one corner (FIGS. 3-24 and 4-14), employing strong ink brushwork to define contours, applying washes of water-and-glue-based pigments, and using applications of heavy mineral pigments. The painting's subject, a Chinese poet who fell out of the emperor's favor and subsequently committed suicide, no doubt resonated with the artist and his associates. It provided a nice analogy to a real-life situation. At the time, Okakura was locked in a battle over his artistic principles with the Ministry of Education. Whether intended or not, this painting, in which the poet stands his ground, staunchly defying the strong winds that agitate the foliage behind him, was perceived as a comment on the friction between Okakura and authorities.

## Showa Period

During the 20th century, Japan became increasingly prominent on the world stage in economics, politics, and culture. Among the events that propelled Japan into the spotlight was its participation in World War II during the Showa period (1926–1989). The most tragic consequences of that involvement were the widespread devastation and loss of life resulting from the atomic bombings of Hiroshima and Nagasaki in 1945. During the succeeding occupation period, the United States imposed new democratic institutions on Japan, with the emperor serving as only a ceremonial head of state. Japan's economy rebounded with remarkable speed, and during the ensuing half century Japan also assumed a positive and productive place in the international art world. As they did in earlier times with the art and culture of China and Korea, Japanese artists internalized Western lessons and transformed them into a part of Japan's own vital culture.

**TANGE KENZO** In the 20th century, Japanese architecture, especially public and commercial building, underwent rapid transformation along Western lines. In fact, architecture may be the art form

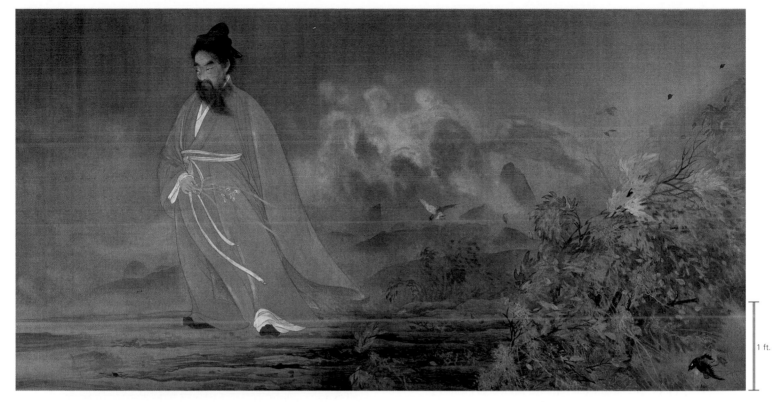

1 ft.

**6-15** Yokoyama Taikan, *Kutsugen*, Itsukushima Shrine, Hiroshima Prefecture, Japan, Meiji period, 1898. Hanging scroll, color on silk, 4′ 4″ × 9′ 6″.

This Meiji silk scroll combines a low horizon line and subtle shading effects taken from Western painting with Asian features, such as strong ink brushwork and anchoring of the composition in one corner.

providing Japanese practitioners the most substantial presence on the world scene today. Japanese architects have made major contributions to both modern and postmodern developments. One of the most daringly experimental architects of the post–World War II period was Tange Kenzo (1913–2005). In the design of the stadiums (FIG. 6-16) for the 1964 Olympics, he employed a cable suspension system that allowed him to shape steel and concrete into remarkably graceful structures. His attention to both the sculptural qualities of each building's raw concrete form and the fluidity of its spaces allied him with architects worldwide who carried on the legacy of the late style of Le Corbusier in France. His stadiums thus bear comparison with Joern Utzon's Sydney Opera House.

**6-16** Tange Kenzo, national indoor Olympic stadiums, Tokyo, Japan, Showa period, 1961–1964.

Tange was one of the most daring architects of post–World War II Japan. His Olympic stadiums employ a cable suspension system that allowed him to shape steel and concrete into remarkably graceful structures.

**6-17** Hamada Shoji, dish, Showa period, 1962. Black trails on translucent glaze, 1′ 10½″ diameter. National Museum of Modern Art, Kyoto.

Hamada was a leading figure in the modern folk art movement in Japan and gained international fame. His unsigned stoneware features casual slip designs and a coarser, darker texture than porcelain.

**6-18** Tsuchiya Kimio, *Symptom*, Showa period, 1987. Branches, 13′ 1½″ × 14′ 9⅛″ × 3′ 11¼″. Installation view, *Jeune Sculpture '87*, Paris 1987.

Tsuchiya's sculptures are constructed of branches or driftwood and despite their abstract nature assert the life forces found in natural materials. His approach to sculpture reflects ancient Shinto beliefs.

**HAMADA SHOJI** Another modern Japanese art form attracting great attention worldwide is ceramics. Many contemporary admirers of folk art are avid collectors of traditional Japanese pottery. A formative figure in Japan's folk art movement, the philosopher Yanagi Soetsu (1889–1961), promoted an ideal of beauty inspired by the Japanese tea ceremony. He argued that true beauty could be achieved only in functional objects made of natural materials by anonymous craftspeople. Among the ceramists who produced this type of folk pottery, known as *mingei*, was HAMADA SHOJI (1894–1978). Although Hamada did espouse Yanagi's selfless ideals, he still gained international fame and in 1955 received official recognition in Japan as a Living National Treasure. Works such as his dish (FIG. **6-17**) with casual slip designs are unsigned, but connoisseurs easily recognize them as his. This kind of stoneware is coarser, darker, and heavier than porcelain and lacks the latter's fine decoration. To those who appreciate simpler, earthier beauty, however, this dish holds great attraction. Hamada's artistic influence extended beyond the production of pots. He traveled to England in 1920 and, along with English potter Bernard Leach (1887–1978), established a community of ceramists committed to the mingei aesthetic. Together, Hamada and Leach expanded international knowledge of Japanese ceramics, and even now, the "Hamada-Leach aesthetic" is part of potters' education worldwide.

**TSUCHIYA KIMIO** Although no one style, medium, or subject dominates contemporary Japanese art, much of it does spring from ideas or beliefs that have been integral to Japanese culture over the years. For example, the Shinto belief in the generative forces in nature and in humankind's position as part of the totality of nature (see "Shinto," Chapter 5, page 93) holds great appeal for contemporary artists, including TSUCHIYA KIMIO (b. 1955), who produces large-scale sculptures (FIG. **6-18**) constructed of branches or driftwood. Despite their relatively abstract nature, his works assert the life forces found in natural materials, thereby engaging viewers in a consideration of their own relationship to nature. Tsuchiya does not specifically invoke Shinto when speaking about his art, but it is clear that he has internalized Shinto principles. He identifies as his goal "to bring out and present the life of nature emanating from this energy of trees. . . . It is as though the wood is part of myself, as though the wood has the same kind of life force."[1]

Tsuchiya is but one of many artists working in Japan today who have attracted international attention. Contemporary art in Japan, as elsewhere in the world, is multifaceted and ever-changing, and the traditional and the modern flourish side by side.

# JAPAN AFTER 1336

## MUROMACHI PERIOD, 1336–1573

■ The period takes its name from the Kyoto district in which the Ashikaga shoguns maintained their headquarters.

■ During the Muromachi period, Zen Buddhism rose to prominence in Japan. Zen temples often featured gardens of the karesansui (dry-landscape) type, which promoted meditation.

■ Muromachi painting displays great variety in both subject matter and style. One characteristic technique is the haboku (splashed-ink) style, which has Chinese roots. An early haboku master was Sesshu Toyo.

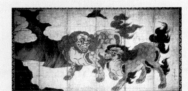

Sesshu Toyo, splashed-ink landscape, 1495

## MOMOYAMA PERIOD, 1573–1615

■ This brief interlude between two long-lasting shogunates was dominated by three successive warlords. The period takes its name from one of their castles (Momoyama, Peach Blossom Hill) outside Kyoto.

■ Many of the finest works of this period were commissions from those warlords, including *Chinese Lions* by Kano Eitoku, a six-part folding screen featuring animals considered to be symbols of power and bravery.

■ The Momoyama period also saw the Japanese tea ceremony become an important social ritual. The tea master Sen no Rikyu designed the first teahouse built as an independent structure. The favored tea utensils were rustic Shino wares.

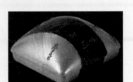

Kano Eitoku, *Chinese Lions*, late 16th century

## EDO PERIOD, 1615–1868

■ The Edo period began when the Momoyama shogun Tokugawa Ieyasu (1542–1616) moved his headquarters from Kyoto to Edo (modern Tokyo).

■ The Rinpa School, named for Ogata Korin, emerged as a major alternative school of painting to the Kano School, which became a virtual national art academy. Rinpa works, both paintings and crafts, feature vivid colors and extensive use of gold, as in the *Boat Bridge* writing box by Honami Koetsu.

Honami Koetsu, *Boat Bridge*, early 17th century

■ Growing urbanization in the major Japanese cities fostered a lively popular culture focused on sensual pleasure and theatrical entertainment. The best-known products of this sophisticated counterculture are the ukiyo-e woodblock prints of Edo's "floating world" by Suzuki Harunobu and others, which feature scenes from brothels and the theater as well as beautiful women in domestic settings.

■ The Katsura Imperial Villa, which relies on subtleties of proportion, color, and texture instead of ornament for its aesthetic appeal, set the standard for all later Japanese domestic architecture.

Suzuki Harunobu, *Evening Bell at the Clock*, ca. 1765

## MODERN JAPAN, 1868–Present

■ The Tokugawa shogunate toppled in 1868, opening the modern era of Japanese history. In art, Western styles and techniques had great influence, and many Japanese artists incorporated shading and perspective in their works and even produced oil paintings.

■ In the post–World War II period, Japanese architects achieved worldwide reputations. Tange Kenzo was a master of creating dramatic shapes using a cable suspension system for his concrete-and-steel buildings.

■ Contemporary art in Japan is multifaceted, and the traditional and the modern flourish side by side.

Tange Kenzo, Olympic stadiums, Tokyo, 1961–1964

**7-1** Court of the Lions, Palace of the Lions, Alhambra, Granada, Spain, 1354–1391.

The Palace of the Lions, named for its fountain's unusual statues, is distinctly Islamic in the use of multilobed pointed arches and the interweaving of Arabic calligraphy and abstract ornament in its stuccoed walls.

# THE ISLAMIC WORLD

The religion of Islam (an Arabic word meaning "submission to God") arose among the peoples of the Arabian Peninsula early in the seventh century (see "Muhammad and Islam," page 123). At the time, the Arabs were nomadic herders and caravan merchants traversing the vast Arabian desert and settling and controlling its coasts. They were peripheral to the Byzantine and Persian empires. Yet within little more than a century, the eastern Mediterranean, which Byzantium once ringed and ruled, had become an Islamic lake, and the armies of Islam had subdued the Middle East, long the seat of Persian dominance and influence.

The swiftness of the Islamic advance is among the wonders of world history. By 640, Muslims ruled Syria, Palestine, and Iraq in the name of Allah. In 642, the Byzantine army abandoned Alexandria, marking the Muslim conquest of Lower (northern) Egypt. In 651, the successors of Muhammad ended more than 400 years of Sasanian rule in Iran. All of North Africa was under Muslim control by 710. A victory at Jerez de la Frontera in southern Spain in 711 seemed to open all of western Europe to the Muslims. By 732, they had advanced north to Poitiers in France, but an army of Franks under Charles Martel, the grandfather of Charlemagne, opposed them successfully, halting Muslim expansion at the Pyrenees. In Spain, in contrast, the Islamic rulers of Córdoba flourished until 1031, and not until 1492 did Muslim influence and power end in the Iberian Peninsula. That year the army of King Ferdinand and Queen Isabella, the sponsors of Columbus's voyage to the New World, overthrew the caliphs of Granada. In the East, the Muslims reached the Indus River by 751, and only in Anatolia could stubborn Byzantine resistance slow their advance. Relentless Muslim pressure against the shrinking Byzantine Empire eventually caused its collapse in 1453, when the Ottoman Turks entered Constantinople.

Military might alone, however, cannot account for the relentless and far-ranging sweep of Islam from Arabia to India to North Africa and Spain (MAP 7-1). That Islam endured in the conquered lands for centuries after the initial victories can be explained only by the nature of the Islamic faith and its appeal to millions of converts. Islam remains today one of the world's great religions, with adherents on all

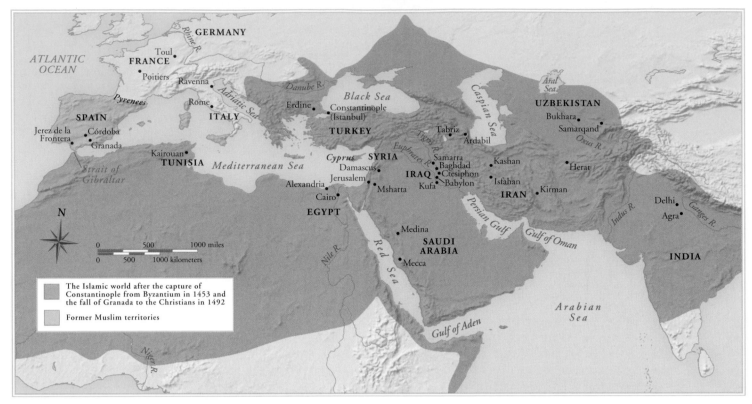

MAP 7-1 The Islamic world around 1500.

continents. Its sophisticated culture has had a profound impact around the globe. Arab scholars laid the foundations of arithmetic and algebra and made significant contributions to astronomy, medicine, and the natural sciences. Christian scholars in the West during the 12th and 13th centuries eagerly studied Arabic translations of Aristotle and other Greek writers of antiquity. Arabic love lyrics and poetic descriptions of nature inspired the early French troubadours.

The triumph of Islam also brought a new and compelling tradition to the history of world art and architecture. Like Islam itself, Islamic art spread quickly both eastward and westward from the land once inhabited by the peoples of the ancient Near East. In the Middle East and North Africa, Islamic art largely replaced Late Antique art. From a foothold in the Iberian Peninsula, Islamic art influenced Western medieval art. Islamic artists and architects also brought their distinctive style to South Asia, where a Muslim sultanate was established at Delhi in India in the early 13th century (see Chapter 2). In fact, perhaps the most famous building in Asia, the Taj Mahal (FIGS. 2-1 and 2-6) at Agra, is an Islamic mausoleum.

## EARLY ISLAMIC ART

During the early centuries of Islamic history, the Muslim world's political and cultural center was the Fertile Crescent of ancient Mesopotamia. The caliphs of Damascus (capital of modern Syria) and Baghdad (capital of Iraq) appointed provincial governors to rule the vast territories they controlled. These governors eventually gained relative independence by setting up dynasties in various territories and provinces: the Umayyads in Syria (661–750) and in Spain (756–1031), the Abbasids in Iraq (750–1258, largely nominal after 945), the Fatimids in Egypt (909–1171), and so on.

## Architecture

Like other potentates before and after, the Muslim caliphs were builders on a grand scale. The first Islamic buildings, both religious and secular, are in the Middle East, but important early examples of Islamic architecture still stand also in North Africa, Spain, and Central Asia.

**DOME OF THE ROCK** The first great Islamic building is the Dome of the Rock (FIG. 7-2) in Jerusalem. The Muslims had taken the city from the Byzantines in 638, and the Umayyad caliph Abd al-Malik (r. 685–705) erected the monumental shrine between 687 and 692 as an architectural tribute to the triumph of Islam. The Dome of the Rock marked the coming of the new religion to the city that was—and still is—sacred to both Jews and Christians. The structure rises from a huge platform known as the Noble Enclosure, where in ancient times the Hebrews built the Temple of Solomon that the Roman emperor Titus destroyed in 70. In time, the site took on additional significance as the reputed place where Adam was buried and where Abraham prepared to sacrifice Isaac. The rock that gives the building its name also later came to be identified with the spot from which Muhammad miraculously journeyed to Heaven and then, in the same night, returned to his home in Mecca.

As Islam took much of its teaching from Judaism and Christianity, so, too, its architects and artists borrowed and transformed design, construction, and ornamentation principles long applied in Byzantium and the Middle East. The Dome of the Rock is a domed octagon resembling San Vitale (FIG. 9-6) in Ravenna in its basic design. In all likelihood, a neighboring Christian monument, Constantine's Church of the Holy Sepulchre, a domed rotunda, inspired the Dome of the Rock's designers. That fourth-century rotunda bore a family resemblance to the roughly contemporary Constantinian

## Muhammad and Islam

**M**uhammad, founder of Islam and revered as its Final Prophet, was a native of Mecca on the west coast of Arabia. Born around 570 into a family of merchants in the great Arabian caravan trade, Muhammad was inspired to prophesy. Critical of the polytheistic religion of his fellow Arabs, he preached a religion of the one and only God ("Allah" in Arabic), whose revelations Muhammad received beginning in 610 and for the rest of his life. Opposition to Muhammad's message among the Arabs was strong enough to prompt the Prophet and his followers to flee from Mecca to a desert oasis eventually called Medina ("City of the Prophet"). Islam dates its beginnings from this flight in 622, known as the *Hijra* ("emigration").* Barely eight years later, in 630, Muhammad returned to Mecca with 10,000 soldiers. He took control of the city, converted the population to Islam, and destroyed all the idols. But he preserved as the Islamic world's symbolic center the small cubical building that had housed the idols, the *Kaaba* (from the Arabic for "cube"). The Arabs associated the Kaaba with the era of Abraham and Ishmael, the common ancestors of Jews and Arabs. Muhammad died in Medina in 632.

The essential meaning of Islam is acceptance of and submission to Allah's will. Believers in Islam are called Muslims ("those who submit"). Islam requires them to live according to the rules laid down in the collected revelations communicated through Muhammad during his lifetime. The *Koran,* Islam's sacred book, codified by the Muslim ruler Uthman (r. 644–656), records Muhammad's revelations. The word "Koran" means "recitations"—a reference to the archangel Gabriel's instructions to Muhammad in 610 to "recite in the name of Allah." The Koran is composed of 114 *surahs* ("chapters") divided into verses.

The profession of faith in the one God, Allah, is the first of five obligations binding all Muslims. In addition, the faithful must worship five times daily facing in Mecca's direction, give alms to the poor, fast during the month of Ramadan, and once in a lifetime—if possible—make a pilgrimage to Mecca. The revelations in the Koran are not the only guide for Muslims. Muhammad's exemplary ways and customs, collected in the *Sunnah,* offer models to the faithful on ethical problems of everyday life. The reward for the Muslim faithful is Paradise.

Islam has much in common with Judaism and Christianity. Its adherents think of it as a continuation, completion, and in some sense a reformation of those other great monotheisms. Islam incorporates many of the Old Testament teachings, with their sober ethical standards and rejection of idol worship, and those of the New Testament Gospels. Muslims acknowledge Adam, Abraham, Moses, and Jesus as the prophetic predecessors of Muhammad, the final and greatest of the prophets. Muhammad did not claim to be divine, as did Jesus. Rather, he was God's messenger, the purifier and perfecter of the common faith of Jews, Christians, and Muslims in one God. Islam also differs from Judaism and Christianity in its simpler organization. Muslims worship God directly, without a hierarchy of rabbis, priests, or saints acting as intermediaries.

In Islam, as Muhammad defined it, religious and secular authority were united even more completely than in Byzantium. Muhammad established a new social order, replacing the Arabs' old decentralized tribal one, and took complete charge of his community's temporal as well as spiritual affairs. After Muhammad's death, the *caliphs* (from the Arabic for "successor") continued this practice of uniting religious and political leadership in one ruler.

*Muslims date events beginning with the Hijra in the same way Christians reckon events from Christ's birth, and the Romans before them began their calendar with Rome's founding by Romulus and Remus in 753 BCE. The Muslim year, however, is a 354-day year of 12 lunar months, and dates cannot be converted by simply subtracting 622 from Christian-era dates.

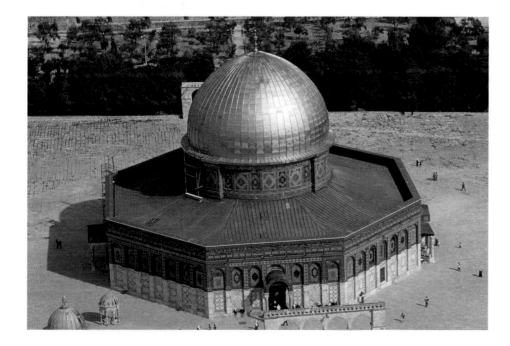

**7-2** Aerial view of the Dome of the Rock, Jerusalem, 687–692.

Abd al-Malik erected the Dome of the Rock to mark the triumph of Islam in Jerusalem on a site sacred to Muslims, Christians, and Jews. The shrine takes the form of an octagon with a towering dome.

much to Roman and Early Christian architecture. The Islamic builders incorporated stone blocks, columns, and capitals salvaged from the earlier structures on the land al-Walid acquired for his mosque. Pier *arcades* reminiscent of Roman aqueducts frame the courtyard (FIG. 7-5). The minarets, two at the southern corners and one at the northern side of the enclosure—the earliest in the Islamic world—are modifications of the preexisting Roman square towers. The grand prayer hall, taller than the rest of the complex, is on the south side of the courtyard (facing Mecca). Its main entrance is distinguished by a facade with a pediment and arches, recalling Roman and Byzantine models. The facade faces into the courtyard, like a Roman forum temple, a plan maintained throughout the long history of mosque architecture. The Damascus mosque synthesizes elements received from other cultures into a novel architectural unity, which includes the distinctive Islamic elements of mihrab, mihrab dome, minbar, and minaret.

An extensive cycle of mosaics once covered the walls of the Great Mosque. In one of the surviving sections (FIG. 7-4), a conch-shell niche "supports" an arcaded pavilion with a flowering rooftop flanked by structures shown in classical perspective. Like the architectural design, the mosaics owe much to Roman, Early Christian, and Byzantine art. Indeed, some evidence indicates that the Great Mosque mosaics were the work of Byzantine mosaicists. Characteristically, temples, clusters of houses, trees, and rivers compose the

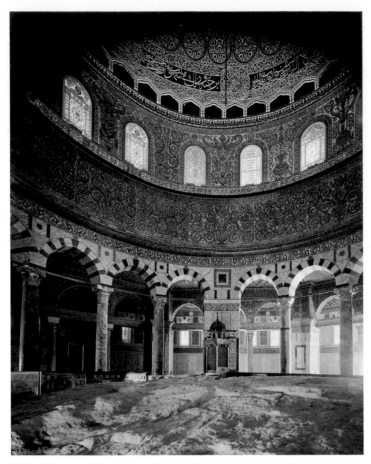

**7-3** Interior of the Dome of the Rock, Jerusalem, 687–692.

Tiles from the 16th century adorn the exterior of the Dome of the Rock, but the interior's original mosaic ornament is preserved. The mosaics conjure the imagery of Paradise awaiting Muslims.

mausoleum later dedicated as Santa Costanza in Rome. The Dome of the Rock is a member of the same extended family. Its double-shelled wooden dome, however, some 60 feet across and 75 feet high, so dominates the elevation as to reduce the octagon to function merely as its base. This soaring, majestic unit creates a decidedly more commanding effect than that produced by Late Roman and Byzantine domical structures. The silhouettes of those domes are comparatively insignificant when seen from the outside.

The building's exterior has been much restored. Tiling from the 16th century and later has replaced the original mosaic. Yet the vivid, colorful patterning that wraps the walls like a textile is typical of Islamic ornamentation. It contrasts markedly with Byzantine brickwork and Greco-Roman sculptured decoration. The interior's rich mosaic ornament (FIG. 7-3) has been preserved and suggests the original appearance of the exterior walls. Islamic practice does not significantly distinguish interior and exterior decor.

**GREAT MOSQUE, DAMASCUS** The Umayyads transferred their capital from Mecca to Damascus in 661. There, Abd al-Malik's son, the caliph al-Walid (r. 705–715), purchased a Byzantine church (formerly a Roman temple) and built an imposing new mosque for the expanding Muslim population (see "The Mosque," page 125). The Umayyads demolished the church, but they used the Roman precinct walls as a foundation for their own construction. Like the Dome of the Rock, Damascus's Great Mosque (FIGS. 7-4 and 7-5) owes

**7-4** Detail of a mosaic in the courtyard arcade of the Great Mosque, Damascus, Syria, 706–715.

The mosaics of the Great Mosque at Damascus are probably the work of Byzantine artists and include buildings and landscape elements common in Late Antique art, but exclude any zoomorphic forms.

## The Mosque

Islamic religious architecture is closely related to Muslim prayer, an obligation laid down in the Koran for all Muslims. In Islam, worshiping can be a private act and requires neither prescribed ceremony nor a special locale. Only the *qibla*—the direction (toward Mecca) Muslims face while praying—is important. But worship also became a communal act when the first Muslim community established a simple ritual for it. To celebrate the Muslim sabbath, which occurs on Friday, the community convened each Friday at noon, probably in the Prophet's house in Medina. The main feature of Muhammad's house was a large square court with rows of palm trunks supporting thatched roofs along the north and south sides. The southern side, which faced Mecca, was wider and had a double row of trunks. The *imam*, or leader of collective worship, stood on a stepped pulpit, or *minbar*, set up in front of the southern (qibla) wall.

These features became standard in the Islamic house of worship, the *mosque* (from Arabic "masjid," a place of prostration), where the faithful gathered for the five daily prayers. The *congregational mosque* (also called the *Friday mosque* or *great mosque*) was ideally large enough to accommodate a community's entire population for the Friday noon prayer. A very important feature both of ordinary mosques and of congregational mosques is the *mihrab* (FIG. 7-8, no. 2), a semicircular niche usually set into the qibla wall. Often a dome over the bay in front of it marked its position (FIGS. 7-5 and 7-8, no. 3). The niche was a familiar Greco-Roman architectural feature, generally enclosing a statue. Scholars still debate its origin, purpose, and meaning in Islamic architecture. The mihrab originally may have honored the place where the Prophet stood in his house at Medina when he led communal worship.

In some mosques, a *maqsura* precedes the mihrab. The maqsura is the area generally reserved for the ruler or his representative and can be quite elaborate in form (FIG. 7-12). Many mosques also have one or more *minarets* (FIGS. 7-5, 7-9, AND 7-20), towers used to call the faithful to worship. When buildings of other faiths were converted into mosques, the Muslims clearly signaled the change on the exterior by the erection of minarets. *Hypostyle halls*, communal worship halls with roofs held up by a multitude of columns (FIGS. 7-8, no. 4, and 7-11), are characteristic features of early mosques. Later variations include mosques with four *iwans* (vaulted rectangular recesses), one on each side of the courtyard (FIGS. 7-22 and 7-23), and *central-plan* mosques with a single large dome-covered interior space (FIGS. 7-20 and 7-21), as in Byzantine churches, some of which later became mosques.

The mosque's origin is still in dispute, although one prototype may well have been the Prophet's house in Medina. Today, despite many variations in design and detail (an adobe-and-wood mosque in Mali, FIGS. 10-1 and 10-8, is discussed later in the context of African architecture) and the employment of modern building techniques and materials unknown in Muhammad's day, the mosque's essential features are unchanged. All mosques, wherever they are built and whatever their plan, are oriented toward Mecca, and the faithful worship facing the qibla wall.

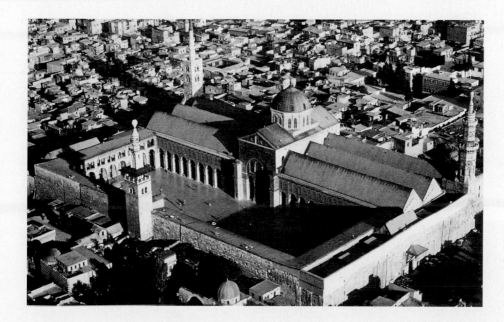

**7-5** Aerial view of the Great Mosque, Damascus, Syria, 706–715.

The hypostyle type of mosque most closely recalls the layout of Muhammad's house in Medina. Damascus's Great Mosque also owes a debt to Roman and Early Christian architecture in its plan and decoration.

pictorial fields, bounded by stylized vegetal designs also found in Roman, Early Christian, and Byzantine ornament. No zoomorphic forms, human or animal, appear in either the pictorial or ornamental spaces. This is true of all the mosaics in the Great Mosque as well as the mosaics in the earlier Dome of the Rock (FIG. 7-3). Islamic tradition shuns the representation of fauna of any kind in sacred places. Accompanying (but now lost) inscriptions explained the world shown in the Damascus mosaics, suspended miragelike in a featureless field of gold, as an image of Paradise. Many passages from the Koran describe the gorgeous places of Paradise awaiting the faithful—gardens, groves of trees, flowing streams, and "lofty chambers."

## UMAYYAD PALACE, MSHATTA

The Umayyad rulers of Damascus constructed numerous palatial residences throughout their domains. The urban palaces are lost, but some rural palaces survive. The latter were not merely idyllic residences removed from the congestion, noise, and disease of the cities. They seem to have served as nuclei for the agricultural development of acquired territories and possibly as hunting lodges. In addition, the Islamic palaces were symbols of authority over new lands as well as expressions of their owners' wealth.

One of the most impressive Umayyad palaces, despite the fact that it was never completed, is at Mshatta in the Jordanian desert. Its plan (FIG. **7-6**) resembles that of Diocletian's palace at Split, which in turn reflects the layout of a Roman fortified camp. The high walls of the Mshatta palace incorporate 25 towers but lack parapet walkways for patrolling guards. The walls, nonetheless, offered safety from marauding nomadic tribes and provided privacy for the caliph and his entourage. Visitors entered the palace through a large portal on the south side. To the right was a mosque (FIG. **7-6**, no. 2; the plan shows the mihrab niche in the qibla wall), in which the rulers and their guests could fulfill their obligation to pray five times a day. A small ceremonial area and an immense open courtyard separated the mosque from the palace's residential wing and official audience hall. Most Umayyad palaces also boasted fairly elaborate bathing facilities that displayed technical features, such as heating systems, adopted from Roman baths. Just as under the Roman Empire, these baths probably served more than merely hygienic purposes. Indeed, in several Umayyad palaces, excavators have uncovered in the baths paintings and sculptures of hunting and other secular themes, including depictions of dancing women—themes traditionally associated with royalty in the Near East. Large halls frequently attached to many of these baths seem to have been used as places of entertainment, as was the case in Roman times. Thus, the bath-spa as social center, a characteristic amenity of Roman urban culture that died out in the Christian world, survived in Islamic culture.

A richly carved stone frieze (FIG. **7-7**) more than 16 feet high enlivens the facade of the Mshatta palace. Triangles contain large rosettes projecting from a field densely covered with curvilinear,

**7-6** Plan of the Umayyad palace, Mshatta, Jordan, ca. 740–750 (after Alberto Berengo Gardin).

The fortified palace at Mshatta resembled Diocletian's palace at Split and incorporated the amenities of Roman baths but also housed a mosque in which the caliph could worship five times daily.

1. Entrance gate
2. Mosque
3. Small courtyard
4. Large courtyard
5. Audience hall

0    25    50    75    100 feet
0    10    20    30 meters

vegetal designs. No two triangles are exactly alike. Animals appear in some of them. Similar compositions of birds, felines, and vegetal scrolls can be found in Roman, Byzantine, and Sasanian art. The Mshatta frieze, however, in keeping with Islam's disavowal of representing living things in sacred contexts, has no animal figures to the right of the entrance portal—that is, on the part of the facade corresponding to the mosque's qibla wall.

**BAGHDAD** In 750, after years of civil war, the Abbasids, who claimed descent from Abbas, an uncle of Muhammad, overthrew the Umayyad caliphs. The new rulers moved the capital from Damascus to a site in Iraq near the old Sasanian capital of Ctesiphon. There the caliph al-Mansur (r. 754–775) established a new capital, Baghdad, which he called Madina al-salam, the City of Peace. The city was laid out in 762 at a time astrologers determined as favorable. It was

**7-7** Frieze of the Umayyad palace, Mshatta, Jordan, ca. 740–750. Limestone, 16′ 7″ high. Museum für Islamische Kunst, Staatliche Museen, Berlin.

A long stone frieze richly carved with geometric, plant, and animal motifs decorated the facade of the Mshatta palace. No animals appear, however, on the exterior wall of the palace's mosque.

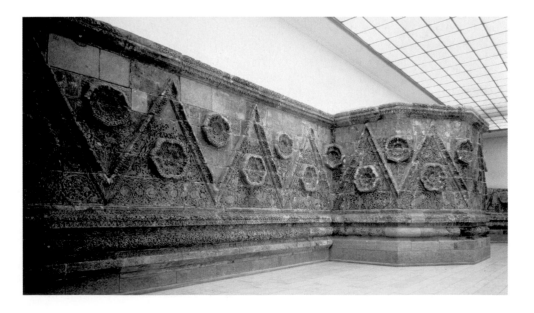

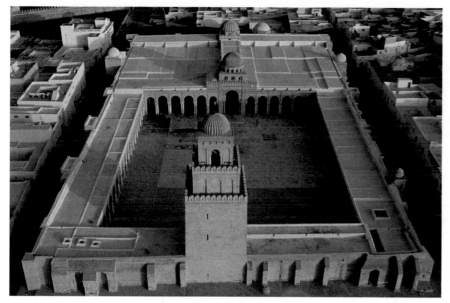

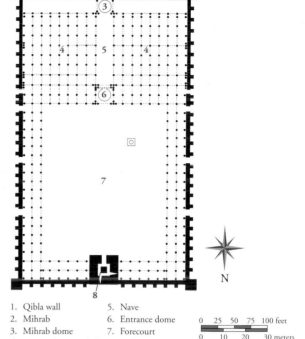

**7-8** Aerial view (*left*) and plan (*right*) of the Great Mosque, Kairouan, Tunisia, ca. 836–875.

The arcaded forecourt in front of the hypostyle hall of the Kairouan mosque resembles a Roman forum, but it incorporates the distinctive Islamic elements of mihrab, mihrab dome, minbar, and minaret.

1. Qibla wall
2. Mihrab
3. Mihrab dome
4. Hypostyle prayer hall
5. Nave
6. Entrance dome
7. Forecourt
8. Minaret

0  25  50  75  100 feet
0  10  20  30 meters

N

round in plan, about a mile and a half in diameter. The shape signified that the new capital was the center of the universe. At the city's center was the caliph's palace, oriented to the four compass points. For almost 300 years Baghdad was the hub of Arab power and of a brilliant Islamic culture. The Abbasid caliphs were renowned throughout the world and even established diplomatic relations with Charlemagne in Germany. The Abbasids lavished their wealth on art, literature, and science and were responsible for the translation of numerous Greek texts that otherwise would have been lost. Many of these works were introduced to the medieval West through their Arabic versions.

**GREAT MOSQUE, KAIROUAN** Of all the variations in mosque plans, the hypostyle mosque most closely reflects the mosque's supposed origin, Muhammad's house in Medina (see "The Mosque," page 125). One of the finest hypostyle mosques, still in use today, is the mid-eighth-century Great Mosque (FIG. **7-8**) at Kairouan in Abbasid Tunisia. It still houses its carved wooden minbar of 862, the oldest known. The precinct takes the form of a slightly askew parallelogram of huge scale, some 450 × 260 feet. Built of stone, its walls have sturdy buttresses, square in profile. A series of lateral entrances on the east and west lead to an arcaded forecourt (FIG. **7-8**, no. 7) resembling a Roman forum, oriented north-south on axis with the mosque's impressive minaret (no. 8) and the two domes of the hypostyle prayer hall (no. 4). The first dome (no. 6) is over the entrance bay, the second (no. 3) over the bay that fronts the mihrab (no. 2) set into the qibla wall (no. 1). A raised nave connects the domed spaces and prolongs the north-south axis of the minaret and courtyard. Eight columned aisles flank the nave on either side, providing space for a large congregation.

**MALWIYA MINARET, SAMARRA** The three-story minaret of the Kairouan mosque is square in plan, and scholars believe it is a near copy of a Roman lighthouse, but minarets can take a variety of forms. Perhaps the most striking and novel is that of the immense (more than 45,000 square yards) Great Mosque at Samarra, Iraq, the largest mosque in the world. The Abbasid caliph al-Mutawakkil (r. 847–861) erected it between 848 and 852. Known as the Malwiya ("snail shell" in Arabic) Minaret (FIG. **7-9**) and more than 165 feet

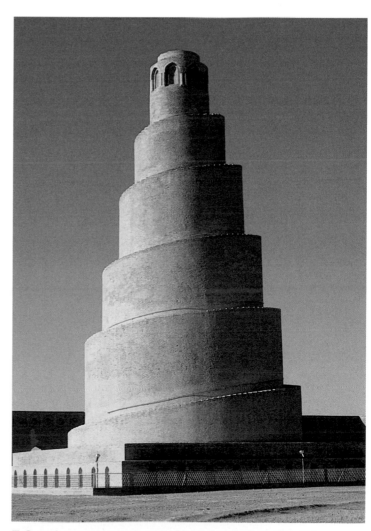

**7-9** Malwiya Minaret, Great Mosque, Samarra, Iraq, 848–852.

The unique spiral Malwiya (snail shell) Minaret of Samarra's Great Mosque is more than 165 feet tall and can be seen from afar. It served to announce the presence of Islam in the Tigris Valley.

Early Islamic Art **127**

Babel. Too tall to have been used to call Muslims to prayer, the Malwiya Minaret, visible from a considerable distance in the flat plain around Samarra, was probably intended to announce the presence of Islam in the Tigris Valley. Unfortunately, in 2005 the minaret suffered some damage during the Iraqi insurgency.

**SAMANID MAUSOLEUM, BUKHARA** Dynasties of governors who exercised considerable independence while recognizing the ultimate authority of the Baghdad caliphs oversaw the eastern realms of the Abbasid Empire. One of these dynasties, the Samanids (r. 819–1005), presided over the eastern frontier beyond the Oxus River (Transoxiana) on the border with India. In the early 10th century, they erected an impressive domed brick mausoleum (FIG. **7-10**) at Bukhara in modern Uzbekistan. Monumental tombs were virtually unknown in the early Islamic period. Muhammad opposed elaborate burials and instructed his followers to bury him in a simple unmarked grave. In time, however, the Prophet's resting place in Medina acquired a wooden screen and a dome. By the ninth century, Abbasid caliphs were laid to rest in dynastic mausoleums.

The Samanid mausoleum at Bukhara is one of the earliest preserved tombs in the Islamic world. Constructed of baked bricks, it takes the form of a dome-capped cube with slightly sloping sides. With exceptional skill, the builders painstakingly shaped the bricks to create a vivid and varied surface pattern. Some of the bricks form *engaged columns* (half-round, attached columns) at the corners. A brick *blind arcade* (a series of arches in relief, with blocked openings) runs around all four sides. Inside, the walls are as elaborate as the exterior. The brick dome rests on arcuated brick *squinches* framed by engaged *colonnettes* (thin columns). The dome-on-cube form had a long and distinguished future in Islamic funerary architecture (FIGS. 2-1 and 7-18).

**GREAT MOSQUE, CÓRDOBA** At the opposite end of the Muslim world, Abd al-Rahman I, the only eminent Umayyad to escape the Abbasid massacre of his clan in Syria, fled to Spain in 750. There, the Arabs had overthrown the Christian kingdom of the Visigoths in 711. The Arab military governors of the peninsula accepted the fugitive as their overlord, and he founded the Spanish Umayyad dynasty, which lasted almost three centuries. The capital of the Spanish Umayyads was Córdoba, which became the center of a brilliant culture rivaling that of the Abbasids at Baghdad and exerting major influence on the civilization of the Christian West.

The jewel of the capital at Córdoba was its Great Mosque, begun in 784 and enlarged several times during the 9th and 10th centuries. It eventually became one of the largest mosques in the Islamic West. The hypostyle prayer hall (FIG. **7-11**) has 36 piers

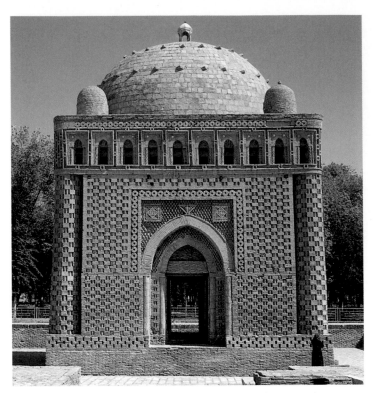

**7-10** Mausoleum of the Samanids, Bukhara, Uzbekistan, early 10th century.

Monumental tombs were virtually unknown in the early Islamic period. The Samanid mausoleum at Bukhara is one of the oldest. Its dome-on-cube form had a long afterlife in Islamic funerary architecture.

tall, it now stands alone, but originally a bridge linked it to the mosque. The distinguishing feature of the brick tower is its stepped spiral ramp, which increases in slope from bottom to top. Once thought to be an ancient Mesopotamian *ziggurat,* the Samarra minaret inspired some European depictions of the biblical Tower of

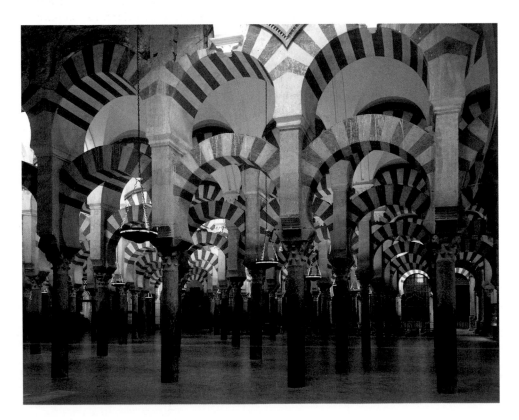

**7-11** Prayer hall of the Great Mosque, Córdoba, Spain, 8th to 10th centuries.

Córdoba was the capital of the Umayyad dynasty in Spain. In the Great Mosque's hypostyle prayer hall, 36 piers and 514 columns support a unique series of double-tiered horseshoe-shaped arches.

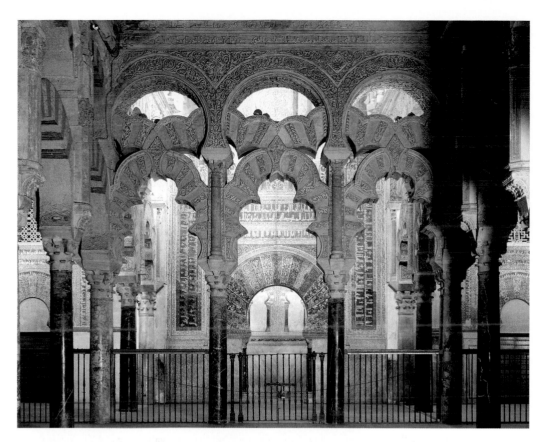

and 514 columns topped by a unique system of double-tiered arches that carried a wooden roof (later replaced by vaults). The two-story system was the builders' response to the need to raise the roof to an acceptable height using short columns that had been employed earlier in other structures. The lower arches are horseshoe-shaped, a form perhaps adapted from earlier Near Eastern architecture or of Visigothic origin. In the West, the horseshoe arch quickly became closely associated with Muslim architecture. Visually, these arches seem to billow out like windblown sails, and they contribute greatly to the light and airy effect of the Córdoba mosque's interior.

The caliph al-Hakam II (r. 961–976) undertook major renovations to the mosque. His builders expanded the prayer hall and added a series of domes. They also erected the elaborate maqsura (FIG. **7-12**), the area reserved for the caliph and connected to his palace by a corridor in the qibla wall. The Córdoba maqsura is a prime example of Islamic experimentation with highly decorative, multilobed arches. The builders created rich and varied abstract patterns and further enhanced the magnificent effect of the complex arches by sheathing the walls with marbles and mosaics. The mosaicists and even the tesserae were brought to Spain from Constantinople by al-Hakam II, who wished to emulate the great mosaic-clad monuments his Umayyad predecessors had erected in Jerusalem (FIG. **7-3**) and Damascus (FIG. **7-4**).

The same desire for decorative effect also inspired the design of the dome (FIG. **7-13**) that covers the area in front of the mihrab. One of the four domes built during the 10th century to emphasize the axis leading to the mihrab, the dome rests on an octagonal base of arcuated squinches. Crisscrossing ribs form an intricate pattern centered on two squares set at 45-degree angles to each other. The mosaics are the work of the same Byzantine artists responsible for the maqsura's decoration.

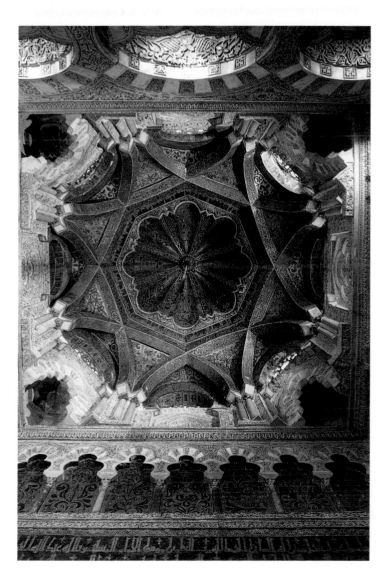

**7-13** Dome in front of the mihrab of the Great Mosque, Córdoba, Spain, 961–965.

The dome in front of the Córdoba mihrab rests on an octagonal base of arcuated squinches. Crisscrossing ribs form an intricate decorative pattern. Byzantine artists fashioned the mosaic ornament.

## Luxury Arts

The furnishings of Islamic mosques and palaces reflect a love of sumptuous materials and rich decorative patterns. Muslim artisans skillfully worked metal, wood, glass, and ivory into a great variety of objects for sacred spaces or the home. Glass workers used colored glass with striking effect in mosque lamps. Artisans produced numerous ornate ceramics of high quality and created basins, ewers, jewel cases, writing boxes, and other decorative items from bronze or brass, often engraving these pieces and adding silver inlays. Artists employed silk and wool to fashion textiles featuring both abstract and pictorial motifs. Because wood is scarce in most of the Islamic world, the kinds of furniture used in the West—beds, tables, and chairs—are rare in Muslim buildings. Movable furnishings, therefore, do not define Islamic architectural spaces. A room's function (eating or sleeping, for example) can be changed simply by rearranging the carpets and cushions.

**SILK** Silk textiles are among the glories of Islamic art. Unfortunately, because of their fragile nature, early Islamic textiles are rare today and often fragmentary. Silk thread was also very expensive. Silkworms, which can flourish only in certain temperate regions, produce silk. Silk textiles were manufactured first in China in the third millennium BCE. They were shipped over what came to be called the Silk Road through Asia to the Middle East and Europe (see "Silk and the Silk Road," Chapter 3, page 54).

One of the earliest Islamic silks (FIG. **7-14**) is today in Nancy, France, and probably dates to the eighth century. Unfortunately, the textile is fragmentary, and its colors, once rich blues, greens, and oranges, faded long ago. Said to come from Zandana near Bukhara, the precious fabric survives because of its association with the relics of Saint Amon housed in Toul Cathedral. It may have been used to wrap the treasures when they were transported to France in 820. The design, perhaps based on Sasanian models, consists of repeated medallions with confronting lions flanking a palm tree. Other animals scamper across the silk between the *roundels* (*tondi*, or circular frames). Such zoomorphic motifs are foreign to the decorative vocabulary of mosque architecture, but they could be found in Muslim households—even in Muhammad's in Medina. The Prophet, however, objected to curtains decorated with human or animal figures and permitted only cushions adorned with animals or birds.

**METALWORK** One of the most striking examples of Islamic metalwork is the cast brass ewer (FIG. **7-15**) in the form of a bird signed by SULAYMAN and dated 796. Some 15 inches tall, the ewer is nothing less than a freestanding statuette, although the holes between the eyes and beak function as a spout and betray its utilitarian purpose. The decoration on the body, which bears traces of silver and copper inlay, takes a variety of forms. In places, the incised lines seem to suggest natural feathers, but the rosettes on the neck, the large

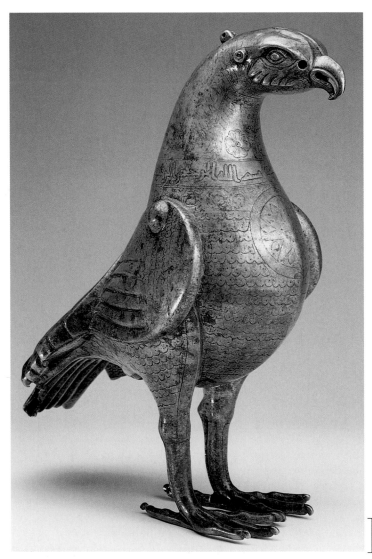

**7-14** Confronting lions and palm tree, fragment of a textile said to be from Zandana, near Bukhara, Uzbekistan, eighth century. Silk compound twill, 2′ 11″ × 2′ 9½″. Musée Historique de Lorraine, Nancy.

Early examples of Islamic silk textiles are rare because of their fragile nature. This fragmentary fabric from Uzbekistan features animal motifs that were common in secular contexts but shunned for mosques.

**7-15** SULAYMAN, Ewer in the form of a bird, 796. Brass with silver and copper inlay, 1′ 3″ high. Hermitage, Saint Petersburg.

Signed and dated by its maker, this utilitarian bird ewer resembles a freestanding statuette. The engraved decoration of the body combines natural feathers with abstract motifs and Arabic calligraphy.

1 in.

**7-16** Koran page with the beginning of surah 18, "Al-Kahf" (The Cave), 9th or early 10th century. Ink and gold on vellum, $7\frac{1}{4}'' \times 10\frac{1}{4}''$. Chester Beatty Library and Oriental Art Gallery, Dublin.

The stately rectilinear Kufic script was used in the oldest known Korans. This page has five text lines and a palm-tree finial but characteristically does not include any depictions of animals or humans.

medallions on the breast, and the inscribed collar have no basis in anatomy. Similar motifs appear in Islamic textiles, pottery, and architectural tiles. The ready adaptability of motifs to various scales and techniques illustrates both the flexibility of Islamic design and the relative independence of the motifs from the surfaces they decorate.

**CALLIGRAPHY** In the Islamic world, the art of *calligraphy,* ornamental writing, held a place of honor even higher than the art of textiles. The faithful wanted to reproduce the Koran's sacred words in as beautiful a script as human hands could contrive. Passages from the Koran appeared not only on the fragile pages of books but also on the walls of buildings, for example, in the mosaic band above the outer ring of columns inside the Dome of the Rock (FIG. 7-3). The practice of calligraphy was itself a holy task and required long and arduous training. The scribe had to possess exceptional spiritual refinement, as attested by an ancient Arabic proverb that proclaims "Purity of writing is purity of soul." Only in China does calligraphy hold as elevated a position among the arts (see "Calligraphy and Inscriptions on Chinese Paintings," Chapter 4, page 80).

Arabic script predates Islam. It is written from right to left with certain characters connected by a baseline. Although the chief

Islamic book, the sacred Koran, was codified in the mid-seventh century, the earliest preserved Korans are datable to the ninth century. Koran pages were either bound into books or stored as loose sheets in boxes. Most of the early examples feature texts written in the script form called *Kufic,* after the city of Kufa, one of the renowned centers of Arabic calligraphy. Kufic script is quite angular, with the uprights forming almost right angles with the baseline. As with Hebrew and other Semitic languages, the usual practice was to write in consonants only. But to facilitate recitation of the Koran, scribes often indicated vowels by red or yellow symbols above or below the line.

All of these features can be seen on a 9th- or early-10th-century page (FIG. 7-16) now in Dublin that carries the heading and opening lines of surah 18 of the Koran. Five text lines in black ink with red vowels appear below a decorative band incorporating the chapter title in gold and ending in a palm-tree *finial* (a crowning ornament). This approach to page design has parallels at the extreme northwestern corner of the then-known world—in the early medieval manuscripts of the British Isles, where text and ornament are similarly united. But the stylized human and animal forms that populate those Christian books never appear in Korans.

Early Islamic Art **131**

# LATER ISLAMIC ART

The great centers of early Islamic art and architecture continued to flourish in the second millennium, but important new regional artistic centers emerged, especially in Turkey and South Asia. The discussion here centers on the later art and architecture of the Islamic Middle East, Spain, and Turkey. Developments in India are treated in Chapter 2.

## Architecture

In the early years of the 11th century, the Umayyad caliphs' power in Spain unraveled, and their palaces fell prey to Berber soldiers from North Africa. The Berbers ruled southern Spain for several generations but could not resist the pressure of Christian forces from the north. Córdoba fell to the Christians in 1236. From then until the final Christian triumph in 1492, the Nasrids, an Arab dynasty that had established its capital at Granada in 1230, ruled the remaining Muslim territories in Spain.

**ALHAMBRA** On a rocky spur at Granada, the Nasrids constructed a huge palace-fortress called the Alhambra ("the Red" in Arabic) because of the rose color of the stone used for its walls and 23 towers. By the end of the 14th century, the complex, a veritable city with a population of 40,000, included at least a half dozen royal residences. Only two of these fared well over the centuries. Paradox-ically, they owe their preservation to the Christian victors, who maintained a few of the buildings as trophies commemorating the expulsion of the Nasrids. The two palaces present a vivid picture of court life in Islamic Spain before the Christian reconquest.

The Palace of the Lions takes its name from its courtyard (FIG. **7-1**) that boasts a fountain with marble lions carrying a water basin on their backs. Colonnaded courtyards with fountains and statues have a long history in the Mediterranean world, especially in the houses and villas of the Roman Empire. The Alhambra's lion fountain is an unusual instance of freestanding stone sculpture in the Islamic world, unthinkable in a sacred setting. But the design of the courtyard is distinctly Islamic and features many multilobed pointed arches and lavish stuccoed walls in which calligraphy and abstract motifs are interwoven. The palace was the residence of Muhammad V (r. 1354–1391), and its courtyards, lush gardens, and luxurious carpets and other furnishings served to conjure the image of Paradise.

The Palace of the Lions is noteworthy also for its elaborate stucco ceilings. A spectacular example is the dome (FIG. **7-17**) of the so-called Hall of the Two Sisters. The dome rests on an octagonal drum supported by squinches and pierced by eight pairs of windows, but its structure is difficult to discern because of the intricate carved stucco decoration. The ceiling is covered with some 5,000 *muqarnas*—tier after tier of stalactite-like prismatic forms that seem aimed at denying the structure's solidity. The muqarnas ceiling was intended to catch and reflect sunlight as well as form beautiful

**7-17** Muqarnas dome, Hall of the Two Sisters, Palace of the Lions, Alhambra, Granada, Spain, 1354–1391.

The structure of this dome on an octagonal drum is difficult to discern because of the intricately carved stucco muqarnas decoration. The prismatic forms catch and reflect sunlight, creating the effect of a starry sky.

**7-18** Madrasa-mosque-mausoleum complex of Sultan Hasan (looking northwest with the mausoleum in the foreground), Cairo, Egypt, begun 1356.

Hasan's mausoleum is a gigantic version of the much earlier Samanid mausoleum (FIG. 7-10). Because of its location directly south of the complex's mosque, praying Muslims faced the Mamluk sultan's tomb.

abstract patterns. The lofty vault in this hall and others in the palace symbolized the dome of Heaven. The flickering light and shadows create the effect of a starry sky as the sun's rays glide from window to window during the day. To underscore the symbolism, the palace walls bear inscriptions with verses by the court poet Ibn Zamrak (1333–1393), who compared the Alhambra's lacelike muqarnas ceilings to "the heavenly spheres whose orbits revolve."

**MAUSOLEUM OF SULTAN HASAN** In the mid-13th century, under the leadership of Genghis Khan, the Mongols from east-central Asia (see Chapter 4) conquered much of the eastern Islamic world. The center of Islamic power moved from Baghdad to Egypt. The lords of Egypt at the time were former Turkish slaves ("mamluks" in Arabic) who converted to Islam. The capital of the Mamluk *sultans* (rulers) was Cairo, which became the largest Muslim city of the late Middle Ages. The Mamluks were prolific builders, and Sultan Hasan, although not an important figure in Islamic history, was the most ambitious of all. He ruled briefly as a child and was deposed, but regained the sultanate in 1354. He was assassinated in 1361.

Hasan's major building project in Cairo was a huge madrasa complex (FIGS. 7-18 and 7-19) on a plot of land about 8,000 square yards in area. A *madrasa* ("place of study" in Arabic) is a theological college devoted to the teaching of Islamic law. Hasan's complex was so large that it housed not only four such colleges for the study of the four major schools of Islamic law but also a mosque,

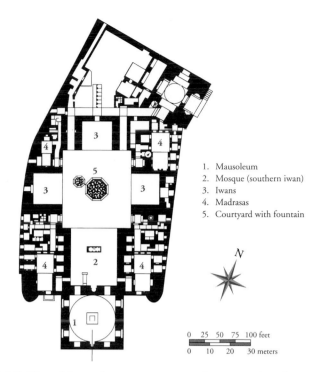

**7-19** Plan of the madrasa-mosque-mausoleum complex of Sultan Hasan, Cairo, Egypt, begun 1356.

Sultan Hasan's complex comprised four madrasas as well as a mosque, his tomb, and various other buildings. The plan with four iwans opening onto a central courtyard derives from that of Iranian mosques.

1. Mausoleum
2. Mosque (southern iwan)
3. Iwans
4. Madrasas
5. Courtyard with fountain

mausoleum, orphanage, and hospital, as well as shops and baths. Like all Islamic building complexes incorporating religious, educational, and charitable functions, this one was supported by an endowment funded by rental properties. The income from these paid the salaries of attendants and faculty, provided furnishings and supplies such as oil for the lamps or free food for the poor, and supported scholarships for needy students.

The grandiose structure has a large central courtyard (FIG. 7-19, no. 5) with a monumental fountain in the center and four vaulted iwans opening onto it, a design used earlier for Iranian mosques (see "The Mosque," page 125). In each corner of the main courtyard, between the iwans (FIG. 7-19, no. 3), is a madrasa (no. 4) with its own courtyard and four or five stories of rooms for the students. The largest iwan (no. 2) in the complex, on the southern side, served as a mosque. Contemporaries believed the soaring vault that covered this iwan was taller than the arch of the Sasanian palace at Ctesiphon, which was then one of the most admired engineering feats in the world. Behind the qibla wall stands the sultan's mausoleum (FIGS. 7-18 and 7-19, no. 1), a gigantic version of the type of the Samanid tomb (FIG. 7-10) at Bukhara. The builders intentionally placed the dome-covered cube south of the mosque so that the prayers of the faithful facing Mecca would be directed toward Hasan's tomb. (Only the sultan's two sons are buried there, however. Hasan's body was not returned when he was killed.)

A muqarnas cornice crowns the exterior walls of the complex, and marble plaques of several colors cover the mihrab in the mosque and the walls of Hasan's mausoleum. But the complex as a whole is relatively austere, characterized by its massiveness and geometric clarity. It presents a striking contrast to the filigreed elegance of the contemporary Alhambra (FIGS. 7-1 and 7-17) and testifies to the diversity of regional styles within the Islamic world, especially after the end of the Umayyad and Abbasid dynasties.

## Sinan the Great and the Mosque of Selim II

Sinan (ca. 1491–1588), called Sinan the Great, was truly the greatest Ottoman architect. Born a Christian, he was recruited for service in the Ottoman government, converted to Islam, and was trained in engineering and the art of building while in the Ottoman army. Officials quickly recognized his talent and entrusted him with increasing responsibility until, in 1538, he was appointed the chief court architect for Suleyman the Magnificent (r. 1520–1566), a generous patron of art and architecture. Architectural historians have attributed to Sinan hundreds of building projects, both sacred and secular, although he could not have been involved with all that bear his name.

The capstone of Sinan's distinguished career was the Edirne mosque (FIGS. 7-20 and 7-21) of Suleyman's son, Selim II, which Sinan designed when he was almost 80 years old. In this masterwork, he sought to surpass the greatest achievements of Byzantine architects, just as Sultan Hasan's builders in Cairo attempted to rival and exceed the Sasanian architects of antiquity. Sa'i Mustafa Çelebi, Sinan's biographer, recorded the architect's accomplishment in his own words:

Sultan Selim Khan ordered the erection of a mosque in Edirne. . . . His humble servant [I, Sinan] prepared for him a drawing depicting, on a dominating site in the city, four minarets on the four corners of a dome. . . . Those who consider themselves architects among Christians say that in the realm of Islam no dome can equal that of the Hagia Sophia; they claim that no Muslim architect would be able to build such a large dome. In this mosque, with the help of God and the support of Sultan Selim Khan, I erected a dome six cubits higher and four cubits wider than the dome of the Hagia Sophia.*

The Edirne dome is, in fact, higher than Hagia Sophia's when measured from its base, but its crown is not as far above the pavement. Nonetheless, Sinan's feat won universal acclaim as a triumph. The Ottomans considered the Mosque of Selim II proof that they finally had outshone the Christian emperors of Byzantium in the realm of architecture.

*Aptullah Kuran, *Sinan: The Grand Old Master of Ottoman Architecture* (Washington, D.C.: Institute of Turkish Studies, 1987), 168–169.

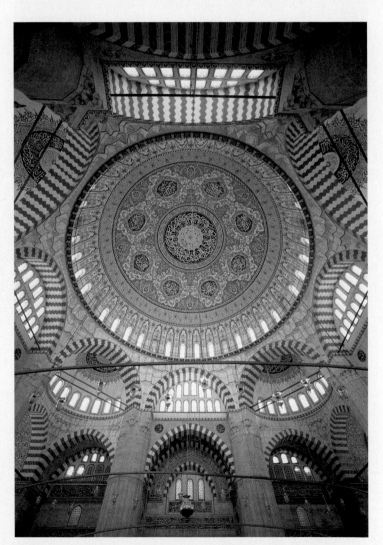

**7-20** SINAN, Mosque of Selim II, Edirne, Turkey, 1568–1575.

The Ottomans developed a new type of mosque with a square prayer hall covered by a dome. Sinan's Mosque of Selim II has a taller dome than Hagia Sophia's and is an engineering triumph.

**7-21** SINAN, interior of the Mosque of Selim II, Edirne, Turkey, 1568–1575.

The interior of Sinan's Edirne mosque is a fusion of an octagon and a dome-covered square with four half-domes at the corners. The plan features geometric clarity and precise numerical ratios.

**OTTOMAN EMPIRE** During the course of the 9th to 11th centuries, the Turkic people, of central Asian origin, largely converted to Islam. They moved into Iran and the Near East in the 11th century, and by 1055 the Seljuk Turkish dynasty had built an extensive, although short-lived, empire that stretched from India to western Anatolia. By the end of the 12th century, this empire had broken up into regional states, and in the early 13th century it came under the sway of the Mongols, led by Genghis Khan (see Chapter 4). After the downfall of the Seljuks, several local dynasties established themselves in Anatolia, among them the Ottomans, founded by Osman I (r. 1281–1326). Under Osman's successors, the Ottoman state expanded for two and a half centuries throughout vast areas of Asia, Europe, and North Africa to become, by the middle of the 15th century, one of the great world powers.

The Ottoman emperors were lavish patrons of architecture. Ottoman builders developed a new type of mosque with a square prayer hall covered by a dome as its core. In fact, the dome-covered square, which had been a dominant form in Iran and was employed for the 10th-century Samanid mausoleum (FIG. 7-10), became the nucleus of all Ottoman architecture. The combination had an appealing geometric clarity. At first used singly, the domed units came to be used in multiples, a turning point in Ottoman architecture.

After the Ottoman Turks conquered Constantinople (Istanbul) in 1453, they firmly established their architectural code. The new lords of Constantinople were impressed by Hagia Sophia, which, in some respects, conformed to their own ideals. They converted the Byzantine church into a mosque with minarets. But the longitudinal orientation of Hagia Sophia's interior never satisfied Ottoman builders, and Anatolian development moved instead toward the central-plan mosque.

**SINAN THE GREAT** The first examples of the central-plan mosque were built in the 1520s, eclipsed later only by the works of the most famous Ottoman architect, SINAN (ca. 1491–1588). A contemporary of the great Italian Renaissance sculptor, painter, and architect Michelangelo, and with equal aspirations to immortality, Sinan perfected the Ottoman architectural style. By his time, Ottoman builders almost universally were using the basic domed unit, which they could multiply, enlarge, contract, or combine as needed. Thus, the typical Ottoman building of Sinan's time was a creative assemblage of domical units and artfully juxtaposed geometric spaces. Builders usually erected domes with an extravagant margin of structural safety that has since served them well in earthquake-prone Istanbul and other Ottoman cities. (Vivid demonstration of the sound construction of Ottoman mosques came in August 1999 when a powerful earthquake centered 65 miles east of Istanbul toppled hundreds of modern buildings and killed thousands of people but caused no damage to the centuries-old mosques.) Working within this architectural tradition, Sinan searched for solutions to the problems of unifying the additive elements and of creating a monumental centralized space with harmonious proportions.

Sinan's vision found ultimate expression in the Mosque of Selim II (FIG. 7-20) at Edirne, which had been the capital of the Ottoman Empire from 1367 to 1472 and where Selim II (r. 1566–1574) maintained a palace. There, Sinan designed a mosque with a massive dome set off by four slender pencil-shaped minarets (each more than 200 feet high, among the tallest ever constructed). The dome's height surpasses that of Hagia Sophia (see "Sinan the Great and the Mosque of Selim II," page 134). But it is the organization of the Edirne mosque's interior space (FIG. 7-21) that reveals the genius of its builder. The mihrab is recessed into an apselike alcove deep enough to permit window illumination from three sides, making the brilliantly colored tile panels of its lower walls sparkle as if with their own glowing light. The plan of the main hall is an ingenious fusion of an octagon with the dome-covered square. The octagon, formed by the eight massive dome supports, is pierced by the four half-dome-covered corners of the square. The result is a fluid interpenetration of several geometric volumes that represents the culminating solution to Sinan's lifelong search for a monumental unified interior space. Sinan's forms are clear and legible, like mathematical equations. Height, width, and masses are related to one another in a simple but effective ratio of 1:2, and precise numerical ratios also characterize the complex as a whole. The forecourt of the building, for example, covers an area equal to that of the mosque proper. The Mosque of Selim II is generally regarded as the climax of Ottoman architecture. Sinan proudly proclaimed it his masterpiece.

**GREAT MOSQUE, ISFAHAN** The Mosque of Selim II at Edirne was erected during a single building campaign under the direction of a single master architect, but the construction of many other major Islamic architectural projects extended over several centuries. A case in point is the Great Mosque (FIG. 7-22) at Isfahan in

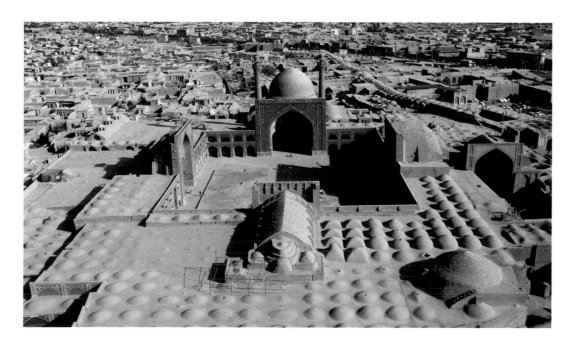

**7-22** Aerial view (looking southwest) of the Great Mosque, Isfahan, Iran, 11th to 17th centuries.

The typical Iranian mosque plan with four vaulted iwans and a courtyard may have been employed for the first time in the mosque Sultan Malik Shah I built in the late 11th century at his capital of Isfahan.

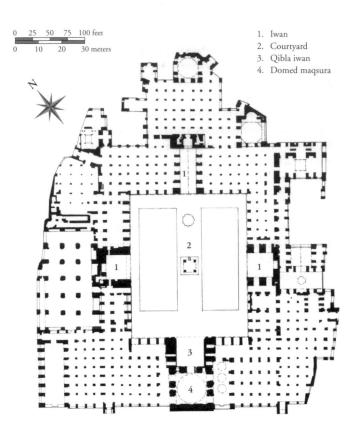

0 25 50 75 100 feet
0 10 20 30 meters

N

1. Iwan
2. Courtyard
3. Qibla iwan
4. Domed maqsura

**7-23** Plan of the Great Mosque, Isfahan, Iran, 11th to 17th centuries.

In the Great Mosque at Isfahan, as in other four-iwan mosques, the qibla iwan is the largest. Its size and the dome-covered maqsura in front of it indicated the proper direction for Muslim prayer.

Iran. The earliest mosque on the site, of the hypostyle type, dates to the eighth century, during the Abbasid caliphate. But Sultan Malik Shah I (r. 1072–1092), whose capital was at Isfahan, transformed the structure in the 11th century. Later remodeling further altered the mosque's appearance. The present mosque, which retains its basic 11th-century plan (FIG. **7-23**), consists of a large courtyard bordered by a two-story arcade on each side. As in the 14th-century complex (FIG. **7-19**) of Sultan Hasan in Cairo, four iwans open onto the courtyard, one at the center of each side. The southwestern iwan (FIG. **7-23**, no. 3) leads into a dome-covered room (no. 4) in front of the mihrab. It functioned as a maqsura reserved for the sultan and his attendants. It is uncertain whether this plan, with four iwans and a dome in front of the mihrab, was employed for the first time in the Great Mosque at Isfahan, but it became standard in Iranian mosque design. In four-iwan mosques, the qibla iwan is always the largest. Its size (and the dome that often accompanied it) immediately indicated to worshipers the proper direction for prayer.

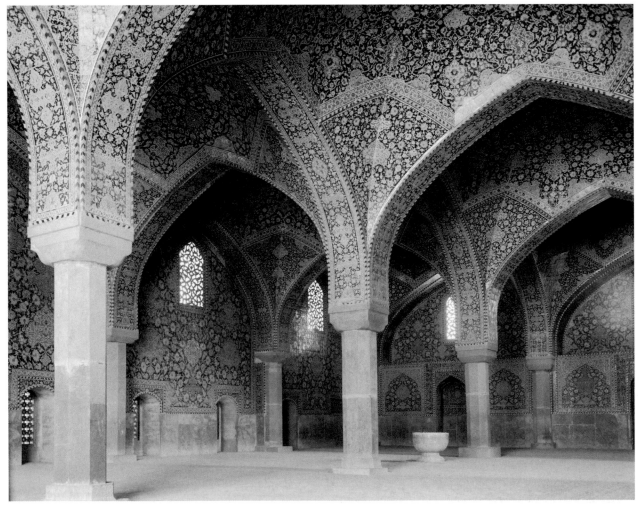

**7-24** Winter prayer hall of the Shahi (Imam) Mosque, Isfahan, Iran, 1611–1638.

The ceramists who produced the cuerda seca tiles of this Isfahan mosque's winter prayer hall had to manufacture a wide variety of shapes with curved surfaces to cover the hall's arches and vaults.

## Islamic Tilework

From the Dome of the Rock (FIGS. 7-2 and 7-3), the earliest major Islamic building, to the present day, architects have used mosaics or ceramic tiles to decorate the walls and vaults of mosques, madrasas, palaces, and tombs. The golden age of Islamic tilework was the 16th and 17th centuries. At that time, Islamic artists used two basic techniques to enliven building interiors with brightly colored tiled walls and to sheathe their exteriors with gleaming tiles that reflected the sun's rays.

In *mosaic tilework* (for example, FIG. 7-25), large ceramic panels of single colors are fired in the potter's kiln and then cut into smaller pieces and set in plaster in a manner similar to the laying of mosaic tesserae of stone or glass.

*Cuerda seca* (dry cord) tilework was introduced in Umayyad Spain during the 10th century—hence its Spanish name even in Middle Eastern and Central Asian contexts. Cuerda seca tiles (for example, FIG. 7-24) are polychrome and can more easily bear complex geometric and vegetal patterns as well as Arabic script. They are more economical to use because vast surfaces can be covered with large tiles much more quickly than they can with thousands of smaller mosaic tiles. But when such tiles are used to sheathe curved surfaces, the ceramists must fire the tiles in the exact shape required. Polychrome tiles have other drawbacks. Because all the glazes are fired at the same temperature, cuerda seca tiles are not as brilliant in color as mosaic tiles and do not reflect light the way the more irregular surfaces of tile mosaics do. The preparation of the multicolored tiles also requires greater care. To prevent the colors from running together during firing, the potters must outline the motifs on cuerda seca tiles with greased cords containing manganese, which leaves a matte black line between the colors after firing.

1 ft.

**7-25** Mihrab from the Madrasa Imami, Isfahan, Iran, ca. 1354. Glazed mosaic tilework, 11′ 3″ × 7′ 6″. Metropolitan Museum of Art, New York.

The Madrasa Imami mihrab is a masterpiece of mosaic tilework. Every piece had to be cut to fit its specific place in the design. It exemplifies the perfect aesthetic union between Islamic calligraphy and ornament.

**IRANIAN TILEWORK** The iwans of the Isfahan mosque feature soaring pointed arches framing tile-sheathed muqarnas vaults. The muqarnas ceilings probably date to the 14th century, and the ceramic-tile revetment on the walls and vaults is the work of the 17th-century Safavid rulers of Iran. The use of glazed tiles has a long history in the Middle East. Even in ancient Mesopotamia, builders sometimes covered gates and walls with colorful baked bricks. In the Islamic world, the art of ceramic tilework reached its peak in the 16th and 17th centuries in Iran and Turkey (see "Islamic Tilework," above). Employed as a veneer over a brick core, tiles could sheathe entire buildings, including domes and minarets.

**SHAHI MOSQUE, ISFAHAN** The Shahi (or Royal) Mosque in Isfahan, now known as the Imam Mosque, which dates from the early 17th century, is widely recognized as one of the masterpieces of Islamic tilework. Its dome is a prime example of tile mosaic, and its winter prayer hall (FIG. 7-24) houses one of the finest ensembles of cuerda seca tiles in the world. Covering the walls, arches, and vaults of the prayer hall presented a special challenge to the Isfahan ceramists. They had to manufacture a wide variety of shapes with curved surfaces to sheathe the complex forms of the hall. The result was a technological triumph as well as a dazzling display of abstract ornament.

**MADRASA IMAMI, ISFAHAN** As already noted, verses from the Koran appeared in the mosaics of the Dome of the Rock (FIG. 7-3) in Jerusalem and in mosaics and other media on the walls of countless later Islamic structures. Indeed, some of the masterworks of Arabic calligraphy are not in manuscripts but on walls. A 14th-century mihrab (FIG. 7-25) from the Madrasa Imami in Isfahan exemplifies the perfect aesthetic union between the Islamic calligrapher's art and abstract ornament. The pointed arch that immediately frames the mihrab niche bears an inscription from the Koran in Kufic, the stately rectilinear script used in the ninth-century Koran (FIG. 7-16) discussed earlier. Many supple cursive styles also

make up the repertoire of Islamic calligraphy. One of these styles, known as *Muhaqqaq,* fills the mihrab's outer rectangular frame. The mosaic tile ornament on the curving surface of the niche and the area above the pointed arch are composed of tighter and looser networks of geometric and abstract floral motifs. The mosaic technique is masterful. Every piece had to be cut to fit its specific place in the mihrab—even the tile inscriptions. The framed inscription in the center of the niche—proclaiming that the mosque is the domicile of the pious believer—is smoothly integrated with the subtly varied patterns. The mihrab's outermost inscription—detailing the five pillars of Islamic faith—serves as a fringelike extension, as well as a boundary, for the entire design. The calligraphic and geometric elements are so completely unified that only the practiced eye can distinguish them. The artist transformed the architectural surface into a textile surface—the three-dimensional wall into a two-dimensional hanging—weaving the calligraphy into it as another cluster of motifs within the total pattern.

## Luxury Arts

The tile-covered mosques of Isfahan, Sultan Hasan's madrasa complex in Cairo, and the architecture of Sinan the Great in Edirne are enduring testaments to the brilliant artistic culture of the Safavid,

Mamluk, and Ottoman rulers of the Muslim world. Yet these are only some of the most conspicuous public manifestations of the greatness of later Islamic art and architecture (see Chapter 2 for the achievements of the Muslim rulers of India). In the smaller-scale, and often private, realm of the luxury arts, Muslim artists also excelled. From the vast array of manuscript paintings, ceramics, textiles, and metalwork, six masterpieces may serve to suggest both the range and the quality of the inappropriately dubbed Islamic "minor arts" of the 13th to 16th centuries.

**TIMURID *BUSTAN*** In the late 14th century, a new Islamic empire arose in Central Asia under the leadership of Timur (r. 1370–1405), known in the Western world as Tamerlane. Timur, a successor of the Mongol Genghis Khan, quickly extended his dominions to include Iran and parts of Anatolia. The Timurids ruled until 1501 and were great patrons of art and architecture in cities such as Herat, Bukhara, and Samarqand. Herat in particular became a leading center for the production of luxurious books under the patronage of the Timurid sultan Husayn Mayqara (r. 1470–1506).

The most famous Persian painter of his age was BIHZAD, who worked at the Herat court and illustrated the sultan's copy of Sadi's *Bustan* (*Orchard*). One page (FIG. 7-26) represents a story in both the Bible and the Koran—the seduction of Yusuf (Joseph) by

**7-26** BIHZAD, *Seduction of Yusuf,* folio 52 verso of the *Bustan* of Sultan Husayn Mayqara, from Herat, Afghanistan, 1488. Ink and color on paper, $11\frac{7}{8}'' \times 8\frac{5}{8}''$. National Library, Cairo.

The most famous Timurid manuscript painter was Bihzad. This page displays vivid color, intricate decorative detailing, and a brilliant balance between two-dimensional patterning and perspective.

1 in.

Potiphar's wife Zulaykha. Sadi's text is dispersed throughout the page in elegant Arabic script in a series of beige panels. According to the tale as told by Jami (1414–1492), an influential mystic theologian and poet whose Persian text appears in blue in the white pointed arch at the lower center of the composition, Zulaykha lured Yusuf into her palace and led him through seven rooms, locking each door behind him. In the last room she threw herself at Yusuf, but he resisted and was able to flee when the seven doors opened miraculously. Bihzad's painting of the story is characterized by vivid color, intricate decorative detailing suggesting luxurious textiles and tiled walls, and a brilliant balance between two-dimensional patterning and perspectival depictions of balconies and staircases.

**SAFAVID *SHAHNAMA*** The successors of the Timurids in Iran were the Safavids. Shah Tahmasp (r. 1524–1576) was a great patron of books. Around 1525 he commissioned an ambitious decade-long project to produce an illustrated 742-page copy of the *Shahnama* (*Book of Kings*). The *Shahnama* is the Persian national epic poem by Firdawsi (940–1025). It recounts the history of Iran from the Creation until the Muslim conquest. Tahmasp's *Shahnama* contains 258 illustrations by many artists, including some of the most renowned painters of the day. It was eventually presented as a gift to Selim II, the Ottoman sultan who was the patron of Sinan's

mosque (FIGS. 7-20 and 7-21) at Edirne. The manuscript later entered a private collection in the West and ultimately was auctioned as a series of individual pages, destroying the work's integrity but underscoring that Western collectors viewed each page as a masterpiece.

The page reproduced here (FIG. 7-27) is the work of SULTAN-MUHAMMAD and depicts Gayumars, the legendary first king of Iran, and his court. According to tradition, Gayumars ruled from a mountaintop when humans first learned to cook food and clothe themselves in leopard skins. In Sultan-Muhammad's representation of the story, Gayumars presides over his court (all the figures wear leopard skins) from his mountain throne. The king is surrounded by light amid a golden sky. His son and grandson perch on multicolored rocky outcroppings to the viewer's left and right, respectively. The court encircles the ruler and his heirs. Dozens of human faces appear within the rocks themselves. Many species of animals populate the lush landscape. According to the *Shahnama*, wild beasts became instantly tame in the presence of Gayumars. Sultan-Muhammad rendered the figures, animals, trees, rocks, and sky with an extraordinarily delicate touch. The sense of lightness and airiness that permeate the painting is enhanced by its placement on the page—floating, off center, on a speckled background of gold leaf. The painter gave his royal patron a singular vision of Iran's fabled past.

**7-27** SULTAN-MUHAMMAD, *Court of Gayumars,* folio 20 verso of the *Shahnama* of Shah Tahmasp, from Tabriz, Iran, ca. 1525–1535. Ink, watercolor, and gold on paper, 1′ 1″ × 9″. Prince Sadruddin Aga Khan Collection, Geneva.

Sultan-Muhammad painted the story of the legendary king Gayumars for the Safavid ruler Shah Tahmasp. The off-center placement on the page enhances the sense of lightness that permeates the painting.

1 in.

**7-28** MAQSUD OF KASHAN, carpet from the funerary mosque of Shaykh Safi al-Din, Ardabil, Iran, 1540. Knotted pile of wool and silk, 34′ 6″ × 17′ 7″. Victoria & Albert Museum, London.

Maqsud of Kashan's enormous Ardabil carpet required roughly 25 million knots. It presents the illusion of a heavenly dome with mosque lamps reflected in a pool of water with floating lotus blossoms.

**ARDABIL CARPETS** Tahmasp also elevated carpet weaving to a national industry and set up royal factories at Isfahan, Kashan, Kirman, and Tabriz. Two of the masterworks of carpet weaving that date to his reign are the pair of carpets from the two-centuries older funerary mosque of Shaykh Safi al-Din (1252–1334), the founder of the Safavid line. The name MAQSUD OF KASHAN is woven into the design of the carpet illustrated here (FIG. 7-28). He must have been the designer who supplied the master pattern to two teams of royal weavers (one for each of the two carpets). The carpet, almost 35 × 18 feet, consists of roughly 25 million knots, some 340 to the square inch. (Its twin has even more knots.)

The design consists of a central sunburst medallion, representing the inside of a dome, surrounded by 16 pendants. Mosque lamps (appropriate motifs for the Ardabil funerary mosque) are suspended from two pendants on the long axis of the carpet. The lamps are of different sizes. This may be an optical device to make the two appear equal in size when viewed from the end of the carpet at the room's threshold (the bottom end in FIG. 7-28). The rich blue background is covered with leaves and flowers attached to delicate stems that spread over the whole field. The entire composition presents the illusion of a heavenly dome with lamps reflected in a pool of water full of floating lotus blossoms. No human or animal figures appear, as befits a carpet intended for a mosque, although they can be found on other Islamic textiles used in secular contexts, both earlier (FIG. 7-14) and later.

**MOSQUE LAMPS** Mosque lamps were often made of glass and highly decorated. Islamic artists perfected this art form and fortunately, despite their exceptionally fragile nature, many examples survive, in large part because the lamps were revered by those who han-

dled them. One of the finest is the mosque lamp (FIG. 7-29) made for Sayf al-Din Tuquztimur (d. 1345), an official in the court of the Mamluk sultan al-Nasir Muhammad. The glass lamps hung on chains from the mosque's ceilings. The shape of Tuquztimur's lamp

1 in.

The enamel decoration of this glass mosque lamp includes a quotation from the Koran comparing God's light to the light in a lamp. The burning wick dramatically illuminated the sacred verse.

is typical of the period, consisting of a conical neck, wide body with six vertical handles, and a tall foot. Inside, a small glass container held the oil and wick. The *enamel* decoration (colors fused to the surfaces) includes Tuquztimur's emblem—an eagle over a cup (Tuquztimur served as the sultan's cup-bearer). Cursive Arabic calligraphy, also in enamel, gives the official's name and titles as well as a quotation of the Koranic verse (24:35) comparing God's light to the light in a lamp. When the lamp was lit, the verse (and Tuquztimur's name) would have been dramatically illuminated.

***BAPTISTÈRE DE SAINT LOUIS*** Metalwork was another early Islamic art form (FIG. 7-15) that continued to play an important role in the later period. An example of the highest quality is a brass basin (FIG. **7-30**) from Egypt inlaid with gold and silver and signed—six times—by the Mamluk artist MUHAMMAD IBN AL-ZAYN. The basin, used for washing hands at official ceremonies, must have been fashioned for a specific Mamluk patron. Some scholars think a court official named Salar ordered the piece as a gift for his sultan, but no inscription identifies him. The central band depicts Mamluk hunters and Mongol enemies. Running animals fill the friezes above and below. Stylized vegetal forms of inlaid silver fill the background of all the bands and roundels. Figures and animals also decorate the

1 in.

**7-30** MUHAMMAD IBN AL-ZAYN, basin (*Baptistère de Saint Louis*), from Egypt, ca. 1300. Brass, inlaid with gold and silver, $8\frac{3}{4}$″ high. Louvre, Paris.

Muhammad ibn al-Zayn proudly signed (six times) this basin used for washing hands at official ceremonies. The central band, inlaid with gold and silver, depicts Mamluk hunters and Mongol enemies.

## Christian Patronage of Islamic Art

During the 11th, 12th, and 13th centuries, large numbers of Christians traveled to Islamic lands, especially to the Christian holy sites in Jerusalem and Bethlehem, either as pilgrims or as Crusaders. Many returned with mementos of their journey, usually in the form of inexpensive mass-produced souvenirs. But some wealthy individuals commissioned local Muslim artists to produce custom-made pieces using costly materials.

A unique brass canteen (FIG. 7-31) inlaid with silver and decorated with scenes of the life of Christ appears to be the work of a 13th-century Ayyubid metalsmith in the employ of a Christian patron. The canteen is a luxurious version of the "pilgrim flasks" Christian visitors to the Holy Land often brought back to Europe. Four inscriptions in Arabic promise eternal glory, secure life, perfect prosperity, and increasing good luck to the canteen's owner, who is unfortunately not named. That the owner was a Christian is sug-

gested not only by the type of object but also by the choice of scenes engraved into the canteen. The Madonna and Christ Child appear enthroned in the central medallion, and three panels depicting New Testament events fill most of the band around the medallion. The narrative unfolds in a counterclockwise sequence (Arabic is read from right to left), beginning with the Nativity (at 2 o'clock) and continuing with the Presentation in the Temple (10 o'clock) and the Entry into Jerusalem (6 o'clock). The scenes may have been chosen because the patron had visited their locales (Bethlehem and Jerusalem). Most scholars believe that the artist used Syrian Christian manuscripts as the source for the canteen's Christian iconography. Many of the decorative details, however, are common in contemporary Islamic metalwork inscribed with the names of Muslim patrons. Whoever the owner was, the canteen testifies to the fruitful artistic interaction between Christians and Muslims in 13th-century Syria.

**7-31** Canteen with episodes from the life of Christ, from Syria, ca. 1240–1250. Brass, inlaid with silver, 1′ 2½″ high. Freer Gallery of Art, Washington, D.C.

This unique canteen is the work of an Ayyubid metalsmith in the employ of a Christian pilgrim to the Holy Land. The three scenes from the life of Jesus appear in counterclockwise sequence.

1 in.

inside and underside of the basin. This Mamluk basin has long been known as the *Baptistère de Saint Louis,* but the association with the famous French king Louis IX is a myth. Louis died before the piece was made. Nonetheless, the *Baptistère,* brought to France long ago, was used in the baptismal rites of newborns of the French royal fam-

ily as early as the 17th century. Like the Zandana silk (FIG. 7-14) from Toul Cathedral and a canteen (FIG. 7-31) adorned with scenes of the life of Christ (see "Christian Patronage of Islamic Art," above), Muhammad ibn al-Zayn's basin testifies to the prestige of Islamic art well outside the boundaries of the Islamic world.

# THE ISLAMIC WORLD

## UMAYYAD SYRIA AND ABBASID IRAQ, 661–1258

- The Umayyads (r. 661–750) were the first Islamic dynasty and ruled from their capital at Damascus in Syria until they were overthrown by the Abbasids (r. 750–1258), who established their capital at Baghdad in Iraq.

- The first great Islamic building is the Dome of the Rock. The domed octagon commemorated the triumph of Islam in Jerusalem, which the Muslims captured from the Byzantines in 638.

- Umayyad and Abbasid mosques, for example, those in Damascus and in Kairouan (Tunisia), are of the hypostyle-hall type and incorporate arcaded courtyards and minarets. The mosaic decoration of early mosques was often the work of Byzantine artists but excludes zoomorphic forms.

- The earliest preserved Korans date to the 9th century and feature Kufic calligraphy and decorative motifs but no figural illustrations.

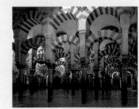

Dome of the Rock, Jerusalem, 687–692

## ISLAMIC SPAIN, 756–1492

- Abd-al-Rahman I established the Umayyad dynasty (r. 756–1031) in Spain after he escaped the Abbasid massacre of his clan in 750.

- The Umayyad capital was at Córdoba, where the caliphs erected and expanded the Great Mosque between the 8th and 10th centuries. The mosque features horseshoe and multilobed arches and mosaic-clad domes that rest on arcuated squinches.

- The last Spanish Muslim dynasty was the Nasrid (r. 1230–1492), whose capital was at Granada. The Alhambra is the best surviving example of Islamic palace architecture. It is famous for its stuccoed walls and arches and its muqarnas vaults and domes.

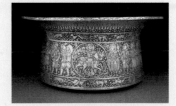

Great Mosque, Córdoba, 8th to 10th centuries

## ISLAMIC EGYPT, 909–1517

- The Fatimids (r. 909–1171) established their caliphate in Egypt in 909 and ruled from their capital in Cairo. They were succeeded by the Ayyubids (r. 1171–1250) and the Mamluks (r. 1250–1517).

- The most ambitious Mamluk builder was Sultan Hasan, whose madrasa-mosque-mausoleum complex in Cairo is based on Iranian four-iwan mosque designs.

- Among the greatest works of the Islamic metalsmith's art is Muhammad ibn al-Zayn's brass basin inlaid with gold and silver and engraved with figures of Mamluk hunters and Mongol enemies.

Muhammad ibn al-Zayn, brass basin, ca. 1300

## TIMURID AND SAFAVID IRAN AND CENTRAL ASIA, 1370–1732

- The Timurid (r. 1370–1501) and Safavid (r. 1501–1732) dynasties ruled Iran and Central Asia for almost four centuries and were great patrons of art and architecture.

- The Timurid court at Herat, Afghanistan, employed the most famous painters of the day, who specialized in illustrating books.

- Persian painting also flourished in Safavid Iran under Shah Tahmasp (r. 1524–1576), who in addition set up royal carpet factories in several cities.

- The art of tilework reached its peak under the patronage of the Safavid dynasty, when builders frequently used mosaic and cuerda seca tiles to cover the walls and vaults of mosques, madrasas, palaces, and tombs.

Sultan-Muhammad, *Court of Gayumars*, ca. 1525–1535

## OTTOMAN TURKEY, 1281–1924

- Osman I (r. 1281–1326) founded the Ottoman dynasty in Turkey. By the middle of the 15th century, the Ottomans had become a fearsome power and captured Byzantine Constantinople in 1453.

- The greatest Ottoman architect was Sinan (ca. 1491–1588), who perfected the design of the domed central-plan mosque. His Mosque of Selim II at Edirne is also an engineering triumph. It has a dome taller than that of Hagia Sophia.

Sinan, Mosque of Selim II, Edirne, 1568–1575

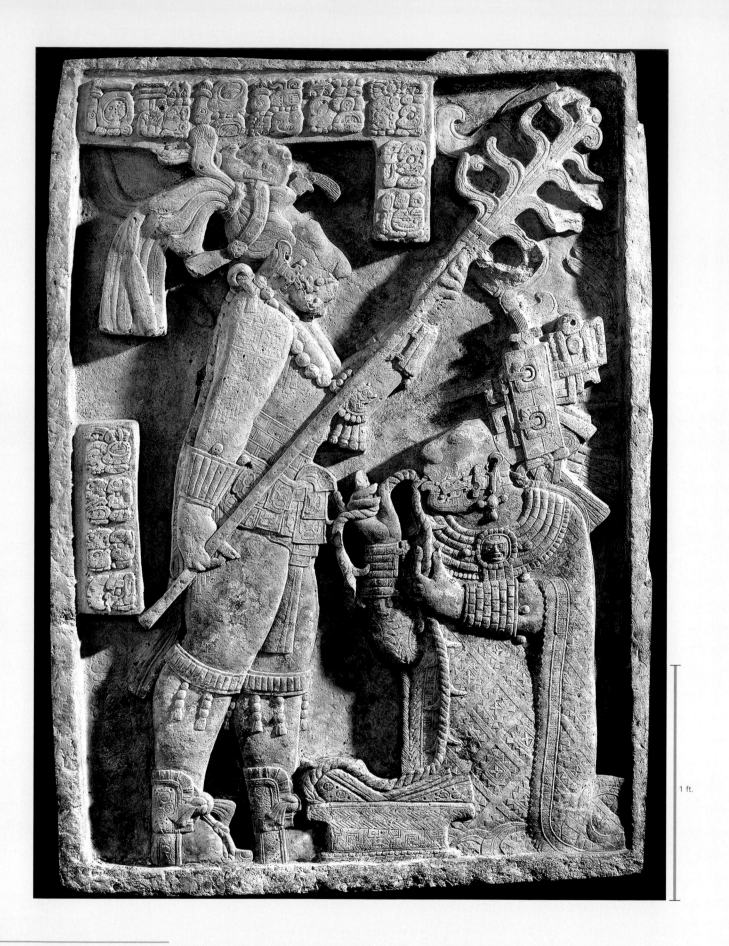

1 ft.

**8-1** Shield Jaguar and Lady Xoc, Maya, lintel 24 of temple 23, Yaxchilán, Mexico, ca. 725 CE. Limestone, 3′ 7″ × 2′ 6½″. British Museum, London.

The Maya built vast complexes of temples, palaces, and plazas and decorated many with painted reliefs. This carved lintel documents the central role that elite Maya women played in religious bloodletting rituals.

# NATIVE ARTS OF THE AMERICAS BEFORE 1300

The origins of the indigenous peoples of the Americas are still uncertain. Sometime no later than 30,000 to 10,000 BCE, these first Americans probably crossed the now-submerged land bridge called Beringia, which connected the shores of the Bering Strait between Asia and North America. Some migrants may have reached the Western Hemisphere via boats traveling along the Pacific coast of North America. These Stone Age nomads were hunter-gatherers. They made tools only of bone, pressure-flaked stone, and wood. They had no knowledge of agriculture but possibly some of basketry. They could control fire and probably build simple shelters. For many centuries, they spread out until they occupied the two American continents. But they were always few in number. When the first Europeans arrived at the end of the 15th century (see Chapter 9), the total population of the Western Hemisphere probably did not exceed 40 million.

Between 8000 and 2000 BCE, a number of the migrants learned to fish, farm cotton, and domesticate plants such as squash and maize (corn). The nomads settled in villages and learned to make ceramic utensils and figurines. Metal technology, although extremely sophisticated when it existed, developed only in the Andean region of South America (eventually spreading north into present-day Mexico) and generally met only the need for ornamentation, not for tools. With these skills as a base, many cultures rose and fell over long periods.

Several of the peoples of North, Central, and South America had already reached a high level of social complexity and technological achievement by the early centuries CE. Although most relied on stone tools, did not use the wheel (except for toys), and had no pack animals but the llama (in South America), the early Americans developed complex agricultural techniques and excelled in the engineering arts associated with the planning and construction of cities, civic and domestic buildings, roads and bridges, and irrigation and drainage systems. They carved monumental stone statues and reliefs, painted extensive murals, and mastered the arts of weaving, pottery, and metalwork. In Mesoamerica, the Maya and other cultural groups even had a highly developed writing system and knowledge of mathematical calculation that allowed them to keep precise records and create a sophisticated calendar and a highly accurate astronomy.

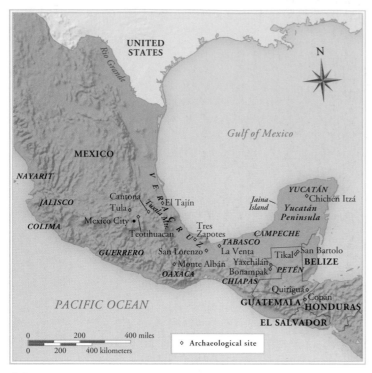

MAP 8-1 Early sites in Mesoamerica.

These advanced civilizations went into rapid decline, however, in the 16th century when the Europeans introduced new diseases to the Western Hemisphere, and Hernán Cortés, Francisco Pizarro, and their armies conquered the Aztec and Inka empires. Some native elites survived and adapted to the Spanish presence, but most of the once-glorious American cities were destroyed in the conquerors' zeal to obliterate all traces of pagan beliefs. Other sites were abandoned to the forces of nature—erosion and the encroachment of tropical forests. But despite the ruined state of the pre-Hispanic cities today, archaeologists and art historians have been able to reconstruct much of the history of art and architecture of ancient America. This chapter examines in turn the artistic achievements of the native peoples of Mesoamerica, South America, and North America before 1300. Chapter 9 treats the art and architecture of the Americas from 1300 to the present.

# MESOAMERICA

The term *Mesoamerica* names the region that comprises part of present-day Mexico, Guatemala, Belize, Honduras, and the Pacific coast of El Salvador (MAP 8-1). Mesoamerica was the homeland of several of the great *pre-Columbian* civilizations—those that flourished before the arrival of Christopher Columbus and the subsequent European invasion.

The principal regions of pre-Columbian Mesoamerica are the Gulf Coast region (Olmec and Classic Veracruz cultures); the states of Jalisco, Colima, and Nayarit, collectively known as West Mexico; Chiapas, Yucatán, Quintana Roo, and Campeche states in Mexico, the Petén area of Guatemala, Belize, and Honduras (Maya culture); southwestern Mexico and the state of Oaxaca (Zapotec and Mixtec cultures); and the central plateau surrounding modern Mexico City (Teotihuacan, Toltec, and Aztec cultures). These cultures were often influential over extensive areas.

The Mexican highlands are a volcanic and seismic region. In highland Mexico, great reaches of arid plateau land, fertile for maize and other crops wherever water is available, lie between heavily forested mountain slopes, which at some places rise to a perpetual snow level. The moist tropical rain forests of the coastal plains yield rich crops, when the land can be cleared. In Yucatán, a subsoil of limestone furnishes abundant material for both building and carving. This limestone tableland merges with the vast Petén region of Guatemala, which separates Mexico from Honduras. Yucatán and the Petén, where dense rain forest alternates with broad stretches of grassland, host some of the most spectacular Maya ruins. The great mountain chains of Mexico and Guatemala extend into Honduras and slope sharply down to tropical coasts. Highlands and mountain valleys, with their chill and temperate climates, alternate dramatically with the humid climate of tropical rain forest and coastlines.

The variegated landscape of Mesoamerica may have much to do with the diversity of languages its native populations speak. Numerous languages are distributed among no fewer than 14 linguistic families. Many of the languages spoken in the pre–Spanish conquest period survive to this day. Various Mayan languages linger in Guatemala and southern Mexico. The Náhuatl of the Aztecs endures in the Mexican highlands. The Zapotec and Mixtec languages persist in Oaxaca and its environs. Diverse as the languages of these peoples were, their cultures otherwise had much in common. The Mesoamerican peoples shared maize cultivation, religious beliefs and rites, myths, social structures, customs, and arts.

Archaeologists, with ever-increasing refinement of technique, have been uncovering, describing, and classifying Mesoamerican monuments for more than a century. In the 1950s, linguists made important breakthroughs in deciphering the Maya hieroglyphic script, and epigraphers have made further progress in recent decades. Scholars can now list many Maya rulers by name and fix the dates of their reigns with precision. Other writing systems, such as that of the Zapotec, who began to record dates at a very early time, are less well understood, but researchers are making rapid progress in their interpretation. The general Mesoamerican chronology is now well established and widely accepted. The standard chronology, divided into three epochs, involves some overlapping of subperiods. The Preclassic (Formative) extends from 2000 BCE to about 300 CE. The Classic period runs from about 300 to 900. The Postclassic begins approximately 900 and ends with the Spanish conquest of 1521.

## Olmec and Preclassic West Mexico

The Olmec culture of the present-day Mexican states of Veracruz and Tabasco has often been called the "mother culture" of Mesoamerica, because many distinctive Mesoamerican religious, social, and artistic traditions can be traced to it. Recent archaeological discoveries, however, have revealed other important centers during the Preclassic period. The notion of a linear evolution of all Mesoamerican art and architecture from the Olmec is giving way to a more complex multicenter picture of early Mesoamerica. Settling in the tropical lowlands of the Gulf of Mexico, the Olmec peoples cultivated a terrain of rain forest and alluvial lowland washed by numerous rivers flowing into the gulf. Here, between approximately 1500 and 400 BCE, social organization assumed the form that later Mesoamerican cultures adapted and developed. The mass of the population—food-producing farmers scattered in hinterland villages—provided the sustenance and labor that maintained a hereditary caste of rulers, hierarchies of priests, functionaries, and artisans. The nonfarming population presumably lived, arranged by rank, within precincts that served ceremonial, administrative, and resi-

1 ft.

**8-2** Colossal head, Olmec, La Venta, Mexico, ca. 900–400 BCE. Basalt, 9′ 4″ high. Museo-Parque La Venta, Villahermosa.

The identities of the Olmec colossi are uncertain, but their individualized features and distinctive headgear, as well as later Maya practice, suggest that these heads portray rulers rather than deities.

1 in.

**8-3** Ceremonial ax in the form of a were-jaguar, Olmec, from La Venta, Mexico, ca. 900–400 BCE. Jadeite, 11½″ high. British Museum, London.

Olmec celts were votive offerings to the gods. The composite human-animal representations may reflect the belief that religious practitioners underwent dangerous transformations on behalf of the community.

dential functions, and perhaps also as marketplaces. At regular intervals, the whole community convened for ritual observances at the religious-civic centers of towns such as San Lorenzo and La Venta. These centers were the formative architectural expressions of the structure and ideals of Olmec society.

**OLMEC RULER PORTRAITS** At La Venta, low clay-and-earthen platforms and stone fences enclosed two great courtyards. At one end of the larger area was a mound almost 100 feet high. Although now very eroded, this early pyramid, built of earth and adorned with colored clays, may have been intended to mimic a mountain, held sacred by Mesoamerican peoples as both a life-giving source of water and a feared destructive force. (Volcanic eruptions and earthquakes still wreak havoc in this region.) The La Venta layout is an early form of the temple-pyramid-plaza complex aligned on a north-south axis that characterized later Mesoamerican ceremonial center design.

Four colossal basalt heads (FIG. **8-2**), weighing about 10 tons each and standing between 6 and 10 feet high, face out from the plaza. More than a dozen similar heads have been found at San Lorenzo and Tres Zapotes. Almost as much of an achievement as the carving of these huge stones with stone tools was their transportation across the 60 miles of swampland from the nearest known basalt source, the Tuxtla Mountains. Although the identities of the colossi are uncertain, their individualized features and distinctive headgear and ear ornaments, as well as the later Maya practice of carving monumental ruler portraits, suggest that the Olmec heads portray rulers rather than deities. The sheer size of the heads and their intensity of expression evoke great power, whether mortal or divine.

**JADE CELTS** The Olmec also made paintings in caves, fashioned ceramic figurines, and carved sculptures in jade, a prized, extremely hard, dark-green stone they acquired from unknown sources far from their homeland. Sometimes the Olmec carved jade into ax-shaped polished forms art historians call *celts*, which they then buried as votive offerings under their ceremonial courtyards or platforms. The celt shape could be modified into a figural form, combining relief carving with incising. Olmec sculptors used stone-tipped drills and abrasive materials, such as sand, to carve jade. Subjects represented include crying babies (of unknown significance) and figures combining human and animal features and postures, such as the *were-jaguar* illustrated here (FIG. **8-3**). The Olmec human-animal representations may refer to the belief that religious practitioners underwent dangerous transformations to wrest power from supernatural forces and harness it for the good of the community.

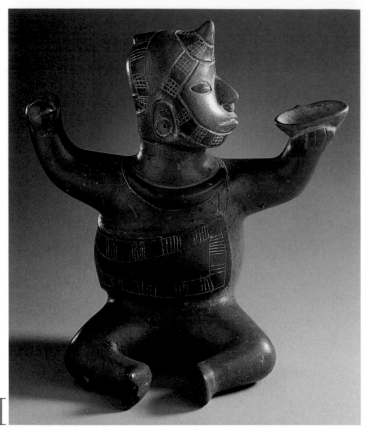

1 in.

**8-4** Drinker (seated figure with raised arms), from Colima, Mexico, ca. 200 BCE–500 CE. Clay with orange and red slip, 1′ 1″ high. Los Angeles County Museum of Art (Proctor Stafford Collection, purchased with funds provided by Mr. and Mrs. Allan C. Balch).

Preclassic West Mexico is famous for its ceramic sculptures. This one may depict a religious practitioner with a horn on his forehead or a political leader wearing a shell ornament—or someone serving both roles.

**WEST MEXICO** Far to the west of the tropical heartland of the Olmec are the Preclassic sites along Mexico's Pacific coast. Scholars long thought the ancient peoples of the modern West Mexican states of Nayarit, Jalisco, and Colima existed at Mesoamerica's geographic and cultural fringes. Recent archaeological discoveries, however, have revealed that although the West Mexicans did not produce large-scale stone sculpture, they did build permanent structures. These included tiered platforms and ball courts (see "The Mesoamerican Ball Game," page 152), architectural features found in nearly all Mesoamerican cultures. Yet West Mexico is best known for its rich tradition of clay sculpture. The sculptures come from tombs consisting of shafts as deep as 50 feet with chambers at their base. Because scientific excavations began only 20–30 years ago, much of what is known about West Mexican tomb contents derives primarily from the artifacts grave robbers found and sold. Researchers believe, however, that the West Mexicans built most of these tombs and filled them with elaborate offerings during the late Preclassic period, the half millennium before 300 CE.

The large ceramic figures found in the Colima tombs are consistently a highly burnished red-orange, instead of the distinctive polychrome surfaces of the majority of other West Mexican ceramics. The area also is noted for small-scale clay narrative scenes that include modeled houses and temples and numerous solid figurines shown in a variety of lively activities. These sculptures, which may provide informal glimpses of daily life, are not found in any other ancient Mesoamerican culture. Although archaeologists often describe the subjects of the sculptures as anecdotal and secular rather than religious, the Mesoamerican belief system did not recognize such a division. Consequently, scholars are unsure whether the figure illustrated here (FIG. 8-4) is a religious practitioner with a horn on his forehead (a common indigenous symbol of special powers) or a political leader wearing a shell ornament (often a Mesoamerican emblem of rulership)—or a person serving both roles.

## Teotihuacan

At Olmec sites, the characteristic later Mesoamerican temple-pyramid-plaza layout appeared in embryonic form. At Teotihuacan (FIG. 8-5), northeast of modern Mexico City, the Preclassic scheme underwent a monumental expansion into a genuine city. Teotihuacan was a large, densely populated metropolis that fulfilled a central civic, economic, and religious role for the region and indeed for much of Mesoamerica. Built up between about 100 BCE and 600 CE, when fire ravaged the city, the site's major monuments were constructed between 50 and 250 CE, during the late Preclassic period. Teotihuacan covers nine square miles, laid out in a grid pattern with the axes oriented by sophisticated surveying. Astronomical phenomena apparently dictated not only the city's orientation but also the placement of some of its key pyramids.

At its peak, around 600 CE, Teotihuacan may have had as many as 125,000–200,000 residents, which would have made it the sixth-largest city in the world at that time. Divided into numerous ward-like sectors, this metropolis must have had a uniquely cosmopolitan character, with Zapotec peoples located in the city's western wards, and merchants from Veracruz living in the eastern wards, importing their own pottery and building their houses and tombs in the style of their homelands. The city's urbanization did nothing to detract from its sacred nature. In fact, it vastly augmented Teotihuacan's importance as a religious center. The Aztecs, who visited Teotihuacan regularly and reverently long after it had been abandoned, gave it its current name, which means "the place of the gods." Because the city's inhabitants left only a handful of undeciphered hieroglyphs, and linguists do not know what language they spoke, the names of many major features of the site are unknown. The Avenue of the Dead and the Pyramids of the Sun and Moon are later Aztec designations that do not necessarily reflect the original names of these entities.

North-south and east-west axes, each four miles in length, divide the grid plan into quarters. The rational scheme recalls Hellenistic and Roman urban planning and is an unusual feature in Mesoamerica before the Aztecs. The main north-south axis, the Avenue of the Dead (FIG. 8-5), is 130 feet wide and connects the Pyramid of the Moon complex with the Citadel and its Temple of Quetzalcoatl. This two-mile stretch is not a continuously flat street but is broken by sets of stairs, giving pedestrians a constantly changing view of the surrounding buildings and landscape.

**PYRAMIDS** The Pyramid of the Sun (FIG. 8-5, *top left*), facing west on the east side of the Avenue of the Dead, dates to the first century CE during the late Preclassic period. It is the city's centerpiece and its largest structure, rising to a height of more than 200 feet in its restored state, which may not accurately reflect the pyramid's original appearance. The Pyramid of the Moon (FIG. 8-5,

**8-5** Aerial view of Teotihuacan (looking south), Mexico. Pyramid of the Moon (*foreground*), Pyramid of the Sun (*top left*), and the Citadel (*background*), all connected by the Avenue of the Dead; main structures ca. 50–250 CE.

At its peak around 600 CE, Teotihuacan was the sixth-largest city in the world. It featured a rational grid plan and a two-mile-long main avenue. Its monumental pyramids echo the shapes of surrounding mountains.

*foreground*) is a century or more later, about 150–250 CE. The shapes of the monumental structures at Teotihuacan echo the surrounding mountains. Their imposing mass and scale surpass those of all other Mesoamerican sites. Rubble-filled and faced with the local volcanic stone, the pyramids consist of stacked squared platforms diminishing in perimeter from the base to the top, much like the Stepped Pyramid of Djoser in Egyptian Saqqara. Ramped stairways led to crowning temples constructed of perishable materials such as wood and thatch, no longer preserved. A distinctive feature of Teotihuacan construction is the alternation of sloping (*talud*) and vertical (*tablero*) rubble layers. The employment of *talud-tablero construction* at other sites is a sure sign of Teotihuacan influence.

The Teotihuacanos built the Pyramid of the Sun over a cave, which they reshaped and filled with ceramic offerings. The pyramid may have been constructed to honor a sacred spring within the now-dry cave. Excavators found children buried at the four corners of each of the pyramid's tiers. The later Aztecs sacrificed children to bring rainfall, and Teotihuacan art abounds with references to water, so the Teotihuacanos may have shared the Aztec preoccupation with rain and agricultural fertility. The city's inhabitants rebuilt the Pyramid of the Moon (currently being excavated) at least five times in Teotihuacan's early history. The Teotihuacanos may have positioned it to mimic the shape of Cerro Gordo, the volcanic mountain behind it, undoubtedly an important source of life-sustaining streams.

**8-6** Partial view of the Temple of Quetzalcoatl, the Citadel, Teotihuacan, Mexico, third century CE.

The stone heads of Quetzalcoatl decorating this pyramid are the earliest representations of the feathered-serpent god. Beneath and around the pyramid excavators found remains of sacrificial victims.

**QUETZALCOATL** At the south end of the Avenue of the Dead is the great quadrangle of the Citadel (FIG. 8-5, *background*). It encloses a smaller pyramidal shrine datable to the third century CE, the Temple of Quetzalcoatl (FIG. 8-6). Quetzalcoatl, the "feathered serpent," was a major god in the Mesoamerican pantheon at the time of the Spanish conquest, hundreds of years after the fall of Teotihuacan. The later Aztecs associated him with wind, rain clouds, and life. Beneath the temple, archaeologists found a tomb looted in antiquity, perhaps that of a Teotihuacan ruler. The discovery has led them to speculate that not only the Maya but the Teotihuacanos as well buried their elite in or under pyramids. Surrounding the tomb both beneath and around the pyramid were the remains of at least a hundred sacrificial victims. Some were adorned with necklaces made of strings of human jaws, both real and sculpted from shell. Like most other Mesoamerican groups, the Teotihuacanos invoked and appeased their gods through human sacrifice. The presence of such a large number of victims also may reflect Teotihuacan's militaristic expansion—throughout Mesoamerica, the victors often sacrificed captured warriors.

The temple's sculptured panels, which feature projecting stone heads of Quetzalcoatl alternating with heads of a long-snouted scaly creature with rings on its forehead, decorate each of the temple's six terraces. This is the first unambiguous representation of the feathered serpent in Mesoamerica. The scaly creature's identity is unclear. Linking these alternating heads are low-relief carvings of feathered-serpent bodies and seashells. The latter reflect Teotihuacan contact with the peoples of the Mexican coasts and also symbolize water, an essential ingredient for the sustenance of an agricultural economy.

**MURAL PAINTING** Like those of most ancient Mesoamerican cities, Teotihuacan's buildings and streets were once stuccoed over and brightly painted. Elaborate murals also covered the walls of the rooms of its elite residential compounds. The paintings chiefly depict deities, ritual activities, and processions of priests, warriors, and even animals. Experimenting with a variety of surfaces, materials, and techniques over the centuries, Teotihuacan muralists finally settled on applying pigments to a smooth lime-plaster surface coated with clay. They then polished the surface to a high sheen. Although some Teotihuacan paintings have a restricted palette of varying tones of red (largely derived from the mineral hematite), creating subtle contrasts between figure and ground, most employ vivid hues arranged in flat, carefully outlined patterns. One mural (FIG. 8-7) depicts an earth or nature goddess who some scholars think was the city's principal deity. Always shown frontally with her face covered by a jade mask, she is dwarfed by her large feathered headdress and reduced to a bust placed upon a stylized pyramid. She stretches her hands out to provide liquid streams filled with bounty, but the stylized human hearts that flank the frontal bird mask in her headdress reflect her dual nature. They remind viewers that the ancient Mesoamericans saw human sacrifice as essential to agricultural renewal.

The influence of Teotihuacan was all-pervasive in Mesoamerica. The Teotihuacanos established colonies as far away as the southern borders of Maya civilization, in the highlands of Guatemala, some 800 miles from Teotihuacan.

## Classic Maya

Strong cultural influences stemming from the Olmec tradition and from Teotihuacan contributed to the development of Classic Maya culture. As was true of Teotihuacan, the foundations of Maya civilization were laid in the Preclassic period, perhaps by 600 BCE or even earlier. At that time, the Maya, who occupied the moist lowland areas of Belize, southern Mexico, Guatemala, and Honduras, seem to have abandoned their early, somewhat egalitarian pattern of village life and adopted a hierarchical autocratic society. This system evolved into the typical Maya city-state governed by hereditary

**8-7** Goddess, mural painting from the Tetitla apartment complex at Teotihuacan, Mexico, 650–750 CE. Pigments over clay and plaster.

Elaborate mural paintings adorned Teotihuacan's elite residential compound. This example may depict the city's principal deity, a goddess wearing a jade mask and a large feathered headdress.

rulers and ranked nobility. How and why this happened are still unknown.

Stupendous building projects signaled the change. Vast complexes of terraced temple-pyramids, palaces, plazas, ball courts (see "The Mesoamerican Ball Game," page 152), and residences of the governing elite dotted the Maya area. Unlike at Teotihuacan, no single Maya site ever achieved complete dominance as the center of power. The new architecture, and the art embellishing it, advertised the power of the rulers, who appropriated cosmic symbolism and stressed their descent from gods to reinforce their claims to legitimate rulership. The unified institutions of religion and kingship were established so firmly, their hold on life and custom was so tenacious, and their meaning was so fixed in the symbolism and imagery of art that the rigidly conservative system of the Classic Maya lasted 600 years. Maya civilization began to decline in the eighth century. By 900, it had vanished.

Although the causes of the beginning and end of Classic Maya civilization are obscure, researchers are gradually revealing its history, beliefs, ceremonies, conventions, and patterns of daily life through scientific excavation and progress made in decoding Mayan script. Two important breakthroughs have radically altered the understanding of both Mayan writing and the Maya worldview. The first was the realization that the Maya depicted their rulers (rather than gods or anonymous priests) in their art and noted their rulers' achievements in their texts. The second was that Mayan writing is largely phonetic—that is, the hieroglyphs are composed of signs representing sounds in the Mayan language. Fortunately, the Spaniards recorded the various Mayan languages in colonial texts and dictionaries, and most are still spoken today. Although perhaps only half of the ancient Mayan script can be translated accurately into spoken Mayan, today experts can at least grasp the general meaning of many more hieroglyphs.

The Maya possessed a highly developed knowledge of mathematical calculation and the ability to observe and record the movements of the sun, the moon, and numerous planets. They contrived an intricate but astonishingly accurate calendar with a fixed-zero date, and although this structuring of time was radically different in form from the Western calendar used today, it was just as precise and efficient. With their calendar, the Maya established the all-important genealogical lines of their rulers, which certified their claim to rule, and created the only true written history in ancient America. Although other ancient Mesoamerican societies, even in the Preclassic period, also possessed calendars, only the Maya calendar can be translated directly into today's calendrical system.

**ARCHITECTURE AND RITUAL** The Maya erected their most sacred and majestic buildings in enclosed, centrally located precincts within their cities. The religious-civic transactions that guaranteed the order of the state and the cosmos occurred in these settings. The Maya held dramatic rituals within a sculptured and painted environment, where huge symbols and images proclaimed the nature and necessity of that order. Maya builders designed spacious plazas for vast audiences who were exposed to overwhelming propaganda. The programmers of that propaganda, the ruling families and troops of priests, nobles, and retainers, incorporated its symbolism in their costumes. In Maya paintings and sculptures, the Maya elite wear extravagant costumery of vividly colorful cotton textiles, feathers, jaguar skins, and jade, all emblematic of their rank and wealth. On the different levels of the painted and polished temple platforms, the ruling classes performed the offices of their rites in clouds of incense to the music of maracas, flutes, and drums. The Maya transformed the architectural complex at each city's center into a theater of religion and statecraft. In the stagelike layout of a characteristic Maya city center, its principal group, or "site core," was the religious and administrative nucleus for a population of dispersed farmers settled throughout a suburban area of many square miles.

# The Mesoamerican Ball Game

After witnessing the native ball game of Mexico soon after their arrival, the 16th-century Spanish conquerors took Aztec ball players back to Europe to demonstrate the novel sport. Their chronicles remark on the athletes' great skill, the heavy wagering that accompanied the competition, and the ball itself, made of rubber, a substance the Spaniards had never seen before.

The game was played throughout Mesoamerica and into the southwestern United States, beginning at least 3,400 years ago, the date of the earliest known ball court. The Olmec were apparently avid players. Their very name—a modern invention in Náhuatl, the Aztec language—means "rubber people," after the latex-growing region they inhabited. Not only do ball players appear in Olmec art, but archaeologists have found remnants of sunken earthen ball courts and even rubber balls at Olmec sites.

The Olmec earthen playing field evolved in other Mesoamerican cultures into a plastered masonry surface, I- or T-shaped in plan, flanked by two parallel sloping or straight walls. Sometimes the walls were wide enough to support small structures on top, as at Copán (FIG. 8-8). At other sites, temples stood at either end of the ball court. These structures were common features of Mesoamerican cities. At Cantona in the Mexican state of Puebla, for example, archaeologists have uncovered 22 ball courts even though only a small portion of the site has been excavated. Teotihuacan (FIG. 8-5) is an exception. Excavators have not yet found a ball court there, but mural paintings at the site illustrate people playing the game with portable markers and sticks. Most ball courts were adjacent to the important civic structures of Mesoamerican cities, such as palaces and temple-pyramids, as at Copán.

Surprisingly little is known about the rules of the ball game itself—how many players were on the field, how goals were scored and tallied, and how competitions were arranged. Unlike a modern soccer field with its standard dimensions, Mesoamerican ball courts vary widely in size. The largest known—at Chichén Itzá—is nearly 500 feet long. Copán's is about 93 feet long. Some have stone rings set high up on the walls at right angles to the ground, which a player conceivably could toss a ball through, but many courts lack this feature. Alternatively, players may have bounced the ball against the walls and into the end zones. As in soccer, the players could not touch the ball with their hands but used their heads, elbows, hips, and legs. They wore thick leather belts, and sometimes even helmets, and padded their knees and arms against the blows of the fast-moving solid rubber ball. Typically, the Maya portrayed ball players wearing heavy protective clothing and kneeling, poised to deflect the ball (FIG. 8-11).

Although widely enjoyed as a competitive spectator sport, the ball game did not serve solely for entertainment. The ball, for example, may have represented a celestial body such as the sun, its movements over the court imitating the sun's daily passage through the sky. Reliefs on the walls of ball courts at certain sites make clear that the game sometimes culminated in human sacrifice, probably of captives taken in battle and then forced to participate in a game they were predestined to lose.

Ball playing also had a role in Mesoamerican mythology. In the Maya epic known as the *Popol Vuh* (*Council Book*), first written down in Spanish in the colonial period, the evil lords of the Underworld force a legendary pair of twins to play ball. The brothers lose and are sacrificed. The sons of one twin eventually travel to the Underworld and, after a series of trials including a ball game, outwit the lords and kill them. They revive their father, buried in the ball court after his earlier defeat at the hands of the Underworld gods. The younger twins rise to the heavens to become the sun and the moon, and the father becomes the god of maize, principal sustenance of all Mesoamerican peoples. The ball game and its aftermath, then, were a metaphor for the cycle of life, death, and regeneration that permeated Mesoamerican religion.

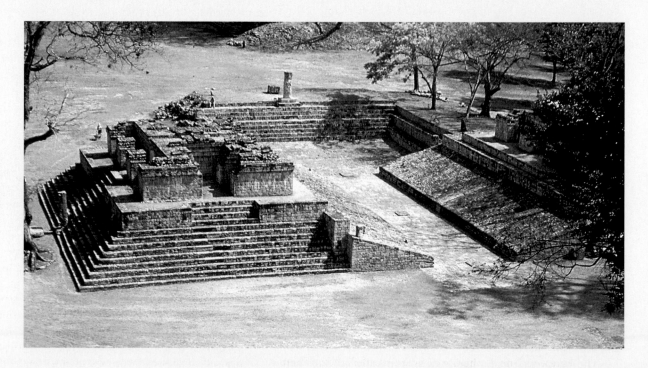

**8-8** Ball court (view looking north), Maya, Middle Plaza, Copán, Honduras, 738 CE.

Ball courts were common in Mesoamerican cities. Copán's is 93 feet long. The rules of the ball game itself are unknown, but games sometimes ended in human sacrifice, probably of captives taken in battle.

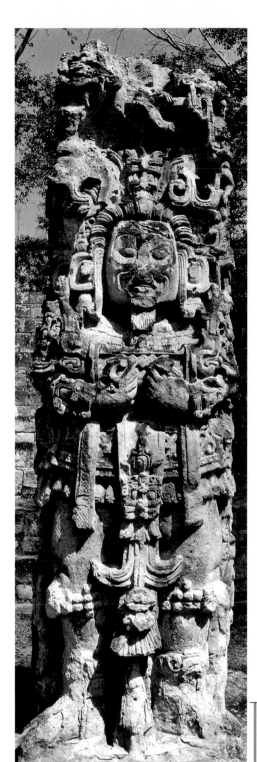

tions of the god K'awiil." Scholars often call him Ruler 13 in the Copán dynastic sequence of 16 rulers. During his long reign, Copán may have reached its greatest physical extent and range of political influence. On Stele D, Ruler 13 wears an elaborate headdress and ornamented kilt and sandals. He holds across his chest a double-headed serpent bar, symbol of the sky and of his absolute power. His features are distinctly Maya, although highly idealized. The Maya elite tended to have themselves portrayed in a conventionalized manner and as eternally youthful. The dense, deeply carved ornamental details that frame the face and figure in florid profusion stand almost clear of the block and wrap around the sides of the stele. The high relief, originally painted, gives the impression of a freestanding statue, although a hieroglyphic text is carved on the flat back side of the stele. Ruler 13 erected many stelae and buildings at Copán, but the king of neighboring Quiriguá eventually captured and beheaded the powerful Copán ruler.

**TIKAL** Another great Maya site of the Classic period is Tikal in Guatemala, some 150 miles north of Copán. Tikal is one of the oldest and largest of the Maya cities. Together with its suburbs, Tikal originally covered some 75 square miles and served as the ceremonial center of a population of perhaps 75,000. The Maya did not lay out central Tikal on a grid plan as did the designers of contemporaneous Teotihuacan. Instead, causeways connected irregular groupings. Modern surveys have uncovered the remains of as many as 3,000 separate structures in an area of about six square miles. The site's nucleus, the Great Plaza, is studded with stelae and defined by numerous architectural complexes. The most prominent monuments are the two soaring pyramids, taller than the surrounding rain forest, that face each other across an open square. The larger pyramid (FIG. 8-10), Temple I (also called the Temple of the Giant Jaguar after a motif on one of its carved wooden lintels), reaches a height of about 150 feet. It is the temple-mausoleum of a great Tikal ruler, Hasaw Chan K'awiil, who died in 732 CE. His body rested in a

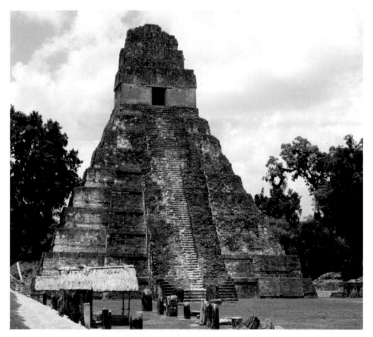

8-10 Temple I (Temple of the Giant Jaguar), Maya, Tikal, Guatemala, ca. 732 CE.

Temple I at Tikal is a 150-foot-tall pyramid that was the temple-mausoleum of Hasaw Chan K'awiil, who died in 732 CE. The nine tiers of the pyramid probably symbolize the nine levels of the Underworld.

**COPÁN** Because Copán, on the western border of Honduras, has more hieroglyphic inscriptions and well-preserved carved monuments than any other site in the Americas, it was one of the first Maya sites excavated. It also has proved one of the richest in the trove of architecture, sculpture, and artifacts recovered, and boasts one of Mesoamerica's best-preserved (and carefully restored) ball courts (FIG. 8-8; see "The Mesoamerican Ball Game," page 152).

Conspicuous plazas dominated the heart of Copán. In the city's Great Plaza, the Maya set up tall, sculpted stone stelae. Carved with the portraits of the rulers who erected them, these stelae also recorded their names, dates of reign, and notable achievements in glyphs on the front, sides, or back. Stele D (FIG. 8-9), erected in 736 CE, represents one of the city's foremost rulers, Waxaklajuun-Ub'aah-K'awiil (r. 695–738), whose name means "18 are the appari-

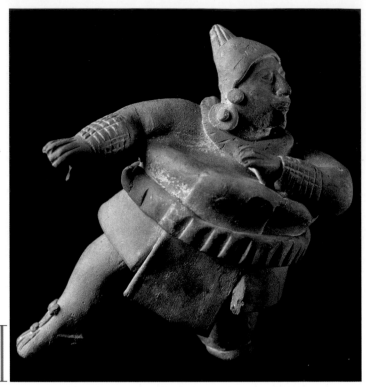

1 in.

**8-11** Ball player, Maya, from Jaina Island, Mexico, 700–900 CE. Painted clay, $6\frac{1}{4}''$ high. Museo Nacional de Antropología, Mexico City.

Maya ceramic figurines represent a wide range of human types and activities. This kneeling ball player wears a thick leather belt and arm- and kneepads to protect him from the hard rubber ball.

vaulted chamber under the pyramid's base. The towering structure consists of nine sharply inclining platforms, probably a reference to the nine levels of the Underworld. A narrow stairway leads up to a three-chambered temple. Surmounting the temple is an elaborately sculpted *roof comb*, a vertical architectural projection that once bore the ruler's giant portrait modeled in stucco. The entire structure exhibits most concisely the ancient Mesoamerican formula for the stepped temple-pyramid and the compelling aesthetic and psychological power of Maya architecture.

**JAINA** The almost unlimited variety of figural attitude and gesture permitted in the modeling of clay explains the profusion of Maya ceramic figurines that, like their West Mexican predecessors (FIG. 8-4), may illustrate aspects of everyday life. Small-scale free-standing figures in the round, they are remarkably lifelike, carefully descriptive, and even comic at times. They represent a wider range of human types and activities than is commonly depicted on Maya stelae. Ball players (FIG. 8-11), women weaving, older men, dwarfs, supernatural beings, and amorous couples, as well as elaborately attired rulers and warriors, make up the figurine repertory. Many of the hollow figurines are also whistles. They were made in ceramic workshops on the mainland, often with molds, but graves in the island cemetery of Jaina, off the western coast of Yucatán, yielded hundreds of these figures, including the ball player illustrated here. Traces of blue remain on the figure's belt—remnants of the vivid pigments that once covered many of these figurines. The Maya used "Maya blue," a combination of a particular kind of clay and indigo, a vegetable dye, to paint both ceramics and murals. This pigment has proved virtually indestructible, unlike the other colors that largely

have disappeared over time. Like the larger terracotta figures of West Mexico, these figurines accompanied the dead on their inevitable voyage to the Underworld. The excavations at Jaina, however, have revealed nothing more that might clarify the meaning and function of the figures. Male figurines do not come exclusively from burials of male individuals, for example.

**BONAMPAK** The vivacity of the Jaina figurines and their variety of pose, costume, and occupation have parallels in the mural paintings of Bonampak (Mayan for "painted walls") in southeastern Mexico. Three chambers in one Bonampak structure contain murals that record important aspects of Maya court life. The example reproduced here (FIG. 8-12) shows warriors surrounding captives on a terraced platform. The figures have naturalistic proportions and overlap, twist, turn, and gesture. The artists used fluid and calligraphic line to outline the forms, working with color to indicate both texture and volume. The Bonampak painters combined their pigments—both mineral and organic—with a mixture of water, crushed limestone, and vegetable gums and applied them to their stucco walls in a technique best described as a cross between *fresco* and *tempera*.

The Bonampak murals are filled with circumstantial detail. The information given is comprehensive, explicit, and presented with the fidelity of an eyewitness report. The royal personages are identifiable by both their physical features and their costumes, and accompanying inscriptions provide the precise day, month, and year for the events recorded. All the scenes at Bonampak relate the events and ceremonies that welcome a new royal heir (shown as a toddler in some scenes). They include presentations, preparations for a royal fete, dancing, battle, and the taking and sacrificing of prisoners. On all occasions of state, public bloodletting was an integral part of Maya ritual. The ruler, his consort, and certain members of the nobility drew blood from their own bodies and sought union with the supernatural world. The slaughter of captives taken in war regularly accompanied this ceremony. Indeed, Mesoamerican cultures undertook warfare largely to provide victims for sacrifice. The torture and eventual execution of prisoners served both to nourish the gods and to strike fear into enemies and the general populace.

The scene (FIG. 8-12) in room 2 of structure 1, depicts the presentation of prisoners to Lord Chan Muwan. The painter arranged the figures in registers that may represent a pyramid's steps. On the uppermost step, against a blue background, is a file of gorgeously appareled nobles wearing animal headgear. Conspicuous among them on the right are retainers clad in jaguar pelts and jaguar headdresses. Also present is Chan Muwan's wife (third from right). The ruler himself, in jaguar jerkin and high-backed sandals, stands at the center, facing a crouching victim who appears to beg for mercy. Naked captives, anticipating death, crowd the middle level. One of them, already dead, sprawls at the ruler's feet. Others dumbly contemplate the blood dripping from their mutilated hands. The lower zone, cut through by a doorway into the structure housing the murals, shows clusters of attendants who are doubtless of inferior rank to the lords of the upper zone. The stiff formality of the victors contrasts graphically with the supple imploring attitudes and gestures of the hapless victims. The Bonampak victory was short-lived. The artists never finished the murals, and shortly after the dates written on the walls, the Maya seem to have abandoned the site.

The Bonampak murals are the most famous Maya wall paintings, but they are not unique. In 2001 at San Bartolo in northeastern Guatemala, archaeologists discovered the earliest examples yet found. They date to about 100 BCE, almost a millennium before the Bonampak murals.

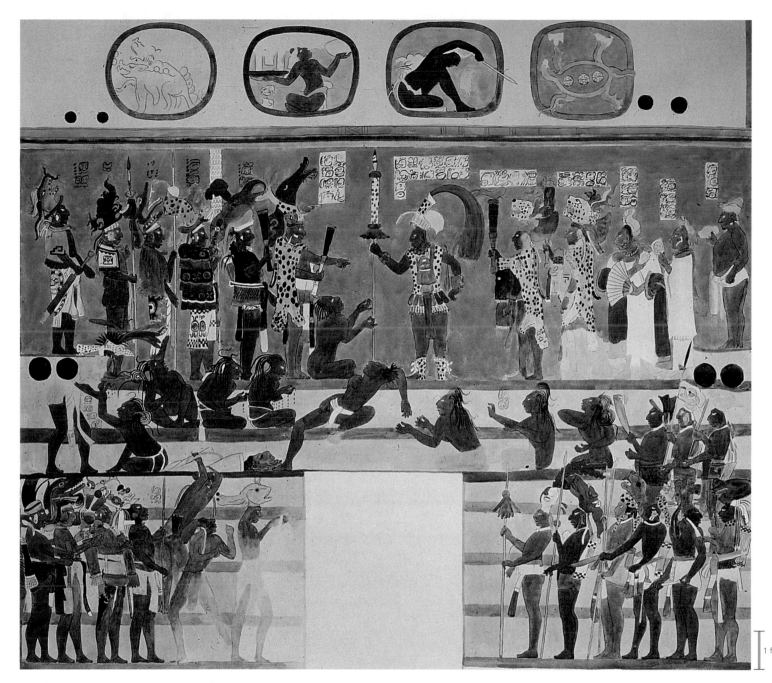

**8-12** Presentation of captives to Lord Chan Muwan, Maya, room 2 of structure 1, Bonampak, Mexico, ca. 790 CE. Mural, 17' × 15'; watercolor copy by Antonio Tejeda. Peabody Museum of Archaeology and Ethnology, Harvard University, Cambridge.

The figures in this mural—a cross between fresco and tempera—may be standing on a pyramid's steps. At the top, the richly attired Chan Muwan reviews naked captives with mutilated hands awaiting their death.

**YAXCHILÁN** Elite women played an important role in Maya society, and some surviving artworks document their high status. The painted reliefs on the lintels of temple 23 at Yaxchilán represent a woman as a central figure in Maya ritual. Lintel 24 (FIG. **8-1**) depicts the ruler Itzamna Balam II (r. 681–742 CE), known as Shield Jaguar, and his principal wife, Lady Xoc. Lady Xoc is magnificently outfitted in an elaborate woven garment, headdress, and jewels. She pierces her tongue with a barbed cord in a bloodletting ceremony that, according to accompanying inscriptions, celebrated the birth of a son to one of the ruler's other wives as well as an alignment between the planets Saturn and Jupiter. The celebration must have been held in a dark chamber or at night because Shield Jaguar provides illumination with a blazing torch. The purpose of these ceremonies was to produce hallucinations. (Lintel 25 depicts Lady Xoc and her vision of an ancestor emerging from the mouth of a serpent.)

## Classic Veracruz

Although the Maya is the most famous Classic Mesoamerican culture today and its remains are the most abundant, other cultures also flourished, and some of their surviving monuments rival those of the Maya in size and sophistication. In the Veracruz plain, for example, the heir to the Olmec culture was a civilization that archaeologists call Classic Veracruz. The name of the people that occupied the area at the time is unknown.

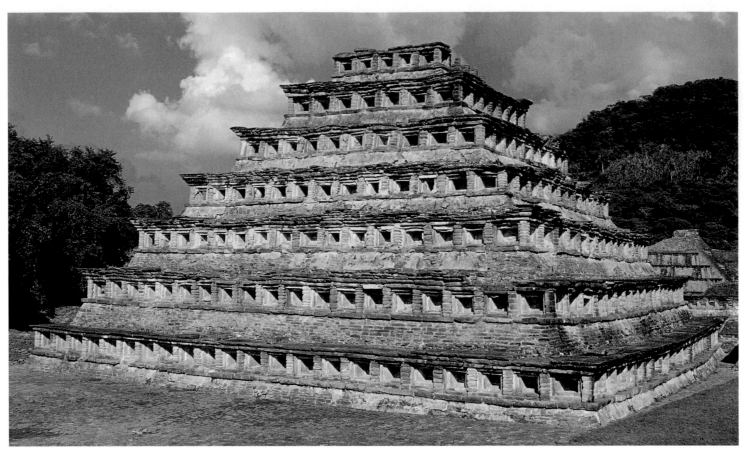

**8-13** Pyramid of the Niches, Classic Veracruz, El Tajín, Mexico, sixth century CE.

The Pyramid of the Niches, although only 66 feet tall, has 365 niches on its four sides, one for each day of the solar year. It is one of many Mesoamerican monuments connected with astronomy and the calendar.

**EL TAJÍN** The major Classic Veracruz site is El Tajín, which was discovered in the dense rain forest of the Gulf of Mexico coast in 1785. At its peak, El Tajín was a thriving city of hundreds of acres and tens of thousands of inhabitants. Its excavated portion has already revealed 17 ball courts. The building that dominates the ceremonial center of El Tajín is the so-called Pyramid of the Niches (FIG. 8-13), a sixth-century CE structure of unusual form. In spite of its small size (only 66 feet tall), the Pyramid of the Niches encases an earlier smaller pyramid. The later structure has a steep staircase on its east side and six stories, each one incorporating a row of niches on each of the four sides, 365 in all. The number of niches, which corresponds to the number of days in a solar year, is unlikely to be coincidental. The Pyramid of the Niches is one of many examples of the close connection between the form of Mesoamerican monuments and astronomical observations and the measurement of time.

## Postclassic Mexico

Throughout Mesoamerica, the Classic period ended at different times with the disintegration of the great civilizations. Teotihuacan's political and cultural empire, for example, was disrupted around 600, and its influence waned. About 600, fire destroyed the center of the great city, but the cause is still unknown. Within a century, however, Teotihuacan was deserted. Around 900, many of the great Maya sites were abandoned to the jungle, leaving a few northern Maya cities to flourish for another century or two before they, too, became depopulated. The Classic culture of the Zapotecs, centered at Monte Albán in the state of Oaxaca, came to an end around 700, and the neighboring Mixtec peoples assumed supremacy in this area during the Postclassic period. Classic El Tajín survived the general crisis that

afflicted the others but burned sometime in the 12th century. The war and confusion that followed the collapse of the Classic civilizations fractured the great states into small, local political entities isolated in fortified sites. The collapse encouraged even more warlike regimes and chronic aggression. The militant city-state of Chichén Itzá dominated Yucatán, while in central Mexico the Toltec and the later Aztec peoples, both ambitious migrants from the north, forged empires by force of arms.

**CHICHÉN ITZÁ** Yucatán, a flat, low, limestone peninsula covered with scrub vegetation, lies north of the rolling and densely forested region of the Guatemalan Petén. During the Classic period, Mayan-speaking peoples sparsely inhabited this northern region. For reasons scholars still debate, when the southern Classic Maya sites were abandoned after 900, the northern Maya continued to build many new temples in this area. They also experimented with building construction and materials to a much greater extent than their cousins farther south. Piers and columns appeared in doorways, and stone mosaics enlivened outer facades. The northern groups also invented a new type of construction, a solid core of coarse rubble faced on both sides with a veneer of square limestone plates.

Dominating the main plaza of Chichén Itzá today is the 98-foot-high pyramid (FIG. 8-14) that the Spaniards nicknamed the Castillo (Castle). As at Tikal (FIG. 8-10), this pyramid has nine levels. Atop the structure is a temple dedicated to Kukulkan, the Maya equivalent of Quetzalcoatl, and, as at El Tajín (FIG. 8-13), the design of the Castillo is tied to the solar year. The north side has 92 steps and the other three sides 91 steps each for a total of 365. At the winter and summer equinoxes, the sun casts a shadow along the north-

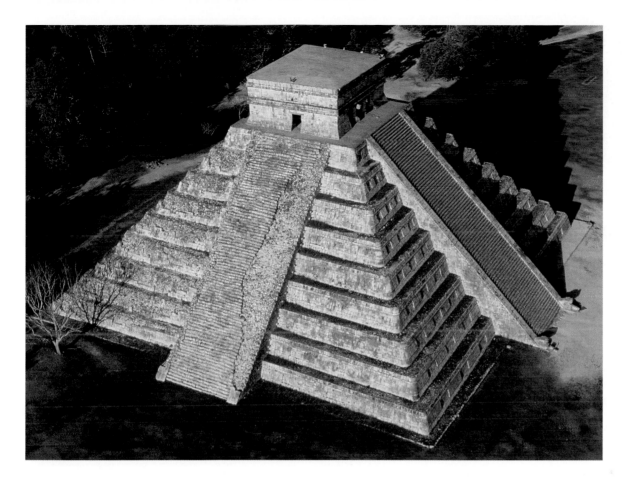

A temple to Kukulkan sits atop this pyramid with a total of 365 stairs on its four sides. At the winter and summer equinoxes, the sun casts a shadow in the shape of a serpent along the northern staircase.

ern staircase of the pyramid. Because of the pyramid's silhouette and the angle of the sun, the shadow takes the shape of a serpent that slithers along the pyramid's face as the sun moves across the sky.

Excavations inside the Castillo in 1937 revealed an earlier nine-level pyramid within the later and larger structure. Inside was a royal burial chamber with a throne in the form of a red jaguar and a stone figure of a type called a *chacmool* depicting a fallen warrior. Chacmools (for example, FIG. 8-15, found near the Castillo) recline on their backs and have receptacles on their chests to receive sacrificial offerings, probably of defeated enemies. The distinctive forms of the Mesoamerican chacmools made a deep impression upon 20th-century sculptors.

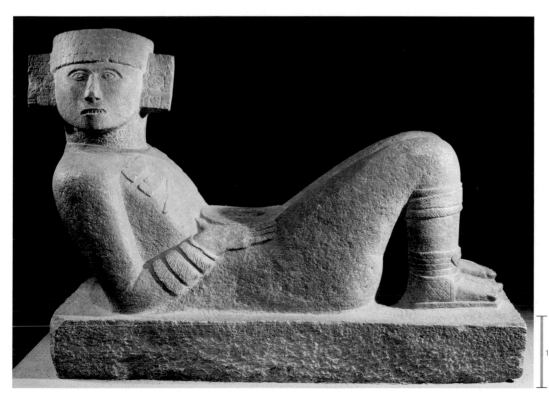

8-15 Chacmool, Maya, from the Platform of the Eagles, Chichén Itzá, Mexico, ca. 800–900 CE. Stone, 4′ 10½″ high. Museo Nacional de Antropología, Mexico City.

Chacmools represent fallen warriors reclining on their backs with receptacles on their chests to receive sacrificial offerings. Excavators discovered one in the burial chamber inside the Castillo (FIG. 8-14).

1 ft.

Mesoamerica 157

**8-16** Aerial view (looking south) of the Caracol, Maya, Chichén Itzá, Mexico, ca. 800–900 CE.

Caracol means "snail shell," and this unusual round northern Maya structure encloses a circular staircase. The building may have been a temple to Kukulkan with an astronomical observatory at its summit.

The Caracol (FIG. **8-16**) at Chichén Itzá establishes that the northern Maya were as inventive with architectural form as they were experimental with construction and materials. A cylindrical tower rests on a broad terrace that is in turn supported by a larger rectangular platform measuring 169 × 232 feet. The tower, composed of two concentric walls, encloses a circular staircase that leads to a small chamber near the top of the structure. In plan, the building recalls the cross-section of a conch shell. (Caracol means "snail" in Spanish.) The conch shell was an attribute of the feathered serpent, and round temples were dedicated to him in central Mexico. This building may therefore also have been a temple to Kukulkan. Windows along the Caracol's staircase and an opening at the summit probably were used for astronomical observation.

**TULA** The name Toltec, which signifies "makers of things," generally refers to a powerful tribe of invaders from the north, whose arrival in central Mexico coincided with the great disturbances that must have contributed to the fall of the Classic civilizations. The Toltec capital at Tula flourished from about 900 to 1200. The Toltecs were expert political organizers and military strategists, dominating large parts of north and central Mexico. They also were master artisans and farmers, and later peoples such as the Aztecs looked back on the Toltecs admiringly, proud to claim descent from them.

Archaeologists have noted many similarities between the sites of Tula and Chichén Itzá.

At Tula, four colossal *atlantids* (male statue-columns; FIG. **8-17**) portraying armed warriors reflect the grim, warlike regime of the Toltecs. These images of brutal authority stand eternally at attention, warding off all hostile threats. Built up of four stone drums each, the sculptures stand atop pyramid B. They wear feathered headdresses and, as breastplates, stylized butterflies, heraldic symbols of the Toltec. In one hand they clutch a bundle of darts and in the other an *atlatl* (spear-thrower), typical weapons of highland Mexico. The figures originally supported a temple roof, now missing. Such an architectural function requires rigidity of pose, compactness, and strict simplicity of contour. The unity and regularity of architectural mass and silhouette here combine perfectly with abstraction of form.

By 1180 the last Toltec ruler abandoned Tula, and most of his people followed. Some years later, the city was catastrophically destroyed, its ceremonial buildings burned to their foundations, its walls demolished, and the straggling remainder of its population scattered. The exact reasons for the Toltecs' departure and for their city's destruction are unknown. Although the Toltec demise set the stage for the rise of the last great civilization of Mesoamerica, the Aztecs (see Chapter 9), that culture did not reach the height of its power for another 300 years.

**8-17** Colossal atlantids, pyramid B, Toltec, Tula, Mexico, ca. 900–1180 CE. Stone, each 16′ high.

The colossal statue-columns of Tula portraying warriors armed with darts and spear-throwers reflect the military regime of the Toltecs, whose arrival in central Mexico coincided with the decline of the Maya.

# INTERMEDIATE AREA

Between the highly developed civilizations of Mesoamerica and the South American Andes lies a region archaeologists have dubbed the "Intermediate Area." Comprising parts of El Salvador, Honduras, Ecuador, and Venezuela, and all of Panama, Costa Rica, Nicaragua, and Colombia, at the time of the European invasion it was by no means a unified political territory but rather was divided among many small rival chiefdoms. Although the people of the Intermediate Area did not produce monumental architecture on the scale of their neighbors to the north and south and, unlike the Mesoamericans, left no written records, they too were consummate artists. Potters in the Intermediate Area made some of the earliest ceramics of the Americas, and they continued to create an astonishing variety of terracotta vessels and figures until the time of the Spanish conquest. Among the other arts practiced in the Intermediate Area were stone sculpture and jade carving. Inhabitants throughout the region prized goldworking, and the first Europeans to make contact here were astonished to see the natives nearly naked but covered in gold jewelry. The legend of El Dorado, a Colombian chief who coated himself in gold as part of his accession rites, was largely responsible for the Spanish invaders' ruthless plunder of the region.

**TAIRONA** In northern Colombia (MAP 8-2), the Sierra Nevada de Santa Marta rises above the Caribbean. The topography of lofty mountains and river valleys provided considerable isolation and fostered the independent development of various groups. The inhabitants of this region after about 1000 CE included a group known as the Tairona, whose metalwork is among the finest of all the ancient American goldworking styles.

MAP 8-2 Early sites in Andean South America.

1 in.

**8-18** Pendant in the form of a bat-faced man, Tairona, from northeastern Colombia, after 1000 CE. Gold, $5\frac{1}{4}$" high. Metropolitan Museum of Art, New York (Jan Mitchell and Sons Collection).

The peoples of the Intermediate Area between Mesoamerica and Andean South America were expert goldsmiths. This pendant depicting a bat-faced man with a large headdress served as an amulet.

Goldsmiths in Peru, Ecuador, and southern Colombia produced technologically advanced and aesthetically sophisticated work in gold mostly by cutting and hammering thin gold sheets. The Tairona smiths, however, who had to obtain gold by trade, used the *lost-wax process* in part to preserve the scarce amount of the precious metal available to them. Tairona pendants were not meant to be worn simply as rich accessories for costumes but as amulets or talismans representing powerful beings who gave the wearer protection and status. The pendant shown here (FIG. **8-18**) represents a bat-faced man—perhaps a masked man rather than a composite being, or a man in the process of spiritual transformation. In local mythology, the first animal created was the bat. This bat-man wears an immense headdress composed of two birds in the round, two great beaked heads, and a series of spirals crowned by two overarching stalks. The harmony of repeated curvilinear motifs, the rhythmic play of their contours, and the precise delineation of minute detail attest to the artist's technical control and aesthetic sensitivity.

## SOUTH AMERICA

As in Mesoamerica, the indigenous civilizations of Andean South America (MAP 8-2) jarred against and stimulated one another, produced towering monuments and sophisticated paintings, sculptures, ceramics, and textiles, and were crushed in violent confrontations with the Spanish conquistadors. Although less well studied than the ancient Mesoamerican cultures, those of South America are actually older, and in some ways they surpassed the accomplishments of their northern counterparts. Andean peoples, for example, mastered metalworking much earlier, and their monumental architecture predates that of the earliest Mesoamerican culture, the Olmec, by more than a millennium. The peoples of northern Chile even began to mummify their dead at least 500 years before the Egyptians.

The Central Andean region of South America lies between Ecuador and northern Chile, with its western border the Pacific Ocean. It consists of three well-defined geographic zones, running north and south and roughly parallel to one another. The narrow western coastal plain is a hot desert crossed by rivers, which create habitable fertile valleys. Next, the high peaks of the great Cordillera of the Andes hem in plateaus of a temperate climate. The region's inland border, the eastern slopes of the Andes, is a hot and humid jungle.

Andean civilizations flourished both in the highlands and on the coast. Highland cave dwellers fashioned the first rudimentary art objects by 8800 BCE. Artisans started producing sophisticated textiles as early as 2500 BCE, and the firing of clay began in Peru before 1800 BCE. Beginning about 800 BCE, Andean chronology alternates between periods known as "horizons," when a single culture appears to have dominated a broad geographic area for a relatively long period, and "intermediate periods" characterized by more independent regional development. The Chavín culture (ca. 800–200 BCE) represents the first period, Early Horizon; the Tiwanaku and Wari cultures (ca. 600–1000 CE) the Middle Horizon; and the Inka Empire (see Chapter 9) the Late Horizon. Among the many regional styles that flourished between these horizons, the most important are the Early Intermediate period (ca. 200 BCE–700 CE) Paracas and Nasca cultures of the south coast of Peru, and the Moche in the north.

The discovery of complex ancient communities documented by radiocarbon dating is changing the picture of early South American cultures. Planned communities boasting organized labor systems and monumental architecture dot the narrow river valleys that drop from the Andes to the Pacific Ocean. In the Central Andes, these early sites began to develop around 3000 BCE, about a millennium before the invention of pottery there. Carved gourds and some fragmentary cotton textiles survive from this early period. They depict composite creatures, such as crabs turning into snakes, as well as doubled and then reversed images, both hallmarks of later Andean art.

The architecture of the early coastal sites typically consists of large U-shaped, flat-topped platforms—some as high as a 10-story building—around sunken courtyards. Many had numerous small chambers on top. Construction materials included both uncut fieldstones and handmade *adobes* (sun-dried mud bricks) in the shape of cones, laid point to point in coarse mud plaster to form walls and platforms. These complexes almost always faced toward the Andes mountains, source of the life-giving rivers on which these communities depended for survival. Mountain worship, which continues in the Andean region to this day, was probably the focus of early religious practices as well. In the highlands, archaeologists also have discovered large ceremonial complexes. In place of the numerous interconnecting rooms found atop many coastal mounds, the highland examples have a single small chamber at the top, often with a stone-lined firepit in the center. These pits probably played a role in ancient fire rituals. Excavators have found burnt offerings in the pits, often of exotic objects such as marine shells and tropical bird feathers.

### Chavín

Named after the ceremonial center of Chavín de Huántar, located in the northern highlands of Peru, the Chavín culture of the Early Horizon period developed and spread throughout much of the coastal region and the highlands during the first millennium BCE. Once thought to be the "mother culture" of the Andean region, the Chavín culture is now seen as the culmination of developments that began elsewhere some 2,000 years earlier.

1 ft.

**8-19** *Raimondi Stele,* from the main temple, Chavín de Huántar, Peru, ca. 800–200 BCE. Incised green diorite, 6′ high. Instituto Nacional de Cultura, Lima.

The *Raimondi Stele* staff god wears a headdress of faces and snakes. Seen upside down, the god's face becomes two faces. The ability of the gods to transform themselves is a core aspect of Andean religion.

The Old Temple of Chavín de Huántar, dated to the first millennium BCE, resembles some of the sacred complexes of the earliest Andean cultures. It is a U-shaped, stone-faced structure between two rivers, with wings up to 83 yards long. Although at first glance its three stories appear to be a solid stepped platform, in fact narrow passageways, small chambers, and stairways penetrate the temple in a labyrinthine pattern. No windows, however, light the interior spaces. The few members of Chavín society with access to these rooms must have witnessed secret and sacred torch-lit ceremonies. The temple is fronted by sunken courts, an arrangement also adopted from earlier coastal sites.

The temple complex at Chavín de Huántar is famous for its extensive stone carvings. The most common subjects are composite creatures that combine feline, avian, reptilian, and human features. Consisting largely of low relief on panels, cornices, and columns, and some rarer instances of freestanding sculpture, Chavín carving is essentially shallow, linear incision. An immense oracular cult image once stood in the center of the temple's oldest part. Other examples of sculpture in the round include heads of mythological creatures, which were pegged into the exterior walls.

*RAIMONDI STELE* Found in the main temple at Chavín de Huántar and named after its discoverer, the *Raimondi Stele* (FIG. **8-19**), represents a figure called the "staff god." He appears in various versions from Colombia to northern Bolivia but always holds staffs. Seldom, however, do the representations have the degree of elaboration found at Chavín. The Chavín god gazes upward, frowns, and bares his teeth. His elaborate headdress dominates the upper two-thirds of the slab. Inverting the image reveals that the headdress is composed of a series of fanged jawless faces, each emerging from the mouth of the one above it. Snakes abound. They extend from the deity's belt, make up part of the staffs, serve as whiskers and hair for the deity and the headdress creatures, and form a braid at the apex of the composition. The *Raimondi Stele* clearly illustrates the Andean artistic tendency toward both multiplicity and dual readings. Upside down, the god's face turns into not one but two faces. The ability of gods to transform before the viewer's eyes is a core aspect of Andean religion.

Chavín iconography spread widely throughout the Andean region via portable media such as goldwork, textiles, and ceramics. For example, more than 300 miles from Chavín on the south coast of Peru, archaeologists have discovered cotton textiles with imagery recalling Chavín sculpture. Painted staff-bearing female deities, apparently local manifestations or consorts of the highland staff god, decorate these large cloths, which may have served as wall hangings in temples. Ceramic vessels found on the north coast of Peru also carry motifs much like those found on Chavín stone carvings.

## Paracas, Nasca, and Moche

Several coastal traditions developed during the millennium from ca. 400 BCE to 700 CE. The most prominent were the Paracas (ca. 400 BCE–200 CE), Nasca (ca. 200 BCE–600 CE), and Moche (ca. 1–700 CE). Together they exemplify the great variations within Peruvian art styles.

**PARACAS** The Paracas culture occupied a desert peninsula and a nearby river valley on the south coast of Peru. Outstanding among the Paracas arts are the funerary textiles used to wrap the bodies of the dead in multiple layers. The dry desert climate preserved the textiles, buried in shaft tombs beneath the sands. These textiles are among the enduring masterpieces of Andean art (see "Andean Weaving," page 162). Most are of woven cotton with designs embroidered onto the fabric in alpaca or vicuña wool imported from the highlands. The weavers used more than 150 vivid colors, the majority derived from

## Andean Weaving

When the Inka first encountered the Spanish conquistadors, they were puzzled by the Europeans' fixation on gold and silver. The Inka valued finely woven cloth just as highly as precious metal. Textiles and clothing dominated every aspect of their existence. Storing textiles in great warehouses, their leaders demanded cloth as tribute, gave it as gifts, exchanged it during diplomatic negotiations, and even burned it as a sacrificial offering. Although both men and women participated in cloth production, the Inka rulers selected the best women weavers from around the empire and sequestered them for life to produce textiles exclusively for the elite.

Andean weavers manufactured their textiles by spinning into yarn the cotton grown in five different shades on the warm coast and the fur sheared from highland llamas, alpacas, vicuñas, or guanacos, and then weaving the yarn into cloth. Rare tropical bird feathers and small plaques of gold and silver were sometimes sewn onto cloth destined for the nobility. Andean weavers mastered nearly every textile technique known today, many executed with a simple device known as a *backstrap loom*. Similar looms are still in use in the Andes. The weavers stretch the long *warp* (vertical) threads between two wooden bars. The top bar is tied to an upright. A belt or backstrap, attached to the bottom bar, encircles the waist of the seated weaver, who maintains the tension of the warp threads by leaning back. The weaver passes the *weft* (horizontal) threads over and under the warps and pushes them tightly against each other to produce the finished cloth. In ancient textiles, the sturdy cotton often formed the warp, and the wool, which can be dyed brighter colors, served to create complex designs in the weft. *Embroidery*, the sewing of threads onto a finished ground cloth to form contrasting designs, was the specialty of the Paracas culture (FIG. 8-20).

The dry deserts of coastal Peru have preserved not only numerous textiles from different periods but also hundreds of finely worked baskets containing spinning and weaving implements. These tools are invaluable sources of information about Andean textile production processes. The baskets found in documented contexts came from women's graves, attesting to the close identity between weaving and women, the reverence for the cloth-making process, and the Andean belief that textiles were necessary in the afterlife.

A special problem all weavers confront is that they must visualize the entire design in advance and cannot easily change it during the weaving process. No records exist of how Andean weavers learned, retained, and passed on the elaborate patterns they wove into cloth, but some painted ceramics depict weavers at work, apparently copying designs from finished models. However, the inventiveness of individual weavers is evident in the endless variety of colors and patterns in surviving Andean textiles. This creativity often led Andean artists to design textiles that are highly abstract and geometric. Paracas embroideries (FIG. 8-20), for example, may depict humans, down to the patterns on the tunics they wear, yet the figures are reduced to their essentials in order to focus on their otherworldly role. The culmination of this tendency toward abstraction may be seen in the Wari compositions (FIG. 8-26) in which figural motifs become stunning blocks of color that overwhelm the subject matter itself.

1 ft.

**8-20** Embroidered funerary mantle, Paracas, from the southern coast of Peru, first century CE. Plain-weave camelid fiber with stem-stitch embroidery of camelid wool, 4′ 7$\frac{7}{8}$″ × 7′ 10$\frac{7}{8}$″. Museum of Fine Arts, Boston (William A. Paine Fund).

Outstanding among the Paracas arts are the woven mantles used to wrap the bodies of the dead. The flying or floating figure repeated endlessly on this mantle is probably either the deceased or a religious practitioner.

plants. Feline, bird, and serpent motifs appear on many of the textiles, but the human figure, real or mythological, predominates. Humans dressed up as or changing into animals are common motifs on the grave mantles—consistent with the Andean transformation theme noted on the *Raimondi Stele* (FIG. 8-19). On one well-preserved mantle (FIG. 8-20), a figure with prominent eyes appears scores of times over the surface. The flowing hair and the slow kicking motion of the legs suggest airy, hovering movement. The flying or floating figure carries batons and fans, or, according to some scholars, knives and hallucinogenic mushrooms. On other mantles the figures carry the skulls or severed heads of enemies. Art historians have interpreted the flying figures either as Paracas religious practitioners dancing or flying during an ecstatic trance or as images of the deceased. Despite endless repetitions of the motif, variations of detail occur throughout each textile, notably in the figures' positions and in subtle color changes.

**NASCA** The Nasca culture takes its name from the Nasca River valley south of Paracas. The early centuries of the Nasca civilization ran concurrently with the closing centuries of the Paracas culture, and Nasca style emulated Paracas style. The Nasca won renown for their pottery, and thousands of their ceramic vessels survive. The vases usually have round bottoms, double spouts connected by bridges, and smoothly burnished polychrome surfaces. The subjects vary greatly, but plants, animals, and composite mythological creatures, part human and part animal, are most common. Nasca painters often represented ritual impersonators, some of whom, like the Paracas flying figures, hold trophy heads and weapons. On the vessel illustrated here (FIG. 8-21) are two costumed flying figures. The painter reduced their bodies and limbs to abstract appendages and focused on the heads. The figures wear a multicolored necklace, a whiskered gold mouthpiece, circular disks hanging from the ears, and a rayed crown on the forehead. Masks or heads with streaming hair, possibly more trophy heads, flow over the impersonators' backs, increasing the sense of motion.

Nasca artists also depicted figures on a gigantic scale. Some 800 miles of lines drawn in complex networks on the dry surface of the Nasca plain have long attracted world attention because of their

1 in.

**8-21** Bridge-spouted vessel with flying figures, Nasca, from Nasca River valley, Peru, ca. 50–200 CE. Painted ceramic, $5\frac{1}{2}''$ high. Art Institute of Chicago, Chicago (Kate S. Buckingham Endowment).

The Nasca were masters of pottery painting. The painter of this bridge-spouted vessel depicted two crowned and bejeweled flying figures, probably ritual impersonators with trophy heads.

colossal size, which defies human perception from the ground. Preserved today are about three dozen images of birds, fish, and plants, including a hummingbird (FIG. 8-22) several hundred feet long. The Nasca artists also drew geometric forms, such as trapezoids, spirals, and straight lines running for miles. Artists produced these Nasca Lines, as the immense earth drawings are called, by selectively

**8-22** Hummingbird, Nasca, Nasca plain, Peru, ca. 500 CE. Dark layer of pebbles scraped aside to reveal lighter clay and calcite beneath.

The earth drawings known as Nasca Lines represent birds, fish, plants, and geometric forms. They may have marked pilgrimage routes leading to religious shrines, but their function is uncertain.

removing the dark top layer of stones to expose the light clay and calcite below. The Nasca created the lines quite easily from available materials and using rudimentary geometry. Small groups of workers have made modern reproductions of them with relative ease. The lines seem to be paths laid out using simple stone-and-string methods. Some lead in traceable directions across the deserts of the Nasca River drainage. Others are punctuated by many shrinelike nodes, like the knots on a cord. Some lines converge at central places usually situated close to water sources and seem to be associated with water supply and irrigation. They may have marked pilgrimage routes for those who journeyed to local or regional shrines on foot. Altogether, the vast arrangement of the Nasca Lines is a system—not a meaningless maze but a map that plotted the whole terrain of Nasca material and spiritual concerns. Remarkably, until quite recently, the peoples of highland Bolivia made and used similar ritual pathways in association with shrines, demonstrating the tenacity of the Andean indigenous belief systems.

**MOCHE** Among the most famous art objects the ancient Peruvians produced are the painted clay vessels of the Moche, who occupied a series of river valleys on the northern coast of Peru around the same time the Nasca flourished to the south. Among ancient civilizations, only the Greeks and the Maya surpassed the Moche in the information recorded on their ceramics. Moche pots illustrate architecture, metallurgy, weaving, the brewing of chicha (fermented maize beer), human deformities and diseases, and even sexual acts. Moche

vessels are predominantly flat-bottomed, stirrup-spouted jars derived from Chavín prototypes. The potters generally decorated them with a *bichrome* (two-color) slip. Although the Moche made early vessels by hand without the aid of a potter's wheel, they fashioned later ones in two-piece molds. Thus, numerous near-duplicates survive. Moche ceramists continued to refine the stirrup spout, making it an elegant slender tube, much narrower than the Chavín examples. The portrait vessel illustrated here (FIG. **8-23**) is an elaborate example of a common Moche type. It may depict the face of a warrior, a ruler, or even a royal retainer whose image may have been buried with many other pots to accompany his dead master. The realistic rendering of the physiognomy is particularly striking.

**SIPÁN** Elite men, along with retinues of sacrificial victims, appear to be the occupants of several rich Moche tombs excavated near the village of Sipán on the arid northwest coast of Peru. The Sipán burial sites have yielded a treasure of golden artifacts and more than a thousand ceramic vessels. The discovery of the tombs in the late 1980s created a great stir in the archaeological world, contributing significantly to the knowledge of Moche culture. Beneath a large adobe platform adjacent to two high but greatly eroded pyramids, excavators found several lavish graves, including the tomb of a man known today as the Lord of Sipán, or the Warrior Priest. The splendor of the funeral trappings that adorned his body, the quantity and quality of the sumptuous accessories, and the bodies of the retainers buried with him indicate that he was a personage of the highest rank. Indeed, he may have been one of the warrior priests so often depicted on Moche ceramic wares and murals (and in this tomb on a golden pyramid-shaped rattle) assaulting his enemies and participating in sacrificial ceremonies.

An ear ornament (FIG. **8-24**) of turquoise and gold found in one Sipán tomb shows a warrior priest clad much like the Lord of Sipán. Two retainers appear in profile to the left and right of the central figure. Represented frontally, he carries a war club and shield and

1 in.

**8-23** Vessel in the shape of a portrait head, Moche, from the northern coast of Peru, fifth to sixth century CE. Painted clay, 1' $\frac{1}{2}$" high. Museo Arqueológico Rafael Larco Herrera, Lima.

The Moche culture produced an extraordinary variety of painted vessels. This one in the shape of a head may depict a warrior, ruler, or royal retainer. The realistic rendering of the face is particularly striking.

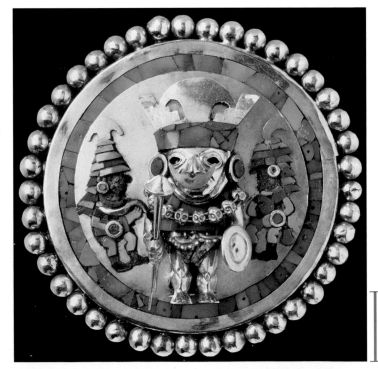

1 in.

**8-24** Ear ornament, Moche, from a tomb at Sipán, Peru, ca. 300 CE. Gold and turquoise, $4\frac{4}{5}$". Bruning Archaeological Museum, Lambayeque.

This ear ornament from a Sipán tomb depicts a Moche warrior priest and two retainers. The priest carries a war club and shield and wears a necklace of owl-head beads. The costume corresponds to actual finds.

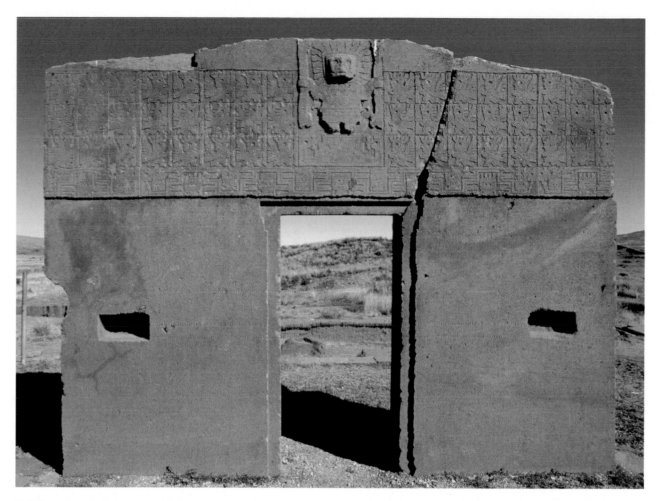

**8-25** Gateway of the Sun, Tiwanaku, Bolivia, ca. 375–700 CE. Stone, 9′ 10″ high.

The Gateway of the Sun probably led into a sacred area at Tiwanaku. The central figure is a version of the Chavín staff god (FIG. 8-19). The relief was once painted, inlaid with turquoise, and covered with gold.

wears a necklace of owl-head beads. The figure's bladelike crescent-shaped helmet is a replica of the large golden one buried with the Sipán lord. The war club and shield also match finds in the Warrior Priest's tomb. The ear ornament of the jewelry image is a simplified version of the piece itself. Other details also correspond to actual finds—for example, the removable nose ring that hangs down over the mouth. The value of the Sipán find is incalculable for what it reveals about elite Moche culture and for its confirmation of the accuracy of the iconography of Moche artworks.

## Tiwanaku and Wari

The bleak highland country of southeastern Peru and southwestern Bolivia contrasts markedly with the warm valleys of the coast. In the Bolivian mountains, the Tiwanaku culture (ca. 100–1000 CE) developed beginning in the second century CE. North of Paracas in Peru, the Wari culture (ca. 500–800 CE) dominated parts of the dry coast.

**TIWANAKU** Named after its principal archaeological site on the southern shore of Lake Titicaca, the Tiwanaku culture flourished for nearly a millennium. It spread to the adjacent coastal area as well as to other highland regions, eventually extending from southern Peru to northern Chile. Tiwanaku was an important ceremonial center. Its inhabitants constructed grand buildings using the region's fine sandstone, andesite, and diorite. Tiwanaku's imposing Gateway of the Sun (FIG. 8-25) is a huge monolithic block of andesite pierced by a single doorway. Moved in ancient times from its original loca-

tion within the site, the gateway now forms part of an enormous walled platform. Relief sculpture crowns the gate. The central figure is a Tiwanaku version of the Chavín staff god (FIG. 8-19). Larger than all the other figures and presented frontally, he dominates the composition and presides over the passageway. Rays project from his head. Many terminate in puma heads, representing the power of the highlands' fiercest predator. The staff god—possibly a sky and weather deity rather than the sun deity the rayed head suggests—appears in art throughout the Tiwanaku horizon, associated with smaller attendant figures. Those of the Gateway of the Sun are winged and have human or condor heads. Like the puma, the condor is an impressive carnivore, the largest raptor in the world. Sky and earth beings thus converge on the gate, which probably served as the doorway to a sacred area, a place of transformation. The reliefs were once colorfully painted. Artists apparently also inlaid the figures' eyes with turquoise and covered the surfaces with gold, producing a dazzling effect.

**WARI** The flat, abstract, and repetitive figures surrounding the central figure on the Gateway of the Sun recall woven textile designs. Indeed, the people of the Tiwanaku culture, like those of Paracas, were consummate weavers, although far fewer textiles survive from the damp highlands. However, excavators have recovered many examples of weaving, especially tunics, from the contemporaneous Wari culture in Peru.

Although Wari weavers fashioned cloth from both wool and cotton fibers, as did earlier Paracas weavers (FIG. 8-20), the resemblance

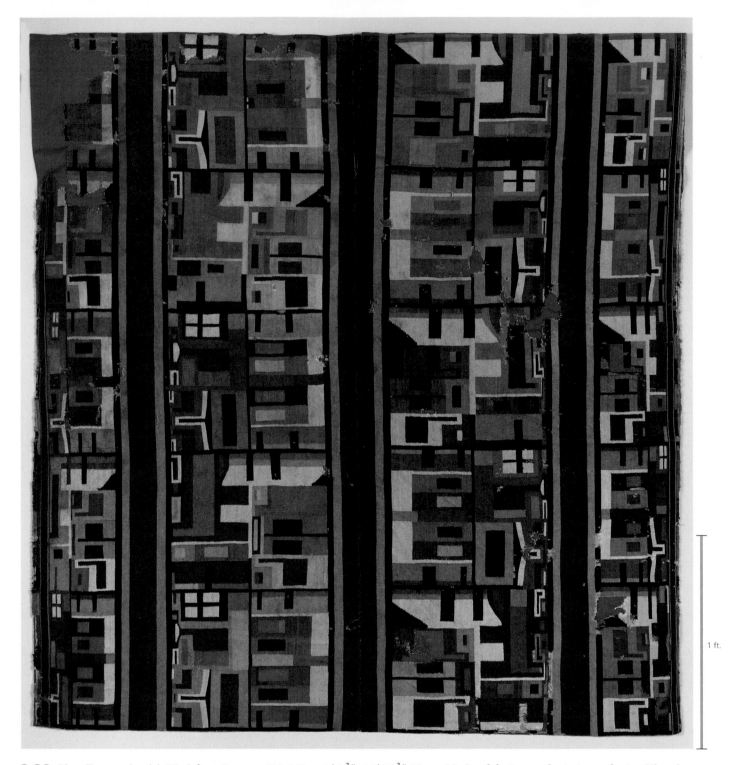

1 ft.

**8-26** *Lima Tapestry* (tunic), Wari, from Peru, ca. 500–800 CE. 3′ 3$\frac{3}{8}$″ × 2′ 11$\frac{3}{8}$″. Museo Nacional de Antropología Arqueología e Historia del Perú, Lima.

Whereas Paracas mantles (FIG. 8-20) are embroideries, Wari textiles are tapestries with the motifs woven directly into the fabric. The figures on this Wari tunic are so abstract as to be nearly unrecognizable.

between the two textile styles ends there. Whereas Paracas artists embroidered motifs onto the plain woven surface, Wari artists wove designs directly into the fabric, the weft threads packed densely over the warp threads in a technique known as *tapestry*. Some particularly fine pieces have more than 200 weft threads per inch. Furthermore, unlike the relatively naturalistic individual figures depicted on Paracas mantles, those appearing on Wari textiles are so closely connected and so abstract as to be nearly unrecognizable. In the tunic

shown here, the so-called *Lima Tapestry* (FIG. **8-26**), the Wari designer expanded or compressed each figure in a different way and placed the figures in vertical rows pressed between narrow red bands of plain cloth. Elegant tunics like this one must have been prestige garments made for the elite. Clothing and status were closely connected in many ancient American societies, especially in the Inka Empire that eventually came to dominate Andean South America (see Chapter 9).

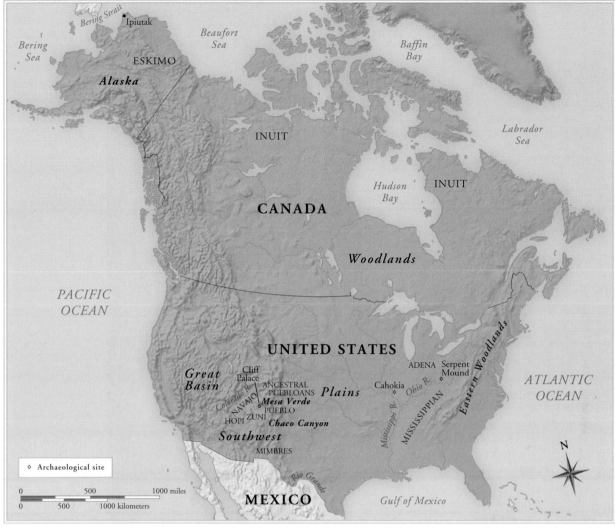

MAP 8-3 Early Native American sites in North America.

# NORTH AMERICA

In many parts of the United States and Canada, archaeologists have identified indigenous cultures that date back as far as 12,000 years ago. Most of the surviving art objects, however, come from the past 2,000 years. Scholars divide the vast and varied territory of North America (MAP 8-3) into cultural regions based on the relative homogeneity of language and social and artistic patterns. Native lifestyles varied widely over the continent, ranging from small bands of migratory hunters to settled—at times even urban—agriculturalists. Among the art-producing peoples who inhabited the continent before the arrival of Europeans are the Eskimo of Alaska and the Inuit of Canada, who hunted and fished across the Arctic from Greenland to Siberia, and the maize farmers of the American Southwest, who wrested water from their arid environment and built effective irrigation systems as well as roads and spectacular cliff dwellings. Farmers also settled in the vast, temperate Eastern Woodlands—ranging from eastern Canada to Florida and from the Atlantic to the Great Plains west of the Mississippi. Some of them left behind great earthen mounds that once functioned as their elite residences or burial places.

## Eskimo

The Eskimoan peoples originally migrated to North America across the Bering Strait. During the early first millennium CE, a community of Eskimo sea mammal hunters and tool makers occupied parts of Alaska during the Norton, or Old Bering Sea, culture that began around 500 BCE.

**IPIUTAK MASK** Archaeologists have uncovered major works of Eskimo art at the Ipiutak site at Point Hope. The finds include a variety of burial goods as well as tools. A burial mask (FIG. 8-27) datable to ca. 100 CE is of special interest. The artist fashioned the mask out of walrus ivory, the material used for most Arctic artworks because of the scarcity of wood in the region. The mask consists of nine carefully shaped parts that are interrelated to produce several faces, both human and animal, echoing the transformation theme noted in other ancient American cultures. The confident, subtle composition in shallow relief is a tribute to the artist's imaginative control over the material. The mask's abstract circles and curved lines are common motifs on the decorated tools discovered at Point Hope. For centuries, the Eskimo also carved human and animal figures, always at small scale, reflecting a nomadic lifestyle that required the creation of portable objects.

## Woodlands

Early Native American artists also excelled in working stone into a variety of utilitarian and ceremonial objects. Some early cultures, such as those of the woodlands east of the Mississippi River, also established great urban centers with populations sometimes exceeding 20,000.

1 in.

**8-27** Burial mask, Ipiutak, from Point Hope, Alaska, ca. 100 CE. Ivory, greatest width 9½″. American Museum of Natural History, New York.

Carved out of walrus ivory, this mask consists of nine parts that can be combined to produce several faces, both human and animal, echoing the transformation theme common in ancient American art.

**8-28** Pipe, Adena, from a mound in Ohio, ca. 500–1 BCE. Stone, 8″ high. Ohio Historical Society, Columbus.

Smoking was an important ritual in ancient North America, and the Adena often buried pipes with men for use in the afterlife. This example resembles some Mesoamerican sculptures in form and costume.

1 in.

**ADENA** The Adena culture of Ohio is documented at about 500 sites in the Central Woodlands. An Adena pipe (FIG. **8-28**) in the shape of a man, carved between 500 BCE and the end of the millennium, is related in form and costume (note the prominent ear spools) to some Mesoamerican sculptures. The Adena buried their elite in great earthen mounds and often placed ceremonial pipes such as this one in the graves. Smoking was an important social and religious ritual in many Native American cultures, and pipes were treasured status symbols that men took with them into the afterlife. The standing figure on the pipe in FIG. 8-28 has naturalistic joint articulations and musculature, a lively flexed-leg pose, and an alert facial expression—all combining to suggest movement.

**MISSISSIPPIAN** The Adena were the first great mound builders of North America, but the Mississippian culture, which emerged around 800 CE and eventually encompassed much of the eastern United States, surpassed all earlier Woodlands peoples in the size and complexity of their communities. One Mississippian mound site, Cahokia in southern Illinois, was the largest city in North America in the early second millennium CE, with a population of at least 20,000 and an area of more than six square miles. There were approximately 120 mounds at Cahokia. The grandest, 100 feet tall and built in stages between about 900 and 1200 CE, was Monk's Mound. It is aligned with the position of the sun at the equinoxes and may have served as an astronomical observatory as well as the site of agricultural ceremonies. Each stage was topped by wooden structures that then were destroyed in preparation for the building of a new layer.

The Mississippians also constructed *effigy mounds* (mounds built in the form of animals or birds). One of the best preserved is Serpent Mound (FIG. **8-29**), a twisting earthwork on a bluff overlooking a creek in Ohio. It measures nearly a quarter mile from its open jaw (FIG. 8-29, *top right*), which seems to clasp an oval-shaped mound in its mouth, to its tightly coiled tail (*far left*). Both its date and meaning are controversial (see "Serpent Mound," page 169).

The Mississippian peoples, like their predecessors in North America, also manufactured small portable art objects. The shell *gorget*, or neck pendant, was a favorite item. One example (FIG. **8-30**), found at a site in Tennessee, dates from about 1250 to 1300 CE and depicts a running warrior, shown in the same kind of composite profile and frontal view with bent arms and legs used to suggest motion in other ancient cultures. The Tennessee warrior wears an elaborate headdress incorporating an arrow. He carries a mace in his left hand and a severed human head in his right. On his face is the painted forked eye of a falcon. Most Mississippian gorgets come from burial and temple mounds, and archaeologists believe they were gifts to the dead to ensure their safe arrival and prosperity in the land of the spirits. Other art objects found in similar contexts include fine mica cutouts and embossed copper cutouts of hands, bodies, snakes, birds, and other presumably symbolic forms.

## Serpent Mound

Serpent Mound (FIG. 8-29) is one of the largest and best known of the Woodlands effigy mounds, but it is the subject of considerable controversy. The mound was first excavated in the 1880s and represents one of the first efforts at preserving a Native American site from destruction at the hands of pot hunters and farmers. For a long time after its exploration, archaeologists attributed its construction to the Adena culture, which flourished in the Ohio area during the last several centuries BCE. Radiocarbon dates taken from the mound, however, indicate that the people known as Mississippians built it much later. Unlike most other ancient mounds, Serpent Mound contained no evidence of burials or temples. Serpents, however, were important in Mississippian iconography, appearing, for example, etched on shell gorgets similar to the one illustrated in FIG. 8-30. These Native Americans strongly associated snakes with the earth and the fertility of crops. A stone figurine found at one Mississippian site, for example, depicts a woman digging her hoe into the back of a large serpentine creature whose tail turns into a vine of gourds.

Some researchers have proposed another possible meaning for the construction of Serpent Mound. The date suggested for it is 1070, not long after the brightest appearance in recorded history of Halley's Comet in 1066. Could Serpent Mound have been built in response to this important astronomical event? Scholars have even suggested that the serpentine form of the mound replicates the comet itself streaking across the night sky. Whatever its meaning, such a large and elaborate earthwork could have been built only by a large labor force under the firm direction of powerful elites eager to leave their mark on the landscape forever.

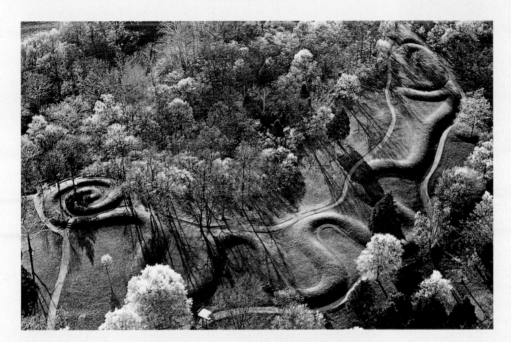

**8-29** Serpent Mound, Mississippian, Ohio, ca. 1070 CE. 1,200′ long, 20′ wide, 5′ high.

The Mississippians constructed effigy mounds in the form of animals and birds. This well-preserved example seems to depict a serpent. Some scholars, however, think it replicates the path of Halley's Comet in 1066.

1 in.

## Southwest

In the Southwest, Native Americans have been producing pottery since the late first millennium BCE, but the most impressive examples of decorated pottery date after 1000 CE.

**MIMBRES** The Mimbres culture of southwestern New Mexico, which flourished between approximately 1000 and 1250 CE, is renowned for its black-on-white painted bowls. Mimbres bowls have been found in burials under house floors, inverted over the head of the deceased and ritually "killed" by puncturing a small hole at the base, perhaps to allow the spirits of the deceased to join their ancestors in the sky (which contemporary Southwestern peoples view as a dome). The

**8-30** Incised gorget with running warrior, Mississippian, from Sumner County, Tennessee, ca. 1250–1300 CE. Shell, 4″ wide. National Museum of the American Indian, Smithsonian Institution, Washington, D.C.

This neck pendant was probably a gift to the dead to ensure safe passage to the afterlife. It represents a Mississippian warrior running. He holds a mace in one hand and a severed human head in the other.

1 in.

**8-31** Bowl with two cranes and geometric forms, Mimbres, from New Mexico, ca. 1250 CE. Ceramic, black-on-white, $1'\frac{1}{2}''$ diameter. Art Institute of Chicago, Chicago (Hugh L. and Mary T. Adams Fund).

Native Americans have been producing pottery for more than 2,000 years, long before the introduction of the potter's wheel. Mimbres bowls feature black-and-white animals and abstract patterns.

bowl illustrated here (FIG. **8-31**) dates to about 1250 and features an animated graphic rendering of two black cranes on a white ground. The contrast between the bowl's abstract border designs and the birds creates a dynamic tension. Thousands of different compositions appear on Mimbres pottery. They range from lively and complex geometric patterns to abstract pictures of humans, animals, and composite mythological beings. Almost all are imaginative creations by artists who seem to have been bent on not repeating themselves. Their designs emphasize linear rhythms balanced and controlled within a clearly defined border. Because the potter's wheel was unknown in the Americas, the artists constructed their pots out of coils of clay, creating countless

sophisticated shapes of varied size, always characterized by technical excellence. Although historians have no direct knowledge about the potters' identities, the fact that pottery making was usually women's work in the Southwest during the historical period (see "Gender Roles in Native American Art," Chapter 9, page 183) suggests that the Mimbres potters also may have been women.

**ANCESTRAL PUEBLOANS** The Ancestral Puebloans, formerly known as the Anasazi, northern neighbors of the Mimbres, emerged as an identifiable culture around 200 CE, but the culture did not reach its peak until about 1000. (Anasazi, Navajo for "enemy ancestors," is a name that the descendants of these early Native Americans dislike, hence the new designation.) The many ruined *pueblos* (urban settlements) scattered throughout the Southwest reveal the masterful building skills of the Ancestral Puebloans. In Chaco Canyon, New Mexico, they built a great semicircle of 800 rooms reaching to five stepped-back stories, the largest of several such sites in and around the canyon. Chaco Canyon was the center of a wide trade network extending as far as Mexico.

Sometime in the late 12th century, a drought occurred, and the Ancestral Puebloans largely abandoned their open canyon-floor dwelling sites to move farther north to the steep-sided canyons and lusher environment of Mesa Verde in southwestern Colorado. Cliff Palace (FIG. **8-32**) is wedged into a sheltered ledge above a valley floor. It contains about 200 rectangular rooms (mostly communal dwellings) of carefully laid stone and timber, once plastered inside and out with adobe. The location for Cliff Palace was not accidental. The Ancestral Puebloans designed it to take advantage of the sun to heat the pueblo in winter and shade it during the hot summer months. Scattered in the foreground of FIG. 8-32 are two dozen large circular semisubterranean structures, called *kivas,* which once were roofed over and entered with a ladder through a hole in the flat roof. These chambers were the spiritual centers of native Southwest life, male council houses where ritual regalia were stored and private rituals and preparations for public ceremonies took place—and still do.

The Ancestral Puebloans did not disappear but gradually evolved into the various Pueblo peoples who still live in Arizona, New Mexico, Colorado, and Utah. They continue to speak their native languages, practice deeply rooted rituals, and make pottery in the traditional manner. Their art is discussed in Chapter 9.

**8-32** Cliff Palace, Ancestral Puebloan, Mesa Verde National Park, Colorado, ca. 1150–1300 CE.

Cliff Palace is wedged into a sheltered ledge to heat the pueblo in winter and shade it during the hot summer months. It contains about 200 stone-and-timber rooms plastered inside and out with adobe.

# NATIVE ARTS OF THE AMERICAS BEFORE 1300

## MESOAMERICA

▋ The Olmec (ca. 1200–400 BCE) is often called the "mother culture" of Mesoamerica. At La Venta and elsewhere, the Olmec built pyramids and ball courts and carved colossal basalt portraits of their rulers during the Preclassic period.

▋ In contrast to the embryonic civic centers of the Olmec, Teotihuacan in the Valley of Mexico was a huge metropolis laid out on a strict grid plan. Its major pyramids and plazas date to the late Preclassic period, ca. 50–250 CE.

▋ The Maya occupied parts of Mexico, Belize, Guatemala, and Honduras. During the Classic period (ca. 300–900 CE), they built vast complexes of temple-pyramids, palaces, plazas, and ball courts and decorated them with monumental sculptures and mural paintings glorifying their rulers and gods. The Maya also left extensive written records and possessed a sophisticated knowledge of astronomy and mathematical calculation.

Colossal head, La Venta, Olmec, ca. 900–400 BCE

Castillo, Chichén Itzá, Maya, ca. 800–900 CE

## SOUTH AMERICA

▋ The ancient civilizations of South America are even older than those of Mesoamerica. The earliest Andean sites began to develop around 3000 BCE.

▋ Between ca. 800 and 200 BCE, during the Early Horizon period, U-shaped temple complexes were erected at Chavín de Huántar in Peru, where archaeologists have also uncovered monumental statues and reliefs.

▋ The Paracas (ca. 400 BCE–200 CE), Nasca (ca. 200 BCE–600 CE), and Moche (ca. 1–700 CE) cultures of the Early Intermediate period in Peru produced extraordinary textiles, distinctive painted ceramics, and turquoise-inlaid goldwork. The subjects range from composite human-animals to ruler portraits.

▋ The Tiwanaku (ca. 100–1000 CE) and Wari (ca. 500–800 CE) cultures of northern Bolivia and southern Peru flourished during the Middle Horizon period. The Tiwanaku culture is noteworthy for its monumental stone architecture. The Wari produced magnificent tapestries.

Ear ornament, from Sipán, Moche, ca. 300 CE

Gateway of the Sun, Tiwanaku, ca. 375–700 CE

## NORTH AMERICA

▋ The indigenous cultures of the United States and Canada date as far back as 10,000 BCE, but most of the surviving art objects date from the past 2,000 years.

▋ The Eskimo produced small-scale artworks in ivory beginning in the early first millennium CE, reflecting a nomadic lifestyle that required portable objects.

▋ The peoples of the Mississippian culture (ca. 800–1500 CE) were great mound builders. Cahokia in Illinois encompassed about 120 mounds and was the largest city in North America during the early second millennium CE.

▋ In the Southwest, Native Americans have been producing pottery for more than 2,000 years. The black-and-white painted bowls of the Mimbres (ca. 1000–1250 CE) are among the finest.

▋ The Ancestral Puebloans were master builders of pueblos. The pueblo at Chaco Canyon, New Mexico, had about 800 rooms. Cliff Palace, Colorado, is noteworthy for its sophisticated design, wedged into a sheltered ledge to take advantage of the winter sun and the summer shade.

Cliff Palace, Colorado, Ancestral Puebloan, ca. 1150–1300 CE

**9-1** Machu Picchu (view from adjacent peak), Inka, Peru, 15th century.

Inka architects designed Machu Picchu so that the windows and doors frame spectacular views. Inka masons cut large upright stones in shapes that echo the contours of nearby sacred peaks.

# NATIVE ARTS
# OF THE AMERICAS
# AFTER 1300

In the years following the arrival of Christopher Columbus (1451–1506) in the New World in 1492, the Spanish monarchs poured money into expeditions that probed the coasts of North and South America, but the Spaniards had little luck in finding the wealth they sought. When brief stops on the coast of Yucatán, Mexico, yielded a small but still impressive amount of gold and other precious artifacts, the Spanish governor of Cuba outfitted yet another expedition. Headed by Hernán Cortés (1485–1547), this contingent of explorers was the first to make contact with the great Aztec emperor Moctezuma II (r. 1502–1521). In only two years, with the help of guns, horses, native allies revolting against their Aztec overlords, and perhaps also a smallpox epidemic that had swept across the Caribbean and already thinned the Aztec ranks, Cortés managed to overthrow the vast and rich Aztec Empire. His victory in 1521 opened the door to hordes of Spanish conquistadors seeking their fortunes and to missionaries eager for new converts to Christianity. The ensuing clash of cultures led to a century of turmoil throughout the Spanish king's new domains.

The Aztec Empire that the Spaniards defeated was but the latest of a series of highly sophisticated indigenous art-producing cultures in the Americas. Their predecessors have been treated in Chapter 8. This chapter examines in turn the artistic achievements of the native peoples of *Mesoamerica*, Andean South America, and North America after 1300.

## MESOAMERICA

After the fall and destruction of the great central Mexican city of Teotihuacan in the eighth century and the abandonment of the southern Maya sites around 900, new cities arose to take their places. Notable were the Maya city of Chichén Itzá in Yucatán and the Toltec capital of Tula, not far from modern Mexico City (see Chapter 8). Their dominance was relatively short-lived, however. For the early Postclassic period (ca. 900–1250) in Mesoamerica, scholars have less information than for Classic Mesoamerica, but much more evidence exists for the cultures of the late Postclassic period.

## Mixteca-Puebla

One of the most impressive art-producing peoples of the Postclassic period in Mesoamerica was the Mixtecs, who succeeded the Zapotecs at Monte Albán in southern Mexico (MAP **9-1**) after 700. They extended their political sway in Oaxaca by dynastic intermarriage as well as by war. The treasures found in the tombs at Monte Albán bear witness to Mixtec wealth, and the quality of these works demonstrates the high level of Mixtec artistic achievement. The Mixtecs were highly skilled goldsmiths and won renown for their work in *mosaic* using turquoise obtained from distant regions such as present-day New Mexico.

**BORGIA CODEX** The peoples of Mesoamerica prized illustrated books. Miraculously, some manuscripts survived the depredations of the Spanish invasion. The Postclassic Maya were preeminent in the art of writing. Their books were precious vehicles for recording history, rituals, astronomical tables, calendrical calculations, maps, and trade and tribute accounts. The texts consisted of *hieroglyphic* columns read from left to right and top to bottom. Unfortunately, only three Maya books exist today. Bishop Diego de Landa (1524–1579), the author of an invaluable treatise on the Maya of Yucatán, described how the "Indians" made their books and why so few remain:

> They wrote their books on a long sheet doubled in folds, which was then enclosed between two boards finely ornamented; the writing was on one side and the other, according to the folds. . . . We found a great number of books in these [Indian] letters and, since they contained nothing but superstitions and falsehoods of the devil, we burned them all, which they took most grievously, and which gave them great pain.[1]

In contrast, 10 non-Maya books survive, five from Mixtec Oaxaca and five from the Puebla region (MAP **9-1**). Art historians have named the style they represent Mixteca-Puebla, an interesting example of a Mesoamerican style that crossed both ethnic and regional boundaries. The Mixteca-Puebla artists painted on long sheets of deerskin, which they first coated with fine white lime plaster and folded into accordion-like pleats. Some of the manuscripts are *codices* (singular, *codex*) and resemble modern books with covers of wood, mosaic, or feathers.

One extensively illustrated book that escaped the Spanish destruction is the *Borgia Codex,* from somewhere in central highland Mexico (possibly the states of Puebla or Tlaxcala). It is the largest and most elaborate of several manuscripts known as the Borgia Group. One illustration (FIG. **9-2**) in the codex shows two richly attired, vividly gesticulating gods rendered predominantly in reds and yellows with black outlines. The god of life, the black Quetzalcoatl (depicted here as a masked human rather than in the usual form of a feathered serpent), sits back-to-back with the god of death, the white Mictlantecuhtli. Below them is an inverted skull with a double keyboard of teeth, a symbol of the Underworld (Mictlan), which could be entered through the mouth of a great earth monster. Both figures hold scepters in one hand and gesticulate with the other. The image conveys the inevitable relationship of life and death, an important theme in Mesoamerican art. Some scholars believe the image may also be a kind of writing conveying a specific divinatory meaning. Symbols of the 13 divisions of 20 days in the 260-day Mesoamerican ritual calendar appear in panels in the margins. The origins of this calendar, used even today in remote parts of Mexico and Central America, are unknown. Except for the Mixtec genealogical codices, most books painted before and immediately after the Spanish conquest deal with astronomy, calendrics, divination, and ritual.

## Aztec

The greatest Mesoamerican culture at the time of the European conquest was that of the Aztecs, a Nahuatl-speaking people who left behind a history of their rise to power. Scholars have begun to question the accuracy of the Aztec account; and some think it is a mythic construct. According to the traditional history, the destruction of Toltec

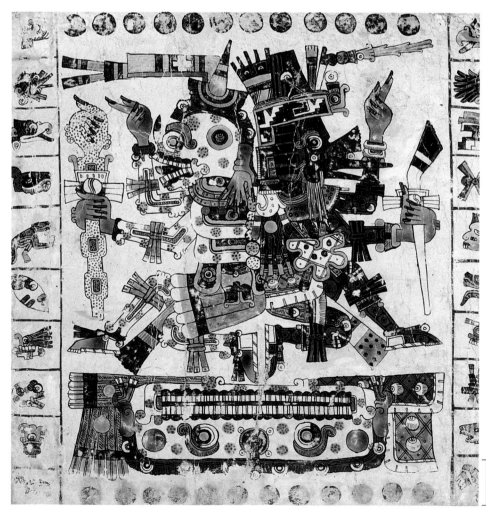

**9-2** Mictlantecuhtli and Quetzalcoatl, from the *Borgia Codex,* Mixteca-Puebla, possibly from Puebla or Tlaxcala, Mexico, ca. 1400–1500. Mineral and vegetable pigments on deerskin, $10\frac{5}{8}'' \times 10\frac{3}{8}''$. Biblioteca Apostolica Vaticana, Rome.

One of the rare surviving Mesoamerican books, the Mixteca-Puebla *Borgia Codex* includes this painting of the gods of life and death above an inverted skull symbolizing the Underworld.

1 in.

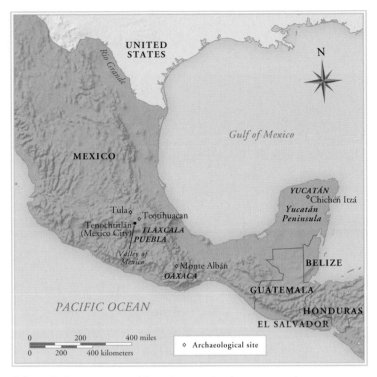

MAP 9-1 Mixteca-Puebla and Aztec sites in Mesoamerica.

Two great staircases originally swept upward from the plaza level to the double sanctuaries at the summit. The Great Temple is a remarkable example of *superimposition*, a common trait in Mesoamerican architecture. The excavated structure, composed of seven shells, indicates how the earlier walls nested within the later ones. (Today, only two of the inner structures remain. The Spaniards destroyed the later ones in the 16th century.) The sacred precinct also contained the temples of other deities, a ball court (see "The Mesoamerican Ball Game," Chapter 8, page 152), a skull rack for the exhibition of the heads of victims killed in sacrificial rites, and a school for children of the nobility.

The Aztecs laid out Tenochtitlán on a grid plan that divided the city into quarters and wards, reminiscent of Teotihuacan (FIG. 8-5), which, long abandoned, had become a pilgrimage site for the Aztecs. Tenochtitlán's island location required conducting communication and transport via canals and other waterways. Many of the Spaniards thought of Venice in Italy when they saw the city rising from the waters like a radiant vision. Crowded with buildings, plazas, and courtyards, the city also boasted a vast and ever-busy marketplace. In the words of Bernal Díaz del Castillo, "Some of the soldiers among us who had been in many parts of the world, in Constantinople, and all over Italy, and in Rome, said that so large a marketplace and so full of people, and so well regulated and arranged, they had never beheld before."[2] The city proper had a population of more than 100,000. (The total population of the area of Mexico the Aztecs dominated at the time of the conquest was approximately 11 million.)

Tula about 1200 (see Chapter 8) brought a century of anarchy to the Valley of Mexico, the vast highland valley 7,000 feet above sea level that now contains sprawling Mexico City (MAP 9-1). Waves of northern invaders established warring city-states and wrought destruction in the valley. The Aztecs were the last of these conquerors. With astonishing rapidity, they transformed themselves within a few generations from migratory outcasts and serfs to mercenaries for local rulers and then to masters in their own right of the Valley of Mexico's small kingdoms. They began to call themselves Mexica, and, following a legendary prophecy that they would build a city where they saw an eagle perched on a cactus with a serpent in its mouth, they settled on an island in Lake Texcoco (Lake of the Moon). Their settlement grew into the magnificent city of Tenochtitlán, which in 1519 amazed Cortés and his small band of adventurers.

Recognized by those they subdued as fierce in war and cruel in peace, the Aztecs indeed seemed to glory in battle and in military prowess. They radically changed the social and political structure in Mexico. Subservient groups not only had to submit to Aztec military power but also had to provide victims to be sacrificed to Huitzilopochtli, the hummingbird god of war, and to other Aztec deities (see "Aztec Religion," page 176). The Aztecs practiced bloodletting and human sacrifice—which had a long history in Mesoamerica (see Chapter 8)—to please the gods and sustain the great cycles of the universe. But the Aztecs engaged in human sacrifice on a greater scale than any of their predecessors, even waging special battles, called the "flowery wars," expressly to obtain captives for future sacrifice. This cruelty is one reason Cortés found ready allies among the peoples the Aztecs had subjugated.

**TENOCHTITLÁN** The ruins of the Aztec capital, Tenochtitlán, lie directly beneath the center of Mexico City. In the late 1970s, Mexican archaeologists identified the exact location of many of the most important structures within the Aztec sacred precinct, and extensive excavations near the cathedral in Mexico City continue. The principal building is the Great Temple (FIG. 9-3), a temple-pyramid honoring the Aztec god Huitzilopochtli and the local rain god Tlaloc.

9-3 Reconstruction drawing with cutaway view of various rebuildings of the Great Temple, Aztec, Tenochtitlán, Mexico City, Mexico, ca. 1400–1500. C = Coyolxauhqui disk (FIG. 9-4).

The Great Temple in the Aztec capital encased successive earlier structures. The latest temple honored the gods Huitzilopochtli and Tlaloc, whose sanctuaries were at the top of a stepped pyramid.

Mesoamerica **175**

## Aztec Religion

The Aztecs saw their world as a flat disk resting on the back of a monstrous earth deity. Tenochtitlán, their capital, was at its center, with the Great Temple (FIG. 9-3) representing a sacred mountain and forming the axis passing up to the heavens and down through the Underworld—a concept with parallels in other cultures (see, for example, "The Stupa," Chapter 1, page 15). Each of the four cardinal points had its own god, color, tree, and calendrical symbol. The sky consisted of 13 layers, whereas the Underworld had nine. The Aztec Underworld was an unpleasant place where the dead gradually ceased to exist.

The Aztecs often adopted the gods of conquered peoples, and their pantheon was complex and varied. When the Aztecs arrived in the Valley of Mexico, their own patron, Huitzilopochtli, a war and sun deity, joined such well-established Mesoamerican gods as Tlaloc and Quetzalcoatl (the latter the feathered serpent who was a benevolent god of life, wind, and learning and culture, as well as the patron of priests). As the Aztecs went on to conquer much of Mesoamerica, they appropriated the gods of their subjects, such as Xipe Totec, a god of early spring and patron of gold workers imported from the Gulf Coast and Oaxaca. Images of the various gods made of stone (FIG. 9-5), terracotta, wood, and even dough (eaten at the end of rituals) stood in and around their temples. Reliefs (FIG. 9-4) depicting Aztec deities, often with political overtones, also adorned the temple complexes.

The Aztec ritual cycle was very full, given that they celebrated events in two calendars—the sacred calendar (260 days) and the solar one (360 days plus 5 unlucky and nameless days). The Spanish friars of the 16th century noted that the solar calendar dealt largely with agricultural matters. The two Mesoamerican calendars functioned simultaneously, requiring 52 years for the same date to recur in both. A ritual called the New Fire Ceremony commemorated this rare event. The Aztecs broke pots and made new ones for the next period, hid their pregnant women, and extinguished all fires. At midnight on a mountaintop, fire priests took out the heart of a sacrificial victim and with a fire drill renewed the flame in the exposed cavity. Then they set ablaze bundles of sticks representing the 52 years that had just passed, ensuring that the sun would rise in the morning and that another cycle would begin.

Most Aztec ceremonies involved the burning of incense (made from copal, resin from conifer trees). Colorfully attired dancers and actors performed, and musicians played conch shell trumpets, drums, rattles, rasps, bells, and whistles. Almost every Aztec festival also included human sacrifice. To Tlaloc, the rain god, the priests offered small children, because their tears brought the rains.

Rituals also marked the completion of important religious structures. The dedication of the last major rebuilding of the Great Temple at Tenochtitlán in 1487, for example, reportedly involved the sacrifice of thousands of captives from recent wars in the Gulf Coast region. Varied offerings have been found within earlier layers of the temple, many representing tribute from subjugated peoples. These include blue-painted stone and ceramic vessels, conch shells, a

1 ft.

**9-4** Coyolxauhqui (She of the Golden Bells), Aztec, from the Great Temple of Tenochtitlán, Mexico City, Mexico, ca. 1469. Stone, diameter 10′ 10″. Museo del Templo Mayor, Mexico City.

The bodies of sacrificed foes that the Aztecs hurled down the stairs of the Great Temple landed on this disk depicting the murdered, segmented body of the moon goddess Coyolxuahqui, Huitzilopochtli's sister.

jaguar skeleton, flint and obsidian knives, and even Mesoamerican "antiques"—carved stone Olmec and Teotihuacan masks made hundreds of years before the Aztec ascendancy.

Thousands of priests served in Aztec temples. Distinctive hairstyles, clothing, and black body paint identified the priests. Women served as priestesses, particularly in temples dedicated to various earth-mother cults. Bernal Díaz del Castillo (1492–1581), a soldier who accompanied Cortés when the Spaniards first entered Tenochtitlán, recorded his shock upon seeing a group of foul-smelling priests with uncut fingernails, long hair matted with blood, and ears covered in cuts, not realizing they were performing rites in honor of the deities they served, including piercing their skin with cactus spines to draw blood. These priests were the opposite of the "barbarians" the European conquistadors considered them to be. They were, in fact, the most highly educated Aztecs. The Spanish reaction to the customs they encountered in the New World has colored popular opinion about Aztec culture ever since. The religious practices that horrified their European conquerors, however, were not unique to the Aztecs but were deeply rooted in earlier Mesoamerican society (see Chapter 8).

**COYOLXAUHQUI** The Temple of Huitzilopochtli at Tenochtitlán commemorated the god's victory over his sister and 400 brothers, who had plotted to kill their mother, Coatlicue (She of the Serpent Skirt). The myth signifies the birth of the sun at dawn, a role Huitzilopochtli sometimes assumed, and the sun's battle with the forces of darkness, the stars and moon. Huitzilopochtli chased away his brothers and dismembered the body of his sister, the moon goddess Coyolxauhqui (She of the Golden Bells, referring to the bells on

her cheeks), at a hill near Tula (represented by the pyramid itself). The mythical event is depicted on a huge stone disk (FIG. 9-4), whose discovery in 1971 set off the ongoing archaeological investigations near the main plaza in Mexico City. The relief had been placed at the foot of the staircase leading up to one of Huitzilopochtli's earlier temples on the site. (Cortés and his army never saw it because it lay within the outermost shell of the Great Temple.) Carved on the disk is an image of the murdered and segmented body of Coyolxauhqui. The mythological theme also carried a contemporary political message. The Aztecs sacrificed their conquered enemies at the top of the Great Temple and then hurled their bodies down the temple stairs to land on this stone. The victors thus forced their foes to reenact the horrible fate of the goddess that Huitzilopochtli dismembered. The Coyolxauhqui disk is a superb example of art in the service of state ideology. The unforgettable image of the fragmented goddess proclaimed the power of the Mexica over their enemies and the inevitable fate that must befall them when defeated. Marvelously composed, the relief has a kind of dreadful yet formal beauty. Within the circular space, the design's carefully balanced, richly detailed components have a slow turning rhythm reminiscent of a revolving galaxy. The carving is in low relief, a smoothly even, flat surface raised from a flat ground. It is the sculptural equivalent of the line and flat tone, the figure and neutral ground, characteristic of Mesoamerican painting.

**COATLICUE** In addition to relief carving, the Aztecs produced freestanding statuary. Perhaps the most impressive is the colossal statue (FIG. 9-5) of the beheaded Coatlicue discovered in 1790 near Mexico City's cathedral. The sculpture's original setting is unknown, but some scholars believe it was one of a group set up at the Great Temple. The main forms are in high relief, the details executed either in low relief or by incising. The overall aspect is of an enormous blocky mass, its ponderous weight looming over awed viewers. From the beheaded goddess's neck writhe two serpents whose heads meet to form a tusked mask. Coatlicue wears a necklace of severed human hands and excised human hearts. The pendant of the necklace is a skull. Entwined snakes form her skirt. From between her legs emerges another serpent, symbolic perhaps of both menses and the male member. Like most Aztec deities, Coatlicue has both masculine and feminine traits. Her hands and feet have great claws, which she used to tear the human flesh she consumed. All her attributes symbolize sacrificial death. Yet, in Aztec thought, this mother of the gods combined savagery and tenderness, for out of destruction arose new life, a theme seen earlier at Teotihuacan (FIG. 8-7).

Given the Aztecs' almost meteoric rise from obscurity to their role as the dominant culture of Mesoamerica, the quality of the art they sponsored is astonishing. Granted, they swiftly appropriated the best artworks and most talented artists of conquered territories, bringing both back to Tenochtitlán. Thus, craftspeople from other areas, such as the Mixtecs of Oaxaca, may have created much of the exquisite pottery, goldwork, and turquoise mosaics the Aztec elite used. Gulf Coast artists probably made the life-size terracotta sculptures of eagle warriors found at the Great Temple. Nonetheless, the Aztecs' own sculptural style, developed at the height of their power in the late 15th century, is unique.

**AZTECS AND SPANIARDS** Unfortunately, much of Aztec and Aztec-sponsored art did not survive the Spanish conquest and the subsequent period of evangelization. The conquerors took Aztec gold artifacts back to Spain and melted them down, zealous friars destroyed "idols" and illustrated books, and perishable materials such as textiles and wood largely disappeared. Aztec artisans also fashioned beautifully worked feathered objects and even created mosaic-like

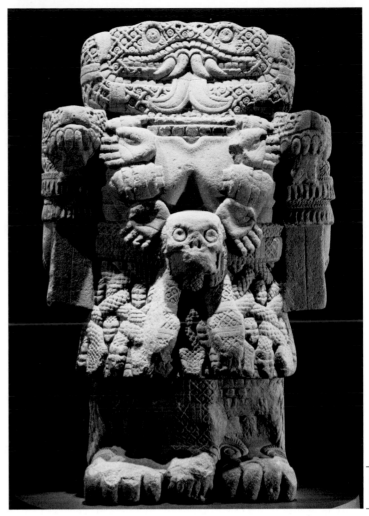

**9-5** Coatlicue (She of the Serpent Skirt), Aztec, from Tenochtitlán, Mexico City, Mexico, ca. 1487–1520. Andesite, 11′ 6″ high. Museo Nacional de Antropología, Mexico City.

This colossal statue may have stood in the Great Temple complex. The beheaded goddess wears a necklace of human hands and hearts. Entwined snakes form her skirt. All her attributes symbolize sacrificial death.

images with feathers, an art they put to service for the Catholic Church for a brief time after the Spanish conquest, creating religious pictures and decorating ecclesiastical clothing with the bright feathers of tropical birds.

The Spanish conquerors found it impossible to reconcile the beauty of the great city of Tenochtitlán with what they regarded as its hideous cults. They admired its splendid buildings ablaze with color, its luxuriant and spacious gardens, its sparkling waterways, its teeming markets, and its grandees resplendent in exotic bird feathers. But when the emperor Moctezuma II brought Cortés and his entourage into the shrine of Huitzilopochtli's temple, the newcomers started back in horror and disgust from the huge statues clotted with dried blood. Cortés was furious. Denouncing Huitzilopochtli as a devil, he proposed to put a high cross above the pyramid and a statue of the Virgin in the sanctuary to exorcise its evil. This proposal came to symbolize the avowed purpose and the historical result of the Spanish conquest of Mesoamerica. The conquistadors venerated the cross and the Virgin, triumphant, in new shrines raised on the ruins of the plundered temples of the ancient American gods. The banner of the Most Catholic King of Spain waved over new atrocities of a European kind.

# SOUTH AMERICA

Late Horizon is the name of the period in the Andes Mountains of Peru and Bolivia (MAP 9-2) that corresponds to the end of the late Postclassic period in Mesoamerica. The dominant power in the region at that time was the Inka.

## Inka

The Inka were a small highland group who established themselves in the Cuzco Valley around 1000. In the 15th century, however, they rapidly extended their power until their empire stretched from modern Quito, Ecuador, to central Chile, a distance of more than 3,000 miles. Perhaps 12 million subjects inhabited the area the Inka ruled. At the time of the Spanish conquest, the Inka Empire, although barely a century old, was the largest in the world. Expertise in mining and metalwork enabled the Inka to accumulate enormous wealth and to amass the fabled troves of gold and silver the Spaniards so coveted. An empire as vast and rich as the Inka's required skillful organizational and administrative control. The Inka had rare talent for both. They divided their Andean empire, which they called Tawantinsuyu, the Land of the Four Quarters, into sections and subsections, provinces and communities, whose boundaries all converged on, or radiated from, the capital city of Cuzco.

The engineering prowess of the Inka matched their organizational talent. They mastered the difficult problems of Andean agriculture with expert terracing and irrigation and knitted together the fabric of their empire with networks of roads and bridges. Shunning wheeled vehicles and horses, they used their highway system to move goods by llama herds and armies by foot throughout their territories. The Inka upgraded or built more than 14,000 miles of roads, one main highway running through the highlands and another along the coast, with connecting roads linking the two regions. They also established a highly efficient, swift communication system of relay runners who carried messages the length of the empire. The Inka emperor in Cuzco could get fresh fish from the coast in only three days. Where the terrain was too steep for a paved flat surface, the Inka built stone steps, and their rope bridges crossed canyons high over impassable rivers. They placed small settlements along the roads no more than a day apart where travelers could rest and obtain supplies for the journey.

The Inka aimed at imposing not only political and economic control but also their art style throughout their realm, subjugating local traditions to those of the empire. Control extended even to clothing, which communicated the social status of the person wearing the garment. The Inka wove bands of small squares of various repeated abstract designs into their fabrics. Scholars believe the patterns had political meaning, connoting membership in particular social groups. The Inka ruler's tunics displayed a full range of abstract motifs, perhaps to indicate his control over all groups. Those the Inka conquered had to wear their characteristic local dress at all times, a practice reflected in the distinctive and varied clothing of today's indigenous Andean peoples.

The Inka never developed a writing system, but they employed a remarkably sophisticated record-keeping system using a device known as the *khipu*, with which they recorded calendrical and astronomical information, census and tribute totals, and inventories. For example, the Spaniards noted that Inka officials always knew exactly how much maize or cloth was in any storeroom in their empire. Not a book or a tablet, the khipu consisted of a main fiber cord and other knotted threads hanging perpendicularly off it. The color and position of each thread, as well as the kind of knot and its location, signified numbers and categories of things, whether people, llamas, or crops. Studies of khipus have demonstrated that the Inka used the

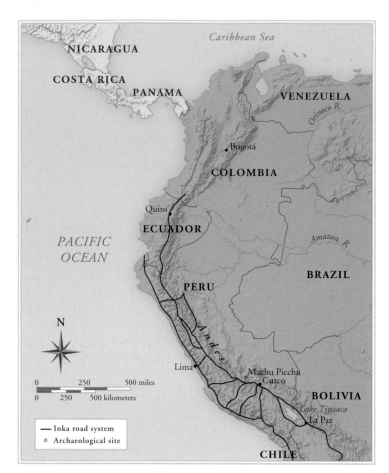

MAP 9-2 Inka sites in Andean South America.

decimal system, were familiar with the zero concept, and could record numbers up to five digits. The Inka census taker or tax collector could easily roll up and carry the khipu, one of the most lightweight and portable "computers" ever invented.

**MACHU PICCHU** The imperial Inka were great architects. Although they also worked with adobe, the Inka were supreme masters of shaping and fitting stone. As a militant people, they selected breathtaking, naturally fortified sites and further strengthened them by building various defensive structures. Inka city planning reveals an almost instinctive grasp of the proper relation of architecture to site.

One of the world's most awe-inspiring sights is the Inka city of Machu Picchu (FIGS. 9-1 and 9-6), which perches on a ridge between two jagged peaks 9,000 feet above sea level. Completely invisible from the Urubamba River Valley some 1,600 feet below, the site remained unknown to the outside world until Hiram Bingham (1875–1956), an American explorer, discovered it in 1911. In the very heart of the Andes, Machu Picchu is about 50 miles north of Cuzco and, like some of the region's other cities, was the estate of a powerful mid-15th-century Inka ruler. Though relatively small and insignificant compared with its neighbors (it had a resident population of little more than a thousand), the city is of great archaeological importance as a rare site left undisturbed since Inka times. The accommodation of its architecture to the landscape is so complete that Machu Picchu seems a natural part of the mountain ranges that surround it on all sides. The Inka even cut large stones to echo the shapes of the mountain beyond (FIG. 9-1). Terraces spill down the mountainsides (FIG. 9-6) and extend even up to the very peak of Huayna Picchu, the great hill just beyond the city's main plaza. The Inka carefully sited buildings so that windows and doors framed spectacular views of sacred peaks and facilitated the recording of important astronomical events.

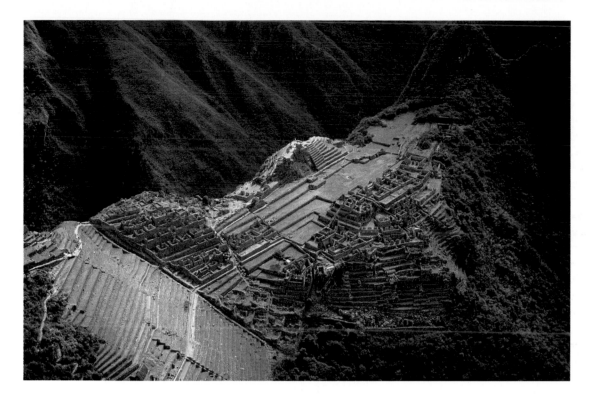

Machu Picchu was the estate of an Inka ruler. Stone terraces spill down the Peruvian mountainsides. Precisely placed windows and doors facilitated astronomical observations.

**CUZCO** In the 16th century, the Spanish conquistadors largely destroyed the Inka capital at Cuzco. Consequently, most of the information about the city has been gleaned from often contradictory Spanish sources rather than from archaeology. Some descriptions state that Cuzco's plan was in the shape of a puma, with a great shrine-fortress on a hill above the city representing its head and the southeastern convergence of two rivers forming its tail. Cuzco residents still refer to the river area as "the puma's tail." A great plaza, still the hub of the modern city, nestled below the animal's stomach. The puma referred to Inka royal power.

One Inka building at Cuzco that survives in small part is the Temple of the Sun (FIG. **9-7**), built of *ashlar masonry* (fitting stone blocks together without mortar), an ancient construction technique the Inka mastered. Inka masons laid the stones with perfectly joined faces so that the lines of separation between blocks and courses were almost undetectable. Remarkably, the Inka produced the close joints of their masonry by abrasion alone, grinding the surfaces to a perfect fit. The stonemasons usually laid the blocks in regular horizontal courses (FIG. **9-7**, *right*). Inka builders were so skilled that they could fashion walls with curved surfaces (FIG. **9-7**, *left*), their planes as level and

**9-7** Remains of the Temple of the Sun (surmounted by the church of Santo Domingo), Inka, Cuzco, Peru, 15th century. Exterior (*left*); interior (*right*).

Perfectly constructed ashlar masonry walls are all that remain of the Temple of the Sun, the most important shrine in the Inka capital. Gold, silver, and emeralds covered the temple's interior walls.

continuous as if they were a single form. The surviving walls of the Temple of the Sun are a prime example of this single-form effect. On the exterior, for example, the stones, precisely fitted and polished, form a curving semi-parabola. The Inka set the ashlar blocks for flexibility in earthquakes, allowing for a temporary dislocation of the courses, which then would return to their original position.

Known to the Spanish as Coricancha (Golden Enclosure), the Temple of the Sun was the most magnificent of all Inka shrines. The 16th-century Spanish chroniclers wrote in awe of Coricancha's splendor, its interior veneered with sheets of gold, silver, and emeralds. Built on the site of the home of Manco Capac, son of the sun god and founder of the Inka dynasty, the temple housed mummies of some of the early rulers. Dedicated to the worship of several Inka deities, including the creator god Viracocha and the gods of the sun, moon, stars, and the elements, the temple was the center point of a network of radiating sight lines leading to some 350 shrines, which had both calendrical and astronomical significance.

Smallpox spreading south from Spanish-occupied Mesoamerica killed the last Inka emperor and his heir before they ever laid eyes on a Spaniard. The deaths of the emperor and his named successor unleashed a struggle among competing elite families that only aided the Europeans in their conquest. In 1532, Francisco Pizarro (1471–1541), the Spanish explorer of the Andes, ambushed the would-be emperor Atawalpa on his way to be crowned at Cuzco after vanquishing his rival half-brother. Although Atawalpa paid a huge ransom of gold and silver, the Spaniards killed him and took control of his vast domain, only a decade after Cortés had defeated the Aztecs in Mexico. Following the murder of Atawalpa, the Spanish erected the church of Santo Domingo (FIG. 9-7, *left*), in an imported European style, on what remained of the Golden Enclosure. A curved section of Inka wall serves to this day as the foundation for Santo Domingo's *apse*. A violent earthquake in 1950 seriously damaged the colonial building, but the Peruvians rebuilt the church. The two contrasting structures remain standing one atop the other. The Coricancha is therefore of more than architectural and archaeological interest. It is a symbol of the Spanish conquest of the Americas and serves as a composite monument to it.

# NORTH AMERICA

In North America during the centuries preceding the arrival of Europeans, power was much more widely dispersed and the native art and architecture more varied than in Mesoamerica and Andean South America. Three major regions of the United States and Canada are of special interest: the American Southwest, the Northwest Coast (Washington and British Columbia) and Alaska, and the Great Plains (MAP 9-3).

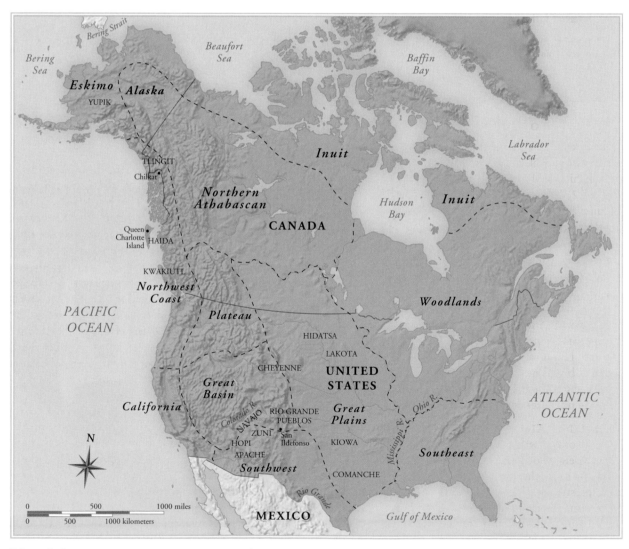

MAP 9-3   Later Native American sites in North America.

1 ft.

**9-8** Detail of a kiva mural from Kuaua Pueblo (Coronado State Monument), Ancestral Puebloan, New Mexico, late 15th to early 16th century. Interior of the kiva, 18′ × 18′. Museum of New Mexico, Santa Fe.

The kiva, or male council house, was the spiritual center of Puebloan life. Kivas were decorated with mural paintings associated with agricultural fertility. This one depicts a lightning man, fish, birds, and seeds.

## Southwest

The dominant culture of the American Southwest between 1300 and 1500 was the Ancestral Puebloan (formerly called the Anasazi), the builders of great architectural complexes such as Chaco Canyon and Cliff Palace (FIG. 8-32). The spiritual center of Puebloan life was the *kiva,* or male council house, decorated with elaborate mural paintings representing deities associated with agricultural fertility. According to their descendants, the present-day Hopi and Zuni, the detail of the Kuaua Pueblo (*pueblo* is Spanish for "urban settlement") mural shown here (FIG. 9-8) depicts a "lightning man" on the left side. Fish and eagle images (associated with rain) appear on the right side. Seeds, a lightning bolt, and a rainbow stream from the eagle's mouth. All these figures are associated with the fertility of the earth and the life-giving properties of the seasonal rains, a constant preoccupation of Southwest farmers. The Ancestral Puebloan painter depicted the figures with great economy, using thick black lines, dots, and a restricted palette of black, brown, yellow, and white. The frontal figure of the lightning man seen against a neutral ground makes an immediate visual impact.

**NAVAJO PAINTING AND WEAVING** When the first Europeans came into contact with the ancient peoples of the Southwest, they called them "Pueblo Indians." The successors of the Ancestral Puebloans and other Southwest groups, the Pueblo Indians include linguistically diverse but culturally similar peoples such as the Hopi of northern Arizona and the Rio Grande Pueblos of New Mexico. Living among them are the descendants of nomadic hunters who arrived in the Southwest from their homelands in northwestern Canada sometime between 1200 and 1500. These

are the Apache and Navajo, who, although culturally quite distinct from the original inhabitants of the Southwest, adopted many features of Pueblo life.

Among these borrowed elements is *sand painting,* which the Navajo learned from the Pueblos but transformed into an extraordinarily complex ritual art form. The temporary sand paintings (also known as *dry paintings*), constructed to the accompaniment of prayers and chants, are an essential part of ceremonies for curing disease. (Because of the sacred nature of sand paintings, the Navajo do not permit photographing them.) In the healing ceremony, the patient sits in the painting's center to absorb the life-giving powers of the gods and their representations. The Navajo perform similar rites to assure success in hunting and to promote fertility in human beings and nature alike. The artists who supervise the making of these complex images are religious leaders or "medicine men" (rarely women), thought to have direct contact with the powers of the supernatural world, which they use to help both individuals and the community.

The natural materials used—sand, varicolored powdered stones, corn pollen, and charcoal—play a symbolic role that reflects the Native Americans' preoccupation with the forces of nature. The paintings depict the gods and mythological heroes whose help the Navajo seek. As part of the ritual, the participants destroy the sand paintings, so no models exist. However, the traditional prototypes, passed on from artist to artist, must be adhered to as closely as possible. Mistakes can render the ceremony ineffective. Navajo dry painting is therefore highly stylized. Simple curves, straight lines, right angles, and serial repetition characterize most sand paintings.

1 in.

By the mid-17th century, the Navajo had also learned how to weave from their Hopi and other Pueblo neighbors, quickly adapting to new materials such as sheep wool and synthetic dyes introduced by Spanish settlers and, later, by Anglo-Americans. They rapidly transformed blankets they wore into handsome rugs in response to the new market created by the arrival of the railroad and early tourists in the 1880s. Other tribes, including those of the Great Plains, also purchased Navajo textiles, which became famous for their quality (the thread count in a typical Navajo rug is extraordinarily high) as well as the sophistication of their designs. Navajo rugs often incorporate vivid abstract motifs known as "eye dazzlers" and copies of sand paintings (altered slightly to preserve the sacred quality of the impermanent ritual images).

**HOPI KATSINAS** Another art form from the Southwest, the *katsina* figurine, also has deep roots in the area. Katsinas are benevolent supernatural spirits personifying ancestors and natural elements living in mountains and water sources. Humans join their world after death. Among contemporary Pueblo groups, masked dancers ritually impersonate katsinas during yearly festivals dedicated to rain, fertility, and good hunting. To educate young girls in ritual lore, the Hopi traditionally give them miniature representations of the masked dancers. The Hopi katsina illustrated here (FIG. **9-9**), carved in cottonwood root with added feathers, is the work of Otto Pentewa (d. 1963). It represents a rain-bringing deity who wears a mask painted in geometric patterns symbolic of water and agricultural fertility. Topping the mask is a stepped shape signifying thunderclouds and feathers to carry the Hopis' airborne prayers. The origins of the katsina figurines have been lost in time (they even may have developed from carved saints the Spaniards introduced during the colonial period). However, the cult is probably very ancient.

**PUEBLO POTTERY** The Southwest has also provided the finest examples of North American pottery. Originally producing utilitarian forms, Southwest potters worked without the potter's wheel and instead coiled clay shapes that they then slipped, polished, and fired. Decorative motifs, often abstract and conventionalized, dealt largely with forces of nature—clouds, wind, and rain. The efforts of San Ildefonso Pueblo potter María Montoya Martínez (1887–1980) and her husband Julian Martínez (see "Gender Roles in Native American Art," page 183) in the early decades of the 20th century revived old techniques to produce forms of striking shape, proportion, and texture. Her black-on-black pieces (FIG. **9-10**) feature matte designs on highly polished surfaces achieved by extensive polishing and special firing in an oxygen-poor atmosphere.

## Northwest Coast and Alaska

The Native Americans of the coasts and islands of northern Washington state, the province of British Columbia in Canada, and southern Alaska have long enjoyed a rich and reliable environment. They fished, hunted sea mammals and game, gathered edible plants, and made their homes, utensils, ritual objects, and even clothing from the region's great cedar forests. Among the numerous groups who make up

**9-9** Otto Pentewa, Katsina figurine, Hopi, New Oraibi, Arizona, carved before 1959. Cottonwood root and feathers, 1′ high. Arizona State Museum, University of Arizona, Tucson.

Katsinas are benevolent spirits living in mountains and water sources. This Hopi katsina represents a rain-bringing deity who wears a mask painted in geometric patterns symbolic of water and agricultural fertility.

## Gender Roles in Native American Art

Although both Native American women and men have created art objects for centuries, they have traditionally worked in different media or at different tasks. Among the Navajo, for example, weavers tend to be women, whereas among the neighboring Hopi the men weave. According to Navajo myth, long ago Spider Woman's husband built her a loom for weaving. In turn, she taught Navajo women how to spin and weave so that they might have clothing to wear. Today, young girls learn from their mothers how to work the loom, just as Spider Woman instructed their ancestors, passing along the techniques and designs from one generation to the next.

Among the Pueblos, pottery making normally has been the domain of women. But in response to heavy demand for her wares, María Montoya Martínez, of San Ildefonso Pueblo in New Mexico, coiled, slipped, and burnished her pots, and her husband Julian painted the designs. Although they worked in many styles, some based on prehistoric ceramics, around 1918 they invented the black-on-black ware (FIG. 9-10) that made María, and indeed the whole pueblo, famous. The elegant shapes of the pots, as well as the traditional but abstract designs, had affinities with the contemporary Art Deco style in architecture and interior design, and collectors avidly sought (and continue to seek) them. When nonnative buyers suggested she sign her pots to increase their value, María obliged, but, in the communal spirit typical of the Pueblos, she also signed her neighbors' names so that they might share in her good fortune. Though María died in 1980, her descendants continue to garner awards as outstanding potters.

Women also produced the elaborately decorated skin and, later, the trade-cloth clothing of the Woodlands and Great Plains regions using moose hair, dyed porcupine quills, and imported beads. Among the Cheyenne, quillworking was a sacred art, and young women worked at learning both proper ritual and correct techniques to obtain membership in the prestigious quillworkers' guild. Women gained the same honor and dignity from creating finely worked utilitarian objects that men earned from warfare. Both women and men painted on tipis and clothing (FIGS. 9-16 and 9-17), with women creating abstract designs (FIG. 9-16) and men working in a more realistic narrative style, often celebrating their exploits in war or recording the cultural changes resulting from the transfer to reservations.

In the far north, women tended to work with soft materials such as animal skins, whereas men were sculptors of wood masks among the Alaskan Eskimos and of walrus ivory pieces (FIG. 8-27) through-

**9-10** MARÍA MONTOYA MARTÍNEZ, jar, San Ildefonso Pueblo, New Mexico, ca. 1939. Blackware, $11\frac{1}{8}'' \times 1' 1''$. National Museum of Women in the Arts, Washington, D.C. (gift of Wallace and Wilhelmina Hollachy).

Pottery is traditionally a Native American woman's art form. María Montoya Martínez won renown for her black-on-black vessels of striking shapes with matte designs on highly polished surfaces.

out the Arctic. The introduction of printmaking, a foreign medium with no established gender associations, to some Canadian Inuit communities in the 1950s provided both native women and men with a new creative outlet. Printmaking became an important source of economic independence vital to these isolated and once-impoverished settlements. Today, both Inuit women and men make prints, but men still dominate in carving stone sculpture, another new medium also produced for and sold to outsiders.

Throughout North America, indigenous artists continue to work in traditional media, such as ceramics, beadwork, and basketry, marketing their wares through museum shops, galleries, regional art fairs, and, most recently, the Internet. Many also obtain degrees in art and express themselves in European media such as oil painting and mixed-media sculpture.

the Northwest Coast area are the Kwakiutl of southern British Columbia; the Haida, who live on Queen Charlotte Island off the coast of the province; and the Tlingit of southern Alaska (MAP 9-3). In the Northwest, a class of professional artists developed, in contrast to the more typical Native American pattern of part-time artists. Working in a

highly formalized, subtle style, Northwest Coast artists have produced a wide variety of art objects for centuries: totem poles, masks, rattles, chests, bowls, clothing, charms, and decorated houses and canoes. Some artistic traditions originated as early as 500 BCE, although others developed only after the arrival of Europeans in North America.

**9-11** Eagle transformation mask, closed (*top*) and open (*bottom*) views, Kwakiutl, Alert Bay, Canada, late 19th century. Wood, feathers, and string, 1' 10" × 11". American Museum of Natural History, New York.

The wearer of this Kwakiutl mask could open and close it rapidly by manipulating hidden strings, magically transforming himself from human to eagle and back again as he danced.

1 ft.

1 ft.

**KWAKIUTL AND TLINGIT MASKS** Northwest Coast religious specialists used masks in their healing rituals. Men also wore masks in dramatic public performances during the winter ceremonial season. The animals and mythological creatures represented in masks and a host of other carvings derive from the Northwest Coast's rich oral tradition and celebrate the mythological origins and inherited privileges of high-ranking families. The artist who made the Kwakiutl mask illustrated here (FIG. **9-11**) meant it to be seen in flickering firelight, and ingeniously constructed it to open and close rapidly when the wearer manipulated hidden strings. He could thus magically transform himself from human to eagle and back again as he danced. The transformation theme, in myriad forms, is a central aspect of the art and religion of the Americas. The Kwakiutl mask's

human aspect also owes its dramatic character to the exaggeration and distortion of facial parts—such as the hooked beaklike nose and flat flaring nostrils—and to the deeply undercut curvilinear depressions, which form strong shadows. In contrast to the carved human face, but painted in the same colors, is the two-dimensional abstract image of the eagle painted on the inside of the outer mask.

The Kwakiutl mask is a refined yet forceful carving typical of the area's more dramatic styles. Others are more subdued, and some, such as a wooden Tlingit war helmet (FIG. **9-12**), are exceedingly naturalistic. Although the helmet mask may be a portrait, it might also represent a supernatural being whose powers enhance the wearer's strength. In either case, the artist surely created its grimacing expression to intimidate the enemy.

9-12 War helmet mask, Tlingit, Canada, collected 1888–1893. Wood, 1′ high. American Museum of Natural History, New York.

This naturalistic wood war helmet mask may be a portrait of a Tlingit warrior or a representation of a supernatural being. The carver intended the face's grimacing expression to intimidate enemies.

1 in.

**HAIDA TOTEM POLES** Although Northwest Coast arts have a spiritual dimension, they are often more important as expressions of social status. Haida house frontal poles, displaying totemic emblems of clan groups, strikingly express this interest in prestige and family history. Totem poles emerged as a major art form about 300 years ago. The examples in FIG. 9-13 date to the 19th century. They stand today in a reconstructed Haida village that BILL REID (1920–1998, Haida) and his assistant DOUG CRANMER (b. 1927, Kwakiutl) completed in 1962. Each of the superimposed forms carved on these poles represents a crest, an animal, or a supernatural being that figures in the clan's origin story.

Additional crests could also be obtained through marriage and trade. The Haida so jealously guarded the right to own and display crests that even warfare could erupt over the disputed ownership of a valued crest. In the poles shown, the crests represented include an upside-down dogfish (a small shark), an eagle with a downturned beak, and a killer whale with a crouching human between its snout and its upturned tail flukes. During the 19th century, the Haida erected more poles and made them larger in response to greater competitiveness and the availability of metal tools. The artists carved poles up to 60 feet tall from the trunks of single cedar trees.

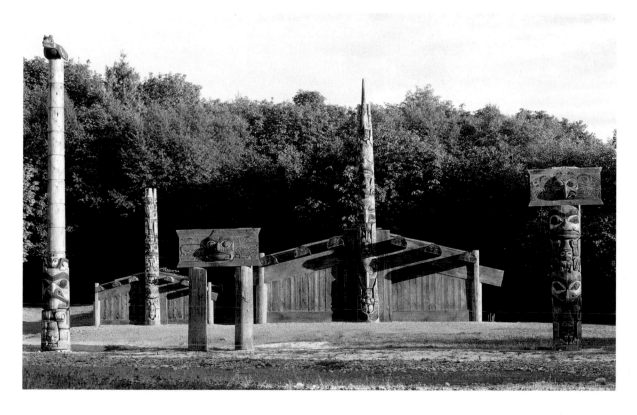

9-13 BILL REID (Haida), assisted by DOUG CRANMER (Nāmgīs), 19th-century-style Haida houses and totem poles, 1962. Courtesy University of British Columbia, Museum of Anthropology, Vancouver, Canada.

Each of the superimposed forms carved on Haida totem poles represents a crest, an animal, or a supernatural being who figures in the clan's origin story. Some Haida poles are 60 feet tall.

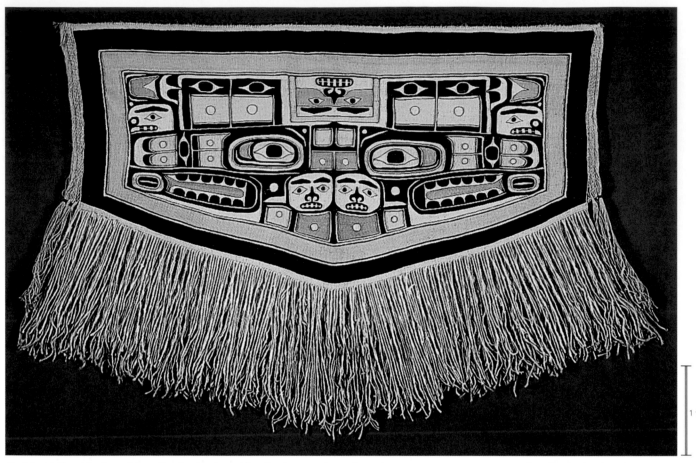

1 ft.

**9-14** Chilkat blanket with stylized animal motifs, Tlingit, Canada, early 20th century. Mountain goat wool and cedar bark, 2′ 11″ × 6′. Southwest Museum of the American Indian, Los Angeles.

Chilkat blankets were collaborations between male designers and female weavers. Decorated with animal and abstract motifs, they were worn over the shoulder and were items of ceremonial dress.

**CHILKAT BLANKETS** Another characteristic Northwest Coast art form is the Chilkat blanket (FIG. **9-14**), named for an Alaskan Tlingit village. Male designers provided the templates for these blankets in the form of wooden pattern boards for female weavers. Woven of shredded cedar bark and mountain goat wool on an upright loom, the Tlingit blankets took at least six months to complete. These blankets, which served as robes worn over the shoulders, became widespread prestige items of ceremonial dress during the 19th century. They display several characteristics of the Northwest Coast style recurrent in all media: symmetry and rhythmic repetition, schematic abstraction of animal motifs (in the robe illustrated, a bear), eye designs, a regularly swelling and thinning line, and a tendency to round off corners.

**YUPIK MASKS** Farther north, the 19th-century Yupik Eskimos living around the Bering Strait of Alaska had a highly developed ceremonial life focused on game animals, particularly seal. Their religious specialists wore highly imaginative masks with moving parts. The Yupik generally made these masks for single occasions and then abandoned them. Consequently, many masks have ended up in museums and private collections. The example shown here (FIG. **9-15**) represents the spirit of the north wind, its face surrounded by a hoop signifying the universe, its voice mimicked by the rattling appendages. The paired human hands commonly found on these masks refer to the wearer's power to attract animals for hunting. The painted white spots represent snowflakes.

The devastating effects of 19th-century epidemics, coupled with government and missionary repression of Native American ritual and social activities, threatened to eradicate the traditional arts of the Northwest Coast and the Eskimos. In the past half century, however, there has been an impressive revival of traditional art forms, some created for collectors and the tourist trade, as well as the development of new ones, such as printmaking. Canadian Eskimos, known as the Inuit, have set up cooperatives to produce and market stone carvings and prints. With these new media, artists generally depict themes from the rapidly vanishing traditional Inuit way of life.

## Great Plains

After colonial governments disrupted settled indigenous communities on the East Coast and the Europeans introduced the horse to North America, a new mobile Native American culture flourished for a short time on the Great Plains. Artists of the Great Plains worked in materials and styles quite different from those of the Northwest Coast and Eskimo/Inuit peoples. Much artistic energy went into the decoration of leather garments, pouches, and horse trappings, first with compactly sewn quill designs and later with beadwork patterns. Artists painted tipis, tipi linings, and buffalo-skin robes with geometric and stiff figural designs prior to about 1830. After that, they gradually introduced naturalistic scenes, often of war exploits, in styles adapted from those of visiting European artists.

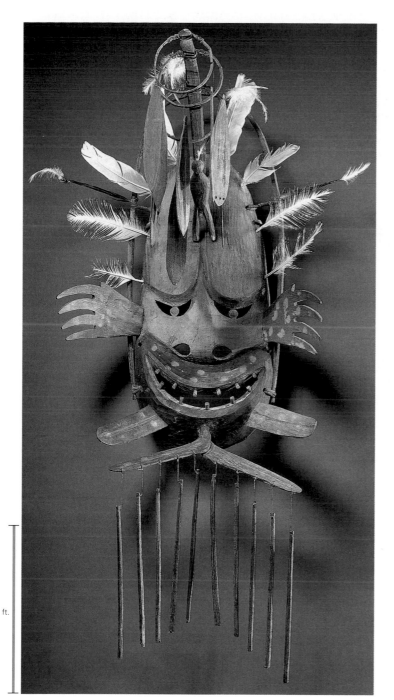

**9-15** Mask, Yupik Eskimo, Alaska, early 20th century. Wood and feathers, 3′ 9″ high. Metropolitan Museum of Art, New York (Michael C. Rockefeller Memorial Collection, gift of Nelson Rockefeller).

This Yupik mask represents the spirit of the north wind, its face surrounded by a hoop signifying the universe, its voice mimicked by the rattling appendages. The white spots represent snowflakes.

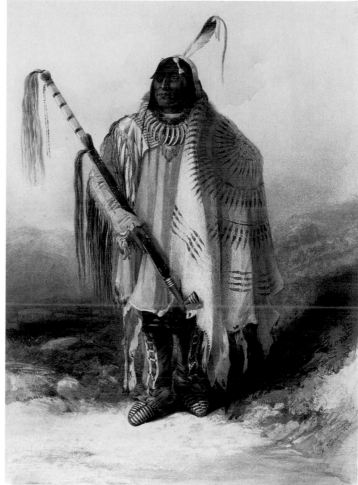

**9-16** Karl Bodmer, *Hidatsa Warrior Pehriska-Ruhpa* (*Two Ravens*), 1833. Watercolor, 1′ 3$\frac{7}{8}$″ × 11$\frac{1}{2}$″. Joslyn Art Museum, Omaha (gift of the Enron Art Foundation).

The personal regalia of a Hidatsa warrior included his pipe, painted buffalo robe, bear-claw necklace, and feather decorations, all symbols of his affiliations and military accomplishments.

**HIDATSA REGALIA** Because most Plains peoples were nomadic, they focused their aesthetic attention largely on their clothing and bodies and on other portable objects, such as shields, clubs, pipes, tomahawks, and various containers. Transient but important Plains art forms can sometimes be found in the paintings and drawings of visiting American and European artists. The Swiss painter KARL BODMER (1809–1893), for example, portrayed the personal decoration of Two Ravens, a Hidatsa warrior, in an 1833 watercolor (FIG. **9-16**). The painting depicts his pipe, painted buffalo robe,

bear-claw necklace, and feather decorations, all symbolic of his affiliations and military accomplishments. These items represent his "biography"—a composite artistic statement in several media that neighboring Native Americans could have "read" easily. The concentric circle design over his left shoulder, for example, is an abstract rendering of an eagle-feather war bonnet.

Plains peoples also made shields and shield covers that were both artworks and "power images." Shield paintings often derived from personal religious visions. The owners believed that the symbolism, the pigments themselves, and added materials, such as feathers, provided them with magical protection and supernatural power.

**LEDGER PAINTINGS** Plains warriors battled incursions into their territory throughout the 19th century. The pursuit of Plains natives culminated in the 1890 slaughter of Lakota participants who had gathered for a ritual known as the Ghost Dance at Wounded Knee Creek, South Dakota. Indeed, from the 1830s on, U.S. troops forcibly removed Native Americans from their homelands and resettled them in other parts of the country. Toward the end of the century, governments confined them to reservations in both the United States and Canada.

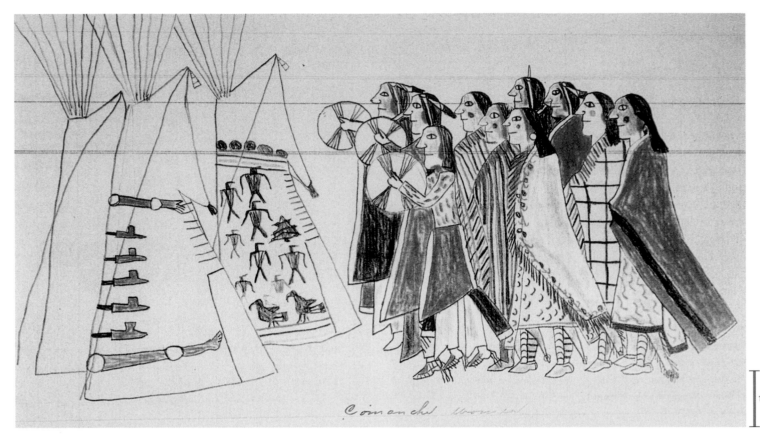

1 in.

**9-17** Honoring song at painted tipi, in Julian Scott Ledger, Kiowa, 1880. Pencil, ink, and colored pencil, $7\frac{1}{2}'' \times 1'$. Mr. and Mrs. Charles Diker Collection.

During the reservation period, some Plains artists recorded their traditional lifestyle in ledger books. This one depicts men and women dancing an honoring song in front of three painted tipis.

During the reservation period, some Plains arts continued to flourish, notably beadwork for the women and painting in ledger books for the men. Traders, the army, and Indian agents had for years provided Plains peoples with pencils and new or discarded ledger books. They, in turn, used them to draw their personal exploits for themselves or for interested Anglo buyers. Sometimes warriors carried them into battle, where U.S. Army opponents retook the ledgers. After confinement to reservations, Plains artists began to record not only their heroic past and vanished lifestyle but also their reactions to their new surroundings, frequently in a state far from home. These images, often poignant and sometimes humorous, are important native documents of a time of great turmoil and change. In the example shown here (FIG. 9-17), the work of an unknown Kiowa artist, a group of men and women, possibly Comanches (allies of the Kiowa), appear to dance an honoring song be-

fore three tipis, the left forward one painted with red stone pipes and a dismembered leg and arm. The women (at the center and right) wear the mixture of clothing typical of the late 19th century among the Plains Indians—traditional high leather moccasins, dresses made from calico trade cloth, and (on the right) a red Hudson's Bay blanket with a black stripe. Although the Plains peoples no longer paint ledger books, beadwork has never completely died out. The ancient art of creating quilled, beaded, and painted clothing has evolved into the elaborate costumes displayed today at competitive dances called *powwows*.

Whether secular and decorative or spiritual and highly symbolic, the diverse styles and forms of Native American art in the United States and Canada reflect the indigenous peoples' reliance on and reverence toward the environment they considered it their privilege to inhabit.

# NATIVE ARTS OF THE AMERICAS AFTER 1300

## MESOAMERICA

▌ When the first Europeans arrived in the New World, they encountered native peoples with sophisticated civilizations and a long history of art production, including illustrated books. The few books that survive provide precious insight into Mesoamerican rituals, science, mythology, and painting style.

▌ The dominant power in Mesoamerica in the centuries before Cortés overthrew it was the Aztec Empire. The Aztec capital was Tenochtitlán (Mexico City), a magnificent island city laid out on a grid plan with a population of more than 100,000.

▌ The Great Temple at Tenochtitlán was a towering pyramid encasing several earlier pyramids. Dedicated to the worship of Huitzilopochtli and Tlaloc, it was also the place where enemies were sacrificed and their battered bodies thrown down the stone staircase to land on a huge disk bearing a representation in relief of the dismembered body of the goddess Coyolxauhqui.

▌ In addition to relief carving, Aztec sculptors produced stone statues, some of colossal size, for example, the 11' 6" image of the beheaded Coatlicue from Tenochtitlán.

*Borgia Codex*, ca. 1400–1500

Coyolxauhqui, Great Temple, Tenochtitlán, ca. 1469

## SOUTH AMERICA

▌ In the 15th century, the Inka Empire, with its capital at Cuzco in modern Peru, extended from Ecuador to Chile. The Inka were superb engineers and constructed 14,000 miles of roads to exert control over their vast empire. They kept track of inventories, census and tribute totals, and astronomical information using a "computer of strings" called a khipu.

▌ Master architects, the Inka were experts in ashlar masonry construction. The most impressive preserved Inka site is Machu Picchu, the estate of an Inka ruler. Stone terraces spill down the mountainsides, and the buildings have windows and doors designed to frame views of sacred peaks and facilitate the recording of important astronomical events.

Machu Picchu, 15th century

## NORTH AMERICA

▌ In North America, power was much more widely dispersed and the native art and architecture more varied than in Mesoamerica and Andean South America.

▌ In the American Southwest, the Ancestral Puebloans built urban settlements (pueblos) and decorated their council houses (kivas) with mural paintings. The Navajo produced magnificent textiles and created temporary sand paintings as part of complex rituals. The Hopi carved katsina figurines representing benevolent supernatural spirits. The Pueblo Indian pottery produced by artists like María Montoya Martínez is among the finest in the world.

▌ On the Northwest Coast, masks played an important role in religious rituals. Some examples can open and close rapidly so that the wearer can magically transform himself from human to animal and back again. Haida totem poles sometimes reach 60 feet in height and are carved with superimposed forms representing clan crests, animals, and supernatural beings. Chilkat blankets are the result of a fruitful collaboration between male designers and female weavers.

▌ The peoples of the Great Plains won renown for their magnificent painted buffalo robes, bead necklaces, feather headdresses, and shields. Native American art lived on even after the U.S. government forcibly relocated the Plains peoples to reservations. Painted ledger books record their vanished lifestyle, but the production of fine crafts continues to the present day.

Martínez, San Ildefonso Pueblo jar, ca. 1939

Kwakiutl eagle transformation mask, late 19th century

**10-1** Detail of the eastern facade of the Great Mosque (FIG. 10-8), Djenne, Mali, begun 13th century, rebuilt 1906–1907.

Africa is a vast continent with a diverse population and myriad art forms. Native forms exist side by side with imported ones, such as this mosque marking the arrival of Islam in Mali.

# 10

# AFRICA BEFORE 1800

Africa (MAP 10-1) is a vast continent of 52 nations comprising more than one-fifth of the world's land mass and many distinct topographical and ecological zones. Parched deserts occupy northern and southern regions, high mountains rise in the east, and three great rivers—the Niger, the Congo, and the Nile—and their lush valleys support agriculture and large settled populations. More than 2,000 distinct ethnic, cultural, and linguistic groups, often but inaccurately called "tribes," long have inhabited this enormous continent. These population groups historically have ranged in size from a few hundred, in hunting and gathering bands, to 10 to 20 million or more. Councils of elders often governed smaller groups, whereas larger populations sometimes formed a centralized state under a king.

Despite this great variety, African peoples share many core beliefs and practices. These include honoring ancestors, worshiping nature deities, and elevating rulers to sacred status. Most peoples also consult diviners or fortune tellers. These beliefs have given rise to many richly expressive art traditions, including rock engraving and painting, body decoration, masquerades and other lavish festivals, figural sculpture, and sacred and secular architecture. Given the size of the African continent and the diversity of ethnic groups, it is not surprising that African art varies enormously in subject, materials, and function. Nomadic and seminomadic peoples excelled in the arts of personal adornment and also produced rock engravings and paintings depicting animals and rituals. Farmers, in contrast, often created figural sculpture in terracotta, wood, and metal for display in shrines to legendary ancestors or nature deities held responsible for the health of crops and the well-being of the people. The regalia, art, and architecture of kings and their courts, as elsewhere in the world, celebrated the wealth and power of the rulers themselves. Nearly all African peoples lavished artistic energy on the decoration of their own bodies to express their identity and status, and many communities mounted richly layered festivals, including masquerades, to celebrate harvests and the New Year and to commemorate the deaths of leaders.

This chapter surveys the art and architecture of sub-Saharan Africa from prehistoric times through the 18th century (see "Dating African Art and Identifying African Artists," page 193), including the first contacts with Europeans, which began along the seacoasts in the late 15th century. Chapter 11 treats the art of the past two centuries, from the beginning of European colonization to the present.

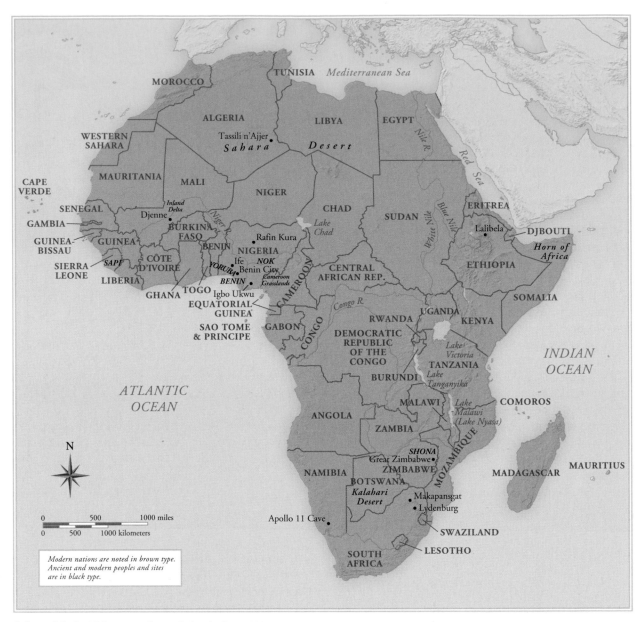

MAP 10-1 African peoples and sites before 1800.

# PREHISTORY AND EARLY CULTURES

Thousands of rock engravings and paintings found at hundreds of sites across the continent constitute the earliest known African art. Some painted animals from the Apollo 11 Cave in southwestern Africa date to perhaps as long ago as 25,000 years, earlier than all but the oldest Paleolithic art of Europe. As humankind apparently originated in Africa, archaeologists may yet discover the world's earliest art there as well.

## Rock Art

The greatest concentrations of rock art are in the Sahara Desert to the north, the Horn of Africa in the east, and the Kalahari Desert to the south, as well as in caves and on rock outcroppings in southern Africa. Accurately naturalistic renderings as well as stylized images on rock surfaces show animals and humans in many different positions and activities, singly or in groups, stationary or in motion. Most of these works date to within the past 4,000 to 6,000 years, but some may have

been created as early as 8000 BCE. They provide a rich record of the environment, human activities, and animal species in prehistoric times.

**TASSILI N'AJJER** A 7,000-year-old painting (FIG. **10-2**) from Tassili n'Ajjer in southeastern Algeria in the central Sahara (at that time a verdant savanna) is one of the earliest and finest surviving examples of rock art. The painter depicted a running woman with convincing animation and significant detail. The dotted marks on her shoulders, legs, and torso probably indicate that she is wearing body paint applied for a ritual. Her face, however, is featureless, a common trait in the earliest art. The white parallel patterns attached to her arms and waist appear to represent flowing raffia decorations and a raffia skirt. Horns—shown in the *twisted perspective*, or *composite* view, typical of prehistoric art—are also part of her ceremonial attire. Notably, the artist painted this detailed image over a field of much smaller painted human beings, an indication of why it is often so difficult to date and interpret art on rock surfaces, as subsequent superimpositions are frequent. Nonetheless, scholars have been able to establish a rough chronology for African rock art, an art form that continues to this day.

# Dating African Art and Identifying African Artists

Most African objects bear neither labels nor signatures, and consequently it is nearly impossible to date them precisely or to identify their makers definitively. Early collectors did not bother to ask the names of artists or when the works were made. Although a firm chronology is currently beyond reach, broad historical trends are reasonably clear. But until archaeologists conduct more extensive fieldwork in sub-Saharan Africa, many artworks will remain difficult to date and interpret, and even whole cultures will continue to be poorly documented. Some African peoples, however, have left written documents that help date their artworks, even when their methods of measuring time differ from those used today. Other cultures, such as the Benin kingdom (FIGS. **10-12** and **10-13**), have preserved complex oral records of past events. Historians can check these against the accounts of European travelers and traders who visited the kingdom.

When artists are members of craft or occupational guilds—such as blacksmiths and brass casters in the western Sudan—commissions for artwork go to the head of the guild, and the specific artist who worked on the commission may never be known. Nevertheless, art historians can identify individual hands if their work is distinctive. Documentation now exists for several hundred individual artists, even if their names are lost. For some sculptors who worked in the late 19th or early 20th centuries, scholars have been able to compile fairly detailed biographies (see "African Artists," Chapter 11, page 213).

Where documentation on authorship or dating is fragmentary or unavailable, art historians sometimes try to establish chronology from an object's style, although, as discussed in the Introduction, stylistic analysis is a subjective tool. Scientific techniques such as *radiocarbon dating* (measuring the decay rate of carbon isotopes in organic matter to provide dates for wood, fiber, and ivory) and *thermoluminescence* (dating the amounts of radiation found in fired clay objects) have proved useful but cannot provide precise dates. Nonetheless, art historians are slowly writing the history of African art, even if there are still large gaps to fill.

One of the major problems impeding compilation of an accurate history is illegal and uncontrolled excavation. By removing artworks from the ground, treasure hunters disturb or ruin their original contexts and reduce or eliminate the possibility of establishing accurate chronologies. This phenomenon is not unique to Africa, however. Archaeologists on all continents have to confront the problem of looting and the consequent loss of knowledge about the provenance and original function of objects that collectors wish to acquire. That is the unfortunate result of the worldwide appreciation of African art that began in the early 20th century, when many European artists looked to "primitive art" for inspiration.

Although the precise meaning of most African rock art also remains uncertain, a considerable literature exists that describes, analyzes, and interprets the varied human and animal activities shown, as well as the evidently symbolic, more abstract patterns. The human and humanlike figures may include representations of supernatural beings as well as mortals. Some scholars have, in fact, interpreted the woman from Tassili n'Ajjer as a horned deity instead of a human wearing ceremonial headgear.

## Nok and Lydenburg

Outside Egypt and neighboring Nubia, the earliest African sculptures in the round have been found at several sites in central Nigeria that archaeologists collectively call the Nok culture. Scholars disagree on whether the Nok sites were unified politically or socially. Named after the site where these sculptures were first discovered in 1928, Nok art dates between 500 BCE and 200 CE. Hundreds of Nok-style human and animal heads, body parts, and figures have been found accidentally during tin-mining operations but not in their original context.

**10-2** Running horned woman, rock painting, from Tassili n'Ajjer, Algeria, ca. 6000–4000 BCE.

This early rock painting is thousands of years older than the first African sculptures. It represents a running woman with body paint, raffia skirt, and horned headgear, apparently in a ritual context.

1 in.

**10-3** Nok head, from Rafin Kura, Nigeria, ca. 500 BCE–200 CE. Terracotta, 1′ 2$\frac{3}{16}$″ high. National Museum, Lagos.

The earliest African sculptures in the round come from Nigeria. The Nok culture produced expressive terracotta heads with large eyes, mouths, and ears. Piercing equalized the heat during the firing process.

1 in.

**10-4** Head, from Lydenburg, South Africa, ca. 500 CE. Terracotta, 1′ 2$\frac{15}{16}$″ high. South African Museum, Iziko Museums of Cape Town, Cape Town.

This Lydenburg head resembles an inverted terracotta pot and may have been a helmet mask. The sculptor depicted the features by applying thin clay fillets. The scarification marks are signs of beauty in Africa.

**RAFIN KURA HEAD** A representative Nok terracotta head (FIG. **10-3**), found at Rafin Kura, is a fragment of what was originally a full figure. Preserved fragments of other Nok statues indicate that sculptors fashioned standing, seated, and kneeling figures. The heads are disproportionately large compared with the bodies. The head shown here has an expressive face with large alert eyes, flaring nostrils, and parted lips. The pierced eyes, mouth, and ear holes are characteristic of Nok sculpture and probably helped to equalize the heating of the hollow clay head during the firing process. The coiffure with incised grooves, the raised eyebrows, the perforated triangular eyes, and the sharp jaw line suggest that the sculptor carved some details of the head while modeling the rest. Researchers are unclear about the function of the Nok terracottas, but the broken tube around the neck of the Rafin Kura figure may be a bead necklace, an indication that the person portrayed held an elevated position in Nok society. The gender of the Nok artists is unknown. Because the primary ceramists and clay sculptors across the continent are women, Nok sculptors may have been as well (see "Gender Roles in African Art Production," Chapter 11, page 212).

**LYDENBURG HEAD** Later than the Nok examples are the seven life-size terracotta heads discovered carefully buried in a pit outside the town of Lydenburg in present-day South Africa. Radiocarbon evidence indicates the heads date to about 500 CE. One of the Lydenburg heads (FIG. **10-4**), reconstructed from fragments, has a humanlike form, although its inverted pot shape differs markedly from the more naturalistic Nok heads. The artist created the eyes, ears, nose, and mouth, as well as the hairline, by applying thin clay fillets onto the head. The same method produced what are probably *scarification* marks (scars intentionally created to form patterns on the flesh) on the forehead, temples, and between the eyes. Incised linear patterns also adorn the back of the head. The horizontal neck bands, with their incised surfaces, resemble the ringed or banded necks that are considered signs of beauty in many parts of the continent. A small, unidentifiable animal sits atop the head. In the

## Art and Leadership in Africa

The relationships between leaders and art forms are strong, complex, and universal in Africa. Political, spiritual, and social leaders—kings, chiefs, titled people, and religious specialists—have the power and wealth to command the best artists and to require the most expensive and durable materials to adorn themselves, furnish their homes, and make visible the cultural and religious organizations they lead. Leaders also possess the power to dispense art or the prerogative to use it.

Several formal or structural principles characterize leaders' arts and thus set them off from the popular arts of ordinary Africans. Leaders' arts—for example, the sumptuous and layered regalia of chiefs and kings—tend to be durable and are often made of costly materials, such as ivory, beads, copper alloys, and other luxurious metals. Some of the objects made specifically for African leaders, such as stools or chairs (FIG. 11-5), ornate clothing (FIG. 11-21), and special weaponry, draw attention to their superior status. Handheld objects—for example, staffs, spears, knives, scepters, pipes, and fly whisks (FIG. 10-5)—extend a leader's reach and magnify his or her gestures. Other objects associated with leaders, such as fans, shields, and umbrellas, protect the leaders both physically and spiritually. Sometimes the regalia and implements of an important person are so heavy that they render the leader virtually immobile (FIG. 11-21), suggesting that the temporary holder of an office is less significant than the eternal office itself.

Although leaders' arts are easy to recognize in centralized, hierarchical societies, such as the Benin (FIGS. I-1, 10-12, and 10-13) and Bamum (FIG. 11-5) kingdoms, leaders among less centralized peoples are just as conversant with the power of art to move people and effect change. For example, African leaders often establish and run masquerades and religious cults in which they may be less visible than the forms they commission and manipulate: shrines, altars, festivals, and rites of passage such as funerals, the last being espe-

10-5 Equestrian figure on fly-whisk hilt, from Igbo Ukwu, Nigeria, 9th to 10th century CE. Copper-alloy bronze, figure $6\frac{3}{16}''$ high. National Museum, Lagos.

The oldest known African lost-wax cast bronze is this fly-whisk hilt, which a leader used to extend his reach and magnify his gestures. The artist exaggerated the size of the ruler compared with his steed.

1 in.

cially elaborate and festive in many parts of Africa. The arts that leaders control thus help create pageantry, mystery, and spectacle, enriching and changing the lives of the people.

---

absence of contemporaneous written documents, scholars can only guess at the use and meaning of a head like this one, but it is noteworthy that animals appear only on those Lydenburg heads large enough to have served as helmet masks. The head, therefore, probably had a ceremonial function.

## Igbo Ukwu

By the 9th or 10th century CE, a West African bronze-casting tradition of great sophistication had developed in the Lower Niger area, just east of that great river. Dozens of refined, varied objects in an extremely intricate style have been unearthed at Igbo Ukwu. The ce-

ramic, copper, bronze, and iron artifacts include basins, bowls, altar stands, staffs, swords, scabbards, knives, and pendants. One grave held numerous prestige objects—copper anklets, armlets, spiral ornaments, a fan handle, and more than 100,000 beads, which may have been used as a form of currency. The tomb also contained three elephant tusks, a crown, and a bronze leopard's skull. These items, doubtless the regalia of a leader (see "Art and Leadership in Africa," above), whether secular or religious, are the earliest cast-metal objects known from regions south of the Sahara.

**EQUESTRIAN FLY WHISK** A lost-wax cast bronze (FIG. 10-5), the earliest yet found in Africa, came from the same grave at Igbo Ukwu. It depicts an equestrian figure on a fly-whisk handle.

## Idealized Naturalism at Ile-Ife

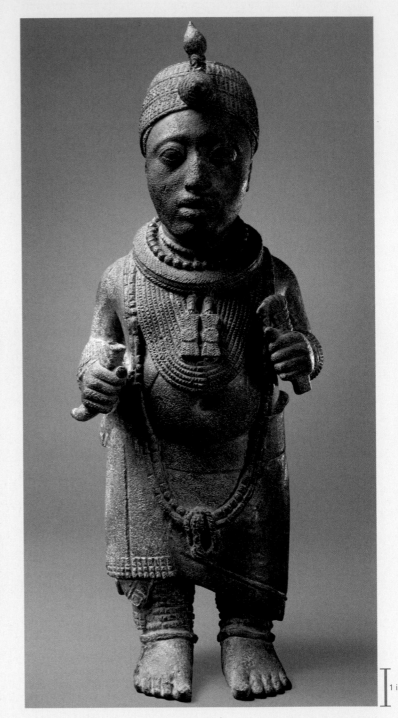

**10-6** King, from Ita Yemoo (Ife), Nigeria, 11th to 12th century. Zinc-brass, 1' 6½" high. Museum of Ife Antiquities, Ife.

Unlike most African sculptures, this royal figure has a naturalistically modeled torso and facial features that approach portraiture. The head, however, the locus of wisdom, is disproportionately large.

1 in.

Just after the turn of the 19th century, the German anthropologist Leo Frobenius "discovered" the sculpture of Ile-Ife in the Lower Niger River region. Because of the refinement and naturalism of Ile-Ife statuary, he could not believe that these works were locally made. Rather, he ascribed authorship to ancient Greece, where similarly lifelike art was well known. Other scholars traced these works to ancient Egypt, along with patterns of sacred kingship that they also believed originated several thousand miles away in the Nile Valley. But excavations in and around Ile-Ife, especially near the king's palace, have established that local sculptors were indeed the artists who made the extraordinary sculptures in stone, terracotta, and copper alloys found at Ile-Ife. Radiocarbon dating places these works as early as the 11th or 12th century. A number of these sculptures served the kings in ceremonies of installation, in funerals, and probably in annual festivals that reaffirmed the sacred power of the ruler and the allegiance of his people.

As is the case with the figure of the king illustrated here (FIG. 10-6), Ife sculptors modeled most heads and figures with focused attention on naturalistic detail, apart from blemishes or signs of age, which they intentionally omitted. Thus Ife style is lifelike but at the same time idealized. The artists portrayed most people as young adults in the prime of life and without any disfiguring warts or wrinkles. Some life-size heads, although still idealized, take naturalism to the point that they give the impression of being individual portraits. This is especially true of a group of 19 heads cast in copper alloys that scholars are quite certain record the features of specific persons, although nearly all their names are lost. Among the most convincing portraits, however, is a mask of almost pure copper that has long carried the name of a famous early king, Obalufon. Now in the Ife museum, the mask resided for centuries in the oni's palace. Several very naturalistic heads have small holes above the forehead and around the lips and jaw, where black beads were found. These suggest that some heads were fitted with beaded veils, such as those known among Yoruba kings today, and perhaps human hair as well. Elaborate beadwork, a Yoruba royal prerogative, is also present on the Ife king's image in FIG. 10-6.

The hundreds of terracotta and copper-alloy heads, body parts and fragments, animals, and ritual vessels from Ile-Ife attest to a remarkable period in African art history, a period during which sensitive, meticulously rendered, idealized naturalism prevailed. To this day, works in this style stand in contrast to the vast majority of African objects, which show the human figure in many different, quite strongly conventionalized styles. Diversity of style in the art of a continent as vast and ancient as Africa, however, should surprise no one.

The African artist made the handle using a casting method similar to that documented much earlier in the Mediterranean and Near East. The sculpture's upper section consists of a figure seated on a horselike animal, perhaps a donkey, and the lower is an elaborately embellished handle with beaded and threadlike patterns. The rider's head is of exaggerated size, a common trait in the art of many early cultures. The prominent facial stripes probably represent marks of titled status, as can still be found among Igbo-speaking peoples today.

# 11TH TO 18TH CENTURIES*

Although kings ruled some African population groups from an early date, the best evidence for royal arts in Africa comes from the several centuries between about 1000 and the beginning of European colonization in the 19th century. This period also brought the construction of major houses of worship for the religions of Christianity and Islam, both of which originated in the Middle East but quickly gained adherents in Africa.

## Ile-Ife

Africans have long considered Ile-Ife, about 200 miles west of Igbo Ukwu in southwestern Nigeria, the cradle of Yoruba civilization, the place where the gods Oduduwa and Obatala created earth and its peoples. Tradition also names Oduduwa the first *oni* (ruler) of Ile-Ife and the ancestor of all Yoruba kings.

**IFE KING** Ife artists often portrayed their sacred kings in sculpture. One of the most impressive examples is a statuette (FIG. **10-6**), cast in a zinc-brass alloy, datable to the 11th or 12th century. This and many similar representations of Ife rulers are exceptional in Africa because of their naturalism in recording facial features and fleshy anatomy (see "Idealized Naturalism at Ile-Ife," page 196). The naturalism does not extend to body proportions, however. The head of the statue, for example, is disproportionately large. For modern Yoruba, the head is the locus of wisdom, destiny, and the essence of being, and these ideas probably developed at least 800 years ago, accounting for the emphasis on the head in Ife statuary. Indicating that the man portrayed was a sacred ruler was also a priority, and the sculptor of the statue illustrated here accurately recorded the precise details of the heavily beaded costume, crown, and jewelry.

## Djenne and Lalibela

The inland floodplain of the Niger River was for the African continent a kind of "fertile crescent," analogous to that of ancient Mesopotamia. By about 800, a walled town, Djenne in present-day Mali, had been built on high ground left dry during the flooding season. Archaeologists have uncovered evidence of many specialist workshops of blacksmiths, sculptors, potters, and other artisans.

**DJENNE TERRACOTTAS** Hundreds of accomplished, confidently modeled terracotta sculptures, most dating to between 1100 and 1500, have been found at numerous sites in the Djenne region. Production tapered off sharply with the arrival of Islam. Unfortunately, as is true of the Nok terracottas, the vast majority of these sculptures came from illegal excavations, and contextual information about them has been destroyed. The subject matter includes equestrians, male and female couples, people with what some scholars interpret as lesions and swellings, and snake-entwined figures. There are seated, reclining, kneeling, and standing human figures. Some wear elaborate jewelry, but many are without adornment. The range of subjects and postures is extraordinary at this date.

The terracotta figure illustrated here (FIG. **10-7**) dates to the 13th to 15th centuries and represents a Djenne warrior with a quiver of arrows on his back and knives strapped to his left arm. The proportions of the figure present a striking contrast to those from Ile-Ife (FIG. **10-6**). The Djenne archer is thin and tall with tubular limbs and an elongated head with a prominent chin, bulging eyes, and large nose—characteristic features of Djenne style.

*From this point on, all dates in this chapter are CE unless otherwise stated.

1 in.

**10-7** Archer, from Djenne, Mali, 13th to 15th century. Terracotta, 2' 3/8" high. National Museum of African Art, Washington, D.C.

Djenne terracottas present a striking contrast to the statues from Ile-Ife (FIG. **10-6**). This archer is thin with tubular limbs and an elongated head featuring a prominent chin, bulging eyes, and large nose.

**10-8** Aerial view (looking northwest) of the Great Mosque, Djenne, Mali, begun 13th century, rebuilt 1906–1907.

The Great Mosque at Djenne resembles Middle Eastern mosques in plan (large courtyard next to a roofed prayer hall), but the construction materials—adobe and wood—are distinctly African.

**GREAT MOSQUE, DJENNE** Djenne is also the site of one of the most ambitious examples of adobe architecture in the world, the city's Great Mosque (FIG. **10-8**), first built in the 13th century and reconstructed in 1906–1907 after a fire destroyed the earlier building in 1830. The mosque has a large courtyard and a roofed prayer hall, emulating the plan of many of the oldest mosques known (see "The Mosque," Chapter 7, page 125). The facade (FIG. **10-1**), however, is unlike any in the Middle East and features soaring adobe towers and vertical buttresses resembling engaged columns that produce a majestic rhythm. The many rows of protruding wooden beams further enliven the walls but also serve a practical function as perches for workers undertaking the essential recoating of sacred clay on the exterior that occurs during an annual festival.

**BETA GIORGHIS, LALIBELA** Many of the early African cultures maintained trade networks that sometimes extended well beyond the continent. The exchange of goods also brought an exchange of artistic ideas and forms. One of the most striking examples is found at Lalibela in the rugged highlands of present-day Ethiopia, where land travel is difficult. Christianity arrived in Ethiopia in the early fourth century, when the region was part of the indigenous Aksum Empire. In the early 13th century, Lalibela, a ruler of the Zagwe dynasty, commissioned 11 churches to be cut from the bedrock at his capital, which still bears his name.

Not the largest but in many ways the most interesting of these rock-cut churches is Beta Giorghis (FIG. **10-9**), the Church of Saint George, which was cut out of the tufa in the form of a Greek cross, revealing that the architect was familiar with contemporary Byzantine architecture. The roof of the structure has a Greek cross sculpted in relief, underscoring the sacred shape of the church. Inside are a carved dome and frescoes. Rock-cut buildings are rare worldwide, but they are documented in Egypt, India, and Jordan (see Chapter 1). Some of the most complex designs are at Lalibela. Carving from the bedrock a complex building such as Beta Giorghis, with all its details, required careful planning and highly skilled labor.

The bedrock tufa is soft and easily worked, but the designer had to visualize all aspects of the complete structure before the work began because there was no possibility of revision or correction.

**10-9** Beta Giorghis (Church of Saint George), Lalibela, Ethiopia, 13th century.

During the 13th century, the Christian kingdom of Lalibela cut many churches out of the Ethiopian bedrock. This one emulates Byzantine models and has a Greek-cross plan and interior frescoes.

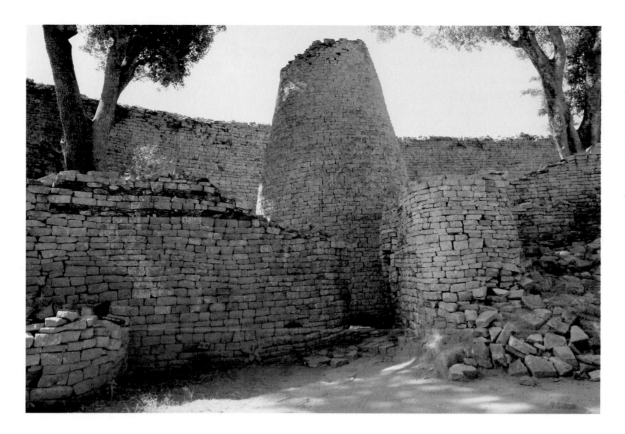

## Great Zimbabwe

Many of the earliest artworks found in Africa come from the southern part of the continent. The most famous southern African site is a complex of stone ruins at the large southeastern political center called Great Zimbabwe. First occupied in the 11th century, the site features walled enclosures and towers that date from about the late 13th century to the middle of the 15th century. At that time, the Great Zimbabwe empire had a wide trade network. Finds of beads and pottery from the Near East and China, along with copper and gold objects, underscore that Great Zimbabwe was a prosperous trade center well before Europeans began their coastal voyaging in the late 15th century.

**GREAT ENCLOSURE** Most scholars agree that Great Zimbabwe was a royal residence with special areas for the ruler (the royal hill complex), his wives, and nobles, including an open court for ceremonial gatherings. At the zenith of the empire's power, as many as 18,000 people may have lived in the surrounding area, with most of the commoners living outside the enclosed structures reserved for royalty. Although the actual habitations do not survive, the remaining enclosures are unusual for their size and the excellence of their stonework. Some perimeter walls reach heights of 30 feet. One of these, known as the Great Enclosure (FIG. **10-10**), houses one large and several small conical towerlike stone structures, which have been interpreted symbolically as masculine (large) and feminine (small) forms, but their precise significance is unknown. The form of the large tower suggests a granary. Grain bins were symbols of royal power and generosity, as the ruler received tribute in grain and dispensed it to the people in times of need.

**SOAPSTONE MONOLITHS** Explorations at Great Zimbabwe have yielded eight soapstone *monoliths* (sculptures carved from a single block of stone). Seven came from the royal hill complex and probably were set up as part of shrines to ancestors. The eighth monolith (FIG. **10-11**), found in an area now considered the ancestral

1 in.

shrine of the ruler's first wife, stands several feet tall. Some have interpreted the bird at the top as symbolizing the first wife's ancestors. (Ancestral spirits among the present-day Shona-speaking peoples of the area take the form of birds, especially eagles, believed to communicate between the sky and the earth.) The crocodile on the front of the monolith may represent the wife's elder male ancestors. The circles beneath the bird are called the "eyes of the crocodile" in Shona and may symbolically represent elder female ancestors. The double- and single-chevron motifs may represent young male and young female ancestors, respectively. The bird perhaps signifies some form of bird of prey, such as an eagle, although this and other bird sculptures from the site have feet with five humanlike toes rather than an eagle's three-toed talons. In fact, experts cannot identify the species of the birds. Some researchers have speculated that the bird and crocodile symbolize previous rulers who would have acted as messengers between the living and the dead, as well as between the sky and the earth.

## Benin

The Benin kingdom (not to be confused with the modern Republic of Benin; see MAP 10-1) was established before 1400, most likely in the 13th century, just west of the lower reaches of the Niger River in what is today Nigeria. According to oral tradition, the first king of the new dynasty was the grandson of a Yoruba king of Ile-Ife. Benin reached its greatest power and geographical extent in the 16th century. The kingdom's vicissitudes and slow decline thereafter culminated in 1897, when the British burned and sacked the Benin palace and city. Benin City thrives today, however, and the palace, where the Benin king continues to live, has been partially rebuilt. Benin artists have produced many complex, finely cast copper-alloy sculptures, as well as artworks in ivory, wood, ceramic, and wrought iron. The hereditary *oba*, or sacred king, and his court still use and dispense art objects as royal favors to title holders and other chiefs (see "Art and Leadership," page 195).

**QUEEN MOTHER IVORY** One of the masterworks of Benin ivory carving is a woman's head (FIG. 10-12) in the Metropolitan Museum of Art, which a Benin king almost certainly wore at his waist. A nearly identical pendant, fashioned from the same piece of ivory, is in the British Museum. Oba Esigie (r. ca. 1504–1550), under whom, with the help of the Portuguese, the Benin kingdom flourished and expanded, probably commissioned the pair. Esigie's mother, Idia, helped him in warfare, and in return he created for her the title of Queen Mother, Iy'oba, and built her a separate palace and court. The pendant, remarkable for its sensitive naturalism, most likely represents Idia. On its crown are alternating Portuguese heads and mudfish, symbolic allusions, respectively, to Benin's trade and diplomatic relationships with the Portuguese and to Olokun, god of the sea, wealth, and creativity. Another series of Portuguese heads also adorns the lower part of the carving. In the late 15th and 16th centuries, Benin people probably associated the Portuguese, with their large ships from across the sea, their powerful weapons, and their wealth in metals, cloth, and other goods, with Olokun, the deity they deemed responsible for abundance and prosperity.

**ALTAR TO THE HAND AND ARM** The centrality of the sacred oba in Benin culture is well demonstrated by his depiction twice on a cast-brass royal shrine called an *ikegobo* (FIG. 10-13). It features symmetrical hierarchical compositions centered on the dominant king, probably Oba Eresonyen (r. 1735–1750). At the

**10-12** Waist pendant of a Queen Mother, from Benin, Nigeria, ca. 1520. Ivory and iron, $9\frac{3}{8}''$ high. Metropolitan Museum of Art, New York (Michael C. Rockefeller Memorial Collection, gift of Nelson A. Rockefeller, 1972).

This ivory head probably portrays Idia, mother of Oba Esigie, who wore it on his waist. Above Idia's head are Portuguese heads and mudfish, symbols, respectively, of trade and of Olokun, god of the sea.

top, flanking and supporting the king, are smaller, lesser members of the court, usually identified as priests, and in front, a pair of leopards, animals the sacred king sacrificed and symbolic of his power over all creatures. Similar compositions are common in Benin arts, as exemplified by the royal plaque (FIG. I-1) discussed in the Introduction. Notably, too, the artist distorted the king's proportions to emphasize his head, the seat of his will and power. Benin men celebrate a festival of the head called Igue. One of the king's praise

1 in.

**10-13** Altar to the Hand and Arm (*ikegobo*), from Benin, Nigeria, 17th to 18th century. Bronze, 1′ 5½″ high. British Museum, London.

One of the Benin king's praise names is "great head," and on this cast-bronze royal shrine, he is represented larger than all other figures and his proportions are distorted to emphasize his head.

names is "great head." At such personal altars, the king and other high-ranking officials made sacrifices to their own power and accomplishments—symbolized by the hand and arm. The inclusion of leopards on the top and around the base, along with ram and elephant heads and crocodiles (not all visible in FIG. 10-13), reiterates royal power.

## Sapi

Between 1490 and 1540, some peoples on the Atlantic coast of Africa in present-day Sierra Leone, whom the Portuguese collectively called the Sapi, created art not only for themselves but also for Portuguese explorers and traders, who took the objects back to Europe.

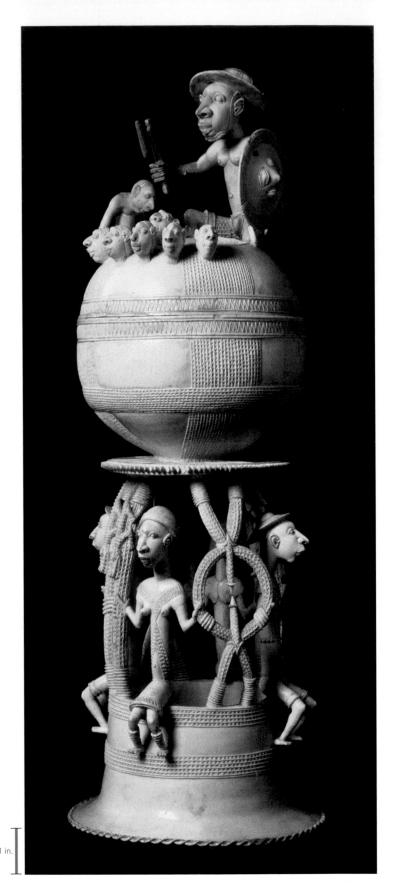

1 in.

**SAPI SALTCELLARS** The Portuguese commissions included delicate spoons, forks, and elaborate containers usually referred to as saltcellars, as well as boxes, hunting horns, and knife handles. Salt was a valuable commodity, used not only as a flavoring but also to keep food from spoiling. Costly saltcellars were prestige items that graced the tables of the European elite. The Sapi export items were all meticulously carved from elephant tusk ivory with refined detail and careful finish. Ivory was plentiful in those early days and was one of the coveted exports in early West and Central African trade with Europe. The Sapi export ivories, the earliest examples of African tourist art, are a fascinating hybrid art form.

Art historians have attributed the saltcellar shown here (FIG. **10-14**), almost 17 inches high, to the MASTER OF THE SYMBOLIC EXECUTION, one of the three major Sapi ivory carvers during the period. This saltcellar, which depicts an execution scene, is one of his best pieces and the source of his modern name. A kneeling figure with a shield in one hand holds an ax (restored) in the other hand over another seated figure about to lose his head. On the ground before the executioner, six severed heads (FIG. **10-14**) grimly testify to the executioner's power. A double zigzag line separates the lid of the globular container from the rest of the vessel. This vessel rests in turn on a circular platform held up by slender rods adorned with crocodile images. Two male and two female figures sit between these rods, grasping them. The men wear European-style pants and have long, straight hair. The women wear skirts, and the elaborate raised patterns on their upper chests surely represent decorative scars.

The European components of this saltcellar are the overall design of a spherical container on a pedestal and some of the geometric patterning on the base and the sphere, as well as certain elements of dress, such as the shirts and hats. Distinctly African are the style of the human heads and figures and their proportions, the latter skewed here to emphasize the head, as so often seen in African art. Identical large noses with flaring nostrils, as well as the conventions for rendering eyes and lips, characterize Sapi stone figures from the same region and period. Scholars cannot be sure whether the African carver or the European patron specified the subject matter and the configurations of various parts, but the Sapi works testify to a fruitful artistic interaction between Africans and Europeans during the early 16th century.

The impact of European art became much more pronounced in the late 19th and especially the 20th centuries. These developments and the continuing vitality of the native arts in Africa are examined in Chapter 11.

**10-14** MASTER OF THE SYMBOLIC EXECUTION, saltcellar, Sapi-Portuguese, from Sierra Leone, ca. 1490–1540. Ivory, $1' 4\frac{7}{8}''$ high. Museo Nazionale Preistorico e Etnografico Luigi Pigorini, Rome.

The Sapi saltcellars made for export combine African and Portuguese traits. This one represents an execution scene with an African-featured man, who wears European pants, seated among severed heads.

# AFRICA BEFORE 1800

## PREHISTORY AND EARLY CULTURES, ca. 25,000 BCE–1000 CE

▌ Humankind apparently originated in Africa, and some of the oldest known artworks come from the Apollo 11 Cave in southwestern Africa. Most African rock art, however, is no earlier than about 6000 BCE.

▌ The Nok culture of central Nigeria produced the oldest African examples of sculpture in the round between 500 BCE and 200 CE. The pierced eyes, noses, and mouths helped equalize the heat during the firing process.

▌ Bronze-casting using the lost-wax method is first documented in Africa in the 9th or 10th century CE at Igbo Ukwu (Nigeria).

Running woman, Tassili n'Ajjer, ca. 6000–4000 BCE

Nok terracotta head, ca. 500 BCE–200 CE

## 11TH TO 15TH CENTURIES

▌ The sculptors of Ile-Ife (Nigeria) fashioned images of their kings in an unusually naturalistic style during the 11th and 12th centuries, but the heads of the figures are disproportionately large, as in most African artworks.

▌ The terracotta sculptures of Djenne (Mali), datable ca. 1100–1500, encompass an extraordinary variety of subjects and display a distinctive style with tubular limbs and elongated heads.

▌ This period brought the construction of major shrines for Islamic and Christian worship that emulate foreign models but employ African building methods. Examples include the adobe Great Mosque at Djenne and the rock-cut church of Beta Giorghis at Lalibela (Ethiopia).

▌ In southern Africa, the Great Zimbabwe empire conducted prosperous trade with the Near East and China well before the first contact with Europeans. Impressive stone walls and towers enclosed the royal palace complex.

Ife king, 11th to 12th century

Great Mosque, Djenne, 13th century

## 16TH TO 18TH CENTURIES

▌ The Benin kingdom in the Lower Niger region was probably founded in the 13th century but reached its zenith in the 16th century. Benin sculptors excelled in ivory carving and bronze-casting, producing artworks that glorified the royal family.

▌ An early example of the interaction between African artists and European patrons is the series of Sapi ivory saltcellars from Sierra Leone datable between 1490 and 1540.

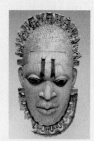

Benin ivory waist pendant, ca. 1520

1 ft.

**11-1** Ancestral screen (nduen fobara), Kalabari Ijaw, Nigeria, late 19th century. Wood, fiber, and cloth, 3′ 9½″ high. British Museum, London.

The hierarchical composition and the stylized human anatomy and facial features in this Kalabari ancestral screen are common in African art, but the shrine's complexity is exceptional.

# AFRICA AFTER 1800

Africa (MAP 11-1) was one of the first art-producing regions of the world (see Chapter 10), but its early history remains largely undocumented. In fact, a mere generation ago, scholars still often presented African art as if it had no history. For the period treated in this chapter, however, art historians are on firmer ground. Information gleaned from archaeology and field research in Africa (mainly interviews with local people) provides much more detail on the use, function, and meaning of art objects produced during the past two centuries than for the period before 1800. As in earlier eras, the arts in Africa exist in greatly varied human situations, and knowledge of these contexts is essential for understanding the artworks. In Africa, art is nearly always an active agent in the lives of its diverse peoples. This chapter presents a sample of characteristic works from different regions of the continent from the early 19th century to the present.

## 19TH CENTURY

Rock paintings are among the most ancient arts of Africa (FIG. 10-2). Yet the tradition also continued well into the historical period. The latest examples date as recently as the 19th century, and some of these depict events involving Europeans. Many examples have been found in South Africa.

### San

Scholars use the generic name San to describe the peoples who occupied the southeastern coast of South Africa at the time of the earliest European colonization. The San were hunters and gatherers, and their art often centered on the animals they pursued.

**BAMBOO MOUNTAIN** One of the most impressive preserved San rock paintings (FIG. 11-2), originally about eight feet long but now regrettably in fragments, comes from near the source of the Mzimkhulu River at Bamboo Mountain and dates to the mid-19th century. At that time, the increasing development of colonial ranches and the settlements of African agriculturists had greatly affected the lifestyle

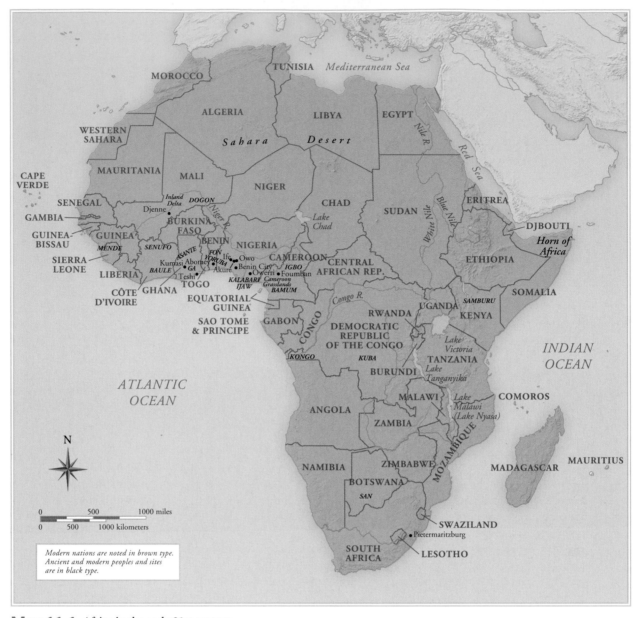

MAP 11-1 Africa in the early 21st century.

and movement patterns of San hunters and gatherers, often displacing them from their ancestral lands. In some regions, they began to raid local ranches for livestock and horses as an alternate food source. The Bamboo Mountain rock painting was probably made after a series of stock raids over a period from about 1838 to 1848. Various South African military and police forces unsuccessfully pursued the San raiders. Poor weather, including frequent rains and fog, added to the difficulty of capturing a people who had lived in the region for many generations and knew its terrain intimately.

On the right side of the composition (not illustrated), two San riders on horses laden with meat drive a large herd of cattle and horses toward a San encampment located left of center and encircled by an outline (FIG. 11-2, *bottom*). Within the camp are various women and children. To the far left (FIG. 11-2, *top*), a single figure (perhaps a diviner or rainmaker) leads an eland, an animal the San considered effective in rainmaking and ancestor rituals, toward the encampment. The similarity of this scene to other rock paintings with spiritual interpretations (a human leading an animal) suggests that this motif

may represent a ritual leader in a trance state. The leader calls on rain—brought by the intervention of the sacred eland—to foil the attempts of the government soldiers and police to locate and punish the San raiders. The close correspondence between the painting's imagery and the events of 1838–1848 adds to the likelihood that the San created this work to record government action as well as to facilitate rainmaking.

## Fang and Kota

Although African works of art are often difficult to date precisely, art historians have been able to assign to the 19th century with some confidence a number of objects that lack historical references. These include the *reliquary* guardian figures made by the Fang and several other migratory peoples living just south of the equator in Gabon and Cameroon. Throughout the continent, Africans venerate ancestors for the continuing aid they believe they provide the living, including help in maintaining the productivity of the earth for bountiful crop pro-

**11-2** Stock raid with cattle, horses, encampment, and magical "rain animal," rock painting (two details), San, Bamboo Mountain, South Africa, mid-19th century. Pigments on rock, full painting 8′ long. Natal Museum, Pietermaritzburg.

Rock paintings are among the most ancient arts in Africa, and the tradition continued into the 19th century. This example depicts events of 1838–1848 and San rainmaking rituals in South Africa.

1 in.

**11-3** Reliquary guardian figure (bieri), Fang, Gabon, late 19th century. Wood, 1′ 8$\frac{3}{8}$″ high. Philadelphia Museum of Art, Philadelphia.

Fang bieri guard cylindrical bark boxes of ancestor bones (reliquaries). The figures have the bodies of infants and the muscularity of adults, a combination of traits suggesting the cycle of life.

duction. The reliquary figures play an important role in ancestor worship. Among both the Fang and the peoples scholars usually refer to as Kota in neighboring areas, ancestor veneration takes material form as collections of cranial and other bones (*relics*) gathered in special containers. These portable reliquaries were ideal for African nomadic population groups such as the Fang and the Kota.

**FANG BIERI** Stylized wooden human figures (FIG. 11-3), or in some cases, simply heads protected the Fang relic containers. The sculptors of these Fang guardian figures, or *bieri*, designed them to sit on the edge of cylindrical bark boxes of ancestral bones, ensuring that no harm would befall the ancestral spirits. The wood figures are symmetrical, with proportions that greatly emphasize the head, and they feature a rhythmic buildup of forms that suggests contained

power. Particularly striking are the proportions of the bodies of the bieri, which resemble those of an infant, although the muscularity of the figures implies an adult. Scholars believe the sculptor chose this combination of traits to suggest the cycle of life, appropriate for an art form connected with the cult of ancestors.

**11-4** Reliquary guardian figure (mbulu ngulu), Kota, Gabon, 19th or early 20th century. Wood, copper, iron, and brass, 1' 9 1/16" high. Musée Barbier-Mueller, Geneva.

Kota guardian figures have bodies in the form of an open lozenge and large heads. Polished copper and brass sheets cover the wood forms. The Kota believe that gleaming surfaces repel evil.

1 in.

1 ft.

**11-5** Throne and footstool of King Nsangu, Bamum, Cameroon, ca. 1870. Wood, textile, glass beads, and cowrie shells, 5' 9" high. Museum für Völkerkunde, Staatliche Museen zu Berlin, Berlin.

King Nsangu's throne features luminous beads and shells and richly colored textiles. The decoration includes intertwining serpents, male and female retainers, and bodyguards with European rifles.

**KOTA MBULU NGULU** The Kota of Gabon also have reliquary guardian figures, called *mbulu ngulu* (FIG. **11-4**). These figures have severely stylized bodies in the form of an open diamond below a wooden head covered with strips and sheets of polished copper and brass. The Kota believe the gleaming surfaces repel evil. The simplified heads have hairstyles flattened out laterally above and beside the face. Geometric ridges, borders, and subdivisions add a textured elegance to the shiny forms. The copper alloy on most of these images is reworked sheet brass (or copper wire) taken from brass basins originating in Europe and traded into this area of equatorial Africa in the 18th and 19th centuries. The Kota insert the lower portion of the image into a basket or box of ancestral relics.

## Kalabari Ijaw

The Kalabari Ijaw peoples have hunted and fished in the eastern delta of the Niger River in present-day Nigeria for several centuries. A cornerstone of this economy, however, has long been trade, and trading organizations known locally as canoe houses play a central role in Kalabari society

**ANCESTRAL SCREENS** As in so many other African cultures, Kalabari artists and patrons have lavished attention on shrines in honor of ancestors. The Kalabari shrines take a unique form and feature elaborate screens of wood, fiber, textiles, and other materials.

An especially elaborate example (FIG. **11-1**) is the almost four-foot-tall *nduen fobara* honoring a deceased chief of a trading corporation. Displayed in the house in which the chief lived, the screen represents the chief himself at the center holding a long silver-tipped staff in his right hand and a curved knife in his left hand. His chest is bare, and drapery covers the lower part of his body. His impressive headdress is in the form of a 19th-century European sailing ship, a reference to the chief's successful trading business. Flanking him are his attendants, smaller in size as appropriate for their lower rank. The heads of his slaves are at the top of the screen and those of his conquered rivals are at the bottom. The hierarchical composition and the stylized rendition of human anatomy and facial features are common in African art, but the richness and complexity of this shrine are exceptional.

## Bamum

In addition to celebrating ancestors, much African art glorifies living rulers (see "Art and Leadership in Africa," Chapter 10, page 195). In the kingdom of Bamum in present-day Cameroon, the ruler lived in a palace compound at the capital city of Foumban until its destruction in 1910. Some items of the royal regalia survive.

**THRONE OF NSANGU** The royal arts of Bamum make extensive use of richly colored textiles and luminous materials, such as glass beads and cowrie shells. The ultimate status symbol was the

**11-6** AKATI AKPELE KENDO, Warrior figure (Gu?), from the palace of King Glele, Abomey, Fon, Republic of Benin, 1858–1859. Iron, 5′ 5″ high. Musée du quai Branly, Paris.

This bocio, or empowerment figure, probably representing the war god Gu, was the centerpiece of a circle of iron swords. The Fon believed it protected their king, and they set it up on the battlefield.

1 ft.

**11-7** Yombe mother and child (pfemba), Kongo, Democratic Republic of Congo, late 19th century. Wood, glass, glass beads, brass tacks, and pigment, $10\frac{1}{8}$″ high. National Museum of African Art, Washington, D.C.

The mother in this Yombe group wears a royal cap and jewelry and displays her chest scarification. The image may commemorate an ancestor or, more likely, a legendary founding clan mother.

1 in.

king's throne. The throne (FIG. **11-5**) that belonged to King Nsangu (r. 1865–1872 and 1885–1887) is a masterpiece of Bamum art. Intertwining blue and black serpents decorate the cylindrical seat. Above are the figures of two of the king's retainers, perpetually at his service. One, a man, holds the royal drinking horn. The other is a woman carrying a serving bowl in her hands. Below are two of the king's bodyguards wielding European rifles. Decorating the rectangular footstool are dancing figures. When the king sat on this throne, his rich garments complemented the bright colors of his seat, advertising his wealth and power to all who were admitted to his palace.

## Fon

The foundation of the Fon kingdom in the present-day Republic of Benin dates to around 1600. Under King Guezo (r. 1818–1858), the Fon became a regional power with an economy based on the trade in palm oil. In 1900 the French dismantled the kingdom and brought many artworks to Paris, where they inspired several prominent early-20th-century Western artists.

**KING GLELE** After his first military victory, Guezo's son Glele (r. 1858–1889) commissioned a prisoner of war, AKATI AKPELE KENDO, to make a life-size iron statue (FIG. **11-6**) of a warrior, probably the war god Gu, for a battle shrine in Glele's palace at Abomey. This *bocio*, or empowerment figure, was the centerpiece of a circle of iron

swords and other weapons set vertically into the ground. The warrior strides forward with swords in both hands, ready to do battle. He wears a crown of miniature weapons and tools on his head. The form of the crown echoes the circle of swords around the statue. The Fon believed that the bocio protected their king, and they transported it to the battlefield whenever they set out to fight an enemy force. King Glele's iron warrior is remarkable for its size and for the fact that not only is the patron's name known but so too is the artist's name—a rare instance in Africa before the 20th century (see "African Artists," page 213).

## Kongo

The Congo River formed the principal transportation route for the peoples of Central Africa during the 19th century, fostering cultural exchanges as well as trade, both among Africans and with Europeans.

**YOMBE PFEMBA** Some scholars have suggested that the mother-and-child groups (*pfemba*) of the Yombe in the Democratic Republic of Congo may reflect the influence of Christian Madonna-and-Child imagery. The Yombe pfemba are not deities, however, but images of Kongo royalty. One 19th-century example (FIG. **11-7**) represents a woman with a royal cap, chest scarification, and jewelry. The image may commemorate an ancestor or, more likely, a legendary founding clan mother. The Kongo call some of these figures "white chalk," a reference to the medicinal power of white kaolin clay. Diviners own some

**11-8** Nail figure (nkisi n'kondi), Kongo, from Shiloango River area, Democratic Republic of Congo, ca. 1875–1900. Wood, nails, blades, medicinal materials, and cowrie shell, 3′ 10¾″ high. Detroit Institute of Arts, Detroit.

Only priests using ritual formulas could consecrate Kongo power figures, which embody spirits that can heal or inflict harm. The statue has simplified anatomical forms and a very large head.

of them, and others have been used by women's organizations to treat infertility, but the function of this 19th-century pfemba is uncertain.

**NKISI N'KONDI** The large standing statue (FIG. 11-8) of a man bristling with nails and blades is a Kongo power figure (*nkisi n'kondi*) that a trained priest consecrated using precise ritual formulas. These images embodied spirits believed to heal and give life or sometimes inflict harm, disease, or even death. Each figure had its specific role, just as it wore particular medicines—here protruding from the abdomen and featuring a large cowrie shell. The Kongo also activated every image differently. Owners appealed to a figure's forces every

time they inserted a nail or blade, as if to prod the spirit to do its work. People invoked other spirits by repeating certain chants, by rubbing them, or by applying special powders. The roles of power figures varied enormously, from curing minor ailments to stimulating crop growth, from punishing thieves to weakening an enemy. Very large Kongo figures, such as this one, had exceptional ascribed powers and aided entire communities. Although benevolent for their owners, the figures stood at the boundary between life and death, and most villagers held them in awe. As is true of the pfemba group (FIG. 11-7), compared with the sculptures of other African peoples, this Kongo figure is relatively naturalistic, although the carver simplified the facial features and magnified the size of the head for emphasis.

## Dogon

The Dogon live in the inland delta region of the great Niger River in what is today Mali. Numbering almost 300,000, spread among hundreds of small villages, the Dogon practice farming as their principal occupation.

**LINKED MAN AND WOMAN** One of the most common themes in Dogon art is the human couple. A characteristic Dogon linked-man-and-woman group (FIG. 11-9) of the early 19th century is probably a shrine or altar, although contextual information is lacking. Interpretations vary, but the image vividly documents primary gender roles in traditional African society. The man wears a quiver on his back, and the woman carries a child on hers. Thus, the man assumes a protective role as hunter or warrior, the woman a nurturing role. The slightly larger man reaches behind his mate's neck and touches her breast, as if to protect her. His left hand points to his genitalia. Four stylized figures support the stool upon which they sit. They are probably either spirits or ancestors, but the identity of the larger figures is uncertain.

The strong stylization of Dogon sculptures contrasts sharply with the organic, relatively realistic treatment of the human body in Kongo art (FIG. 11-7). The artist who carved the Dogon couple (FIG. 11-9) based the forms more on the idea or concept of the human body than on observation of individual heads, torsos, and limbs. The linked body parts are tubes and columns articulated inorganically. The carver reinforced the almost abstract geometry of the overall composition by incising rectilinear and diagonal patterns on the surfaces. The Dogon artist also understood the importance of space, and charged the voids, as well as the sculptural forms, with rhythm and tension.

## Baule

The Baule of present-day Côte d'Ivoire do not have kings, and their societies are more egalitarian than many others in Africa, but Baule art encompasses some of the same basic themes seen elsewhere on the continent.

**BUSH SPIRITS** The wooden Baule statues (FIG. 11-10) of a man and woman probably portray bush spirits (*asye usu*). The sculptor most likely carved them for a trance diviner, a religious specialist who consulted the spirits symbolized by the figures on behalf of clients either sick or in some way troubled. In Baule thought, bush spirits are short, horrible-looking, and sometimes deformed creatures, yet Baule sculptors represent them in the form of beautiful, ideal human beings, because ugly figures would offend the spirits and would refuse to work for the diviner. Among the Baule, as among many West African peoples, bush or wilderness spirits both cause difficulties in life and, if properly addressed and placated, may solve problems or cure sickness. In dance and trance performances—with wooden figures and other objects displayed nearby—the diviner can

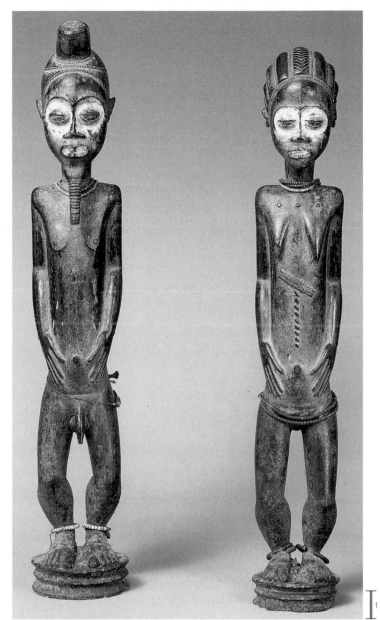

**11-9** Seated couple, Dogon, Mali, ca. 1800–1850. Wood, 2′ 4″ high. Metropolitan Museum of Art, New York (gift of Lester Wunderman).

This Dogon carving of a linked man and woman documents gender roles in traditional African society. The protective man wears a quiver on his back. The nurturing woman carries a child on hers.

**11-10** Male and female figures, probably bush spirits (asye usu), Baule, Côte d'Ivoire, late 19th or early 20th century. Wood, beads, and kaolin, man 1′ 9¾″ high, woman 1′ 8⅝″ high. Metropolitan Museum of Art, New York (Michael C. Rockefeller Memorial Collection, gift of Nelson A. Rockefeller).

In contrast to the Dogon couple (FIG. 11-9), this pair includes many naturalistic aspects of human anatomy, but the sculptor enlarged the necks, calves, and heads, a form of idealization in Baule culture.

divine, or understand, the will of unseen spirits as well as their needs or prophecies, which the diviner passes on to clients. When not set up outdoors for a performance, the figures and other objects remain in the diviner's house or shrine, where more private consultations take place. In striking contrast to the Dogon sculptor of the seated man and woman (FIG. 11-9), the artist who created this matched pair of Baule male and female images recorded many naturalistic aspects of human anatomy, skillfully translating them into finished sculptural form. At the same time, the sculptor was well aware of creating *waka sran* (people of wood) rather than living beings. Thus, the artist freely exaggerated the length of the figures' necks and the size of their heads and calf muscles, all of which are forms of idealization in Baule culture.

# 20TH CENTURY

The art of Africa during the past 100 years ranges from traditional works depicting age-old African themes to modern works that are international in both content and style. Both men and women have long been active in African art production, usually specializing in different types of objects (see "Gender Roles in African Art Production," page 212).

## Benin

Some of the most important 20th-century African artworks come from areas with strong earlier artistic traditions. The kingdom of Benin (see Chapter 10) in present-day Nigeria is a prime example.

## Gender Roles in African Art Production

Until the past decade or two, art production in Africa has been quite rigidly gender-specific. Men have been, and largely still are, iron smiths and gold and copper-alloy casters. Men were architects, builders, and carvers of both wood and ivory. Women were, and for the most part remain, wall and body painters, calabash decorators, potters, and often clay sculptors, although men make clay figures in some areas. Both men and women work with beads and weave baskets and textiles, with men executing narrow strips (later sewn together) on horizontal looms and women working wider pieces of cloth on vertical looms.

Much African art, however, is collaborative. Men may build a clay wall, for example, but women will normally decorate it. The Igbo people build *mbari* houses (FIG. 11-23)—for ceremonies to honor the earth goddess—that are truly collaborative despite the fact that professional male artists model the figures displayed in the houses. Festivals, invoking virtually all the arts, are also collaborative. Masquerades (see "African Masquerades," page 215) are largely the province of men, yet in some cases women are asked to contribute costume elements such as skirts, wrappers, and scarves. And even though women dance masks among the Mende and related peoples (see "Mende Women," page 217), men have always carved the masks themselves.

In late colonial and especially in postcolonial times, earlier gender distinctions in art production began breaking down. Women, as well as men, now weave kente cloth, and a number of women are now sculptors in wood, metal, stone, and composite materials. Men are making pottery, once the exclusive prerogative of women. Both women and men make international art forms in urban and university settings, although male artists are more numerous. One well-known Nigerian woman artist, Sokari Douglas Camp (b. 1958), produces welded metal sculptures, sometimes of masqueraders. Douglas Camp is thus doubly unusual. She might find it difficult to do this work in her traditional home in the Niger River delta, but as she lives and works in London, she encounters no adverse response. In the future there will undoubtedly be a further breaking down of restrictive barriers and greater mobility for artists.

**SHRINE OF EWEKA II** In 1897, when the British sacked Benin City, there were still 17 shrines to ancestors in the Benin royal palace. Today only one 20th-century altar (FIG. 11-11) remains. According to oral history, it is similar to centuries-earlier versions. With a base of sacred riverbank clay, it is an assemblage of varied materials, objects, and symbols: a central copper-alloy altarpiece depicting a sacred king flanked by members of his entourage, plus copper-alloy heads, each fitted on top with an ivory tusk carved in relief. Behind are wood staffs and metal bells. The heads represent both the kings themselves and, through the durability of their material, the enduring nature of kingship. Their glistening surfaces, seen as red and signaling danger, repel evil forces that might adversely affect the shrine and thus the king and kingdom. Elephant-tusk relief carvings atop the heads commemorate important events and personages in Benin history. Their bleached white color signifies purity and goodness (probably of royal ancestors), and the tusks themselves represent male physical power. The carved wood rattle-staffs standing at the back refer to generations of dynastic ancestors by their bamboolike, segmented forms. The rattle-staffs and the pyramidal copper-alloy bells serve the important function of calling royal ancestral spirits to rituals performed at the altar.

The Benin king's head stands for wisdom, good judgment, and divine guidance for the kingdom. The several heads in the ancestral altar multiply these qualities. By means of animal sacrifices at this site, the living king annually purifies his own head (and being) by invoking the collective strength of his ancestors. Thus, the varied

**11-11** Royal ancestral altar of Benin King Eweka II, in the palace in Benin City, Nigeria, photographed in 1970. Clay, copper alloy, wood, and ivory.

This shrine to the heads of royal ancestors is an assemblage of varied materials, objects, and symbols. By sacrificing animals at this site, the Benin king annually invokes the collective strength of his ancestors.

## African Artists and Apprentices

Traditionally, Africans have tended not to exalt artistic individuality as much as Westerners have. Many people, in fact, consider African art as anonymous, but that is primarily because early researchers rarely asked for artists' names. Nonetheless, art historians can recognize many individual hands or styles even when an artist's name has not been recorded. During the past century, art historians and anthropologists have been systematically noting the names and life histories of specific individual artists, many of whom have strong regional reputations. One of the earliest recorded names is that of the mid-19th-century Fon sculptor and metalsmith Akati Akpele Kendo (FIG. 11-6). Two 20th-century artists, renowned even from one kingdom to another, were Osei Bonsu (FIGS. 11-12 and 11-13), based in the Asante capital of Kumasi, and the Yoruba sculptor called Olowe of Ise (FIG. 11-14) because he came from the town of Ise. Both artists were master carvers, producing sculptures for kings and commoners alike.

Like other great artists in other places and times, both Bonsu and Olowe had apprentices to assist them for several years while learning their trade. Although there are various kinds of apprenticeship in Africa, novices typically lived with their masters and were household servants as well as assistant carvers. They helped fell trees, carry logs, and rough out basic shapes that the master later transformed into finished work. African sculptors typically worked on commission. Sometimes, as in Bonsu's case, patrons traveled to the home of the artist. But other times, even Bonsu moved to the home of a patron for weeks or months while working on a commission. Masters, and in some instances also apprentices, lived and ate in the patron's compound. Olowe, for example, resided with different kings for many months at a time while he carved doors, veranda posts (FIG. 11-14), and other works for royal families.

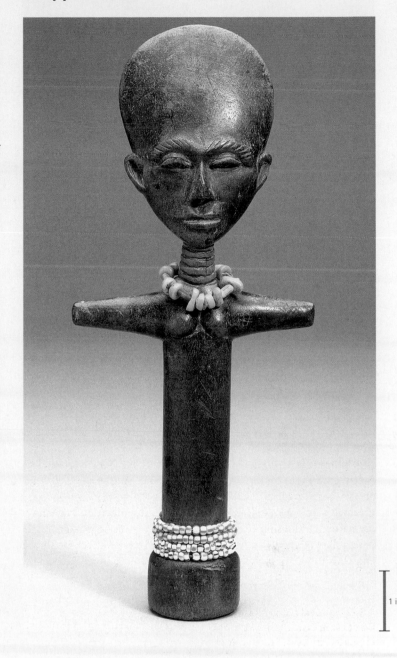

**11-12** OSEI BONSU, Akua'ba (Akua's child), Asante, Ghana, ca. 1935. Wood, beads, and pigment, $10\frac{1}{4}$" high. Private collection.

Osei Bonsu was one of Africa's leading sculptors. This figure, carried by women hoping to conceive a child, has a flattened face and cross-hatched eyebrows, typical of the artist's style.

1 in.

objects, symbols, colors, and materials comprising this shrine contribute both visually and ritually to the imaging of royal power, as well as to its history, renewal, and perpetuation. The composition of the shrine, like that of the altar at its center and the Altar to the Hand and Arm (FIG. 10-13), is hierarchical. At the center of all Benin hierarchies stands the king (FIG. I-1).

### Asante

The Asante of modern Ghana formed a strong confederacy around 1700. They are one of several peoples, including the Baule of Côte d'Ivoire, who speak an Akan dialect.

**OSEI BONSU** A common stylistic characteristic of Asante figural art is the preference for conventionalized, flattened heads. Many

Akan peoples considered long, slightly flattened foreheads to be emblems of beauty, and mothers gently molded their children's cranial bones to reflect this value. These anatomical features appear in a wooden image of a young girl (FIG. 11-12), or *akua'ba* (Akua's child), by one of the 20th century's leading African sculptors, OSEI BONSU (1900–1976). After consecrating a simplified wood akua'ba sculpture at a shrine, a young woman hoping to conceive carried it with her. Once pregnant, she continued to carry the figure to ensure the safe delivery of a healthy and handsome child—among these matrilineal people, preferably a girl. Compared with traditional sculptures of this type, the more naturalistic rendering of the face and crosshatched eyebrows in Osei Bonsu's sculpture are distinctive features of his personal style (see "African Artists and Apprentices," above).

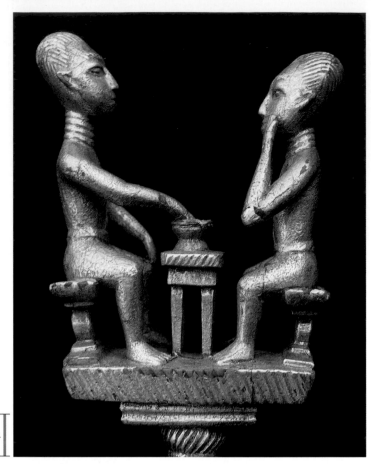

1 in.

**11-13** Osei Bonsu, linguist's staff of two men sitting at a table of food, Asante, Ghana, mid-20th century. Wood and gold leaf, section shown 10″ high. Collection of the Paramount Chief of Offinso, Asante.

Osei Bonsu carved this gold-covered wooden linguist's staff for someone who could speak for the Asante king. At the top are two men sitting at a table of food—a metaphor for the office of the king.

**LINGUIST'S STAFF** Bonsu also carved the gold-covered wood sculpture (FIG. **11-13**) that depicts two men sitting at a table of food. This object, commonly called a *linguist's staff* because its carrier often speaks for a king or chief, has a related proverb: "Food is for its rightful owner, not for the one who happens to be hungry." Food is a metaphor for the office the king or chief rightfully holds. The "hungry" man lusts for the office. The linguist, who is an important counselor and adviser to the king, might carry this staff to a meeting at which a rival contests the king's title to the stool (his throne, the office). Many hundreds of sculptures from this region have proverbs or other sayings associated with them, which has created a rich verbal tradition relating to the visual arts of the Akan peoples.

## Yoruba

The Yoruba have a long history in southwestern Nigeria and the southern Republic of Benin dating to the founding of Ile-Ife in the 11th century (see Chapter 10). In the 20th century, Yoruba artists were among the most skilled on the continent. One who achieved international recognition was OLOWE OF ISE (ca. 1873–1938).

**OLOWE OF ISE** Olowe was the leading Yoruba sculptor of the early 20th century, and kings throughout Yorubaland sought his services. The king of Ikere, for example, employed Olowe for four years starting in 1910. A tall veranda post (FIG. **11-14**) that Olowe

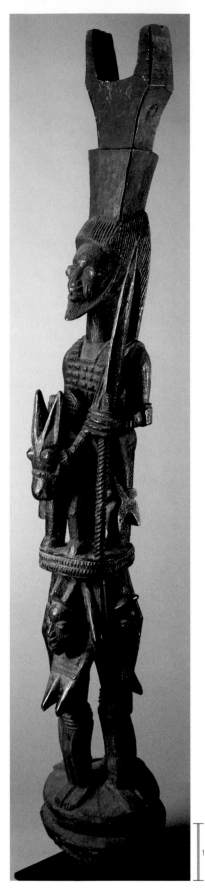

**11-14** Olowe of Ise, veranda post, from Akure, Yoruba, Nigeria, 1920s. Wood and pigment, 14′ 6″ high. Denver Art Museum, Denver.

Olowe carved this post when Europeans had already become familiar among Yoruba peoples. He subtly recorded this colonialism in the European cap of one of the men supporting the equestrian warrior.

1 ft.

carved in the 1920s for the house of Chief Elefoshan of Akure is typical of his style. To achieve greater height, Olowe stacked his weapon-carrying equestrian warrior on top of a platform supported on the heads and upraised arms of four attenuated figures, two men and two women, with long necks and enlarged heads. The latter trait is common among most Yoruba sculptors, but elongated bodies are an Olowe characteristic, along with finely textured detail, seen in the warrior's tunic.

The post dates to a time when Europeans had already become a colonial presence among Yoruba peoples. Olowe subtly recorded this presence by placing a European-style billed cap on one of the male supporting figures. The overall design, more complex and with more open space than most posts by other carvers, signals Olowe's virtuosity.

## African Masquerades

The art of masquerade has long been a quintessential African expressive form, replete with meaning and cultural importance. This is so today, but was even more critically true in colonial times and earlier, when African masking societies boasted extensive regulatory and judicial powers. In stateless societies, such as those of the Senufo (FIGS. 11-15 and 11-16), Dogon (FIG. 11-17), and Mende (FIG. 11-18), masks sometimes became so influential they had their own priests and served as power sources or as oracles. Societies empowered maskers to levy fines and to apprehend witches (usually defined as socially destructive people) and criminals, and to judge and punish them. Normally, however—especially today—masks are less threatening and more secular and educational, and they serve as diversions from the humdrum of daily life. Masked dancers usually embody either ancestors, seen as briefly returning to the human realm, or various nature spirits called upon for their special powers.

The mask, a costume ensemble's focal point, combines with held objects, music, and dance gestures to invoke a specific named character, almost always considered a spirit. A few masked spirits appear by themselves, but more often several characters come out together or in turn. Maskers enact a broad range of human, animal, and fantastic otherworldly behavior that is usually both stimulating and didactic. Masquerades, in fact, vary in function or effect along a continuum from weak spirit power and strong entertainment value to those rarely seen but possessing vast executive powers backed by powerful shrines. Most operate between these extremes, crystallizing varieties of human and animal behavior—caricatured, ordinary, comic, bizarre, serious, or threatening. These actions inform and affect audience members because of their dramatic staging. It is the purpose of most masquerades to move people, to affect them, to effect change.

Thus, masks and masquerades are mediators—between men and women, youths and elders, initiated and uninitiated, powers of nature and those of human agency, and even life and death. For many groups in West and Central Africa, masking plays (or once played) an active role in the socialization process, especially for men, who control most masks. Maskers carry boys (and, more rarely, girls) away from their mothers to bush initiation camps, put them through ordeals and schooling, and welcome them back to society as men months or even years later. A second major role is in aiding the transformation of important deceased persons into productive ancestors who, in their new roles, can bring benefits to the living community. Because most masking cultures are agricultural, it is not surprising that Africans often invoke masquerades to increase the productivity of the fields, to stimulate the growth of crops, and later to celebrate the harvest.

11-15 Senufo masquerader, Côte d'Ivoire, photographed ca. 1980–1990.

Senufo masqueraders are always men. Their masks often represent composite creatures that incarnate both ancestors and bush powers. They fight malevolent spirits with their aggressively powerful forms.

## Senufo

The Senufo peoples of the western Sudan region in what is now northern Côte d'Ivoire have a population today of more than a million. They speak several different languages, sometimes even in the same village. Not surprisingly, there are many different Senufo art forms, all closely tied to community life.

**MASQUERADES** Senufo men dance many masks (see "African Masquerades," above), mostly in the context of Poro, the primary men's association for socialization and initiation, a protracted process that takes nearly 20 years to complete. Maskers also perform at funerals and other public spectacles. Large Senufo masks (for example, FIG. 11-15) are composite creatures, combining characteristics of antelope, crocodile, warthog, hyena, and human: sweeping horns, a head, and an open-jawed snout with sharp teeth. These masks incarnate both ancestors and bush powers that combat witchcraft and sorcery, malevolent spirits, and the wandering dead. They are protectors who fight evil with their aggressively powerful forms and their medicines.

At funerals, Senufo maskers attend the corpse and help expel the deceased from the village. This is the deceased individual's final

1 in.

**11-16** "Beautiful Lady" dance mask, Senufo, Côte d'Ivoire, late 20th century. Wood, 1' ½" high. Musée Barbier-Mueller, Geneva.

Some Senufo men dance female masks like this one with a hornbill bird rising from the forehead. The female characters are sometimes the wives of the terrorizing male masks (FIG. 11-15).

transition, a rite of passage parallel to that undergone by all men during their years of Poro socialization. When an important person dies, the convergence of several masking groups, as well as the music, dancing, costuming, and feasting of many people, constitute a festive and complex work of art that transcends any one mask or character.

Some men also dance female masks. The most recurrent type has a small face with fine features, several extensions, and varied motifs—a hornbill bird in the illustrated example (FIG. **11-16**)—rising from the forehead. The men who dance these feminine characters also wear knitted body suits or trade-cloth costumes to indicate their beauty and their ties with the order and civilization of the village. They may be called "pretty young girl," "beautiful lady," or "wife" of one of the heavy, terrorizing masculine masks (FIG. 11-15) that appear before or after them.

# Dogon

The Dogon (FIG. 11-9) continue to excel at carving wood figures, but many Dogon artists are specialists in fashioning large masks for elaborate cyclical masquerades.

**SATIMBE MASKS** Dogon masqueraders dramatize creation legends. These stories say that women were the first ancestors to imitate spirit maskers and thus the first human masqueraders. Men later took over the masks, forever barring women from direct involvement with masking processes. A mask called *Satimbe* (FIG. **11-17**), that is, "sister on the head," seems to represent all women and commemo-

**11-17** Satimbe masquerader, Dogon, Mali, mid- to late 20th century.

Satimbe ("sister on the head") masks commemorate the legend describing women as the first masqueraders. The mask's crown is a woman with large breasts and sticklike bent arms.

## Mende Women as Maskers

The Mende and neighboring peoples of Sierra Leone, Liberia, and Guinea are unique in Africa in that women rather than men are the masqueraders. The masks (FIG. 11-18) and costumes they wear conceal the women's bodies from the audience attending their performance. The Sande society of the Mende is the women's counterpart to the Senufo men's Poro society. These associations control the initiation, education, and acculturation of female and male youth, respectively. Women leaders who dance these masks serve as priestesses and judges during the three years the women's society controls the ritual calendar (alternating with the men's society in this role), thus serving the community as a whole. Women maskers, also initiators, teachers, and mentors, help girl novices with their transformation into educated and marriageable women. Sande women associate their Sowie masks with water spirits and the color black, which the society, in turn, connects with human skin color and the civilized world. The women wear these helmet masks on top of their heads as headdresses, with black raffia and cloth costumes to hide the wearers' identity during public performances. Elaborate coiffures, shiny black color, dainty triangular-shaped faces with slit eyes, rolls around the neck, and actual and carved versions of amulets and various emblems on the top commonly characterize Sowie masks (FIG. 11-18). These symbolize the adult women's roles as wives, mothers, providers for the family, and keepers of medicines for use within the Sande association and the society at large.

Sande members commission the masks from male carvers, with the carver and patron together determining the type of mask needed for a particular societal purpose. The Mende often keep, repair, and reuse masks for many decades, thereby preserving them as models for subsequent generations of carvers.

**11-18** Female mask, Mende, Sierra Leone, 20th century. Wood and pigment, 1′ 2½″ high. Fowler Museum of Cultural History, University of California, Los Angeles (gift of the Wellcome Trust).

This Mende mask refers to ideals of female beauty, morality, and behavior. The large forehead signifies wisdom, the neck design beauty and health, and the plaited hair the order of ideal households.

1 in.

---

rates this legend. Satimbe masks consist of a roughly rectangular covering for the head with narrow rectangular openings for the eyes and a crowning element, much larger than the mask proper, depicting a schematic woman with large protruding breasts and sticklike bent arms. In ceremonies called Dama, held every several years to honor the lives of people who have died since the last Dama, Satimbe is among the dozens of different masked spirit characters that escort dead souls away from the village. The deceased are sent off to the land of the dead where, as ancestors, they will be enjoined to benefit their living descendants and stimulate agricultural productivity.

### Mende

The Mende are farmers who occupy the Atlantic coast of Africa in Sierra Leone. Although men own and perform most masks in Africa, in Mende society the women control and dance the masks (see "Mende Women as Maskers," above).

**SOWIE MASKS** The glistening black surface of Mende Sowie masks (FIG. 11-18) evokes female ancestral spirits newly emergent from their underwater homes (also symbolized by the turtle on top). The mask and its parts refer to ideals of female beauty, morality, and behavior. A high, broad forehead signifies wisdom and success. The neck ridges have multiple meanings. They are signs of beauty, good health, and prosperity and also refer to the ripples in the water from which the water spirits emerge. Intricately woven or plaited hair is the essence of harmony and order found in ideal households. A small closed mouth and downcast eyes indicate the silent, serious demeanor expected of recent initiates.

### Kuba

The Kuba have been well established in the Democratic Republic of Congo since at least the 16th century. They represent almost 20 different ethnic groups who all recognize the authority of a single king.

**11-19** Bwoom masquerader, Kuba, Democratic Republic of Congo, photographed ca. 1950.

At Kuba festivals, masqueraders reenact creation legends involving Bwoom, Mwashamboy, and Ngady Amwaash. The first two are males who vie for the attention of Ngady, the first female ancestor.

**11-20** Ngady Amwaash mask, Kuba, Democratic Republic of Congo, late 19th or early 20th century. Peabody Museum, Harvard University, Cambridge.

Ngady's mask incorporates beads, shells, and feathers in geometric patterns. The stripes on her cheeks are tears from the pain of childbirth after incest with her father, represented by the Mwashamboy mask.

**BWOOM AND NGADY AMWAASH** At the court of Kuba kings, three masks, known as Mwashamboy, Bwoom, and Ngady Amwaash, represent legendary royal ancestors. Mwashamboy symbolizes the founding ancestor, Woot, and embodies the king's supernatural and political powers. Bwoom (FIG. **11-19**), with its bulging forehead, represents a legendary dwarf or pygmy who signifies the indigenous peoples on whom kingship was imposed. Bwoom also vies with Mwashamboy for the attention of the beautiful female ancestor, Ngady Amwaash (FIG. **11-20**), who symbolizes both the first woman and all women. On her cheeks are striped tears from the pain of childbirth, and because to procreate, Ngady must commit incest with her father, Woot. These three characters reenact creation stories while rehearsing various forms of archetypal behaviors that instruct young men during initiation and reinforce basic Kuba societal values. The masks and their costumes, with elaborate beads, feathers, animal pelts, cowrie shells, cut-pile cloth, and ornamental trappings, as well as geometric patterning, make for a sumptuous display at Kuba festivals.

**KING KOT A-MBWEEKY III** Throughout history, African costumes have been laden with meaning and have projected messages that all members of the society could read. A photograph (FIG. **11-21**) taken in 1970 shows Kuba King Kot a-Mbweeky III (r. 1969–) seated in state before his court, bedecked in a dazzling multimedia costume with many symbolic elements. The king commissioned the costume he wears and now has become art himself. Eagle feathers, leopard skin, cowrie shells, imported beads, raffia, and other materials combine to overload and expand the image of the man, making him larger than life and most

**11-21** Kuba King Kot a-Mbweeky III during a display for photographer and filmmaker Eliot Elisofon in 1970, Mushenge, Democratic Republic of Congo.

Eagle feathers, leopard skin, cowrie shells, imported beads, raffia, and other materials combine to make the Kuba king larger than life. He is a collage of wealth, dignity, and military might.

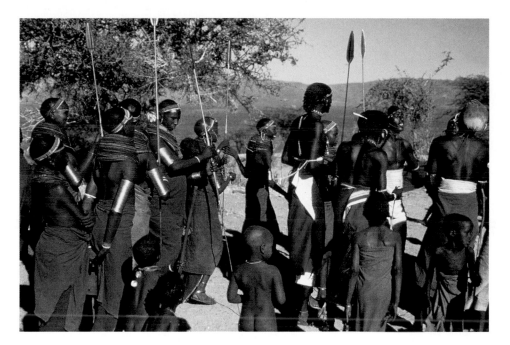

Men and women in many rural areas of Africa embellish themselves with elaborate hairstyles, painted bodies, and beaded jewelry. This personal decoration reveals age, marital status, and parentage.

deities, often Ala, goddess of the earth. The houses are elaborate unified artistic complexes that incorporate numerous unfired clay sculptures and paintings—occasionally more than a hundred in a single mbari house. In an mbari house at Umugote Orishaeze, near Owerri, two of the sculptures (FIG. 11-23) depict Ala and her consort, the thunder god Amadioha. The god wears modern clothing, whereas Ala appears with traditional body paint and a fancy hairstyle. These differing modes of dress relate to Igbo concepts of modernity and tradition, both viewed as positive by the men who control the ritual and art. They allow themselves modern attire but want their women to remain traditional. The artist enlarged and extended both figures' torsos, necks, and heads to express their aloofness, dignity, and power. More informally

certainly a work of art. He is a *collage*, an assemblage. He holds not one but two weapons, symbolic of his military might and underscoring his wealth, dignity, and grandeur. The man, with his regalia, embodies the office of sacred kingship. He is a superior being actually and figuratively, raised upon a dais, flanked by ornate drums, with a treasure basket of sacred relics by his left foot. The geometric patterns on the king's costume and nearby objects, and the abundance and redundancy of rich materials, epitomize the opulent style of Kuba court arts.

## Samburu

In addition to wearing masks and costumes on special occasions, people in many rural areas of eastern Africa, including the Samburu in northern Kenya, continue to embellish their bodies.

**BODY ADORNMENT** The Samburu men and women shown in FIG. 11-22 at a spontaneous dance have distinct styles of personal decoration. Men, particularly warriors who are not yet married, expend hours creating elaborate hairstyles for one another. They paint their bodies with red ocher, and wear bracelets, necklaces, and other bands of beaded jewelry young women make for them. For themselves, women fashion more lavish constellations of beaded collars, which they mass around their necks. As if to help separate the genders, women shave their heads and adorn them with beaded headbands. Personal decoration begins in childhood, increasing to become lavish and highly self-conscious in young adulthood, and diminishing as people age. Much of the decoration contains coded information—age, marital or initiation status, parentage of a warrior son—that can be read by those who know the codes. Dress ensembles have evolved over time. Different colors and sizes of beads became available, as did plastics and aluminum, and specific fashions have changed, but the overall concept of fine personal adornment—that is, dress raised to the level of art—remains much the same today as it was centuries ago.

## Igbo

The Igbo of the Lower Niger region in present-day Nigeria have a distinguished artistic tradition dating back more than a thousand years (see Chapter 10). The arts still play a vital role in Igbo society today.

**MBARI HOUSES** The powerful nature gods of the Igbo demand about every 50 years that a community build an *mbari* house. The Igbo construct these houses from mud as sacrifices to major

11-23 Ala and Amadioha, painted clay sculptures in an mbari, Igbo, Umugote Orishaeze, Nigeria, photographed in 1966.

The Igbo erect mud mbari houses to the earth goddess Ala. The painted statues inside this one represent Ala in traditional dress with body paint and the thunder god Amadioha in modern dress.

**11-24** Togu na (men's house of words), Dogon, Mali, photographed in 1989. Wood and pigment.

Dogon men hold their communal deliberations in togu na. The posts of this one are of varied date. The oldest have traditional carvings, and the newest feature polychrome narrative or topical paintings.

posed figures and groups appear on the other sides of the house, including beautiful, amusing, or frightening figures of animals, humans, and spirits taken from mythology, history, dreams, and everyday life—a kaleidoscope of subjects and meanings. The mbari construction process, veiled in secrecy behind a fence, is a stylized world-renewal ritual. Ceremonies for unveiling the house to public view indicate that Ala accepted the sacrificial offering (of the mbari) and, for a time at least, will be benevolent. An mbari house never undergoes repair. Instead, the Igbo allow it to disintegrate and return to its source, the earth.

of legendary female ancestors, similar to stylized ancestral couples (FIG. 11-9) or masked figures (FIG. 11-17). Recent replacement posts feature narrative and topical scenes of varied subjects, such as horsemen or hunters or women preparing food, and these artworks include abundant descriptive detail, bright polychrome painting in enamels, and even some writing. Unlike earlier traditional sculptors, the contemporary artists who made these posts want to be recognized and are eager to sell their work (other than these posts) to tourists.

## CONTEMPORARY ART

The art forms of contemporary Africa are immensely varied and defy easy classification. Four examples, however, can give a sense of the variety and vitality of African art today.

**DOGON TOGU NA** Traditionalism and modernism unite in the contemporary Dogon *togu na*, or "men's house of words." The togu na is so called because men's deliberations vital to community welfare take place under its sheltering roof. It is considered the "head" and the most important part of the community, which the Dogon characterize with human attributes. The Dogon build the men's houses over time. Earlier posts, such as the central one in the illustrated togu na (FIG. **11-24**), show schematic renderings

**11-25** TRIGO PIULA, *Ta Tele,* Democratic Republic of Congo, 1988. Oil on canvas, 3′ 3⅜″ × 3′ 4⅜″. Collection of the artist.

*Ta Tele* is a commentary on modern life showing Congolese citizens transfixed by television pictures of the world outside Africa. Even the traditional power figure at the center has a TV screen for a chest.

1 ft.

**TRIGO PIULA** The Democratic Republic of Congo's TRIGO PIULA (b. ca. 1950) is a painter trained in Western artistic techniques and styles whose works fuse Western and Congolese images and objects in a pictorial blend that provides social commentary on present-day Congolese culture. *Ta Tele* (FIG. **11-25**) depicts a group of Congolese citizens staring transfixed at colorful pictures of life beyond Africa displayed on 14 television screens. The TV images include references to travel to exotic places, sports events, love, the earth seen from a satellite, and Western worldly goods. A traditional Kongo power figure (compare FIG. **11-8**) associated with warfare and divination stands at the composition's center as a visual mediator between the anonymous foreground viewers and the multiple TV images. In traditional Kongo contexts, this figure's feather headdress links it to supernatural and magical powers from the sky, such as lightning and storms. In Piula's rendition, the headdress perhaps refers to the power of airborne televised pictures. In the stomach area, where Kongo power figures often have glass in front of a medicine packet, Piula painted a television screen showing a second power figure, as if to double the figure's power. The artist shows most of the television viewers with a small white image of a foreign object—for example, a car, shoe, or bottle—on the backs of their heads. One meaning of this picture appears to be that television messages have deadened the minds of Congolese peoples to anything but modern thoughts or commodities. The power figure

stands squarely on brown earth. Two speaker cabinets set against the back wall beneath the TV screens have wires leading to the figure, which in the past could inflict harm. In traditional Kongo thinking and color symbolism, the color white and earth tones are associated with spirits and the land of the dead. Perhaps Piula suggests that like earlier power figures, the contemporary world's new television-induced consumerism is poisoning the minds and souls of Congolese people as if by magic or sorcery.

**WILLIE BESTER** Social and political issues also figure in contemporary South African art. For example, artists first helped protest against apartheid (government-sponsored racial separation), then celebrated its demise and the subsequent democratically elected government under the first president, Nelson Mandela, in 1994. WILLIE BESTER (b. 1956) was among the critics of the apartheid system. His 1992 *Homage to Steve Biko* (FIG. **11-26**) is a tribute to the gentle and heroic leader of the South African Black Liberation Movement whom the authorities killed while he was in detention. The exoneration of the two white doctors in charge of him sparked protests around the world. Bester packed his picture with references to death and injustice. Biko's portrait, at the center, is near another of the police minister, James Kruger, who had Biko transported 1,100 miles to Pretoria in the yellow Land Rover ambulance seen left of center and again beneath Biko's portrait. Bester portrayed Biko

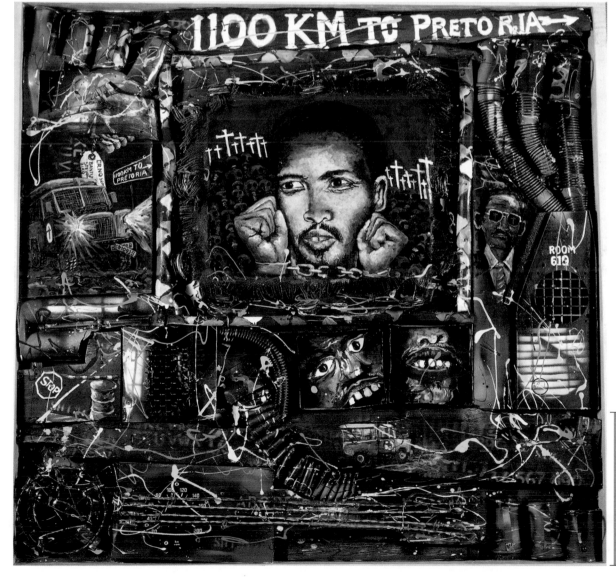

**11-26** WILLIE BESTER, *Homage to Steve Biko*, South Africa, 1992. Mixed media, 3′ 7⅚″ × 3′ 7⅚″. Collection of the artist.

*Homage to Steve Biko* is a tribute to a leader of the Black Liberation Movement that protested apartheid in South Africa. References to the injustice of Biko's death fill this complex painting.

**11-27** PAA JOE, Airplane and cow coffins in the artist's showroom in Teshi, Ga, Ghana, 2000.

The wood caskets of Paa Joe take many forms, including animals, airplanes, and automobiles. When commissioned, the form always relates to the deceased, but many collectors buy the caskets as art objects.

with his chained fists raised in the recurrent protest gesture. This portrait memorializes both Biko and the many other antiapartheid activists indicated by the white graveyard crosses above a blue sea of skulls beside Biko's head. The crosses stand out against a red background that recalls the inferno of burned townships. The stop sign (lower left) seems to mean "stop Kruger" or perhaps "stop apartheid." The tagged foot, as if in a morgue, above the ambulance (to the left) also refers to Biko's death. The red crosses on the ambulance door and on Kruger's reflective dark glasses echo, with sad irony, the graveyard crosses.

Blood red and ambulance yellow are in fact unifying colors dripped or painted on many parts of the work. Writing and numbers, found fragments and signs, both stenciled and painted—favorite Cubist motifs—also appear throughout the composition. Numbers refer to dehumanized life under apartheid. Found objects—wire, sticks, cardboard, sheet metal, cans, and other discards—from which the poor construct fragile, impermanent township dwellings, remind viewers of the degraded lives of most South African people of color. The oil-can guitar (bottom center), another recurrent Bester symbol, refers both to the social harmony and joy provided by music and to the control imposed by apartheid policies. The whole composition is rich in texture and dense in its collage combinations of objects, photographs, signs, symbols, and painting. *Homage to Steve Biko* is a radical and powerful critique of an oppressive sociopolitical system, and it exemplifies the extent to which art can be invoked in the political process.

**KANE KWEI AND PAA JOE** Some contemporary African artists specialize in the most traditional African art form, wood sculpture, but have pioneered new forms, often under the influence of modern Western art movements such as Pop Art. Kane Kwei (1922–1992) of the Ga people in urban coastal Ghana created a new kind of wooden casket that brought him both critical acclaim and commercial success. Beginning around 1970, Kwei, trained as a carpenter, created figurative coffins intended to reflect the deceased's life, occupation, or major accomplishments. On commission he made such diverse shapes as a cow, a whale, a bird,

a Mercedes-Benz, and various local food crops, such as onions and cocoa pods, all pieced together using nails and glue rather than carved. Kwei also created coffins in traditional leaders' symbolic forms, such as an eagle, an elephant, a leopard, and a stool. Kwei's sons and his cousin PAA JOE (b. 1944) have carried on his legacy. In a 2000 photograph (FIG. **11-27**) of Joe's showroom in Teshi, prospective customers view the caskets on display, including an airplane and a cow. Only some of the coffins made by Kwei and Joe were ever buried. Many are in museum galleries and the homes of private collectors today.

**AFRICAN ART TODAY** During the past two centuries and especially in recent decades, the encroachments of Christianity, Islam, Western education, and market economies have led to increasing secularization in all the arts of Africa. Many figures and masks earlier commissioned for shrines or as incarnations of ancestors or spirits are now made mostly for sale to outsiders, essentially as tourist arts. They are sold in art galleries abroad as collector's items for display. In towns and cities, painted murals and cement sculptures appear frequently, often making implicit comments about modern life. Nonetheless, despite the growing importance of urbanism, most African people still live in rural communities. Traditional values, although under pressure, hold considerable force in villages especially, and some people adhere to spiritual beliefs that uphold traditional art forms. African art remains as varied as the vast continent itself and continues to evolve.

# AFRICA AFTER 1800

## 19TH CENTURY

▌ Most of the traditional forms of African art continued into the 19th century. Among these are sculptures and shrines connected with the veneration of ancestors. Wooden or metal-covered figures guarded Fang and Kota reliquaries. Especially elaborate are some Kalabari Ijaw screens with figures of a deceased chief, his retainers, and the heads of his slaves and conquered rivals.

▌ The royal arts also flourished in the 19th century. The ultimate status symbol was the king's throne. That of Nsangu of Bamum makes extensive use of richly colored textiles and luminous materials like glass beads and cowrie shells.

▌ One of the earliest African artists whose name survives is Akati Akpele Kendo, who worked for the Fon king Glele around 1858, but most African art remains anonymous.

▌ Throughout history, African artists have been masters of woodcarving. Especially impressive examples are the Kongo power figures bristling with nails and blades, and the Dogon and Baule sculptures of male and female couples. Although stylistically diverse, most African sculpture exhibits hierarchy of scale, both among figures and within the human body, and enlarged heads are common.

Kalabari Ijaw ancestral screen, late 19th century

Throne of King Nsangu, Bamum, ca. 1870

## 20TH CENTURY

▌ As in the 19th century, traditional arts flourished in 20th-century Africa, but the names of many more individual artists are known. Two of the most famous are the Asante sculptor Osei Bonsu and the Yoruba sculptor Olowe of Ise.

▌ Osei Bonsu worked for kings and commoners alike, carving both single figures and groups, sometimes for the linguist's staff of a leader's spokesman. The distinctive features of his style are the flattened faces and crosshatched eyebrows of his figures.

▌ Olowe of Ise won renown for the multifigure veranda posts that he carved for houses and palaces. Elongated bodies are an Olowe characteristic, along with finely textured detail.

▌ In Africa, art is nearly always an active agent in the lives of its peoples. A major African art form is the fashioning of masks for festive performances. Masqueraders are almost always men, even when the masks they dance are female, as among the Senufo, Dogon, and Kuba, but in Mende society, women are the masqueraders.

Bonsu, linguist's staff, mid-20th century

Senufo dance mask, late 20th century

## CONTEMPORARY ART

▌ The art forms of contemporary Africa range from the traditional to works of international character using Western techniques and motifs. Among the former are the sculpted wooden posts of Dogon men's houses.

▌ Two contemporary painters whose works often incorporate social and political commentary are Trigo Piula of the Democratic Republic of Congo and Willie Bester of South Africa.

Bester, *Homage to Steve Biko*, 1992

**12-1** Moai, Anakena, Rapa Nui (Easter Island), Polynesia, 10th to 12th centuries. Volcanic tuff and red scoria.

The colossal stone sculptures of Easter Island predate the arrival of Europeans in Oceania by several centuries. Almost 900 moai are known, even though each statue took 30 men a full year to carve.

# 12

# OCEANIA

When people think of the South Pacific, images of balmy tropical islands usually come to mind. But the islands of the Pacific Ocean encompass a wide range of habitats. Environments range from the arid deserts of the Australian outback to the tropical rain forests of inland New Guinea to the coral atolls of the Marshall Islands. In all, more than 25,000 islands dot Oceania (MAP **12-1**), and the region is not only geographically varied but also politically, linguistically, culturally, and artistically diverse. In 1831 the French explorer Jules Sébastien César Dumont d'Urville (1790–1842) proposed dividing the Pacific into major regions based on general geographical, racial, and linguistic distinctions. Despite its limitations, his division of Oceania into the areas of Melanesia ("black islands"), Micronesia ("small islands"), and Polynesia ("many islands") continues in use today. Melanesia includes New Guinea, New Ireland, New Britain, New Caledonia, the Admiralty Islands, and the Solomon Islands, along with other smaller island groups. Micronesia consists primarily of the Caroline, Mariana, Gilbert, and Marshall Islands in the western Pacific. Polynesia covers much of the eastern Pacific and consists of a triangular area defined by the Hawaiian Islands in the north, Rapa Nui (Easter Island) in the east, and New Zealand in the southwest.

Although documentary evidence does not exist for Oceanic cultures until the arrival of seafaring Europeans in the early 16th century, archaeologists have determined that the islands have been inhabited for tens of thousands of years. Their research has revealed that different parts of the Pacific experienced distinct migratory waves. The first group arrived during the last Ice Age, at least 40,000 and perhaps as many as 75,000 years ago, when a large continental shelf extended from Southeast Asia and gave land access to Australia and New Guinea. After the end of the Ice Age, descendants of these first settlers dispersed to other islands in Melanesia. The most recent migratory wave occurred sometime after 3000 BCE and involved peoples of Asian ancestry moving to areas of Micronesia and Polynesia. The last Pacific islands to be settled were those of Polynesia, but habitation on its most far-flung islands—Hawaii, New Zealand, and Easter Island—began no later than 500 to 1000 CE. Because of the lengthy chronological span of these migrations, Pacific cultures vary widely. For example, the Aboriginal peoples of Australia speak a language unrelated to those of New Guinea, whose languages fall into a distinct but diverse group. In contrast, most of the rest of the Pacific islanders speak languages derived from the Austronesian language family.

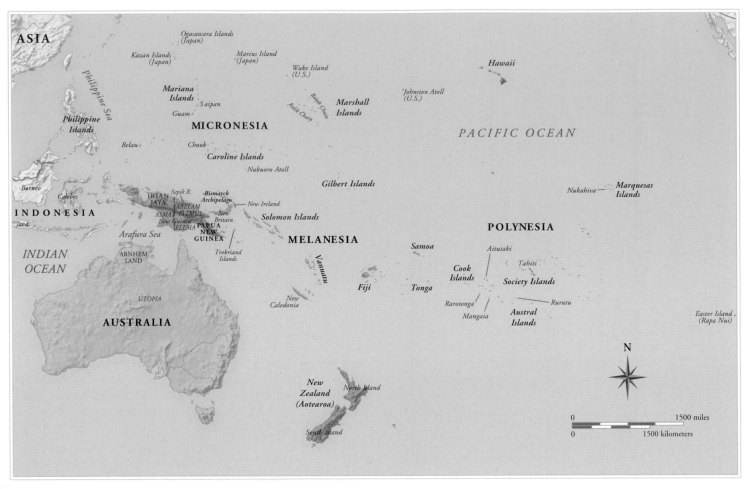

MAP 12-1 Oceania.

## AUSTRALIA AND MELANESIA

These island groups came to Western attention as a result of the extensive exploration and colonization that began in the 16th century and reached its peak in the 19th century. Virtually all of the major Western nations—including Great Britain, France, Spain, Holland, Germany, and the United States—established a presence in the Pacific. Much of the history of Oceania in the 20th century revolved around indigenous peoples' struggles for independence from these colonial powers. Yet colonialism also facilitated an exchange of ideas—not solely the one-way transfer of Western cultural values and technology to the Pacific. Oceanic art, for example, had a strong impact on many Western artists, including Paul Gauguin. The "primitive" art of Oceania also influenced many early-20th-century artists.

This chapter focuses on Oceanic art from the European discovery of the islands in the 16th century until the present, although the colossal stone statues of Easter Island (FIG. **12-1**) predate the arrival of Europeans by several centuries. Knowledge of early Oceanic art and the history of the Pacific islands in general is unfortunately very incomplete. Traditionally, the transmission of information from one generation to the next in Pacific societies was largely oral, rather than written, and little archival documentation exists. Nonetheless, archaeologists, linguists, anthropologists, ethnologists, and art historians continue to make progress in illuminating the Oceanic past.

## AUSTRALIA AND MELANESIA

The westernmost Oceanic islands are the continent-nation of Australia and New Guinea in Melanesia. Together they dwarf the area of all the other Pacific islands combined.

## Australia

Over the past 40,000 years, the Aboriginal peoples of Australia spread out over the entire continent and adapted to a variety of ecological conditions, ranging from those of tropical and subtropical areas in the north to desert regions in the interior and to more temperate locales in the south. European explorers reaching the region in the late 18th and early 19th centuries found that the Aborigines had a special relationship with the land they lived on. The Aboriginal perception of the world centers on a concept known as the Dreamings, ancestral beings whose spirits pervade the present. All Aborigines identify certain Dreamings as totemic ancestors, and those who share the same Dreamings have social links. The Aborigines call the spiritual domain that the Dreamings occupy Dreamtime, which is both a physical space within which the ancestral beings moved in creating the landscape and a psychic space that provides Aborigines with cultural, religious, and moral direction. Because of the importance of Dreamings to all aspects of Aboriginal life, native Australian art symbolically links Aborigines with these ancestral spirits. The Aborigines recite creation myths in concert with songs and dances, and many art forms—body painting, carved figures, sacred objects, decorated stones, and rock and bark painting—serve as essential props in these dramatic re-creations. Most Aboriginal art is relatively small and portable. As hunters and gatherers in difficult terrain, the Aborigines were generally nomadic peoples. Monumental art was impractical.

**BARK PAINTING** Bark, widely available in Australia, is portable and lightweight, and bark painting became a mainstay of Aboriginal art. Dreamings, mythic narratives (often tracing the movement of var-

**12-2** Auuenau, from Western Arnhem Land, Australia, 1913. Ochre on bark, 4′ 10⅔″ × 1′ 1″. South Australian Museum, Adelaide.

Aboriginal painters frequently depicted Dreamings, ancestral beings whose spirits pervade the present, using the "X-ray style" that shows both the figure's internal organs and external appearance.

**EMILY KAME KNGWARREYE** Aboriginal artists today retain close ties to the land and the spirits that inhabit it, but some contemporary painters have eliminated figures from their work and produced canvases that, superficially at least, resemble American *Abstract Expressionist* paintings. EMILY KAME KNGWARREYE (1910–1996) began painting late in life after cofounding a communal women's *batik* group in Utopia. Her canvases (FIG. **12-3**) clearly reveal her background as a fabric artist, but they draw their inspiration from the landscape of her native land. Using thousands of color dots that sometimes join to form thick curvilinear bands, she conjured the image of arid land, seeds, and plants. The often huge size of her paintings further suggests the vastness of the Australian countryside.

ious ancestral spirits through the landscape), and sacred places were common subjects. Ancestral spirits pervade the lives of the Aborigines, and these paintings served to give visual form to that presence. Traditionally, an Aborigine could depict only a Dreaming with which the artist had a connection. Thus, specific Aboriginal lineages, clans, or regional groups "owned" individual designs. The bark painting illustrated here (FIG. **12-2**) depicts a Dreaming known as Auuenau and comes from Arnhem Land in northern Australia. The artist represented the elongated figure in a style known as "X-ray," which Aboriginal painters used to depict both animal and human forms. In this style, the artist simultaneously portrays the subject's internal organs and exterior appearance. The painting possesses a fluid and dynamic quality, with the X-ray-like figure clearly defined against a solid background.

## New Guinea

Because of its sheer size, New Guinea dominates Melanesia. This 309,000-square-mile island consists today of parts of two countries— Irian Jaya, a province of nearby Indonesia, on the island's western end, and Papua New Guinea on the eastern end. New Guinea's inhabitants together speak nearly 800 different languages, almost one quarter of the world's known tongues. Among the Melanesian cultures discussed in this chapter, the Asmat, Iatmul, Elema, and Abelam peoples of New Guinea all speak Papuan-derived languages. Scholars believe they are descendants of the early settlers who came to the island in the remote past. In contrast, the people of New Ireland and the Trobriand Islands are Austronesian speakers and probably descendants of a later wave of Pacific migrants.

Typical Melanesian societies are fairly democratic and relatively unstratified. What political power exists belongs to groups of elder men and, in some areas, elder women. The elders handle the people's affairs in a communal fashion. Within some of these groups, persons of local distinction, known as "Big Men," renowned for their political, economic, and, historically, warrior skills, have accrued power. Because power and position in Melanesia can be earned (within limits), many cultural practices (such as rituals and cults) revolve around the acquisition of knowledge that allows advancement in society. To represent and acknowledge this advancement in rank, Melanesian societies mount elaborate festivals, construct communal meetinghouses, and produce art objects. These cultural products serve to reinforce the social order and maintain social stability.

**12-3** EMILY KAME KNGWARREYE, Untitled, 1992. Synthetic polymer paint on canvas, 5′ 5″ × 15′ 9″. Art Gallery of New South Wales, Sydney.

Aboriginal painter Kngwarreye's canvases reveal her background as a batik artist. Her abstract paintings draw their inspiration from the seeds and plants of the arid Australian landscape.

**12-4** *Left:* Asmat bisj poles, Buepis village, Fajit River, Casuarina Coast, Irian Jaya, Melanesia, early to mid-20th century. *Above:* Detail of a bisj pole. Painted wood. Asmat Museum, Agats.

The Asmat carved bisj poles from mangrove tree trunks and erected them before undertaking a headhunting raid. The carved figures represent the relatives whose deaths the hunters must avenge.

Given the wide diversity in environments and languages, it is no surprise that hundreds of art styles are found on New Guinea alone. Only a sample can be presented here.

**ASMAT** Living along the southwestern coast of New Guinea, the Asmat people of Irian Jaya eke out their existence by hunting and gathering the varied flora and fauna found in the mangrove swamps, rivers, and tropical forests. Each Asmat community is in constant competition for limited resources. Historically, the Asmat extended this competitive spirit beyond food and materials to energy and power as well. To increase one's personal energy or spiritual power required taking it forcibly from someone else. As a result, warfare and headhunting became central to Asmat culture and art. The Asmat did not believe any death was natural. Death could result only from a direct assault (headhunting or warfare) or sorcery, and it diminished ancestral power.

Thus, to restore a balance of spirit power, an enemy's head had to be taken to avenge a death and to add to one's communal spirit power. Headhunting was still common in the 1930s when Europeans established an administrative and missionary presence among the Asmat, but as a result of European efforts, the custom ceased by the 1960s.

When they still practiced headhunting, the Asmat erected *bisj poles* (FIG. 12-4) that served as a pledge to avenge a relative's death. A man would set up a bisj pole when he could command the support of enough men to undertake a headhunting raid. Carved from the trunk of the mangrove tree, bisj poles include superimposed figures of dead individuals. At the top, extending flangelike from the bisj pole, was one of the tree's buttress roots carved into an openwork pattern. All of the decorative elements on the pole related to headhunting and foretold a successful raid. The many animals carved on bisj poles (and in Asmat art in general) are symbols of headhunting.

uninitiated boys cannot enter the men's house. In this manner, the Iatmul men control access to knowledge and therefore to power. Given its important political and cultural role, the men's house is appropriately monumental, physically dominating Iatmul villages and dwarfing family houses. Although men's houses are common in New Guinea, those of the Iatmul are the most lavishly decorated.

Traditionally, the house symbolizes the protective mantle of the ancestors and represents an enormous female ancestor. The Iatmul house and its female ancestral figures symbolize a reenacted death and rebirth when a clan member scales a ladder and enters and then exits the second story of the house. The gable ends of men's houses are usually covered and include a giant female gable mask, making the ancestral symbolism visible. The interior carvings, however, are normally hidden from view. The Iatmul placed carved images of clan ancestors on the central ridge-support posts and on the roof-support posts on both sides of the house. They capped each roof-support post with large faces representing mythical spirits of the clans. At the top of the two raised spires at each end, birds symbolizing the war spirit of the village men sit above carvings of headhunting victims (on occasion, male ancestors).

The subdivision of the house's interior into parts for each clan reflects the social demographic of the village. Many meetinghouses have three parts—a front, middle, and end—representing the three major clans who built it. These parts have additional subclan divisions, which also have support posts carved with images of mythical male and female ancestors. Beneath the house, each clan keeps large carved slit-gongs to serve as both instruments of communication (for sending drum messages within and between villages) and the voices of ancestral spirits. On the second level of the house, above the horizontal crossbeam beneath the gable, the Iatmul placed carved wooden figures symbolizing female clan ancestors, depicted in a birthing position. The Iatmul also keep various types of portable art in their ceremonial houses. These include ancestors' skulls overmodeled with clay in a likeness of the deceased, ceremonial chairs, sacred flutes, hooks for hanging sacred items and food, and several types of masks.

**ELEMA** Central to the culture of the Elema people of Orokolo Bay in the Papuan Gulf was *Hevehe*, an elaborate cycle of ceremonial activities. Conceptualized as the mythical visitation of the water spirits (*ma-hevehe*), the Hevehe cycle involved the production and presentation of large, ornate masks (also called hevehe). The Elema last practiced Hevehe in the 1930s. Primarily organized by the male elders of the village, the cycle was a communal undertaking, completion of which normally took from 10 to 20 years. The duration of the Hevehe and the resources and human labor required reinforced cultural and economic relations and maintained the social structure in which elder male authority dominated.

Throughout the cycle, the Elema held ceremonies to initiate male youths into higher ranks. These ceremonies involved the exchange of wealth (such as pigs and shell ornaments), thereby serving an economic purpose as well. The cycle culminated in the display of the finished hevehe masks. Each mask consisted of painted bark-cloth (see "Barkcloth," page 235) wrapped around a cane-and-wood frame that fit over the wearer's body. A hevehe mask was normally 9 to 10 feet tall, although extensions often raised the height to as much as 25 feet. Because of its size and intricate design, a hevehe mask required great skill to construct, and only trained men would participate in mask making. Designs were specific to particular clans, and elder men passed them down to the next generation from memory. Each mask represented a female sea spirit, but the decoration of the mask often incorporated designs from local flora and fauna as well.

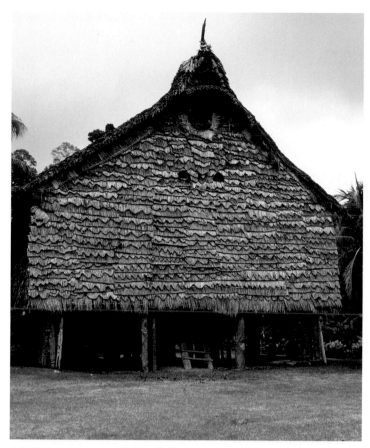

**12-5** Iatmul ceremonial men's house, East Sepik, Papua New Guinea, Melanesia, mid- to late 20th century.

The men's house is the center of Iatmul life. Its distinctive saddle-shaped roof symbolizes the protective mantle of ancestors. The carved ornament includes female ancestors in the birthing position.

The Asmat see the human body as a tree—the feet as the roots, the arms as the branches, and the head as the fruit. Thus any fruit-eating bird or animal (such as the black king cockatoo, the hornbill, or the flying fox) was symbolic of the headhunter and appeared frequently on bisj poles. Asmat art also often includes representations of the praying mantis. The Asmat consider the female praying mantis's practice of beheading her mate after copulation and then eating him as another form of headhunting. The curvilinear or spiral patterns that fill the pierced openwork at the top of the bisj poles can be related to the characteristic curved tail of the cuscus (a fruit-eating mammal) or the tusk of a boar (related to hunting and virility). Once the Asmat carved the bisj poles, they placed them on a rack near the community's men's house. After the success of the head-hunting expedition, the men discarded the bisj poles and allowed them to rot, because they had served their purpose.

**IATMUL** The Iatmul people live along the middle Sepik River in Papua New Guinea in communities based on kinship. Villages include extended families as well as different clans. The social center of every Iatmul village is a massive saddle-shaped men's ceremonial house (FIG. 12-5). In terms of both function and form, the men's house reveals the primacy of the kinship network. The meeting-house reinforces kinship links by serving as the locale for initiation of local youths for advancement in rank, for men's discussions of community issues, and for ceremonies linked to the Iatmul's ancestors. Because only men can advance in Iatmul society, women and

**12-6** Elema hevehe masks retreating into the men's house, Orokolo Bay, Papua New Guinea, Melanesia, early to mid-20th century.

The Hevehe was a cycle of ceremonial activities spanning 10 to 20 years, culminating in the dramatic appearance of hevehe masks from the Elema men's house. The masks represent female sea spirits.

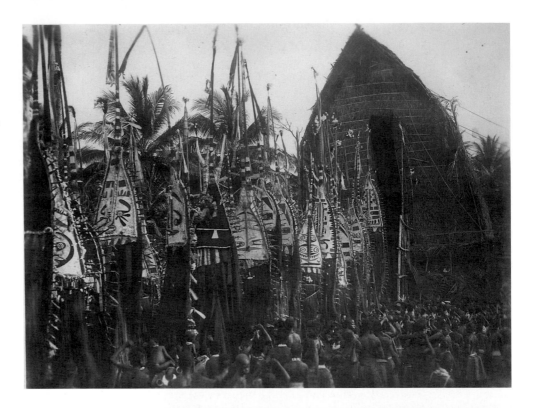

The final stage of the cycle (FIG. **12-6**) focused on the dramatic appearance of the masks from the *eravo* (men's house). After a procession, men wearing the hevehe mingled with relatives. Upon conclusion of related dancing (often lasting about one month), the Elema ritually killed the masks and then dumped them in piles and burned them. This destruction allowed the sea spirits to return to their mythic domain and provided a pretext for commencing the cycle again.

**ABELAM** The art of the Abelam people highlights that Oceanic art relates not only to fundamental spiritual beliefs but also to basic subsistence. The Abelam are agriculturists living in the hilly regions north of the Sepik River. Relatively isolated, the Abelam received only sporadic visits from foreigners until the 1930s, and thus little is known about early Abelam history. The principal crop is the yam. Because of the importance of yams to the survival of Abelam society, those who can grow the largest yams achieve power and prestige. Indeed, the Abelam developed a complex yam cult, which involves a series of rites and activities intended to promote the growth of the tubers. Special plantations focus on yam cultivation. Only initiated men who observe strict rules of conduct, including sexual abstinence, can work these fields. The Abelam believe that ancestors aid in the growth of yams, and they hold ceremonies to honor these ancestors. Special long yams (distinct from the short yams cultivated for consumption) are on display during these festivities, and the largest bear the names of important ancestors. Yam masks (FIG. **12-7**) with cane or wood frames, usually painted red, white, yellow, and black, are an integral part of the ceremonies. The most elaborate masks also incorporate sculpted faces, cassowary feathers, and shell ornaments. The Abelam use the same designs to decorate their bodies for dances, revealing how closely they identify with their principal food source.

**12-7** Abelam yam mask, from Maprik district, Papua New Guinea, Melanesia. Painted cane, 1′ 6 $\frac{9}{10}$″ high. Musée Barbier-Mueller, Geneva.

The Abelam believe their ancestors aid in the growth of their principal crop, the yam. Painted cane yam masks are an important part of the elaborate ceremonies honoring these ancestors.

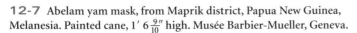

1 in.

## New Ireland and the Trobriand Islands

East of New Guinea but part of the modern nation of Papua New Guinea are New Ireland and the Trobriand Islands, two important Melanesian art centers.

**NEW IRELAND** Mortuary rites and memorial festivals are a central concern of the Austronesian-speaking peoples who live in the northern section of New Ireland. The term *malanggan* refers to both the festivals held in honor of the deceased and the carvings and objects produced for these festivals. One of the first references to malanggan appears in an 1883 publication, and these rituals continue today. Malanggan rites are part of an ancestor cult and are critical in facilitating the transition of the soul from the world of the living to the realm of the dead. In addition to the religious function of malanggan, the extended ceremonies also promote social solidarity and stimulate the economy (as a result of the resources necessary to mount impressive festivities). To educate the younger generation about these practices, malanggan ceremonies also include the initiation of young men.

Among the many malanggan carvings produced—masks, figures, poles, friezes, and ornaments—are tatanua masks (FIG. **12-8**). *Tatanua* represent the spirits of specific deceased people. The materials used to make New Ireland tatanua masks are primarily soft wood, vegetable fiber, and rattan. The crested hair, made of fiber, duplicates a hairstyle formerly common among the men. For the eyes, the mask makers insert sea snail opercula (the operculum is the plate that closes the shell). Traditionally, artists paint the masks black, white, yellow, and red—colors the people of New Ireland associate with warfare, magic spells, and violence. Although some masks are display pieces, dancers wear most of them. Rather than destroying their ritual masks after the conclusion of the ceremonies, as some other cultures do, the New Irelanders store them for future use.

**TROBRIAND ISLANDS** The various rituals of Oceanic cultures discussed thus far often involve exchanges that cement social relationships and reinforce or stimulate the economy. Further, these rituals usually have a spiritual dimension. All of these aspects apply to the practices of the Trobriand Islanders, who live off the coast of the southeastern corner of New Guinea. *Kula*—an exchange of white conus-shell arm ornaments for red chama-shell necklaces—is a char-

**12-8** Tatanua mask, from New Ireland, Papua New Guinea, Melanesia, 19th to 20th centuries. Wood, fiber, shell, lime, and feathers, 1′ 5½″ high. Otago Museum, Dunedin.

In New Ireland, malanggan rites facilitate the transition of the soul from this world to that of the dead. Dancers wearing tatanua masks representing the deceased play a key role in these ceremonies.

acteristic practice of the Trobriand Islanders. Possibly originating some 500 years ago, kula came to Western attention through the extensive documentation of anthropologist Bronislaw Malinowski (1884–1942), published in 1920 and 1922. Kula exchanges can be complex, and there is great competition for valuable shell ornaments (determined by aesthetic appeal and exchange history). Because of the isolation imposed by their island existence, the Trobriand Islanders had to undertake potentially dangerous voyages to participate in kula trading. Appropriately, the Trobrianders lavish a great deal of effort on decorating their large and elaborately carved canoes, which feature ornate prows and splashboards (FIG. **12-9**). To ensure a successful kula expedition, the Trobrianders invoke spells when attaching these prows to the canoes. Human, bird, and serpent motifs—references to sea spirits, ancestors, and totemic animals—appear on the prows and splashboards.

**12-9** Canoe prow and splashboard, from Trobriand Islands, Papua New Guinea, Melanesia, 19th to 20th centuries. Wood and paint, 1′ 3½″ high, 1′ 11″ long. Musée du quai Branly, Paris.

To participate in kula exchanges, the Trobriand Islanders had to undertake dangerous sea voyages. They decorated their canoes with abstract human, bird, and serpent motifs referring to sea spirits.

Because the sculptors use highly stylized motifs in intricate, intertwined curvilinear designs, identification of the specific representations is difficult. In recent decades, the Trobrianders have adapted kula to modern circumstances, largely abandoning canoes for motorboats. The exchanges now facilitate business and political networking.

# MICRONESIA

The Austronesian-speaking cultures of Micronesia tend to be more socially stratified than those found in New Guinea and other Melanesian areas. Micronesian cultures frequently center on chieftainships with craft and ritual specializations, and their religions include named deities as well as honored ancestors. Life in virtually all Micronesian cultures focuses on seafaring activities—fishing, trading, and long-distance travel in large oceangoing vessels. For this reason, much of the artistic imagery of Micronesia relates to the sea.

## Caroline Islands

The Caroline Islands are the largest island group in Micronesia. The arts of the Caroline Islands include the carving of canoes and the fashioning of charms and images of spirits to protect travelers at sea and for fishing and fertility magic.

**CHUUK** Given the importance of seafaring, it is not surprising that many of the most highly skilled artists in the Caroline Islands were master canoe builders. The canoe prow ornament illustrated here (FIG. 12-10) comes from Chuuk. Carved from a single plank of wood and fastened to a large, paddled war canoe, the prow ornament provided protection on arduous or long voyages. That this and similar prow ornaments are not permanent parts of the canoes reflects their function. When approaching another vessel, the Micronesian seafarers lowered these ornaments as a signal that their voyage was in peace. The seemingly abstract design of the Chuuk prow may represent, at the top, two facing sandpipers. Some scholars, however, think the entire piece represents a stylized human figure, with the "birds" constituting the arms.

**BELAU** On Belau (formerly Palau) in the Caroline Islands, the islanders put much effort into creating and maintaining elaborately painted men's ceremonial clubhouses called *bai*. Whereas the Iatmul make their ceremonial houses (FIG. 12-5) by tying, lashing, and weaving different-size posts, trees, saplings, and grasses, the Belau people construct the main structure of the bai entirely of worked, fitted, joined, and pegged wooden elements, which allows them to assemble it easily. The Belau bai (FIG. 12-11) have steep overhanging roofs decorated with geometric patterns along the roof boards. Skilled artists carve the gable in low relief and paint it with narrative scenes as well as various abstracted forms of the shell money used traditionally on Belau as currency. These decorated storyboards illustrate important historical events and myths related to the clan who built the bai. Similar carved and painted crossbeams are inside the house. The rooster images along the base of the facade symbolize the rising sun, while the multiple frontal human faces carved and painted above the entrance and on the vertical elements above the

**12-10** Canoe prow ornament, from Chuuk, Caroline Islands, late 19th century. Painted wood, birds 11″ × 10⅝″. British Museum, London.

Prow ornaments protected canoe paddlers and could be lowered to signal a peaceful voyage. This Micronesian example may represent facing sandpipers or perhaps a stylized human figure.

**12-11** Men's ceremonial house, from Belau (Palau), Republic of Belau, Micronesia, 20th century. Ethnologisches Museum, Staatliche Museen zu Berlin, Berlin.

The Belau men's clubhouses (bai) have extensive carved and painted decorations illustrating important events and myths related to the clan who built the bai. The central motif is a Dilukai (FIG. 12-12).

## Women's Roles in Oceania

Given the prominence of men's houses and the importance of male initiation in so many Oceanic societies, one might conclude that women are peripheral members of these cultures. Much of the extant material culture—ancestor masks, shields, clubs—seems to corroborate this. In reality, however, women play crucial roles in most Pacific cultures, although those functions may be less ostentatious or public than those of men. In addition to their significant contributions through exchange and ritual activities to the maintenance and perpetuation of the social network upon which the stability of village life depends, women are important producers of art.

Historically, Oceanic women's artistic production has been restricted mainly to forms such as barkcloth, weaving, and pottery. In some cultures in New Guinea, potters were primarily female. Throughout much of Polynesia, women produced barkcloth (see "Tongan Barkcloth," page 235), which they often dyed and stenciled and sometimes even perfumed. Women in the Trobriand Islands still make brilliantly dyed skirts of shredded banana fiber that not only are aesthetically beautiful but also serve as a form of wealth, presented symbolically during mortuary rituals.

**12-12** Dilukai, from Belau (Palau). Wood, pigment, and fiber, 1′ 11 5/8″ high. Linden Museum, Stuttgart.

Sculpted wooden figures of a splayed female, or Dilukai, commonly appear over the entrance to a Belau bai (FIG. 12-11). The figures served as symbols of fertility and protected the men's house.

In most Oceanic cultures, women cannot use specialized tools and work in hard materials, such as wood, stone, bone, or ivory, or produce images that have religious or spiritual powers or that confer status on their users. Scholars investigating the role of the artist in Oceania have concluded that the reason for these restrictions is a perceived difference in innate power. Because women have the natural power to create and control life, male-dominated societies developed elaborate ritual practices that served to counteract this female power. By excluding women from participating in these rituals and denying them access to knowledge about specific practices, men derived a political authority that could be perpetuated. It is important to note, however, that even in rituals or activities restricted to men, women often participate. For example, in the now-defunct Hevehe ceremonial cycle (FIG. 12-5) in Papua New Guinea, women helped to construct the masks but feigned ignorance about these sacred objects, because such knowledge was the exclusive privilege of initiated men.

Pacific cultures often acknowledged the innate power of women in the depictions of them in Oceanic art. For example, the splayed Dilukai female sculpture (FIG. 12-12) that appears regularly on Belau

bai (men's houses; FIG. 12-11) celebrates women's procreative powers. The Dilukai figure also confers protection upon visitors to the bai, another symbolic acknowledgment of female power. Similar concepts underlie the design of the Iatmul men's house (FIG. 12-5). Conceived as a giant female ancestor, the men's house incorporates women's natural power into the conceptualization of what is normally the most important architectural structure of an Iatmul village. In addition, the Iatmul associate entrance and departure from the men's house with death and rebirth, thereby reinforcing the primacy of fertility and the perception of the men's house as representing a woman's body.

One reason scholars have tended to overlook the active participation of women in all aspects of Oceanic life is that until recently the objects visitors to the Pacific collected were primarily those that suggest aggressive, warring societies. That the majority of these Western travelers were men and therefore had contact predominantly with men no doubt accounts for this pattern of collecting. Recent scholarship has done a great deal to rectify this misperception, thereby revealing the richness of social, artistic, and political activity in the Pacific.

rooster images represent a deity called Blellek. He warns women to stay away from the ocean and the bai or he will molest them.

Although the bai was the domain of men, women figured prominently in the imagery that covered it, consistent with the important symbolic and social positions that women held in Belau culture (see

"Women's Roles in Oceania," above). A common element surmounting the main bai entrance was a simple, symmetrical wooden sculpture (on occasion, a painting) of a splayed female figure, known as *Dilukai* (FIGS. 12-11 and 12-12). Serving as a symbol of both protection and fertility, the Dilukai faces east to absorb the sun's life-giving rays.

# POLYNESIA

Polynesia was one of the last areas in the world that humans settled. Habitation in the western Polynesian islands did not begin until about the end of the first millennium BCE, and in the south not until the first millennium CE. The settlers brought complex sociopolitical and religious institutions with them. Whereas Melanesian societies are fairly egalitarian and advancement in rank is possible, Polynesian societies typically are highly stratified, with power determined by heredity. Indeed, rulers often trace their genealogies directly to the gods of creation. Most Polynesian societies possess elaborate political organizations headed by chiefs and ritual specialists. By the 1800s, some Polynesian cultures (Hawaii and the Society Islands, for example) evolved into kingdoms. Because of this social hierarchy, historically most Polynesian art belonged to persons of noble or high religious background and served to reinforce their power and prestige. These objects, like their eminent owners, often possessed *mana*, or spiritual power.

## Easter Island

**MOAI** Some of the earliest datable artworks in Oceania are also the largest. The *moai* (FIG. **12-13**) found on Easter Island are monumental sculptures as much as 40 feet tall. They stand as silent sentinels on stone platforms (*ahu*) marking burial or sacred sites used for religious ceremonies. Most of the moai consist of huge, blocky figures with planar facial features—large staring eyes, strong jaws, straight noses with carefully articulated nostrils, and elongated earlobes. A number of the moai have *pukao*—small red scoria cylinders that serve as a sort of topknot or hat—placed on their heads (FIG. **12-1**). Although debate continues, many scholars believe that lineage heads or their sons erected the moai and that the sculptures depict ancestral chiefs. The moai, however, are not individual portraits but generic images that the Easter Islanders believed had the ability to accommodate spirits or gods. The statues thus mediate between chiefs and gods, and between the natural and cosmic worlds.

Archaeological surveys have documented nearly 900 moai. Most of the stones are soft volcanic tuff and came from the same quarry. Some of the sculptures are red scoria, basalt, or trachyte. After quarrying and carving the moai, the Easter Islanders dragged them to the particular ahu site and then positioned them vertically. Given the extraordinary size of these *monoliths*, their production and placement serve as testaments to the achievements of this Polynesian culture. Each statue weighs up to 100 tons. According to one scholar, it would have taken 30 men one year to carve a moai, 90 men two months to move it from the quarry, and 90 men three months to position it vertically on the platform.

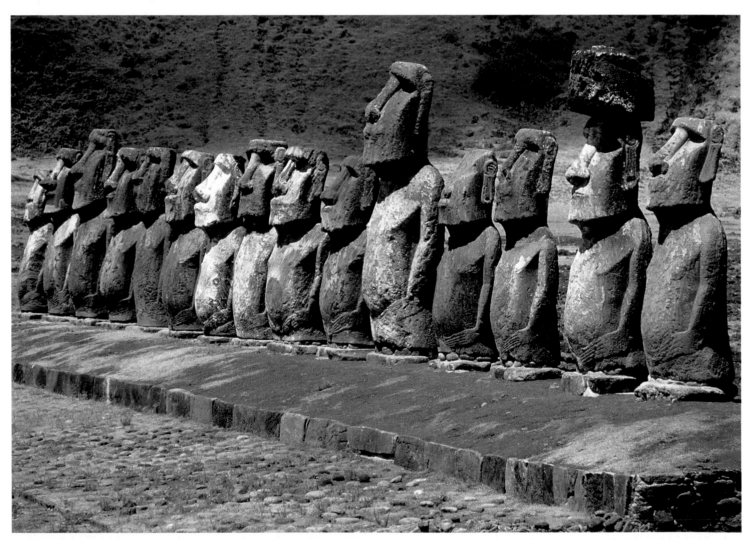

**12-13** Row of moai on a stone platform, Rapa Nui (Easter Island), Polynesia, 10th to 12th centuries. Volcanic tuff and red scoria.

The moai of Easter Island are monoliths as much as 40 feet tall. Most scholars believe they portray ancestral chiefs. They stand on platforms marking burials or sites for religious ceremonies.

## Tongan Barkcloth

Tongan barkcloth provides an instructive example of the labor-intensive process of tapa production. At the time of early contact between Europeans and Polynesians in the late 18th and early 19th centuries, ranking women in Tonga made decorated barkcloth (*ngatu*). Today, organizations called *kautaha*—groups of women not of noble birth—produce it, although high-ranking women are often sponsors of the kautaha. In Tonga men plant the paper mulberry tree and harvest it in two to three years. They cut the trees into about 10-foot lengths and allow them to dry for several days. Then the women strip off the outer bark and soak the inner bark in water to prepare it for further processing. They place these soaked inner bark strips over a wooden anvil and repeatedly strike them with a wooden beater until they spread out and flatten. Folding and layering the strips while beating them, a type of felting process, results in a wider piece of ngatu than the original strips. Afterward, the beaten barkcloth dries and bleaches in the sun.

The next stage of ngatu production involves the placement of the thin, beaten sheets over semicircular boards. The women then fasten embroidered design tablets (*kupesi*—usually produced by men) of low-relief leaf, coconut leaf midribs, and string patterns to the boards. They transfer the patterns on the design tablets to the barkcloth by rubbing. Then the women fill in the lines and patterns by painting, covering the large white spaces with painted figures. The Tongans use brown, red, and black pigments derived from various types of bark, clay, fruits, and soot to create the colored patterns on ngatu. Sheets, rolls, and strips of ngatu play an important role in weddings, funerals, and ceremonial presentations for ranking persons.

**12-14** MELE SITANI, ngatu with manulua designs, Tonga, Polynesia, 1967. Barkcloth.

In Tonga, the production of decorated barkcloth, or ngatu, involves dyeing, painting, stenciling, and perfuming. Mele Sitani made this one with a two-bird design for the coronation of Tupou IV.

# Tonga

Tonga is the westernmost island in Polynesia. Its arts are varied, but one of its most distinctive products is barkcloth, which women have traditionally produced throughout Polynesia.

**BARKCLOTH** Artists produce barkcloth from the inner bark of the paper mulberry tree. The finished product goes by various names in Polynesia, but during the 19th century, when the production of barkcloth reached its zenith, *tapa* became the most widely used term. Although the primary use of tapa in Polynesia was for clothing and bedding, in Tonga large sheets (FIG. **12-14**) were (and still are) produced for exchange (see "Tongan Barkcloth," above). In addition, barkcloth has a spiritual dimension in that it can confer sanctity upon an object wrapped in it. Appropriately, the Polynesians traditionally wrapped the bodies of high-ranking deceased chiefs in barkcloth.

The use and decoration of tapa have varied over the years. In the 19th century, tapa used for everyday clothing was normally unadorned, whereas tapa intended for ceremonial or ritual purposes was dyed, painted, stenciled, and sometimes even perfumed. The designs applied to the tapa differed depending upon the particular island group producing it and the function of the cloth. The production process was complex and time-consuming. Indeed, some Oceanic cultures, such as those of Tahiti and Hawaii, constructed buildings specifically for the beating stage in the production of barkcloth. Tapa production reached its peak in the early 19th century, partly as a result of the interest expressed by Western whalers and missionaries. By the late 19th century, the use of tapa for cloth had

been abandoned throughout much of eastern Polynesia, although its use in rituals (for example, as a wrap for corpses of deceased chiefs or as a marker of tabooed sites) continued. Even today, tapa exchanges are still an integral part of funerals and marriage ceremonies and even the coronation of kings.

The decorated barkcloth, or *ngatu*, shown in FIG. 12-14 clearly shows the richness of pattern, subtlety of theme, and variation of geometric forms that characterize Tongan royal barkcloth. MELE SITANI made this ngatu for the accession ceremony of King Tupou IV (r. 1965–2006) of Tonga. She kneels in the middle of the ngatu, which features triangular patterns known as *manulua*. This pattern results from the intersection of three or four triangular points. "Manulua" means "two birds," and the design gives the illusion of two birds flying together. The motif symbolizes chieftain status derived from both parents.

## Cook and Marquesas Islands

Even though the Polynesians were skillful navigators, various island groups remained isolated from one another for centuries by the vast distances they would have had to cover in open outriggers. This geographical separation allowed distinct regional styles to develop within a recognizable general Polynesian style.

**RAROTONGA** Deity images with multiple figures attached to their bodies are characteristic of Rarotonga and Mangaia in the Cook Islands and Rurutu in the Austral Islands. These carvings probably represented clan and district ancestors, revered for their protective and procreative powers. Ultimately, the images refer to the creator deities the Polynesians venerate for their central role in human fertility.

The residents of the central Polynesian island of Rarotonga used various types of carved deity figures well into the early decades of the 19th century, when Christians converted the islanders and destroyed their deities as part of the process. These included carved wooden fishermen's gods, large naturalistic deity images, and at least three types of staff gods (also called district gods), some more than 20 feet long.

One of the smaller but best-preserved examples (FIG. 12-15) may depict the Polynesian creator god Tangaroa. His head, with its enormous eyes, is about a third of the height of the sculpture. The "body" of the god resembles a spinal column and consists of seven figures with alternating frontal and profile heads. They probably represent the successive generations of humans Tangaroa created. The imagery suggests that these humans come from the body of the god. Several of the figures have erect penises, an unmistakable reference to sexual reproduction and the continuation of the race for many generations to come.

**MARQUESAS ISLANDS** Although Marquesan chiefs trace their right to rule genealogically, the political system before European contact allowed for the acquisition of power by force. As a result, warfare was widespread through the late 19th century. Among the items produced by Marquesan artists were ornaments (FIG. 12-16) that often adorned the hair of warriors. The hollow, cylindrical bone or ivory ornaments (*ivi p'o*) functioned as protective amulets. Warriors wore them until they avenged the death of a kinsman. The ornaments are in the form of *tiki*—carvings of exalted, deified ancestor figures. The large, rounded eyes and wide mouths of the tiki are typically Marquesan.

Another important art form for Marquesan warriors during the 19th century was *tattoo,* which, like the hair ornaments, protected the individual, serving in essence as a form of spiritual armor. Body decoration in general is among the most pervasive art forms found throughout Oceania. Polynesians developed the painful but prestigious art of tattoo more fully than many other Oceanic peoples (see "Tattoo in Polynesia," page 237), although tattooing was also common in Micronesia. In Polynesia, with its hierarchical social structure, nobles and warriors in particular accumulated various tattoo patterns over the years to enhance their status, mana, and personal beauty. Largely as a result of missionary pressure in the 19th century,

**12-15** Staff god (Tangaroa?), from Rarotonga, Cook Islands, Polynesia. Wood, 2′ 4½″ high. Cambridge University Museum of Archaeology and Anthropology, Cambridge.

The "body" of the Polynesian god Tangaroa consists of seven figures that probably represent generations of his human offspring. Several of the figures have erect penises, a reference to procreation.

**12-16** Hair ornaments from the Marquesas Islands, Polynesia, collected in the 1870s. Bone, 1½″ high (*left*), 1⅖″ high (*right*). University of Pennsylvania Museum of Archaeology and Anthropology, Philadelphia.

These hollow cylindrical bone ornaments representing deified ancestors adorned the hair of Marquesan warriors during the 19th century. The warriors wore them until they avenged the death of a kinsman.

# Tattoo in Polynesia

Throughout Oceanic cultures, body decoration was an important means of representing cultural and personal identity. In addition to clothing and ornaments, body adornment most often took the form of tattoo. Tattooing was common among Micronesian cultures, but it was even more extensively practiced in Polynesia. Indeed, the English term *tattoo* is Polynesian in origin, related to the Tahitian, Samoan, and Tongan word *tatau* or *tatu*. In New Zealand, the markings are called *moko*. Within Polynesian cultures, tattooing reached its zenith in the highly stratified societies—New Zealand, the Marquesas Islands, Tahiti, Tonga, Samoa, and Hawaii. Both sexes displayed tattoos. In general, men had more tattoos than did women, and the location of tattoos on the body differed. For instance, in New Zealand, the face and buttocks were the primary areas of male tattooing, whereas tattoos appeared on the lips and chin of women.

Historically, tattooing served a variety of functions in Polynesia beyond personal beautification. It indicated status, because the quantity and quality of tattoos often reflected rank. In the Marquesas Islands, for example, tattoos completely covered the bodies of men of high status (FIG. 12-17). Certain patterns could be applied only to ranking individuals, but commoners also had tattoos, generally on a less extensive scale than elite individuals. For identification purposes, slaves had tattoos on their foreheads in Hawaii and on their backs in New Zealand. There are also accounts of defeated warriors being tattooed. In some Polynesian societies, tattoos identified clan or familial connections. The markings could also serve a protective function by in essence wrapping the body in a spiritual armor. On occasion, tattoos marked significant events. In Hawaii, for example, a tattooed tongue was a sign of grief. The pain the tattooed person endured was a sign of respect for the deceased.

Priests who were specially trained in the art form usually applied the tattoos. Rituals, chants, or ceremonies often accompanied the procedure, which took place in a special structure. Tattooing involves the introduction of black, carbon-based pigment under the skin with the use of a bird-bone tattooing comb or chisel and a mallet. In New Zealand, a distinctive technique emerged for tattooing the face. In a manner similar to Maori woodcarving, a serrated chisel created a groove in the skin to receive pigment, thereby producing a colored line.

Polynesian tattoo designs were predominantly geometric, and affinities with other forms of Polynesian art are evident. For example, the curvilinear patterns that predominate in Maori facial moko recall the patterns found on *poupou*, decorated wall panels in Maori meetinghouses (FIG. 12-20). Depending on their specific purpose, many tattoos could be "read" or deciphered. For facial tattoos, the Maori generally divided the face into four major symmetrical zones: the left and right forehead down to the eyes, the left lower face, and the right lower face. The right-hand side conveyed information on the father's rank, tribal affiliations, and social position, while the

**12-17** Tattooed warrior with war club, Nukahiva, Marquesas Islands, Polynesia, early 19th century. Color engraving in Carl Bertuch, *Bilderbuch für Kinder* (Weimar, 1813).

In Polynesia, with its hierarchical social structure, nobles and warriors accumulated tattoo patterns to enhance their status and beauty. Tattoos wrapped a warrior's body in spiritual armor.

left-hand side provided matrilineal information. Smaller secondary facial zones imparted information about the tattooed individual's profession and position in society. Te Pehi Kupe (FIG. I-5) was the chief of the Ngato Toa in the early 19th century. The upward and downward *koru* (unrolled spirals) in the middle of his forehead connote his descent from two paramount tribes. The small design in the center of his forehead documents the extent of his domain—north, south, east, and west. The five double koru in front of his left ear indicate that the supreme chief (the highest rank in Maori society) was part of his matrilineal line. The designs on his lower jaw and the anchor-shaped koru nearby reveal that Te Pehi Kupe was not only a master carver but descended from master carvers as well.

tattooing virtually disappeared in many Oceanic societies, but some Pacific peoples have revived tattooing as an expression of cultural pride.

An 1813 engraving (FIG. 12-17) depicts a Marquesan warrior from Nukahiva Island covered with elaborate tattoo patterns. The warrior holds a large wooden war club over his right shoulder and carries a decorated water gourd in his left hand. The various tattoo patterns marking his entire body seem to subdivide his body parts into zones on both sides of a line down the center. Some tattoos accentuate joint areas, whereas others separate muscle masses into horizontal and vertical geometric shapes. The warrior also covered his face, hands, and feet with tattoos.

**12-18** Feather cloak, from Hawaii, Polynesia, ca. 1824–1843. Feathers and fiber netting, 4′ 8⅓″ × 8′. Bishop Museum, Honolulu.

Costly Hawaiian feather cloaks (ʻahu ʻula) like this one, which belonged to King Kamehameha III, provided the protection of the gods. Each cloak required the feathers of thousands of birds.

1 ft.

# Hawaii

The Hawaiians developed the most highly stratified social structure in the Pacific. By 1795 the chief Kamehameha unified the major islands of the Hawaiian archipelago and ascended to the pinnacle of power as King Kamehameha I (r. 1810–1819). This kingdom did not endure, however, and Hawaii soon came under American control. The United States annexed Hawaii as a territory in 1898 and eventually conferred statehood on the island group in 1959.

**FEATHER CLOAKS** Because perpetuation of the social structure was crucial to social stability, most of the Hawaiian art forms produced before American control served to visualize and reinforce the hierarchy. Regalia for chieftains and other elite individuals were a prominent part of artistic production. For example, elegant feather cloaks (ʻahu ʻula) such as the early-19th-century example shown here (FIG. **12-18**) belonged to men of high rank. Every aspect of the ʻahu ʻula reflected the status of its wearer. The materials were exceedingly precious, particularly the red and yellow feathers from the ʻiʻiwi, ʻapapane, ʻoʻo, and mamo birds. Some of these birds yield only six or seven suitable feathers, and given that a full-length cloak could require up to 500,000 feathers, extraordinary resources and labor went into producing the garment. The cloak also linked its owner to the gods. The Polynesians associated the sennit (plaited fiber or cord) base for the feathers with deities. Not only did these cloaks confer the protection of the gods on their wearers, but their dense fiber base and feather matting also provided physical protection. The cloak in FIG. **12-18** originally belonged to King Kamehameha III (r. 1824–1854), who gave it to Commodore Lawrence Kearny of the U.S. frigate *Constellation* in 1843 in gratitude for Kearny's assistance during a temporary occupation of Hawaii.

**KUKAʻILIMOKU** The gods were a pervasive presence in Hawaiian society and were part of every person's life, regardless of status. Chiefs in particular invoked them regularly and publicized their own genealogical links to the gods to reinforce their right to rule. One prominent Hawaiian deity was Kukaʻilimoku, the war god. As chiefs in the prekingdom years struggled to maintain and expand their control, warfare was endemic, hence Kukaʻilimoku's importance. Indeed, Kukaʻilimoku served as Kamehameha I's special tutelary deity, and the

**12-19** Kukaʻilimoku, from Hawaii, Polynesia, late 18th or early 19th century. Wood, 2′ 5¾″ high (figure only). British Museum, London.

This wooden statue of the Hawaiian war god comes from a temple. His muscular body is flexed to attack, and his wide mouth and bared teeth set in a large head convey aggression and defiance.

1 ft.

Kuka'ilimoku sculpture illustrated here (FIG. 12-19) stood in a *heiau* (temple) on the island of Hawaii, where Kamehameha I originally ruled before expanding his authority to the entire Hawaiian chain. This late-18th- or early-19th-century Hawaiian wooden temple image, more than four feet tall, confronts its audience with a ferocious expression. The war god's head comprises nearly a third of his entire body. His enlarged, angled eyes and wide-open figure-eight-shaped mouth, with its rows of teeth, convey aggression and defiance. His muscular body appears to stand slightly flexed, as if ready to act. The artist realized this Hawaiian war god's overall athleticism through the full-volume, faceted treatment of his arms, legs, and the pectoral area of the chest. In addition to sculptures of deities such as this, Hawaiians placed smaller versions of lesser deities and ancestral images in the heiau. Differing styles have surfaced in the various islands of the Hawaiian chain, but the sculptured figures share a tendency toward athleticism and expressive defiance.

## New Zealand

The Maori of New Zealand (Aotearoa) share many cultural practices with other Polynesian societies. As in other cultures, ancestors and lineage play an important role.

**MEETINGHOUSES** The Maori meetinghouses demonstrate the primacy of ancestral connections. The Maori conceptualize the entire building as the body of an ancestor. The central beam across the roof is the spine, the rafters are ribs, and the barge boards (the angled boards that outline the house gables) in front represent arms. Construction of the Mataatua meetinghouse (FIG. 12-20) at Whakatane began in 1871 and took four years to complete. The lead sculptor was WEPIHA APANUI of the Ngati Awa clan. On the inside of the meetinghouse, ancestors constitute a potent presence through their appearance on *poupou* (the relief panels along the walls). The panels depict specific ancestors, each of which appears frontally with hands across the stomach. The elaborate curvilinear patterns covering the entire poupou may represent tattoos. Decoration appears on virtually every surface of the meetinghouse. In the spaces between the poupou are *tukutuku* (stitched lattice panels). Above, intricate painted shapes cover the rafters. In the center of the meetinghouse stand *pou tokomanawa*, sculptures of ancestors that support the building's ridgepoles (not visible in FIG. 12-20). The composite presence of all of these ancestral images and of the energetic, persistent patterning creates a charged space for the initiation of collective action.

**12-20** WEPIHA APANUI, Mataatua meetinghouse (view of interior), Maori, Whakatane, New Zealand, Polynesia, 1871–1875.

Maori meetinghouses feature elaborate decoration. In this late-19th-century example, Wepiha Apanui carved figures of ancestors along the interior walls. The patterns on their bodies may be tattoos.

1 ft.

**12-21** Cliff Whiting (Te Whanau-A-Apanui), *Tawhiri-Matea* (*God of the Winds*), Maori, Polynesia, 1984. Oil on wood and fiberboard, 6′ 4⅜″ × 11′ 10¾″. Meteorological Service of New Zealand, Wellington.

In this carved wooden mural depicting the Maori creation myth, Cliff Whiting revived native formal and iconographic traditions and techniques. The abstract curvilinear design suggests wind turbulence.

**CLIFF WHITING** Largely as a result of colonial and missionary intervention in the 18th through 20th centuries, many Oceanic cultures abandoned traditional practices, and production of many of the art forms illustrated in this chapter ceased. In recent years, however, a new, confident cultural awareness has led some Pacific artists to assert their inherited values with pride and to express them in a resurgence of traditional arts, such as weaving, painting, tattooing, and carving. Today's thriving tourist trade has also contributed to a resurgence of traditional art production.

One example that represents the many cases of cultural renewal in native Oceanic art is the vigorously productive school of New Zealand artists who draw on their Maori heritage for formal and iconographic inspiration. The historical Maori woodcarving craft (FIG. **12-20**) brilliantly reemerges in what the artist Cliff Whiting (Te Whanau-A-Apanui, b. 1936) calls a "carved mural" (FIG. **12-21**). Whiting's *Tawhiri-Matea* is a masterpiece of woodcrafting designed for the very modern environment of an exhibition gallery. The artist suggested the wind turbulence with the restless curvature of the main motif and its myriad serrated edges. The 1984 mural depicts events

in the Maori creation myth. The central figure, Tawhiri-Matea, god of the winds, wrestles to control the children of the four winds, seen as blue spiral forms. Ra, the sun, energizes the scene from the top left, complemented by Marama, the moon, in the opposite corner. The top right image refers to the primal separation of Ranginui, the Sky Father, and Papatuanuku, the Earth Mother. Spiral koru motifs symbolizing growth and energy flow through the composition. Blue waves and green fronds around Tawhiri suggest his brothers Tangaroa and Tane, gods of the sea and forest.

Whiting is securely at home with the native tradition of form and technique, as well as with the worldwide aesthetic of modern design. Out of the seamless fabric made by uniting both, he feels something new can develop that loses nothing of the power of the old. The artist champions not only the renewal of Maori cultural life and its continuity in art but also the education of the young in the values that made that culture great—values he asks them to perpetuate. The salvation of the native identity of the next generation of New Zealanders will depend on their success in making the Maori culture once again their own.

# OCEANIA

## AUSTRALIA AND MELANESIA

▌ The westernmost Oceanic islands have been populated for at least 40,000 years, but most of the preserved art dates to the past several centuries.

▌ The Aboriginal art of Australia focuses on ancestral spirits called Dreamings, whom artists represented in an X-ray style showing the internal organs.

▌ The Asmat of New Guinea avenged a relative's death by headhunting. Before embarking on a raid, they erected bisj poles bearing carved and painted figures of ancestors and animals.

▌ The center of every Iatmul village was a saddle-shaped ceremonial men's house representing a woman. Images of clan ancestors decorated the interior.

▌ Masks figured prominently in many Melanesian cultures. The Elema celebrated water spirits in the festive cycle called Hevehe, which involved ornate masks up to 25 feet tall. The Abelam fashioned yam masks for rituals revolving around their principal crop. In New Ireland, dancers wore tatanua masks representing the spirits of the deceased.

▌ Seafaring was also a major theme of much Melanesian art. The Trobriand Islanders decorated their canoes with elaborately carved prows and splashboards.

Auuenau, Western Arnhem Land, Australia, 1913

Canoe prow and splashboard, Trobriand Islands, 19th to 20th centuries

## MICRONESIA

▌ The major themes of Melanesian art are also found in Micronesia. For example, the people of the Caroline Islands produced carved and painted prow ornaments for their canoes.

▌ The Micronesian peoples also erected ceremonial men's houses. The bai of Belau are distinctive in having Dilukai figures in the gable of the eastern entrance. The Dilukai is a woman with splayed legs who faces the sun and serves as a symbol of procreation and as a guardian of the house.

Men's ceremonial house, Belau, 20th century

## POLYNESIA

▌ Polynesia was one of the last areas of the world that humans settled, but the oldest monumental art of Oceania is the series of moai on Easter Island. These colossal monolithic sculptures, which stood in rows on stone platforms, probably represent ancestors.

▌ Barkcloth is an important art form in Polynesia even today. The decorated barkcloth, or ngatu, of Tonga was used to wrap the corpses of deceased chiefs and for other ritual purposes, including the coronation of kings.

▌ Body adornment in the form of tattooing was widespread in Polynesia, especially in the Marquesas Islands and New Zealand. In addition to personal beautification, tattoos served to distinguish rank and provided warriors with a kind of spiritual armor.

▌ Meetinghouses played an important role in Polynesian societies, as elsewhere in the Pacific islands. The meetinghouses of the Maori of New Zealand are notable for their elaborate ornament featuring carved relief panels depicting ancestors.

▌ Images of named gods are common in Polynesia. Wood sculptures from Rarotonga represent the creator god Tangaroa. The Hawaiians erected statues of the war god Kuka'ilimoku in their temples. The tradition continues today in the work of sculptors such as Cliff Whiting of New Zealand.

Moai, Easter Island, 10th to 12th centuries

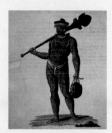

Tattooed warrior, Marquesas Islands, early 19th century

# GLOSSARY

**abhaya**—See *mudra.*

**Abstract Expressionism**—The first major American avant-garde movement, Abstract Expressionism emerged in New York City in the 1940s. The artists produced abstract paintings that expressed their state of mind and that they hoped would strike emotional chords in viewers. The movement developed along two lines: *gestural abstraction* and *chromatic abstraction.*

**additive light**—Natural light, or sunlight, the sum of all the wavelengths of the visible *spectrum.* See also *subtractive light.*

**additive sculpture**—A kind of sculpture *technique* in which materials (for example, clay) are built up or "added" to create form.

**adobe**—The clay used to make a kind of sun-dried mud brick of the same name; a building made of such brick.

**ahu**—A stone platform on which the *moai* of Easter Island stand. Ahu marked burial sites or served ceremonial purposes.

**'ahu 'ula**—A Hawaiian feather cloak.

**akua'ba**—"Akua's child." A Ghanaian image of a young girl.

**album leaf**—A painting on a single sheet of paper for a collection stored in an album.

**amalaka**—In Hindu temple design, the large flat disk with ribbed edges surmounting the beehive-shaped tower.

**ambulatory**—A covered walkway, outdoors (as in a church *cloister*) or indoors; especially the passageway around the *apse* and the *choir* of a church. In Buddhist architecture, the passageway leading around the *stupa* in a *chaitya* hall.

**apse**—A recess, usually semicircular, in the wall of a building, commonly found at the east end of a church.

**apsidal**—Rounded; *apse*-shaped.

**arcade**—A series of *arches* supported by *piers* or *columns.*

**arch**—A curved structural member that spans an opening and is generally composed of wedge-shaped blocks (*voussoirs*) that transmit the downward pressure laterally. See also *thrust.*

**armature**—The crossed, or diagonal, *arches* that form the skeletal framework of a *Gothic rib vault.* In sculpture, the framework for a clay form.

**asceticism**—Self-discipline and self-denial.

**ashlar masonry**—Carefully cut and regularly shaped blocks of stone used in construction, fitted together without mortar.

**asye usu**—Baule (Côte d'Ivoire) bush spirits.

**atlantid**—A male figure that functions as a supporting *column.*

**atlatl**—Spear-thrower, the typical weapon of the Toltecs of ancient Mexico.

**attribute**—(n.) The distinctive identifying aspect of a person, for example, an object held, an associated animal, or a mark on the body. (v.) To make an *attribution.*

**attribution**—Assignment of a work to a maker or makers.

**avatar**—A manifestation of a deity incarnated in some visible form in which the deity performs a sacred function on earth. In Hinduism, an incarnation of a god.

**bai**—An elaborately painted men's ceremonial house on Belau (formerly Palau) in the Caroline Islands of Micronesia.

**baray**—One of the large reservoirs laid out around Cambodian *wats* that served as means of transportation as well as irrigation. A network of canals connected the reservoirs.

**bas-relief**—See *relief.*

**batik**—An Indonesian fabric-dyeing technique using melted wax to form patterns the dye cannot penetrate.

**bay**—The space between two columns, or one unit in the *nave arcade* of a church; also, the passageway in an *arcuated* gate.

**beam**—A horizontal structural member that carries the load of the superstructure of a building; a timber *lintel.*

**bhakti**—In Buddhist thought, the adoration of a personalized deity (*bodhisattva*) as a means of achieving unity with it; love felt by the devotee for the deity. In Hinduism, the devout, selfless direction of all tasks and activities of life to the service of one god.

**bhumisparsha**—See *mudra.*

**bi**—In ancient China, jade disks carved as ritual objects for burial with the dead. They were often decorated with piercings that extended entirely through the object, as well as with surface carvings.

**bichrome**—Two-color.

**bieri**—The wooden *reliquary* guardian figures of the Fang in Gabon and Cameroon.

**bisj pole**—An elaborately carved pole constructed from the trunk of the mangrove tree. The Asmat people of southwestern New Guinea created bisj poles to indicate their intent to avenge a relative's death.

**blind arcade**—An *arcade* having no true openings, applied as decoration to a wall surface.

**bocio**—A Fon (Republic of Benin) empowerment figure.

**bodhisattva**—In Buddhist thought, a potential Buddha who chooses not to achieve enlightenment in order to help save humanity.

**boss**—A circular knob.

**brocade**—The weaving together of threads of different colors.

**Buddha triad**—A three-figure group with a central Buddha flanked on each side by a *bodhisattva.*

**buttress**—An exterior masonry structure that opposes the lateral *thrust* of an *arch* or a *vault.* A pier buttress is a solid mass of masonry. A flying buttress consists typically of an inclined member carried on an arch or a series of arches and a solid buttress to which it transmits lateral *thrust.*

**byobu**—Japanese painted folding screens.

**caliph(s)**—Islamic rulers, regarded as successors of Muhammad.

**calligrapher**—One who practices *calligraphy.*

**calligraphy**—Greek, "beautiful writing." Handwriting or penmanship, especially elegant writing as a decorative art.

**canon**—A rule, for example, of proportion. The ancient Greeks considered beauty to be a matter of "correct" proportion and sought a canon of proportion, for the human figure and for build-

ings. The fifth-century BCE sculptor Polykleitos wrote the *Canon*, a treatise incorporating his formula for the perfectly proportioned statue.

**carving**—A *technique* of sculpture in which the artist cuts away material (for example, from a stone block) in order to create a *statue* or a *relief.*

**casting**—A sculptural *technique* in which the artist pours liquid metal, plaster, clay or another material into a *mold*. When the material dries, the sculptor removes the cast piece from the mold.

**celadon**—A Chinese-Korean pottery *glaze*, fired in an oxygen-deprived kiln to a characteristic gray-green or pale blue color.

**celt**—In Olmec Mexico, an ax-shaped form made of polished jade; generally, a prehistoric metal or stone implement shaped like a chisel or ax head.

**central plan**—See *plan.*

**chacmool**—A Mesoamerican statuary type depicting a fallen warrior on his back with a receptacle on his chest for sacrificial offerings.

**chaitya hall**—A South Asian rock-cut temple hall having a votive *stupa* at one end.

**chakra**—The Buddha's wheel, set in motion at Sarnath.

**chakravartin**—In South Asia, the ideal king, the Universal Lord who ruled through goodness.

**Chan**—See *Zen.*

**characters**—In Chinese writing, signs that record spoken words.

**chatra**—See *yasti.*

**chigi**—Decorative extensions of the *rafters* at each end of the roof of a Japanese shrine.

**choir**—The space reserved for the clergy and singers in the church, usually east of the *transept* but, in some instances, extending into the *nave.*

**chronology**—In art history, the dating of art objects and buildings.

**circumambulation**—In Buddhist worship, walking around the *stupa* in a clockwise direction, a process intended to bring the worshiper into harmony with the cosmos.

**codex** (pl. **codices**)—Separate pages of *vellum* or *parchment* bound together at one side; the predecessor of the modern book. The codex superseded the *rotulus*. In *Mesoamerica*, a painted and inscribed book on long sheets of bark paper or deerskin coated with fine white plaster and folded into accordion-like pleats.

**collage**—A composition made by combining on a flat surface various materials, such as newspaper, wallpaper, printed text and illustrations, photographs, and cloth.

**colonnette**—A thin *column.*

**colophon**—An inscription, usually on the last page, giving information about a book's manufacture. In Chinese painting, written texts on attached pieces of paper or silk.

**color**—The value, or tonality, of a color is the degree of its lightness or darkness. The intensity, or saturation, of a color is its purity, its brightness or dullness. See also *primary colors, secondary colors,* and *complementary colors.*

**column**—A vertical, weight-carrying architectural member, circular in cross-*section* and consisting of a *base* (sometimes omitted), a *shaft*, and a *capital.*

**complementary colors**—Those pairs of colors, such as red and green, that together embrace the entire spectrum. The complement of one of the three *primary colors* is a mixture of the other two.

**compose**—See *composition.*

**composite view**—A convention of representation in which part of a figure is shown in profile and another part of the same figure is shown frontally; also called twisted perspective.

**composition**—The way in which an artist organizes *forms* in an artwork, either by placing shapes on a flat surface or arranging forms in space.

**congregational mosque**—A city's main *mosque*, designed to accommodate the entire Muslim population for the Friday noonday prayer. Also called the great mosque or Friday mosque.

**connoisseur**—An expert in *attributing* artworks to one artist rather than another. More generally, an expert on artistic *style.*

**contour line**—In art, a continuous line defining the outer shape of an object.

**corona civica**—Latin, "civic crown." A Roman honorary wreath worn on the head.

**cuerda seca**—A type of polychrome tilework used in decorating Islamic buildings.

**cutaway**—An architectural drawing that combines an exterior view with an interior view of part of a building.

**cylinder seal**—A cylindrical piece of stone usually about an inch or so in height, decorated with an *incised* design, so that a raised pattern is left when the seal is rolled over soft clay. In the ancient Near East, documents, storage jars, and other important possessions were signed, sealed, and identified in this way. Stamp seals are an earlier, flat form of seal used for similar purposes.

**daguerreotype**—A photograph made by an early method on a plate of chemically treated metal; developed by Louis J. M. Daguerre.

**daimyo**—Local lords who controlled small regions and owed obeisance to the *shogun* in the Japanese *shogunate* system.

**darshan**—In Hindu worship, seeing images of the divinity and being seen by the divinity.

**dharma**—In Buddhism, moral law based on the Buddha's teaching.

**dharmachakra**—See *mudra.*

**dhyana**—See *mudra.*

**Dilukai**—A female figure with splayed legs, a common motif over the entrance to a Belau *bai,* serving as both guardian and fertility symbol.

**documentary evidence**—In art history, the examination of written sources in order to determine the date of an artwork, the circumstances of its creation, or the identity of the artist(s) who made it.

**dotaku**—Ancient Japanese bronze ceremonial bells, usually featuring raised decoration.

**dry painting**—See *sand painting.*

**earthenware**—Pottery made of clay that is fired at low temperatures and is slightly porous. Also, clay figurines and statues produced in the same manner.

**eaves**—The lower part of a roof that overhangs the wall.

**effigy mounds**—Ceremonial mounds built in the shape of animals or birds by native North American peoples.

**elevation**—In architecture, a head-on view of an external or internal wall, showing its features and often other elements that would be visible beyond or before the wall.

**embroidery**—The technique of sewing threads onto a finished ground to form contrasting designs. Stem stitching employs short overlapping strands of thread to form jagged lines. Laid-and-couched work creates solid blocks of color.

**enamel**—A decorative coating, usually colored, fused onto the surface of metal, glass, or ceramics.

**engaged column**—A half-round *column* attached to a wall.

**eravo**—A ceremonial men's meetinghouse constructed by the Elema people in New Guinea.

**finial**—A crowning ornament.

**foreshortening**—The use of *perspective* to represent in art the apparent visual contraction of an object that extends back in space at an angle to the perpendicular plane of sight.

**form**—In art, an object's shape and structure, either in two dimensions (for example, a figure painted on a surface) or in three dimensions (such as a statue).

**formal analysis**—The visual analysis of artistic *form.*

**freestanding sculpture**—See *sculpture in the round.*

**fresco**—Painting on lime plaster, either dry (dry fresco, or fresco secco) or wet (truc, or buon, fresco). In the latter method, the pigments are mixed with water and become chemically bound to the freshly laid lime plaster. Also, a painting executed in either method.

**Friday mosque**—See *congregational mosque.*

**fusuma**—Japanese painted sliding-door panels.

**garbha griha**—Hindi, "womb chamber." In Hindu temples, the *cella*, the holy inner sanctum often housing the god's image or symbol.

**genre**—A style or category of art; also, a kind of painting that realistically depicts scenes from everyday life.

**glaze**—A vitreous coating applied to pottery to seal and decorate the surface; it may be colored, transparent, or opaque, and glossy or *matte*. In oil painting, a thin, transparent, or semitransparent layer applied over a color to alter it slightly.

**gopuras**—The massive, ornamented entrance gateway towers of southern Indian temple compounds.

**gorget**—A neck pendant, usually made of shell.

**Gothic**—Originally a derogatory term named after the Goths, used to describe the history, culture, and art of western Europe in the 12th to 14th centuries. Typically divided into periods designated Early (1140–1194), High (1194–1300), and Late (1300–1500).

**great mosque**—See *congregational mosque.*

**guang**—An ancient Chinese covered vessel, often in animal form, holding wine, water, grain, or meat for sacrificial rites.

**haboku**—In Japanese art, a loose and rapidly executed painting style in which the ink seems to have been applied by flinging or splashing it onto the paper.

**haiku**—A 17-syllable Japanese poetic form.

**handscroll**—In Asian art, a horizontal painted scroll that is unrolled right to left, section by section, and often used to present illustrated religious texts or *landscapes*.

**hanging scroll**—In Asian art, a vertical scroll hung on a wall with pictures mounted or painted directly on it.

**haniwa**—Sculpted fired pottery cylinders, modeled in human, animal, or other forms and placed on Japanese *tumuli* of the Kofun period.

**hard-edge painting**—A variant of *Post-Painterly Abstraction* that rigidly excluded all reference to gesture and incorporated smooth knife-edge geometric forms to express the notion that painting should be reduced to its visual components.

**harmika**—In Buddhist architecture, a stone fence or railing that encloses an area surmounting the *dome* of a *stupa* that represents one of the Buddhist heavens; from the center arises the *yasti*.

**heiau**—A Hawaiian temple.

**Hevehe**—An elaborate cycle of ceremonial activities performed by the Elema people of the Papuan Gulf region of New Guinea. Also, the large, ornate masks produced for and presented during these ceremonies.

**hierarchy of scale**—An artistic convention in which greater size indicates greater importance.

**hieroglyphic**—A system of writing using symbols or pictures.

**high relief**—See *relief*.

**Hijra**—The flight of Muhammad from Mecca to Medina in 622, the year from which Islam dates its beginnings.

**hiragana**—A sound-based writing system developed in Japan from Chinese characters; it came to be the primary script for Japanese court poetry.

**hue**—The name of a *color*. See also *primary colors*, *secondary colors*, and *complementary colors*.

**hypostyle hall**—A hall with a roof supported by *columns*.

**iconography**—Greek, the "writing of images." The term refers both to the content, or subject, of an artwork and to the study of content in art. It also includes the study of the symbolic, often religious, meaning of objects, persons, or events depicted in works of art.

**ikegobo**—A Benin royal shrine.

**illusionism** (adj. **illusionistic**)—The representation of the three-dimensional world on a two-dimensional surface in a manner that creates the illusion that the person, object, or place represented is three-dimensional. See also *perspective*.

**imam**—In Islam, the leader of collective worship.

**installation**—An artwork that creates an artistic environment in a room or gallery.

**intensity**—See *color*.

**internal evidence**—In art history, the examination of what an artwork represents (people, clothing, hairstyles, and so on) in order to determine its date. Also, the examination of the *style* of an artwork to identify the artist who created it.

**iron-wire lines**—In ancient Chinese painting, thin brush lines suggesting tensile strength.

**ivi p'o**—Hollow, cylindrical bone or ivory ornaments produced in the Marquesas Islands (Polynesia).

**iwan**—In Islamic architecture, a *vaulted* rectangular recess opening onto a courtyard.

**jataka**—Tales of the past lives of the Buddha. See also *sutra*.

**jomon**—Japanese, "cord markings." A type of Japanese ceramic technique characterized by ropelike markings.

**junzi**—Chinese, "superior person" or "gentleman." A person who is a model of Confucian behavior.

**Kaaba**—Arabic, "cube." A small cubical building in Mecca, the Islamic world's symbolic center.

**kami**—Shinto deities or spirits, believed in Japan to exist in nature (mountains, waterfalls) and in charismatic people.

**karesansui**—Japanese dry-landscape gardening.

**karma**—In Vedic religions (see *Veda*), the ethical consequences of a person's life, which determine his or her fate.

**katsina**—An art form of Native Americans of the Southwest, the katsina doll represents benevolent supernatural spirits (katsinas) living in mountains and water sources.

**katsuogi**—Wooden logs placed at right angles to the *ridgepole* of a Japanese shrine to hold the thatched roof in place.

**kautaha**—Women's organizations in Tonga (Polynesia) that produce barkcloth.

**khipu**—Andean record-keeping device consisting of numerous knotted strings hanging from a main cord; the strings signified, by position and color, numbers and categories of things.

**kiva**—A square or circular underground structure that is the spiritual and ceremonial center of Pueblo Indian life.

**kogan**—A *Shino* water jar.

**kondo**—Japanese, "golden hall." The main hall for worship in a Japanese Buddhist temple complex. The kondo contained statues of the Buddha and the *bodhisattvas* to whom the temple was dedicated.

**Koran**—Islam's sacred book, composed of *surahs* (chapters) divided into verses.

**koru**—An unrolled spiral design used by the Maori of New Zealand in their *tattoos*.

**Kufic**—An early form of Arabic script, characterized by angularity, with the uprights forming almost right angles with the baseline.

**kula**—An exchange of white conus-shell arm ornaments and red chama-shell necklaces that takes place among the Trobriand Islanders of Papua New Guinea.

**kupesi**—Embroidered design tablets used by Tonga (Polynesia) women in the production of barkcloth.

**lacquer**—A varnishlike substance made from the sap of the Asiatic sumac tree, used to decorate wood and other organic materials. Often colored with mineral pigments, lacquer cures to great hardness and has a lustrous surface.

**lakshana**—One of the distinguishing marks of the Buddha. The lakshanas include the *urna* and *ushnisha*.

**lalitasana**—In Buddhist iconography, the body pose with one leg folded and the other hanging down, indicating relaxation.

**landscape**—A picture showing natural scenery, without narrative content.

**lateral section**—See *section*.

**line**—The extension of a point along a path, made concrete in art by drawing on or chiseling into a *plane*.

**linga**—In Hindu art, the depiction of Shiva as a phallus or cosmic *pillar*.

**linguist's staff**—In Africa, a staff carried by a person authorized to speak for a king or chief.

**literati**—In China, talented amateur painters and scholars from the landed gentry.

**lohan**—A Buddhist holy person who has achieved enlightenment and *nirvana* by suppression of all desire for earthly things.

**longitudinal section**—See *section*.

**lost-wax (cire perdue) process**—A bronze-casting method in which a figure is modeled in wax and covered with clay; the whole is fired, melting away the wax (French, cire perdue) and hardening the clay, which then becomes a mold for molten metal.

**low relief**—See *relief*.

**madrasa**—An Islamic theological college adjoining and often containing a *mosque*.

**maebyong**—A Korean vase similar to the Chinese *meiping*.

**ma-hevehe**—Mythical Oceanic water spirits. The Elema people of New Guinea believed these spirits visited their villages.

**malanggan**—Festivals held in honor of the deceased in New Ireland (Papua New Guinea). Also, the carvings and objects produced for these festivals.

**mana**—In Polynesia, spiritual power.

**mandala**—Sanskrit term for the sacred diagram of the universe; Japanese, mandara.

**mandapa**—*Pillared* hall of a Hindu temple.

**mandara**—See *mandala*.

**mandorla**—An almond-shaped *nimbus* surrounding the figure of Christ or other sacred figure. In Buddhist Japan, a lotus-petal-shaped nimbus.

**mantra**—Sanskrit term for the ritual words or syllables recited in *Shingon* Buddhism.

**manulua**—Triangular patterns based on the form of two birds, common in Tongan *tapa* designs.

**maqsura**—In some *mosques*, a screened area in front of the *mihrab* reserved for a ruler.

**mass**—The bulk, density, and weight of matter in *space*.

**Mass**—The Catholic and Orthodox ritual in which believers understand that Christ's redeeming sacrifice on the cross is repeated when the priest consecrates the bread and wine in the *Eucharist*.

**matte**—In painting, pottery, and photography, a dull finish.

**mausoleum**—A monumental tomb. The name derives from the mid-fourth-century BCE tomb of Mausolos at Halikarnassos, one of the Seven Wonders of the ancient world.

**mbari**—A ceremonial Igbo (Nigeria) house built about every 50 years in honor of the earth goddess Ala.

**mbulu ngulu**—The wood-and-metal *reliquary* guardian figures of the Kota of Gabon.

**medium** (pl. **media**)—The material (for example, marble, bronze, clay, *fresco*) in which an artist

works; also, in painting, the vehicle (usually liquid) that carries the pigment.

**megalith** (adj. **megalithic**)—Greek, "great stone." A large, roughly hewn stone used in the construction of monumental prehistoric structures.

**meiping**—A Chinese vase of a high-shouldered shape; the *sgraffito technique* was used in decorating such vases.

**Mesoamerica**—The region that comprises Mexico, Guatemala, Belize, Honduras, and the Pacific coast of El Salvador.

**mihrab**—A semicircular niche set into the *qibla* wall of a *mosque*.

**minaret**—A distinctive feature of *mosque* architecture, a tower from which the faithful are called to worship.

**minbar**—In a *mosque*, the *pulpit* on which the *imam* stands.

**mingei**—A type of modern Japanese folk pottery.

**miniatures**—Small individual Indian paintings intended to be held in the hand and viewed by one or two individuals at one time.

**mithuna**—In South Asian art, a male-female couple embracing or engaged in sexual intercourse.

**moai**—Large, blocky figural stone sculptures found on Rapa Nui (Easter Island) in Polynesia.

**modernism**—A movement in Western art that developed in the second half of the 19th century and sought to capture the images and sensibilities of the age. Modernist art goes beyond simply dealing with the present and involves the artist's critical examination of the premises of art itself.

**module** (adj. **modular**)—A basic unit of which the dimensions of the major parts of a work are multiples. The principle is used in sculpture and other art forms, but it is most often employed in architecture, where the module may be the dimensions of an important part of a building, such as the diameter of a *column*.

**moko**—The form of tattooing practiced by the Maori of New Zealand.

**moksha**—See *nirvana*.

**mold**—A hollow form for *casting*.

**monolith** (adj. **monolithic**)—A stone *column shaft* that is all in one piece (not composed of *drums*); a large, single block or piece of stone used in *megalithic* structures. Also, a colossal statue carved from a single piece of stone.

**mortise-and-tenon system**—See *tenon*.

**mosaic**—Patterns or pictures made by embedding small pieces (*tesserae*) of stone or glass in cement on surfaces such as walls and floors; also, the technique of making such works.

**mosaic tilework**—An Islamic decorative technique in which large ceramic panels are fired, cut into smaller pieces, and set in plaster.

**mosque**—The Islamic building for collective worship. From the Arabic word *masjid*, meaning a "place for bowing down."

**mudra**—In Buddhist and Hindu iconography, a stylized and symbolic hand gesture. The dhyana (meditation) mudra consists of the right hand over the left, palms upward, in the lap. In the bhumisparsha (earth-touching) mudra, the right hand reaches down to the ground, calling the earth to witness the Buddha's enlightenment. The dharmachakra (Wheel of the Law, or

teaching) mudra is a two-handed gesture with right thumb and index finger forming a circle. The abhaya (do not fear) mudra, with the right hand up, palm outward, is a gesture of protection or blessing.

**Mughal**—"Descended from the Mongols." The Muslim rulers of India, 1526–1857.

**Muhaqqaq**—A cursive style of Islamic *calligraphy*.

**muqarnas**—Stucco decorations of Islamic buildings in which stalactite-like forms break a structure's solidity.

**Muslim**—A believer in Islam.

**nduen fobara**—A Kalabari Ijaw (Nigeria) ancestral screen in honor of a deceased chief of a trading house.

**ngatu**—Decorated *tapa* made by women in Tonga.

**nihonga**—A 19th-century Japanese painting style that incorporated some Western techniques in Japanese-style painting, as opposed to *yoga* (Western painting).

**nimbus**—A halo or aureole appearing around the head of a holy figure to signify divinity.

**nirvana**—In Buddhism and Hinduism, a blissful state brought about by absorption of the individual soul or consciousness into the supreme spirit. Also called moksha.

**nishiki-e**—Japanese, "brocade pictures." Japanese polychrome *woodcut prints* valued for their sumptuous colors.

**nkisi n'kondi**—A power figure carved by the Kongo people of the Democratic Republic of Congo. Such images embodied spirits believed to heal and give life or to be capable of inflicting harm or death.

**oba**—An African sacred king.

**oni**—An African ruler.

**overglaze**—In *porcelain* decoration, the technique of applying mineral colors over the *glaze* after the work has been fired. The overglaze colors, or *enamels*, fuse to the glazed surface in a second firing at a much lower temperature than the main firing. See also *underglaze*.

**pagoda**—An East Asian tower, usually associated with a Buddhist temple, having a multiplicity of winged *eaves*; thought to be derived from the Indian *stupa*.

**parinirvana**—Image of the reclining Buddha, a position often interpreted as representing his death.

**patron**—The person or entity that pays an artist to produce individual artworks or employs an artist on a continuing basis.

**period style**—See *style*.

**personal style**—See *style*.

**personification**—An abstract idea represented in bodily form.

**perspective** (adj. **perspectival**)—A method of presenting an illusion of the three-dimensional world on a two-dimensional surface. In linear perspective, the most common type, all parallel lines or surface edges converge on one, two, or three vanishing points located with reference to the eye level of the viewer (the horizon line of the picture), and associated objects are rendered smaller the farther from the viewer they are intended to seem. Atmospheric, or aerial, perspective creates the illusion of distance by the greater diminution of color intensity, the shift in color toward an almost neutral blue,

and the blurring of contours as the intended distance between eye and object increases.

**pfemba**—A Yombe (Democratic Republic of Congo) mother-and-child group.

**physical evidence**—In art history, the examination of the materials used to produce an artwork in order to determine its date.

**pictograph**—A picture, usually stylized, that represents an idea; also, writing using such means; also, painting on rock. See also *hieroglyphic*.

**pier**—A vertical, freestanding masonry support.

**pillar**—Usually a weight-carrying member, such as a *pier* or a *column;* sometimes an isolated, freestanding structure used for commemorative purposes.

**plan**—The horizontal arrangement of the parts of a building or of the buildings and streets of a city or town, or a drawing or diagram showing such an arrangement. In an axial plan, the parts of a building are organized longitudinally, or along a given axis; in a central plan, the parts of the structure are of equal or almost equal dimensions around the center.

**plane**—A flat surface.

**pointed arch**—A narrow *arch* of pointed profile, in contrast to a semicircular arch.

**porcelain**—Extremely fine, hard, white ceramic. Unlike *stoneware,* porcelain is made from a fine white clay called kaolin mixed with ground petuntse, a type of feldspar. True porcelain is translucent and rings when struck.

**postmodernism**—A reaction against *modernist formalism,* seen as elitist. Far more encompassing and accepting than the more rigid confines of modernist practice, postmodernism offers something for everyone by accommodating a wide range of *styles,* subjects, and formats, from traditional easel painting to *installation* and from abstraction to *illusionistic* scenes. Postmodern art often includes irony or reveals a self-conscious awareness on the part of the artist of art-making processes or the workings of the art world.

**Post-Painterly Abstraction**—An American art movement that emerged in the 1960s and was characterized by a cool, detached rationality emphasizing tighter pictorial control. See also *hard-edge painting*.

**pou tokomanawa**—A sculpture of an ancestor that supports a *ridgepole* of a Maori (New Zealand) meetinghouse.

**pouncing**—The method of transferring a sketch onto paper or a wall by tracing, using thin paper or transparent gazelle skin placed on top of the sketch, pricking the contours of the design into the skin or paper with a pin, placing the skin or paper on the surface to be painted, and forcing black pigment through the holes.

**poupou**—A decorated wall panel in a Maori (New Zealand) meetinghouse.

**powwow**—A traditional Native American ceremony featuring dancing in quilled, beaded, and painted costumes.

**prasada**—In Hindu worship, food that becomes sacred by first being given to a god.

**pre-Columbian** (adj.)—The cultures that flourished in the Western Hemisphere before the arrival of Christopher Columbus and the beginning of European contact and conquest.

**primary colors**—Red, yellow, and blue—the *colors* from which all other colors may be derived.

**proportion**—The relationship in size of the parts of persons, buildings, or objects, often based on a *module*.

**provenance**—Origin or source; findspot.

**pueblo**—A communal multistoried dwelling made of stone or *adobe* brick by the Native Americans of the Southwest. Upper-case *Pueblo* refers to various groups that occupied such dwellings.

**pukao**—A small red scoria cylinder serving as a topknot or hat on Easter Island *moai.*

**purlins**—Horizontal *beams* in a roof structure, parallel to the *ridgepoles,* resting on the main *rafters* and giving support to the secondary rafters.

**qibla**—The direction (toward Mecca) Muslims face when praying.

**radiocarbon dating**—A method of measuring the decay rate of carbon isotopes in organic matter to determine the age of organic materials such as wood and fiber.

**rafters**—The sloping supporting timber planks that run from the *ridgepole* of a roof to its edge.

**ratha**—Small, freestanding Hindu temple carved from a huge boulder.

**regional style**—See *style.*

**relics**—The body parts, clothing, or objects associated with a holy figure, such as the Buddha or Christ or a Christian *saint.*

**relief**—In sculpture, figures projecting from a background of which they are part. The degree of relief is designated high, low (bas), or sunken. In the last, the artist cuts the design into the surface so that the highest projecting parts of the image are no higher than the surface itself. See also *repoussé.*

**reliquary**—A container for holding *relics.*

**ren**—Chinese, "human-heartedness." The quality that the ideal Confucian *junzi* possesses.

**rib**—A relatively slender, molded masonry *arch* that projects from a surface. In *Gothic* architecture, the ribs form the framework of the *vaulting.* A diagonal rib is one of the ribs that form the **X** of a *groin vault.* A transverse rib crosses the *nave* or *aisle* at a 90-degree angle.

**ridgepole**—The beam running the length of a building below the peak of the gabled roof.

**roof comb**—The elaborately sculpted vertical projection surmounting a Maya temple-pyramid.

**rotulus**—The manuscript scroll used by Egyptians, Greeks, Etruscans, and Romans; predecessor of the *codex.*

**rotunda**—The circular area under a *dome;* also a domed round building.

**roundel**—See *tondo.*

**rubbing**—An impression of a relief made by placing paper over the surface and rubbing with a pencil or crayon.

**sabi**—Japanese; the value found in the old and weathered, suggesting the tranquility reached in old age.

**saint**—From the Latin word *sanctus,* meaning "made holy by God." Applied to persons who suffered and died for their Christian faith or who merited reverence for their Christian de-

votion while alive. In the Roman Catholic Church, a worthy deceased Catholic who is canonized by the pope.

**samsara**—In Hindu belief, the rebirth of the soul into a succession of lives.

**samurai**—Medieval Japanese warriors.

**sand painting**—A temporary painting *technique* using sand, varicolored powdered stones, corn pollen, and charcoal. Sand paintings, also called dry paintings, are integral parts of sacred Navajo rituals.

**Satimbe**—"Sister on the head." A Dogon (Mali) mask representing all women.

**saturation**—See *color.*

**scarification**—Decorative markings on the human body made by cutting or piercing the flesh to create scars.

**school**—A chronological and stylistic classification of works of art with a stipulation of place.

**sculpture in the round**—Freestanding figures, carved or modeled in three dimensions.

**seal**—In Asian painting, a stamp affixed to a painting to identify the artist, the *calligrapher,* or the owner. See also *cylinder seals.*

**secondary colors**—Orange, green, and purple, obtained by mixing pairs of *primary colors* (red, yellow, blue).

**section**—In architecture, a diagram or representation of a part of a structure or building along an imaginary plane that passes through it vertically. Drawings showing a theoretical slice across a structure's width are lateral sections. Those cutting through a building's length are longitudinal sections. See also *elevation* and *cutaway.*

**sgrafitto**—A Chinese ceramic technique in which the design is *incised* through a colored *slip.*

**shakti**—In Hinduism, the female power of the deity Devi (or Goddess), which animates the matter of the cosmos.

**shaykh**—An Islamic mystic *saint.*

**sherd**—A fragmentary piece of a broken ceramic vessel.

**shikara**—The beehive-shaped tower of a northern-style Hindu temple.

**Shingon**—The primary form of Buddhism in Japan through the mid-10th century. Lowercase *shingon* is the Japanese term for the words or syllables recited in Buddhist ritual.

**Shino**—Japanese ceramic wares produced during the late 16th and early 17th centuries in kilns in Mino.

**shogun**—In 12th- through 19th-century Japan, a military governor who managed the country on behalf of a figurehead emperor.

**shogunate**—The Japanese military government of the 12th through 19th centuries.

**slip**—A mixture of fine clay and water used in ceramic decoration.

**space**—In art history, both the actual area an object occupies or a building encloses, and the *illusionistic* representation of space in painting and sculpture.

**spectrum**—The range or band of visible colors in natural light.

**splashed-ink painting**—See *haboku.*

**squinch**—An architectural device used as a transition from a square to a polygonal or circular base for a *dome.* It may be composed of *lintels, corbels,* or *arches.*

**statue**—A three-dimensional sculpture.

**still life**—A picture depicting an arrangement of inanimate objects.

**stoneware**—Pottery fired at high temperatures to produce a stonelike hardness and density.

**strut**—A timber plank or other structural member used as a support in a building. Also a short section of marble used to support an arm or leg in a statue.

**stupa**—A large, mound-shaped Buddhist shrine.

**style**—A distinctive artistic manner. Period style is the characteristic style of a specific time. Regional style is the style of a particular geographical area. Personal style is an individual artist's unique manner.

**stylistic evidence**—In art history, the examination of the *style* of an artwork in order to determine its date or the identity of the artist.

**subtractive light**—The painter's light in art; the light reflected from pigments and objects. See also *additive light.*

**subtractive sculpture**—A kind of sculpture technique in which materials are taken away from the original mass; carving.

**sultan**—A *Muslim* ruler.

**Sunnah**—The collection of the Prophet Muhammad's moral sayings and descriptions of his deeds.

**superimposed orders**—*Orders* of architecture that are placed one above another in an *arcaded* or *colonnaded* building, usually in the following sequence: *Doric* (the first story), *Ionic,* and *Corinthian.* Superimposed orders are found in later Greek architecture and were used widely by Roman and *Renaissance* builders.

**superimposition**—In *Mesoamerican* architecture, the erection of a new structure on top of, and incorporating, an earlier structure; the nesting of a series of buildings inside each other.

**surah**—A chapter of the *Koran,* divided into verses.

**sutra**—In Buddhism, an account of a sermon by or a dialogue involving the Buddha. A scriptural account of the Buddha. See also *jataka.*

**symbol**—An image that stands for another image or encapsulates an idea.

**tablero**—See *talud-tablero construction.*

**taj**—Arabic and Persian, "crown."

**talud-tablero construction**—The alternation of sloping (talud) and vertical (tablero) rubble layers, characteristic of Teotihuacan architecture in Mesoamerica.

**tapa**—Barkcloth made particularly in Polynesia. Tapa is often dyed, painted, stenciled, and sometimes perfumed.

**tapestry**—A weaving technique in which the *weft* threads are packed densely over the *warp* threads so that the designs are woven directly into the fabric.

**tarashikomi**—In Japanese art, a painting *technique* involving the dropping of ink and pigments onto surfaces still wet with previously applied ink and pigments.

**tatami**—The traditional woven straw mat used for floor covering in Japanese architecture.

**tatanua**—In New Ireland (Papua New Guinea), the spirits of the dead.

**tatau**—*See* tattoo.

**tattoo**—A permanent design on the skin produced using indelible dyes. The term derives from the Tahitian, Samoan, and Tongan word tatau or tatu.

**tatu**—*See* tattoo.

**technique**—The processes artists employ to create *form,* as well as the distinctive, personal ways in which they handle their materials and tools.

**tempera**—A *technique* of painting using pigment mixed with egg yolk, glue, or casein; also, the *medium* itself.

**tenon**—A projection on the end of a piece of wood that is inserted into a corresponding hole (mortise) in another piece of wood to form a joint.

**tessera** (pl. **tesserae**)—Greek, "cube." A tiny stone or piece of glass cut to the desired shape and size for use in forming a *mosaic.*

**texture**—The quality of a surface (rough, smooth, hard, soft, shiny, dull) as revealed by light. In represented texture, a painter depicts an object as having a certain texture even though the paint is the actual texture.

**thermoluminescence**—A method of dating by measuring amounts of radiation found within the clay of ceramic or sculptural forms, as well as in the clay cores from metal castings.

**togu na**—"House of words." A Dogon (Mali) men's house, where deliberations vital to community welfare take place.

**tokonoma**—A shallow alcove in a Japanese room, which is used for decoration, such as a painting or stylized flower arrangement.

**tonality**—*See* color.

**tondo** (pl. **tondi**)—A circular painting or *relief* sculpture.

**torana**—Gateway in the stone fence around a *stupa,* located at the cardinal points of the compass.

**trefoil**—A cloverlike ornament or symbol with stylized leaves in groups of three.

**tukutuku**—A stitched lattice panel found in a Maori (New Zealand) meetinghouse.

**tumulus** (pl. **tumuli**)—Latin, "burial mound." In Etruscan architecture, tumuli cover one or more subterranean multichambered tombs cut out of the local tufa (limestone). Also characteristic of the Japanese Kofun period of the third and fourth centuries.

**twisted perspective**—*See* composite view.

**ukiyo-e**—Japanese, "pictures of the floating world." During the Edo period, *woodcut prints* depicting brothels, popular entertainment, and beautiful women.

**underglaze**—In *porcelain* decoration, the *technique* of applying mineral colors to the surface before the main firing, followed by an application of clear *glaze.* See also *overglaze.*

**Upanishads**—South Asian religious texts of ca. 800–500 BCE that introduced the concepts of *samsara, karma,* and *moksha.*

**urna**—A whorl of hair, represented as a dot, between the brows; one of the *lakshanas* of the Buddha.

**ushabti**—In ancient Egypt, a figurine placed in a tomb to act as a servant to the deceased in the afterlife.

**ushnisha**—A knot of hair on the top of the head; one of the *lakshanas* of the Buddha.

**value**—*See* color.

**Veda**—Sanskrit, "knowledge." One of four second-millennium BCE South Asian compilations of religious learning.

**vihara**—A Buddhist monastery, often cut into a hill.

**vimana**—A pyramidal tower over the *garbha griha* of a Hindu temple of the southern, or Dravida, style.

**volume**—The *space* that *mass* organizes, divides, or encloses.

**wabi**—A 16th-century Japanese art style characterized by refined rusticity and an appreciation of simplicity and austerity.

**waka sran**—"People of wood." Baule (Côte d'Ivoire) wooden figural sculptures.

**warp**—The vertical threads of a loom or cloth.

**wat**—A Buddhist *monastery* in Cambodia.

**weft**—The horizontal threads of a loom or cloth.

**weld**—To join metal parts by heating, as in assembling the separate parts of a *statue* made by *casting.*

**were-jaguar**—A composite human-jaguar; a common motif in Olmec art.

**yaksha** (m.), **yakshi** (f.)—Lesser local male and female Buddhist and Hindu divinities. Yakshis are goddesses associated with fertility and vegetation. Yakshas, the male equivalent of yakshis, are often represented as fleshy but powerful males.

**yamato-e**—Also known as native-style painting, a purely Japanese style that often involved colorful, decorative representations of Japanese narratives or *landscapes.*

**yang**—In Chinese cosmology, the principle of active masculine energy, which permeates the universe in varying proportions with yin, the principle of passive feminine energy.

**yasti**—In Buddhist architecture, the mast or pole that arises from the dome of the *stupa* and its *harmika* and symbolizes the axis of the universe; it is adorned with a series of chatras (stone disks).

**yin**—*See* yang.

**yoga**—A method for controlling the body and relaxing the mind used in later Indian religions to yoke, or unite, the practitioner to the divine.

**Zen**—A Japanese Buddhist sect and its doctrine, emphasizing enlightenment through intuition and introspection rather than the study of scripture. In Chinese, Chan.

**ziggurat**—In ancient Mesopotamian architecture, a monumental platform for a temple.

# BIBLIOGRAPHY

*This list of books is very selective but comprehensive enough to satisfy the reading interests of the beginning art history student and general reader. The resources listed range from works that are valuable primarily for their reproductions to those that are scholarly surveys of schools and periods or monographs on individual artists. The emphasis is on recent in-print books and on books likely to be found in college and municipal libraries. No entries for periodical articles appear, but the bibliography begins with a list of some of the major journals that publish art historical scholarship in English.*

## SELECTED PERIODICALS

*African Arts*
*American Art*
*American Indian Art*
*American Journal of Archaeology*
*Antiquity*
*Archaeology*
*Archives of American Art*
*Archives of Asian Art*
*Ars Orientalis*
*Art Bulletin*
*Art History*
*Art in America*
*Art Journal*
*Artforum International*
*Burlington Magazine*
*Gesta*
*History of Photography*
*Journal of Roman Archaeology*
*Journal of the Society of Architectural Historians*
*Journal of the Warburg and Courtauld Institutes*
*Latin American Antiquity*
*Oxford Art Journal*
*Women's Art Journal*

## GENERAL STUDIES

Baxandall, Michael. *Patterns of Intention: On the Historical Explanation of Pictures.* New Haven, Conn.: Yale University Press, 1985.

Bindman, David, ed. *The Thames & Hudson Encyclopedia of British Art.* London: Thames & Hudson, 1988.

Boström, Antonia. *The Encyclopedia of Sculpture.* 3 vols. London: Routledge, 2003.

Broude, Norma, and Mary D. Garrard, eds. *The Expanding Discourse: Feminism and Art History.* New York: Harper Collins, 1992.

Bryson, Norman. *Vision and Painting: The Logic of the Gaze.* New Haven, Conn.: Yale University Press, 1983.

Bryson, Norman, Michael Ann Holly, and Keith Moxey. *Visual Theory: Painting and Interpretation.* New York: Cambridge University Press, 1991.

Büttner, Nils. *Landscape Painting: A History.* New York: Abbeville, 2006.

Chadwick, Whitney. *Women, Art, and Society.* 4th ed. New York: Thames & Hudson, 2007.

Cheetham, Mark A., Michael Ann Holly, and Keith Moxey, eds. *The Subjects of Art History: Historical Objects in Contemporary Perspective.* New York: Cambridge University Press, 1998.

Chilvers, Ian, and Harold Osborne, eds. *The Oxford Dictionary of Art.* 3d ed. New York: Oxford University Press, 2004.

Corbin, George A. *Native Arts of North America, Africa, and the South Pacific: An Introduction.* New York: Harper Collins, 1988.

Crouch, Dora P., and June G. Johnson. *Traditions in Architecture: Africa, America, Asia, and Oceania.* New York: Oxford University Press, 2000.

Curl, James Stevens. *Oxford Dictionary of Architecture and Landscape Architecture.* 2d ed. New York: Oxford University Press, 2006.

*Encyclopedia of World Art.* 17 vols. New York: McGraw-Hill, 1959–1987.

Fielding, Mantle. *Dictionary of American Painters, Sculptors, and Engravers.* 2d ed. Poughkeepsie, N.Y.: Apollo, 1986.

Fine, Sylvia Honig. *Women and Art: A History of Women Painters and Sculptors from the Renaissance to the 20th Century.* Rev. ed. Montclair, N.J.: Alanheld & Schram, 1978.

Fleming, John, Hugh Honour, and Nikolaus Pevsner. *The Penguin Dictionary of Architecture and Landscape Architecture.* 5th ed. New York: Penguin, 2000.

Frazier, Nancy. *The Penguin Concise Dictionary of Art History.* New York: Penguin, 2000.

Freedberg, David. *The Power of Images: Studies in the History and Theory of Response.* Chicago: University of Chicago Press, 1989.

Gaze, Delia., ed. *Dictionary of Women Artists.* 2 vols. London: Routledge, 1997.

Hall, James. *Illustrated Dictionary of Subjects and Symbols in Eastern and Western Art.* New York: Icon Editions, 1994.

Harris, Anne Sutherland, and Linda Nochlin. *Women Artists: 1550–1950.* Los Angeles: Los Angeles County Museum of Art; New York: Knopf, 1977.

Hauser, Arnold. *The Sociology of Art.* Chicago: University of Chicago Press, 1982.

Hults, Linda C. *The Print in the Western World: An Introductory History.* Madison: University of Wisconsin Press, 1996.

Kemp, Martin. *The Science of Art: Optical Themes in Western Art from Brunelleschi to Seurat.* New Haven, Conn.: Yale University Press, 1990.

Kostof, Spiro, and Gregory Castillo. *A History of Architecture: Settings and Rituals.* 2d ed. Oxford: Oxford University Press, 1995.

Kultermann, Udo. *The History of Art History.* New York: Abaris, 1993.

Lucie-Smith, Edward. *The Thames & Hudson Dictionary of Art Terms.* 2d ed. New York: Thames & Hudson, 2004.

Moffett, Marian, Michael Fazio, and Lawrence Wadehouse. *A World History of Architecture.* Boston: McGraw-Hill, 2004.

Murray, Peter, and Linda Murray. *A Dictionary of Art and Artists.* 7th ed. New York: Penguin, 1998.

Nelson, Robert S., and Richard Shiff, eds. *Critical Terms for Art History.* Chicago: University of Chicago Press, 1996.

Penny, Nicholas. *The Materials of Sculpture.* New Haven, Conn.: Yale University Press, 1993.

Pevsner, Nikolaus. *A History of Building Types.* London: Thames & Hudson, 1987. Reprint of 1979 ed.

———. *An Outline of European Architecture.* 8th ed. Baltimore: Penguin, 1974.

Pierce, James Smith. *From Abacus to Zeus: A Handbook of Art History.* 7th ed. Upper Saddle River, N.J.: Pearson Prentice Hall, 1998.

Placzek, Adolf K., ed. *Macmillan Encyclopedia of Architects.* 4 vols. New York: Macmillan, 1982.

Podro, Michael. *The Critical Historians of Art.* New Haven, Conn.: Yale University Press, 1982.

Pollock, Griselda. *Vision and Difference: Femininity, Feminism, and Histories of Art.* London: Routledge, 1988.

Preziosi, Donald, ed. *The Art of Art History: A Critical Anthology.* New York: Oxford University Press, 1998.

Read, Herbert. *The Thames & Hudson Dictionary of Art and Artists.* Rev. ed. New York: Thames & Hudson, 1994.

Reid, Jane D. *The Oxford Guide to Classical Mythology in the Arts 1300–1990s.* 2 vols. New York: Oxford University Press, 1993.

Roth, Leland M. *Understanding Architecture: Its Elements, History, and Meaning.* 2d ed. Boulder, Colo.: Westview, 2006.

Schama, Simon. *The Power of Art.* New York: Ecco, 2006.

Slatkin, Wendy. *Women Artists in History: From Antiquity to the 20th Century.* 4th ed. Upper Saddle River, N.J.: Prentice Hall, 2000.

Steer, John, and Antony White. *Atlas of Western Art History: Artists, Sites, and Monuments from Ancient Greece to the Modern Age.* New York: Facts on File, 1994.

Stratton, Arthur. *The Orders of Architecture: Greek, Roman, and Renaissance.* London: Studio, 1986.

Sutton, Ian. *Western Architecture: From Ancient Greece to the Present.* New York: Thames & Hudson, 1999.

Trachtenberg, Marvin, and Isabelle Hyman. *Architecture, from Prehistory to Post-Modernism*. 2d ed. Upper Saddle River, N.J.: Prentice Hall, 2003.

Turner, Jane, ed. *The Dictionary of Art*. 34 vols. New ed. New York: Oxford University Press, 2003.

Wittkower, Rudolf. *Sculpture Processes and Principles*. New York: Harper & Row, 1977.

Wren, Linnea H., and Janine M. Carter, eds. *Perspectives on Western Art: Source Documents and Readings from the Ancient Near East through the Middle Ages*. New York: Harper & Row, 1987.

### Chapter 1:
### South and Southeast Asia before 1200

Asher, Frederick M. *The Art of Eastern India, 300–800*. Minneapolis: University of Minnesota Press, 1980.

Blurton, T. Richard. *Hindu Art*. Cambridge, Mass.: Harvard University Press, 1993.

Chaturachinda, Gwyneth, Sunanda Krishnamurty, and Pauline W. Tabtiang. *Dictionary of South and Southeast Asian Art*. Chiang Mai, Thailand: Silkworm Books, 2000.

Chihara, Daigoro. *Hindu-Buddhist Architecture in Southeast Asia*. Leiden: E. J. Brill, 1996.

Craven, Roy C. *Indian Art: A Concise History*. Rev. ed. London: Thames & Hudson, 1997.

Dehejia, Vidya. *Early Buddhist Rock Temples*. Ithaca, N.Y.: Cornell University Press, 1972.

———. *Indian Art*. London: Phaidon, 1997.

Desai, Vishakha N., and Darielle Mason. *Gods, Guardians, and Lovers: Temple Sculptures from North India AD 700–1200*. New York: Asia Society Galleries, 1993.

*Encyclopedia of Indian Temple Architecture*. 8 vols. New Delhi: American Institute of Indian Studies; Philadelphia: University of Pennsylvania Press, 1983–1996.

Fisher, Robert E. *Buddhist Art and Architecture*. New York: Thames & Hudson, 1993.

Frederic, Louis. *Borobudur*. New York: Abbeville, 1996.

Gopinatha Rao, T. A. *Elements of Hindu Iconography*. 2d ed. 4 vols. New York: Paragon, 1968.

Harle, James C. *The Art and Architecture of the Indian Subcontinent*. 2d ed. New Haven, Conn.: Yale University Press, 1994.

Huntington, Susan L., and John C. Huntington. *The Art of Ancient India: Buddhist, Hindu, Jain*. New York: Weatherhill, 1985.

Jacques, Claude, and Michael Freeman. *Angkor: Cities and Temples*. Bangkok: River Books, 1997.

Jessup, Helen Ibbitson, and Thierry Zephir, eds. *Sculpture of Angkor and Ancient Cambodia: Millennium of Glory*. Washington, D.C.: National Gallery of Art, 1997.

McIntosh, Jane R. *A Peaceful Realm: The Rise and Fall of the Indus Civilization*. Boulder, Colo.: Westview, 2002.

Michell, George. *Hindu Art and Architecture*. New York: Thames & Hudson, 2000.

———. *The Hindu Temple: An Introduction to Its Meaning and Forms*. Chicago: University of Chicago Press, 1988.

Mitter, Partha. *Indian Art*. New York: Oxford University Press, 2001.

Possehl, Gregory L. *The Indus Civilization: A Contemporary Perspective*. Lanham, Md.: AltaMira, 2002.

Rawson, Phillip. *The Art of Southeast Asia*. New York: Thames & Hudson, 1990.

Srinivasan, Doris Meth. *Many Heads, Arms, and Eyes: Origin, Meaning, and Form of Multiplicity in Indian Art*. Leiden: E. J. Brill, 1997.

Stierlin, Henri. *Hindu India from Khajuraho to the Temple City of Madurai*. Cologne: Taschen, 1998.

Williams, Joanna G. *The Art of Gupta India: Empire and Province*. Princeton, N.J.: Princeton University Press, 1982.

### Chapter 2:
### South and Southeast Asia after 1200

Asher, Catherine B. *Architecture of Mughal India*. New York: Cambridge University Press, 1992.

Beach, Milo Cleveland. *Mughal and Rajput Painting*. Cambridge: Cambridge University Press, 1992.

Blurton, T. Richard. *Hindu Art*. Cambridge, Mass.: Harvard University Press, 1993.

Chaturachinda, Gwyneth, Sunanda Krishnamurty, and Pauline W. Tabtiang. *Dictionary of South and Southeast Asian Art*. Chiang Mai, Thailand: Silkworm Books, 2000.

Craven, Roy C. *Indian Art: A Concise History*. Rev. ed. London: Thames & Hudson, 1997.

Dallapiccola, Anna Libera, ed. *Vijayanagara: City and Empire*. 2 vols. Stuttgart: Steiner, 1985.

Dehejia, Vidya. *Indian Art*. London: Phaidon, 1997.

*Encyclopedia of Indian Temple Architecture*. 8 vols. New Delhi: American Institute of Indian Studies; Philadelphia: University of Pennsylvania Press, 1983–1996.

Girard-Geslan, Maud, ed. *Art of Southeast Asia*. New York: Abrams, 1998.

Harle, James C. *The Art and Architecture of the Indian Subcontinent*. 2d ed. New Haven, Conn.: Yale University Press, 1994.

Huntington, Susan L., and John C. Huntington. *The Art of Ancient India: Buddhist, Hindu, Jain*. New York: Weatherhill, 1985.

Michell, George. *Architecture and Art of Southern India: Vijayanagara and the Successor States, 1350–1750*. Cambridge: Cambridge University Press, 1995.

———. *Hindu Art and Architecture*. New York: Thames & Hudson, 2000.

———. *The Hindu Temple: An Introduction to Its Meaning and Forms*. Chicago: University of Chicago Press, 1988.

Mitter, Partha. *Indian Art*. New York: Oxford University Press, 2001.

Pal, Pratapaditya, ed. *Master Artists of the Imperial Mughal Court*. Mumbai: Marg, 1991.

Rawson, Phillip. *The Art of Southeast Asia*. New York: Thames & Hudson, 1990.

Stadtner, Donald M. *The Art of Burma: New Studies*. Mumbai: Marg, 1999.

Stevenson, John, and John Guy, eds. *Vietnamese Ceramics: A Separate Tradition*. Chicago: Art Media Resources, 1997.

Stierlin, Henri. *Hindu India from Khajuraho to the Temple City of Madurai*. Cologne: Taschen, 1998.

Welch, Stuart Cary. *Imperial Mughal Painting*. New York: Braziller, 1978.

———. *India: Art and Culture 1300–1900*. New York: Metropolitan Museum of Art, 1985.

### Chapter 3:
### China and Korea to 1279

Bush, Susan, and Shio-yen Shih. *Early Chinese Texts on Painting*. Cambridge, Mass.: Harvard University Press, 1985.

Cahill, James. *The Painter's Practice: How Artists Lived and Worked in Traditional China*. New York: Columbia University Press, 1994.

Clunas, Craig. *Art in China*. New York: Oxford University Press, 1997.

Fahr-Becker, Gabriele, ed. *The Art of East Asia*. Cologne: Könemann, 1999.

Fisher, Robert E. *Buddhist Art and Architecture*. New York: Thames & Hudson, 1993.

Fong, Wen C. *Beyond Representation: Chinese Painting and Calligraphy, 8th–14th Century*. New Haven, Conn.: Yale University Press, 1992.

———. *The Great Bronze Age of China: An Exhibition from the People's Republic of China*. New York: Metropolitan Museum of Art, 1980.

Fong, Wen C., and James C. Y. Watt. *Preserving the Past: Treasures from the National Palace Museum, Taipei*. New York: Metropolitan Museum of Art, 1996.

Howard, Angela Falco, Li Song, Wu Hong, and Yang Hong. *Chinese Sculpture*. New Haven, Conn.: Yale University Press, 2006.

Li, Chu-tsing, ed. *Artists and Patrons: Some Social and Economic Aspects of Chinese Painting*. Lawrence, Kans.: Kress Department of Art History, in cooperation with Indiana University Press, 1989.

Little, Stephen, and Shawn Eichman. *Taoism and the Arts of China*. Chicago: Art Institute of Chicago, 2000.

Portal, Jane. *Korea: Art and Archaeology*. New York: Thames & Hudson, 2000.

Powers, Martin J. *Art and Political Expression in Early China*. New Haven, Conn.: Yale University Press, 1991.

Rawson, Jessica. *Ancient China: Art and Archaeology*. New York: Harper & Row, 1980.

———, ed. *The British Museum Book of Chinese Art*. New York: Thames & Hudson, 1992.

Sickman, Laurence, and Alexander C. Soper. *The Art and Architecture of China*. 3d ed. New Haven, Conn.: Yale University Press, 1992.

Silbergeld, Jerome. *Chinese Painting Style: Media, Methods, and Principles of Form*. Seattle and London: University of Washington Press, 1982.

Steinhardt, Nancy S., ed. *Chinese Architecture*. New Haven, Conn.: Yale University Press, 2002.

Sullivan, Michael. *The Arts of China*. 4th ed. Berkeley: University of California Press, 2000.

———. *The Birth of Landscape Painting*. Berkeley: University of California Press, 1962.

Thorp, Robert L., and Richard Ellis Vinograd. *Chinese Art and Culture*. New York: Abrams, 2001.

Vainker, S. J. *Chinese Pottery and Porcelain: From Prehistory to the Present*. New York: Braziller, 1991.

Watson, William. *The Arts of China to AD 900*. New Haven, Conn.: Yale University Press, 1995.

———. *The Arts of China 900–1620*. New Haven, Conn.: Yale University Press, 2000.

Weidner, Marsha, ed. *Flowering in the Shadows: Women in the History of Chinese and Japanese Painting*. Honolulu: University of Hawaii Press, 1990.

Whitfield, Roger, and Anne Farrer. *Caves of the Thousand Buddhas: Chinese Art of the Silk Route*. New York: Braziller, 1990.

Wu, Hung. *Monumentality in Early Chinese Art*. Stanford, Calif.: Stanford University Press, 1996.

———. *The Wu Liang Shrine: The Ideology of Early Chinese Pictorial Art*. Stanford, Calif.: Stanford University Press, 1989.

Xin, Yang, Nic Chongzheng, Lang Shaojun, Richard M. Barnhart, James Cahill, and Hung Wu. *Three Thousand Years of Chinese Painting*. New Haven, Conn.: Yale University Press, 1997.

### Chapter 4:
### China and Korea after 1279

Andrews, Julia Frances, and Kuiyi Shen. *A Century in Crisis: Modernity and Tradition in the Art of Twentieth-Century China*. New York: Guggenheim Museum, 1998.

Barnhart, Richard M. *Painters of the Great Ming: The Imperial Court and the Zhe School*. Dallas: Dallas Museum of Art, 1993.

Cahill, James. *The Painter's Practice: How Artists Lived and Worked in Traditional China*. New York: Columbia University Press, 1994.

Clunas, Craig. *Art in China*. New York: Oxford University Press, 1997.

Fahr-Becker, Gabriele, ed. *The Art of East Asia*. Cologne: Könemann, 1999.

Fisher, Robert E. *Buddhist Art and Architecture*. New York: Thames & Hudson, 1993.

Fong, Wen C., and James C. Y. Watt. *Preserving the Past: Treasures from the National Palace Museum, Taipei*. New York: Metropolitan Museum of Art, 1996.

Laing, Ellen Johnston. *The Winking Owl: Art in the People's Republic of China*. Berkeley: University of California Press, 1989.

Li, Chu-tsing, ed. *Artists and Patrons: Some Social and Economic Aspects of Chinese Painting*. Lawrence, Kans.:

Kress Department of Art History in cooperation with Indiana University Press, 1989.

Nakata, Yujiro, ed. *Chinese Calligraphy.* New York: Weatherhill, 1983.

Portal, Jane. *Korea: Art and Archaeology.* New York: Thames & Hudson, 2000.

Rawson, Jessica, ed. *The British Museum Book of Chinese Art.* New York: Thames & Hudson, 1992.

Silbergeld, Jerome. *Chinese Painting Style: Media, Methods, and Principles of Form.* Seattle: University of Washington Press, 1982.

Steinhardt, Nancy S., ed. *Chinese Architecture.* New Haven, Conn.: Yale University Press, 2002.

Sullivan, Michael. *Art and Artists of Twentieth-Century China.* Berkeley: University of California Press, 1996.

———. *The Arts of China.* 4th ed. Berkeley: University of California Press, 1999.

Thorp, Robert L. *Son of Heaven: Imperial Arts of China.* Seattle: Son of Heaven, 1988.

Thorp, Robert L., and Richard Ellis Vinograd. *Chinese Art and Culture.* New York: Abrams, 2001.

Vainker, S. J. *Chinese Pottery and Porcelain: From Prehistory to the Present.* London: Braziller, 1991.

Watson, William. *The Arts of China 900–1260.* New Haven, Conn.: Yale University Press, 2000.

———. *The Arts of China after 1260.* New Haven, Conn.: Yale University Press, 2007.

Weidner, Marsha, ed. *Flowering in the Shadows: Women in the History of Chinese and Japanese Painting.* Honolulu: University of Hawaii Press, 1990.

———. *Views from Jade Terrace: Chinese Women Artists 1300–1912.* Indianapolis: Indianapolis Museum of Art, 1988.

Xin, Yang, Nie Chongzheng, Lang Shaojun, Richard M. Barnhart, James Cahill, and Wu Hung. *Three Thousand Years of Chinese Painting.* New Haven, Conn.: Yale University Press, 1997.

## CHAPTER 5:
### JAPAN BEFORE 1333

Aikens, C. Melvin, and Takayama Higuchi. *Prehistory of Japan.* New York: Academic, 1982.

Coaldrake, William H. *Architecture and Authority in Japan.* London: Routledge, 1996.

Elisseeff, Danielle, and Vadime Elisseeff. *Art of Japan.* Translated by I. Mark Paris. New York: Abrams, 1985.

Kidder, J. Edward, Jr. *The Art of Japan.* New York: Park Lane, 1985.

Kurata, Bunsaku. *Horyu-ji: Temple of the Exalted Law.* Translated by W. Chie Ishibashi. New York: Japan Society, 1981.

Mason, Penelope. *History of Japanese Art.* New York: Abrams, 1993.

Nishi, Kazuo, and Kazuo Hozumi. *What Is Japanese Architecture?* Translated by H. Mack Horton. New York: Kodansha International, 1985.

Nishikawa, Kyotaro, and Emily Sano. *The Great Age of Japanese Buddhist Sculpture AD 600–1300.* Fort Worth, Tex.: Kimbell Art Museum, 1982.

Okudaira, Hideo. *Narrative Picture Scrolls.* Adapted by Elizabeth ten Grotenhuis. New York: Weatherhill, 1973.

Pearson, Richard J. *Ancient Japan.* New York: Braziller, 1992.

Pearson, Richard J., Gina Lee Barnes, and Karl L. Hutterer, eds. *Windows on the Japanese Past.* Ann Arbor: Center for Japanese Studies, University of Michigan, 1986.

Rosenfield, John M. *Japanese Art of the Heian Period, 794–1185.* New York: Asia Society, 1967.

Shimizu, Yoshiaki, ed. *The Shaping of Daimyo Culture 1185–1868.* Washington, D.C.: National Gallery of Art, 1988.

Stanley-Baker, Joan. *Japanese Art.* Rev. ed. New York: Thames & Hudson, 2000.

Suzuki, Kakichi. *Early Buddhist Architecture in Japan.* Translated and adapted by Mary Neighbor Parent and Nancy Shatzman Steinhardt. New York: Kodansha International, 1980.

## CHAPTER 6:
### JAPAN AFTER 1336

Addiss, Stephen. *The Art of Zen.* New York: Abrams, 1989.

Baekeland, Frederick. *Imperial Japan: The Art of the Meiji Era (1868–1912).* Ithaca, N.Y.: Herbert F. Johnson Museum of Art, 1980.

Brown, Kendall. *The Politics of Reclusion: Painting and Power in Muromachi Japan.* Honolulu: University of Hawaii Press, 1997.

Cahill, James. *Scholar Painters of Japan.* New York: Asia Society, 1972.

Coaldrake, William H. *Architecture and Authority in Japan.* London: Routledge, 1996.

Fontein, Jan, and Money L. Hickman. *Zen Painting and Calligraphy.* Greenwich, Conn.: New York Graphic Society, 1970.

Guth, Christine. *Art of Edo Japan: The Artist and the City, 1615–1868.* New York: Abrams, 1996.

Hickman, Money L., John T. Carpenter, Bruce A. Coats, Christine Guth, Andrew J. Pekarik, John M. Rosenfield, and Nicole C. Rousmaniere. *Japan's Golden Age: Momoyama.* New Haven, Conn.: Yale University Press, 1996.

Kawakita, Michiaki. *Modern Currents in Japanese Art.* Translated by Charles E. Terry. New York: Weatherhill, 1974.

Kidder, J. Edward, Jr. *The Art of Japan.* New York: Park Lane, 1985.

Lane, Richard. *Images from the Floating World: The Japanese Print.* New York: Dorset, 1978.

Mason, Penelope. *History of Japanese Art.* New York: Abrams, 1993.

Munroe, Alexandra. *Japanese Art after 1945: Scream against the Sky.* New York: Abrams, 1994.

Nishi, Kazuo, and Kazuo Hozumi. *What Is Japanese Architecture?* Translated by H. Mack Horton. New York: Kodansha International, 1985.

Sanford, James H., William R. LaFleur, and Masatoshi Nagatomi. *Flowing Traces: Buddhism in the Literary and Visual Arts of Japan.* Princeton, N.J.: Princeton University Press, 1992.

Shimizu, Yoshiaki, ed. *Japan: The Shaping of Daimyo Culture, 1185–1868.* Washington, D.C.: National Gallery of Art, 1988.

Singer, Robert T. *Edo: Art in Japan 1615–1868.* Washington, D.C.: National Gallery of Art, 1998.

Stanley-Baker, Joan. *Japanese Art.* Rev. ed. New York: Thames & Hudson, 2000.

Stewart, David B. *The Making of a Modern Japanese Architecture, 1868 to the Present.* New York: Kodansha International, 1988.

## CHAPTER 7:
### THE ISLAMIC WORLD

Allan, James, and Sheila R. Canby. *Hunt for Paradise: Court Arts of Safavid Iran 1501–76.* Geneva: Skira, 2004.

Atil, Esin. *The Age of Sultan Suleyman the Magnificent.* Washington, D.C.: National Gallery of Art, 1987.

Baker, Patricia L. *Islamic Textiles.* London: British Museum, 1995.

Blair, Sheila S., and Jonathan Bloom. *The Art and Architecture of Islam 1250–1800.* New Haven, Conn.: Yale University Press, 1994.

Bloom, Jonathan, and Sheila S. Blair. *Islamic Arts.* London: Phaidon, 1997.

Brend, Barbara. *Islamic Art.* Cambridge, Mass.: Harvard University Press, 1991.

Canby, Sheila R. *Persian Painting.* London: British Museum, 1993.

Dodds, Jerrilynn D., ed. *Al-Andalus: The Art of Islamic Spain.* New York: Metropolitan Museum of Art, 1992.

Ettinghausen, Richard, Oleg Grabar, and Marilyn Jenkins-Madina. *The Art and Architecture of Islam, 650–1250.* Rev. ed. New Haven, Conn.: Yale University Press, 2001.

Ferrier, Ronald W., ed. *The Arts of Persia.* New Haven, Conn.: Yale University Press, 1989.

Frishman, Martin, and Hasan-Uddin Khan. *The Mosque: History, Architectural Development, and Regional Diversity.* New York: Thames & Hudson, 1994.

Goodwin, Godfrey. *A History of Ottoman Architecture.* 2d ed. New York: Thames & Hudson, 1987.

Grabar, Oleg. *The Alhambra.* Cambridge, Mass.: Harvard University Press, 1978.

———. *The Formation of Islamic Art.* Rev. ed. New Haven, Conn.: Yale University Press, 1987.

Grube, Ernst J. *Architecture of the Islamic World: Its History and Social Meaning.* 2d ed. New York: Thames & Hudson, 1984.

Hattstein, Markus, and Peter Delius, eds. *Islam: Art and Architecture.* Cologne: Könemann, 2000.

Hillenbrand, Robert. *Islamic Architecture: Form, Function, Meaning.* Edinburgh: Edinburgh University Press, 1994.

———. *Islamic Art and Architecture.* New York: Thames & Hudson, 1999.

Irwin, Robert. *Islamic Art in Context: Art, Architecture, and the Literary World.* New York: Abrams, 1997.

Michell, George, ed. *Architecture of the Islamic World.* New York: Thames & Hudson, 1978.

Necipoglu, Gulru. *The Age of Sinan: Architectural Culture in the Ottoman Empire.* Princeton, N.J.: Princeton University Press, 2005.

Porter, Venetia. *Islamic Tiles.* London: British Museum, 1995.

Robinson, Frank. *Atlas of the Islamic World.* Oxford: Equinox, 1982.

Schimmel, Annemarie. *Calligraphy and Islamic Culture.* New York: New York University Press, 1984.

Stierlin, Henri. *Islam I: Early Architecture from Baghdad to Cordoba.* Cologne: Taschen, 1996.

———. *Islamic Art and Architecture from Isfahan to the Taj Mahal.* New York: Thames & Hudson, 2002.

Ward, Rachel M. *Islamic Metalwork.* New York: Thames & Hudson, 1993.

Welch, Anthony. *Calligraphy in the Arts of the Islamic World.* Austin: University of Texas Press, 1979.

## CHAPTER 8:
### NATIVE ARTS OF THE AMERICAS BEFORE 1300

Alva, Walter, and Christopher Donnan. *Royal Tombs of Sipán.* Los Angeles: Fowler Museum of Cultural History, 1993.

Benson, Elizabeth P., and Beatriz de la Fuente, eds. *Olmec Art of Ancient Mexico.* Washington, D.C.: National Gallery of Art, 1996.

Berlo, Janet Catherine, ed. *Art, Ideology, and the City of Teotihuacan.* Washington, D.C.: Dumbarton Oaks, 1992.

Berlo, Janet Catherine, and Ruth B. Phillips. *Native North American Art.* New York: Oxford University Press, 1998.

Berrin, Kathleen, ed. *The Spirit of Ancient Peru: Treasures from the Museo Arqueologico Rafael Larco Herrera.* San Francisco: Fine Arts Museums of San Francisco, 1997.

Brody, J. J., and Rina Swentzell. *To Touch the Past: The Painted Pottery of the Mimbres People.* New York: Hudson Hills, 1996.

Brose, David. *Ancient Art of the American Woodland Indians.* New York: Abrams, 1985.

Bruhns, Karen O. *Ancient South America.* New York: Cambridge University Press, 1994.

Burger, Richard. *Chavín and the Origins of Andean Civilization.* New York: Thames & Hudson, 1992.

Carrasco, David. *The Oxford Encyclopedia of Mesoamerican Cultures: The Civilizations of Mexico and Central America.* New York: Oxford University Press, 2001.

Clark, John E., and Mary E. Pye, eds. *Olmec Art and Archaeology in Mesoamerica.* Washington, D.C.: National Gallery of Art, 2000.

Coe, Michael D. *The Maya.* 7th ed. New York: Thames & Hudson, 2005.

———. *Mexico: From the Olmecs to the Aztecs.* 5th ed. New York: Thames & Hudson, 2002.

Cordell, Linda S. *Ancient Pueblo Peoples.* Washington, D.C.: Smithsonian Institution, 1994.

Fagan, Brian. *Ancient North America: The Archaeology of a Continent.* 4th ed. New York: Thames & Hudson, 2005.

Fash, William. *Scribes, Warriors, and Kings: The City of Copan and the Ancient Maya.* New York: Thames & Hudson, 1991.

Feest, Christian F. *Native Arts of North America.* 2d ed. New York: Thames & Hudson, 1992.

Foster, Michael S., and Shirley Gorenstein, eds. *Greater Mesoamerica: The Archaeology of West and Northwest Mexico.* Salt Lake City: University of Utah Press, 2000.

Grube, Nikolai, ed. *Maya: Divine Kings of the Rain Forest.* Cologne: Könemann, 2000.

Kolata, Alan. *The Tiwanaku: Portrait of an Andean Civilization.* Cambridge: Blackwell, 1993.

Kubler, George. *The Art and Architecture of Ancient America: The Mexican, Maya, and Andean Peoples.* 3d ed. New Haven, Conn.: Yale University Press, 1992.

Miller, Mary Ellen. *The Art of Mesoamerica, from Olmec to Aztec.* 4th ed. New York: Thames & Hudson, 2006.

———. *Maya Art and Architecture.* New York: Thames & Hudson, 1999.

Miller, Mary Ellen, and Karl Taube. *The Gods and Symbols of Ancient Mexico and the Maya: An Illustrated Dictionary of Mesoamerican Religion.* New York: Thames & Hudson, 1993.

Morris, Craig, and Adriana von Hagen. *The Inka Empire and Its Andean Origins.* New York: Abbeville, 1993.

Nabokov, Peter, and Robert Easton. *Native American Architecture.* New York: Oxford University Press, 1989.

Pasztory, Esther. *Pre-Columbian Art.* New York: Cambridge University Press, 1998.

Paul, Anne. *Paracas Ritual Attire: Symbols of Authority in Ancient Peru.* Norman: University of Oklahoma Press, 1990.

Penney, David, and George C. Longfish. *Native American Art.* Hong Kong: Hugh Lauter Levin and Associates, 1994.

Schele, Linda, and Peter Mathews. *The Code of Kings: The Language of Seven Sacred Maya Temples and Tombs.* New York: Scribner, 1998.

Schele, Linda, and Mary E. Miller. *The Blood of Kings: Dynasty and Ritual in Maya Art.* Fort Worth, Tex.: Kimbell Art Museum, 1986.

Schmidt, Peter, Mercedes de la Garza, and Enrique Nalda, eds. *Maya.* New York: Rizzoli, 1998.

Stone-Miller, Rebecca. *Art of the Andes from Chavín to Inca.* 2d ed. New York: Thames & Hudson, 2002.

Townsend, Richard F., ed. *Ancient West Mexico.* Chicago: Art Institute of Chicago, 1998.

Von Hagen, Adriana, and Craig Morris. *The Cities of the Ancient Andes.* New York: Thames & Hudson, 1998.

Wardwell, Allen. *Ancient Eskimo Ivories of the Bering Strait.* New York: Rizzoli, 1986.

Whiteford, Andrew H., Stewart Peckham, and Kate Peck Kent. *I Am Here: Two Thousand Years of Southwest Indian Arts and Crafts.* Santa Fe: Museum of New Mexico Press, 1989.

## CHAPTER 9:
### NATIVE ARTS OF THE AMERICAS AFTER 1300

Bawden, Garth. *Moche.* Oxford: Blackwell, 1999.

Berlo, Janet Catherine, ed. *Plains Indian Drawings 1865–1935.* New York: Abrams, 1996.

Berlo, Janet Catherine, and Ruth B. Phillips. *Native North American Art.* New York: Oxford University Press, 1998.

Boone, Elizabeth. *The Aztec World.* Washington, D.C.: Smithsonian Institution Press, 1994.

Bruhns, Karen O. *Ancient South America.* New York: Cambridge University Press, 1994.

Coe, Michael D. *The Maya.* 7th ed. New York: Thames & Hudson, 2005.

———. *Mexico: From the Olmecs to the Aztecs.* 5th ed. New York: Thames & Hudson, 2002.

D'Altroy, Terence N. *The Incas.* New ed. Oxford: Blackwell, 2003.

Davies, Nigel. *The Ancient Kingdoms of Peru.* New York: Penguin, 1997.

Feest, Christian F. *Native Arts of North America.* 2d ed. New York: Thames & Hudson, 1992.

Fienup-Riordan, Ann. *The Living Tradition of Yup'ik Masks.* Seattle: University of Washington Press, 1996.

Fitzhugh, William W., and Aron Crowell, eds. *Crossroads of Continents: Cultures of Siberia and Alaska.* Washington, D.C.: Smithsonian Institution Press, 1988.

Gasparini, Graziano, and Luise Margolies. *Inca Architecture.* Bloomington: Indiana University Press, 1980.

Hill, Tom, and Richard W. Hill, Sr., eds. *Creation's Journey: Native American Identity and Belief.* Washington, D.C.: Smithsonian Institution Press, 1994.

Kubler, George. *The Art and Architecture of Ancient America: The Mexican, Maya, and Andean Peoples.* 3d ed. New Haven, Conn.: Yale University Press, 1992.

Malpass, Michael A. *Daily Life in the Inca Empire.* Westport, Conn.: Greenwood, 1996.

Mathews, Zena, and Aldona Jonaitis, eds. *Native North American Art History.* Palo Alto, Calif.: Peek, 1982.

Matos, Eduardo M. *The Great Temple of the Aztecs: Treasures of Tenochtitlan.* New York: Thames & Hudson, 1988.

Maurer, Evan M. *Visions of the People: A Pictorial History of Plains Indian Life.* Seattle: University of Washington Press, 1992.

McEwan, Gordon F. *The Incas: New Perspectives.* Santa Barbara, Calif.: ABC-CLIO, 2006.

Miller, Mary Ellen. *The Art of Mesoamerica, from Olmec to Aztec.* 4th ed. New York: Thames & Hudson, 2006.

Morris, Craig, and Adriana von Hagen. *The Inka Empire and Its Andean Origins.* New York: Abbeville, 1993.

Moseley, Michael E. *The Incas and Their Ancestors: The Archaeology of Peru.* Rev. ed. New York: Thames & Hudson, 2001.

Nabokov, Peter, and Robert Easton. *Native American Architecture.* New York: Oxford University Press, 1989.

Pasztory, Esther. *Aztec Art.* New York: Abrams, 1983.

———. *Pre-Columbian Art.* New York: Cambridge University Press, 1998.

Penney, David W. *North American Indian Art.* New York: Thames & Hudson, 2004.

Phillips, Ruth B. *Trading Identities: The Souvenir in Native North American Art.* Seattle: University of Washington Press, 1998.

Samuel, Cheryl. *The Chilkat Dancing Blanket.* Norman: University of Oklahoma Press, 1982.

Schaafsma, Polly, ed. *Kachinas in the Pueblo World.* Albuquerque: University of New Mexico Press, 1994.

Silverman, Helaine. *The Nasca.* Oxford: Blackwell, 2002.

———, ed. *Andean Archaeology.* Oxford: Blackwell, 2004.

Smith, Michael Ernest. *The Aztecs.* 2d ed. Oxford: Blackwell, 2002.

Stewart, Hilary. *Looking at Totem Poles.* Seattle: University of Washington Press, 1993.

Von Hagen, Adriana, and Craig Morris. *The Cities of the Ancient Andes.* New York: Thames & Hudson, 1998.

Wardwell, Allen. *Tangible Visions: Northwest Coast Indian Shamanism and Its Art.* New York: Monacelli, 1996.

Washburn, Dorothy. *Living in Balance: The Universe of the Hopi, Zuni, Navajo, and Apache.* Philadelphia: University Museum, 1995.

Weaver, Muriel Porter. *The Aztecs, Mayas, and Their Predecessors.* 3d ed. San Diego: Academic, 1993.

Wright, Robin K. *Northern Haida Master Carvers.* Seattle: University of Washington Press, 2001.

Wyman, Leland C. *Southwest Indian Drypainting.* Albuquerque: University of New Mexico Press, 1983.

## CHAPTER 10:
### AFRICA BEFORE 1800

Bacquart, Jean-Baptiste. *The Tribal Arts of Africa.* New York: Thames & Hudson, 2002.

Bassani, Ezio. *Arts of Africa: 7,000 Years of African Art.* Milan: Skira, 2005.

Ben-Amos, Paula. *The Art of Benin.* New York: Thames & Hudson, 1980.

Blier, Suzanne P. *Royal Arts of Africa: The Majesty of Form.* New York: Abrams, 1998.

Campbell, Alec, and David Coulson. *African Rock Art: Paintings and Engravings on Stone.* New York: Abrams, 2001.

Connah, Graham. *African Civilizations.* 2d ed. Cambridge: Cambridge University Press, 2001.

Dewey, William J. *Legacies of Stone: Zimbabwe Past and Present.* Tervuren: Royal Museum for Central Africa, 1997.

Drewal, Henry J., John Pemberton, and Rowland Abiodun. *Yoruba: Nine Centuries of African Art and Thought.* New York: Center for African Art, in association with Abrams, 1989.

Eyo, Ekpo, and Frank Willett. *Treasures of Ancient Nigeria.* New York: Knopf, 1980.

Fagg, Bernard. *Nok Terracottas.* Lagos: Ethnographica, 1977.

Garlake, Peter. *Early Art and Architecture of Africa.* Oxford: Oxford University Press, 2002.

———. *Great Zimbabwe.* London: Thames & Hudson, 1973.

Huffman, Thomas N. *Snakes and Crocodiles: Power and Symbolism in Ancient Zimbabwe.* Johannesburg: Witwatersrand University Press, 1996.

Lajoux, Jean-Dominique. *The Rock Paintings of Tassili.* Cleveland: World Publishing, 1963.

Phillips, Tom, ed. *Africa, the Art of a Continent.* New York: Prestel, 1995.

Phillipson, D. W. *African Archaeology.* 2d ed. New York: Cambridge University Press, 1993.

———. *Ancient Ethiopia: Aksum, Its Antecedents and Successors.* London: British Museum Press, 1998.

Schädler, Karl-Ferdinand. *Earth and Ore: 2,500 Years of African Art in Terra-Cotta and Metal.* Munich: Panterra Verlag, 1997.

Shaw, Thurstan. *Nigeria: Its Archaeology and Early History.* London: Thames & Hudson, 1978.

———. *Unearthing Igbo-Ukwu: Archaeological Discoveries in Eastern Nigeria.* New York: Oxford University Press, 1977.

Visonà, Monica Blackmun, ed. *A History of Art in Africa.* Upper Saddle River, N.J.: Prentice Hall, 2003.

Willett, Frank. *Ife in the History of West African Sculpture.* New York: McGraw-Hill, 1967.

## CHAPTER 11:
### AFRICA AFTER 1800

Abiodun, Roland, Henry J. Drewal, and John Pemberton III, eds. *The Yoruba Artist: New Theoretical Perspectives on African Arts.* Washington, D.C.: Smithsonian Institution Press, 1994.

Bassani, Ezio. *Arts of Africa: 7,000 Years of African Art.* Milan: Skira, 2005.

Blier, Suzanne P. *The Royal Arts of Africa.* New York: Abrams, 1998.

Cole, Herbert M. *Icons: Ideals and Power in the Art of Africa.* Washington, D.C.: National Museum of African Art, Smithsonian Institution, 1989.

———, ed. *I Am Not Myself: The Art of African Masquerade.* Los Angeles: UCLA Fowler Museum of Cultural History, 1985.

Cole, Herbert M., and Chike C. Aniakor. *Igbo Art: Community and Cosmos.* Los Angeles: UCLA Fowler Museum of Cultural History, 1984.

Fraser, Douglas F., and Herbert M. Cole, eds. *African Art and Leadership.* Madison: University of Wisconsin Press, 1972.

Geary, Christraud M. *Things of the Palace: A Catalogue of the Bamum Palace Museum in Foumban (Cameroon).* Weisbaden: Franz Steiner Verlag, 1983.

Glaze, Anita J. *Art and Death in a Senufo Village.* Bloomington: Indiana University Press, 1981.

Kasfir, Sidney L. *Contemporary African Art.* London: Thames & Hudson, 1999.

———. *West African Masks and Cultural Systems.* Tervuren: Musée Royal de l'Afrique Centrale, 1988.

Magnin, Andre, with Jacques Soulillou. *Contemporary Art of Africa.* New York: Abrams, 1996.

McGaffey, Wyatt, and Michael Harris. *Astonishment and Power (Kongo Art).* Washington, D.C.: Smithsonian Institution Press, 1993.

Nooter, Mary H. *Secrecy: African Art That Conceals and Reveals.* New York: Museum for African Art, 1993.

Oguibe, Olu, and Okwui Enwezor, eds. *Reading the Contemporary: African Art from Theory to the Marketplace.* London: Institute of International Visual Arts, 1999.

Phillips, Ruth B. *Representing Women: Sande Masquerades of the Mende of Sierra Leone.* Los Angeles: UCLA Fowler Museum of Cultural History, 1995.

Sieber, Roy, and Roslyn A. Walker. *African Art in the Cycle of Life.* Washington, D.C.: Smithsonian Institution Press, 1987.

Thompson, Robert F., and Joseph Cornet. *The Four Moments of the Sun: Kongo Art in Two Worlds.* Washington, D.C.: National Gallery of Art, 1981.

Vinnicombe, Patricia. *People of the Eland: Rock Paintings of the Drakensberg Bushmen as a Reflection of Their Life and Thought.* Pietermaritzburg: University of Natal Press, 1976.

Visonà, Monica Blackmun, ed. *A History of Art in Africa.* Upper Saddle River, N.J.: Prentice Hall, 2003.

Vogel, Susan M. *Baule: African Art, Western Eyes.* New Haven, Conn.: Yale University Press, 1997.

———, ed. *Africa Explores: Twentieth-Century African Art.* New York: Te Neues, 1990.

Walker, Roslyn A. *Olowe of Ise: A Yoruba Sculptor to Kings.* Washington, D.C.: National Museum of African Art, 1998.

## Chapter 12:
### Oceania

Caruana, Wally. *Aboriginal Art.* 2d ed. New York: Thames & Hudson, 2003.

Cox, J. Halley, and William H. Davenport. *Hawaiian Sculpture.* Rev. ed. Honolulu: University of Hawaii Press, 1988.

D'Alleva, Anne. *Arts of the Pacific Islands.* New York: Abrams, 1998.

Feldman, Jerome, and Donald H. Rubinstein. *The Art of Micronesia.* Honolulu: University of Hawaii Art Gallery, 1986.

Greub, Suzanne, ed. *Authority and Ornament: Art of the Sepik River, Papua New Guinea.* Basel: Tribal Art Centre, 1985.

Hanson, Allan, and Louise Hanson, eds. *Art and Identity in Oceania.* Honolulu: University of Hawaii Press, 1990.

Kaeppler, Adrienne L., Christian Kaufmann, and Douglas Newton. *Oceanic Art.* New York: Abrams, 1997.

Kooijman, Simon. *Tapa in Polynesia.* Honolulu: Bishop Museum Press, 1972.

Mead, Sidney Moko, ed. *Te Maori: Maori Art from New Zealand Collections.* New York: Abrams in association with the American Federation of Arts, 1984.

Morphy, Howard. *Aboriginal Art.* London: Phaidon, 1998.

Sayers, Andrew. *Australian Art.* New York: Oxford University Press, 2001.

Schneebaum, Tobias. *Embodied Spirits: Ritual Carvings of the Asmat.* Salem, Mass.: Peabody Museum of Salem, 1990.

Smidt, Dirk, ed. *Asmat Art: Woodcarvings of Southwest New Guinea.* New York: Braziller in association with Rijksmuseum voor Volkenkunde, Leiden, 1993.

Starzecka, Dorota, ed. *Maori Art and Culture.* Chicago: Art Media Resources, 1996.

Sutton, Peter, ed. *Dreamings: The Art of Aboriginal Australia.* New York: Braziller in association with the Asia Society Galleries, 1988.

Thomas, Nicholas. *Oceanic Art.* London: Thames & Hudson, 1995.

# CREDITS

*The author and publisher are grateful to the proprietors and custodians of various works of art for photographs of these works and permission to reproduce them in this book. Sources not included in the captions are listed here.*

**Introduction—I-1:** Metropolitan Museum of Art, Michael C. Rockefeller Memorial Collection, Gift of Nelson A. Rockefeller, 1965. (1987.412.309) Photograph © 1983 The Metropolitan Museum of Art; **I-2:** National Gallery, London. NG14. Bought, 1824; **I-3:** MOA Art Museum, Shizuoka-ken, Japan; **I-4:** Bayerische Staatsgemäldesammlungen, Alte Pinakothek, Munich and Kunstdia-Archiv ARTOTHEK, Weilheim, Germany; **I-5a:** © National Library of Australia, Canberra, Australia/The Bridgeman Art Library, NY; **I-5b:** From *The Childhood of Man* by Leo Frobenius (New York: J.B. Lippincott, 1909).

**Chapter 1—1-1:** © cphotocorp.com; **1-2:** © Borromeo/Art Resource, NY; **1-3:** © John C. Huntington; **1-4:** © Borromeo/Art Resource, NY; **1-5:** © National Museum of India, New Delhi/Bridgeman Art Library; **1-6:** © Benoy K. Behl; **1-7b:** © Scala/Art Resource, NY; **1-8:** akg-images/Jean-Louis Nou; **1-10:** © The Trustees of the National Museums of Scotland; **1-11:** Freer Gallery of Art, Smithsonian Institution, Washington, D.C. Purchase, F1949.9a-d; **1-12:** © Benoy K. Behl; **1-13:** © John C. Huntington; **1-14:** © Lindsay Hebberd/CORBIS; **1-15:** © Benoy K. Behl; **1-16:** Courtesy Saskia Ltd., © Dr. Ron Wiedenhoeft; **1-17:** akg-images/Jean-Louis Nou; **1-18:** © Werner Forman/CORBIS; **1-19:** © Borromeo/Art Resource, NY; **1-20:** akg-images/Jean-Louis Nou; **1-21:** © James Davis; Eye Ubiquitous/CORBIS; **1-22:** © JC Harle Collection; **1-23a:** © David Cumming; Eye Ubiquitous/CORBIS; **1-24:** © Jack Fields/CORBIS; **1-25:** Robert L. Brown; **1-26:** © Yadid Levy/ Robert Harding Picture Library; **1-27:** © Charles & Josette Lenars/CORBIS; **1-28:** © Luca I. Tettoni/CORBIS; **1-29:** © John Gollings; **1-30:** © Christophe Loviny/CORBIS; **1-31:** © John Gollings; **1-32:** © Giraudon/Art Resource, NY.

**Chapter 2—2-1:** © Kevin R. Morris/CORBIS; **2-2:** © The Art Archive; **2-3:** © Geoffrey Taunton/Cordaiy Photo Library Ltd./CORBIS; **2-4:** © Victoria & Albert Museum, London/Art Resource, NY; **2-5:** Freer Gallery of Art, Smithsonian Institution, Washington, D.C., Purchase, F1942.15a; **2-6:** © Yann-Arthus Bertrand/CORBIS; **2-7:** National Museum, New Delhi; **2-8:** © Christophe Boisvieux/CORBIS; **2-9:** © Tony Waltham/Robert Harding Picture Library; **2-10:** The Brooklyn Museum of Art, 87.234.6; **2-11:** © Stuart Westmorland; **2-12:** © Luca Tettoni Photography; **2-13:** © Ladislav Janicek/zefa/CORBIS; **2-14:** Pacific Asia Museum Collection, Gift of Hon. and Mrs. Jack Lydman, Museum No. 1991.47.34; **2-15:** © Benoy K. Behl.

**Chapter 3—3-1:** The Art Archive/National Palace Museum, Taiwan; **3-2:** © Cultural Relics Publishing House, Beijing; **3-3:** © Asian Art Museum of San Francisco, The Avery Brundage Collection, B60B1032. Used by permission.; **3-4:** © ChinaStock/Sanxingdui Museum of China; **3-5:** The Nelson-Atkins Museum of Art, Kansas City, Missouri. Purchase, Nelson Trust, 33-81. Photo: E. G. Schempf; **3-6:** akg-images/Laurent Lecat; **3-7:** © Hunan Provincial Museum, Changsa City; **3-8:** Niche, South Wall Rubbing, h. 68.5 cm, w. 143.3 cm, Far Eastern Seminar Collection, Princeton University Art Museum. Photo: Bruce M. White. © 2006 Trustees of Princeton University; **3-9:** The Nelson-Atkins Museum of Art, Kansas City, Missouri. Purchase, Nelson Trust, 33-521. Photo: Robert Newcombe; **3-11:** © Asian Art Museum of San Francisco, The Avery Brundage Collection, B60B1034. Used by permission.; **3-12:** © British Museum/HIP/Art Resource, NY; **3-13:** © Réunion des Musées Nationaux/Art Resource, NY; **3-14:** © Lowell Georgia/CORBIS; **3-15:** © Cultural Relics Publishing House, Beijing; **3-17:** © Museum of Fine Arts, Boston, MA, USA, Denman Waldo Ross Collection/The Bridgeman Art Library, NY; **3-18:** © ChinaStock/Liu Liqun; **3-19:** © Victoria & Albert Museum, London/Art Resource, NY; **3-20:** © Lee & Lee Communications/Art Resource, NY; **3-21:** © Cultural Relics Publishing House, Beijing; **3-22:** © Asian Art Museum of San Francisco, The Avery Brundage Collection, B60B161. Used by permission.; **3-23a:** © Liu Liqun/CORBIS; **3-24:** © Collection of the National Palace Museum, Taiwan, Republic of China; **3-25:** Toyko National Museum. Image © TNM Image Archives. Source: http://TnmArchives.jp; **3-26:** © Museum of Fine Arts, Boston, MA, USA, General Funds/The Bridgeman Art Library, NY; **3-27:** © Kyongju National Museum, Kyongju; **3-28:** © Archivo Iconografico, S.A./CORBIS; **3-29:** National Treasure No. 68, Kansong Museum of Fine Arts. © Kansong Museum, Seoul, Korea.

**Chapter 4—4-1:** © Alfred Ko/CORBIS; **4-2:** Collection of the National Palace Museum, Taiwan, Republic of China; **4-3:** Collection of the National Palace Museum, Taiwan, Republic of China; **4-4:** Collection of the National Palace Museum, Taiwan, Republic of Chiina; **4-5:** Percival David Foundation of Chinese Art, B614; **4-6:** photos12.com, Panorama Stock; **4-7:** © Carl and Ann Purcell/CORBIS; **4-8:** © Werner Forman/Art Resource, NY; **4-9:** © Victoria & Albert Museum/Art Resource, NY; **4-10:** Cultural Relics Publishing House, Beijing; **4-11:** Collection of the National Palace Museum, Taiwan, Republic of China; **4-12:** Leonard C. Hanna Bequest, 1980, photo copyright © Cleveland Museum of Art, Cleveland; **4-13:** Gift of Mr. Robert Allerton, 1957 (2306.1), photo copyright © Honolulu Academy of Arts; **4-14:** John Taylor Photography, C. C. Wang Family Collection, NY; **4-15:** Cultural Relics Publishing House, Beijing; **4-16:** Percival David Foundation of Chinese Art, A821; **4-17:** © Audrey R. Topping; **4-18:** Copyright © Xu Bing, courtesy Chazen Museum of Art (formerly Elvehjem Museum of Art), University of Wisconsin; **4-19:** © Ludovic Maisant/CORBIS; **4-20:** Hoam Art Museum, Kyunggi-Do; **4-21:** Heritage Images, © The British Museum.

**Chapter 5—5-1:** © Sakamoto Photo Research Laboratory/CORBIS; **5-2:** Toyko National Museum. Image © TNM Image Archives. Source: http://TnmArchives.jp; **5-3:** Toyko National Museum. Image © TNM Image Archives. Source: http://TnmArchives.jp; **5-4:** © Georg Gerster/Photo Researchers, Inc.; **5-5:** Toyko National Museum. Image © TNM Image Archives. Source: http://TnmArchives.jp; **5-6:** Jingu-Shicho, Mie; **5-7:** © Archivo Iconografico, S.A./CORBIS; **5-8:** Yakushiji Temple, Nara; **5-9a:** © Archivo Iconografico, S.A./CORBIS; **5-9b:** © DAJ/Getty Images; **5-10:** Horyuji, Nara. Photo:Benrido; **5-11:** © Sakamoto Photo Research Laboratory/CORBIS; **5-12:** Kyoogokokuji (Toji), Kyoto; **5-13:** © Sakamoto Photo Research Laboratory/CORBIS; **5-14:** © The Gotoh Art Museum, Tokyo; **5-15:** © Chogosonshiji Temple, Nara, Japan; **5-16:** Todaiji, Nara; **5-17:** © Museum of Fine Arts, Boston, MA, USA, Fenollosa-Weld Collection/The Bridgeman Art Library, NY; **5-18:** © Zenrin-ji Temple, Kyoto.

**Chapter 6—6-1:** Photo copyright © MOA Art Museum, Shizuoka-ken, Japan; **6-2:** © Patricia J. Graham; **6-3:** TNM Image Archives, Source: http//TNMArchives.jp/; **6-4:** TNM Image Archives, Source: http//TNMArchives.jp/; **6-5:** © Sakamoto Photo Research Laboratory/CORBIS; **6-6:** TNM Image Archives, Source: http//TNMArchives.jp/; **6-8:** © The Hatakeyama Memorial Museum of Fine Art, Tokyo; **6-10:** TNM Image Archives, Source: http//TNMArchives.jp/; **6-11:** Photo copyright © Hiraki Ukiyo-e Museum, Yokohama, **6-12:** 1925.2043, Photography © The Art Institute of Chicago; **6-13:** 11.17652, Photograph © 2008 Museum of Fine Arts, Boston; **6-14:** Tokyo National University of Fine Arts and Music; **6-15:** Copyright © Shokodo Co., Ltd.; **6-16:** National Yoyogi Stadium, photo courtesy Tokyo Convention and Visitors Bureau; **6-17:** National Museum of Modern Art, Kyoto; **6-18:** Association de la Jeune Sculpture 1987/2 photo © Serge Goldberg.

**Chapter 7—7-1:** The Art Archive/Dagli Orti; **7-2:** © Moshe Shai/CORBIS; **7-3:** © Erich Lessing/Art Resource, NY; **7-4:** Photo Archives Skira, Geneva, Switzerland; **7-5:** Photo, Henri Stierlin; **7-7:** © Bildarchiv Preussischer Kulturbesitz/Art Resource, NY; **7-8a:** © Yann Arthus-Bertrand/CORBIS; **7-9:** Photo, Henri Stierlin; **7-10:** © E. Simanor/Robert Harding Picture Library; **7-11:** www.bednorz-photo.de; **7-12:** www.bednorz-photo.de; **7-13:** © Adam Woolfit/ Robert Harding Picture Library; **7-14:** © Musée Lorrain, Nancy, France/photo G. Mangin; **7-15:** © The State Hermitage Museum, St. Petersburg; **7-16:** © The Trustees of the Chester Beatty Library, Dublin; **7-17:** © Toyohiro Yamada/Getty Images/Taxi; **7-18:** Photo, Henri Stierlin; **7-20:** Photo, Henri Stierlin; **7-21:** Photo, Henri Stierlin; **7-22:** Photo Henri Stierlin; **7-24:** © SEF/Art Resource, NY; **7-25:** Metropolitan Museum of Art, Harris Brisbane Dick Fund, 1939 (39.20) Photograph © 1982 The Metropolitan Museum of Art; **7-26:** © Erich Lessing/Art Resource, NY; **7-27:** AKTC 2005.01 [M200] © Aga Khan Trust for Culture, formerly in the collection of Prince and Princess Sadruddin Aga Khan; **7-28:** © Victoria & Albert Museum, London/Art Resource, NY; **7-29:** © Copyright the Trustees of the British Museum; **7-30:** © Réunion des Musées Nationaux/Art Resource, NY; **7-31:** Freer Gallery of Art Washington, D.C., Purchase, F1941.10.

**Chapter 8—8-1:** © The British Museum/HIP/The Image Works; **8-2:** © Danny Lehman/ CORBIS; **8-3:** © Werner Forman/Art Resource NY; **8-4:** Los Angeles County Museum of Art, The Proctor Stafford Collection, purchased with funds provided by Mr. and Mrs. Allan C. Balch. Photograph © 2006 Museum Associates/LACMA; **8-5:** © Georg Gerster/Photo Researchers, Inc.; **8-6:** © Gianni Dagli Orti/CORBIS; **8-7:** The Art Archive/Dagli Orti; **8-8:** © Philip Baird www.anthroarcheart.org; **8-9:** © Sean Sprague/The Image Works; **8-10:** © Enzo and Paolo Rogazzini/CORBIS; **8-11:** akg-images/François Guénet; **8-12:** © 2007 Peabody Museum of Archaeology and Ethnology , Harvard University, Cambridge.

# INDEX

*Boldface names refer to artists. Page numbers in italics refer to illustrations.*